THE MASTERPIECES OF FRENCH PAINTING FROM THE METROPOLITAN MUSEUM OF ART 1800–1920

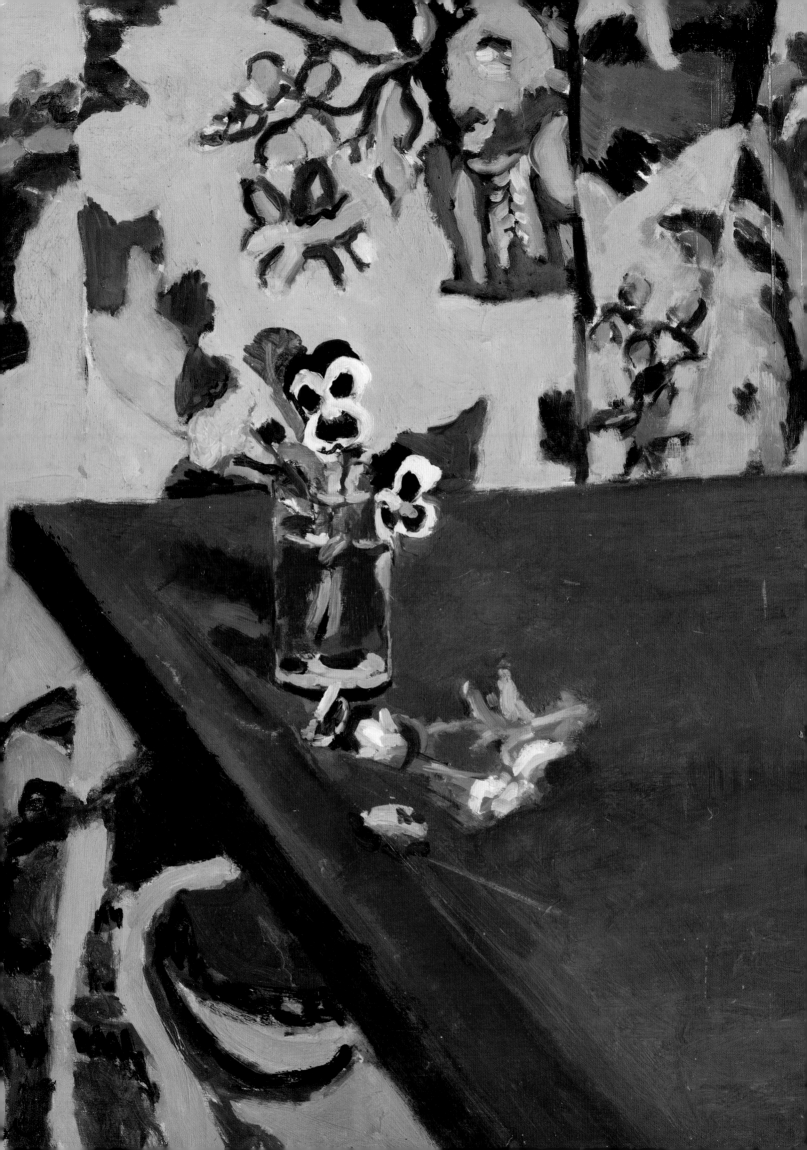

THE MUSEUM OF FINE ARTS, HOUSTON
FEBRUARY 4–MAY 6, 2007

THE MASTERPIECES OF FRENCH PAINTING FROM THE METROPOLITAN MUSEUM OF ART 1800–1920

INTRODUCTION BY GARY TINTEROW

TEXTS BY KATHRYN CALLEY GALITZ, SABINE REWALD,
SUSAN ALYSON STEIN, AND GARY TINTEROW

THE METROPOLITAN MUSEUM OF ART, NEW YORK

This volume has been published in conjunction with the exhibition "The Masterpieces of French Painting from The Metropolitan Museum of Art: 1800–1920," held at The Museum of Fine Arts, Houston, February 4–May 6, 2007

Published by The Metropolitan Museum of Art, New York
Copyright © 2007 by The Metropolitan Museum of Art, New York

John P. O'Neill, Editor in Chief
Gwen Roginsky, Associate General Manager of Publications
Ellen Shultz and Cynthia Clark, Senior Editors
Bruce Campbell, Designer
Peter Antony, Chief Production Manager
Sally Van Devanter, Production Manager

Cataloging-in-Publication Data is available from the Library of Congress.
ISBN 978-1-58839-213-8 (hc: The Metropolitan Museum of Art)
ISBN 978-1-58839-214-5 (pbk: The Metropolitan Museum of Art)

Photographs by The Photograph Studio, The Metropolitan Museum of Art

Cover/jacket: Camille Pissarro. *The Boulevard Montmartre on a Winter Morning* (detail). See no. 52

Frontispiece: Henri Matisse. *Pansies* (detail). See no. 129

Printed and bound in Italy

Lead sponsor:

JPMorganChase ⬡

Major underwriting is provided by The Hamill Foundation.

Additional generous support is provided by:

The Albert and Margaret Alkek Foundation

The M. D. Anderson Foundation

The Sarah Campbell Blaffer Foundation

Mr. Charles Butt

Mr. and Mrs. Philip J. Carroll

Mr. and Mrs. Charles W. Duncan, Jr.

Mr. and Mrs. James C. Flores

Mr. and Mrs. Richard D. Kinder

Mr. and Mrs. C. Berdon Lawrence

Mr. and Mrs. Meredith J. Long

Mr. Fayez Sarofim

The Bob and Vivian Smith Foundation

John L. Wortham & Son, L.P. / Chadwick G. Dodd

Mr. and Mrs. Russell M. Frankel

The Wallace Foundation

The Scaler Foundation

Linda K. Finger

Mr. and Mrs. Rodney H. Margolis

Education programs receive generous support
from the Favrot Fund.

Contents

Acknowledgments vi

Director's Foreword viii

New Galleries for Old, *by Gary Tinterow* 3

Catalogue *by Kathryn Calley Galitz, Sabine Rewald,
Susan Alyson Stein, and Gary Tinterow* 17

Illustrated Checklist 179

ACKNOWLEDGMENTS

Presenting an exhibition of this magnitude is truly a once-in-a-lifetime opportunity. The Metropolitan Museum of Art's renowned collection of nineteenth- and early-twentieth-century French paintings is without doubt the finest outside Paris, and will afford Houstonians an unparalleled look at some of the greatest art from this remarkably creative period. The exposure to these extraordinary works will leave an indelible mark on the cultural life of our city, much as the memorable loan exhibition "The Heroic Century: The Museum of Modern Art Masterpieces, 200 Paintings and Sculptures" did in 2003. Although in recent years Houstonians have had superb opportunities at The Museum of Fine Arts to see fine French paintings lent by such important museums as the Musée d'Orsay, Paris; the State Pushkin Museum of Fine Arts, Moscow; the Ordrupgaard Museum, Copenhagen; and The Phillips Collection, Washington, D.C., the scope of the Metropolitan Museum's collection is unrivaled, and its impact will thus be exponentially greater.

The decision by Philippe de Montebello, director of the Metropolitan Museum, and the trustees to lend these treasures during the planned renovation of the Metropolitan's galleries for nineteenth-century European art must be applauded as a genuinely visionary gesture, as it affords hundreds of thousands of people beyond New York a unique occasion to enjoy this superlative collection. The Metropolitan Museum's holdings reflect more than a century of outstanding philanthropy by many private collectors, including Louisine and H. O. Havemeyer, Stephen C. Clark, and Sam A. Lewisohn, all of whom had the vision and insight to acquire paintings that in many cases were still quite controversial, and also the munificence to make these works available to the public. Through the combined efforts of these donors and the expertise of a series of dedicated and discerning curators, including Bryson Burroughs; Theodore Rousseau, Jr.; Everett Fahy; and Gary Tinterow, the collection today comprises great paintings from every artistic movement spanning Neoclassicism to Cubism.

The trustees of The Museum of Fine Arts, Houston, extend their appreciation above all to Philippe de Montebello and the trustees of the Metropolitan, for allowing these masterpieces to travel to Houston—the only venue in the United States chosen to host this exhibition. In particular, we wish to acknowledge the great insight and circumspection of Gary Tinterow, Engelhard Curator in Charge, Department of Nineteenth-Century, Modern, and Contemporary Art, curator of this exhibition and an author of the accompanying catalogue, together with Susan Alyson Stein, Curator, and Kathryn Calley Galitz, Assistant Curator, Nineteenth-Century European Paintings, and Sabine Rewald, Jacques and Natasha Gelman Curator, Modern and Contemporary Art. Special thanks go to Asher E. Miller, Research Associate, for his editorial assistance, and to Nykia Omphroy, Assistant for Administration, for her help with the project. We extend our appreciation to Mahrukh Tarapor, Associate Director for Exhibitions / Director of International Affairs, Geneva office; Aileen Chuk, Registrar, and

vi

Frances Wallace, Associate Registrar. Our sincere thanks go to John P. O'Neill, Editor in Chief and General Manager of Publications; Ellen Shultz and Cynthia Clark, Senior Editors; Peter Antony, Chief Production Manager; Sally Van Devanter, Production Manager; and Bruce Campbell, Designer, for their work on the beautiful catalogue. We also thank Kent Lydecker, John Welch, Stella Paul, and William B. Crow of the Education Department.

In Houston, we wish to thank JPMorgan Chase, the lead sponsor, and the Hamill Foundation, for providing major underwriting support, as well as the Albert and Margret Alkek Foundation; the Sarah Campbell Blaffer Foundation; Mr. Charles Butt; Mr. and Mrs. Philip J. Carroll; Mr. and Mrs. Charles W. Duncan, Jr.; Mr. and Mrs. James C. Flores; Mr. and Mrs. Richard D. Kinder; Mr. and Mrs. C. Berdon Lawrence; Mr. and Mrs. Meredith J. Long; Mr. Fayez Sarofim; John L. Wortham & Son, L.P. / Chadwick G. Dodd; the Wallace Foundation; the Scaler Foundation; Linda K. Finger; and Mr. and Mrs. Rodney H. Margolis. Education programs have received generous support from the Favrot Fund. The full list of funders was still in preparation at press time.

Among the many colleagues in Houston who deserve thanks for helping to implement this exhibition are Bill Cochrane and Jack Eby, who are responsible for the design and installation of this monumental show. For their advice and assistance we would like to acknowledge our curatorial colleagues, especially Alison de Lima Greene and Karen Bremer Vetter, for their efforts in coordinating this undertaking with all departments. Special thanks are due Teresa Harson of the European Art Department, for her untiring help; Diane Lovejoy and Phenon Finley-Smiley of the Publications and Graphics departments, respectively; Frances Carter Stephens and the Public Relations Department; Andrew Huang and the Marketing Department; Julie Bakke and Kathleen Crain of the Registrar's Department; Wynne Phelan and Andrea di Bagno of the Conservation Department; and Beth Schneider and Margaret Mims of the Education Department. Further thanks go to Marty Stein, Jon Evans, Patricia Smith, Bernard Bonnet, and Chick Bianchi, and to Michael Kennaugh and the Preparations Department for helping to convince the Metropolitan Museum staff to lend these treasures to Houston.

In addition, we are grateful to Paul Johnson and the Development Department for their tenacious fund-raising efforts, as well as to Gwendolyn Goffe. Finally, we wish to sincerely thank Isabel B. Wilson, Chairman of the Board of Trustees, and Peter C. Marzio, Director of The Museum of Fine Arts, for their dedicated commitment to ensuring that the "best of the best" of the Metropolitan's French art made the journey to Houston.

Edgar Peters Bowron
The Audrey Jones Beck Curator

Helga Kessler Aurisch
Assistant Curator of European Art

Director's Foreword

Once again, the Metropolitan Museum is expanding its galleries for nineteenth-century European painting. The present rooms, opened to the public in 1993 and visited by some forty million people since then, require repainting and refurbishing. Nine more galleries will be created as well, in ten thousand square feet of additional space, in order to accommodate over one hundred and twenty-five new pictures acquired in the last fourteen years. The expansion and renovation of the existing galleries—themselves, only thirteen years old—is only the latest manifestation of the Metropolitan's continual cycle of development and renewal. In fact, the collections and the galleries that contain them have undergone a steady growth and change, from the moment that the Metropolitan Museum was founded in 1870. The Museum's first, provisional display, in the skylit gallery of a former dancing academy at 681 Fifth Avenue (see fig. 1); the temporary quarters in the Douglas mansion on Fourteenth Street (see fig. 2); the skylit gallery that, today, houses the magnificent Tiepolos at the top of the great stairs; and the side-lit gallery paved in granite that greets visitors to the Lila Acheson Wallace Wing for twentieth-century art, all have reflected the constant preoccupation of the Museum's curators and architects: the establishment of ample, well-lit, and attractive rooms in which to view its modern paintings.

The construction and renovation is taking place during 2007—making possible the loan of a large group of pictures from among what has become the most comprehensive collection of French nineteenth-century painting outside of France. Never before has the Museum allowed so many of its most popular pictures to leave the building en masse, and, I would venture to say, it is not likely that such an extraordinary opportunity will be repeated again.

Philippe de Montebello
Director
The Metropolitan Museum of Art

The Masterpieces of French Painting from The Metropolitan Museum of Art
1800–1920

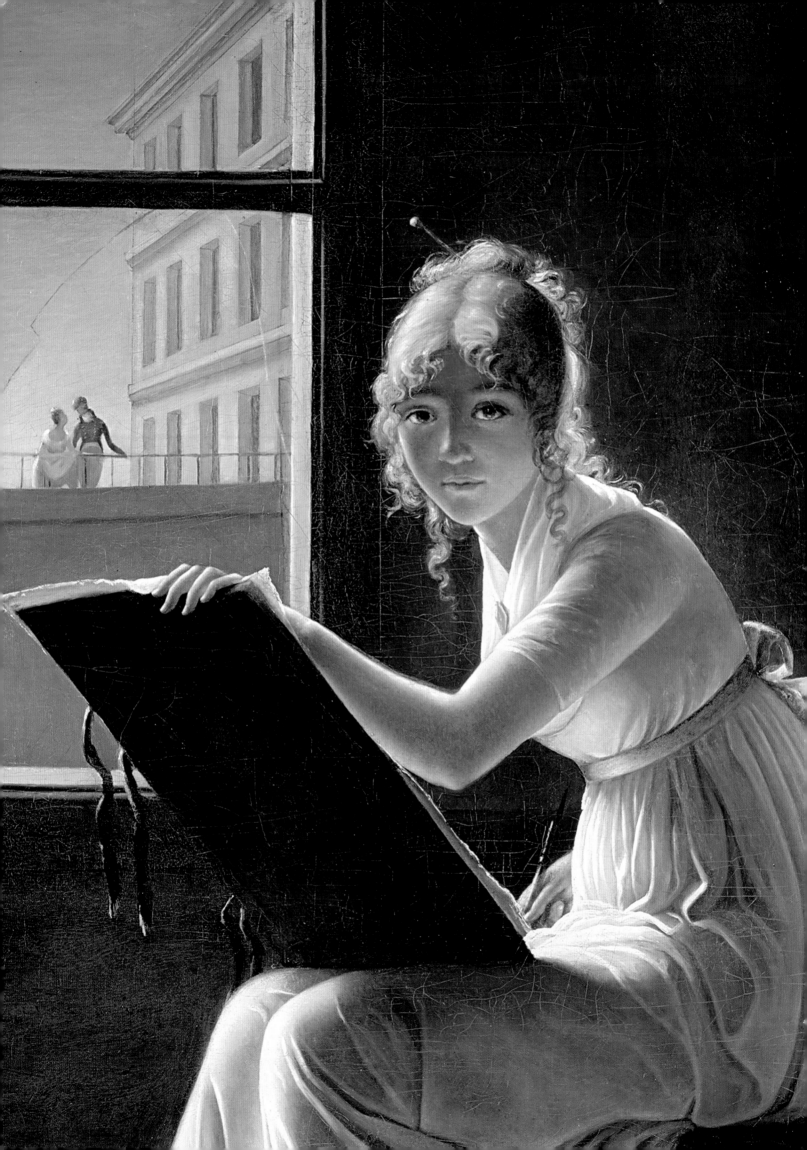

New Galleries for Old

by Gary Tinterow

The Metropolitan Museum of Art owned only a small picture collection—174 mostly Dutch and Flemish paintings—when the Central Park Commission requested from Calvert Vaux a plan for the Museum's first permanent home (fig. 3). Vaux, along with Jacob Wrey Mould, the architect of all the buildings in Central Park, nevertheless completed four commodious paintings galleries on the second floor of the structure in 1879. This was the first wing of what was intended to be a mammoth complex of buildings. Like the exterior, the paintings galleries were Neo-Gothic in their decorative detail and High Victorian in their proportions and arrangement, but they were governed overall by a modest and simple aesthetic (fig. 4). The walls were skirted with a wainscoting made up of painted tongue-in-groove boards, and they were faced above the chair rail with inexpensive burlap that was deep red in some rooms and pale cinnamon in others. A wide frieze was situated just below a narrow cornice crowned with a curved plaster cove. The laylight, a narrow tent of rectangular glass panes, was supported by an iron frame pierced with decorative ventilation grilles. Daylight was supplemented by gaslight, which was very quickly converted to electric light, powered by DC generators that remained on the premises until the early 1950s.

New York painters Frederic Church, Eastman Johnson, and J. F. Kensett played central roles in the creation of the Museum; from the beginning, in addition to antiquities and Old Master paintings, the Museum exhibited contemporary

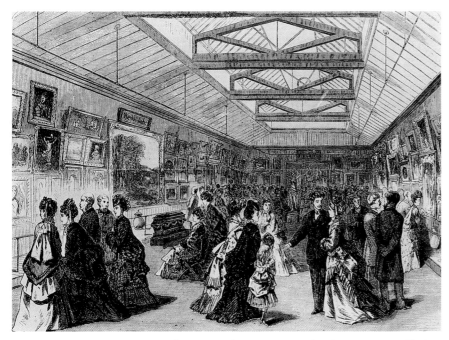

Figure 1. Opening reception in The Metropolitan Museum of Art's temporary galleries at 681 Fifth Avenue, February 20, 1872. (Archives of The Metropolitan Museum of Art)

Opposite: Marie-Denise Villers. *Young Woman Drawing* (detail). See no. 1

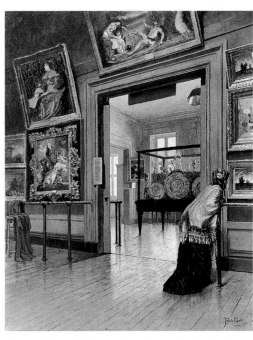

Figure 2. Frank Waller (American, 1842–1923). *Interior View of The Metropolitan Museum of Art When on Fourteenth Street.* 1873–80. Oil on canvas. Purchase, 1895 (95.29)

Figure 3. The Museum's first building in Central Park, Wing A, designed by Calvert Vaux and Jacob Wrey Mould, opened in 1880. The western façade may still be seen today, from the Robert Lehman Wing. (Photo: Archives of The Metropolitan Museum of Art)

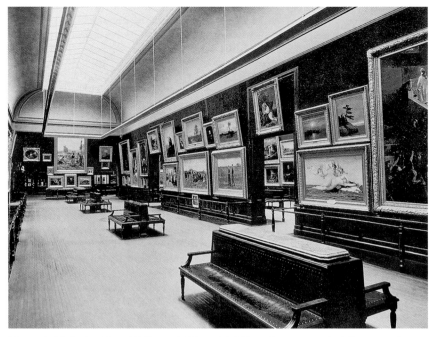

Figure 4. Galleries U and V (later, A 21 and A 20), at the west end of the second floor of the Vaux building, Wing A, as they appeared between 1887 and 1902. Sixteenth-century European paintings now occupy this space, whose façade may be seen, today, from the Petrie Court. (Photo: Archives of The Metropolitan Museum of Art)

Figure 5. The picture galley of Alexander T. Stewart, showing Ernest Meissonier's *1807, Friedland* (87.20.1), and Rosa Bonheur's *The Horse Fair* (87.25), bought at auction in 1887 and presented as gifts to the Metropolitan Museum. (Photo: *The Opulent Interiors of the Gilded Age*, 1987)

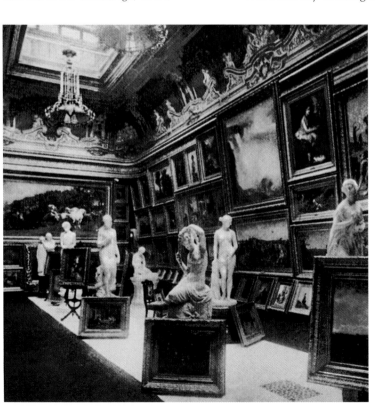

works, both American and international, owned by New York artists and collectors. This would become the foundation of its permanent collection of modern Western art, and would continue to evolve as a reflection of the interests and tastes of prominent New Yorkers as well as of a few collectors from other cities who had special attachments to the Metropolitan. At the east end of the Vaux building, later known as Wing A, two paintings galleries were reserved for the Old Masters, in the permanent collection or on loan. At the west end, near the Park Drive, the modern pictures—primarily loans—were installed. According to *The Saturday Evening Post*, "The Hanging Committee has done the most remarkable and admirable work ever seen in this country at a public exhibition of paintings. The features of this work are conspicuously two: the system of bold or delicate and suggestive balancings, and the commingling of Americans and foreigners without respect to persons. You walk through the two large western galleries and you feel that American art is not so bad after all, because you see that it stands up like a man by the side of its fellows and neither blushes nor faints. . . . The eye is not shocked to find a Gérôme balancing an Eastman Johnson, a Troyon balancing a William Magrath, a Bouguereau balancing a Henry Loop."[1] As a matter of course, the paintings were hung frame to frame, three and four rows high, in the manner that had been customary in Europe since the late sixteenth century, but the effect must have appeared restrained and institutional in comparison to the luxurious private galleries (fig. 5)—upholstered in silk and enriched by ormolu—in the homes of the same New Yorkers who lent their modern paintings to the Museum.

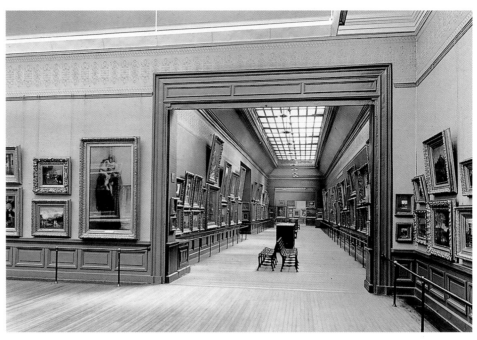

Figure 6. Galleries R and L (later, B 16 and B 17), the central spine of the second floor of the building designed by Theodore Weston, Wing B, which opened in 1888, as seen in 1910. These galleries, much altered today, are used for special exhibitions. (Photo: Archives of The Metropolitan Museum of Art)

No sooner had Wing A opened than its galleries were deemed inadequate in size. In 1884 Theodore Weston, a minor architect who was a member of the Museum's Board, was commissioned by his fellow trustees to provide an extension at the south side of the Vaux building. Wing B opened in 1888. Although it had the virtue of a more up-to-date façade—Neo-Greek was deemed an improvement over Vaux's Ruskinian Gothic—the new paintings galleries on the second floor retained the proportions of Vaux's original rooms: narrow rectangular spaces often three times longer than they were wide. The new galleries were mean in appearance (fig. 6). The wainscoting and door surrounds were pressed metal instead of wood, the coves were flat and ungenerous, and the floor was laid down in narrow strips of oak.[2]

Dissatisfied with Weston, the trustees chose an even less accomplished architect, Arthur L. Tuckerman, then manager of the Museum's art schools, to design the next extension, Wing C, to the north. It was an infelicitous decision. Richard Morris Hunt, a truly distinguished architect and a founding trustee, resigned from the Board in protest. Having complained about the original decision to hire Vaux, and having issued a warning about Weston, Hunt found the situation hopeless.[3] The trustees discovered that he was right: the Museum's art schools were discontinued, and over time Tuckerman's Wing C, which opened in 1894, has been subsumed in the course of the Museum's perpetual rebuilding, so that hardly a trace of the original is visible today.

The new wings did provide locations for the display of the rapidly enlarging collection of modern art. In 1887 Catharine Lorillard Wolfe, the formidable daughter of an American tobacco magnate, bequeathed the collection of British, French, German, and Spanish contemporary art that she had specifically assembled for the Museum (fig. 7). Knowing that she could not compete with such institutions as the Louvre in Paris or the Gemäldegalerie in Berlin, Wolfe commissioned copies or variants of the most famous pictures by the most celebrated

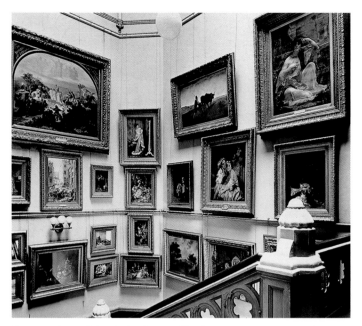

Figure 7. Part of the Catharine Lorillard Wolfe Collection, installed in Wing A, in 1918. (Photo: Archives of The Metropolitan Museum of Art)

European artists of her day. Her bequest of 143 pictures immediately made the Metropolitan a destination for "modern" art, although not in the sense that we use the term today: the works that she collected were by artists like Bouguereau, Cabanel, and Cot, or Gabriel Max and August Schenck, who did not break with tradition, and whose pictures, hence, fetched the highest prices and took all the honors. Through a series of unintended incidents, in 1889 the Museum also received the gift of two paintings now regarded as icons of the "New Painting"—the modern approach developed by artists in Paris in the 1860s—Manet's *Young Lady in 1866* and *Boy with a Sword*. Arriving at the Metropolitan only six years after the artist's premature death, they would become the first paintings by Manet to enter a museum collection anywhere. Just as Manet's works, with their broad planes of bright and unmodulated color, disturbed viewers at the Paris Salon, the Metropolitan's Manets must likewise have been conspicuous outsiders among Catharine Lorillard Wolfe's favorite pictures, with their meticulous technique and anachronistic subjects.

Richard Morris Hunt was mollified when he was asked to create a comprehensive master plan for the Museum—one that would redirect it away from the park and toward Fifth Avenue, abandoning the old-fashioned red-brick eclecticism of the first structure in favor of the splendid Beaux-Arts style that was then considered essential for any building with civic pretensions. Sadly, he did not live to see his first wing—now encompassing the Great Hall—completed. When it opened in 1902, the Museum administration made an effort to bring the paintings galleries in Wings A, B, and C up to the standard of Hunt's magnificent hall. The fabric-covered gallery walls, already shoddy, were refitted with Lincrusta Walton, a durable paper pressed with patterns in low relief, but this superficial change could not remedy the poor proportions of the rooms or the uneven light that poured in without control.

The firm of McKim, Mead & White was chosen in 1904 to succeed Hunt as house architects. For the first time, the requirements for proper display of the Museum's collections were given serious consideration. Museum trustees in other American cities—notably, Boston, Detroit, and Saint Louis—had commissioned extensive studies of the best examples of European museum design in London, Vienna, Berlin, Munich, Saint Petersburg, and elsewhere, but the Metropolitan's trustees had been in too much of a hurry to put a roof over their burgeoning collections. By the time McKim, Mead & White were hired, however, Museum administrators had become painfully aware of the limitations of their existing galleries, and Building Committee meetings were devoted to discussions of such technical issues as display practices, lighting needs, and ventilation and humidity control, as well as more controversial issues such as gallery sizes and ceiling heights, about which the architects had opinions as strong as those of the Museum's policy makers.

The result of the new collaboration between the Museum and McKim, Mead & White was the procession of handsome rooms up and down the new Fifth

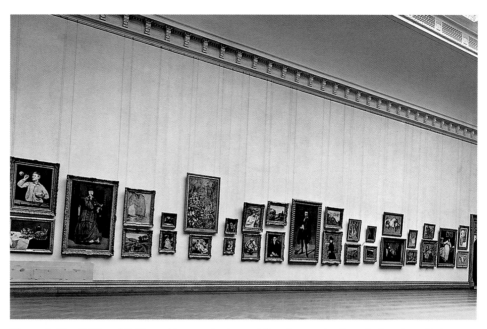

Figure 8. The 1921 exhibition of Impressionist and Post-Impressionist painting, installed on the second floor of Wing D. (Photo: Archives of The Metropolitan Museum of Art)

Avenue buildings—Wings E, H, J, and K—but these galleries were primarily occupied, then as now, not by the paintings department but by other curatorial departments. Surprisingly, there was not yet a proper curator of paintings at the Museum, but that would soon change: the brilliant English critic Roger Fry was hired in 1906, along with the American painter Bryson Burroughs as his assistant. Fry, and, in turn, his successor, Burroughs, set out to change the complexion of the collection. Using funds bequeathed by Catharine Lorillard Wolfe, they made several notable purchases—Puvis de Chavannes's *Shepherd's Song,* in 1906; Renoir's portrait of Madame Charpentier and her children, in 1907; Manet's *The Funeral,* in 1909; and Cézanne's *View of the Domaine Saint-Joseph* (from the New York Armory Show), in 1913—and although these few acquisitions were outnumbered by those that reflected the academic tastes of the nineteenth century, comprehensive collections of Barbizon painting were bequeathed to the Museum not long after by Benjamin Altman and Isaac D. Fletcher.

To help inform a larger public about the activities of some of New York's serious collectors, Burroughs organized special exhibitions of paintings in the large galleries off the second-floor balcony of Hunt's Great Hall—such as that devoted to Courbet in 1919 and to Impressionism and Post-Impressionism in 1921, but these were exceptional events (fig. 8). Whenever he was not hampered by restrictions of gift or deed, Bryson Burroughs continually refined the collection of Old Masters by weeding out misattributed paintings and replacing inferior pictures with superior ones. He also brought the installation of modern pictures in line with the emerging notion that avant-garde French painting was inherently more significant than academic or Salon painting. In part, this was a function of taste—Renoir surpassed Sorolla in popularity during World War I—but in large measure it represented a triumph of the theories advanced by European art critics and historians such as Roger Fry, Léon Rosenthal, Robert Rey, and Julius Meier-Graefe, who asserted that there was a direct qualitative link between the great ancients, such as Raphael and Poussin, and the moderns, such as Cézanne and

Renoir. The critical preference for French modern painters was further supported by the preferences of many important New York collectors, from Erwin Davis and Adolph Lewisohn to Lillie P. Bliss and Louisine and H. O. Havemeyer. It was the paintings that these New Yorkers chose for themselves—and, indirectly, for the Metropolitan—that Burroughs displayed in the galleries, and by the early 1930s they far outnumbered the Bonheurs, Meissoniers, Cots, and Bastien-Lepages that had been given to the Museum by Cornelius Vanderbilt, Henry Hilton, and Catharine Lorillard Wolfe.

The 1929 bequest of the collection formed by Louisine Havemeyer and her husband, H. O. Havemeyer, an industrialist who controlled sugar production in the United States, transformed the Metropolitan. The Havemeyers had bought, often on the advice of Mary Cassatt, over twenty examples each of the paintings of Corot, Courbet, Manet, Degas, and Monet; many of these pictures came to the Museum. The two thousand works of art they donated and bequeathed range from Ancient Near Eastern glass to the modern glass of Louis Comfort Tiffany, from Chinese ceramics to Japanese textiles, from paintings by Rembrandt to those by the Havemeyers' contemporaries. Yet, the French paintings, from early Corots to late Monets, were the most important component of the collection, and instantly made the Metropolitan's holdings of modern French painting the most extensive in Western Europe or the United States.

Regardless of the aesthetic shortcomings of the paintings galleries in Wings A, B, and C, they nonetheless fulfilled the elemental requirements for the proper display of art. They were nineteenth-century rooms in which, in the case of the modern pictures, nineteenth-century paintings were hung. The galleries were lit from above, like those of the French Salons and many of the rooms that were rented by the Impressionists or other artists' societies for their exhibitions. Furthermore, the Museum's walls were articulated in the nineteenth-century manner, with baseboards, wainscots, hanging rails, friezes, cornices, and coves. All of this changed after World War II. Francis Henry Taylor, the energetic new director of the Museum, was not content to rehang the pictures as they had always been shown. He sought to renovate and modernize the space to make stylish new rooms for the paintings. After the collections returned to Manhattan from wartime storage, he embarked on a campaign that completely transformed the oldest sections of the building.

The Neo-Gothic detail of Vaux's rooms and the Neoclassical moldings of the galleries in the Weston and Tuckerman wings were stripped away. Plain, unarticulated blocks of travertine marble replaced baseboards and door surrounds. Wainscoting was removed so that walls could rise uninterrupted from the floor to the hanging rail. The narrow, tent-shaped laylights in the center of each gallery were discarded in favor of wide, glass ceilings, divided into square rather than rectangular panes, which extended over the entire floor. There were curved, plaster coves, but the new ones were much shallower than the previous

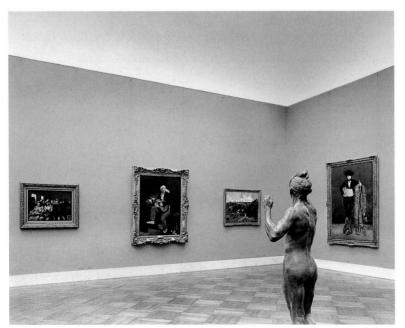

Figure 9. The European Paintings galleries after the renovation by R. B. O'Connor and Aymar Embury II, 1954. (Photo: Archives of The Metropolitan Museum of Art)

coves. Cornices were simplified or, in most rooms, eliminated altogether. Ceilings were lowered from about twenty-four to less than twenty feet, and the spaces themselves were redivided into more regular shapes: squares or rectangles, which were only twice as long as they were wide. The old, narrow corridors were gone, and the new rooms seemed wide, expansive, and modern.

When the refurbished galleries, installed by Theodore Rousseau, Jr., the curator of paintings, opened in January 1954 (fig. 9), they were received enthusiastically. Critics saw the spaces as attractively modern, and most agreed that the mix of light was a success. "It was a period when everyone wanted light and air," Rousseau later wrote.[4] In that same spirit, Rousseau had many of the heavy, nineteenth-century gilded-plaster frames removed, replacing them with more delicate eighteenth-century examples in gilded wood. The selection of yellow, red, and green Fortuny fabric, loosely draped from the hanging rail, was considered an appropriately opulent note.

Nonetheless, a few critics, including the modernist John McAndrew, thought the Fortuny was too strongly colored and somewhat ersatz: they questioned why genuine silk damask was not used rather than cotton printed to look like silk. In his article entitled "The Perils of Pompier,"[5] McAndrew lodged another, much more serious criticism of Rousseau's installation. While he agreed that grouping by chronological period rather than by country of origin was meaningful—ensuring that works by Velázquez were near those of Hals, Vermeer, and Van Dyck—he found the display of the nineteenth-century pictures "startlingly reactionary." Rousseau had followed the lead of the Louvre's postwar rearrangement of its galleries, and abandoned national schools as the organizing principle in favor of chronological periods, which was a new trend at the time. Philip Hendy, the director of the National Gallery in London, gave voice to this approach when he said that "arrangement by period is infinitely more valid than by national school. Nationalities grew up after many of the pictures were painted."[6] However, in hanging a Bonheur between a Corot and a Courbet, or in placing Henri Regnault's *Salomé* on the same wall as works by Degas and Manet, Rousseau was on his own. In an article in the Museum's *Bulletin*, he noted that the Bonheur *Horse Fair*, "unjustly relegated to storage in recent years by fashionable taste, holds its own with the best of the period,"[7] thus rejecting the judgment of his predecessor, Bryson Burroughs. This led McAndrew to ask Rousseau, "Does it mean that taste is to be discarded in selecting pictures or exhibitions or merely that today's taste should not be heeded? Is all the work of the most discriminating collectors of the last generation—a formidably admirable group—to be dismissed as 'fashionable taste,' while we return to the fashionable taste of two generations ago?"[8]

The paintings galleries were further modernized with the introduction of air conditioning in 1963 and 1964, at the same time that Theodore Rousseau; Claus Virch, a younger associate curator; and James J. Rorimer, the director, replaced some of the Fortuny fabrics with silk, and freshened the paint, but the decorative details and arrangements remained largely the same until 1969. In that year, the permanent collection was moved to the north wing on Fifth Avenue, above the Egyptian collections. Wings A, B, and C were required for the vast exhibitions planned for the Museum's centennial celebration in 1970, so the galleries were

Figure 10. European paintings installed in temporary galleries during the Museum's centennial celebration, 1970. (Photo: Archives of The Metropolitan Museum of Art)

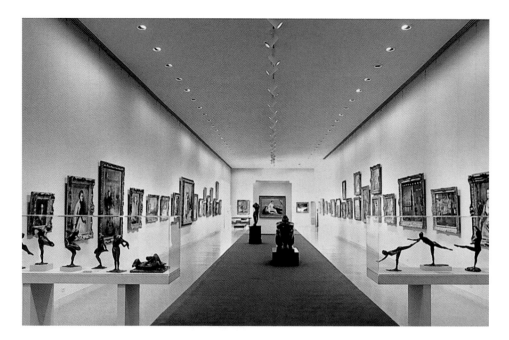

Figure 11. After the centennial exhibitions closed, the Impressionist paintings were reinstalled in rooms painted dark blue. (Photo: Archives of The Metropolitan Museum of Art)

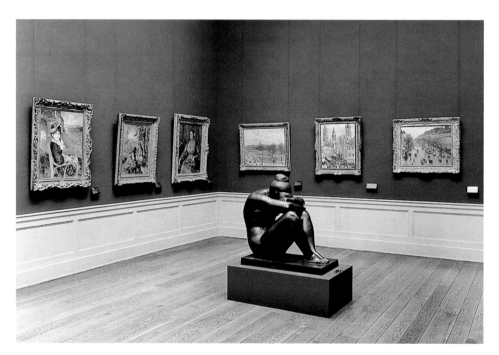

stripped of their fabrics and marbleized door surrounds, and the permanent collection was installed in modern splendor in newly renovated spaces (fig. 10). Like the galleries at the Museum of Modern Art, this temporary space had only artificial light. Enormous blank walls, lit by spotlights concealed in suspended plaster ceilings, and seemingly endless polished terrazzo floors, created an effect as up-to-date as the International Style airport lounges then springing up all over the United States. Area rugs and modern furniture contributed to the contemporary look, which was emphasized by asymmetrical groupings of paintings and modern pedestals for the sculpture. The Bonheur was back, ensconced above paintings by Manet.

In 1971, after the centennial exhibitions closed, Everett Fahy, Rousseau's successor as curator of paintings, reinstalled the permanent collection in the paintings galleries. Abandoning the previous chronological arrangement, he regrouped the pictures by national schools, as Burroughs had done, and had the galleries devoted to a particular school painted the same color. Fahy favored

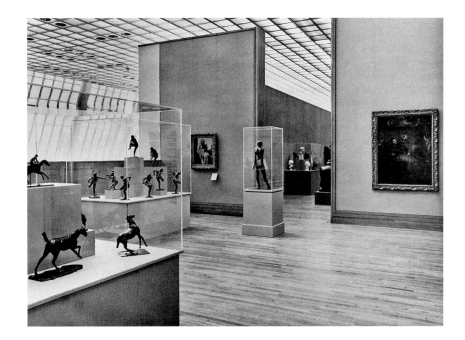

Figure 12. The B. Gerald Cantor Sculpture Galleries, 1988

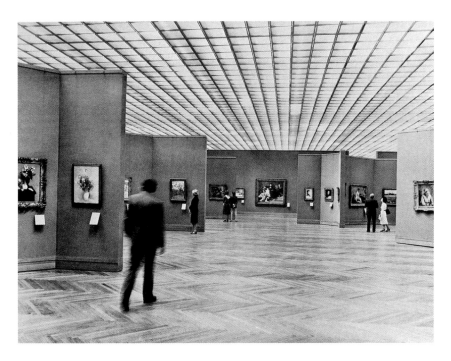

Figure 13. The Andre Meyer Galleries, 1988

strong, saturated colors that made the paintings appear more luminous. Most striking was the dark blue chosen for the rooms of Impressionist pictures, which looked even more vivid than usual against the deep-colored background (fig. 11). More than one hundred paintings were reframed, now in frames dating to the same period as the pictures (a policy that continues today). Works by the Salon artists were mostly separated from those by the avant-garde, but the collection of avant-garde French paintings now far outnumbered examples by the painters admired by nineteenth-century New Yorkers. Pictures given or bequeathed by the Lewisohns, Mr. and Mrs. John L. Loeb, Stephen C. Clark, Miss Adelaide Milton de Groot, Joan Whitney Payson, and Mr. and Mrs. Douglas Dillon reinforced the redirection of the collection effected by the Havemeyer bequest: key works by Gauguin (*Ia Orana Maria*), Van Gogh (*Irises*; *Oleanders*), Seurat (*Study for "A Sunday on La Grande Jatte"*; *Circus Sideshow*), Le Douanier Rousseau (*The Repast of the Lion*), and Cézanne (*Madame Cézanne in the Conservatory*; *The Card Players*) amplified the existing holdings.

11

The display of Old Masters changed yet again when Sir John Pope-Hennessy, who was appointed consultative chairman of the paintings department in 1976, reinstalled the galleries. The organizational principle still depended on national schools, but within this category, they were grouped stylistically. By far the most dramatic change, however, was the installation of the nineteenth-century pictures in the huge hall atop the Rockefeller Wing designed by the firm of Kevin Roche John Dinkeloo and Associates, engaged by the Museum's director, Thomas P. Hoving, to prepare yet another master plan for the building.

Unlike the master plans devised over the previous century by Calvert Vaux; Richard Morris Hunt; McKim, Mead & White; and John Russell Pope, the Roche-Dinkeloo plan, initiated by Hoving in 1970 and completed in 1992 during the tenure of Philippe de Montebello, was actually realized. Alluding to the glass-and-iron conservatory-like "crystal palaces" erected for exhibitions in the nineteenth century, Roche designed large shed-like structures in glass and limestone to house the Temple of Dendur, on the north end; the collections of what was then called Primitive art, on the south end; and, on the west end, American art, twentieth-century art, European sculpture and decorative arts, and the semi-autonomous wing for the collection Robert Lehman bequeathed to the Museum in 1975. For the first time since the 1880s, the Museum presented a handsome and orderly façade to Central Park, by the hand of a single architect, complementing the integrated design McKim, Mead & White had created for the façade on Fifth Avenue.

As early as 1972, plans were laid to construct a picture gallery in the Michael C. Rockefeller Wing (fig. 12 and fig. 13). An enormous clear-span space, 200 by 120 feet and uninterrupted by columns, was decided upon. This was the decade of the Pompidou Center at Beaubourg in Paris by the architects Richard Rogers and Renzo Piano, who had designed vast, clear-span floors on which partitions could be placed in any possible configuration. (In retrospect, flexibility stands out as the key concept in museum design of the 1970s.) The ceiling of the new gallery was made entirely of 2-by-2-foot glass panes suspended from the trusses that supported the roof and skylights; it seemed to stretch to infinity, letting in a large measure of New York's strong daylight. The space was given over to nineteenth-century paintings, which were placed on screen-like partitions composed of either three or five panels. "The installation is monographic in focus," noted Sir John, who installed the galleries with associate curator Charles S. Moffett. "The principle of the arrangement is that works by single artists will be shown together."[9] The Impressionists and Post-Impressionists were given pride of place in the large central gallery, and the Salon painters, although segregated, were not ignored. That their works were visible at all annoyed critic Hilton Kramer of *The New York Times*. In his review "Does Gérôme Go with Goya and Monet?" he wrote, "We look to art museums for a sense of quality—a standard of excellence . . . to be upheld without compromise. It alters the very purpose of the art museum when the inanities of kitsch . . . Salon painting . . . are admitted into the precincts of high achievement."[10] In this new installation Kramer recognized the sounding of the death knell of modernism, yet John McAndrew had heard the same bells in 1954!

By the end of the 1980s these heavily visited galleries needed attention. The putty-colored silk in the central gallery had become frayed, and the floors

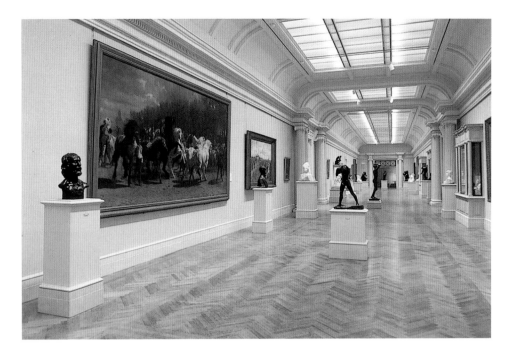

Figure 14. The Nineteenth-century Paintings and Sculpture Galleries, 1993. At the left is Bonheur's *The Horse Fair* (87.25)

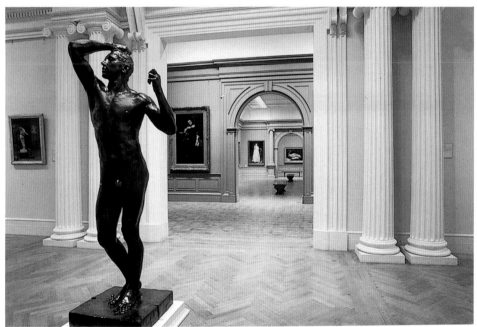

Figure 15. The Nineteenth-century Paintings and Sculpture Galleries, 1993. Auguste Rodin's *The Bronze Age* (07.127) is in the foreground

required refurbishing. The question of renovation versus redesign was posed, and it became clear that the open plan of the 1970s was no longer viable. Visitors continued to complain about the lack of a clear circuit, and the partitions could not accommodate the ever-changing collections. As Philip Johnson expounded at a symposium in 1985, "That modern architecture thing—with movable partitions—is gone. We're over that, over, over. We're back to where Schinkel put us. Let's stay there."[11] Thus, in 1989, after the close of the well-received Degas exhibition in the Tisch Galleries, Philippe de Montebello asked David Harvey, senior exhibition designer, and me to develop a new plan for the space then occupied by The Andre Meyer Galleries. Alvin Holm, a Philadelphia architect, acted as a consultant.

Working within the existing envelope of 200 by 120 feet, with a ceiling just over 20 feet high, we developed a sequence of rooms that would have a clear start and finish, without the rigidity imposed by an enfilade, as in early Neoclassical museums, or the constraints of a single enforced circuit, as in the

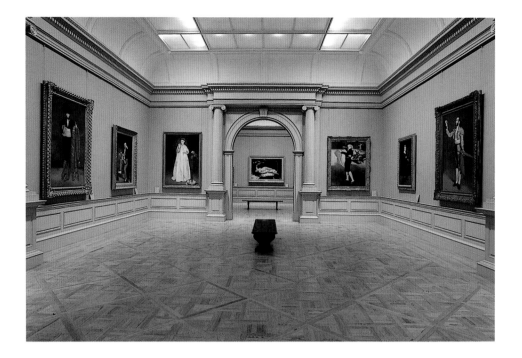

Figure 16. The Manet Gallery, within the Nineteenth-century Paintings and Sculpture Galleries, 1993. In the distance is Courbet's *Woman with a Parrot* (29.100.57)

Museum of Modern Art's new permanent installation. We then planned a circuit that would encompass a series of rooms devoted to the art of the first half of the nineteenth century—Neoclassicism, Romanticism, the Barbizon school, and Realism—in a sequence that would lead the visitor to a large central gallery (fig. 14 and fig. 15).

The idea governing the design of the new galleries was for the rooms to be similar in scale and appearance to those for which the artists had created their pictures: well-proportioned, and articulated with baseboards, wainscoting, cornices, and coves. While this may seem obvious and inconsequential, there are many who believe that only rooms that are modern in design are legitimate today. Yet, just as it would appear preposterous to most people to place paintings by Ellsworth Kelly or Morris Louis in Louis XV frames, or a work by Boucher in a chrome strip frame, so do we think it misleading to hang nineteenth-century paintings in modern-style rooms. A modern room, no matter how simple or

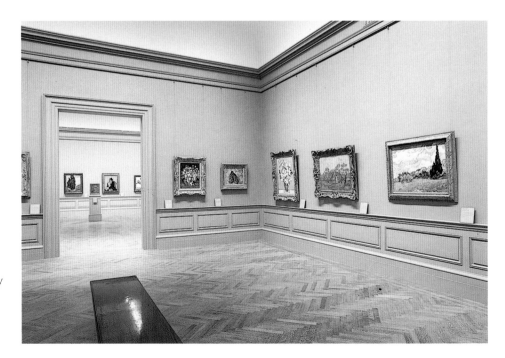

Figure 17. One of the three galleries housing the Annenberg Collection, within the Nineteenth-century Paintings and Sculpture Galleries, 1993. Three paintings by Van Gogh are visible on the right wall (from left to right): *Vase of Roses* (1993.400.5), *Women Picking Olives* (1995.535), and *Wheat Field with Cypresses* (1993.132)

elegant, is not invisible: it colors our perception of what is displayed within it. Therefore, our aim was to make the new galleries look as if they had been designed and built by McKim, Mead & White at the turn of the century. We associated their firm with the best exhibition spaces in the building, and we wanted visitors to feel that they were in old galleries that had simply been repainted and rehung (fig. 16 and fig. 17).

Our plan for the twenty-one new galleries was approved in 1990, and the next year the Honorable and Mrs. Walter H. Annenberg, longtime trustees of the Museum, pledged five million dollars toward the ten-million-dollar renovation. At the opening of the galleries in 1993, the Annenbergs announced their intention to bequeath their collection of fifty-three French paintings—from Corot and Manet to Renoir and Monet, from Cézanne to Van Gogh and Gauguin, and from Matisse to Picasso—to the Museum. "From strength to strength," said Ambassador Annenberg. Not since the 1929 Havemeyer bequest had one collection made such a profound impact on the character of the Museum's nineteenth-century French paintings: seven Van Goghs and four Gauguins created instant depth; masterworks by Monet, Cézanne, Vuillard, Picasso, and Braque filled gaps in the existing collection.

Now, in 2007, we are currently engaged in a ten-thousand-square-foot expansion of these rooms. Nine new galleries, consistent in scale and decoration, will provide space for early-nineteenth-century painting, including the Wheelock Whitney Collection of plein-air oil sketches, and recent gifts from E. V. Thaw. A large gallery devoted to the work of Gustave Courbet will finally provide an appropriate room for the paintings of this grand master, and early modern paintings from the School of Paris will take their place alongside similar works in the Annenberg Collection. However, we have not, by any means, completed our task. In order to make the collections more representative, we need to acquire additional works by British, Scandinavian, and German-speaking artists; by the Symbolists; and by the Neo-Impressionists—and, when we have accomplished that, no doubt we will then need to create even more galleries to accommodate them all.

This essay has been adapted from "New Galleries for Old," in *The New Nineteenth-Century European Paintings and Sculpture Galleries*, New York, The Metropolitan Museum of Art, 1993.

1. *The Saturday Evening Post*, March 29, 1880; quoted in Leo Lerman, *The Museum*, New York, 1970, p. 66.
2. Minutes of the Building Committee, 1911. Archives of The Metropolitan Museum of Art.
3. Letters to the Building Committee. Archives of The Metropolitan Museum of Art.
4. Memo from Theodore Rousseau, Jr., to Everett Fahy, October 4, 1971. Archives of the Department of European Paintings.
5. *The Art Digest*, March 1, 1954, pp. 6ff.
6. Quoted in "As Museum Officials See Tasks," *The New York Times*, January 10, 1954, p. 10.
7. Theodore Rousseau, Jr., "A Guide to the Picture Galleries," *The Metropolitan Museum of Art Bulletin*, January 1954, Part II, p. 6.
8. *The Art Digest*, op. cit., p. 7.
9. Sir John Pope-Hennessy, quoted in a Metropolitan Museum press release, "Metropolitan to Open New Galleries for 19th-Century European Art," 1980.
10. *The New York Times*, April 13, 1980.
11. Suzanne Stephens, ed., *Building the New Museum*, New York, 1985, p. 28.

Overleaf: Claude Monet. *La Grenouillère* (detail). See no. 85

CATALOGUE

MARIE-DENISE VILLERS
French, 1774–1821

1. *Young Woman Drawing*

1801
Oil on canvas
63½ x 50⅝ in. (161.3 x 128.6 cm)
Mr. and Mrs. Isaac D. Fletcher Collection, Bequest of
Isaac D. Fletcher, 1917
17.120.204

This painting has intrigued visitors and puzzled art historians since it entered the Museum's collection in 1917 as a portrait of Charlotte du Val d'Ognes by Jacques-Louis David. No plausible explanation has yet been found for the presence of the broken window or for the couple looking on from behind a parapet. By 1951, art historians had concluded that the painting was not by David, but that its author had exhibited it at the Paris Salon of 1801, where it was recorded in an engraving, and an attribution to Constance Charpentier was suggested. Only in 1996 was the painting recognized as probably the work of Marie-Denise Villers, the younger sister of the better-known Marie-Victoire Lemoine, both of whom were students of Anne-Louis Girodet-Trioson (1767–1824), himself a student of David. The curious *contre-jour* light effect and the transparent quality of the flesh tones and the muslin dress are characteristic of Girodet's work. GT

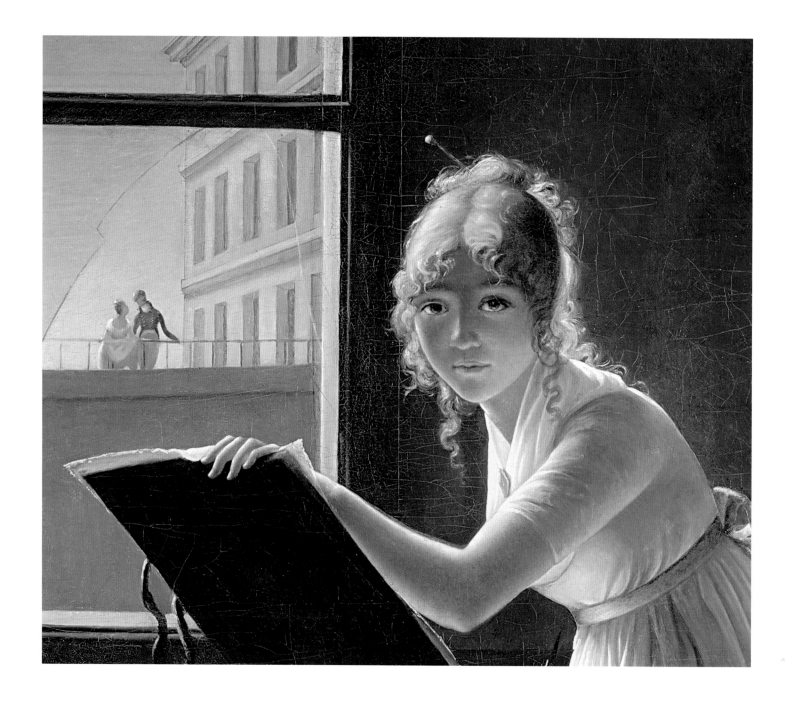

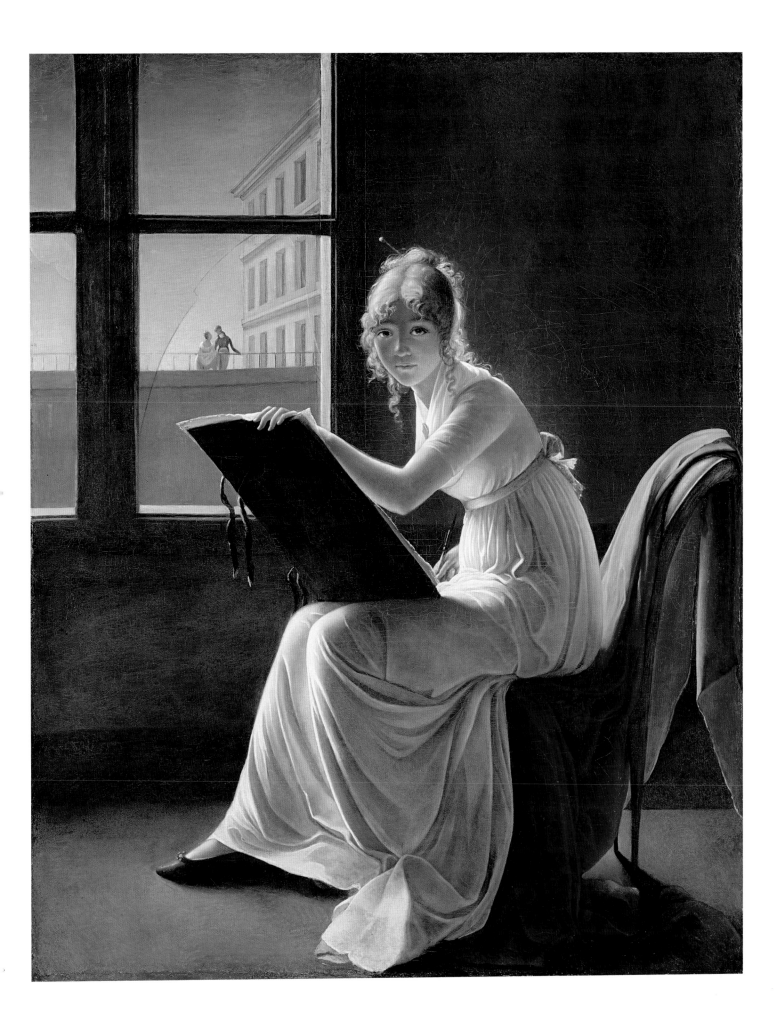

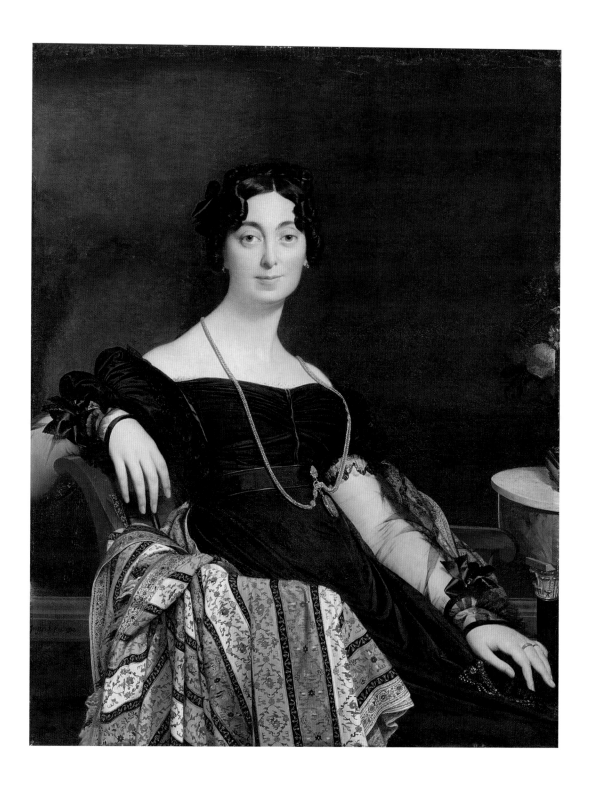

JEAN-AUGUSTE-DOMINIQUE
INGRES
French, 1780–1867

2. *Madame Jacques-Louis Leblanc*
(Françoise Poncelle, 1788–1839)

1823
Oil on canvas
47 x 36½ in. (119.4 x 92.7 cm)
Signed, dated, and inscribed (lower left):
Ingres P. flor. 1823.
Catharine Lorillard Wolfe Collection, Wolfe Fund,
1918
19.77.2

3. *Jacques-Louis Leblanc*
(1774–1846)

1823
Oil on canvas
47⅞ x 37⅝ in. (121 x 95.6 cm)
Signed (at the right, on the paper):
Ingres / Pinx.
Catharine Lorillard Wolfe Collection, Wolfe Fund,
1918
19.77.1

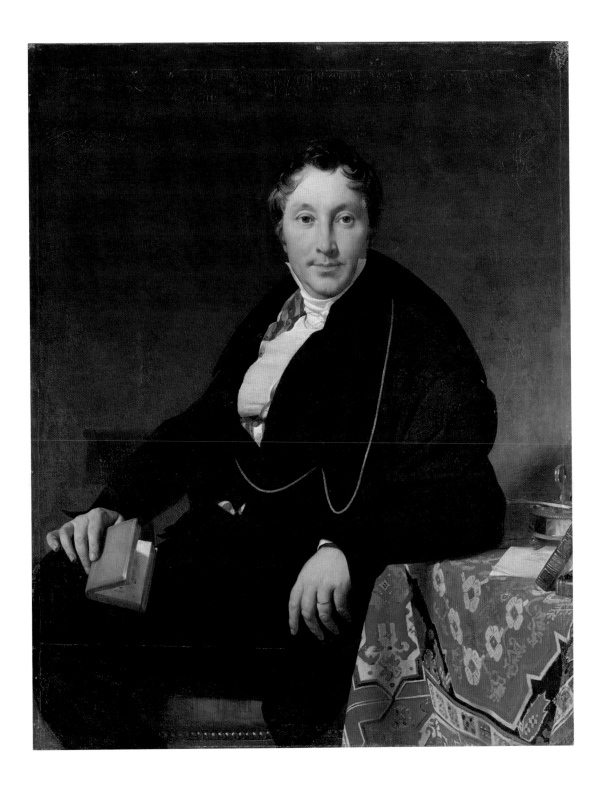

Jacques-Louis Leblanc and his wife were French functionaries attached to the court of the grand duchess of Tuscany, Élisa Bacchiochi, née Bonaparte. After the fall of Napoleon's empire in 1814–15, the Leblancs remained in Florence, at the center of the French expatriate community. Ingres, who met them when he arrived there from Rome, in 1820, described Monsieur Leblanc as "a Frenchman, very rich and also quite generous and good, who has adopted us, to the point of overwhelming us with kindnesses and also with requests for paintings, portraits, etc."

The portraits that resulted from this association rank among the largest Ingres ever produced, apart from royal commissions, and represent the only pair. They were probably intended to hang facing one another, since the light falls differently in each. Numerous drawings, including some in full scale, were required to perfect the subtle rhythms of the portraits, which are unified by the visual rhymes of hands, gold chains, and rich textiles that enhance the couple's black clothing. Madame Leblanc's scarf is embroidered with an *E* for Élisa, as she had served the grand duchess as lady-in-waiting.

Edgar Degas bought the portraits in 1896 at the posthumous sale of the estate of the Leblancs' daughter. He considered them to be the finest of the works by Ingres in his extensive collection. The Metropolitan Museum purchased the paintings, in turn, at the posthumous sale of Degas's collection in 1918. GT

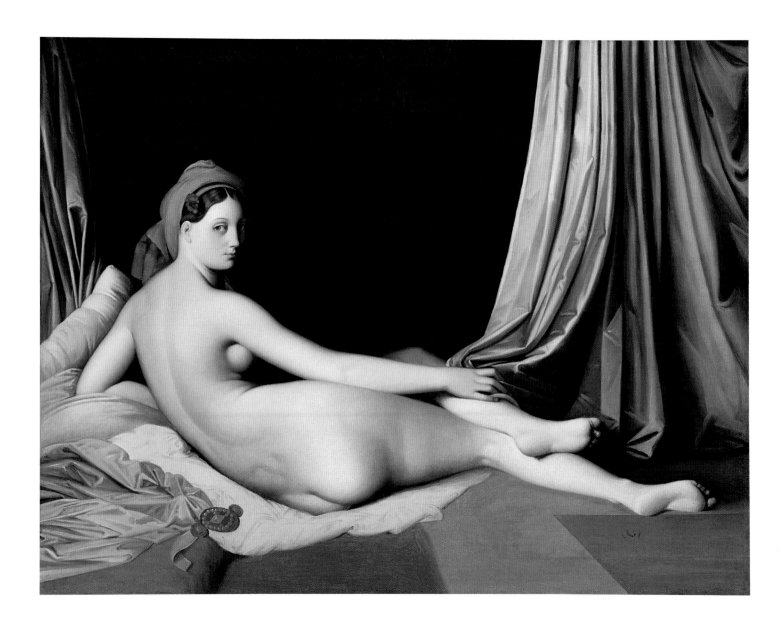

JEAN-AUGUSTE-DOMINIQUE
INGRES *and* WORKSHOP
French, 1780–1867

4. *Odalisque in Grisaille*

ca. 1824–34
Oil on canvas
32¾ x 43 in. (83.2 x 109.2 cm)
Catharine Lorillard Wolfe Collection, Wolfe Fund,
1938
38.65

Ingres included this picture—an unfinished repetition of the celebrated *Grande Odalisque* of 1814 (Musée du Louvre, Paris)—in a list of works that he painted between his return to Paris in 1824 and his departure for the French Academy in Rome in 1834. Although the quality of execution is not as fine as that of the primary version in the Louvre, which was painted during Ingres's first stay in Rome, there is no reason to question the authenticity of the work. After 1824, Ingres invited his students to assist him with all large paintings, and that is probably true of this canvas as well.

When the *Grande Odalisque* was exhibited at the 1819 Paris Salon, critics considered the anatomical distortions both extravagant and odd, and the Turkish accessories out of fashion. The painting did not receive the admiration it deserved until it was reexhibited in 1846 and 1855. By then, writers such as Baudelaire recognized that the bizarre was an essential component of Ingres's aesthetic: "*The beautiful is always bizarre. . . .* I do not mean to say that it should be coldly, deliberately bizarre, for in that case it would be a monster that had jumped the tracks of life. I am saying that it always contains a little bizarreness, a naïve, intentional and unconscious bizarreness, and that it is this bizarreness that particularly makes it beautiful." Baudelaire blamed Ingres's excesses on an "immoderate taste for *style*."

The Metropolitan's grisaille *Odalisque* passed from the artist's estate to his widow; it was exhibited for the first time in the twentieth century. GT

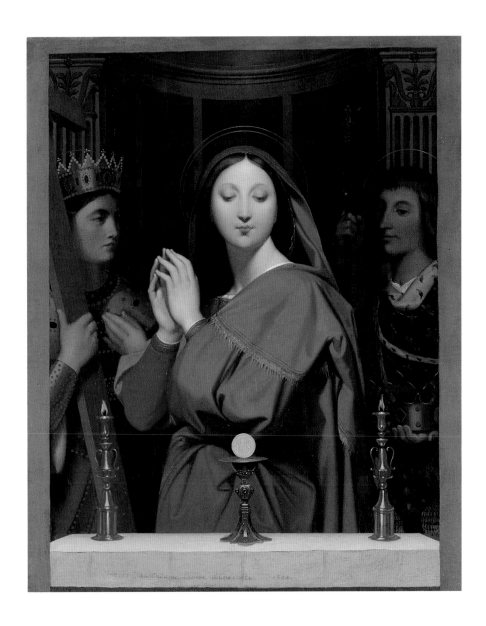

JEAN-AUGUSTE-DOMINIQUE
INGRES
French, 1780–1867

5. *The Virgin Adoring the Host*
1852
Oil on canvas
15⅞ x 12⅞ in. (40.3 x 32.7 cm)
Inscribed (at the bottom): Ingres à Madame Louise
Marcotte, 1852
Gift of Lila and Herman Shickman, 2005
2005.186

While serving as director of the French Academy in Rome, Ingres received a commission from the Russian czarevitch, the future Alexander II, to paint a devotional image of the Virgin and the Host with the two patron saints of Russia, Alexander Nevsky and Nicholas. Ingres was exceptionally proud of the finished picture: he exhibited it to critical acclaim in Paris in April 1842 before shipping it to Saint Petersburg.

Ingres subsequently lamented that this painting was lost to France, and he made four variants of the rigorously Raphaelesque composition over the ensuing years: he painted this small, jewel-like picture, the first of the sequels, for his close friend Louise Marcotte. Ingres replaced the Russian saints with two French ones, Louis and Helena, who must have had special significance for Madame Marcotte. GT

THÉODORE GERICAULT
French, 1791–1824

6. *Evening: Landscape with an Aqueduct*

1818
Oil on canvas
98½ x 86½ in. (250.2 x 219.7 cm)
Purchase, Gift of James A. Moffett 2nd, in memory of
George M. Moffett, by exchange, 1989
1989.183

This work is one panel in a projected set of four monumental landscapes representing the times of day. However, Gericault only completed three: *Morning: Landscape with Fishermen* (Alte Pinakothek, Munich), *Noon: Landscape with a Roman Tomb* (Musée du Petit-Palais, Paris), and the present work.

Painted in Paris during the summer of 1818, the landscapes were conceived as decor, in the manner of Joseph Vernet, either to be exhibited as such at the Salon or to be placed in a specific interior. Nothing is known about a commission; nevertheless, the receipts for the delivery of the canvases to Gericault's studio enable the works to be dated with precision.

The landscapes fuse souvenirs of ruins in the Italian countryside, which Gericault had visited in 1817—the aqueduct at Spoleto is visible here—with the stormy skies and turbulent moods characteristic of the emerging aesthetic of Romanticism and the Anglo-French concept of the Sublime. Gericault's primary achievement was to invest French Neoclassical painting, as practiced by Jacques-Louis David and his many students, with deep currents of feeling. The present picture, while not typical of Gericault's subject matter, conveys through the vehicle of landscape all of the emotion expressed in his figural compositions, and, through its large scale, the heightened ambition with which the artist approached his work.

Gericault painted these landscapes at a moment of personal turmoil: his uncle's second wife was about to give birth to a child whom Gericault had fathered. This event interrupted his work on the "Times of Day," and explains why only three of the four landscapes were realized. However, Gericault's next painting, the celebrated *Raft of the Medusa* of 1819 (Musée du Louvre, Paris), is, in fact, a night scene that can be regarded as the conclusion of the "Times of Day" series (incidents of drowning were often found in depictions of night). Several of the Michelangelesque poses of the animated figures in the landscapes were also repeated in the *Raft*. GT

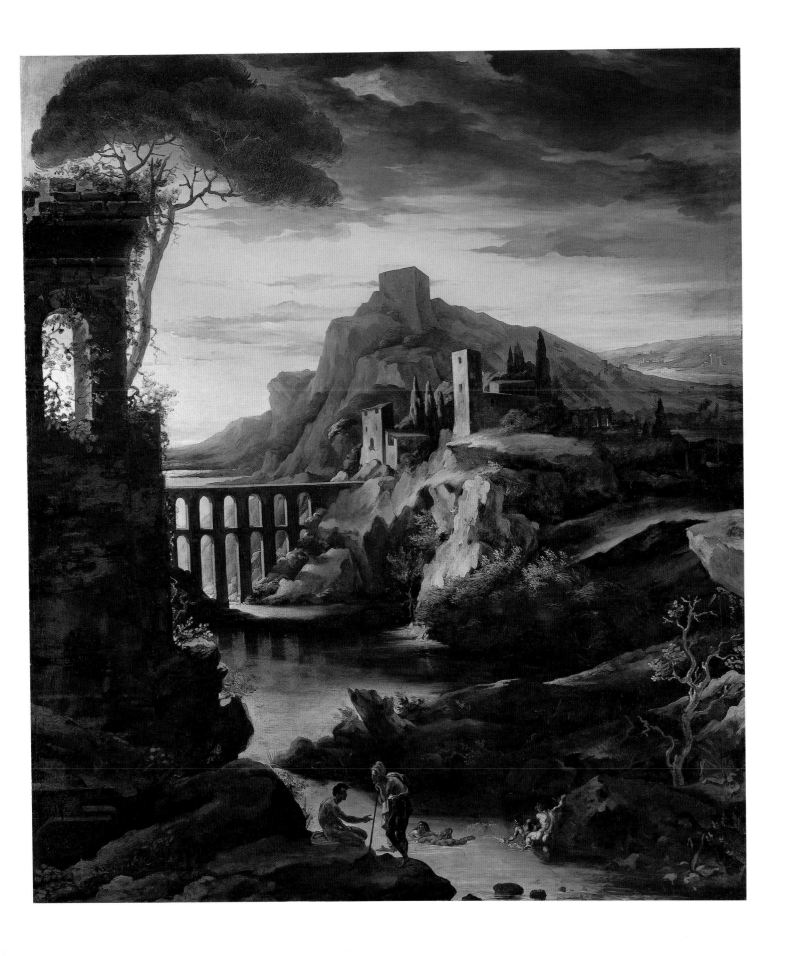

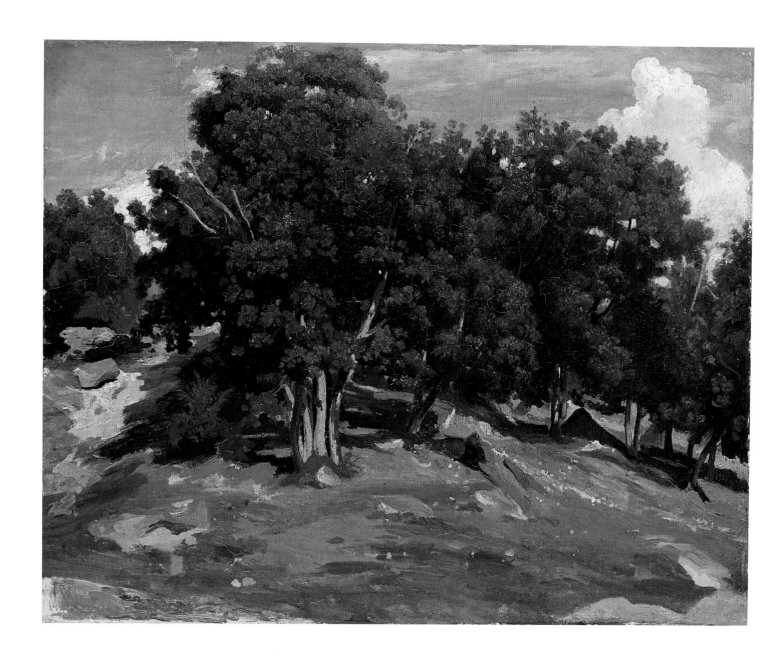

Corot painted this study in Bas-Bréau, a section of the Forest of Fontainebleau that was famous for its immense oak trees, in the summer of 1832 or 1833, when he was living in the nearby village of Chailly-en-Bière. He employed the direct approach to nature that he had developed in Italy during his sojourn there, from 1825 to 1828, copying the sketch for the large oak in *Hagar in the Wilderness*, the enormous canvas he exhibited at the 1835 Paris Salon. Improbably, Corot transported this oak from northern France to the Palestine desert in his realization of the biblical scene.

A long inscription on the back of the panel by the painter Louis Français (1814–1897) records the history of this picture. In 1835, Corot gave it to his friend the artist Célestin Nanteuil (1813–1873), presumably in return for Nanteuil's lithographic copy of Corot's *Hagar in the Wilderness*. After Nanteuil's death, Français discovered the picture in Marseilles, cleaned it, and mounted it on its present wood panel. GT

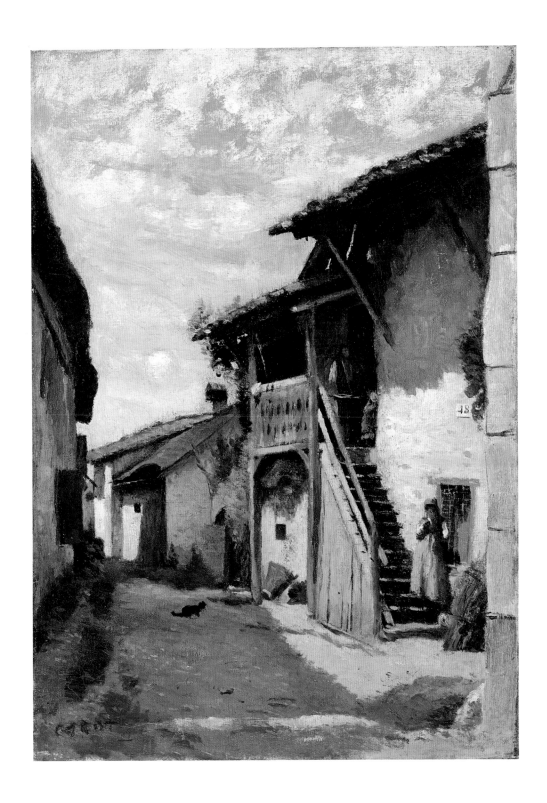

CAMILLE COROT
French, 1796–1875

8. *A Village Street: Dardagny*

1852, 1857, or 1863
Oil on canvas
13½ x 9½ in. (34.3 x 24.1 cm)
Signed (lower left): COROT
Bequest of Collis P. Huntington, 1900
25.110.17

Corot was a tireless traveler, and the extension of the network of French railroads in the 1850s widened the range of his summer journeys. In 1852, 1857, and 1863, he visited Dardagny, a small village near Geneva. This view, essentially unchanged today, was probably painted on Corot's first visit. It is an excellent example of his remarkable ability to derive a poetic scene from a prosaic site.

GT

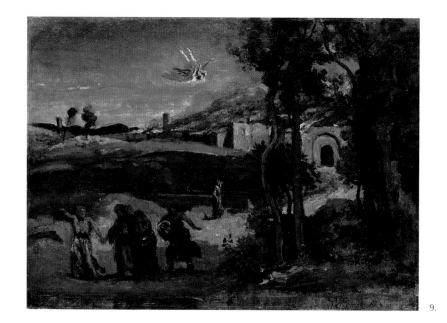

9.

CAMILLE COROT
French, 1796–1875

9. *Study for "The Destruction of Sodom"*
1843
Oil on canvas
14⅛ x 19⅝ in. (35.9 x 49.8 cm)
Catharine Lorillard Wolfe Collection, Wolfe Fund,
1984
1984.75

10. *The Burning of Sodom*
(formerly, *The Destruction of Sodom*)
1843 and 1857
Oil on canvas
36⅜ x 71⅜ in. (92.4 x 181.3 cm)
Signed (lower right): COROT.
H. O. Havemeyer Collection, Bequest of Mrs. H. O.
Havemeyer, 1929
29.100.18

10.

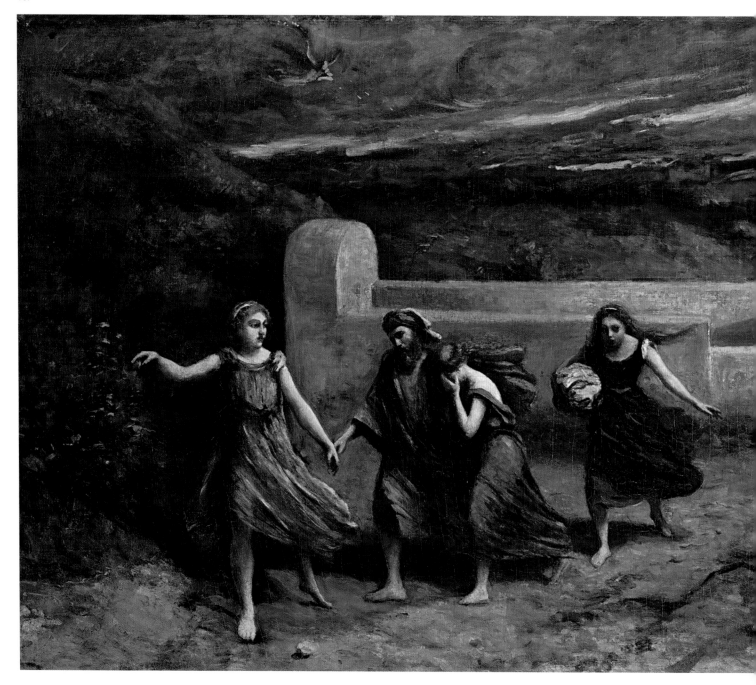

The finished painting is one of Corot's most impassioned, made at a time when the artist had the ambition to tackle grand historical subjects. The scene, taken from Genesis (19: 15–26), shows an angel in the sky hurling fire and brimstone upon Sodom, to destroy the city for its wickedness. At the left, another angel leads Lot and his two daughters to safety. Behind them, Lot's wife, who looked back in regret despite a warning, has become a pillar of salt.

The small sketch records Corot's composition as he conceived it in 1843. That year, the painting was rejected at the Paris Salon, but it was accepted when he resubmitted it in 1844. Nevertheless, critics found the painting unsatisfactory, citing the small scale of the figures relative to the landscape. Corot quipped that he had wept over the fate of Lot's wife, hoping to melt her.

Much later, Corot cut down the painting substantially, reducing the sky and the landscape at the right. He repainted the foreground in a darker palette and exhibited the canvas at the 1857 Salon. By then his stature ensured a better reception by the critics.

Corot based his figures on those from similar scenes by Raphael (Vatican) and Veronese (Musée du Louvre, Paris). The oddly shaped fountain derives from a study Corot made in the village of Mûr-en-Bretagne in the early 1840s. GT

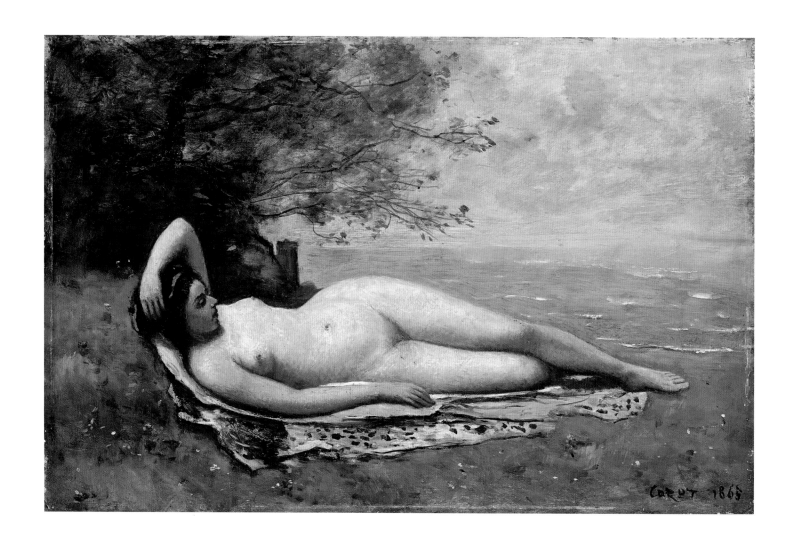

CAMILLE COROT
French, 1796–1875

11. *Bacchante by the Sea*

1865
Oil on wood
15¼ x 23⅜ in. (38.7 x 59.4 cm)
Signed and dated (lower right): COROT 1865
H. O. Havemeyer Collection, Bequest of Mrs. H. O.
Havemeyer, 1929
29.100.19

In his study of Corot, the German art historian Julius Meier-Graefe extolled the series of "Odalisques" that the artist painted throughout his career, beginning in 1837: "The progressive development of his [Corot's] Odalisques continued until he was past sixty; not a development of a type but of the painting. . . . In the course of fifty years, this figure seems to grow and take on broader, more majestic contours. The forms become rounder, the limbs learn movement, the flesh becomes more elastic and finally, perfected beauty emerges. His women painted in the sixties take on a brilliant loveliness."

Corot exhibited this work, along with another, also of a reclining nude, at the 1865 Paris Salon. GT

CAMILLE COROT
French, 1796–1875

1 2. *A Woman Reading*

1869 and 1870
Oil on canvas
21⅜ x 14¾ in. (54.3 x 37.5 cm)
Signed (lower left): [COR]OT
Gift of Louise Senff Cameron, in memory of her
uncle, Charles H. Senff, 1928
28.90

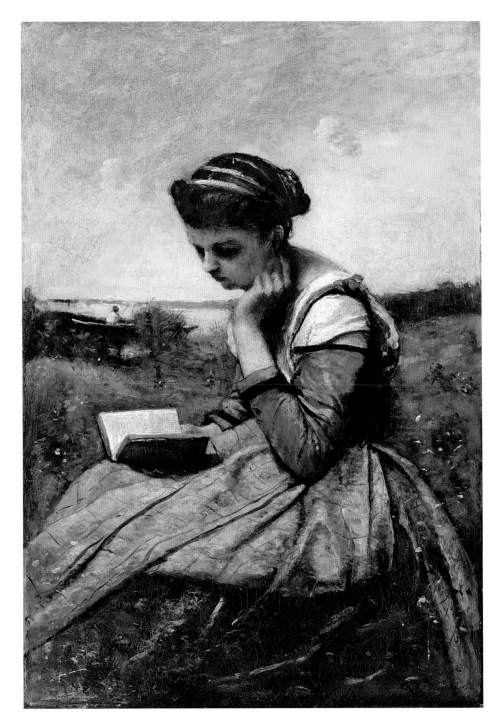

When the seventy-two-year-old Corot showed *A Woman Reading* at the Salon of 1869, the critic Théophile Gautier praised its naïveté and its color but criticized the faulty drawing of the figure, noting the rarity of figures in Corot's work. Although the artist had painted a number of similar figure studies after the late 1850s, this was the first and one of the very few that he exhibited. Corot was known as a landscapist, yet he wrote, "I have derived as much pleasure painting these women as in painting my landscapes. On their flesh I have seen the poem of the hours unroll—as beautiful, as enchanting as on the earth, the water, the hills, the leaves. The mysteries of the woods were in their hair, the mystery of the sky and ponds in their eyes. Spring and autumn passed before me when they smiled, joyously or sadly. And their ingenuous words let me see the dance of the nymphs."

Close examination of the surface reveals that Corot reworked the landscape. A photograph of the painting when it was exhibited at the Salon indicates that originally there was a willow at the left whose foliage nearly covered the sky, and a mass of trees at the right. A lithographic copy of the painting, made by Émile Vernier in 1870, reproduces it with the present, open sky; consequently, Corot must have repainted the work immediately after he retrieved it from the Salon. GT

CAMILLE COROT
French, 1796–1875

13. *Sibylle*

ca. 1870
Oil on canvas
32¼ x 25½ in. (81.9 x 64.8 cm)
H. O. Havemeyer Collection, Bequest of Mrs. H. O.
Havemeyer, 1929
29.100.565

This handsome work ranks as one of Corot's most accomplished attempts to approximate Raphael's High Renaissance style. The pose closely follows the portrait of *Bindo Altoviti* (National Gallery of Art, Washington, D.C.), believed, in Corot's day, to be Raphael's self-portrait. Yet, for all of the self-conscious *disegno*—the arch of the back mirrored in the swan-like curve of the neck—Corot arrived at this composition incrementally. X-radiographs reveal an earlier state in which the model is playing the cello: the left hand held the neck of the instrument and the right hand, slightly raised, held the bow. Corot made several adjustments to the contour of the cello and numerous efforts to position the bow before painting over both forms altogether, dropping the right hand to the model's lap, and inserting a rose, or pink, in her left hand.

Corot may have conceived the work as a depiction of Polyhymnia, the cello-playing Muse of music. (Musical instruments appear frequently in Corot's late studio pictures.) The ivy in the figure's hair perhaps is a reference to the immortality of the arts. However, only after painting out the cello did Corot refine the graceful contours of the model's back, chest, and left shoulder with strong outlines, even as he recognized that the beauty of the line did not require a niggling perfection in the description of the surfaces.

The painting remained unfinished and unsigned, and was not exhibited, during Corot's lifetime. It belonged to the artist's biographer and the author of the catalogue raisonné of his work, Alfred Robaut, who was the first to title the picture with a woman's name, Sibylle (not Sibyl, an ancient female prophet). Robaut sold the painting to the Galerie Durand-Ruel in 1899, after which it was known as *L'Italienne*, which is hardly surprising since the model's name was Agostina, and she was called "L'Italienne de Montparnasse." The writer Alexandre Arsène extolled "this . . . pensive Italian beauty, made to bring to life all the novels that you would want, [who] clasps to her breast a little bouquet of the simplest symbolism." He remarked "how Corot felt, recalled and understood—I was going to say equaled—Raphaël, infinitely more than Ingres ever did. How this man is sweet and strong!" GT

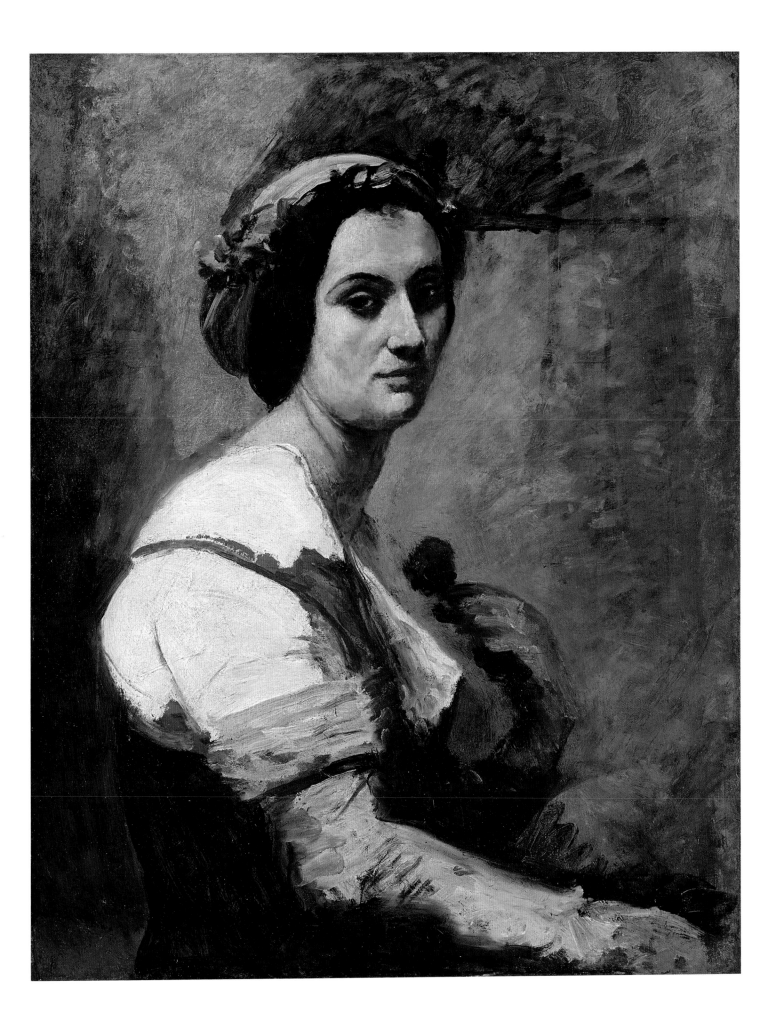

33

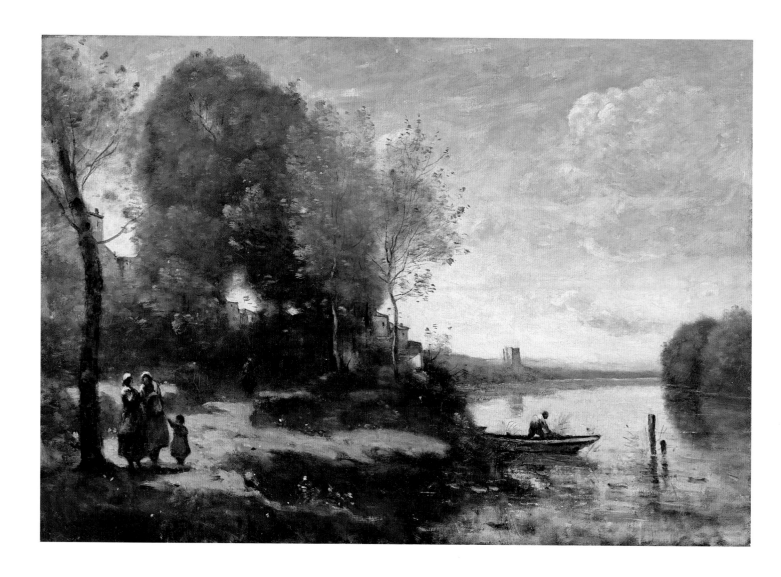

The famous writer Théophile Thoré repeated his habitual criticism of Corot, with regard to the paintings the artist exhibited at the Salon of 1865—the date of the present picture: "Corot almost never made anything besides the same one landscape, but it is good." The landscape here was created by Corot in his studio from stock elements that he knew by heart: the cluster of silvery trees, the body of leaden water, the peasant figures and boatman, the distant tower. Like his idol Claude Lorrain, Corot could generate a landscape and a mood through the power of his imagination.

This painting was purchased by the Société Artésienne des Amis des Arts and offered as a prize in a lottery in 1866 in order to encourage art collecting in Artois. GT

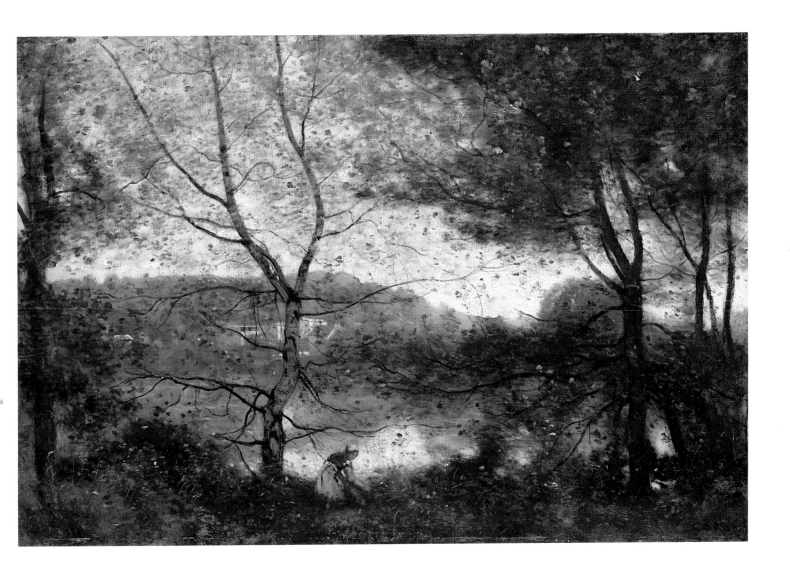

CAMILLE COROT
French, 1796–1875

15. *Ville-d'Avray*

1870
Oil on canvas
21⅝ x 31½ in. (54.9 x 80 cm)
Signed (lower right): COROT
Catharine Lorillard Wolfe Collection, Bequest of
Catharine Lorillard Wolfe, 1887
87.15.141

When Corot sent this small canvas and one other to the 1870 Salon, he had long enjoyed the privilege to exhibit his entries without submitting them to the jury. Secure in his reputation, he showed modest works, as if to reassure a nation about to enter into war with Prussia that all was well at Ville-d'Avray—and also that all was well in the studio. The view of the village of Ville-d'Avray that he exhibited at the 1868 Salon (Musée des Beaux-Arts, Rouen) had been very well received: although many critics were tired of Corot's repetitive scenes, there were also admirers, such as René Ménard: "He is no seeker after reality, he is a dreamer, who through all the changing and varied aspects of nature, pursues always the same poetic and uniform note. . . . They still say that when he paints Ville-d'Avray

he knows how to be realistic when he feels like it. Well, no; what he sees everywhere is not what is in nature, it is what is in himself. If you sent him to Egypt to paint beside the pyramids, he would find there his silvery tones and mysterious thickets."

Corot depicts the villas at the far side of the large pond at Ville-d'Avray, where he had inherited property from his parents. It is a scene that he depicted countless times, but each time he took certain liberties. The tree in the foreground changed most frequently. Because of the silhouette of branches against the pewter sky, Corot's biographer Robaut called this work "the spider's web." Initially, Corot had included a child to the right of the peasant woman in the foreground. GT

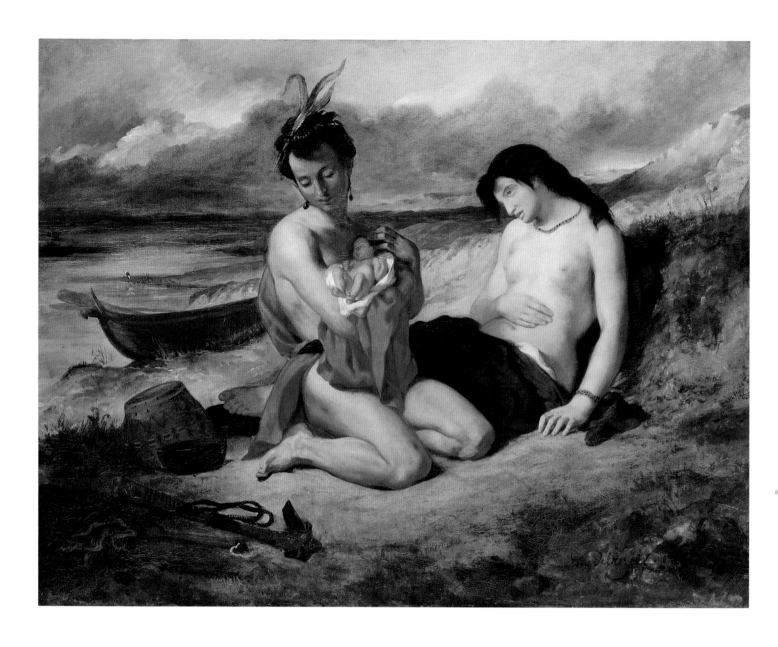

EUGÈNE DELACROIX
French, 1798–1863

16. *The Natchez*

1835
Oil on canvas
35½ x 46 in. (90.2 x 116.8 cm)
Signed (lower right): EugDelacroix
Purchase, Gifts of George N. and Helen M. Richard
and Mr. and Mrs. Charles S. McVeigh and Bequest of
Emma A. Sheafer, by exchange, 1989
1989.328

In 1822, the twenty-four-year-old Delacroix wrote in his journal that he wished to paint these two American Indians, characters in Chateaubriand's famous novel *Atala, ou les amours des deux sauvages dans le désert.* He began the painting, but abandoned it until the

mid-1830s, when he resumed work on the picture in order to exhibit it at the Paris Salon of 1835. For the Salon catalogue, Delacroix provided the following explanation: "Fleeing the massacre of their tribe, two young savages traveled up the Meschacébé (Mississippi River). During the voyage, the young woman was seized by labor pains. The moment is that when the father holds the newborn in his hands, and both regard him tenderly."

Chateaubriand's tale describes the human wreckage that resulted from the French and Indian War of the mid-eighteenth century and the ensuing clash of cultures as Europeans forcibly settled the Native Americans' lands. The heroine of the novel, an Indian named Atala, begins the tale of her suffering with the remark, "We are the sole remains of the

Natchez." The French had fought the Natchez Nation sporadically in the first years of the eighteenth century and in 1731 the tribe was almost extinguished. By the time Delacroix decided upon the subject of this picture, Girodet-Trioson's famous evocation of a different scene from the novel, *The Burial of Atala* of 1808 (Musée du Louvre, Paris), had been acquired by the French state and placed on view in the Musée du Luxembourg in 1822.

In style and mood, this work is similar to Delacroix's *Massacre at Chios* of 1824 (Musée du Louvre, Paris), which he conceived at about the same time. As in that picture, Delacroix adapted poses from works by the Old Masters for his composition: the two figures here derive from Raphael. GT

36

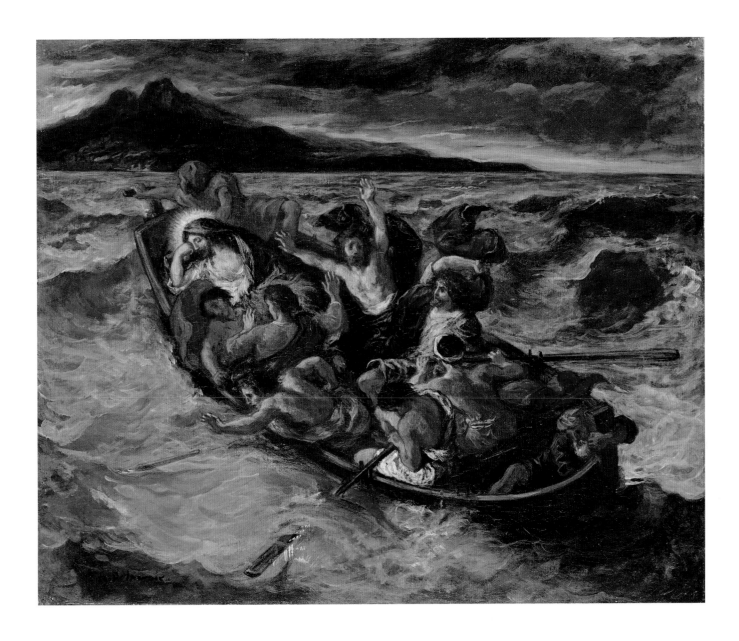

EUGÈNE DELACROIX
French, 1798–1863

17. *Christ Asleep during the Tempest*

ca. 1853
Oil on canvas
20 x 24 in. (50.8 x 61 cm)
Signed (lower left): Eug. Delacroix
H. O. Havemeyer Collection, Bequest of
Mrs. H. O. Havemeyer, 1929
29.100.131

When one of the versions of *Christ Asleep during the Tempest* was shown in the 1864 Delacroix memorial exhibition, a critic described it as "one of the subjects that Delacroix has caressed most, and to which it seems that he returns with a singular readiness to oblige. Everything seduces him in this episode, the whipped-up water, the sky black with storms, the sails torn by the wind, the terror of the sailors, and, above all that the sweet sleep of the Saviour in the midst of the revolt of nature."

Delacroix painted fourteen variations of

this New Testament lesson in faith: when awakened by his terrified disciples, Christ scolded them for their lack of trust in Providence. In the earlier works, the seascape is more prominent; in the later ones, as here, Christ's bark occupies a more significant place. After Vincent van Gogh saw this version in Paris in 1886, he wrote, "The 'Christ in the Boat'—I am speaking here of the sketch in blue and green with touches of violet, red and a little citron-yellow for the nimbus, the halo—speaks a symbolic language through color alone." GT

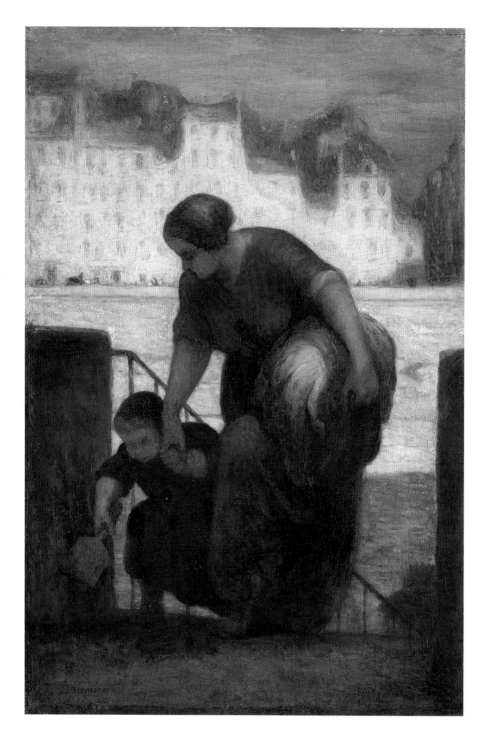

HONORÉ DAUMIER
French, 1808–1879

18. *The Laundress*
1863
Oil on wood
19¼ x 13 in. (48.9 x 33 cm)
Signed and dated (lower left): h. Daumier / 186[3?]
Bequest of Lillie P. Bliss, 1931
47.122

Best known for his lithographs—political caricatures and social satires that were published in the newspapers *Le Charivari* and *La Caricature* during the reign of Louis-Philippe (1830–48)—Daumier also produced some three hundred paintings, most of which were unknown at the time of his death. *The Laundress* is the largest and possibly the last of three painted versions of this composition, one of which was exhibited at the Salon of 1861. It also represents the artist's only known dated painting, although the last digit of its date is now obscured.

From his studio on the quai d'Anjou, overlooking the Seine, Daumier observed the laundresses returning from the laundry boats moored on the river, their bodies hunched over from the weight of their loads as they ascended the stone steps of the embankment. Daumier invests the laundress in this painting with a sense of monumental dignity, silhouetting her darkened form against the starkly lit buildings on the opposite bank. A contemporary recognized the iconic quality of Daumier's laundress, calling her "the touching and desolate image of misery." When this painting was included in a retrospective of Daumier's work in 1878, the critic Édmond Duranty, who championed the Impressionists, admired its freedom of handling, noting "an energy, a sureness of palette, an intensity of tonality, and an awareness of oppositions." Daumier's laundresses resonate as images of modern life in Paris, which, in the 1870s and 1880s, would be echoed in the novels of Émile Zola and in the art of Edgar Degas.

KCG

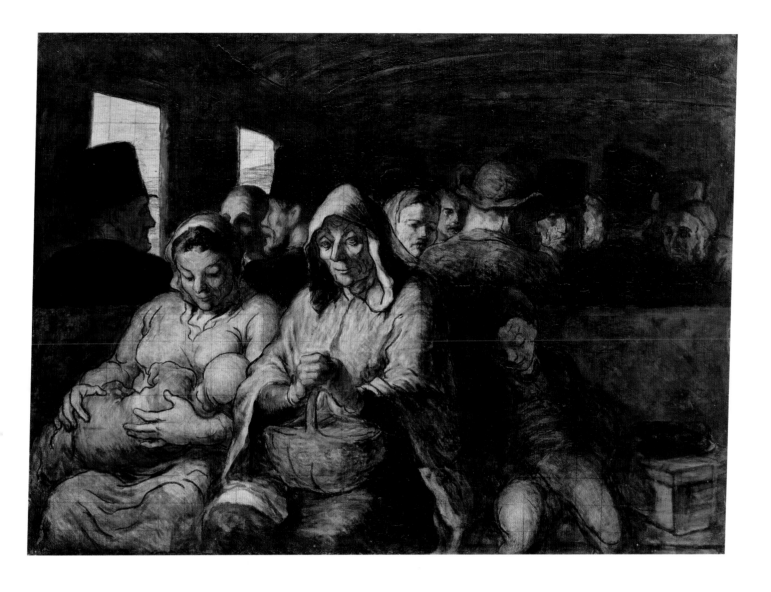

HONORÉ DAUMIER

French, 1808–1879

19. *The Third-Class Carriage*

ca. 1862–64
Oil on canvas
25¾ x 35½ in. (65.4 x 90.2 cm)
H. O. Havemeyer Collection, Bequest of Mrs. H. O.
Havemeyer, 1929
29.100.129

As a chronicler of modern urban life, Daumier captured the effects of industrialization in mid-nineteenth-century Paris. Images of railway travel first appeared in his art in the 1840s; in 1855, "Railways," a suite of four lithographs, was published in the pages of the daily *Le Charivari*, followed by two more lithographs the following year. The last of these depicts travelers in a third-class carriage, huddled against the snow and the gusts of cold wind blowing through the unglazed windows. The composition of this lithograph prefigures that of *The Third-Class Carriage*, which was possibly painted between 1862 and 1864. Unfinished and squared for transfer, the present version in oil closely corresponds to a watercolor of 1864 (Walters Art Museum, Baltimore). In addition, Daumier also executed another oil of the subject, which he finished but extensively reworked (National Gallery of Canada, Ottawa). The chronological sequence of these three compositions, however, remains unresolved. The Metropolitan's picture reveals Daumier's fluid draftsmanship in the outlines of the central figure group as well as his expressive use of light and color, which illuminates the two women in the foreground, set against a frieze of heads. A late-nineteenth-century critic expressed the universality inherent in *The Third-Class Carriage*, describing it as "a comprehensive survey of human life, with all its miseries and blemishes, thwarted joys and excruciating trials that force one to a fatalistic resignation."

KCG

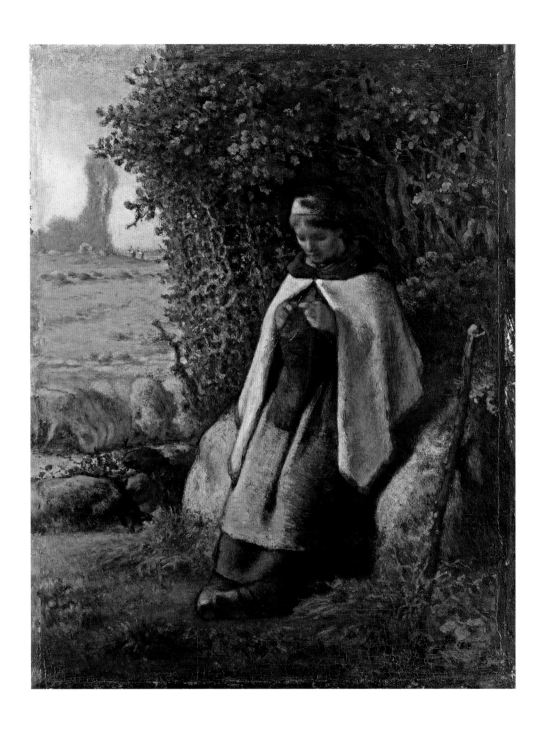

JEAN-FRANÇOIS MILLET
French, *1814–1875*

20. *Shepherdess Seated on a Rock*
1856
Oil on wood
14⅛ x 11⅛ in. (35.9 x 28.3 cm)
Gift of Douglas Dillon, 1983
1983.446

Millet had almost finished a painting of the same subject in 1856 (Cincinnati Art Museum), when the young American artist Edward Wheelwright admired it in his studio and asked to buy it. As that work was promised to a patron, Millet agreed to make a replica for Wheelwright, who recalled that Millet brought the second version to the same state of completion as the original, and then

"worked on the two pictures alternatively," advancing on one, then turning to the other, and "in this way making both . . . better than either would have been without the rivalry." Millet completed both paintings in their frames, and then gave Wheelwright his choice. Of the two nearly identical versions, Wheelwright selected the one now in Cincinnati. SAS

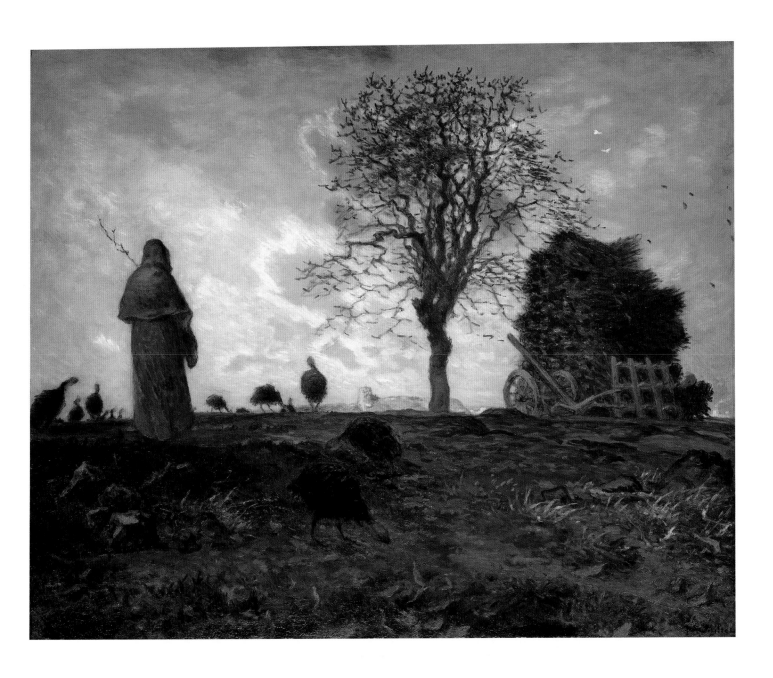

JEAN-FRANÇOIS MILLET
French, 1814–1875

21. *Autumn Landscape with a Flock of Turkeys*

1872–73
Oil on canvas
31⅞ x 39 in. (81 x 99.1 cm)
Signed (lower right): J.F. Millet
Mr. and Mrs. Isaac D. Fletcher Collection, Bequest of
Isaac D. Fletcher, 1917
17.120.209

In a letter of February 18, 1873, to his patron Frédéric Hartmann, Millet wrote that he had nearly completed this painting and hoped to deliver it to his dealer Durand-Ruel within the week: "It is a hillock, with a single tree almost bare of leaves, and which I have tried to place rather far back in the picture. The figures are a woman turning her back, and a few turkeys. I have also tried to indicate the village in the background on a lower plane." The setting is a plain near Barbizon, where Millet lived for most of his career; the distinctive tower of the neighboring hamlet of Chailly-en-Bière is visible in the distance. Millet's prosaic description betrays little of the character of his haunting conception. With great economy of means, however, he conveyed the stark beauty of late autumn and its place—as evoked by the gnarled, barren tree, and the hooded twig gatherer, shrouded against the cold—in the cycle of birth, death, and regeneration.

SAS

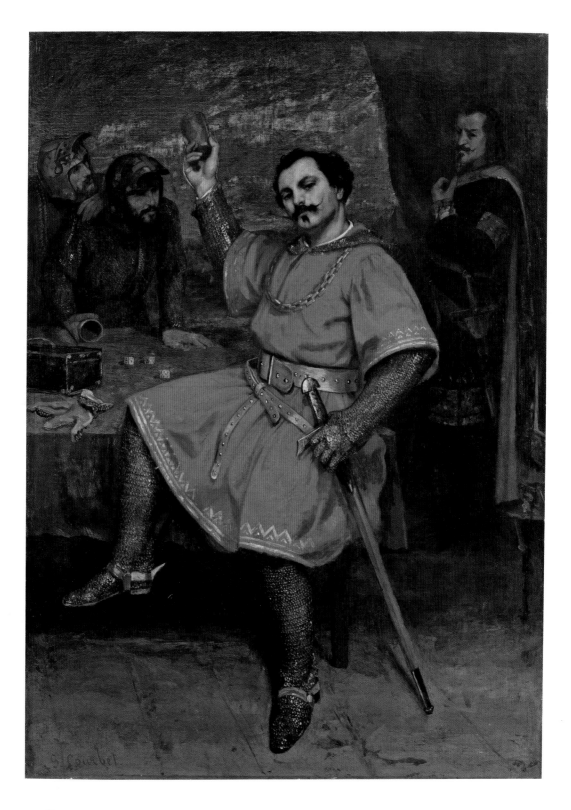

GUSTAVE COURBET
French, 1819–1877

22. *Louis Gueymard (1822–1880)
as Robert le Diable*

1857
Oil on canvas
58½ x 42 in. (148.6 x 106.7 cm)
Signed (lower left): G. Courbet.
Gift of Elizabeth Milbank Anderson, 1919
19.84

Portraits of theatrical performers were unusual in Courbet's oeuvre. This portrayal of the tenor Louis Gueymard, exhibited at the Salon of 1857, was preceded by only one other such work—Courbet's portrait of the Spanish dancer Adela Guerrero, painted in 1851 (Musées Royaux des Beaux-Arts de Belgique, Brussels). Gueymard made his Paris Opéra debut in 1848 in the title role of Meyerbeer's grand opera *Robert le Diable* (1831), which he also sang at its five-hundredth performance in 1867. In this portrait, Courbet re-creates a moment during the singer's celebrated aria, "Oui, l'or est une chimère" ("Yes, gold is a chimera"). The overt theatricality of Courbet's composition recalls the contemporary vogue for photographs of costumed performers enacting well-known scenes while posing before theatrical backdrops, as popularized by the photographer Julien Vallou de Villeneuve (1795–1866).

The writer Théophile Silvestre noted that the portrait was unfinished in 1856; the following year, Courbet exhibited it along with five other canvases at the Salon, where critics expressed their hostility toward Realism, calling Courbet a "sign-painter" who paints "like someone waxing boots." KCG

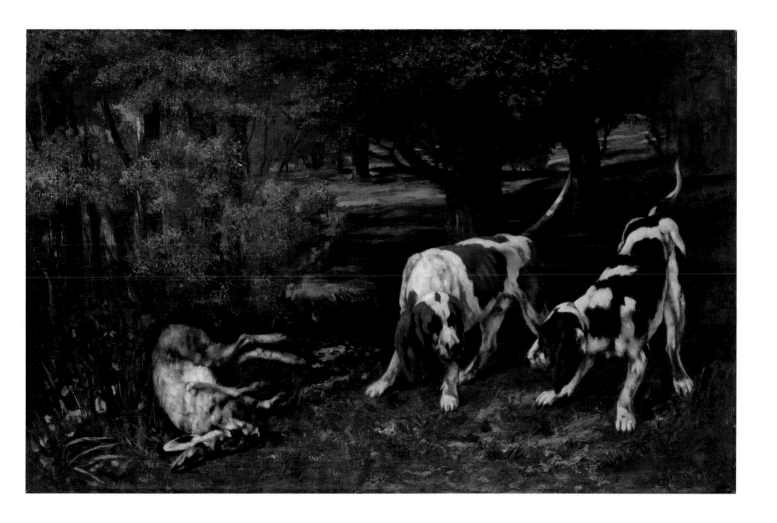

GUSTAVE COURBET
French, 1819–1877

23. *Hunting Dogs with Dead Hare*

ca. 1858–59
Oil on canvas
36½ x 58½ in. (92.7 x 148.6 cm)
Signed (lower right): G. Courbet.
H. O. Havemeyer Collection, Gift of Horace
Havemeyer, 1933
33.77

Courbet first exhibited hunting scenes at the Salon of 1857. One of these, *The Quarry* (Museum of Fine Arts, Boston), elicited critical acclaim for its "marvelous fidelity" to nature and was hailed as the artist's "best painting to date." In the present painting, Courbet repeated the motif of the two hunting dogs from the foreground of *The Quarry* and replaced the dead stag with a hare, similarly displayed.

This work is possibly the painting described in a letter written by the young German painter Otto Scholderer (1834–1902), whose studio was above the one that Courbet rented during his stay in Frankfurt in the winter of 1858–59. Comparing the picture

to *The Quarry*, Scholderer describes two dogs "placed a bit differently . . . and they're quarreling over a hare on the ground a few paces away. The landscape is magnificent . . . it's at the edge of the woods, through the trees. You see the setting sun." He also observed that, while the two dogs and the landscape were painted from memory, the hare was modeled from life. In fact, the hare in the present work appears to have been painted from a higher vantage point than that of the two hunting hounds. As a variant of a popular painting, *Hunting Dogs with Dead Hare* would have been in keeping with Courbet's practice of making replicas of marketable works.

KCG

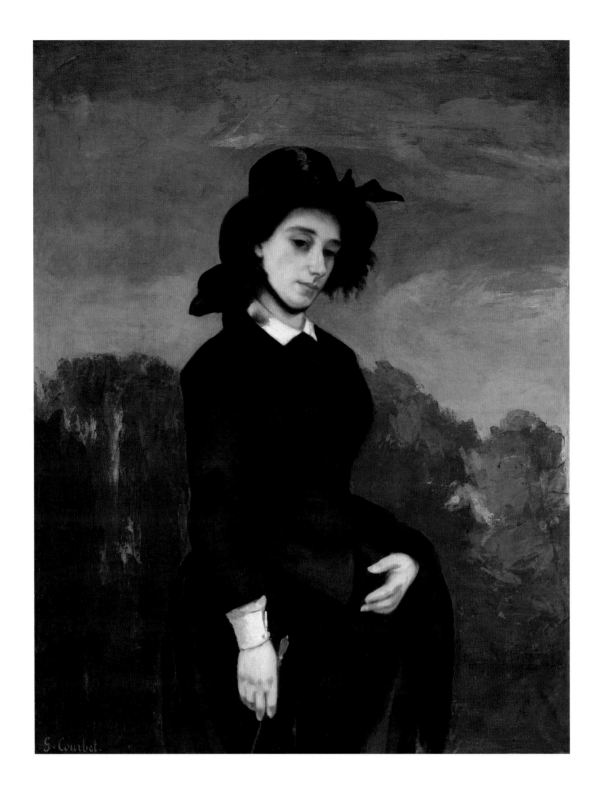

GUSTAVE COURBET
French, 1819–1877

24. *Woman in a Riding Habit*
(*L'Amazone*)

1856
Oil on canvas
45½ x 35⅛ in. (115.6 x 89.2 cm)
Signed (lower left): G. Courbet.
H. O. Havemeyer Collection, Bequest of Mrs. H. O.
Havemeyer, 1929
29.100.59

Despite the rural emphasis in Courbet's Realist paintings, his portraits encompass a wide range of sitters, from members of his family to prominent figures in Parisian society. This image of a woman in a riding habit, or *amazone*, traditionally has been identified as a portrait of Louise Colet (1810–1876), a professional writer, influential salon hostess, and the muse of Gustave Flaubert, who reportedly modeled the character of Emma Bovary after her. She would have been in her mid-forties when Courbet painted this work. Although Courbet did not exhibit this portrait in his lifetime, the critic Zacharie Astruc wrote at length about the painting, which he saw in Courbet's studio in 1859, calling the sitter, whom he did not name, "charming, very noble, elegant," and praising the painting for its "charm and truthfulness." Recently, however, it has been suggested that the sitter is the same model who appears in two paintings by Courbet from the mid-1850s—*A Spanish Lady* of 1854 (Philadelphia Museum of Art) and *The Woman with Red Sleeves* of 1853–54 (Pulitzer Collection, Saint Louis)—the latter formerly thought to be a portrait of Courbet's sister Juliette. The summarily rendered landscape of *L'Amazone* closely resembles the background of the *Woman with Red Sleeves* as well.

KCG

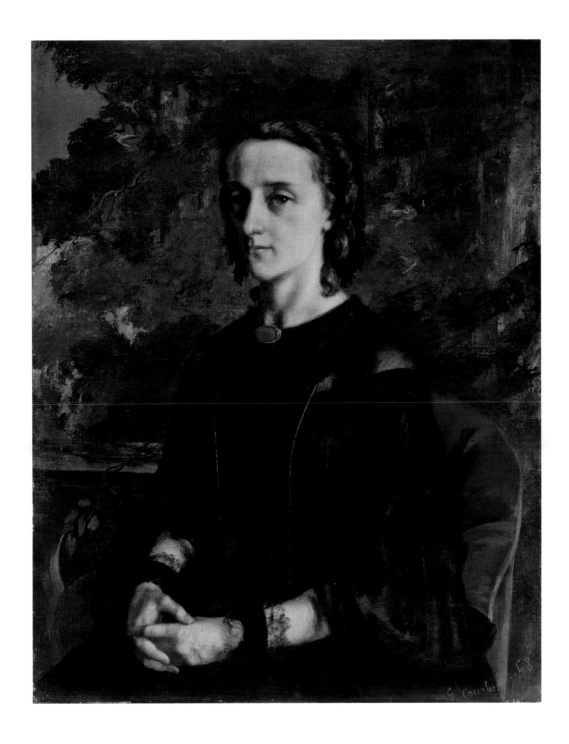

GUSTAVE COURBET
French, 1819–1877

25. *Madame de Brayer*
1858
Oil on canvas
36 x 28⅝ in. (91.4 x 72.7 cm)
Signed and dated (lower right): G. Courbet..58
H. O. Havemeyer Collection, Bequest of Mrs. H. O.
Havemeyer, 1929
29.100.118

Courbet traveled to Brussels in September 1857 and spent several months there the following summer. As he explained in a letter to his father on his return visit, "I am in Belgium to try to develop a new line of action," adding, "I have two more portraits to do here." One of these might well be the present portrait of Madame de Brayer. The painting was exhibited in Antwerp in August 1858, where critics praised its realism: one wrote of the sitter, "I did not know her at all, and I know her now . . . her physiognomy is etched with a very serene power."

Its format of a figure set against a stone balustrade with a landscape in the background recalls Renaissance aristocratic portraiture, as well as more recent portraits by Ingres and his students—perhaps reflecting Courbet's emulation of popular taste. Yet, the directness of the sitter's gaze also suggests psychological depth. Edgar Degas, who later saw the portrait exhibited in Belgium, is said to have expressed his admiration, comparing Courbet's rendering of the sitter's folded hands to the work of Rembrandt. KCG

GUSTAVE COURBET
French, 1819–1877

26. *The Source of the Loue*
1864
Oil on canvas
39¼ x 56 in. (99.7 x 142.2 cm)
Signed (bottom center): G. Courbet
H. O. Havemeyer Collection, Bequest of Mrs. H. O.
Havemeyer, 1929
29.100.122

The source of the Loue River, a geological curiosity not far from Courbet's birthplace of Ornans in the Franche-Comté, recurs in his imagery. In a letter of July or August 1864, Courbet informed his dealer Jules Luquet: "I went to the source of the Loue recently and did four landscapes 1.4 meters long." The size of the present canvas places it among this group of paintings, which depict the Loue as it surges forth from the mouth of the cave in which it originates. In this composition, Courbet sets the opening of the cave further back, widening his view to include the mill on the left, which does not appear in the other three works. His rendering of the rock forma-

tions and the foaming surface of the rushing water, using a palette knife rather than brush, evokes the materiality of the landscape.

It has been suggested that Courbet painted these views with an eye to the art market, as this site in Ornans was fast becoming a tourist attraction. These paintings might also be read as his Realist response to the allegorical *Sources*—female nudes holding a vessel from which water flows—that proliferated in the academic art on view at the Salons, as embodied by Ingres's *Source* of 1856 (Musée d'Orsay, Paris), which was exhibited in Paris in 1861. KCG

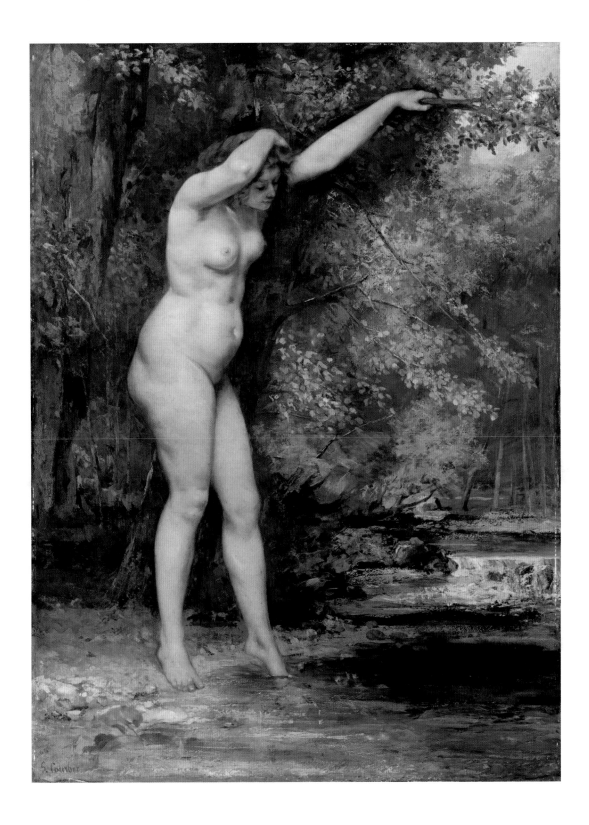

GUSTAVE COURBET
French, 1819–1877

27. *The Young Bather*
1866
Oil on canvas
51¼ x 38¼ in. (130.2 x 97.2 cm)
Signed and dated (lower left): 66 / G. Courbet.
H. O. Havemeyer Collection, Bequest of Mrs. H. O.
Havemeyer, 1929
29.100.124

In 1853, Courbet created a scandal when he exhibited *Bathers* (Musée Fabre, Montpellier), one of his earliest paintings of nudes in a landscape, which flouted the ideals of academic painting with its emphatic realism. He reprised this theme in a series of nudes painted between 1864 and 1868, including *Woman with a Parrot* of 1866 and *The Woman in the Waves* of 1868, as well as in this image of a bather poised beside a stream. The realism that his contemporaries found shocking in the 1850s informs this work, yet, when it was exhibited in 1878, critics responded to the

tactile qualities of the figure's flesh and its "radiant paleness." The highly finished nude contrasts with the more loosely painted landscape background, which was possibly executed with a palette knife rather than a brush.

This painting, along with five others by Courbet, once belonged to the Turkish collector Khalil Bey. When his collection was sold at auction in 1868, the painter Eugène Boudin recorded his impressions of *The Young Bather*: "Painting fine, pearly, strong in tone and modeling, of a distinctive tone, neither violet, nor red, nor gray." KCG

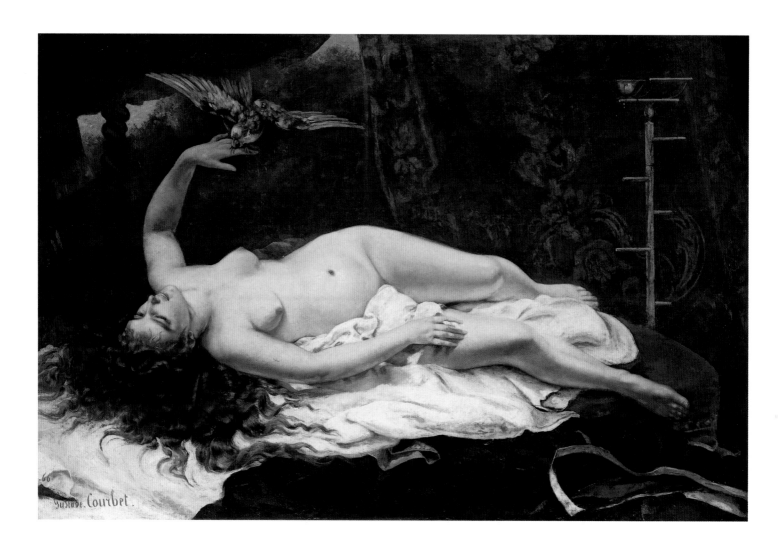

Galvanized by the success of Cabanel's *Birth of Venus* at the Salon of 1863, Courbet sought to challenge the Academy on its own terms with a painting of a nude that would be accepted by the increasingly rigid—and arbitrary—Salon jury. His first attempt, in 1864, was rejected on the grounds of indecency. When the jurors accepted his *Woman with a Parrot* for the Salon of 1866, Courbet boasted in a letter to a childhood friend, "I told you a long time ago that I would find a way to give them a fist right in the face. That bunch of scoundrels, they caught it!"

While certain aspects of Courbet's *Woman with a Parrot* align it with academic art—notably, the figure's pose and subtly modeled flesh tones—the presence of the model's discarded clothing in the scene clearly differentiated Courbet's work from the mythologized and idealized nudes shown at the Salon. More than one Salon critic referred to Courbet's nude as a courtesan, with one interpreting the undone ribbons of her skirt as a sign that "she has a proper name . . . and her entirely real charms could be verified if necessary." The prominence of her disheveled hair—"spread like tentacles," as a reviewer observed—further provoked Courbet's critics. Jules-Antoine Castagnary, Courbet's great defender, praised Courbet for eschewing the idealized nudes of academic art and representing a "woman of our time."

Édouard Manet painted *Young Lady in 1866* (The Metropolitan Museum of Art) in response to Courbet's Realist nude.

KCG

ALEXANDRE CABANEL
French, 1823–1889

29. *The Birth of Venus*
1875
Oil on canvas
41¼ x 71⅞ in. (106 x 182.6 cm)
Signed (lower left): ALEX CABANEL
Gift of John Wolfe, 1893
94.24.1

Cabanel's *Birth of Venus* (Musée d'Orsay, Paris) created a sensation at the Salon of 1863, which was known as the "Salon of the Venuses" because several paintings of the goddess on exhibition had captured the public's attention. Cabanel's picture established his reputation, and was purchased by Napoleon III for his personal collection. In 1875, the American banker John Wolfe commissioned the present canvas, one of numerous replicas made after the original. The writer Émile Zola, who would become Manet's defender and an early champion of the Impressionists, dismissed Cabanel's Venus in 1867 as "an adorable doll," made of "white and pink almond paste" and "drowning in a river of milk." His opinion, however, ran counter to popular taste in Second Empire France, which favored the academic art that Cabanel's painting embodied in its careful modeling, polished surface finish, and mythological subject.

Two years after the triumph of Cabanel's *Venus*, Salon-goers would greet Manet's *Olympia* (Musée d'Orsay, Paris), a demythologized and utterly modern nude, with jeers and derision in 1865. Cabanel, in turn, dominated the Salons of the 1860s and 1870s while shaping the development of a generation of artists, including Jules Bastien-Lepage and Henri Gervex, in his influential atelier.

KCG

GUSTAVE COURBET
French, 1819–1877

30. *Jo, La Belle Irlandaise*
1866
Oil on canvas
22 x 26 in. (55.9 x 66 cm)
Signed and dated (lower left): . . 66 /
Gustave.Courbet.
H. O. Havemeyer Collection, Bequest of Mrs. H. O.
Havemeyer, 1929
29.100.63

During his three-month stay in Trouville in 1865, Courbet attracted a following as a portraitist among the society women at this fashionable coastal resort, boasting in a letter to his family, "I have received over two thousand ladies in my studio, all wishing to have their portraits painted." He possibly encountered Johanna Hiffernan (born 1842/43), this "beautiful Irishwoman," through his acquaintance with fellow artist James McNeill Whistler, who was also working in Trouville in 1865. This image of Jo, Whistler's mistress and model, although dated 1866, was likely painted the previous year, when Courbet wrote of his admiration for "the beauty of a superb redhead whose portrait I have begun." He would paint three repetitions, with minor variations. In an 1877 letter to Whistler, Courbet nostalgically recalled, "I still have the portrait of Jo, which I will never sell. Everyone admires it."

Recent scholarship has posited this canvas as the original and the version that Courbet retained as his copy after it (Nationalmuseum, Stockholm).

While the motif of a woman holding a mirror was not new in Courbet's oeuvre, his treatment of the theme radically departs from his earlier imagery. Jo's face, dominated by her abundant red hair, fills the canvas, as Courbet captures her in a private moment of contemplation, absorbed by her reflected image. Rather than an allegory of Vanity or a stock genre subject, Courbet presents an intimate portrayal of Jo, one which celebrates the sensuality inherent in her cascading hair and translucent flesh. KCG

GUSTAVE COURBET
French, *1819–1877*

31. *The Woman in the Waves*

1868
Oil on canvas
25¼ x 21¼ in. (65.4 x 54 cm)
Signed and dated (lower left): 68 / G. Courbet
H. O. Havemeyer Collection, Bequest of Mrs. H. O.
Havemeyer, 1929
29.100.62

Between 1864 and 1868, Courbet produced a series of paintings of female nudes, including *The Woman in the Waves* of 1868. He could not have failed to witness the triumph of Alexandre Cabanel's *Birth of Venus* at the Salon of 1863, along with the popularity of two other representations of Venus by Cabanel's fellow academicians. Thus, his *Woman in the Waves*, which evokes the myth of Venus, born of the sea, responds to the contemporary taste for female nudes. Courbet slyly subverts the figure's pose, which derives from academic convention, by depicting the model's underarm hair—an element of realism underscored by the almost palpable quality of her flesh. Similarly, the boat, barely visible on the distant horizon line, removes the painting from the mythological realm. In this work, Courbet transforms the thinly veiled erotic content of the Salon "Venuses" into an overtly sexualized image. His model, assuming the same pose, appears full length in a related work from the same year, *Reclining Nude* (Philadelphia Museum of Art). KCG

GUSTAVE COURBET
French, 1819–1877

32. *The Calm Sea*

1869
Oil on canvas
23 1/2 x 28 3/4 in. (59.7 x 73 cm)
Signed and dated (lower left): .69 / G.Courbet.
H. O. Havemeyer Collection, Bequest of Mrs. H. O.
Havemeyer, 1929
29.100.566

Courbet's first encounter with the Mediterranean in 1854 resulted in a group of seascapes—a genre that the artist did not explore further until his sojourn in Trouville some ten years later. During a prolific three-month period in 1865, in the company of James McNeill Whistler and Claude Monet, he executed, by his own estimate, thirty-eight canvases, including twenty-five seascapes. Returning to Étretat along the coast of Normandy in August 1869, he painted this view of the Channel coast at low tide. Its subtle color harmonies, rendered in a lighter palette than the artist's Ornans landscapes, evoke the luminosity of watercolors. The com-position, in which an immense sky reduces the landscape to narrow bands of sea and shore, is one that Courbet favored for his seascapes. The overall effect is not unlike the marine photographs of Gustave Le Gray (1820–1894), whose images from the 1850s might well have inspired Courbet.

By 1869, such tranquil seascapes were unusual among Courbet's marine paintings, which were then dominated by dramatically crashing waves that embodied the elemental power of nature. The following year, Courbet exhibited only seascapes at the Salon—a calculated assertion of his command of the genre. KCG

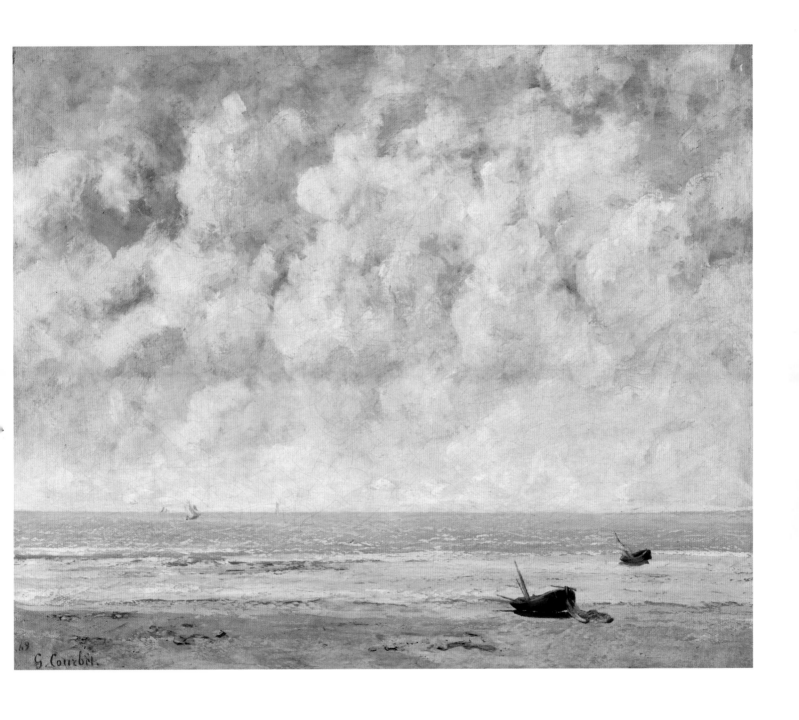

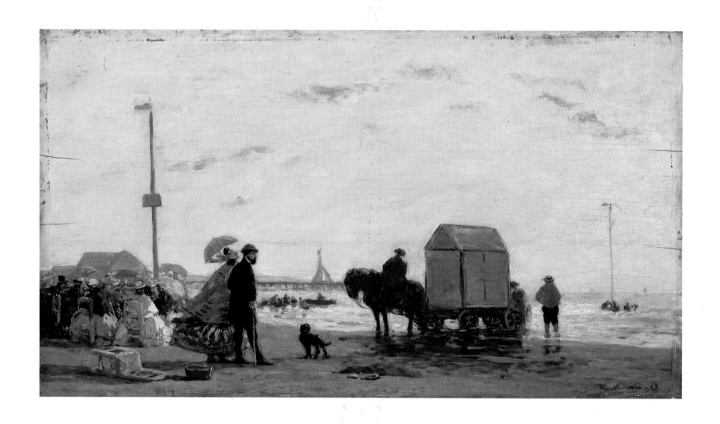

EUGÈNE BOUDIN
French, 1824–1898

33. *On the Beach at Trouville*
1863
Oil on wood
10 x 18 in. (25.4 x 45.7 cm)
Signed and dated (lower right): E. Boudin.63
Bequest of Amelia B. Lazarus, 1907
07.88.4

Boudin, a native of Honfleur, began painting scenes of fashionable beach resorts along the Normandy coast in the early 1860s. In a letter from 1863, the year in which this view of the beach at Trouville was painted, the artist acknowledged the popularity of his paintings of "little ladies on the beach," adding that "some people say that in them there lies a vein of gold to be exploited." The modernity of Boudin's imagery attracted the attention of such critics as Charles Baudelaire and Émile Zola. The latter, reviewing the Salon of 1868, praised Boudin's "exquisite originality" and commented on his "rare accuracy of observation in the details and attitudes of these figures on the edge of the vast expanse." In this

work, the billowing crinoline and the parasol of the woman in the foreground, as well as the bathing machine, or changing booth, evoke contemporary fashion and leisure pursuits.

On the Beach at Trouville reflects Boudin's interest in capturing the effects of light and atmosphere, from the flag and crinoline fluttering in the stiff breeze to the cool gray light of the overcast sky. Painted in his studio, the work was likely based on studies made on site, which the artist often annotated with the date, time of day, and wind conditions. The naturalistic approach to landscape that Boudin espoused in the 1860s prefigured that of the Impressionists. KCG

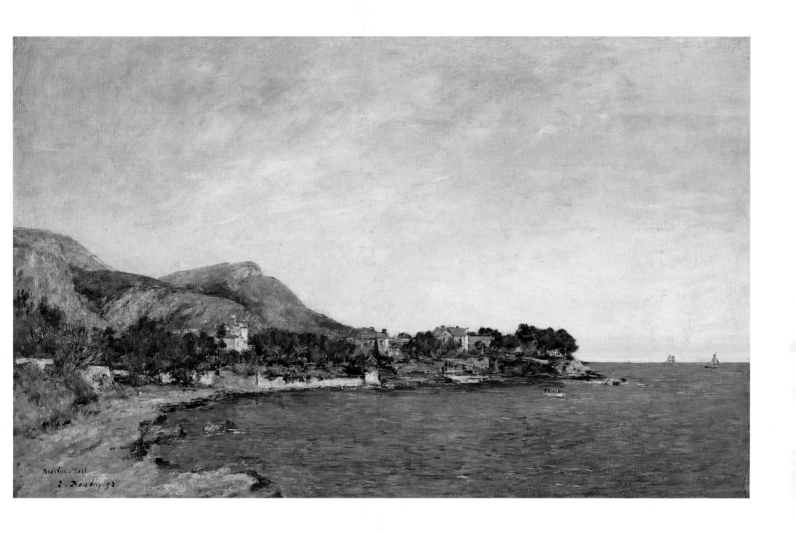

EUGÈNE BOUDIN
French, 1824–1898

34. *Beaulieu: The Bay of Fourmis*
1892
Oil on canvas
21⅝ x 35½ in. (54.9 x 90.2 cm)
Signed, dated, and inscribed (lower left):
Beaulieu-Mars / [E].Boudin 92.
Bequest of Jacob Ruppert, 1939
39.65.2

Boudin discovered the Midi late in his life, first visiting the region in 1885. From 1890 he wintered in the South of France, where he continued his practice of plein-air painting. He extolled "these beautiful coasts so warm in tone . . . these trees green in the middle of winter, this light of the skies." The present canvas, painted in Beaulieu, along the French Riviera, in the spring of 1892, was exhibited along with two other views of Beaulieu in that year's Salon in Paris. Its bright hues reflect the heightening effect of the Mediterranean light on Boudin's palette.

Although Boudin participated in the first Impressionist exhibition in 1874, he did not assimilate the stylistic innovations of Impressionism into his work, as his handling in this painting reveals. Similarly, the composition, with its broad expanse of shoreline and sea, shows little change from his coastal scenes executed nearly three decades earlier. Boudin returned to this motif in 1898, the last year of his life, producing an almost identical view from the same vantage point (Private collection).

KCG

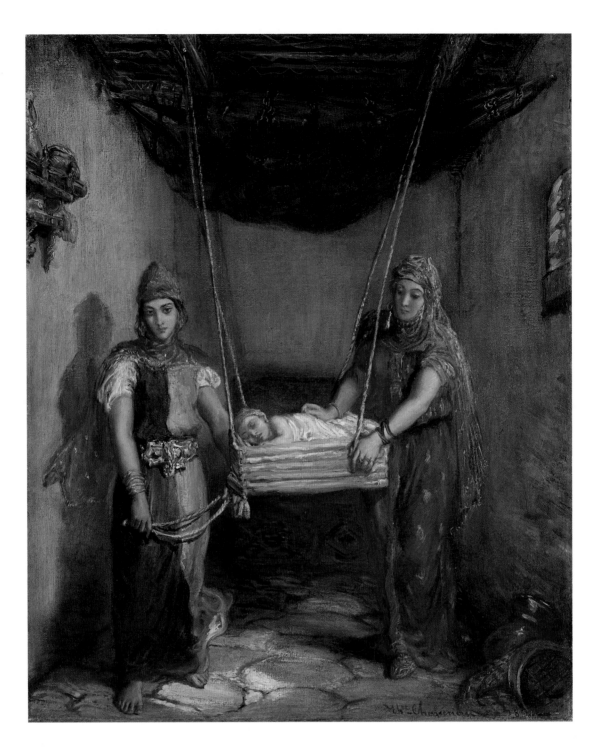

THÉODORE CHASSÉRIAU
French, 1819–1856

35. Scene in the Jewish Quarter of Constantine

1851
Oil on canvas
22⅞ x 18½ in. (56.8 x 47 cm)
Signed and dated (lower right): Th^re Chassériau 1851
Purchase, The Annenberg Foundation Gift, 1996
1996.285

The son of a French consul in Saint Domingue and a Creole woman, Chassériau exhibited precocious talent as a child. He entered Ingres's atelier at the age of ten, and by the age of seventeen his works were accepted at the Salon. Unfortunately, his brilliant career ended twenty years later with his death.

Chassériau began by imitating the Mannerist classicism of his teacher, Ingres, but he soon created a style characterized by baroque compositions and Rubensian color. His portrait of Ali-Ben-Hamet (Musée National du Château, Versailles), exhibited at the Salon of 1845, was considered by critics to rival Delacroix's *Sultan of Morocco* of the same year. A trip to Algeria in 1846 confirmed his predilection for Orientalist imagery. For the rest of his life he tapped his experiences in Algeria to produce a remarkable oeuvre of genre scenes. He received several important commissions to decorate public buildings in Paris, and these works served as inspiration to Puvis de Chavannes, Gustave Moreau, and other painters who came of age in the 1850s.

From the ancient town of Constantine, Chassériau wrote, "I have seen some highly curious things, primitive and overwhelming, touching and singular. At Constantine, which is high up in some enormous mountains, one sees the Arab people and the Jewish people as they were at the very beginning of time." An 1846 sketch of this scene (Musée du Louvre, Paris) served as the basis for an elaborate watercolor also of 1846 (Private collection), destined for an album presented to the duchesse d'Orléans, the new wife of the heir to the French throne. Although the watercolor included a third figure crouching at the right, Chassériau reverted to a simpler composition for this version in oil.

GT

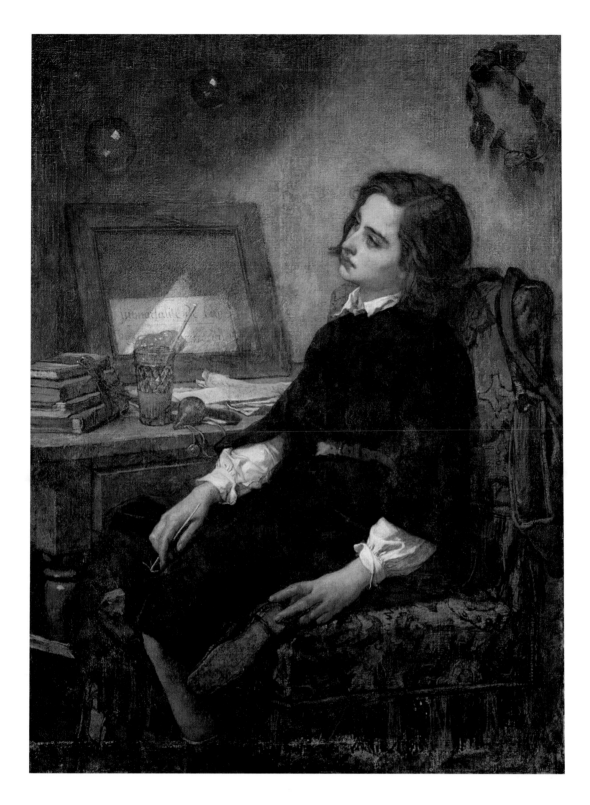

THOMAS COUTURE

French, 1815–1879

36. *Soap Bubbles*

ca. 1859
Oil on canvas
51½ x 38⅝ in. (130.8 x 98.1 cm)
Signed and inscribed: (lower left) T.C.; (on paper)
immortalité de l'un . . . (one's immortality . . .)
Catharine Lorillard Wolfe Collection, Bequest of
Catharine Lorillard Wolfe, 1887
87.15.22

Couture triumphed at the Salon of 1847 with his *Romans of the Decadence* (Musée d'Orsay, Paris), a monumental canvas whose depiction of the debauchery of a Roman orgy was interpreted as a satire of the corrupt regime of the July Monarchy (1830–48). Couture's rendering of traditional academic subjects in a looser, more painterly style represented the sort of artistic compromise that appealed to contemporary *juste-milieu* taste. Despite several major projects undertaken for the government of Napoleon III in the 1850s, Couture focused on private commissions after 1859. With *Soap Bubbles*, he reprised a traditional *vanitas* image: the bubbles symbolize the transience of life, while the wilting laurel wreath on the wall suggests the fleeting nature of praise and honors. The word *"immortalité,"* inscribed on the paper inserted in the framed mirror, reinforces the painting's allegorical content.

Soap Bubbles is possibly contemporaneous with a version dated 1859 (Walters Art Museum, Baltimore). In 1867, Édouard Manet, who studied in Couture's Paris atelier, painted *Boy Blowing Bubbles* (Museu Calouste Gulbenkian, Lisbon), which, although recalling Couture's precedent, counters his master's allegory with an emphatically naturalistic portrayal. KCG

37. *1807, Friedland*

1875
Oil on canvas
53½ x 95½ in. (135.9 x 242.6 cm)
Signed and dated (lower left): EMeissonier [initials in
monogram] / 1875
Gift of Henry Hilton, 1887
87.20.1

Meissonier, largely self taught, established his reputation in the 1840s as a painter of small-scale genre scenes rendered in meticulous detail, which were sought after by wealthy collectors. An 1864 history painting, *1814, The Campaign of France* (Musée d'Orsay, Paris), signaled the artist's new interest in epic Napoleonic subjects. Countering this image of Bonaparte in defeat, *1807, Friedland*, completed in 1875, evokes one of the emperor's greatest victories. These were the only realized works in a projected cycle of five paintings intended to represent episodes in the life of Napoleon.

Meissonier's largest and most ambitious painting, *1807, Friedland,* preoccupied the artist for over a decade. He embarked on extensive research—from interviewing veterans to studying the movement of horses—and even commissioned replicas of military uniforms and equipment, which he then depicted in his painting. In addition, he executed oil studies of the individual figures and horses in the composition; more than ninety of these studies, painted on panel, were included in the artist's 1893 estate sale. The result reflects Meissonier's avowed fidelity to nature, down to such minute details as the individually delineated blades of grass in the foreground and the reflected light on the soldiers' armor and swords.

The painting gained notoriety in 1876 when the American department-store magnate Alexander T. Stewart (1803–1876) purchased it from the artist, sight unseen, for an astronomical sum. In 1887, Judge Henry Hilton, who had acquired the work at Stewart's estate sale, bequeathed it to the Museum. KCG

JEAN-LÉON GÉRÔME
French, 1824–1904

38. *Prayer in the Mosque*

1871
Oil on canvas
35 x 29½ in. (88.9 x 74.9 cm)
Signed (upper right, on beam): J.L. GEROME
Catharine Lorillard Wolfe Collection, Bequest of
Catharine Lorillard Wolfe, 1887
87.15.130

Orientalist images comprise more than two-thirds of Gérôme's painted oeuvre, and are based on the artist's extensive travels in the Near East, especially North Africa. According to the critic Théophile Gautier, writing in 1857, Gérôme's approach to these subjects was that of a history painter. The precision and photographic detail of the artist's technique reinforces the notion of his paintings as historical records.

Gérôme's 1868 visit to Egypt is recorded by one of his traveling companions, Paul-Marie Lenoir, who was also his student. Lenoir's account offers a detailed description of their visit to the mosque of ʿAmr in Cairo—founded in A.D. 640— whose interior Gérôme depicts in this painting. The rows of wor-

shipers, ranging from the dignitary and his attendants to the nude Muslim holy man, face Mecca during one of the five daily prayers. It is unlikely, however, that Gérôme witnessed such a scene at this particular mosque, which, by 1868, had fallen into disuse. Rather, the image was probably a composite of sketches as well as photographs of various sites: Gérôme is known to have worked from photographs, especially when depicting the backgrounds of his paintings, and the plunging perspective of columns and arcades in this picture closely resembles the view in a contemporary photograph of the interior of the mosque of ʿAmr. No traces of the original architecture of the mosque remain today.

KCG

JEAN-LÉON GÉRÔME
French, 1824–1904

39. *Tiger and Cubs*

ca. 1884
Oil on canvas
29 x 36 in. (73.7 x 91.4 cm)
Signed (lower left): J.L. GÉROME
Bequest of Susan P. Colgate, in memory of her
husband, Romulus R. Colgate, 1936
36.162.4

Although his fame rests on his Orientalist imagery, Gérôme was also a prolific *animalier*. Late in his life, he recalled his daily visits as a young artist to the Jardin des Plantes in Paris during the summer months and the studies of animals that these visits inspired. Animals figured in his first Salon submission in 1847, *The Cockfight* (Musée d'Orsay, Paris), a historicizing genre scene. Four years later, he exhibited his first large canvas of a solitary animal in a vast landscape setting.

While his animal paintings reflect his predilection for lions, tigers recur in his works from the 1880s. In 1882, he was asked to illustrate Victor Hugo's "La Douleur du Pacha" for a volume of the author's poetry. Hugo's poem invokes the pasha's grief at the death of his "Nubian tiger." Undeterred, like Hugo, by the fact that the tiger is not indigenous to North Africa, Gérôme persisted in painting tigers in imaginary landscapes. The rocky terrain of *Tiger and Cubs* is evocative of Egypt, where he had first traveled in 1856. The picture was probably painted about 1884, corresponding to a nocturnal desert scene with a tiger that he exhibited in that year's Salon (*La Nuit au désert*; now lost). The work is rendered in Gérôme's characteristic precise, highly polished style. KCG

JEAN-LÉON GÉRÔME
French, 1824–1904

40. *Pygmalion and Galatea*

ca. 1890
Oil on canvas
35 x 27 in. (88.9 x 68.6 cm)
Signed (on base of statue): J.L. GEROME.
Gift of Louis C. Raegner, 1927
27.200

Late in his career, Gérôme turned to the medium of sculpture, responding to the new interest in polychrome marbles. He identified with the mythical sculptor, Pygmalion, and, between 1890 and 1893, he executed both sculpted and painted variations on the theme of Pygmalion and Galatea, as told in Ovid's *Metamorphoses*. All of these works depict the moment when the sculpture of Galatea is brought to life by the goddess Venus, in fulfillment of Pygmalion's wish for a wife as beautiful as the sculpture he created.

In 1890, Gérôme commented that he had "just begun" a painting of Pygmalion and Galatea. This is one of three known versions of the subject, all likely based on the plaster model of a life-sized marble sculpture (Hearst Castle, San Simeon, California) that Gérôme exhibited at the Salon of 1892. In each painting, the sculpture appears at a different angle, in emulation of the experience of viewing it in the round, and Gérôme renders the contrast between the rosy flesh of Galatea's upper body and the inanimate marble of her lower legs and feet, still bound to the base on which she stands.

The present picture is included as a painting within a painting in the background of Gérôme's *The Artist's Model*, a self-portrait from 1895 showing him at work on his statue *Tanagra* (The Haggin Museum, Stockton, California). KCG

41.

In a career that spanned fifty years, Pierre Puvis de Chavannes played a seminal role in the resurgence of mural painting in nineteenth-century France. His first decorative paintings, *War* and *Peace*, exhibited at the Salon of 1861, led to the commissioning, three years later, of the monumental mural, *Ave Picardia Nutrix* (Hail, Picardy the Nourisher), to decorate a large stairwell in the newly constructed Musée de Picardie in Amiens. *Cider* and *The River* are studies for the left and right sides, respectively, of the mural.

Puvis detailed his work's symbolic intent—an allegory of the richness of the province of Picardy—in an 1864 letter, in which he refers to his composition as "my poem." His Arcadian imagery and the classicizing style that he adopted typify his approach to mural painting, as does his use of pale, mat colors suggestive of the appearance of fresco.

Although *Cider* and *The River* present an idealized vision of Picardy's distant past, their subjects would have resonated in the 1860s, at a time when each region of France was rediscovering its unique history, character, and culture as part of a broader movement toward decentralization.

The simplified forms and the minimal modeling characteristic of Puvis's murals influenced the next generation of artists that included Georges Seurat and Paul Gauguin and, later, Henri Matisse and Pablo Picasso.

KCG

64

42.

PIERRE PUVIS
DE CHAVANNES
French, 1824–1898

43. *Sleep*

ca. 1867–70
Oil on canvas
26⅛ x 41¾ in. (66.4 x 106 cm)
Signed (lower left): P. Puvis de Chavannes.
Theodore M. Davis Collection, Bequest of Theodore
M. Davis, 1915
30.95.253

At the Salon of 1867, Puvis exhibited *Sleep* (Musée des Beaux-Arts, Lille), an unusually large canvas, which he had proclaimed his "favorite work" soon after its completion that year. Although he conceived of it as an independent canvas, Puvis executed "reductions" of *Sleep* in keeping with the practice followed for his mural paintings. The present work was possibly the reduced-scale version that Puvis exhibited in 1870 in Limoges.

An inscription from Virgil's *Aeneid* appears on a pen-and-ink compositional study for *Sleep* (The Metropolitan Museum of Art) as well as within the entry for the painting in the 1867 Salon catalogue: "It was the hour when for weary mortals their first rest begins" (Book 2, line 268). Despite the literary allusion, *Sleep* does not illustrate Virgil's text; rather, it depicts a generalized and idealized vision of untroubled slumber. A contemporary described Puvis's painting as "a beautiful dream, as if sketched with a silver crayon on the gray canvas of night." Fittingly, the artist Émile Bernard later called Puvis a "French Virgil." KCG

PIERRE PUVIS
DE CHAVANNES
French, 1824–1898

44. *The Shepherd's Song*

1891
Oil on canvas
41⅛ x 43¼ in. (104.5 x 109.9 cm)
Signed and dated (lower left): P.Puvis de Chavannes /
1891
Rogers Fund, 1906
06.177

From 1884 to 1886, Puvis executed mural decorations for the Musée des Beaux-Arts in Lyons that are allegorical representions of the origins of art. The present work, which dates from 1891, is one of several variants of a portion of the Lyons mural entitled *Antique Vision* (1885)—a tribute to the art of antiquity that evokes "the rhythmic poetry and the heroic movements of ancient Greece," as a contemporary critic wrote. Puvis's subject reflects his preference for classicizing imagery in his decorative murals. The poses of the foreground figures in *The Shepherd's Song* derive from antique sources, including statues and relief sculpture, further reinforcing the artist's allusions to antiquity.

Shortly after completing this work, Puvis wrote to a friend, urging him to go see the painting at his dealer's in Paris before it got sent to America—a signal of the growing interest abroad in his work. The same year, 1891, Puvis agreed to paint nine murals for the Boston Public Library, his only mural commission outside of France. KCG

67

GUSTAVE MOREAU
French, 1826–1898

45. *Oedipus and the Sphinx*

1864
81¼ x 41¼ in. (206.4 x 104.8 cm)
Signed and dated (lower left): .Gustave Moreau .64.
Bequest of William H. Herriman, 1920
21.134.1

Moreau, a virtually unknown artist at the age of thirty-eight, triumphed at the Salon of 1864 with his interpretation of the myth of Oedipus and the Sphinx. Critics hailed him as the "hero" of the Salon, caricaturists parodied his painting in the popular press, and the Salon jury awarded him a medal. His painting represents the moment when Oedipus confronts the winged monster outside Thebes, faced with solving her riddle in order to save his life as well as the besieged Thebans. Moreau had established the composition in a watercolor dated 1861 but completed the painting only in 1864.

His work shows his awareness of Ingres's version of the subject (Musée du Louvre, Paris), painted in 1808 and exhibited in Paris in 1846 and 1855, which Moreau had sketched. Its precisely delineated contours, rendered in a crisp black line, suggest the style of the Early Renaissance painter Andrea Mantegna, whose work Moreau had studied at the Louvre. More than one Salon reviewer made this comparison, positing Moreau as the "new Mantegna." Moreau's choice of a mythological subject and his deliberately archaizing style distinguished his work from the Realist and naturalist currents of the 1860s. Years later, the artist Odilon Redon would recall the impact of seeing Moreau's painting in 1864: "I long retained the memory of this first impression; it perhaps had sufficient power over me to give me the strength to pursue an isolated path." KCG

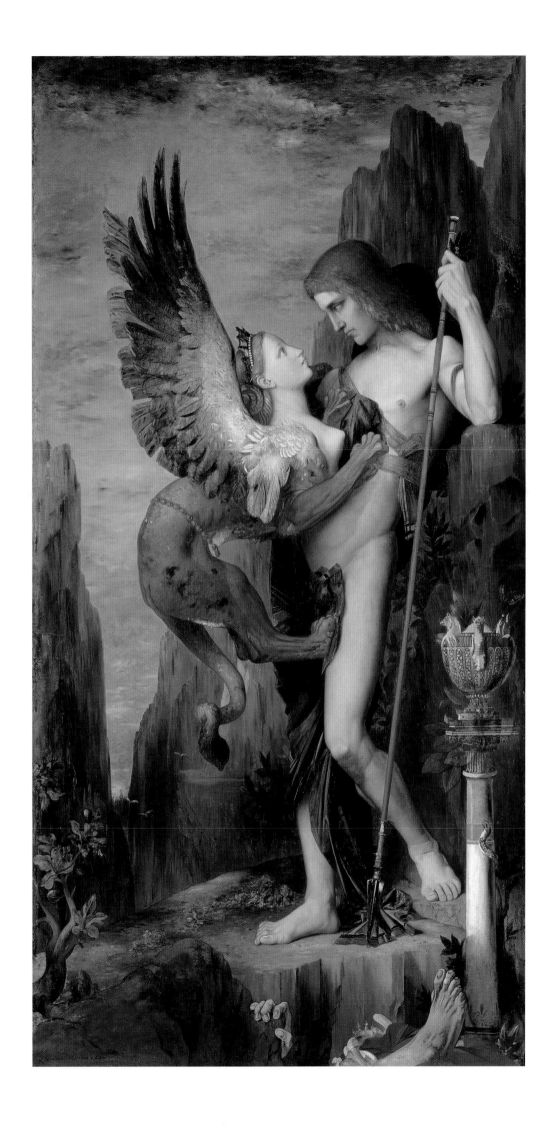

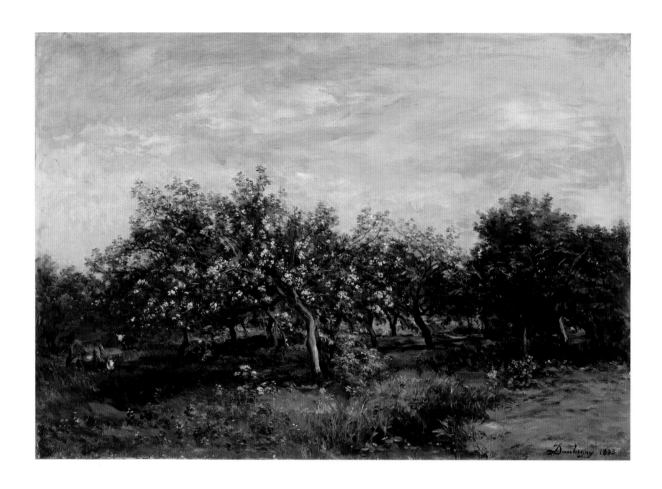

CHARLES-FRANÇOIS
DAUBIGNY
French, 1817–1878

46. *Apple Blossoms*
1873
Oil on canvas
23⅛ x 33⅜ in. (58.7 x 84.8 cm)
Signed and dated (lower right): Daubigny 1873
Bequest of Collis P. Huntington, 1900
25.110.3

Daubigny was a member of the Barbizon school of artists, active in the Fontainebleau region of France in the 1830s and 1840s, who espoused a naturalistic approach to landscape painting. While the critic Théophile Gautier extolled the naturalism of Daubigny's landscapes in 1859, describing them as "pieces of nature cut out and set into golden frames," the artist's detractors faulted his loose handling and the lack of finish in his works. These qualities, however, appealed to the emerging generation of Impressionists in the 1860s, whose art Daubigny would champion late in his career.

Daubigny first painted scenes of flowering orchards about 1857, reprising the motif almost every spring. This canvas, dated 1873, reflects his assimilation of the lightened palette of the Impressionists, first evidenced in his paintings from the end of the previous decade. The vivid hues of the greenery and the crystalline sky mark a departure from the subdued, somber tonality of his earlier work. Daubigny's use of rapid, summary brushstrokes, in turn, influenced the development of the Impressionists' technique in the 1860s. Claude Monet, who, as a young artist, had admired Daubigny's landscapes, painted two views of blossoming apple trees, also dated 1873. KCG

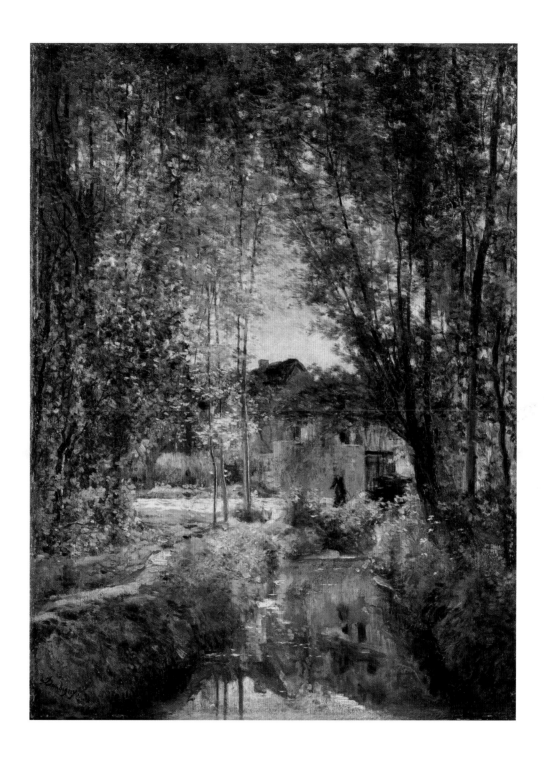

CHARLES-FRANÇOIS
DAUBIGNY
French, 1817–1878

47. *Landscape with a
Sunlit Stream*
ca. 1877
Oil on canvas
25⅛ x 18⅞ in. (63.8 x 47.9 cm)
Signed (lower left): Daubigny.
Bequest of Martha T. Fiske Collord, in memory of her
first husband, Josiah M. Fiske, 1908
08.136.4

Daubigny began exhibiting his work regularly at the Salon in 1838, and, by the early 1850s, he had achieved considerable success as a landscape painter, prompting the critic Théophile Gautier to call him "the first among objective landscapists." The motif of water figures prominently in Daubigny's imagery—notably, in his riverscapes painted from the vantage point of his famous studio-boat, the "Botin," which he purchased in the autumn of 1857. Following Daubigny's example, Monet had a studio-boat built in the 1870s from which he made paintings of the Seine.

Late in his career, Daubigny executed several views of streams in the woods near Valmondais, a village on the Oise River. The present work is possibly contemporaneous with a similar scene of a sunlit stream flanked by soaring, leafy trees, also vertical in format, which has been identified with the same site and dated to about 1877 (Museum Mesdag, The Hague). Its flickering brushwork and lightened palette relate the picture to the works of the Impressionists, whose influence on Daubigny grew out of his contact with Camille Pissarro and Claude Monet in the 1860s and early 1870s. KCG

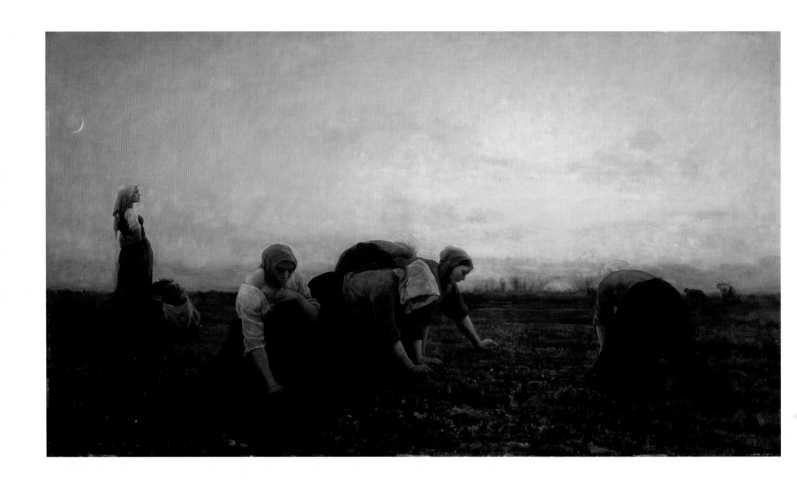

Jules Breton
French, 1827–1906

48. *The Weeders*

1868
Oil on canvas
28⅛ x 50¼ in. (71.4 x 127.6 cm)
Signed, dated, and inscribed (lower right):
Jules Breton / Courrières 1868
Bequest of Collis P. Huntington, 1900
25.110.66

This is a smaller variant of Breton's painting *The Weeders* of 1860 (Joslyn Art Museum, Omaha), which was widely admired at the Salon of 1861 and at the 1867 Exposition Universelle in Paris. In his autobiography, the artist wrote that he had discovered the subject—"ready-made"—one evening in the fields near his native village of Courrières in northern France. He claimed that this twilight scene of peasants pulling up "thistles and weeds . . . their faces haloed by the pink transparency of their violet hoods, as if to venerate a fecundating star," had presented itself to him as a "finished picture," replete even so far as "the breadth of the lines, intensity of the effect, character, richness and simplicity."

SAS

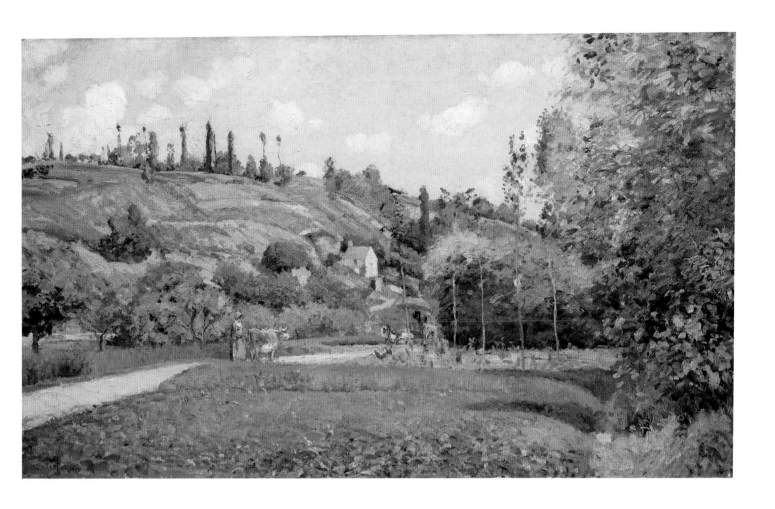

CAMILLE PISSARRO
French, 1830–1903

49. A Cowherd at Valhermeil, Auvers-sur-Oise

1874
Oil on canvas
21⅝ x 36¼ in. (54.9 x 92.1 cm)
Signed and dated (lower left): C. Pissarro. 1874
Gift of Edna H. Sachs, 1956
56.182

Pissarro lived in the town of Pontoise from 1866 to 1869, and returned there in 1872, having spent the intervening years in the company of Monet, Renoir, and Sisley in Louveciennes, and in exile in London during the Franco-Prussian War. Over the next decade, adapting the looser touch, broken brushstrokes, and lighter palette of his younger Impressionist colleagues, and enjoying contact with Cézanne, who lived in nearby Auvers, Pissarro developed his inimitable approach to landscape painting in surroundings that blended old and new. Nestled in the Oise River valley just northwest of Paris, the neighboring towns of Pontoise and Auvers harbored vestiges of their rural past in the farms, thatched cottages, and market gardens that dotted the hilly terrain; yet there were signposts of change, such as the modern factories that had sprung up along the riverbank. With characteristic interest in the pulse of daily life, Pissarro routinely painted inhabited—as opposed to pure—landscapes, frequently depicting villagers walking on paths that wind their way through a French countryside in flux.

Formerly known as *A Cowherd on the Route du Chou, Pontoise*, this view actually shows the rue de Pontoise in the adjacent hamlet of Valhermeil in Auvers. Between 1873 and 1882, Pissarro painted some twenty works in the area, including a half-dozen in which the red-roofed house adds a contrasting color note to the hillside's lush greenery. SAS

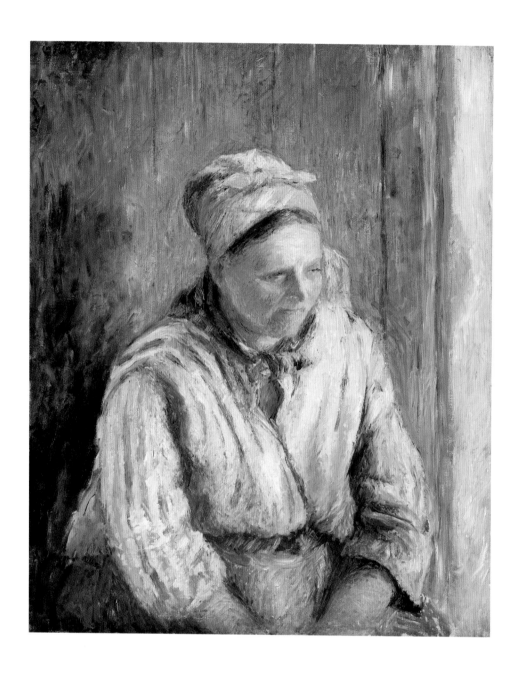

CAMILLE PISSARRO
French, 1830–1903

50. *Washerwoman, Study*
1880
Oil on canvas
28¾ x 23¼ in. (73 x 59.1 cm)
Signed and dated (upper left): C. Pissarro 80
Gift of Mr. and Mrs. Nate B. Spingold, 1956
56.184.1

Indicative of Pissarro's recent shift in artistic focus, the majority of the works that he submitted to the 1882 Impressionist exhibition were figure paintings in which the local villagers who had routinely animated his rustic landscapes assumed monumental form. The artist's neighbor in Pontoise, a fifty-six-year-old mother of four named Marie Larchevêque, sat for this work, which was shown as "*Laveuse, étude*." Pissarro's study of a washerwoman joined other large-format portrayals of wholesome peasant girls and the occasional weathered farmhand, similarly disposed in quiet meditation. While critics invariably invoked Millet's towering example, they were generally impressed with the refreshing authenticity of Pissarro's "country women," who, as one writer put it, "are rustic but not clumsy, vigorous, but not coarse." SAS

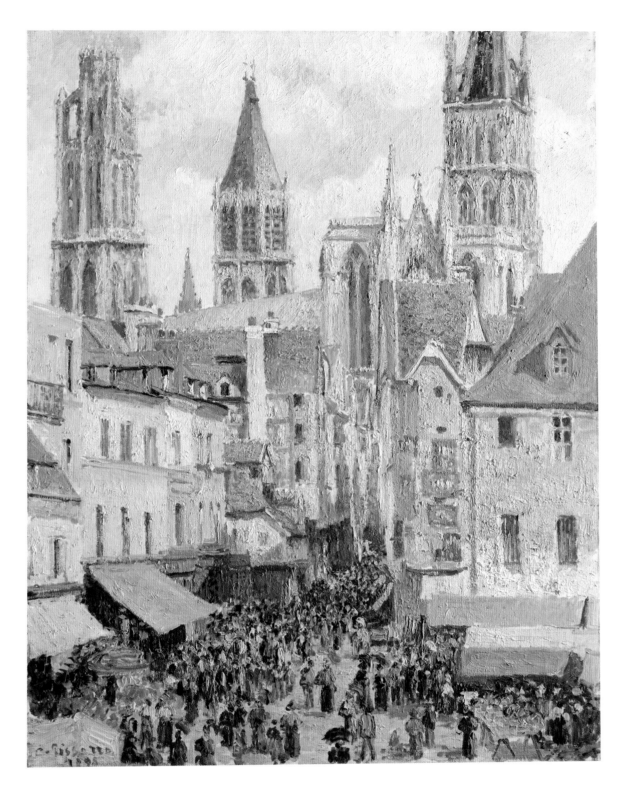

CAMILLE PISSARRO
French, 1830–1903

51. *Rue de l'Épicerie, Rouen
(Effect of Sunlight)*
1898
Oil on canvas
32 x 25⅝ in. (81.3 x 65.1 cm)
Signed and dated (lower left): C.Pissarro. / 1898
Purchase, Mr. and Mrs. Richard J. Bernhard Gift,
1960
60.5

Pissarro first worked in Rouen in 1883. He returned to this harbor city in Normandy twice, in 1896 and in 1898, for three extended painting campaigns in the wake of Monet's "Rouen Cathedral" series of the early 1890s, which he greatly admired. By the time of his last sojourn, from July to October 1898, he was "already familiar with the motifs there," but, perhaps unsatisfied with the mixed reception of his most recent Rouen paintings (which did not always fare well in comparison to Monet's), Pissarro tackled many of the same cityscapes again and was inspired to scout out some scenes that were new. Writing to his son Lucien on August 19, Pissarro announced:

"Yesterday I found an excellent place from which I can paint the Rue de l'Épicerie and even the market, a really interesting one, which takes place every Friday." Ultimately, he painted the view three times, but the Metropolitan's picture is the only one that shows the market, in the Place de la Haute-Vieille-Tour, in progress. He chose a vantage point similar to that of the present *Effect of Sunlight* for a morning view in *Rainy Weather* (Yoshino Gypsum Collection, Tokyo) and shifted his perspective in *Late Afternoon* (Private collection) to reveal the southern transept of the cathedral, at the end of the street. SAS

75

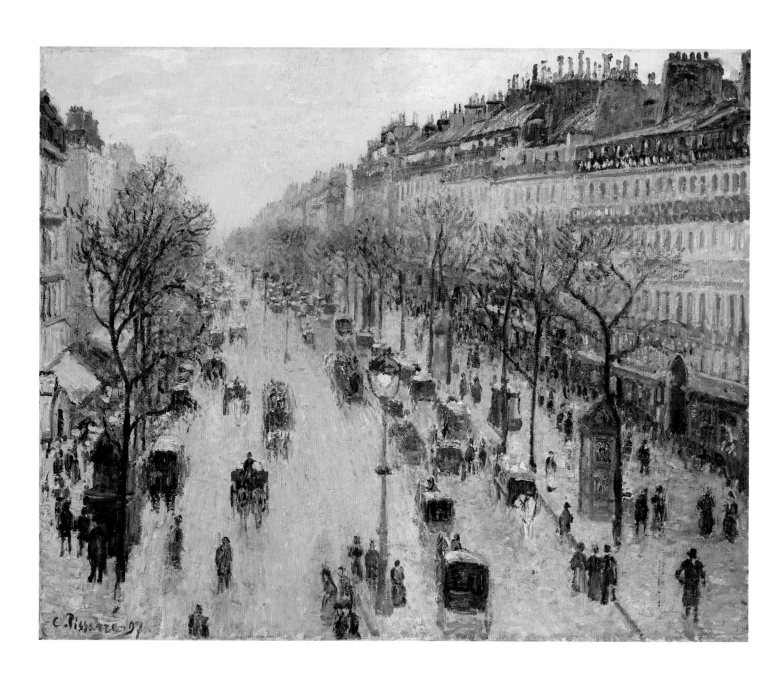

Having broken ranks with his Impressionist colleagues, from 1885 to 1891, to explore the virtues of Pointillism in the rural setting of Éragny, Pissarro reasserted his authority as a painter of modern life in the 1890s. He devoted several series to subjects such as the *grands boulevards* of Paris, redolent of the glory days of Impressionism. Pissarro took up the practice of painting cityscapes from the vantage point of hotel-room windows, marveling as he surveyed the view from his lodgings at the Grand Hôtel de Russie, in early 1897, that not only could he "see down the whole length of the boulevards" but he had "almost a bird's-eye view of carriages, omnibuses, people, between big trees, big houses that have to be set straight." From February through April, Pissarro set out to record—in two views of the Boulevard des Italiens to the right, and fourteen of the Boulevard Montmartre to the left—the spectacle of urban life as it unfolded below his window during different seasons (from winter to spring), times of day, and weather conditions. SAS

CAMILLE PISSARRO
French, 1830–1903

53. *The Garden of the Tuileries
on a Winter Afternoon*

1899

Oil on canvas

28⅞ x 36⅜ in. (73.3 x 92.4 cm)

Signed and dated (lower right): C.Pissarro.99

Gift from the Collection of Marshall Field III, 1979

1979.414

Pissarro rented a large apartment at 204, rue de Rivoli, in Paris for the first half of 1899 with space enough for his family and windows facing the Jardin des Tuileries, one of the most picturesque spots in the city. He painted eight views of the gardens looking east toward the Louvre, and six, including this work (and two others in the Metropolitan Museum: 66.36; 1992.103.3), in which the twin steeples of the church of Sainte-Clotilde punctuate the vast expanse of sky. Attentive to the changes in light, atmosphere, and climate, as well as to the comings and goings of strollers, at different times of day and seasons of the year,

Pissarro was able to extract a variety of pictures from a single site. Consequently, while one canvas (66.36) shows the Tuileries in the gray light of a cloudy, late winter afternoon, and another (1992.103.3), bathed in the bright light of a spring morning, here Pissarro captured the effect of pale sunlight breaking through the clouds and a light mist on the chestnut trees.

Pissarro leased the flat again from November 1899 to May 1890 and painted a "Second Series" of fourteen views, including several from this vantage point. SAS

ÉDOUARD MANET

French, 1832–1883

54. *Copy after Delacroix's "Bark of Dante"*

ca. 1859
Oil on canvas
13 x 16⅛ in. (33 x 41 cm)
H. O. Havemeyer Collection, Bequest of Mrs. H. O.
Havemeyer, 1929
29.100.114

This is one of two versions by Manet of Delacroix's celebrated painting of 1822 (Musée du Louvre, Paris). The closer, more literal copy (Musée des Beaux-Arts, Lyons) dates from about 1855, when the original was on view at the Exposition Universelle. The present freely executed color study is thought to have been painted about 1859, the year of Manet's first Salon submission. GT

ÉDOUARD MANET
French, 1832–1883

55. *Fishing*

ca. 1862–63
Oil on canvas, transferred from the original canvas
30¼ x 48½ in. (76.8 x 123.2 cm)
Signed (lower left, on the raft): éd.Manet
Purchase, Mr. and Mrs. Richard J. Bernhard Gift,
1957
57.10

Manet's lifelong friend Antonin Proust, recalling their visit to Delacroix in 1856, recorded the master's injunction: "Look at Rubens, draw inspiration from Rubens, copy Rubens. Rubens was God." The present painting could be considered a direct result of Delacroix's admonition. For the composition, Manet borrowed elements from Rubens's *Park of the Château de Steen* (Kunsthistorisches Museum, Vienna) and *Landscape with Rainbow* (Musée du Louvre, Paris), which he probably copied from details in the engravings in Charles Blanc's *Histoire des peintres de toutes les écoles*, published in 1861. While the fishing scene may derive from an Annibale Carracci landscape in the Louvre, Léon-Koëlla Leenhoff, Manet's stepson, inscribed the back of an early photograph with a note that this canvas was painted from "studies made in front of the subject"— hence, the early title *Fishing at Saint-Ouen*. This notation was written at a time when Manet's admirers sought to associate him with the pleinairism of Impressionism, which, in fact, he would not adopt until the early 1870s.

Far from being a study from nature, this is a demonstration piece of Manet's affinities with Baroque painting. There is a further message as well: in the foreground Manet substituted figures of himself and his companion, Suzanne Leenhoff, for those of Rubens and his second wife, Helena Fourment. For this reason, the painting is associated with the wedding in October 1863 of Suzanne and Manet. As the artist had concealed his relationship with Suzanne from his father, who died in September 1862, it is likely that the painting was made sometime between then and the wedding the next year. GT

ÉDOUARD MANET
French, 1832–1883

56. *Boy with a Sword*

1861
Oil on canvas
51⅝ x 36¾ in. (131.1 x 93.4 cm)
Signed (lower left): Manet
Gift of Erwin Davis, 1889
89.21.2

Later in his life, Léon Koëlla-Leenhoff, Manet's stepson, recalled that he had posed for this picture in 1861, when he was about ten years old. Manet had dressed him in a seventeenth-century costume and had used a borrowed sword from the same period as a prop—a tribute to Velázquez and to other Spanish artists whom he admired. The pose is similar to that of a figure by Zurburán in a painting that had been on view in the Galerie Espagnole at the Louvre from 1838 to 1848, but it could also derive from a sketch of a painting Manet made during his 1857 trip to Italy.

Manet liked this picture: he exhibited it five times between 1862 and 1872, when it was bought by Alexis-Joseph Fevre, a dealer. Early on, the critic Ernest Chesneau had singled it out as a "very fine painting, of unusual sincerity and feeling."

In 1889, Erwin Davis, a New York collector, donated this picture and Manet's *Young Lady in 1866* (89.21.3) to the Metropolitan Museum, after failing to sell them at auction. They were the first paintings by Manet to enter a museum collection. GT

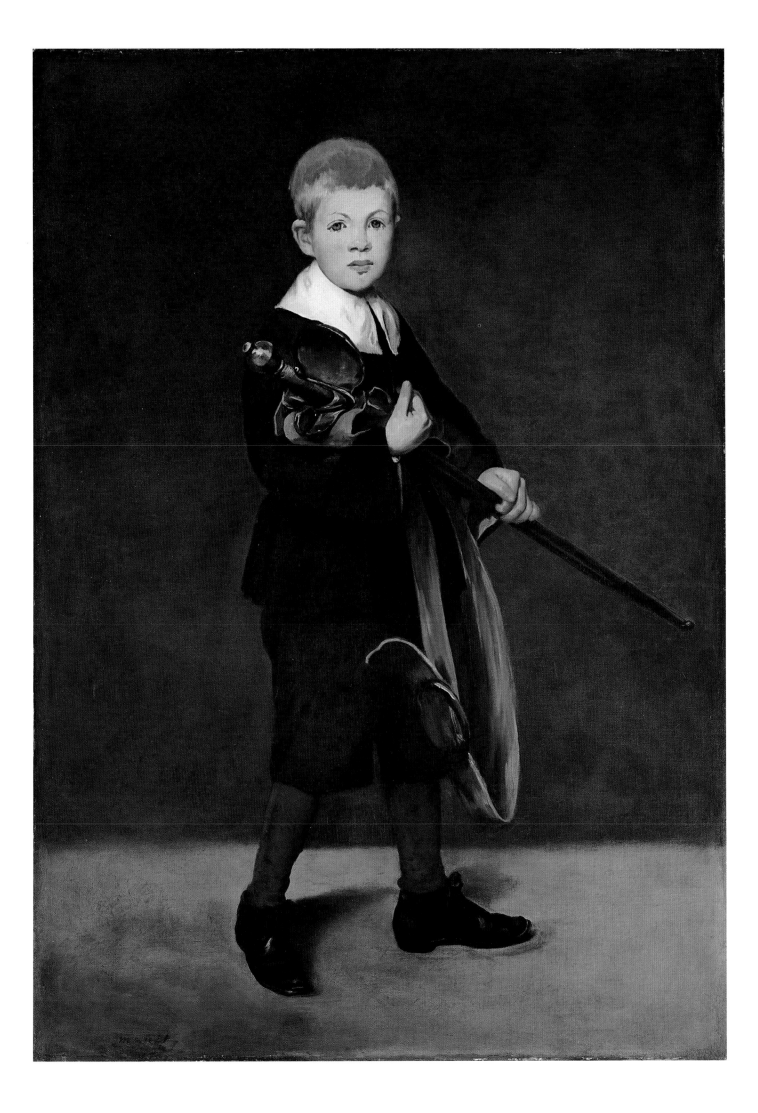

ÉDOUARD MANET
French, 1832–1883

57. *Mademoiselle V . . . in the Costume of an Espada*
1862
Oil on canvas
65 x 50¼ in. (165.1 x 127.6 cm)
Signed and dated (lower left): éd. Manet. / 1862
H. O. Havemeyer Collection, Bequest of Mrs. H. O.
Havemeyer, 1929
29.100.53

At the infamous Salon des Refusés of 1863, Manet assembled his *Déjeuner sur l'Herbe* (Musée du Louvre, Paris), *Young Man in the Costume of a Majo* (The Metropolitan Museum of Art; 29.100.54), and the present painting as a triptych. All three pictures were heaped with derisive comments from the press, although a few understanding writers praised Manet's use of color and his apparent admiration for Spanish art. One writer noted, "His three paintings look a bit like a provocation to the public, which is dazzled by the too-vivid color. . . . Manet loves Spain, and his favorite master seems to be Goya, whose vivid and contrasting hues, whose free and fiery touch, he imitates."

The present picture, now one of Manet's most famous, is a manifesto of the artist's stylistic approach early in the mature phase of his career: an emphasis on the artifice of art, the use of broad planes of unmodulated color, and quotations from the works of the Old Masters as well as references to contemporary life.

As many observed, Manet reproduced a scene from Goya's "Tauromaquia" as the backdrop for the picture, which he painted in his studio. The artist depicted his favorite model, Victorine Meurent (1848–1928), as if she were being photographed in her costume for a fancy-dress ball, borrowing her pose from a print by Marcantonio Raimondi after a work by Raphael. X-radiographs reveal an unfinished painting of a nude beneath the surface of the picture.

Meurent, a painter herself, exhibited her work in the 1870s, 1880s, and at the turn of the century. GT

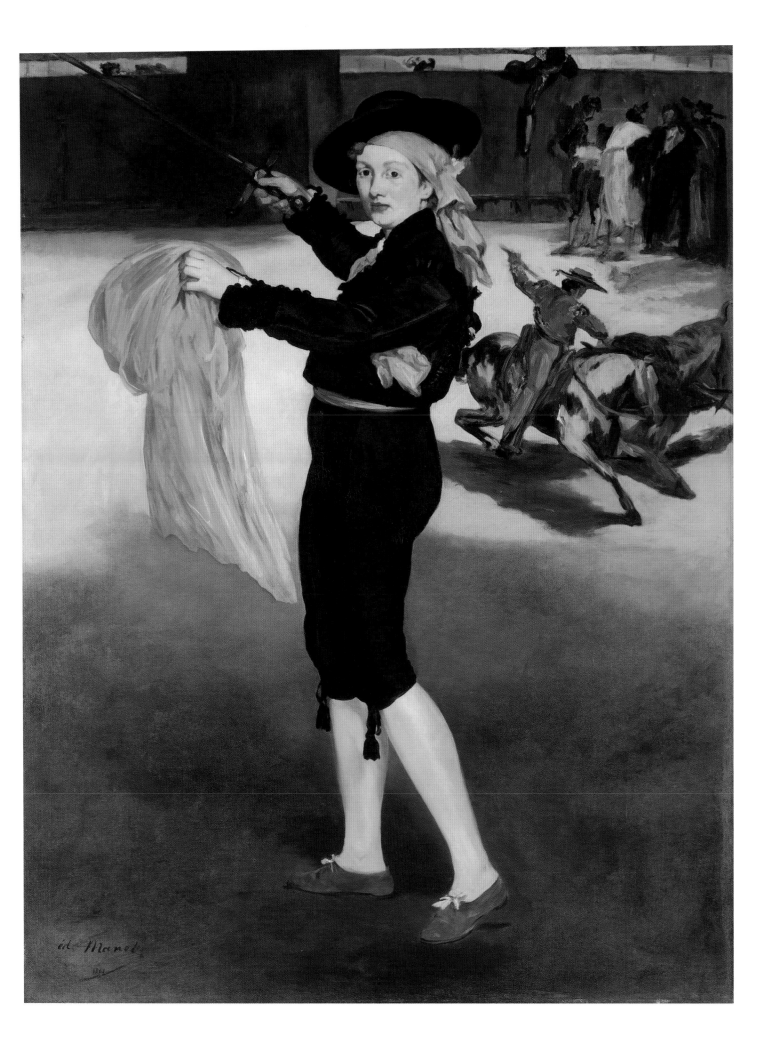

ÉDOUARD MANET
French, 1832–1883

58. *The Dead Christ with Angels*
1864
Oil on canvas
70⅝ x 59 in. (179.4 x 149.9 cm)
Signed and inscribed: (lower left) Manet; (lower right, on the rock) évang[ile]. sel[on]. St Jean / chap[ître]. XXv.XII (Gospel according to Saint John, chapter xx, verse xii)
H. O. Havemeyer Collection, Bequest of Mrs. H. O. Havemeyer, 1929
29.100.51

This was the first of several paintings by Manet with a religious theme. He told his friend the abbé Hurel, "I am going to make a dead Christ, with the angels, a variant of the scene of Mary Magdalene at the tomb according to Saint John." The inscription indicates Manet's source, but the passage he cites describes Mary Magdalene's visit to Christ's tomb, empty except for two angels. After the painting was already on its way to the 1864 Salon, Manet realized that he made an even greater departure from the text: he had depicted Christ's wound on the wrong side. He wrote to Baudelaire, recounting his mistake, and the critic sensibly instructed him to correct the position of the wound in the painting before the vernissage adding, "take care not to give the malicious something to laugh at."

Manet did not repaint the wound, and the malicious laughed. Only Émile Zola gave the painting the respect it deserved, writing in 1867: "There I recognize Manet completely, his obstinate eye and audacious hand. It has been said that this Christ was not really *the* Christ and I admit that this could be so. For

me it is a cadaver freely and vigorously painted in a strong light—and I even like the angels in the background, those children with great blue wings who are so strangely elegant and gentle." Zola felt that Manet's intention was to emphasize the reality of the corpse, although he underscored its holiness by including a halo. This interpretation corresponds to the realistic approach adopted by Ernest Renan in his contemporary and influential treatise *La Vie de Jésus*. One critic even remarked that Manet's Christ looked like a "poor miner, dragged out from the coal underground, painted for M. Renan. Despite the scorn that this work received in 1864, Manet continued to harbor the ambition to undertake a painting of the Crucifixion: "What a symbol! . . . It is at the heart of humanity. It is its poem."

Although Théophile Thoré accused Manet of having created a pastiche of El Greco's compositions, this picture was based on an engraving after Francisco de Ribalta, published in Charles Blanc's *Histoire des peintres de toutes les écoles*. GT

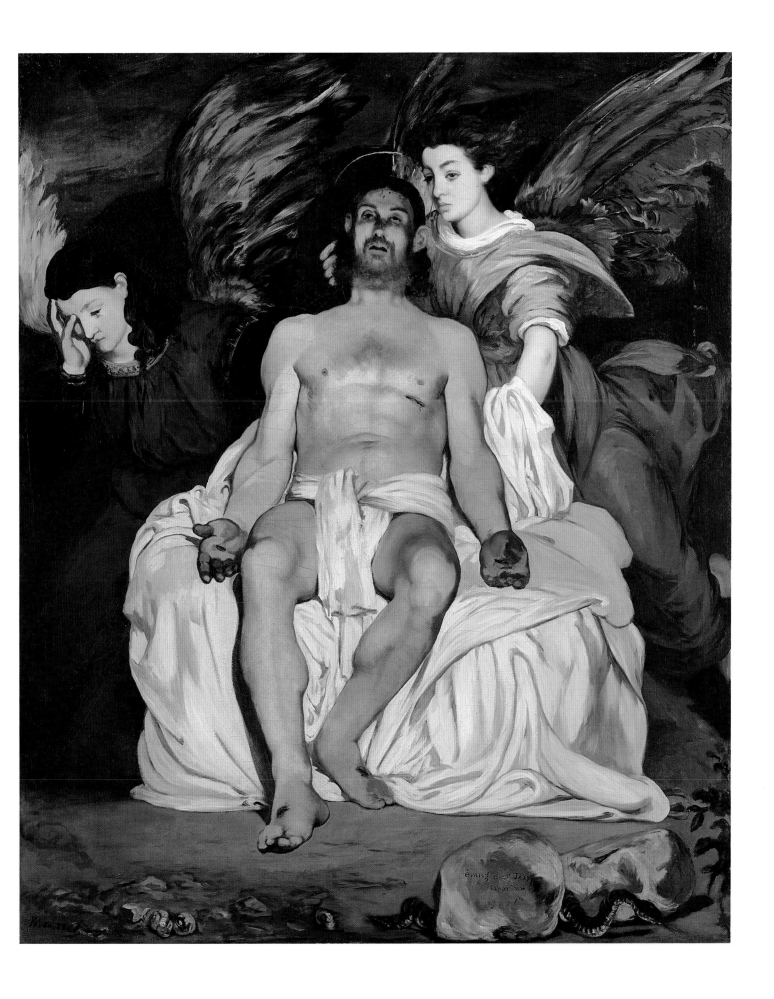

ÉDOUARD MANET
French, 1832–1883

59. *A Matador*
ca. 1866–67
Oil on canvas
67⅜ x 44½ in. (171.1 x 113 cm)
Signed (lower left): Manet
H. O. Havemeyer Collection, Bequest of Mrs. H. O.
Havemeyer, 1929
29.100.52

After painting pictures inspired by the Spanish masters of the seventeenth century for six years, Manet finally took a trip to Spain in September 1865. Upon his return, he wrote to a friend, "I stayed a week in Madrid and had plenty of time to see everything, the Prado with all those mantillas was absolutely delightful, but the outstanding sight was the bullfight. I saw a magnificent one, and when I get back to Paris I plan to put a quick impression on canvas: the colorful crowd, and the dramatic aspect as well, the picador and the horse overturned, with the bull's horns ploughing into them and the horde of chulos trying to draw the furious beast away."

Manet attended a corrida on Sunday, September 3, 1865, and one of the toreros was the illustrious Cayetano Sanz y Pozas (1821–1890). Only recently was he recognized—with his distinctive muttonchops—in this, the first of Manet's full-length figure paintings completed after he studied the works of Velázquez in the original in Madrid. He painted the picture in Paris, probably following his two scenes of a bullfight (The Art Institute of Chicago; Musée d'Orsay, Paris). Cayetano Sanz, who appears in the foreground of the bullfight painting now in Chicago, is seen saluting the president of the corrida prior to the contest. Unlike all of Manet's previous depictions of matadors, this bullfighter carries a proper red cape.

Manet exhibited this painting, along with some twenty others on Spanish themes, at the solo exhibition he organized in a private pavilion adjacent to the 1867 Exposition Universelle in Paris. His biographers recorded that his brother Eugène (who was married to Berthe Morisot) posed for this work, without recognizing that Manet had used photographs or engravings of the torero Cayetano Sanz. Nevertheless, Eugène would have been a handy substitute to pose in the matador costume.

Théodore Duret, the writer who accompanied Manet to the Prado and probably also to the bullfight, bought this painting from the artist in 1870. GT

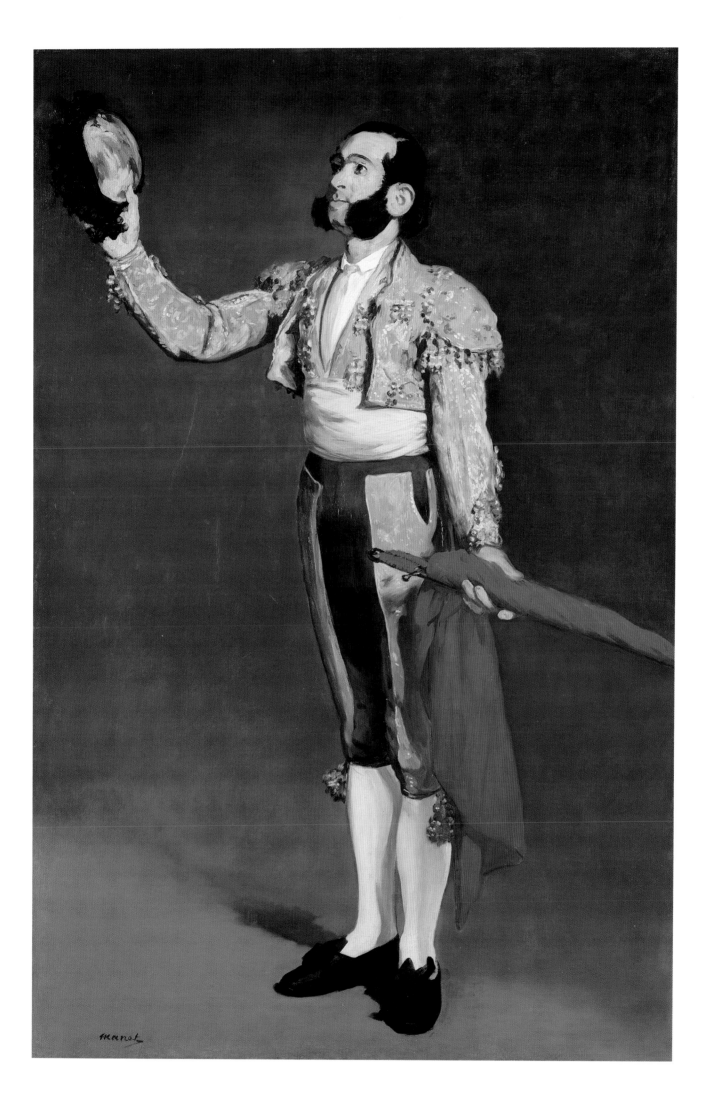

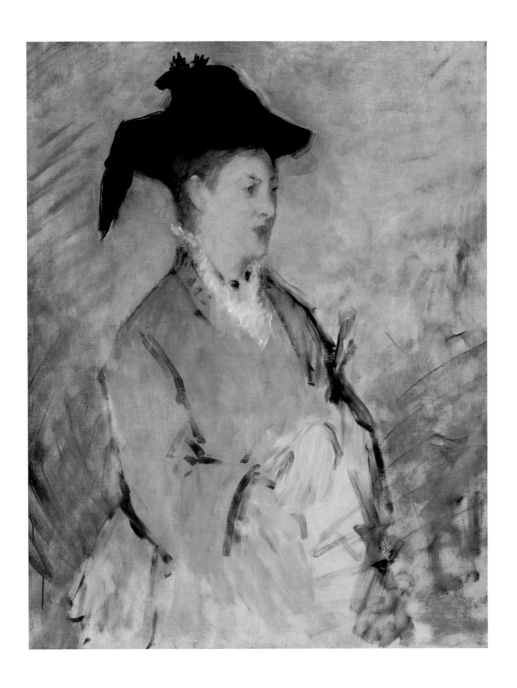

ÉDOUARD MANET
French, 1832–1883

60. *Madame Édouard Manet*
(Suzanne Leenhoff, 1830–1906)

ca. 1866–69
Oil on canvas
39½ x 30⅞ in. (100.3 x 78.4 cm)
Bequest of Miss Adelaide Milton de Groot
(1876–1967), 1967
67.187.81

Suzanne Leenhoff had joined the Manet house-hold as a piano instructor to the painter's brother, Eugène. Her son, Léon, was born out of wedlock in 1852. Although she referred to him as her younger brother, both Manet and his father have since been proposed as the boy's natural father. By 1860, Manet and Suzanne were living together as companions, and the artist always showed an avuncular, if not paternal, interest in Léon. While it is thought that the couple enjoyed a happy marriage, there are relatively few portraits of Suzanne compared with those of Manet's favorite models, such as Victorine Meurent and Berthe Morisot.

This unfinished canvas provides rare insight into Manet's painting technique. He sketched the figure and the background with broad strokes before beginning work on the facial features, and scraped off the face at least twice before eventually abandoning the picture.

It may be significant that Manet had such trouble rendering his wife's face. A famous, related, incident centered around a portrait by Degas of Manet listening to his wife play the piano (Musée d'Orsay, Paris). Manet, dissatisfied with Degas's depiction of his wife, trimmed the canvas so that the cut fell just at her ears, removing her nose, eyes, and mouth from Degas's double portrait. Insulted, Degas demanded the return of the mutilated canvas.

GT

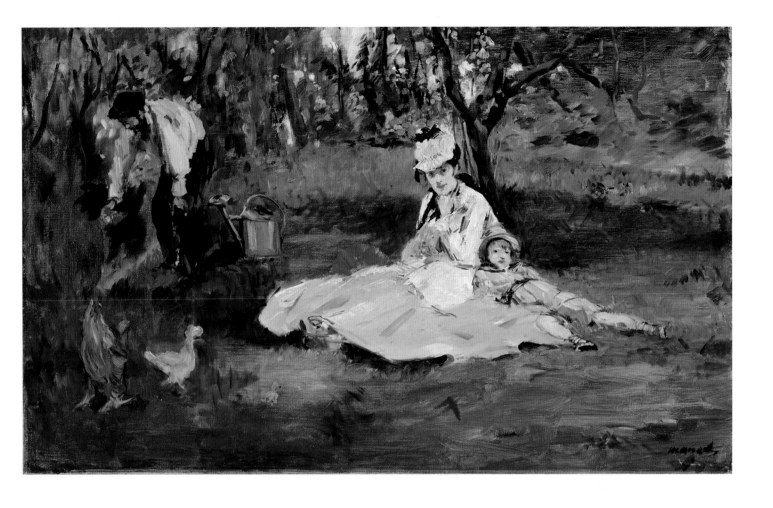

ÉDOUARD MANET
French, 1832–1883

61. *The Monet Family in Their Garden at Argenteuil*

1874
Oil on canvas
24 x 39¼ in. (61 x 99.7 cm)
Signed (lower right): Manet
Bequest of Joan Whitney Payson, 1975
1976.201.14

In 1924, Monet recounted to an interviewer the circumstances surrounding the creation of this painting in his garden at Argenteuil: "One day, Manet, enthralled by the color and the light, undertook an outdoor painting of figures under trees. During the sitting, Renoir arrived. He, too, was caught up in the spirit of the moment. He asked me for palette, brush and canvas, and there he was, painting away alongside Manet. The latter was watching him out of the corner of his eye, and from time to time came over for a closer look at the canvas. Then he made a face, passed discreetly near me, and whispered in my ear about Renoir: 'He has no talent, that boy! Since you are his friend, tell him to give up painting!' Wasn't that amusing of Manet?"

Renoir and Manet both gave their pictures to Monet. Renoir's painting is now in the National Gallery of Art in Washington, D.C. It seems almost certain that a now-lost painting by Monet depicting Manet working at the easel in the Monet family's garden was painted the same day, and given to Manet in exchange.

Manet was Monet's hero in the late 1860s, and the younger artist even suffered from Salon jurists' confusing his name with that of the older and more provocative painter. By 1874, Manet and Monet had become friends. Manet had helped the Monets find their house at Argenteuil, and he came under the sway of Monet's approach to painting quickly, out of doors. The portrait of the Monet family—Camille Monet and Jean, with Claude Monet gardening at the left—is one of Manet's most significant essays in this new style. Nevertheless, he was not yet comfortable working *en plein air*, and the canvas was scraped down at least once before completion—a practice Manet typically resorted to when painting indoors in the studio. Nevertheless, his fluent and elegant brushwork and his innate ability to transform his sitters into paradigms of chic give this work an enduring freshness and immediacy. GT

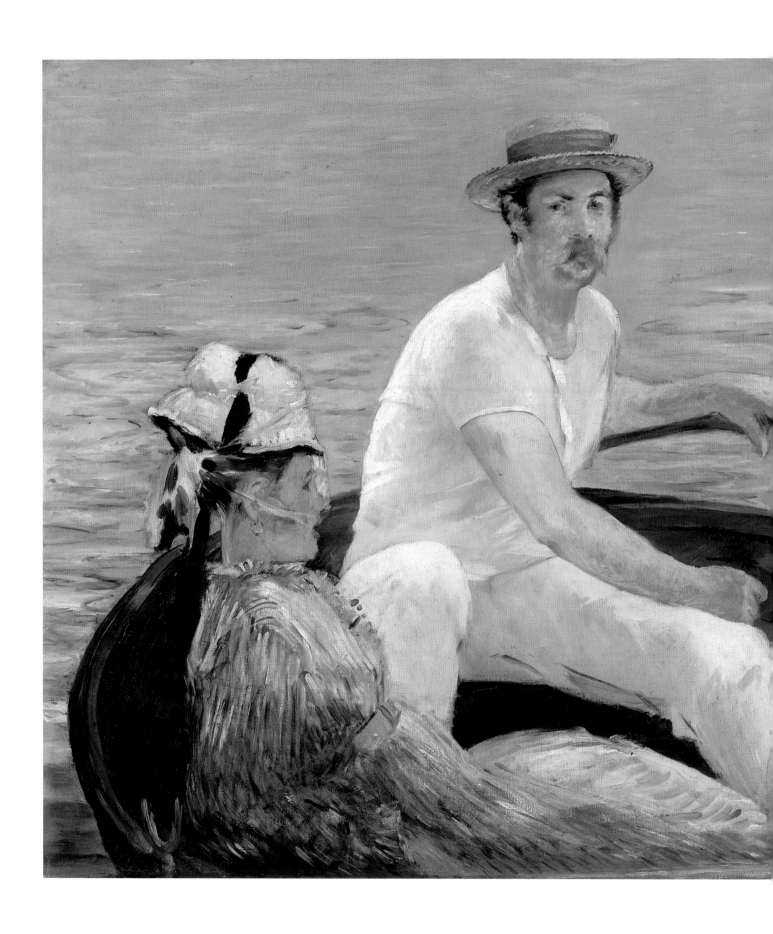

ÉDOUARD MANET
French, 1832–1883

62. *Boating*
1874
Oil on canvas
38¼ x 51¼ in. (97.2 x 130.2 cm)
Signed (lower right): Manet
H. O. Havemeyer Collection, Bequest of Mrs. H. O.
Havemeyer, 1929
29.100.115

In the summer of 1874, Manet was staying outside Paris at Gennevilliers, not far from the house in Argenteuil that he had found for the Monet family. Although he had refused to participate in the independent exhibition organized in the spring by the newly dubbed Impressionists—who included Monet, Pissarro, Renoir, and Degas—Manet clearly wished to adopt the high-keyed palette; informal, sketch-like brushwork; and subject matter centered on leisurely pursuits, of his young colleagues. *Boating* is the manifesto of Manet's new allegiance to Impressionism.

While Monet dug trenches so that he could lower his large canvases into the ground as he painted outdoors, Manet remained a conventional studio artist. Manet's biographers recount that Rodolphe Leenhoff, the painter's brother-in-law, posed for the sailor, and they identify the woman as possibly Alice Lecouvé, who also modeled for *Le Linge* (The Barnes Foundation, Merion, Pennsylvania). The simplicity of the composition and the use of broad planes of color accented by strong diagonals reveals Manet's admiration for Japanese color woodblock prints—an interest that Monet shared with his older colleague.

This *Japonisme* was noted when Manet exhibited *Boating* at the 1879 Salon. The critic J. K. Huysmans wrote: "The bright blue water continues to exasperate a number of people.... Manet has never, thank heavens, known those prejudices stupidly maintained in the academies. He paints, by abbreviations, nature as it is and as he sees it. The woman, dressed in blue, seated in a boat cut off by the frame as in certain Japanese prints, is well-placed, in broad daylight, and her figure energetically stands out against the oarsman dressed in white, against the vivid blue of the water. These are, indeed, pictures the likes of which, alas, we shall rarely find in this tedious Salon."

The artist Mary Cassatt, who recommended this acquisition to the New York collectors Louisine and H. O. Havemeyer, called it "the last word in painting." GT

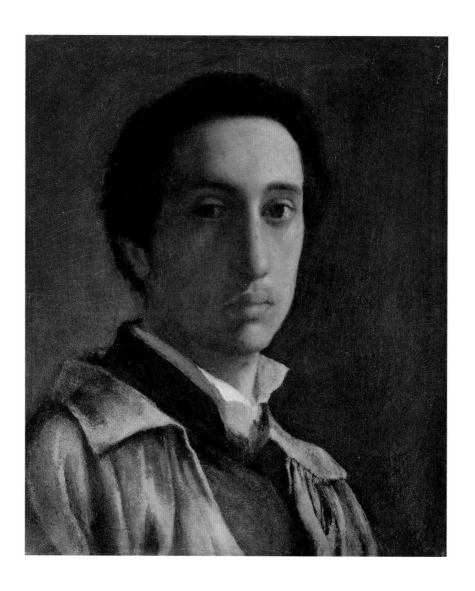

EDGAR DEGAS
French, 1834–1917

63. *Self-Portrait*
ca. 1854
Oil on paper, laid down on canvas
16 x 13½ in. (40.6 x 34.3 cm)
Bequest of Stephen C. Clark, 1960
61.101.6

In the 1850s and 1860s, Degas, like most young artists, produced numerous self-portraits in various media, eighteen of them paintings. This one is usually dated 1854, the year that the twenty-year-old law student decided to devote himself to art. Degas's mother had died when he was thirteen, and his father, an affluent banker, reluctantly supported his decision, although he was concerned for his son's future. According to Degas's niece, "With great sadness and no less nobility Degas left his father's house and went to live in an attic."

Degas began making copies after the Old Masters at the Louvre in 1854; one of the first was of a so-called self-portrait by Raphael. Degas's self-portraits, however, more closely resemble those by Romantic artists and their seventeenth-century forebears: one of Degas's instructors in high school had been Léon Cogniet, a leading Romantic painter. GT

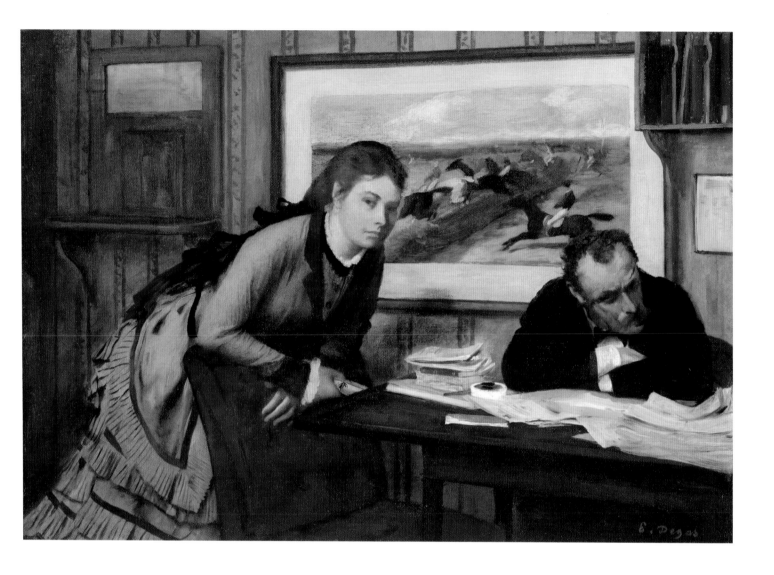

EDGAR DEGAS
French, 1834–1917

64. *Sulking*
ca. 1870
Oil on canvas
12¾ x 18¼ in. (32.4 x 46.4 cm)
Signed (lower right): E. Degas
H. O. Havemeyer Collection, Bequest of Mrs. H. O.
Havemeyer, 1929
29.100.43

Like several of Degas's genre pictures from the late 1860s and early 1870s, this painting seems to reflect a literary or theatrical source. None has been found, yet the drama that exists between this man and woman continues to invite speculation. Is it a husband and wife, a man and his lover, a father and his daughter, a banker and his client, a woman placing bets on horse races? The ambiguity of the relationship harbors an endless fascination.

The picture's anecdotal character is reminiscent of Victorian painting, which Degas had studied in the British section of the 1867 Exposition Universelle in Paris. At the time that he was at work on this canvas, Degas was closely allied with James Tissot, the most Anglophilic of French artists. Tissot himself had painted similar genre scenes, although they do not have the psychological weight of Degas's compositions.

Degas asked the writer Édmond Duranty and the young model Emma Dobigny, who had been a favorite of Corot, Puvis de Chavannes, and Tissot, to pose for him. The racing print behind them is Degas's careful copy of a color lithograph by J. F. Herring.

The title, *Sulking*, was first recorded in 1895 when Degas deposited the canvas with his dealer, Durand-Ruel. The Havemeyers of New York bought the picture the following year.

GT

EDGAR DEGAS
French, 1834–1917

65. *The Collector of Prints*

1866
Oil on canvas
20⅞ x 15¾ in. (53 x 40 cm)
Signed and dated (lower left): Degas / 1866
H. O. Havemeyer Collection, Bequest of Mrs. H. O.
Havemeyer, 1929
29.100.44

Like Daumier, Degas was fascinated with the variety of human facial types, but he brought a much more exacting realism to his approach in depicting them. This collector is instantly recognizable, regardless of the items he collects, as an obsessive accumulator rather than as an experienced connoisseur—closer to a ragpicker than to the formidable collector Degas himself would become later in his life. Degas added immediacy to his scene by portraying a distinctive individual, his features perhaps exaggerated to effect a lasting impression.

The prints that Degas includes in the painting, colored lithographs by the flower painter Redouté, were outmoded by the Second Empire, and cheap; only the Tang dynasty horse and the Japanese fabrics pinned to the bulletin board convey the mode of the moment. Here, the artist has succeeded in conjuring up a vanishing species: the old-fashioned collector, a relic of the July Monarchy. Degas would later reminisce about his outings with his father, an affluent banker, to visit the notable collectors of this bygone era, Marcille and La Caze: "He [Marcille] wore a hooded cape and a rumpled hat. People in those days all wore rumpled hats." GT

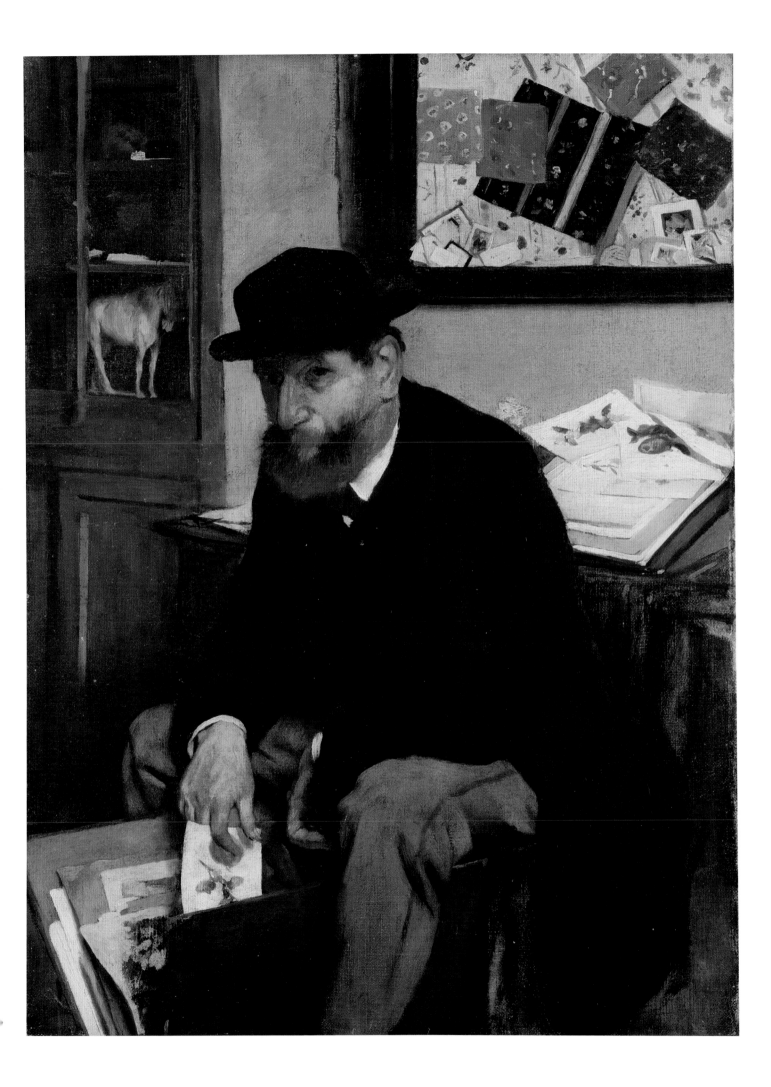

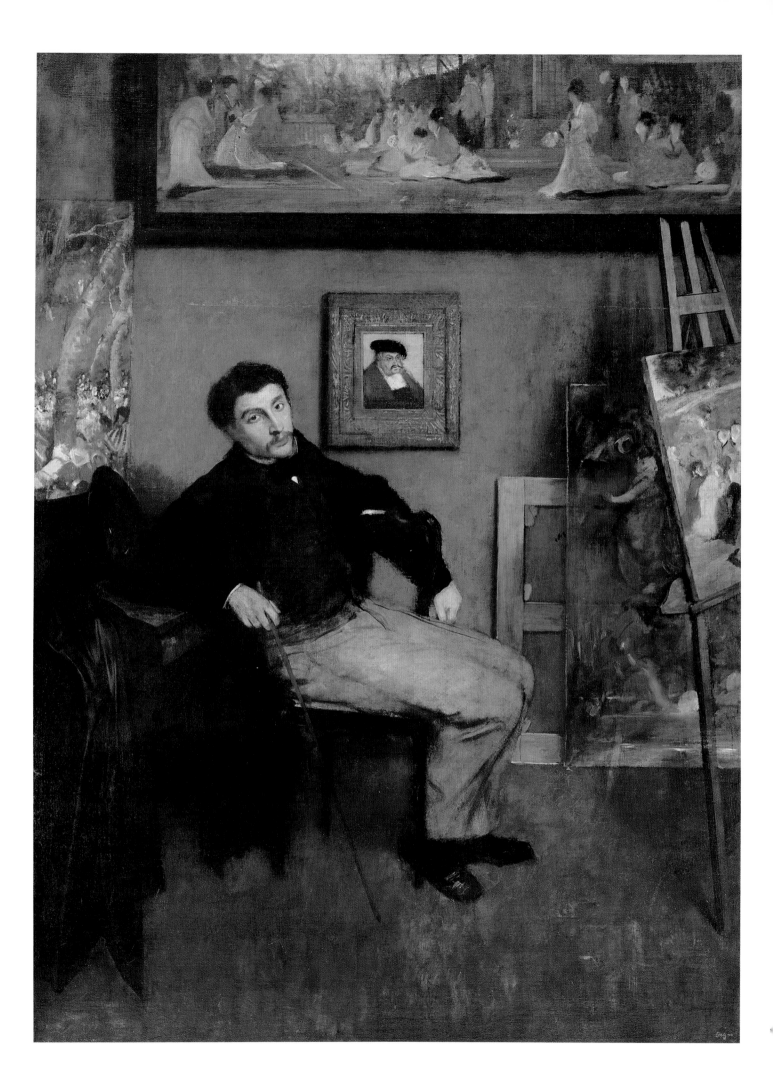

EDGAR DEGAS
French, 1834–1917

66. *James-Jacques-Joseph Tissot* (1836–1902)

ca. 1867–68
Oil on canvas
59⅞ x 44 in. (151.4 x 111.8 cm)
Stamped (lower right): Degas
Rogers Fund, 1939
39.161

This canvas, the largest Degas devoted to an individual portrait in the 1860s (only his painting of the Bellelli family is larger), is one of a series of seemingly casual likenesses of artists caught in characteristic moments of repose. James Tissot, the fashionable Anglo-French painter of richly detailed genre scenes, who was Degas's mentor at this time, has doffed his top hat and satin-lined cape to pose for his friend. Until recently, art historians believed that the room depicted belonged to neither painter and was not even a studio. However, the large canvas at the top of the composition and the one on the easel have since been identified as works by Tissot. Therefore, we can presume that the copy after Cranach's portrait of Frederick the Wise (the version in the Musée du Louvre, Paris) is also by Tissot, and that the chic interior is thus Tissot's studio.

Lurking behind the picture's studied asymmetry and the sense of a chance encounter with its subject is the memory of Velázquez's *Las Meninas*. Although it was known to Degas only through reproduction—a set of photographs of masterworks from the Museo del Prado had just been made available in Paris—Velázquez's composition is palpably present in the placement of the pictures on the back wall, in the use of a curtain and an easel to frame the view, and in the conceit of having the sitter appear to be pausing for only a moment at center stage.

Degas and Tissot may have first met when both were students of the portraitist Louis Lamothe, but they were reintroduced about 1862, perhaps through Élie Delaunay—like Tissot a Nantais. They were close friends until Tissot, fleeing the Commune, sought refuge in London in 1871. While Degas actually copied works by Tissot and continually sought his advice through the mid-1870s, their art grew apart as Degas became more confident and, eventually, audacious, while Tissot remained true to his genre and his meticulous technique. Perhaps some insight can be gleaned from the Goncourt brothers, who disliked Tissot, calling him "a complex creature, half mystic, half trickster." GT

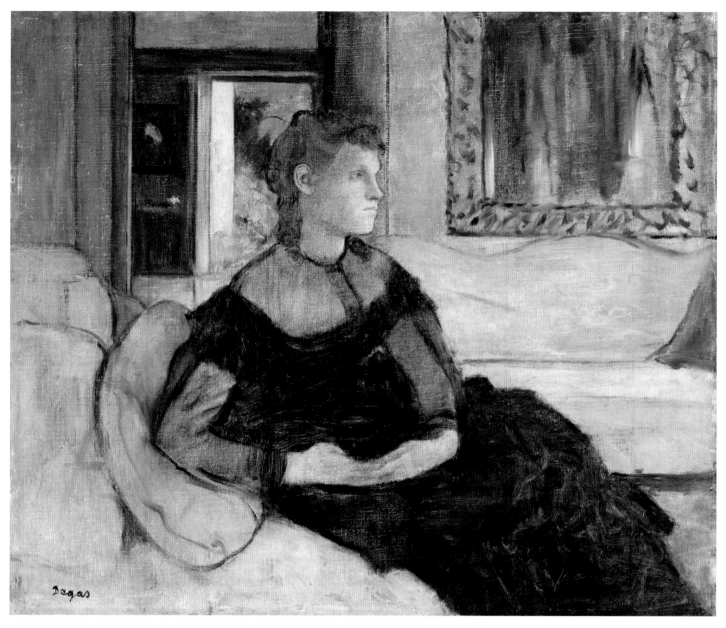

EDGAR DEGAS
French, 1834–1917

67. *Madame Théodore Gobillard*
(Yves Morisot, 1838–1893)

1869
Oil on canvas
21¾ x 25⅝ in. (55.2 x 65.1 cm)
Signed (lower left): Degas
H. O. Havemeyer Collection, Bequest of Mrs. H. O.
Havemeyer, 1929
29.100.45

The three daughters of Tiburce and Marie-Cornélie Morisot, Yves, Edme, and Berthe, lived to paint. The young women attracted many aspiring artists to the Morisot home, among them Fantin-Latour, Alfred Stevens, Puvis de Chavannes, and, eventually, Manet and Degas. By the time Degas embarked on this portrait of the eldest sister, Yves, Berthe had become well known as a disciple of Manet, with whom Degas had both a competitive and a contentious relationship. Berthe

and Degas were each circumspect of the other, and, as a result, she was especially attentive to the gestation of this portrait.

Letters exchanged among the Morisot sisters provide unmatched insight into the genesis of the painting. Working in the bustling Morisot household, Degas chose the unpretty Yves for his sitter rather than the ravishing Berthe. Berthe responded by describing Degas's first sketch as "mediocre." Her mother was excited to see that "M. Degas is mad about Yves's face." Yves herself reported, "the drawing that M. Degas made of me in the last two days is really very pretty, both true to life and delicate. . . . I doubt if he can transfer it to the canvas without spoiling it."

Two fully developed drawings and a nearly life-size pastel of Yves's face remain from the sittings (all, now in The Metropolitan Museum of Art). The final painting, however, is muted and restrained, more like a Whistler. Degas chose the salon of Yves's parents—its tall windows reflected in the mirror above the sofa and its garden visible through an open door—

for the setting of his painting of her, but Yves's dress is summarily treated and the brightly colored chintz is barely suggested. It is as if Degas studiously avoided making a picture that might resemble a work by Yves's sister Berthe. For her part, Berthe did portray her sister Edme and her mother seated in the same room, at about the same time.

Louisine Havemeyer bought this painting on Mary Cassatt's recommendation. She recognized that it was atypical, but was ever confident of her choice: "Well! I paid a large sum for that picture and I do not regret it, not a farthing of it. I bought neither beauty nor glamor, no, nor still life, nor a great composition; nothing but art, just pure incandescent art, right out of the crucible; its author heated it over the sacred fire. It seems to me it is not a picture, it is not a portrait, it is an inspiration. Degas never did anything like it again. I doubt if he ever could, I doubt if *ever* any painter could do such a picture. It is forever! it is an art epoch in itself." GT

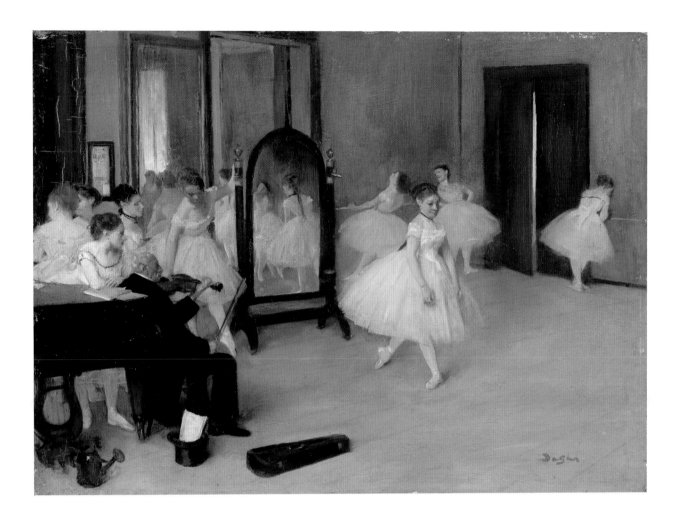

EDGAR DEGAS
French, 1834–1917

68. *The Dancing Class*

ca. 1870
Oil on wood
7¾ x 10⅜ in. (19.7 x 27 cm)
Signed (lower right): Degas
H. O. Havemeyer Collection, Bequest of Mrs. H. O.
Havemeyer, 1929
29.100.184

This is the very first of Degas's innumerable scenes of ballet dancers going through their paces in the studios and rehearsal rooms of the Paris Opéra. It is painted in the meticulous style that Degas adopted at this time, encouraged by James Tissot. Late in his life, when he looked again at these early pictures, Degas lamented that he no longer had the eyes for such exacting work.

When Degas painted this small picture—for which there are many large, drawn studies—he did not yet have privileges to go backstage at the rue Le Peletier Opéra. One of Degas's good friends was the writer Ludovic Halévy, whose satirical stories about the young dancers—*rats*—at the Opéra no doubt informed the artist about the rehearsals. In the late 1870s, Degas appealed to another Opéra habitué, Albert Hecht, for a pass to enable him to visit the rehearsals, explaining, "I have done

[painted] so many of these dance examinations without having seen them that I am a little ashamed of it."

The dancer at the center of the composition is Josephine Gaujelin (or Gozelin), whom Degas also portrayed in a stunning portrait (Isabella Stewart Gardner Museum, Boston). Here, she awaits the starting note from the ballet master, who resembles the ballet director named Gard. His features were probably copied from a photograph, although Gaujelin would have posed in Degas's studio. The watering can (to wet down the rosin on the floor), the top hat as music holder, and the empty violin case are accessories that the artist would continue to use to enliven his ballet pictures. Similarly, the poses that Degas established for this primordial picture would recur in his work until the end of his life.

GT

EDGAR DEGAS
French, 1834–1917

69. *Dancers in the Rehearsal Room with a Double Bass*

ca. 1882–85
Oil on canvas
15⅜ x 35¼ in. (39.1 x 89.5 cm)
Signed (lower left): Degas
H. O. Havemeyer Collection,
Bequest of Mrs. H.O. Havemeyer, 1929
29.100.127

More than any other genre in Degas's oeuvre, the frieze-format ballet rehearsals constitute a genuine series. For over twenty years, the artist elaborated—in a style gradually evolving from a precise rendering of observed detail to an expressive notation of linear rhythm and suffused color—on a fixed set of dancers depicted in an oblong rehearsal room, who appear, disappear, or are reproduced in reverse images of themselves in an unending stream of con-trapuntal variation. Although Degas used a similar method in his paintings of jockeys, it is only in the dance pictures that one feels that one has entered a world not unlike that created by a powerful novelist.

This painting is probably the second in a series of over forty such works. It was preceded by *The Dance Lesson* of 1879 (formerly, Mellon collection; National Gallery of Art, Washington, D.C.), which shows a room with

different details and a violin case rather than the contrabass. Otherwise, the essential features of the entire series are present: the long wall that recedes precipitously back into space, providing a foil for one, two, or three principal figures in front; the pocket of space where the room widens, with two tall French windows illuminating a group of dancers limbering up before a rehearsal, or cooling off afterward; the chair; and the bench, which was to become the locus for many of Degas's late images of dancers.

Although the critic George Moore stated in 1892 that Degas had recently retouched this picture, that pronouncement is not supported by the X-radiographic evidence. A lithograph of this picture made in 1889 by George William Thornley shows it exactly as it appears today.　　　　GT

EDGAR DEGAS
French, 1834–1917

70. *Dancers, Pink and Green*

ca. 1890
Oil on canvas
32⅜ x 29¾ in. (82.2 x 75.6 cm)
Signed (lower right): Degas
H. O. Havemeyer Collection, Bequest of Mrs. H. O.
Havemeyer, 1929
29.100.42

Taking a cue from his illustrations for Ludovic Halévy's satiric account of the backstage lives of ballet dancers, *La Famille Cardinale*, Degas punctuated this picture with the ominous shadow of a top-hatted patron of the Opéra, a select member of the Jockey Club who, with his friends, had special permission to linger in the wings during a performance. Here, Degas constructs a scene in which two dancers on the stage are performing their pas de deux, as others, waiting in the wings, risk missing their cue while they dally with their patron. The inclusion of this figure adds a suggestion of menace to an otherwise unguarded moment of preparation and anticipation.

There are no known drawings for this picture; instead, Degas seems to have relied on his stock of earlier studies of dancers. Indeed, the thickly impastoed surface suggests that Degas worked directly and extensively on the canvas, building up passages of color with brushes and with his fingers, thereby imparting rich textural effects. By mixing his colors with white to make them opaque, and by applying his pigments thickly and in several layers, he approximated the pastel technique that he had perfected in the previous decade.

Somewhat later, Degas painted a variant of this picture in which the dancers' costumes are blue (Musée d'Orsay, Paris). GT

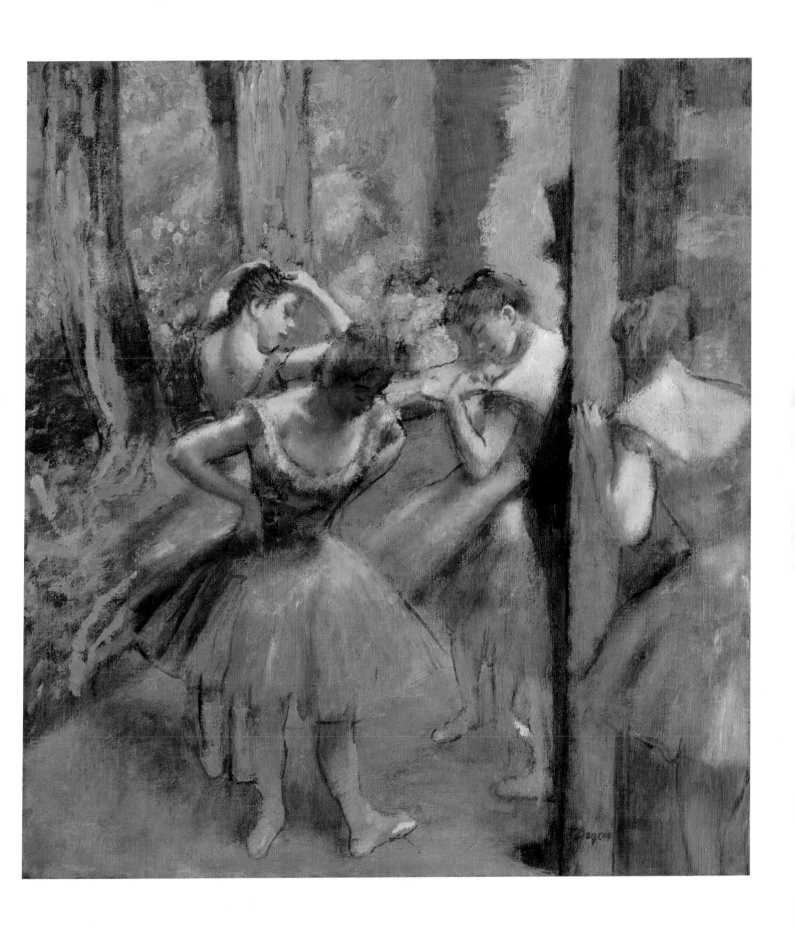

HENRI FANTIN-LATOUR
French, 1836–1904

71. *Still Life with Flowers and Fruit*

1866
Oil on canvas
28¾ x 23⅝ in. (73 x 60 cm)
Signed and dated (upper left): Fantin. 1866.
Purchase, Mr. and Mrs. Richard J. Bernhard Gift, by exchange, 1980
1980.3

This is one of four still lifes commissioned from the artist in 1866 by Michael Spartali, a wealthy Greek businessman and diplomat who lived in London. Fantin-Latour worked on the suite of pictures from March through September, inspired to produce variations on an ambitious composition that he debuted at the Salon of 1866 (National Gallery of Art, Washington, D.C.). On the basis of the lilacs and gillyflowers that grace this handsome tabletop arrangement, the canvas probably dates to May, when the Salon painting that anchored the group was on view in Paris. Impressive as these individual still lifes are on their own—indeed, they number among the artist's great early achievements in the glorious Realist tradition of Chardin and Courbet—the collector found them too similar to hang *ensemble* in his home, and he returned two to the artist. SAS

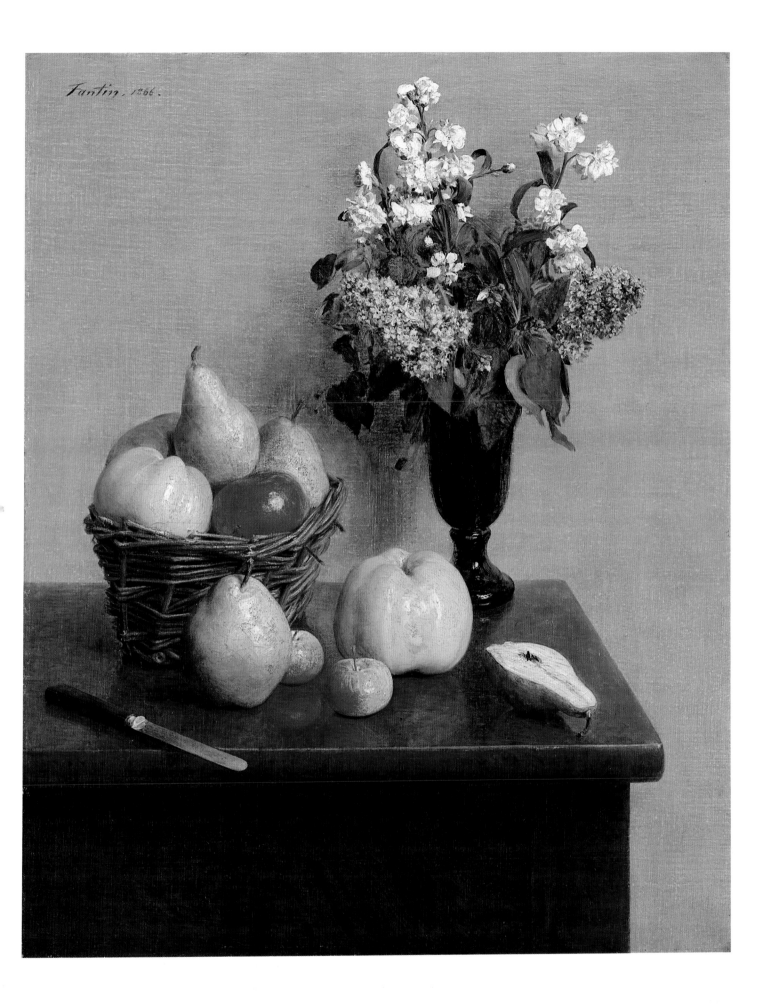

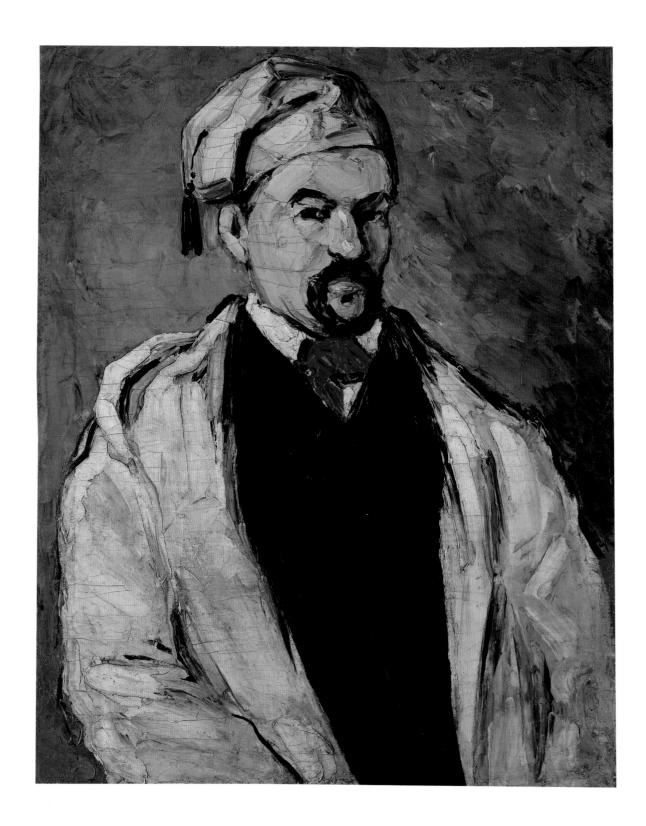

PAUL CÉZANNE
French, 1839–1906

72. Antoine Dominique Sauveur
Aubert (born 1817),
the Artist's Uncle

1866
Oil on canvas
31⅜ x 25¼ in. (79.7 x 64.1 cm)
Wolfe Fund, 1951; acquired from The Museum of
Modern Art, Lillie P. Bliss Collection
53.140.1

Cézanne set out to make his mark at the onset of his career with a group of highly wrought landscapes and figure paintings that he later described as "ballsy" (*"couillard"*), given their forceful, even brute, character. In emulation of his hero, Courbet, he often dispensed with a brush in the 1860s and applied his paint directly with a palette knife on the coarse, unprimed canvas, in thick, blocky passages (destined to produce cracks), Cézanne's approach imparted weight and vigor to the series

of at least nine portraits of his maternal uncle Dominique Aubert. The forty-nine-year-old bailiff not only indulged his nephew with multiple sittings but also agreed to pose in various costumes. In other depictions, Uncle Dominque is shown in the guise of a lawyer as well as a Dominican monk. Bemused by the unfolding sequence of works, a friend reported in November 1866: "Every day there appears a [new] portrait of him." SAS

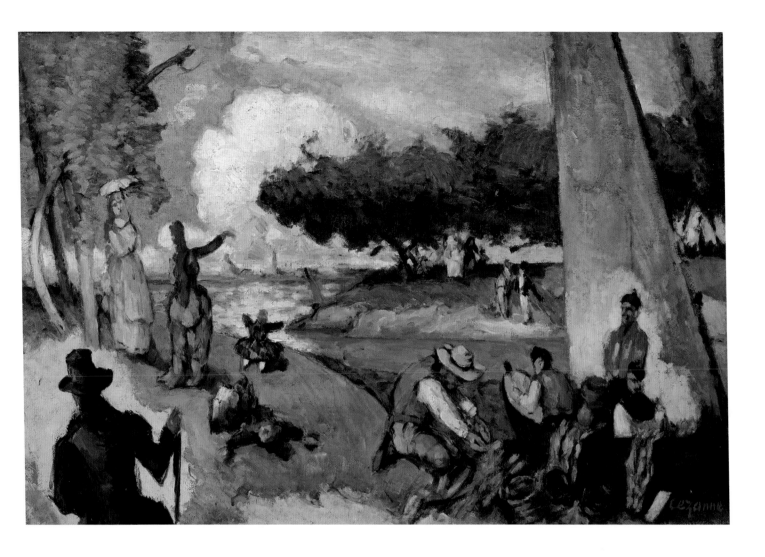

PAUL CÉZANNE
French, 1839–1906

73. *The Fishermen (Fantastic Scene)*

ca. 1875
Oil on canvas
21¾ x 32¼ in. (55.2 x 81.9 cm)
Gift of Heather Daniels and Katharine Whild, Promised Gift of Katharine Whild, and Purchase, The Annenberg Foundation Gift, Gift of Joanne Toor Cummings, by exchange, Wolfe Fund, and Ellen Lichtenstein and Joanne Toor Cummings Bequests, Mr. and Mrs. Richard J. Bernhard Gift, Gift of Mr. and Mrs. Richard Rodgers, and Wolfe Fund, by exchange, and funds from various donors, 2001
2001.473

When this painting was shown at the Impressionist exhibition in 1877, the critic Georges Rivière offered the following description:

Under the bright sun, a man in a black redingote and tall hat advances, clip-clop, leaning on a thick walking stick. It is the proverbial good fellow of the evening, the curious one, the Ahasuerus who knows the story of everyone within ten leagues, bonesetter and sorcerer, rich or poor, no one knows.

There he is, the one who is going to warm his cold body and look, with his red, blinking eyes, at the wide blue sea. In front of this nice old man, a woman calls to the passer-by with a gesture full of grandeur, and in a little channel of the sea, a fisherman's boat with a tall white sail has stopped. A sailor on the bank pulls the fishnet from the water; another [is] standing in the boat; an old salt in a red shirt directs the maneuver. It is vast and sublime like a beautiful memory; the landscape is grandiose, with large trees stirred by the sea breeze, the water blue and transparent and the clouds striking in the sun.

With pictures comparable to the most beautiful works of antiquity, these are the weapon with which Cézanne fights against [the] bad faith of some and ignorance of others; this is what will assure his triumph.

It is thought that the man with a hat in the left foreground was originally meant to depict an artist, perhaps Cézanne himself. The imagery, a composite of scenes of leisure, derives from paintings by Manet and Monet from the 1860s. Underlying the Impressionist motifs are prototypes found in the work of Giorgione, Titian, and Veronese. Cézanne often included references to Venetian painting when he was working in his pastoral mode—a strain in his art that culminated in the late pictures of bathers.

The Nationalgalerie in Berlin attempted to buy this painting in 1908, but when the director, Hugo von Tschudi, was unable to secure the proper authorization the picture was acquired instead by the German painter Max Liebermann in 1909; it was inherited by his granddaughters, from whom the Metropolitan acquired it in 2001. GT

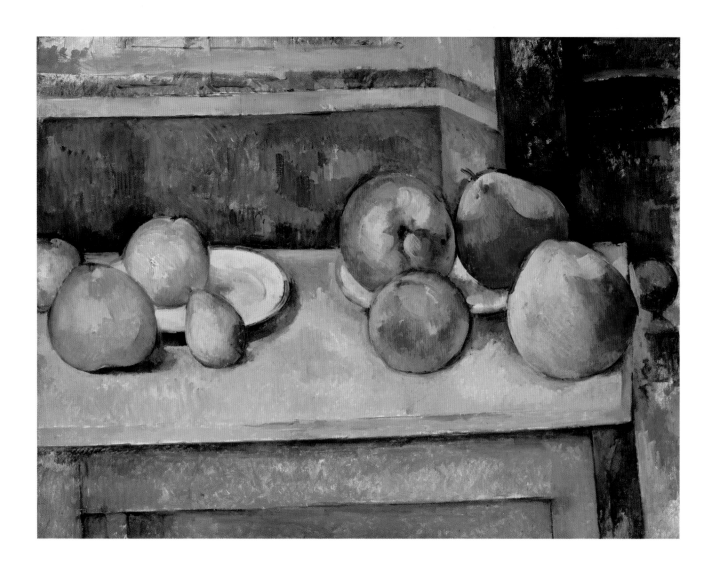

PAUL CÉZANNE
French, 1839–1906

74. *Still Life with Apples and Pears*

ca. 1891–92
Oil on canvas
17⅝ x 23⅛ in. (44.8 x 58.7 cm)
Bequest of Stephen C. Clark, 1960
61.101.3

Cézanne once proclaimed, "With an apple I want to astonish Paris," and he succeeded, even in the most deceptively simple still lifes, to dazzle and delight. Turning to the prized large Provençal apples and Beurré Diel pears, grown locally not far from the family's estate near Aix, he set up this arrangement in the same room of the Jas de Bouffan in which he painted a portrait of Madame Cézanne in 1891–92 (The Barnes Foundation, Merion, Pennsylvania) and, later, depicted Joachim Gasquet (Národní Galerie, Prague). The artist dispensed with traditional one-point perspective to examine the fruit, plates, and table from various viewpoints—straight on, from above, and sideways. He then ensured the integrity of the whole through canny placement and geometric juxtapositions that bridge his idiosyncratic pictorial space: the jutting corner of the table and proportion of its apron relate to the banded wall in the background, and the bulbous shapes of the apples and pears echo the rounded finial of the andiron glimpsed in the pocket of space to their right. SAS

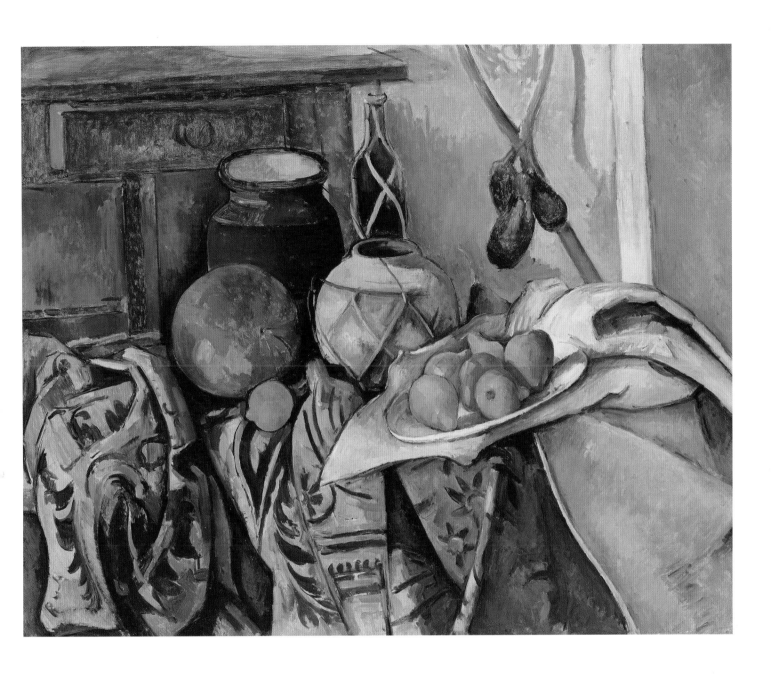

PAUL CÉZANNE
French, 1839–1906

75. *Still Life with a Ginger Jar and Eggplants*

1893–94
Oil on canvas
28½ x 36 in. (72.4 x 91.4 cm)
Bequest of Stephen C. Clark, 1960
61.101.4

For this commanding still life, with its richly orchestrated play of overlapping shapes, patterns, color, and textures, Cézanne relied on a battery of familiar objects such as the raffia-wrapped ginger jar, which is featured in more than a dozen compositions, including three of comparable verve dating to the early 1890s. In contrast to the bountiful, low-lying arrangement that spills forth like a turbulent sea—in unanchored splendor—a plain wood table stands guard in the background. At the right three eggplants dangling from a forked branch keynote the unfolding dialogue below between the rhythmic curves of the fruit and the drape of the table linen on the one hand, and the crisscrossing willow strands around the ginger jar and the bottle of rum, on the other.

SAS

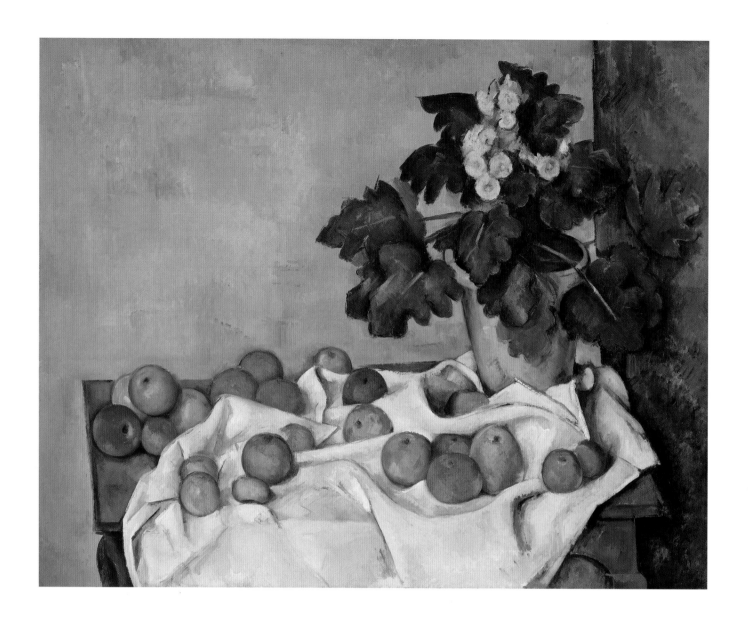

PAUL CÉZANNE
French, 1839–1906

76. *Still Life with Apples and a Pot of Primroses*

ca. 1890
Oil on canvas
28¾ x 36⅜ in. (73 x 92.4 cm)
Bequest of Sam A. Lewisohn, 1951
51.112.1

The pot of Chinese primroses adds a novel note to this sublime still-life arrangement in which apples nestled in tidy groups in and around the pitched folds of a crisp white tablecloth take their cue from its clustered pink blossoms and angular splayed leaves. Cézanne rarely painted flowering plants or fresh-cut bouquets, which were even more susceptible to wilting under his studious gaze; purportedly, he preferred artificial flowers that could withstand his protracted painting sessions. All told, he included potted plants in only three still lifes, two views of the conservatory at the Jas de Bouffan, and nearly a dozen exquisite watercolors made over the course of two decades (from about 1878 to 1906). He painted primroses on one other occasion (Courtauld Institute of Art Gallery, London), juxtaposing the plant with a plate of fruit and a canvas propped against the wall. Cézanne seems to have reserved this particular table, with its scalloped apron and distinctive bowed legs (which set it apart from another, more ubiquitous one), for three of his finest still lifes of the 1890s. In addition to its inclusion in this painting of primroses—formerly owned by the ardent gardener Monet—the table is shown adorned with tulips (The Art Institute of Chicago) and laden with onions (Musée d'Orsay, Paris). It also appears in a few figure drawings ranging widely in date from the mid-1880s to the end of the artist's career.

SAS

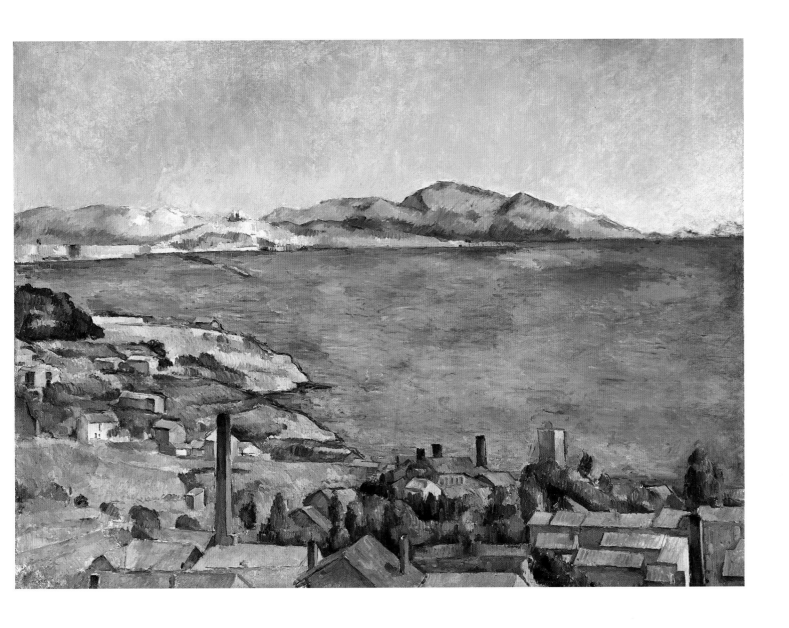

PAUL CÉZANNE
French, 1839–1906

77. *The Gulf of Marseilles Seen from L'Estaque*

ca. 1885
Oil on canvas
28¾ x 39½ in. (73 x 100.3 cm)
H. O. Havemeyer Collection, Bequest of Mrs. H. O. Havemeyer, 1929
29.100.67

Cézanne seems to have first visited the fishing village of L'Estaque about 1865. During the Franco-Prussian War (1870–71) he sought refuge in this picturesque sheltered port, lodged between the mountains and the sea near Marseilles. Upon his return there in the summer of 1876, he enthused to Pissarro: "It is like a playing card. Red roofs over the blue sea. . . . The sun is so terrific here that it seems to me as if the objects were silhouetted not only in black and white, but in blue, red, brown and violet." Surveying the prospect from an elevated vantage point, often from a

shady spot in the pine groves above town, Cézanne painted some twenty canvases of L'Estaque over the next decade—a dozen facing toward or across the gulf of Marseilles and beyond. He originally captured this panoramic view, looking east, in a work dating to the mid-1870s (Musée d'Orsay, Paris) and he adopted it for another, comparably majestic, picture in the mid-1880s (The Art Institute of Chicago). Atop the hill in the distance, just to the right of the jetty, the towers of Notre-Dame-de-la-Garde stand watch over the city of Marseilles. SAS

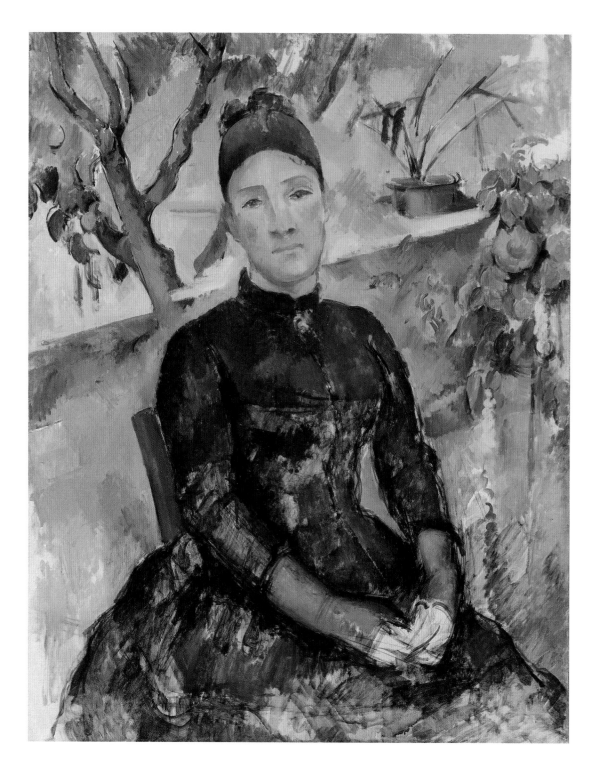

PAUL CÉZANNE
French, 1839–1906

78. *Madame Cézanne*
(Hortense Fiquet, 1850–1922)
in the Conservatory

1891
Oil on canvas
36¼ x 28¾ in. (92.1 x 73 cm)
Bequest of Stephen C. Clark, 1960
61.101.2

Cézanne met Hortense Fiquet, a former artist's model, about 1869, but they did not marry until 1886, By this date, their son, Paul, was fourteen. According to him, this portrait was painted in 1891 in the conservatory of the Jas de Bouffan, the Cézanne family estate, near Aix-en-Provence. Of the more than two dozen paintings for which Hortense posed over the course of her long and unorthodox relationship with the artist, this one, left unfinished, offers compelling insight into Cezanne's working method. Having established his pyramidal design, with Madame Cézanne's carefully modeled head set just slightly off-center, cradled between a lush tree and a spindly plant, he succeeded in puzzling out the forms of the composition, building up his armature touch by exacting touch. Her expression seems to lay bare—not unlike various other passages in the canvas—the demands that the artist's restless, unremitting search for the perfect means to realize his conception placed on his most faithful model. SAS

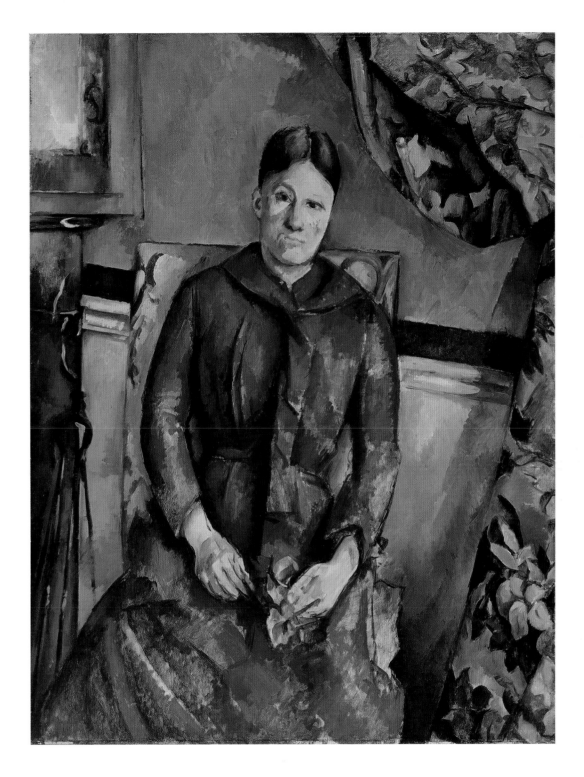

PAUL CÉZANNE
French, 1839–1906

79. *Madame Cézanne*
(Hortense Fiquet, 1850–1922)
in a Red Dress
1888–90
Oil on canvas
45⅞ x 35¼ in. (116.5 x 89.5 cm)
The Mr. and Mrs. Henry Ittleson Jr. Purchase Fund,
1962
62.45

In size and conception, this is the most ambitious portrait of the many that Cézanne painted of his wife. It is closely related to three smaller paintings in which she also wears a shawl-collared red dress: one shows her posed in a similar fashion, holding a flower in her hand, against a neutral backdrop (Museu de Arte de São Paulo); and two present her seated in the same room and high-backed yellow chair (The Art Institute of Chicago; Private collection). In effect, these more modest works seem to set the stage for the imposing role Madame Cézanne assumes in the elaborately outfitted setting of the Metropolitan's picture, where she is wedged between well-placed props that bend to her form, shift to her weight, and together conspire to hold the spatially complex design in perfect balance. Within a composition in which almost all elements are askew, each has its own logic and raison d'être: from the way the fire tongs at the left echo the triangular swath of the curtain at the right to the dynamic created by the juxtaposed rectangular shapes of the chairback and mirror. The architectural features of the interior, including the mottled-blue wall, the dark red band that edges the wainscoting, and the mirror over the fireplace, may be identified with the apartment that Cézanne rented at 15, quai d'Anjou, in Paris, from 1888 to 1890. Presumably preparatory to this painting, the artist devoted an oil and a watercolor to the sumptuously patterned drapery that serves to frame the composition at the right. He later brought the curtain to Aix and used it in several portraits and numerous still lifes he painted in his Lauves studio. SAS

PAUL CÉZANNE
French, 1839–1906

80. *The Card Players*
1890–92
Oil on canvas
25¾ x 32¼ in. (65.4 x 81.9 cm)
Bequest of Stephen C. Clark, 1960
61.101.1

This formidable scene of peasants playing cards was undertaken as part of a painting campaign in the early 1890s, which included five distillations of the subject based on numerous preparatory studies. Cézanne enlisted local farmhands to pose as models, and he may have drawn inspiration for his Provençal genre scene from a local treasure—the Le Nain brothers' painting of the same theme—in the museum in Aix. The largest and most complex of Cézanne's five *Card Players* is the version in The Barnes Foundation in Merion, Pennsylvania. The Metropolitan's picture, at half the size and with one less figure, came next. Cézanne tightened the composition, streamlining the decor and the cast of four fellows wearing hats. He pared away extraneous details in each successive rendition. The last three (Courtauld Institute of Art Gallery, London; Musée d'Orsay, Paris; and Private collection) depict only two players starkly confronting one another across the table.

SAS

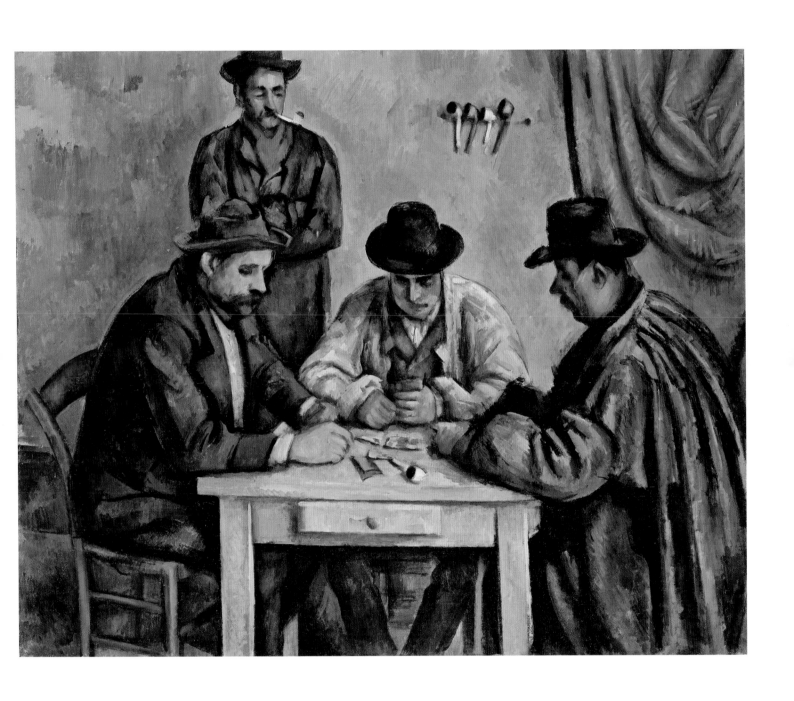

ALFRED SISLEY
English, 1839–1899

**81. *The Bridge at
Villeneuve-la-Garenne***

1872
Oil on canvas
19½ x 25¾ in. (49.5 x 65.4 cm)
Signed and dated (lower left): Sisley. 1872
Gift of Mr. and Mrs. Henry Ittleson Jr., 1964
64.287

Recently built, state-of-the-art bridges, emblematic of modernity, recur as motifs in Impressionist paintings of the 1870s and 1880s. The cast-iron and stone suspension bridge at Villeneuve-la-Garenne, constructed in 1844 to connect the village with the Paris suburb of Saint-Denis, appears in two paintings executed by Sisley in 1872. These works resulted from two painting campaigns, which Sisley undertook during the spring and summer of that year in this small village along the Seine north of Paris. The first painting (Fogg Art Museum, Cambridge, Massachusetts) offers a more distant view of the highway bridge, which becomes the focal point of the present composition, painted in the summer of 1872. Here, as in Sisley's earlier *Bridge at Argenteuil* (Musée d'Orsay, Paris), he renders the bridge at a dramatic diagonal, plunging into depth.

Sisley's technique demonstrates his mastery of the Impressionist idiom in his application of separate colors of paint in flat, rectangular brushstrokes—notably, in the various colored reflections on the water's surface. His high-keyed palette is also typical of early Impressionist works, as is his interest in capturing the fleeting effects of sunlight. KCG

ALFRED SISLEY
English, 1839-1899

82. *The Road from Versailles to
Louveciennes*

ca. 1879
Oil on canvas
18 x 22 in. (45.7 x 55.9 cm)
Signed (lower left): Sisley.
Gift of Mr. and Mrs. Richard Rodgers, 1964
64.154.2

In the 1870s, Sisley, like his fellow Impressionists Monet and Pissarro, painted in the villages to the north and west of Paris, including Argenteuil, Bougival, Louveciennes, and Marly-le-Roi, which were rapidly becoming suburbs of the capital. The landscapes by the three artists often depicted the roads, bridges, and waterways that linked these outlying villages with Paris.

In 1877, Sisley settled in Sèvres, but he would return to paint familiar motifs in the area around Louveciennes, where he had first worked in the early 1870s. The site in this painting is near Louveciennes, on the main road between Versailles and Saint-Germain-en-Laye. Sisley's juxtaposition of two figures on the road—a rural laborer pushing a cart and a man clad in the urban "uniform" of black suit and top hat—alludes to the transformative effects of industrialization and suburbanization on the French countryside. Sisley's summary, loose technique in this work is in keeping with his style of the late 1870s, as he moved away from the broken brushwork of his earlier Impressionist paintings. KCG

ALFRED SISLEY
English, 1839–1899

83. *Rue Eugène Moussoir at Moret: Winter*

1891
Oil on canvas
18⅜ x 22¼ in. (46.7 x 56.5 cm)
Signed (lower right): Sisley.
Bequest of Ralph Friedman, 1992
1992.366

Snow scenes figured in the oeuvre of several of the Impressionists, especially Claude Monet and Camille Pissarro. These artists perhaps were responding to a group of snowy landscapes exhibited in Paris by Gustave Courbet in 1867. The Impressionist exhibitions of the 1870s also included several snow scenes, often entitled—or subtitled—"*Effet de neige*." Following the lead of his Impressionist colleagues, Sisley painted his first snow scene in the winter of 1871–72: a street in the village of Louveciennes (Museum of Fine Arts, Boston). While interest in painting winter landscapes waned among the Impressionists

after 1880, Sisley, like Monet, continued to produce them for the rest of his life.

In 1889, Sisley settled in Moret-sur-Loing, on the fringes of the Fontainebleau forest, where he would remain for the rest of his life. He described the town in a letter to Monet as "not a bad part of the world, rather a chocolate-box landscape." This work, with its subtly nuanced palette, is one of several scenes set in Moret and its environs that Sisley painted in the winter of 1891. The view here is of the rue Eugène Moussoir, bordered by the wall of the village hospital. KCG

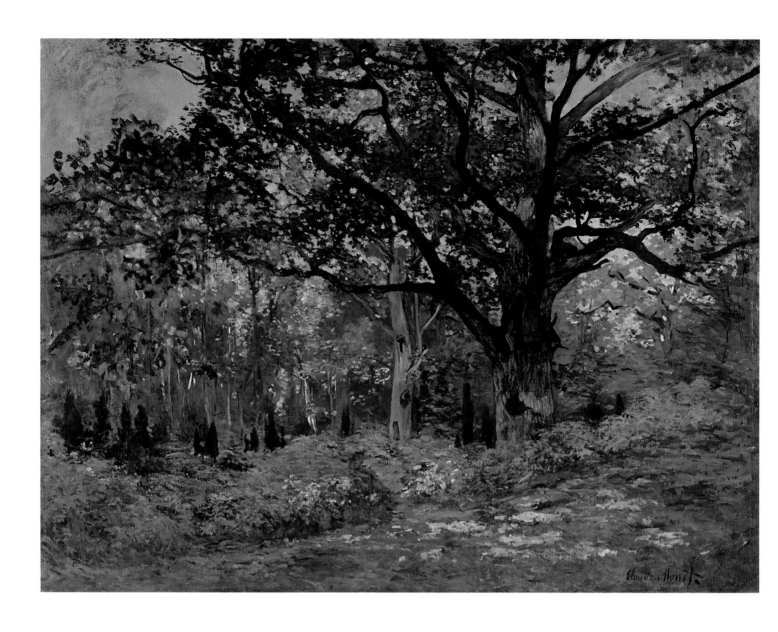

CLAUDE MONET
French, 1840–1926

84. *The Bodmer Oak, Fontainebleau Forest*

1865
Oil on canvas
37⅞ x 50⅞ in. (96.2 x 129.2 cm)
Gift of Sam Salz and Bequest of Julia W. Emmons,
by exchange, 1964
64.210

The Bodmer Oak—named after the Swiss artist Karl Bodmer (1809–1893), who exhibited his painting of the tree at the 1850 Salon— was one of several imposing trees in the Fontainebleau forest that had acquired a special appellation. It was a favorite of painters and photographers alike. The calotype by Gustave Le Gray (1820–1884), of about 1850, is probably the best-known photograph of the oak and one that Monet may have seen.

The carpet of russet leaves signals that Monet painted this canvas just before he left Chailly-en-Bière, near Fontainebleau, in October 1865. It is probably the last of several landscapes executed in connection with his monumental *Dejeuner sur l'Herbe* (fragments of which are now at the Musée d'Orsay, Paris). Although the site Monet depicted in the *Déjeuner* was probably situated in an area at the edge of the Chailly road rather than under this majestic oak, the actual *sous-bois* setting is similar to the effect captured in this painting. As in the *Déjeuner*, the light streams in from behind the screen of trees at the left, and the sky in both pictures is represented as patches of deep ultramarine punctuating the veil of branches and leaves.

The slash in the upper-right corner of the painting may have been made by Monet, who reputedly mutilated some canvases in order to discourage a landlord from seizing them in 1866. GT

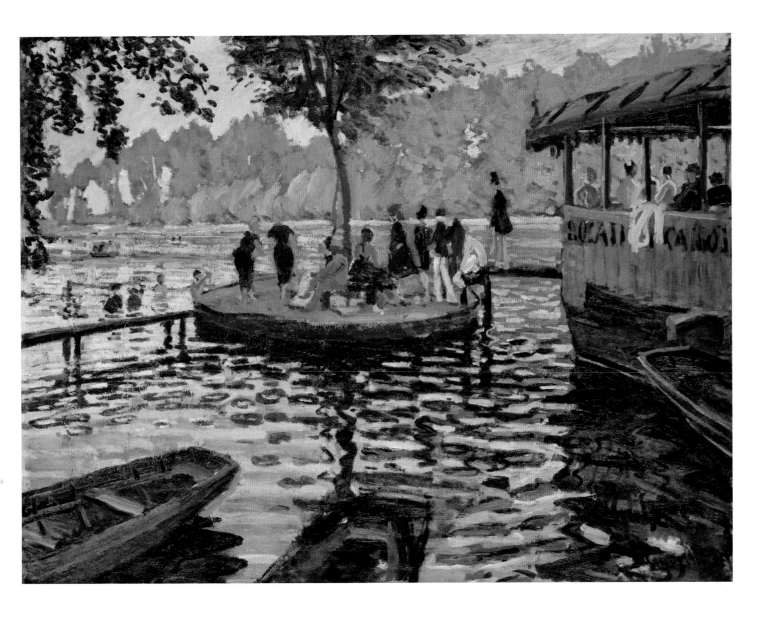

CLAUDE MONET
French, 1840–1926

85. *La Grenouillère*
1869
Oil on canvas
29⅜ x 39¼ in. (74.6 x 99.7 cm)
Signed and inscribed (lower right): Claude Monet
H. O. Havemeyer Collection, Bequest of Mrs. H. O.
Havemeyer, 1929
29.100.112

Monet noted on September 25, 1869, "I do have a dream, a painting [*tableau*], the baths of La Grenouillère, for which I have made some bad sketches [*pochades*], but it is only a dream. Renoir, who has just spent two months here, also wants to do this painting." Monet and Renoir, both desperately poor, were quite close at this time. Years later, Monet recalled, "As pleasant as it has been to travel as a tourist with Renoir, I would find it awkward to travel with someone if I wanted to work. I have always worked better alone and from my own impressions."

This painting and one in London (National Gallery) are probably the "*pochades*" Monet mentions; another painting, now lost but formerly in the Arnhold collection in Berlin, may well have been the "*tableau*" that he dreamed of. The broad, constructive brushstrokes here are clearly those of a sketch; at this time Monet sought a more delicate and carefully calibrated surface for his exhibition pictures. (A nearly identical composition by Renoir is now in the Nationalmuseum, Stockholm.)

Monet and Renoir both recognized in La Grenouillère—a spa and working-class resort—an ideal subject for the images of leisure they hoped to sell. Optimistically promoted as a "Trouville-sur-Seine," it was easily accessible by train from Paris, and had just been favored with a visit by the emperor Napoleon III, his wife, and his son. GT

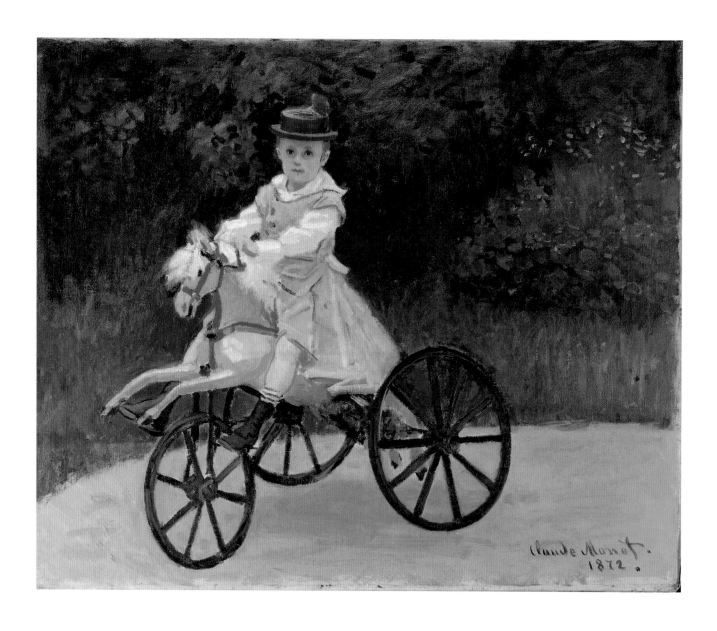

CLAUDE MONET
French, 1840–1926

86. *Jean Monet (1867–1913) on His Hobby Horse*

1872
Oil on canvas
23¼ x 29¼ in. (59.1 x 74.3 cm)
Signed and dated (lower right): Claude Monet- /
1872.
Gift of Sara Lee Corporation, 2000
2000.195

When Monet painted this picture of his eldest son in the summer of 1872, the artist and his family had recently returned to France from their self-imposed exile during the Franco-Prussian War. Through the efforts of the dealer Paul Durand-Ruel, the artist's finances had begun to improve. Consequently, the once impoverished Monets were able to install themselves in a rented house in Argenteuil, an agreeable suburb northwest of Paris.

For this portrait, Monet posed the five-year-old in the garden of their new home. While he surely wished to show off Jean's fancy clothes and expensive mechanical horse, his primary aim was to capture a likeness of the child, whose deep-set eyes resembled those of his mother, Camille.

Monet never exhibited the picture, which is freely and thinly painted, with areas of bare canvas showing here and there; he kept it throughout his life. GT

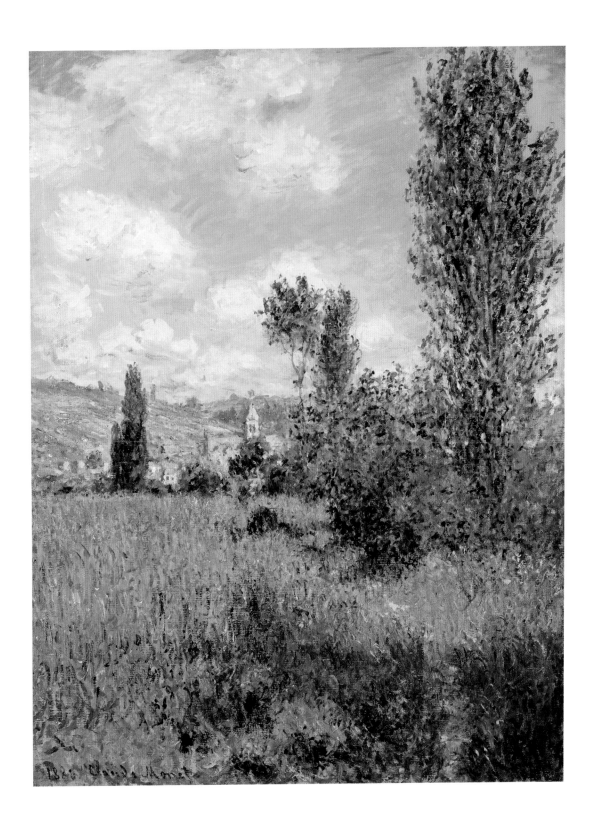

CLAUDE MONET
French, 1840–1926

87. *View of Vétheuil*
1880
Oil on canvas
31½ x 23¾ in. (80 x 60.3 cm)
Signed and dated (lower left): 1880 Claude Monet
Bequest of Julia W. Emmons, 1956
56.135.1

In August 1878, Monet settled in Vétheuil, a picturesque village along the Seine some twenty-five miles northwest of Paris, where he spent the next three years. During the summer of 1880, he painted twenty-six views of Vétheuil and its environs. The Île Saint-Martin served as the vantage point for six of these works, including the present painting. Here, the cluster of poplars on the right obscures the Seine, beyond which lies Vétheuil, the tower of its thirteenth-century Gothic church rising up to meet the horizon line. The absence of figures—typical of Monet's views of Vétheuil—

marks a departure from his earlier approach to landscape.

Monet's varied brushwork animates the composition—from the short, vertical strokes used to render the poppy field in the foreground to the loosely brushed summer clouds. In 1881, Monet returned to this site, painting two similar landscapes; one, shown in the seventh Impressionist exhibition in 1882 as *Path in the Île Saint-Martin*, was described by a critic described as "wonderfully in bloom."

KCG

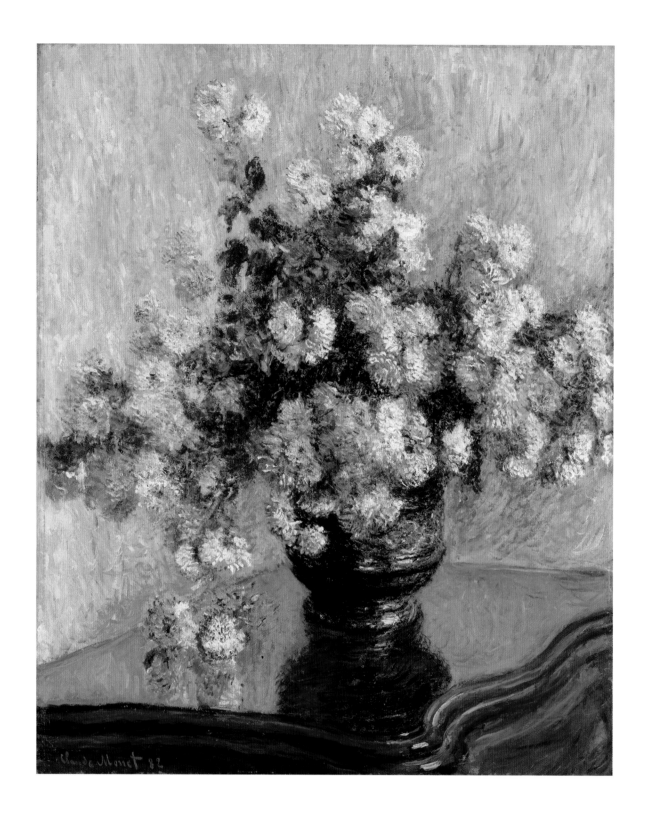

CLAUDE MONET
French, 1840–1926

88. *Chrysanthemums*

1882
Oil on canvas
39½ x 32¼ in. (100.3 x 81.9 cm)
Signed and dated (lower left): Claude Monet 82
H. O. Havemeyer Collection, Bequest of Mrs. H. O.
Havemeyer, 1929
29.100.106

Although landscapes dominate his oeuvre, Monet also produced a variety of still lifes throughout his career, including a group of some twenty rapidly painted depictions of garden flowers, dating from 1878 to 1883. These still lifes of sunflowers, nasturtiums, dahlias, and other flowers—captured in paint as they bloomed—were sought after by collectors. When Monet exhibited six of the still lifes in the 1882 Impressionist exhibition, a critic observed, "Claude Monet paints flowers, chrysanthemums and gladiolas, varnished vases, pheasants—in a word, still lifes—with great talent."

Although dated 1882—the year that Monet sold this picture to his dealer, Durand-Ruel—*Chrysanthemums* likely belongs to a group of nine still lifes (seven of which are floral subjects) that Monet painted during the winter of 1880–81. A profusion of chrysanthemums, rendered in richly textured pigments in varying rose-pink hues, fills the canvas, which seems barely to contain them. Monet's bravura brushwork is evidenced in the freely rendered flowers and in the reflection on the polished surface of the table.

In 1897, Monet would execute four related paintings of chrysanthemum beds, in each of which the mass of multicolored flowers fills the entire canvas, prefiguring his "Water Lilies" series. KCG

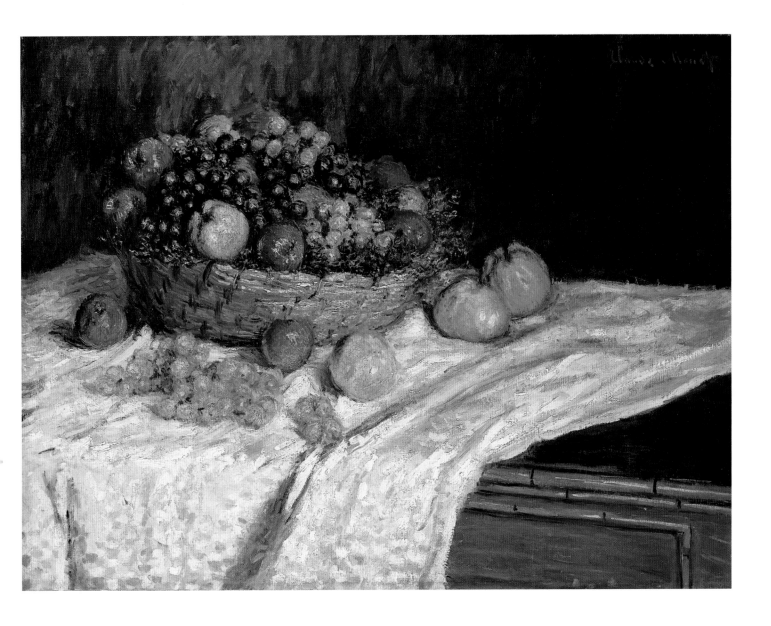

CLAUDE MONET
French, 1840–1926

89. *Apples and Grapes*

ca. 1879–80
Oil on canvas
26⅞ x 35¼ in. (67.6 x 89.5 cm)
Signed (upper right): Claude Monet
Gift of Henry R. Luce, 1957
57.183

Apples and Grapes figures among a group of three similar still lifes painted in 1879–80, when bad weather forced Monet to work indoors. Marthe Hoschedé, the artist's future stepdaughter, observed in a letter from late November 1879, "M. Monet is working hard at his still lifes which are very pretty," mentioning a "painting of fruits" as a work in progress. All three still lifes from this period depict apples and grapes in the same basket, asymmetrically placed on a bright white tablecloth. Only one of these paintings, *Still Life: Apples and Grapes* of 1880 (The Art Institute of Chicago), is dated.

This group of still lifes reveals the modernity of Monet's approach to the genre. In *Apples and Grapes*, as in the other works, the seemingly unordered, informal arrangement of the objects is in keeping with the spontaneity of the Impressionists' style, while the colored reflections depicted on the surface of the white tablecloth reveal Monet's exploration of optical effects.

Monet probably sold this painting in January 1880 to the dealer Georges Petit for five hundred francs; it was subsequently owned by an early collector of Impressionist art, the customs official Victor Chocquet (1821–1891). KCG

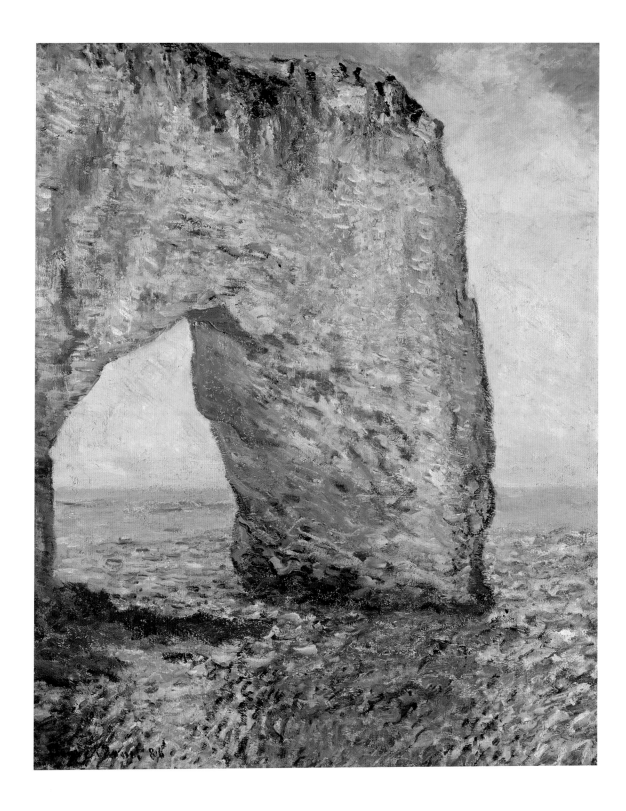

CLAUDE MONET
French, 1840–1926

90. *The Manneporte near Étretat*

1886
Oil on canvas
32 x 25¾ in. (81.3 x 65.4 cm)
Signed and dated (lower left): Claude Monet 86
Bequest of Lillie P. Bliss, 1931
31.67.11

Monet visited Étretat, a fishing village and resort along the Normandy coast, in 1883, 1885, and 1886. His paintings from these trips focus on the dramatic rock formations—in particular, the Manneporte, which is the subject of six paintings. In this picture, he paints the monumental arch as seen from the bottom of the Valleuse de Jambourg, looking toward the west so as to capture its full height. The chalky surface of the stone arch vibrates with the reflected light of the sea and sky, rendered in broken touches of pink and orange and blue and violet.

Monet's canvases from Étretat mark the beginning of his practice of painting in series, which would dominate his oeuvre in the next decade. In 1886, the writer Guy de Maupassant published his eyewitness account of Monet on the beach at Étretat, followed by children carrying "five or six canvases representing the same subject at different times of the day and with different effects. He took them up and put them aside by turns according to changes in the sky and shadows." After working in plein air, Monet refined his Étretat pictures in the studio at Giverny, prefiguring his approach to the series paintings in the 1890s.

KCG

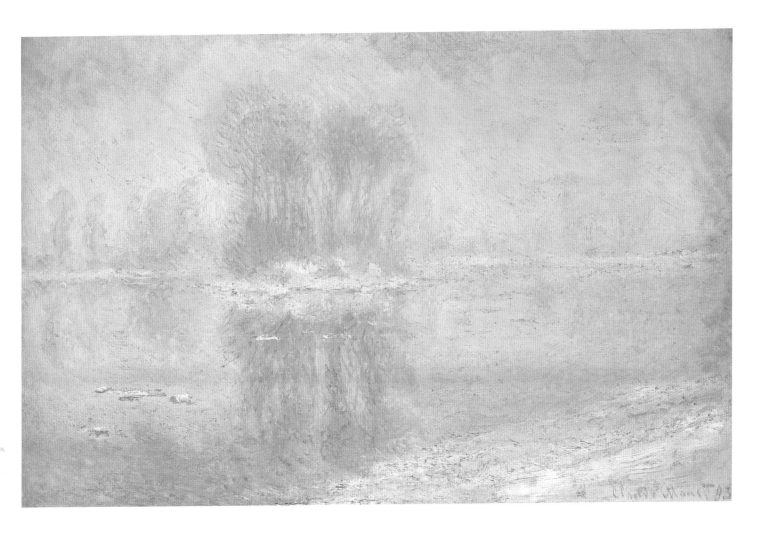

C LAUDE M ONET
French, 1840–1926

91. *Ice Floes*

1893
Oil on canvas
26 x 39½ in. (66 x 100.3 cm)
Signed and dated (lower right): Claude Monet 93
H. O. Havemeyer Collection, Bequest of Mrs. H. O.
Havemeyer, 1929
29.100.108

The prolonged freeze and heavy snowfalls in the winter of 1892–93 inspired Monet to capture their effects on the Seine in a series of paintings for which he chose a vantage point not far from his home in Giverny. The river had frozen in mid-January but began to thaw on the 23rd; the following day, in a letter to his dealer, Durand-Ruel, Monet lamented that "the thaw came too soon for me . . . the results—just four or five canvases and they are far from complete." By the end of February, however, he had finished more than a dozen paintings, including this view of the melting ice floes. Monet had previously treated this subject in the winter of 1879–80, depicting the frozen Seine near Vétheuil.

Observed from the banks of the Seine on the outskirts of the village of Bennecourt, the composition centers on the islet of Forée, which appears in the six other, almost identical paintings that comprise this group. In *Ice Floes*, Monet limited his palette to shades of white tinted with pale blues and pinks, producing an almost monochromatic effect in which the trees are barely differentiated from their reflections. Like the other works in this series, Monet possibly completed the painting in his studio. KCG

CLAUDE MONET
French, 1840–1926

92. *Bridge over a Pond of
Water Lilies*

1899
Oil on canvas
36½ x 29 in. (92.7 x 73.7 cm)
Signed and dated (lower right): Claude Monet / 99
H. O. Havemeyer Collection, Bequest of Mrs. H. O.
Havemeyer, 1929
29.100.113

In 1893, Monet, a passionate horticulturalist, purchased land with a pond near his property in Giverny, intending to build something "for the pleasure of the eye and also for motifs to paint." The result was his water-lily garden, which he would memorialize in his paintings over the ensuing decades. In 1899, he began a series of eighteen views of the wooden footbridge over the pond, completing twelve paintings, including the present one, that summer. Monet's arched footbridge is reminiscent of similar structures depicted in the Japanese prints that he collected.

For the works in this series, Monet maintained a consistent vantage point, which he altered only slightly. Photographs of the pond from this period document the presence of a sort of floating studio that would have allowed him to observe the bridge from the middle of the pond, as it appears here. Monet's brushwork reprises his Impressionist technique in the juxtaposition of individual touches of color. The vertical format of the picture, unusual in this series, gives prominence to the water lilies and their reflections on the pond; the composition also suggests a recession in depth that is absent in Monet's later "Water Lilies" series, in which the imagery verges on abstraction. When this painting, along with the eleven other canvases in the group, was included in an exhibition of Monet's work at the Durand-Ruel gallery in Paris in 1900, critics praised Monet's ability to capture such varied light effects. KCG

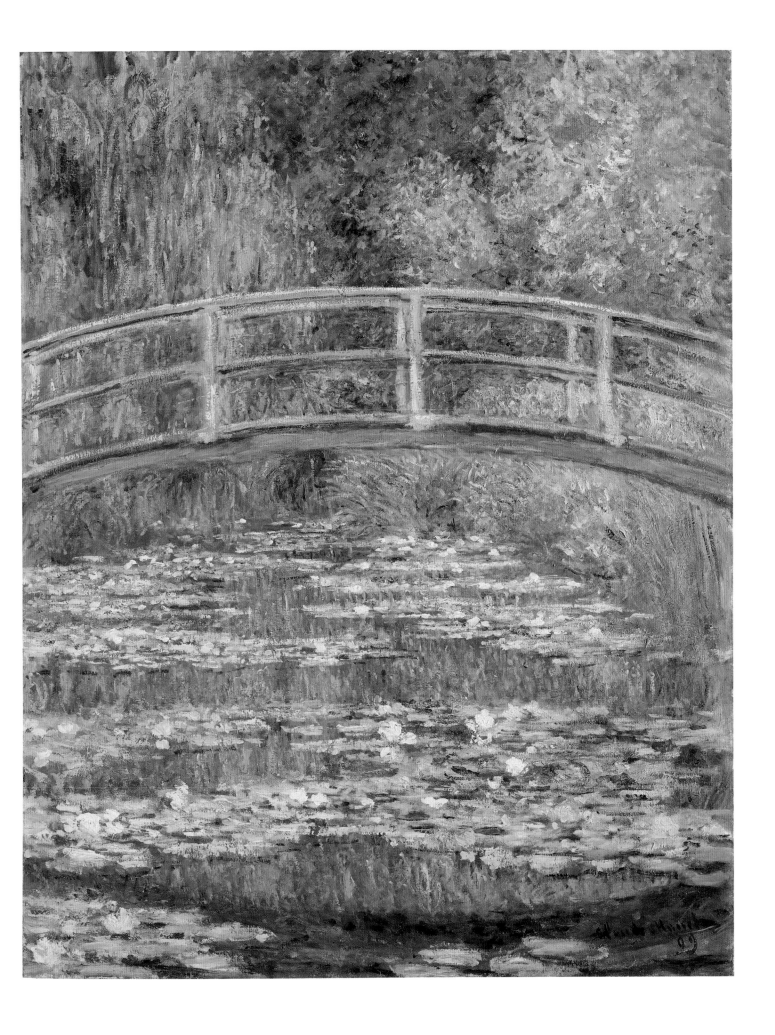

CLAUDE MONET
French, 1840–1926

93. *The Houses of Parliament (Effect of Fog)*

1903–4
Oil on canvas
32 x 36⅜ in. (81.3 x 92.4 cm)
Signed and dated (lower left): Claude Monet 1903
Bequest of Julia W. Emmons, 1956
56.135.6

In the fall of 1899 and the early months of 1900 and 1901, Monet executed a series of views of the Thames River in London dedicated to three motifs. From his room at the Savoy Hotel, he painted Waterloo Bridge, looking downstream to the east, and Charing Cross Bridge to the west; beginning in February 1900, he set up his easel on a terrace at Saint Thomas's Hospital across the river, reserving time in the late afternoon to depict the Houses of Parliament at sunset or under the fading light of day.

While in London Monet produced nearly a hundred canvases, reportedly moving from one to another as the light changed. In his studio at Giverny, he worked on the paintings until 1903, when he wrote to his dealer Durand-Ruel: "I cannot send you a single canvas of London. . . . It is indispensable to have them all before me, and to tell the truth not one is definitely finished. I develop them all together." In May 1904 thirty-seven were exhibited at the Galerie Durand-Ruel in Paris, including this view of the Houses of Parliament cloaked in dense fog. Monet reworked the painting after the show, replacing the original signature and date of 1904, at the right, with the present inscription and 1903 date. SAS

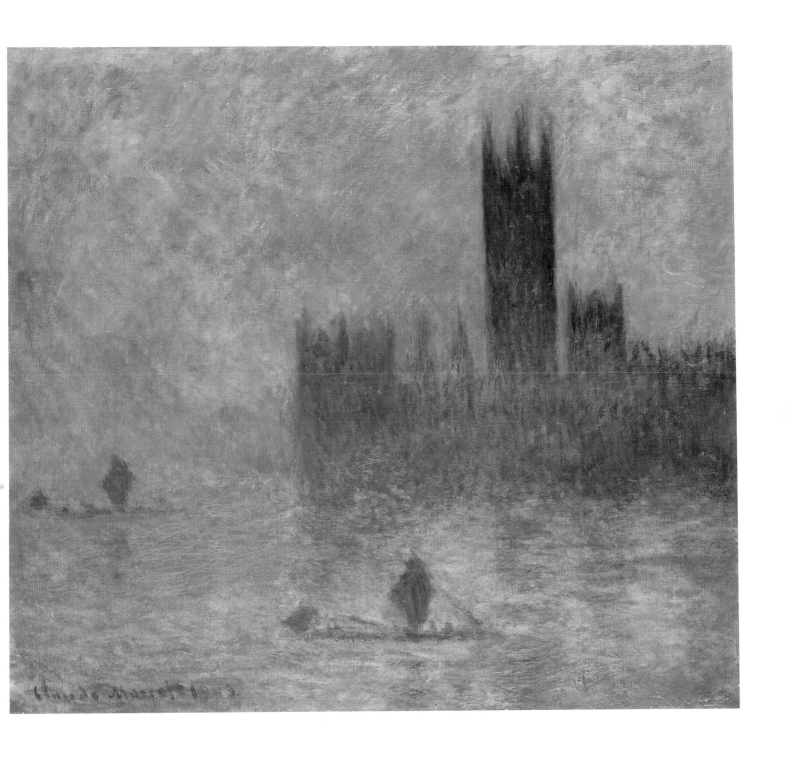

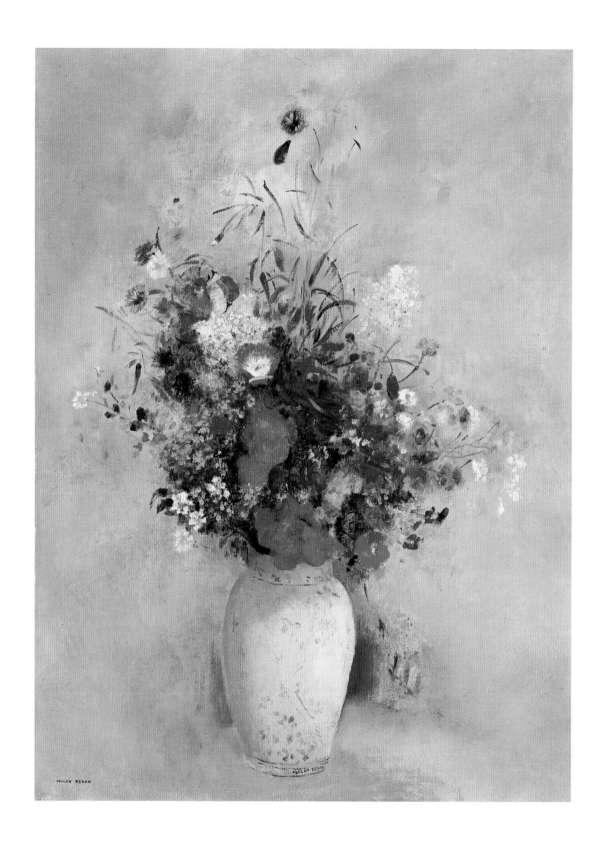

ODILON REDON
French, 1840–1916

94. *Vase of Flowers*
(*Pink Background*)

ca. 1906
Oil on canvas
28⅞ x 21¼ in. (72.7 x 54 cm)
Signed (lower left and at the base of the vase):
ODILON REDON
Bequest of Mabel Choate, in memory of her father,
Joseph Hodges Choate, 1958
59.16.3

Having worked almost exclusively in black and white for over two decades, Redon revealed his gifts as a colorist in the luminous pastels and paintings he made after 1895. The brooding imagery that had haunted his youthful vision and won him a devoted Symbolist following gave way to still lifes and mythological scenes in a more decorative and joyous vein, extending his circle of admirers in the early twentieth century. No less inventive, Redon's late flower pictures remain true to his artistic aim: "to place the logic of the visible at the service of the invisible." As in this bouquet, such identifiable flowers as poppies and cornflowers, which he had closely studied with a naturalist's sense of wonder, tend to emerge, anew, as fanciful re-creations in jewel-like patches of color against a misty, undefined field. SAS

ODILON REDON
French, 1840–1916

95. *Pandora*

ca. 1914
Oil on canvas
56½ x 24½ in. (143.5 x 62.2 cm)
Signed (lower right): ODILON REDON
Bequest of Alexander M. Bing, 1959
60.19.1

In the mythological and imaginary scenes dating from his maturity, Redon gave free rein to color, inventive floral imagery, and an idealized vision of feminine beauty. Partial to ill-fated goddesses, he often turned to the mythic beauties Venus, Andromeda, and Pandora, between 1908 and 1914, in works that tend to recast the female figure he introduced in the paradisiacal setting of *Rebirth* of about 1908 (State Pushkin Museum of Fine Arts, Moscow). Here, Redon represents Pandora—the exquisite woman fashioned from clay by Vulcan, and sent to earth by Jupiter—as a willowy nude amid a profusion of flowers. Her innocence still intact, Pandora cradles in her arms the infamous box, yet unopened, which will unleash all the evils destined to plague mankind, thereby bringing the Golden Age to an end.

In the spring of 1914, Redon explored this theme in conjunction with his last major commission. Asked to paint two decorative panels for the collector Jules Chavasse's library in Nîmes, Redon devoted one to the pagan goddess Pandora and the other to the Christian martyr Saint Sebastian. Curiously, his treatment of the figures only heightens the disparity between the oddly paired couple. The classicizing nude in the Metropolitan's picture, painted in the same elongated format, offers a more compelling pendant to the persecuted soldier in contrapposto. It may represent Redon's first conception for the Chavasse panel or a reprisal inspired by the challenge of more effectively rendering a subject that had particular resonance on the eve of world war.

SAS

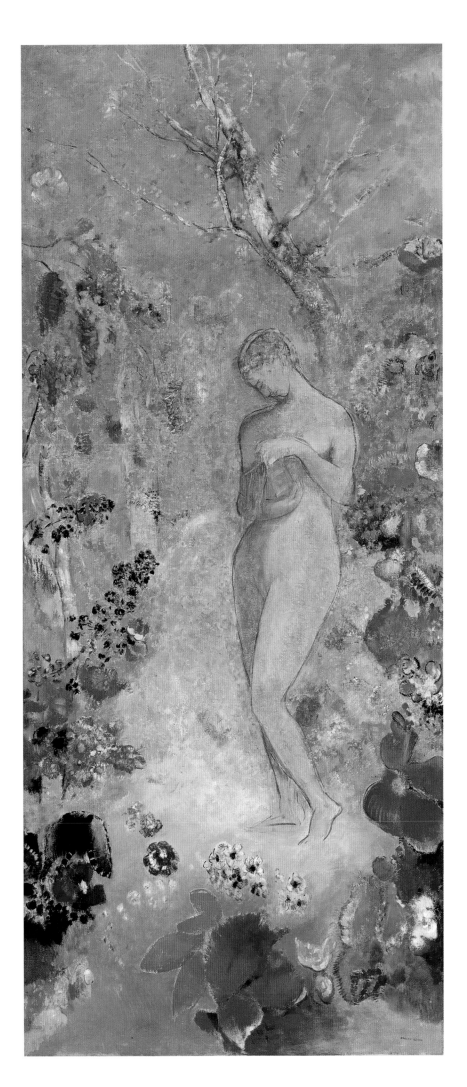

BERTHE MORISOT
French, 1841–1895

96. *Young Woman Seated on a Sofa*

ca. 1879
Oil on canvas
31¾ x 39¼ in. (80.6 x 99.7 cm)
Signed (lower left): Berthe Morisot
Partial and Promised Gift of Mr. and Mrs. Douglas
Dillon, 1992
1992.103.2

Morisot was at her apogee when she painted this model in her Paris apartment. By then she had melded the bravura brushwork adopted from her mentor and brother-in-law, Édouard Manet, with her own opalescent palette. When she showed similar canvases at the 1880 Impressionist exhibition some critics disliked their lack of polish, but one, Charles Ephrussi, appreciated them: "She grinds flower petals onto her palette, in order to spread them later on her canvas with airy, witty touches. . . . These harmonize, blend, and finish by producing something vital, fine, and charming that you do not see so much as intuit." GT

AUGUSTE RENOIR
French, 1841–1919

97. *A Waitress at Duval's Restaurant*

ca. 1875
Oil on canvas
39½ x 28⅛ in. (100.3 x 71.4 cm)
Signed (lower left): Renoir.
Bequest of Stephen C. Clark, 1960
61.101.14

In this painting from about 1875, Renoir portrays a waitress who worked at one of several Parisian restaurants established by a butcher named Duval. A large chain described at some length in an 1881 Baedeker's guidebook, these "Établissements de Bouillon," offered a limited and affordable menu to patrons "waited on by women, soberly garbed, and not unlike sisters of charity." Renoir imparted to his comely model—shown in uni-

form, informally posed, arm akimbo with an expression of patience and gentility—the unaffected grace of a server whom one might expect to find at these unpretentious eateries. As he once explained in a different context, "I like painting best when it looks eternal without boasting about it: an everyday eternity, revealed on the street corner: a servant-girl pausing a moment as she scours a saucepan, and becoming a Juno on Olympus." SAS

AUGUSTE RENOIR
French, 1841–1919

98. *Madame Édouard Bernier*
(Marie-Octavie-Stéphanie Laurens,
1838–1920)
1871
Oil on canvas
30¾ x 24½ in. (78.1 x 62.2 cm)
Signed and dated (lower right): A. Renoir .71.
Gift of Margaret Seligman Lewisohn, in memory of
her husband, Sam A. Lewisohn, and of her sister-in-
law, Adele Lewisohn Lehman, 1951
51.200

Long thought to represent Madame Alfred Darras, the sitter recently has been identified as Marie-Octavie Bernier, the wife of the commander of Renoir's regiment during the Franco-Prussian War (1870–71). In the spring of 1871, Renoir stayed with the couple, who were then living with her father in the town of Tarbes in southwestern France. Enjoying their hospitality and a level of comfort that is reflected in this portrait of Madame Bernier, Renoir fondly recalled that he spent "two months in a château," where he was "treated like a prince," rode horses every day, and taught his hosts' daughter to paint. During this visit, Renoir also executed a portrait of Captain Édouard Bernier shown in uniform, seated on his military greatcoat, under a dramatic sky (it is now in the Staatliche Kunstsammlungen, Dresden). Widowed in 1880, Madame Bernier kept both portraits until 1919, just shortly before her death the following year. SAS

AUGUSTE RENOIR

French, 1841–1919

99. *Marguerite-Thérèse (Margot)*
Berard (1874–1956)

1879

Oil on canvas

16⅛ x 12¾ in. (41 x 32.4 cm)

Signed and dated (upper left): Renoir 79.

Bequest of Stephen C. Clark, 1960

61.101.15

Renoir depicts the five-year-old daughter of his devoted patron Paul Berard, a French diplomat and banker whom he met in the winter of 1878. The artist often spent his summers at the Berards' country home in Wargemont, near Dieppe, on the Normandy coast, where he painted decorative pictures for the house and a veritable family album of portraits, which range from formal commissions to more intimate works that reflect a genuine fondness for the four children. According to the sitter's nephew, Renoir painted this spirited portrait of Margot to "cheer her up" in the aftermath of a disagreeable lesson with her German tutor that had brought the wide-eyed little girl to tears.

SAS

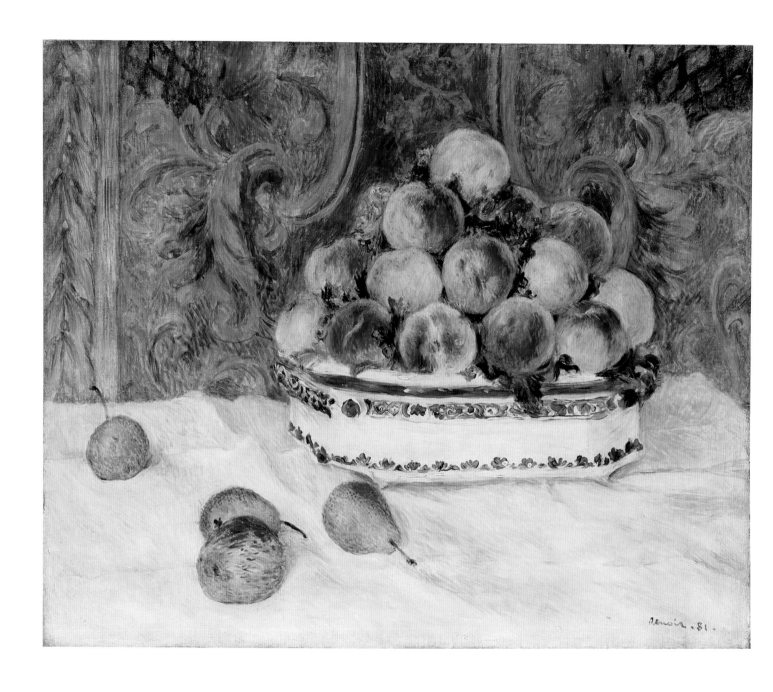

AUGUSTE RENOIR
French, 1841–1919

100. *Still Life with Peaches*

1881
Oil on canvas
21 x 25½ in. (53.3 x 64.8 cm)
Signed and dated (lower right): Renoir. 81.
Bequest of Stephen C. Clark, 1960
61.101.12

Starting out as an artist, Renoir painted decorative motifs on porcelain, and the graceful, fluid manner that characterized this work in a florid Rococo-revival style seems to have held sway over his approach to his art throughout his career. While reviewers of the 1882 Impressionist exhibition may have known little about Renoir's early training, the qualities they admired in this "very appealing" still life of "a certain fruit bowl of *Peaches*, whose velvety execution verges on a trompe l'oeil," are apropos. Painted the previous summer at his patron Paul Berard's country house in Wargemont (Normandy), it is one of two related still lifes that feature the same faïence jardinière; the other version is also in the Metropolitan Museum (56.218). SAS

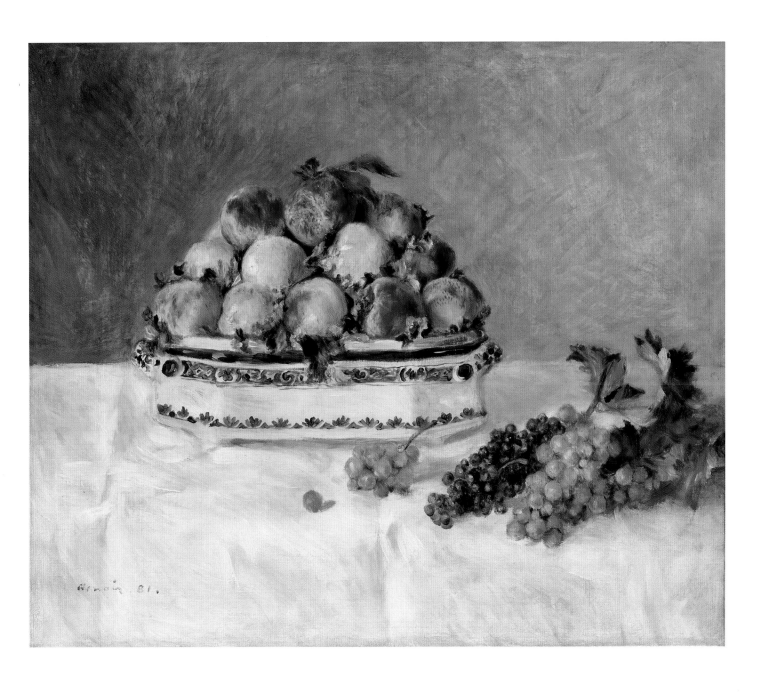

AUGUSTE RENOIR
French, 1841–1919

101. *Still Life with Peaches
and Grapes*

1881
Oil on canvas
21¼ x 25⅞ in. (54 x 65.1 cm)
Signed and dated (lower left): Renoir. 81.
The Mr. and Mrs. Henry Ittleson Jr. Purchase Fund,
1956
56.218

From 1878, Renoir enjoyed the patronage of the French banker and diplomat Paul Berard and was a frequent guest at the collector's country house in the small Norman village of Wargemont—described by Mary Cassatt as "a pretty place, an English park, rather isolated." During a visit in the summer of 1881, Renoir painted two similar still lifes, albeit in contrasting color harmonies, which show the family's faïence jardinière piled high with peaches (both pictures are now in the Metropolitan Museum). The present work, with its elegant interplay of blues and whites, was purchased by Berard later that year; the other version (61.101.12), distinguished by a richer and warmer palette, in concert with the lush tonality of the fruit, was featured in the Impressionist exhibition in the spring of 1882. SAS

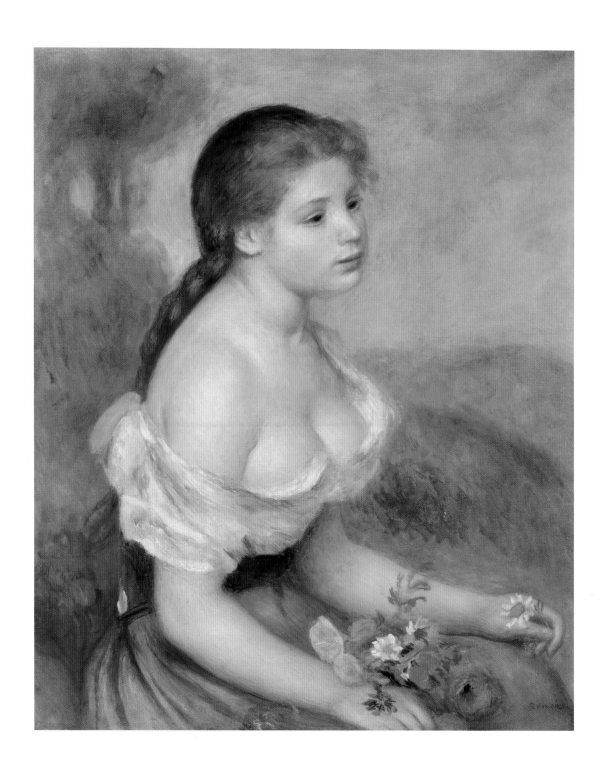

"I have taken up again, never to abandon it, my old style, soft and light of touch," Renoir announced to his dealer Durand-Ruel in 1888. In *A Young Girl with Daisies,* painted a year later, the artist cast aside the so-called "dry" and tautly modeled forms that had governed his recent efforts for a freer and suppler approach closer to his Impressionist style of the previous decade. Turning to the idle pastimes of young, middle-class girls in images that vacillate between idyll and everyday life, Renoir gave inimitable expression to his feeling that a picture, above all, "should be something likeable, joyous and pretty—yes, pretty. There are enough ugly things in life not to add to them." Unlike the lackluster reception accorded his latest *Ingriste* phase, these paintings, which incline toward the graceful informality of Fragonard and the demure naturalism of Corot, found a ready market in the early 1890s. SAS

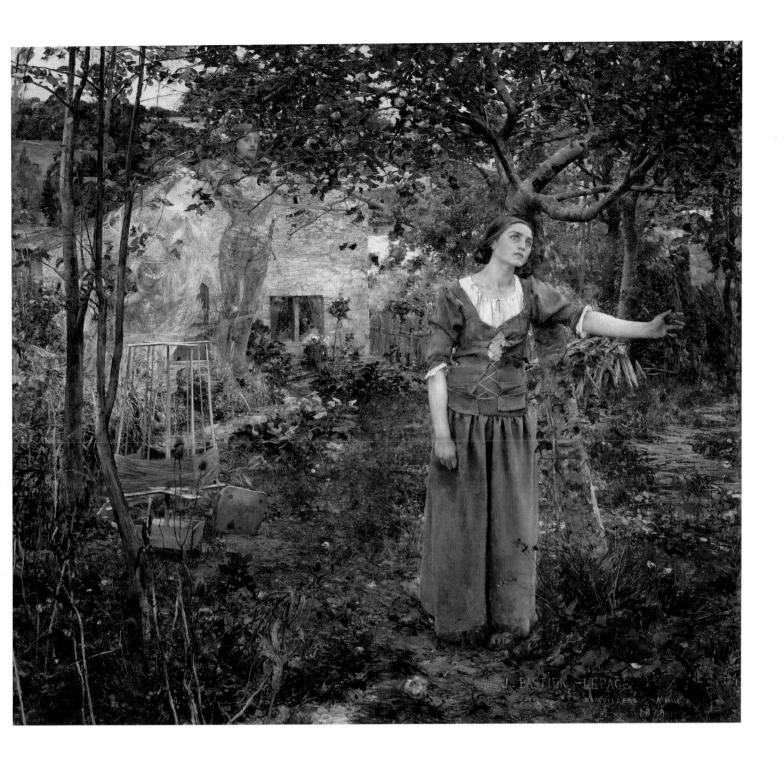

JULES BASTIEN-LEPAGE
French, 1848–1884

103. *Joan of Arc*
1879
Oil on canvas
100 x 110 in. (254 x 279.4 cm)
Signed, dated, and inscribed (lower right):
J.BASTIEN-LEPAGE / DAMVILLERS Meuse / 1879
Gift of Erwin Davis, 1889
89.21.1

With the loss of the provinces of Alsace and Lorraine to Germany in the aftermath of the Franco-Prussian War of 1870–71, the national heroine from Lorraine, Joan of Arc, acquired new symbolic resonance among the French. A succession of sculpted and painted images of the medieval teenaged martyr appeared in the Salons of the 1870s and 1880s. In 1880, Bastien-Lepage, himself a native of Lorraine, exhibited this painting, which represents the moment of Joan of Arc's divine revelation in her parents' garden. His depiction of the saints whose voices she heard elicited a mixed reaction from Salon critics, many of whom found the saints' presence at odds with the naturalism of the artist's style.

Known for his portraits as well as for his scenes of rural life, Bastien-Lepage developed a technique that incorporated elements of Impressionism, including its high-keyed palette and emphasis on outdoor light effects, with the realistic handling and surface finish associated with academic art. The hybrid nature of his style was not lost on the writer Émile Zola, who in 1879 called Bastien-Lepage "the grandson of Courbet and Millet," adding that "the influence of the impressionist painters is also obvious." Although this painting established Bastien-Lepage's reputation in France as well as abroad following its exhibition in 1880, his popularity would peak by the end of the decade. KCG

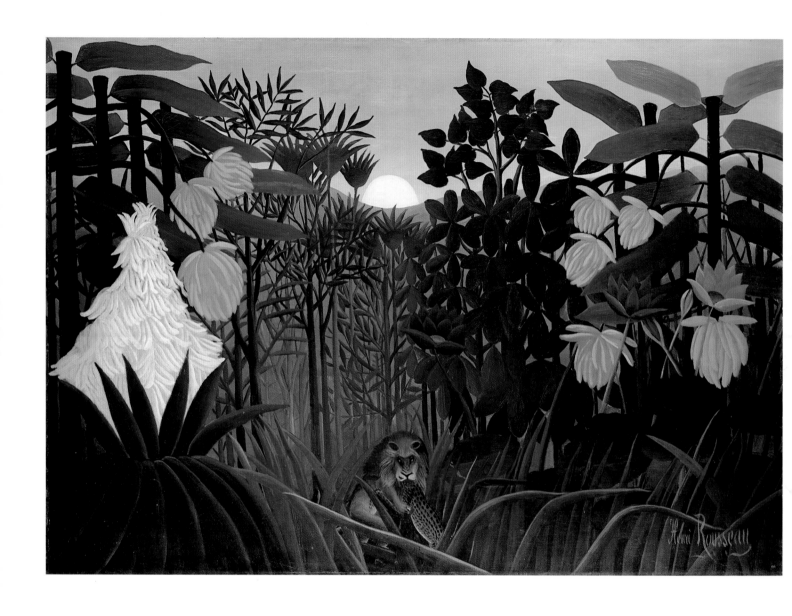

Henri Rousseau (le Douanier)

French, 1844–1910

104. *The Repast of the Lion*

ca. 1907
Oil on canvas
44¾ x 63 in. (113.7 x 160 cm)
Signed (lower right): Henri Rousseau
Bequest of Sam A. Lewisohn, 1951
51.112.5

This is probably one of the "Paysage exotique" paintings Rousseau showed at the 1907 Salon d'Automne in Paris. Yet he had first explored this theme in *Surprise* of 1891 (Private collection), two years before he retired from his post as a customs official (hence his nickname, "le Douanier") to devote himself full time to his art. Rousseau's early biographers, keen to bridge the yawning gap between his fantastic jungle scenes and his pedestrian life as a civil servant, traced the self-taught artist's inspiration to his supposed far-flung adventures as a young soldier in Mexico and South America. However, once these tales began to unravel, Rousseau was forced to admit that he had "never traveled further than to the hothouses in the Jardin des Plantes in Paris," adding, "when I am in the greenhouses and see the strange plants from exotic countries, it is as though I am experiencing a dream. I feel myself to be a completely different person." Besides frequenting the botanical gardens in Paris and the city's many orangeries and menageries, Rousseau depended on popular ethnographic journals and illustrated children's books as sources for the lush vegetation and wild beasts of his hothouse fantasies. SAS

PAUL GAUGUIN
French, 1848–1903

105. *Tahitian Landscape*
1892
Oil on canvas
25⅜ x 18⅝ in. (64.5 x 47.3 cm)
Inscribed (lower left): PGauguin–9[2]
Anonymous Gift, 1939
39.182

Donated in 1939, *Tahitian Landscape* was the first painting by Gauguin to enter the Metropolitan Museum's collection. Forty years later, its authorship was challenged, largely on the basis of stylistic analysis that found certain passages weak and atypical. From 1979 until 2002, it languished in storage as a work in the "Style of Paul Gauguin."

Recent cleaning and reexamination of this painting have put to rest any question of its authenticity. The picture's ground, paint layers, pigments, and handling are entirely consistent with Gauguin's practice. In addition, there are three drawings that closely relate to the composition, including a study for the two standing figures (The Art Institute of Chicago) that had earlier escaped notice. Various features of the work—from the detached introspection of the figures to the ambiguous space—may be found in comparable landscapes that Gauguin painted in 1892 during his first Tahitian sojourn. SAS

PAUL GAUGUIN
French, 1848–1903

106. *Ia Orana Maria (Hail Mary)*
1891
Oil on canvas
44¾ x 34½ in. (113.7 x 87.6 cm)
Signed, dated, and inscribed: (lower right) P Gauguin 91;
(lower left) IA ORANA MARIA
Bequest of Sam A. Lewisohn, 1951
51.112.2

Before embarking on a series of pictures inspired by Polynesian religious beliefs, Gauguin devoted his first major Tahitian canvas to a Christian theme, describing it in a letter of March 1892: "An angel with yellow wings reveals Mary and Jesus, both Tahitians, to two Tahitian women, nudes dressed in *pareus*, a sort of cotton cloth printed with flowers that can be draped from the waist. Very somber, mountainous background and flowering trees . . . a dark violet path and an emerald green foreground, with bananas on the left. I'm rather happy with it." Gauguin based much of the composition on a photograph he owned of a bas-relief in the Javanese temple of Borobudur.

The title of this work is native dialect for the angel Gabriel's first words to the Virgin Mary at the Annunciation; "*Ia orana*" is the standard greeting in Tahiti. The painting was acquired in 1919 by New York financier and philanthropist Adolph Lewisohn, who lent it the following year to the Metropolitan's "Fiftieth Anniversary Exhibition"; this marked the first time that Gauguin's works were shown at the Museum. SAS

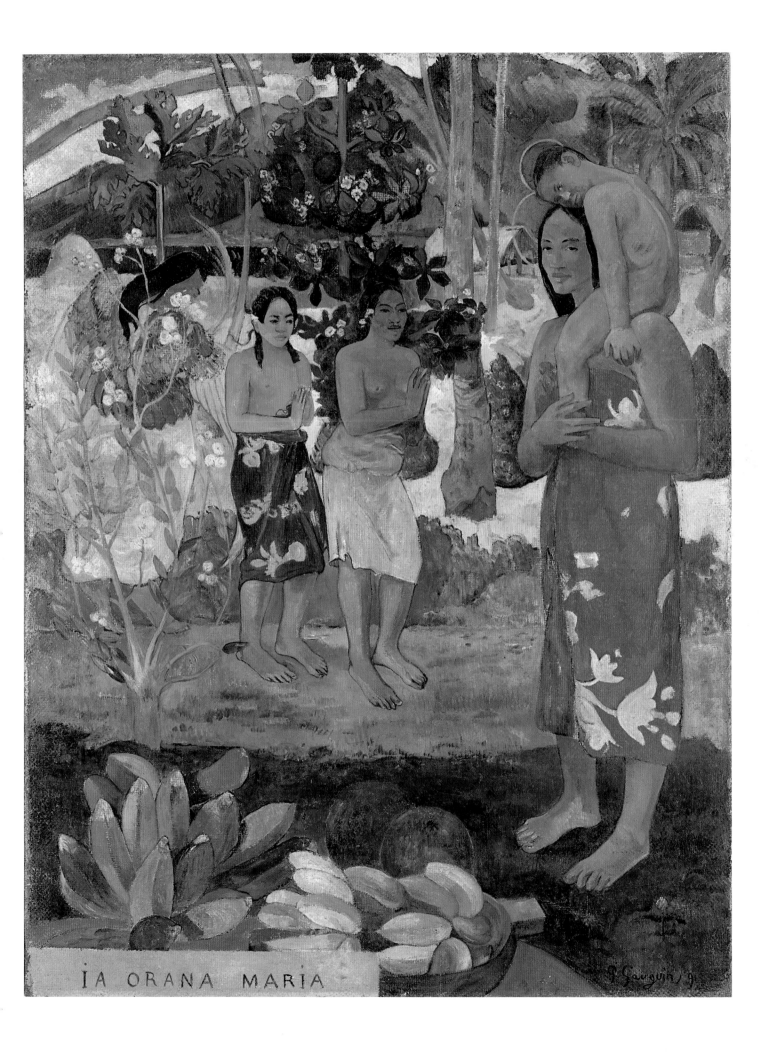

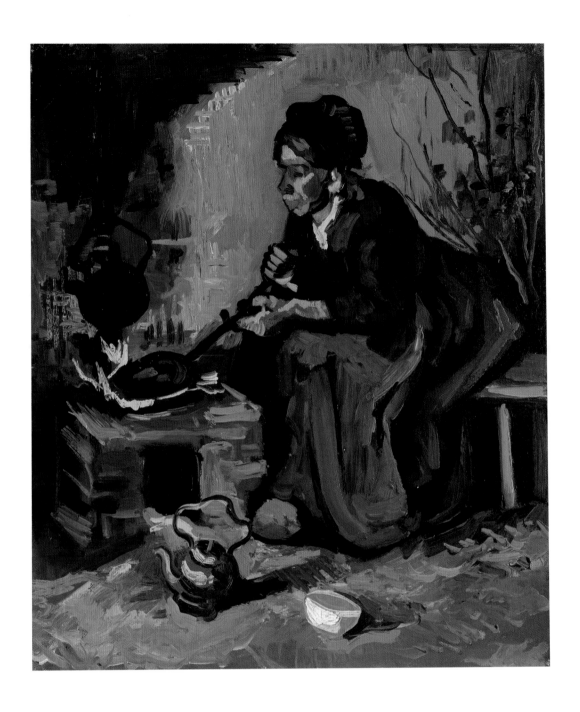

This domestic scene was painted in the rural Dutch village of Nuenen in 1885, shortly after Van Gogh completed *The Potato Eaters* (Van Gogh Museum, Amsterdam), in the same range of earth tones that reminded the artist of "green soap" or a "good dusty potato, unpeeled, of course." Van Gogh was "convinced that in the long run to portray peasants in their coarseness gives better results than introducing conventional sweetness. If a peasant painting smells of bacon, smoke, potato steam, very well, that's not unhealthy; if a stable smells of manure, alright, that's why it's a stable."

The painting is closely related to a drawing the artist made of a woman seated at the hearth, stoking the fire under the kettle with a pair of tongs (Van Gogh Museum, Amsterdam). Preceded by a sketch from life (Kröller-Müller Museum, Otterlo), the drawing has recently been dated, on convincing stylistic grounds, to August 1885, when Van Gogh undertook "studies of interiors" in which he sought to give a fuller sense of humble cottage settings; his concern for descriptive detail and lighting effects carries over to the present oil. SAS

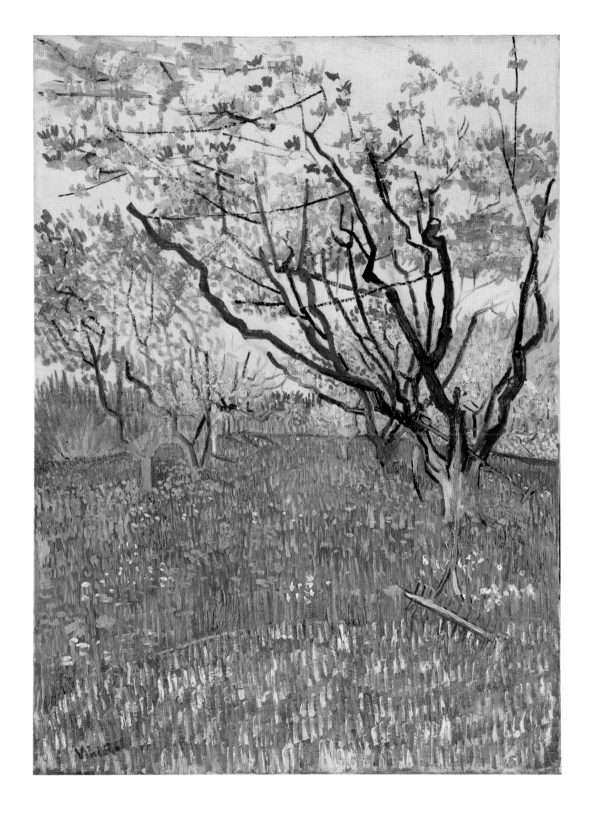

VINCENT VAN GOGH
Dutch, 1853–1890

108. *The Flowering Orchard*

1888
Oil on canvas
28½ x 21 in. (72.4 x 53.3 cm)
Signed (lower left): Vincent
The Mr. and Mrs. Henry Ittleson Jr. Purchase Fund,
1956
56.13

During his sojourn in the town of Arles in 1888–89, Van Gogh embarked on successive painting campaigns devoted to depicting char-acteristic aspects of the countryside, as it unfolded through the seasons, under the bright sulfur light of the South of France. From late March to late April 1888, he found himself "up to [his] ears in work, for," as he wrote to his brother Theo, "the trees are in blossom and I want to paint a Provençal orchard of astounding gaiety." In less than a month's time he produced fourteen canvases that celebrate the arrival of spring and his vision of the Midi as seemingly "as beautiful as Japan as far as the limpidity of the atmosphere and the gay color effects are concerned."

Although unified in theme, his pictures of flowering fruit trees vary greatly in approach. The present work, one of seven in vertical format, betrays the idiosyncratic brushwork, which he characterized as "having no system at all. I hit the canvas with irregular touches of the brush, which I leave as they are," so that patches of color alternate with "spots of can-vas left uncovered." In this spirited and *japoniste* composition, Van Gogh was persuaded to add an outsized rake and scythe that are compa-rable to a clunky ladder he included, some-what more successfully, in his one other view of an orchard that hints at a human presence (Private collection). SAS

VINCENT VAN GOGH
Dutch, 1853–1890

109. *Cypresses*
1889
Oil on canvas
36¾ x 29⅛ in. (93.4 x 74 cm)
Rogers Fund, 1949
49.30

Cypresses was painted in late June 1889, shortly after Van Gogh began his year-long stay as a voluntary patient at the asylum in Saint-Rémy. The subject, which he found "as beautiful of line and proportion as an Egyptian obelisk," both captivated and challenged the artist: "It is a splash of *black* in a sunny landscape, but it is one of the most interesting black notes, and the most difficult to hit off exactly that I can imagine." Van Gogh's initial fascination with cypresses resulted in three paintings: two showing the "big and massive trees" at close range, in vertical format (this one and another in the Kröller-Müller Museum, Otterlo), and a majestic horizontal view, *Wheat Field with Cypresses*, also in the Metropolitan Museum (1993.132), which he later repeated in two variants. They were intended to form part of a series that would be "the contrast and yet equivalent" of the sunflower pictures he had made earlier in Arles.

Having relied on a large pen-and-ink drawing (Brooklyn Museum, New York) to work out various aspects of the present composition, Van Gogh painted the landscape with unhesitating gusto, making only one substantive revision; X-rays reveal that he shifted the placement of the crescent moon to the right. Presumably, this was the "*Cyprès*" shown at the 1890 Salon des Indépendants in Paris. SAS

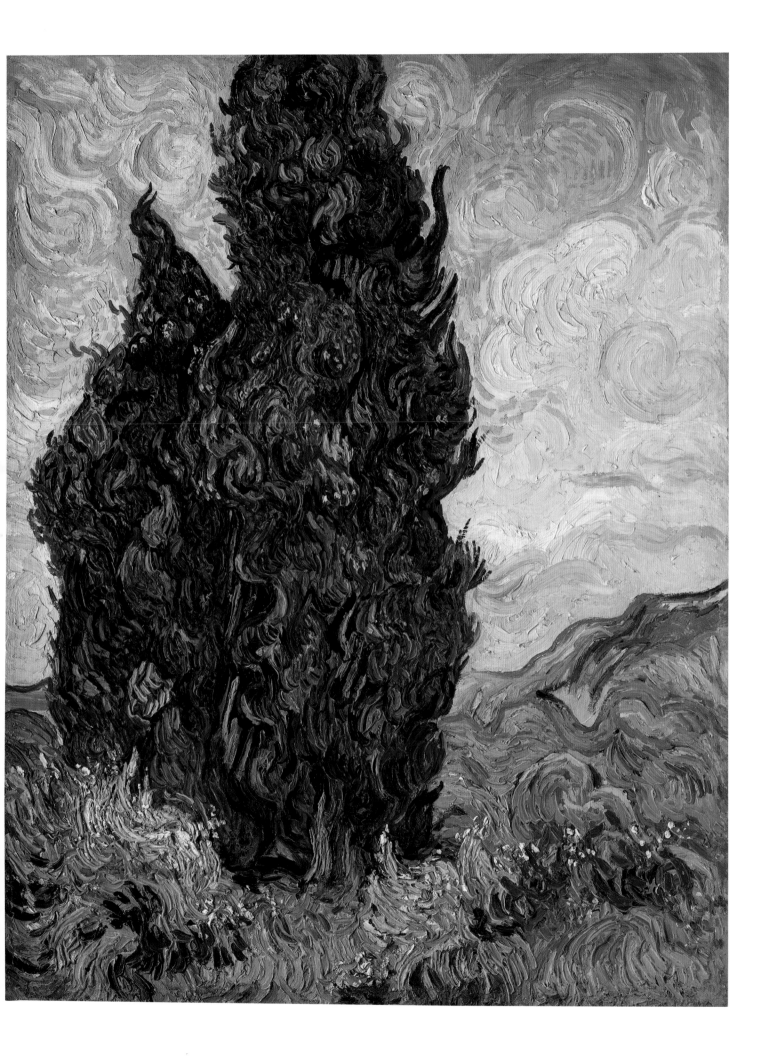

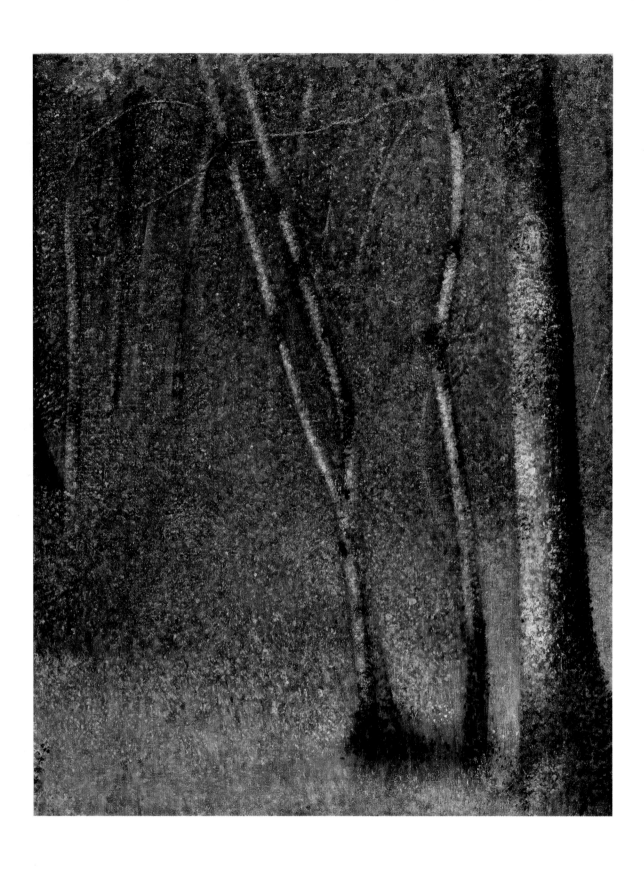

Seurat spent two months in the late summer and early fall of 1881 in Pontaubert, a village in the Cousin Valley southeast of Paris frequented by Daubigny, Corot, and other Barbizon artists. The visit inspired this *sous-bois*, which was probably completed the following winter in the studio he shared with his traveling companion and former École des Beaux-Arts schoolmate Aman-Jean. Seurat's precocious talent is reflected in his first major effort as a painter: in its concert of greens; subtle, shimmering light effects; and vertical pattern of tree trunks, this forest scene anticipates the landscapes in his two great subsequent works, *Bathers at Asnières* of 1883–84 (National Gallery, London) and *A Sunday Afternoon on the Island of La Grande Jatte* of 1884–86 (The Art Institute of Chicago). Here, Seurat's early conté-crayon drawings, which depict forms gradually revealed by light, find a poetical equivalent in paint. SAS

GEORGES SEURAT
French, 1859–1891

111. *Study for "A Sunday on La Grande Jatte"*

1884
Oil on canvas
27¾ x 41 in. (70.5 x 104.1 cm)
Bequest of Sam A. Lewisohn, 1951
51.112.6

Seurat recorded that he began work on his most famous painting, *A Sunday Afternoon on the Island of La Grande Jatte* (The Art Institute of Chicago), two years before its historic debut in May 1886 at the last Impressionist exhibition. From May through December 1884, he made more than fifty preliminary drawings and oil sketches, including the present study of the overall composition. He managed to complete the mural-sized park scene by March 1885—albeit in time for a show that was canceled. In the fall, Pissarro persuaded Seurat to repaint the monumental canvas, using new pigments that, unfortunately, proved so unstable that fading was already evident six years later. The present work, therefore, provides a vital record of the chromatic intensity that the artist hoped to affect in the full-scale painting through juxtaposed touches of color, which here are woven together with short, patchy brushstrokes, but were more systematically applied, with discrete dabs of paint, on the final canvas.

Although Seurat's innovative style came to be known as Pointillism (from *point*, the French word for "dot"), he preferred the term Divisionism, which spoke to the principle of color division, or the separation of color into small touches, placed side by side on the canvas, and meant to blend in the eye of the spectator. Colors applied in this fashion, as opposed to being mixed on the palette or muddied by overlapping strokes, would, he felt, retain their integrity, promising a more brilliant and harmonious result.

Recent technical examination of the Metropolitan's painting reveals that Seurat made use of grid lines, dividing the image into square units, to aid in the process of transferring and enlarging the design for his full-scale work. He also restretched the canvas at both sides (but not at the top and bottom) in order to accommodate the painted border, which was added later. SAS

MAXIMILIEN LUCE
French, 1858–1941

112. *Morning, Interior*
1890
Oil on canvas
25½ x 31⅞ in. (64.8 x 81 cm)
Signed and dated (lower right): Luce 90
Bequest of Miss Adelaide Milton de Groot
(1876–1967), 1967
67.187.80

Titled *Le Lever, Intérieur,* in an 1894 exhibition held in Paris, this intimate scene depicts Luce's close friend and fellow Neo-Impressionist Gustave Perrot "getting up" and dressing as morning light streams through a garret window. Very little is known about the sitter. In the late 1880s, Perrot seems to have joined Luce on painting expeditions to the outskirts of Paris, where they adapted Seurat's newly minted pointillist technique to views of Arcueil, Gentilly, and Villejuif—Perrot's hometown. Like Seurat, Perrot died young. In 1892, his brief career was remembered in a fifteen-work tribute held at the Salon des Indépendants in Paris. SAS

PAUL SIGNAC
French, 1863–1935

113. *The Jetty at Cassis*
1889
Oil on canvas
18¼ x 25⅝ in. (46.4 x 65.1 cm)
Signed, dated, and inscribed: (lower left) P.Signac 89;
(lower right) Op.198; (on stretcher) La Jetée de
Cassis – PS [monogram]
Bequest of Joan Whitney Payson, 1975
1976.201.19

Between 1887 and 1891, Signac spent winters in Paris and the warmer months pursuing his two passions, marine painting and boating, on excursions to seaside resorts. One of the five views he brought back from his sojourn in the Mediterranean port of Cassis, from April to June 1889, this work was singled out for praise when the series debuted at the Salon des Indépendants later that year: by critic Jules Christophe, for expressing "maritime Provence, with great charm and fidelity," and by Félix Fénéon, for synthesizing the decorative sensibility of Japanese prints and the vibrancy of majolica pottery.

Influenced by his friendships with Symbolist writers and the theories of the "psychophysicist" Charles Henry, Signac conceived his works in terms of tonalities, rhythms, and harmonies of color. At Cassis, as he recorded in a letter to fellow colorist Van Gogh, he found "White, blue and orange, harmoniously spread over the beautiful rise and fall of the land. All around the mountains with rhythmic curves." Until 1894, Signac evoked analogies to musical compositions by inscribing each of his pictures with an opus number. SAS

HENRI DE
TOULOUSE-LAUTREC
French, 1864–1901

114. *Albert (René) Grenier*
(1858–1925)

1887
Oil on wood
13⅜ x 10 in. (34 x 25.4 cm)
Inscribed (on the verso): Mon portrait par /
Toulouse Lautrec / en 1887 /
atelier rue Caulaincourt / [Grenier ?]
Bequest of Mary Cushing Fosburgh, 1978
1979.135.14

Lautrec met Réne Grenier at the atelier of
Léon Bonnat in 1882 and they remained
fellow students at Fernand Cormon's studio,
where, over the next few years, other kindred—
rebel—spirits, including Louis Anquetin, Émile
Bernard, and Vincent van Gogh, joined their
fledgling ranks. Before Lautrec established his
own quarters in the rue Caulaincourt in 1886,
he lived with Réne and his wife, Lili Grenier,
an actress and artist's model, who also posed
for their formidable downstairs neighbor at
19 bis, rue Fontaine, Edgar Degas. In this por-
trait, which has often invited comparison with
the work of the older Impressionist, thin
washes of pigment are laid over a fine graphite
underdrawing to produce a sensitive character
study that captures the vitality of the sitter—a
bon vivant, and the artist's close friend.

SAS

From 1889 to 1891, Lautrec experimented with the plein-air approach of the Impressionists, producing a group of studies of figures set against the foliage of what was known as the garden of Monsieur (Père) Forest. Forest's "garden," actually a public park, was not far from the artist's Montmartre studio. Lautrec referred to these self-imposed exercises in technique as "*impositions*," for which his friends as well as models would pose. According to a contemporary description of his working method, Lautrec began his studies "with an eye, a nose, a mouth, at random," building up the surface using "small strokes" of paint.

In this painting, Lautrec portrays his sitter—likely a working-class woman from the neighborhood—with his characteristic unsparing naturalism. Less finished than his other plein-air figure studies, this one appears to have been rapidly executed, with color applied in thinned oils over the outlines of the woman and the foliage. His palette is dominated by the mauve of the model's smock and her auburn hair, which contrast with the vivid, almost acidic tones of the greenery. The composition recalls the profile portraits of women in garden settings painted by such artists as Auguste Renoir and Édouard Manet. KCG

116. *The Sofa*

ca. 1894–96
Oil on cardboard
24¾ x 31⅞ in. (62.9 x 81 cm)
Stamped (lower left): HTL [monogram]
Rogers Fund, 1951
51.33.2

An inveterate chronicler of the colorful and tawdry nightlife of fin-de-siècle Montmartre, Lautrec set out to document the lives of prostitutes in a series of pictures made between 1892 and 1896. He seems to have found the artistic license in Degas's monotypes of brothel scenes and in erotic Japanese Shunga prints to create images of like candor and graphic verve, but in remarkably uninhibited, large-format works. Lautrec was no stranger to the world-weary *filles de maison* whose companionship he sought out on his nightly rounds and whose habits he observed, off-hours, with rapt fascination. Critical of stiff and lifeless models (whom he described as *"empaillées"*), he appreciated the naturalness of prostitutes "who stretch themselves out on the divans . . . entirely without pretensions." At first Lautrec made sketches in the brothels but, apparently hampered by insufficient lighting, he had the prostitutes pose in his studio.

The Sofa is related to three other paintings from the mid-1890s (Gemäldegalerie, Dresden; Foundation E. G. Bührle Collection, Zürich; and Private collection) that focus on the intimacies exchanged between lesbian couples. In 1896 Lautrec devoted a suite of eleven lithographs to "Elles" ("Those Women").

SAS

ÉDOUARD VUILLARD
French, 1868–1940

117. *Self-Portrait with a Friend*

1889
Oil on canvas
36½ x 28½ in. (92.7 x 72.4 cm)
Signed (lower left): E. Vuillard
Gift of Alex M. Lewyt, 1955
55.173

In his sober, high-collared garment, the bearded and pensive twenty-three-year-old Vuillard might be taken for a civil servant or a clergyman. Only the palette and paintbrushes in his right hand identify him as a painter. The artist's friend Waroquy, with a cigarette between his lips, looms behind him, his facial features and his body rendered more vaguely. Waroquy's name appears frequently in the artist's journal between the years 1888 and 1889, and while the two seem to have been close, nearly nothing is known about him.

In its hushed stillness, this large, double portrait evokes the psychologically charged early views of interiors by Degas. The dream-like quality of the picture derives from the fact that it is a mirror image. This is underscored by the small bottle at the lower right, which is placed in front of the mirror and is also reflected in it. The bottle appears to be part of Vuillard's artists' supplies, although the room, with its gray-green mottled wall, partially visible gold-framed picture, and commode, is not his studio. According to one of Vuillard's autobiographical journal entries, he was posing in front of a mirror in the bedroom of his beloved *grand-mère* Michaud's apartment in the rue de Miromesnil in Paris. SR

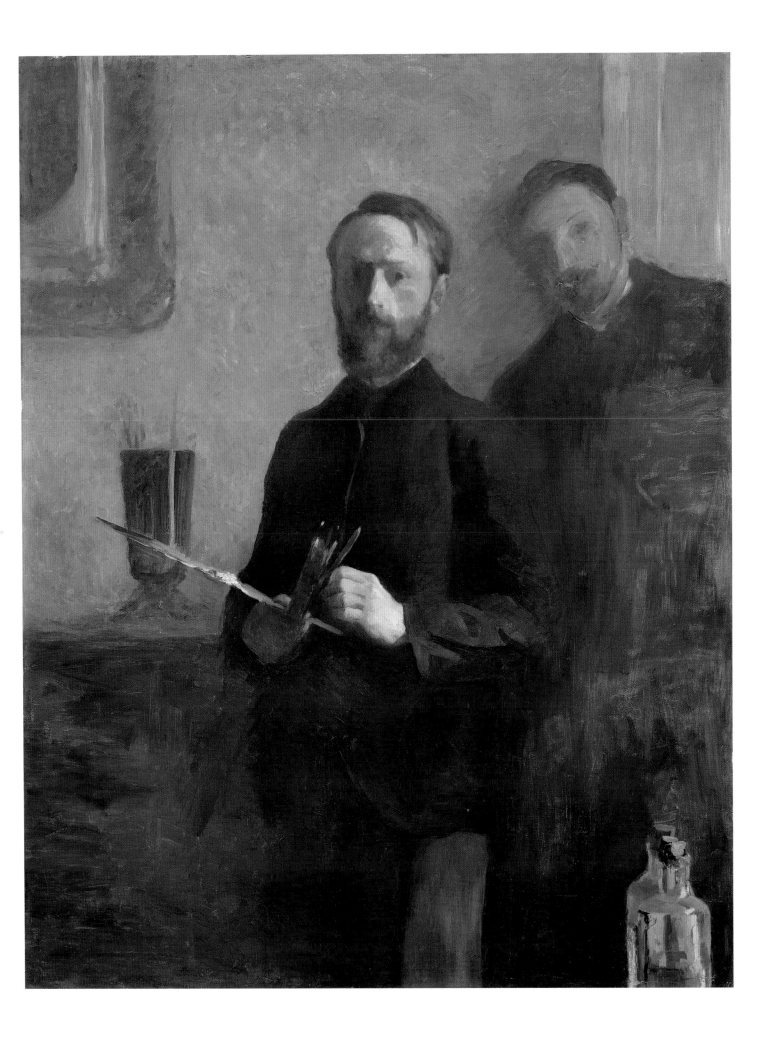

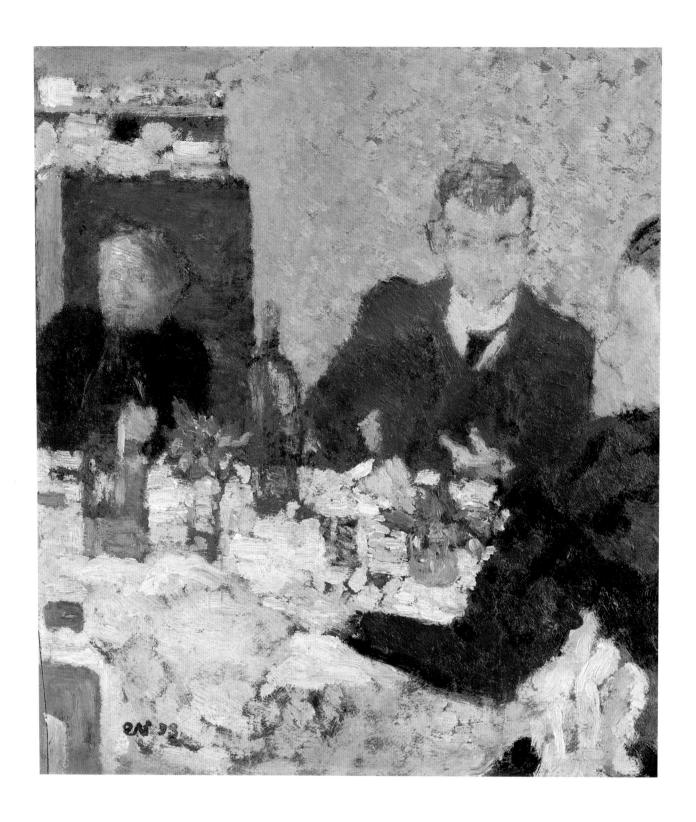

ÉDOUARD VUILLARD
French, 1868–1940

118. *At Table*

1893
Oil on cardboard
Signed and dated (lower left): ev 93
11½ x 10 in. (29.2 x 25.4 cm)
Bequest of Scofield Thayer, 1982
1984.433.25

Vuillard is best known for his small, poetic, and dimly lit *intimiste* interiors of the 1890s. The settings of these works were the modest Parisian apartments that the artist shared with his sisters and his mother, and from which she operated her corset-making business. Vuillard often depicted his widowed mother (and lifelong muse) at work with her assistants, unrolling bolts of materials, and cutting and sewing amid a profusion of subtly hued patterned wallpapers, screens, curtains, tablecloths, and clothing.

In this small picture Vuillard limited his palette to various shades of grays and off-whites to provide a contrasting foil to the black garments of the three figures. They are seated at a table covered with flowers and various still-life objects. The interior is the living room at 346, rue St.-Honoré, which served as dining room and also as workshop for Madame Vuillard, seen at the left; it is perhaps the artist's sister Marie who appears in profile at the right. Both women are in mourning for the family's matriarch, *grand-mère* Michaud. It has been suggested that the young man is Julien Mangnin, a friend of Vuillard from their school days, who dropped in to cheer up the ladies.

SR

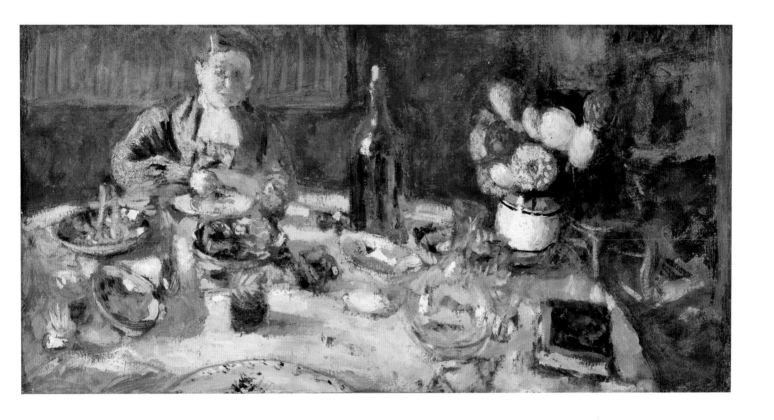

ÉDOUARD VUILLARD
French, 1868–1940

119. *Luncheon*
1901
Oil on cardboard
8¾ x 17 in. (22.2 x 43.2 cm)
Signed (upper right): E. Vuillard
Bequest of Mary Cushing Fosburgh, 1978
1979.135.28

Vuillard shared various apartments with his mother in Paris. After Madame Vuillard retired from her corset-making business in 1898, the artist ceased to depict her at work, but showed her at leisure, reading the paper, playing with her grandchildren, receiving guests, or, as here, at a meal. Madame Vuillard remained her son's principal muse until her death in 1928.

Vuillard chose an unusual horizontal format for this picture, to accommodate the expanse of the oval table that fills the fore-ground. Madame Vuillard, who wears a blue-and-mauve striped housecoat, is seen, as if by a luncheon companion, from across the table, which is covered with still-life objects that reflect the daylight entering the picture from the left. Among these sparkling dishes and glasses are a bouquet of guilder roses and red flowers, two fruit bowls with a red-and-blue design, a water carafe, a bottle of wine and a wine-filled glass, and, for good measure, a book with a brown binding. SR

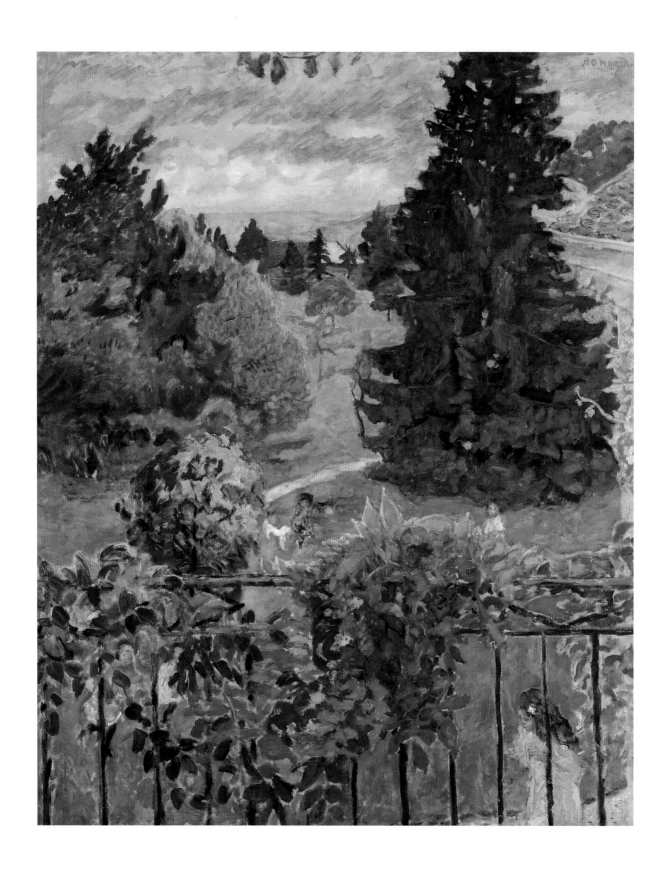

PIERRE BONNARD
French, 1867–1947

120. *From the Balcony*

1909
Oil on canvas
49 x 39⅛ in. (124.5 x 99.4 cm)
Signed (upper right): Bonnard
Bequest of Charles Goldman, 1966
66.65.1

Luscious creepers hang down from the iron balustrade of a balcony. Beyond is a garden traversed by a winding path and dotted with different kinds of trees. Here, Bonnard has captured another bucolic summer day at the family estate in Le Grand-Lemps, a small town in the Isère region northwest of Grenoble. Bonnard was very attached to the place, which belonged to his mother, Élisabeth Mertzdorff.

The artist had spent his childhood summers in Le Grand-Lemps, and he returned there as a young man. The first landscapes Bonnard painted were of the garden and park, where, now, his sister Andrée and her husband, the composer Claude Terrasse, summered. Five of their children, at play with two dogs and a cat, can be glimpsed through and over the balustrade. SR

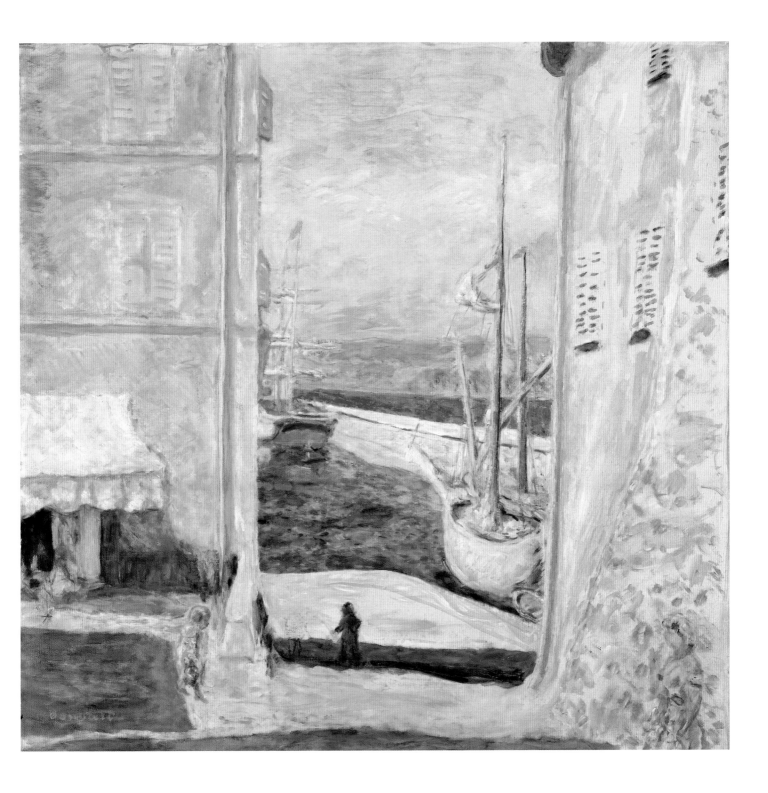

PIERRE BONNARD
French, 1867–1947

121. *View of The Old Port,
Saint-Tropez*

1911
Oil on canvas
33 x 34 in. (83.8 x 86.4 cm)
Signed (lower left): Bonnard
Bequest of Scofield Thayer, 1982
1984.433.1

"It struck me like a Thousand and One Nights . . . the sea, yellow walls, reflections as bright as light." With these words Bonnard evoked his first impressions of Saint-Tropez, on the Mediterranean coast of France, which he visited in 1909. They seem an apt description of this picture, in which the heat and sunlight extinguish volume and forms.

In 1911, Bonnard made three separate trips to Saint-Tropez, then still a small fishing port. He probably painted this work during his second visit in the summer, when he stayed with his friend the artist Paul Signac. The old port, with its narrow streets, is seen from the Place de la Mairie through an opening between two shuttered buildings facing the quay. A mottled, shimmering effect is created by the short dashes of paint that make up the various colors: the buildings' pinkish oranges and pale yellows, accentuated by celadon green and purple-gray, and the different shades of blue of water and sky. Several figures are discernible in the street: the forms of all but the central one, cast in purple shadow, are diffused by the light. SR

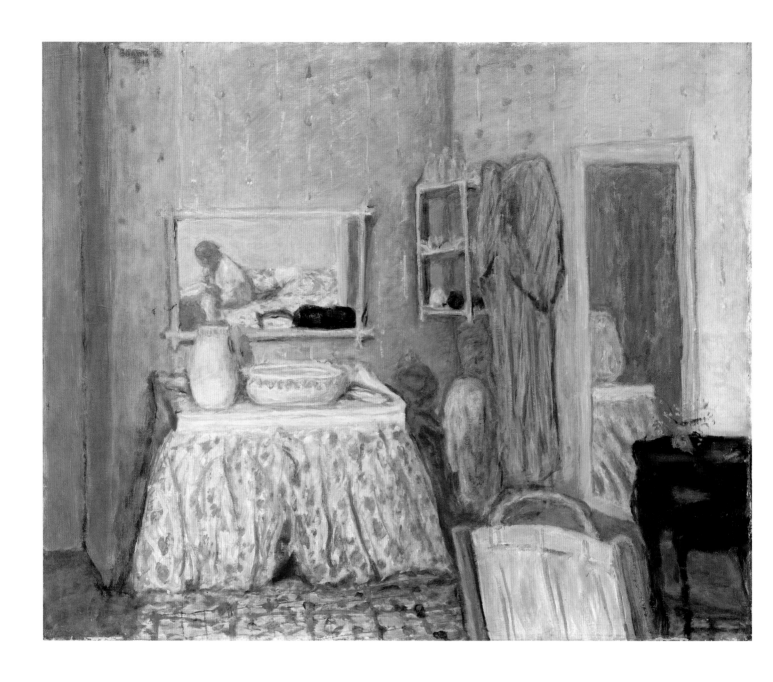

PIERRE BONNARD
French, 1867–1947

122. *The Dressing Room*
1914
Oil on canvas
28⅜ x 34¾ in. (72.1 x 88.3 cm)
Signed and dated (upper left): Bonnard / 1914
Bequest of Scofield Thayer, 1982
1984.433.3

Bonnard delighted in portraying scenes of domesticity—everyday events that take place mostly in dining rooms and in the bath. This picture presents a casual view into the corner of a dressing room in the artist's house at Saint-Germain-en-Laye, near Paris, where he lived during World War I. Scattered around the room are items of a personal nature—a striped bathrobe hanging on the wall, a washbowl and basin on the skirted table, and a three-tiered shelf on which there are various bottles. Space and light seem to be created by the two mirrors, the vertical one on the right and the horizontal one that reflects a young woman holding a white cloth and her curled-up, sleeping dog. She is probably Marthe (Maria Boursin; 1869–1942), Bonnard's companion and later his wife (after 1925). Obsessed with taking care of her body, Marthe—who never seems to age—appears more than any other person in Bonnard's work. She is seen either in her bath, at her toilette, or, as here, as an almost unnoticeable presence, glimpsed in the reflection of a mirror. SR

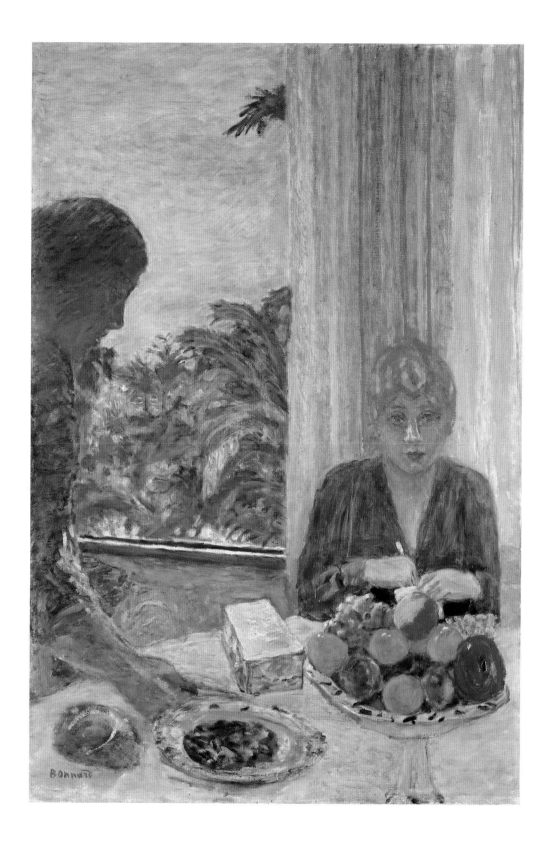

PIERRE BONNARD
French, 1867–1947

123. *The Green Blouse*

1919
Oil on canvas
40⅛ x 26⅞ in. (101.9 x 68.3 cm)
Signed (lower left): Bonnard
The Mr. and Mrs. Henry Ittleson Jr. Purchase Fund,
1963
63.64

This painting captures a scene the artist must often have observed. His longtime companion and future wife, Maria Boursin, is seated at a table laden with dishes and a fruit bowl. The profile of an attendant or maid is visible at the left. The luminous colors and warm light suggest early or mid-afternoon. The lush Mediterranean vegetation and palm trees outside the large window echo Martha's green blouse, whereas the yellow, gold, and pink of

the striped curtain seem to diffuse the tones of her skin and hair. Except for the brightly colored fruit, the objects on the table are rendered in various shades of purple, blue, and pink. Although Martha was fifty years old at the time, she appears as ageless as always in Bonnard's paintings. SR

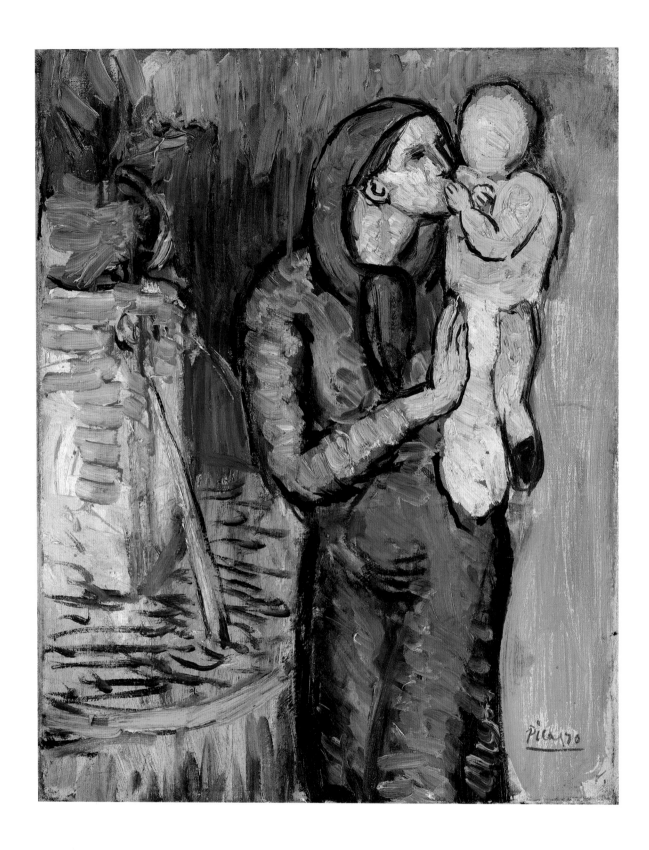

PABLO PICASSO
Spanish, 1881–1973

124. *Mother and Child by
a Fountain*

1901
Oil on canvas
16 x 12¾ in. (40.6 x 32.4 cm)
Bequest of Scofield Thayer, 1982
1984.433.23

In the fall of 1901 Picasso painted several pictures of mothers with their children that were inspired by his visits to the women's prison of Saint-Lazare in Paris. He was shocked to find that among the inmates were children. The prison was run by nuns and offered a certain security; therefore, some pregnant criminals and prostitutes timed their arrests so that they could give birth in these relatively sheltered surroundings. For Picasso, his prison visits served him well: the models were free of charge, and the misery and gloom he encountered there corresponded to his melancholy view at the time that love and sex lead to suffering and death—a theme that he explored in his Blue Period paintings.

In these paintings, as here, however, Picasso turned grim reality into idealized images of motherhood. He transformed the inmates' actual prison uniforms of bonnets and striped hospital jackets into a timeless, dark blue El Greco–like robe with a flattering cowl. Even the fountain in the prison's laundry strikes a bucolic note. SR

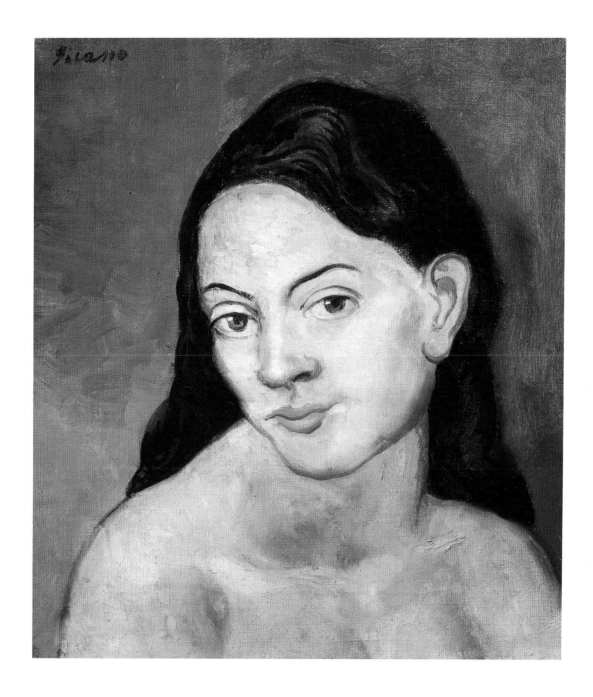

PABLO PICASSO
Spanish, 1881–1973

125. *Head of a Woman*
1903
Oil on canvas
15⅞ x 14 in. (40.3 x 35.6 cm)
Signed (upper left): Picasso
Bequest of Miss Adelaide Milton de Groot
(1876–1967), 1967
67.187.91

Among the artist's Blue Period subjects—gaunt ascetics, old Jews, emaciated guitarists, blind beggars, sullen prostitutes, and imprisoned mothers—this woman appears wholesome and sensuous. The immediacy of her expression, the specificity of her facial features, and the coquettish tilt of her head suggest that Picasso painted this work directly from the model, or perhaps from a quick watercolor sketch made from life.

Between 1900 and 1904, Picasso made several trips to Paris, but he would always return home to Spain, where he continued to paint. The period from January 1903 to the spring of 1904 was a prolific time: working in Barcelona, he created numerous drawings and some fifty paintings, including the present one.

SR

PABLO PICASSO
Spanish, 1881–1973

126. *Self-Portrait*
1906
Oil on canvas, mounted on wood
10½ x 7¾ in. (26.7 x 19.7 cm)
Jacques and Natasha Gelman Collection, 1998
1999.363.59

Picasso painted this small self-portrait in the autumn of 1906 after he returned to Paris from Gosol, the small mountain village high in the Spanish Pyrenees close to the Andorran border. The artist always felt rejuvenated by visits to his native Spain where, according to his companion at the time, Fernande Olivier, he would become "serene, healthier, and happier."

The twenty-five-year-old Picasso depicted himself younger here than in any of his earlier self-portraits, in which poverty and hunger often seem to have aged him. If he looks like a painted terracotta sculpture without any furrows or wrinkles, it is because he gave himself the stylized features of the archaic Iberian stone reliefs and bronze figures (600–200 B.C.) that he saw in the spring of 1906 on exhibition at the Musée du Louvre. The Iberian influence first appeared in the artist's work at the end of his stay in Gosol, and becomes more prominent in the paintings that he completed upon his return to Paris in the autumn of 1906. It was at this time that he also completed the portrait of his friend the American writer and art collector Gertrude Stein. S R

HENRI MATISSE
French, 1869–1954

127. *Still Life with Vegetables*
1905
Oil on canvas
15⅛ x 18⅛ in. (38.4 x 46 cm)
Signed (lower left): Henri-Matisse
Jacques and Natasha Gelman Collection, 1998
1999.363.38

Matisse and Derain first introduced unnaturalistic color and bold brushstrokes into their paintings in the summer of 1905 as they worked together in the small fishing port of Collioure on the Mediterranean coast. When these pictures were exhibited later that year at the Salon d'Automne in Paris, they inspired the witty critic Louis Vauxcelles to call them *"fauves"* ("wild beasts") in his review for the magazine *Gil Blas*. This term was later applied to the artists themselves.

Dominated by complementary reddish and greenish hues, this composition nevertheless still evokes the art of Cézanne. With rhythmic brushstrokes, Matisse rendered space and objects alike, in flat color planes. He depicted what he saw around him. The green, white, and blue plate; the round red pitcher; and the yellow coffeepot are typical of the pottery produced in the South of France. Similarly, the vegetables look as if they had just tumbled out of Matisse's shopping basket after a trip to the local market: there are zucchini, red and green peppers, tomatoes, an onion, and a carrot. — S R

HENRI MATISSE
French, 1869–1954

128. *The Goldfish Bowl*
Winter 1921–22
Oil on canvas
21⅜ x 25¾ in. (54.3 x 65.4 cm)
Signed (lower right): Henri Matisse
Bequest of Scofield Thayer, 1982
1984.433.19

Matisse painted *The Goldfish Bowl* in the studio, at 1, Place Charles-Félix, his first apartment in Nice. He must have liked the large and bold decorative pattern of the wallpaper because he made it compete with the still-life elements in this picture—an effect he explored in several other works during this period. He included another favorite feature in the composition: one of his own paintings; here, it is a fragment of his small canvas *Two Young Women in a Landscape in the Loup Valley* (1921), visible in the upper-right corner. The two women in the painting seem to gaze out at the still life arranged on the table, which is dominated by the footed glass bowl of goldfish—a motif that recurs in Matisse's oeuvre throughout the 1910s and 1920s. Miscellaneous objects adorn the table: a tall glass bottle half filled with clear liquid that reveals the patterned wallpaper behind it; a periodical, entitled *les modes*; four apples; and a small, covered glass jar containing red beads. SR

HENRI MATISSE
French, 1869–1954

129. *Pansies*
1918–19
Oil on paper, mounted on wood
19¼ x 17¾ in. (48.9 x 45.1 cm)
Signed (lower left): H. Matisse
Bequest of Joan Whitney Payson, 1975
1976.201.22

In this still life Matisse took delight in juxtaposing actual flowers against a backdrop of printed floral motifs. The contrasts between these different elements are illuminating. Modest pansies are played off against the sophisticated bluish decorative pattern of the toile de jouy. The textile, whose folds disrupt the continuity of its bold, oversized pattern of baskets of flowers and ornaments, dwarfs the small, unassuming garden flowers, rendering them even more fragile. However, it is these modest flowers that add sparkling colors—deep purple, pink, orange, yellow, white, and green—to the otherwise nearly monochromatic palette. They are placed in a simple drinking glass and lie randomly about, somewhat too close to the edge of the brown table that boldly juts forward. SR

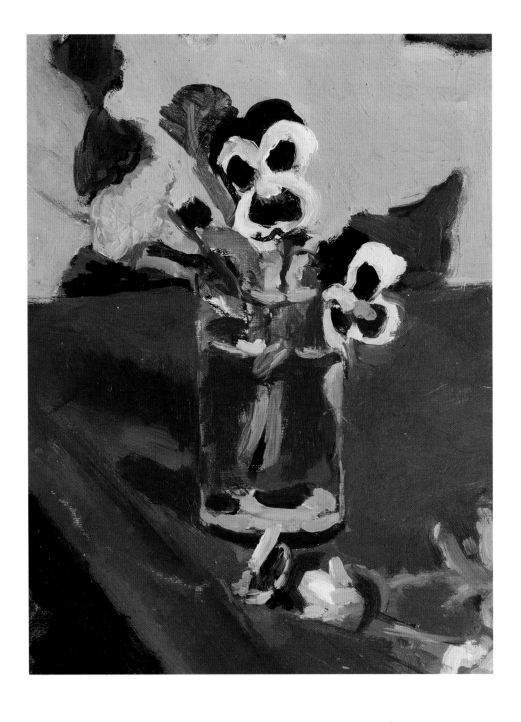

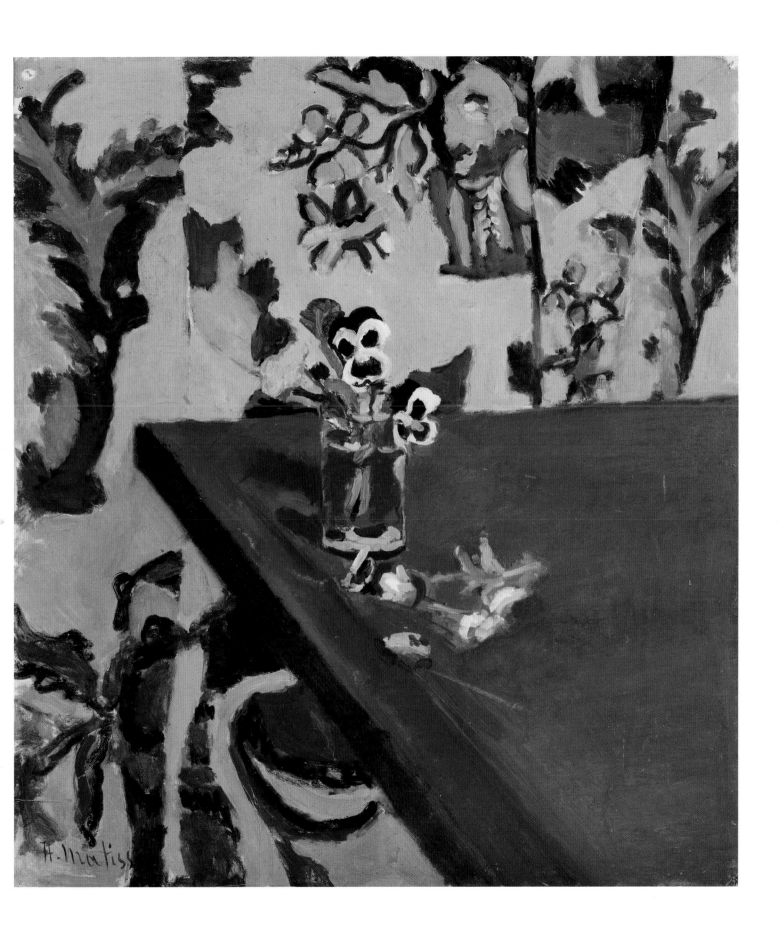

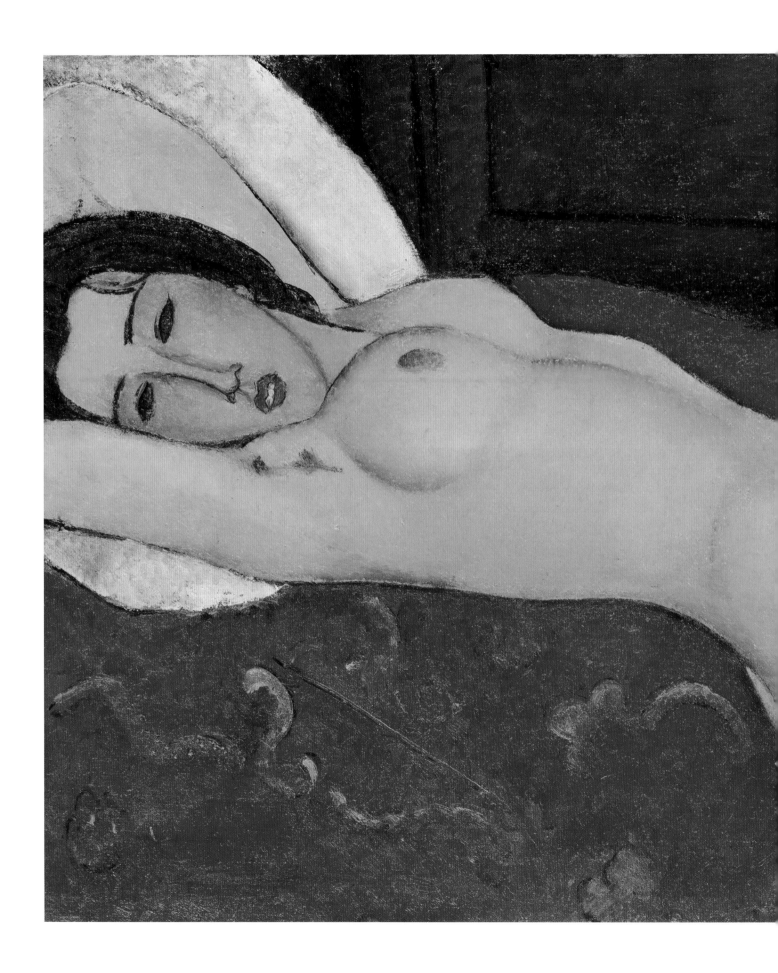

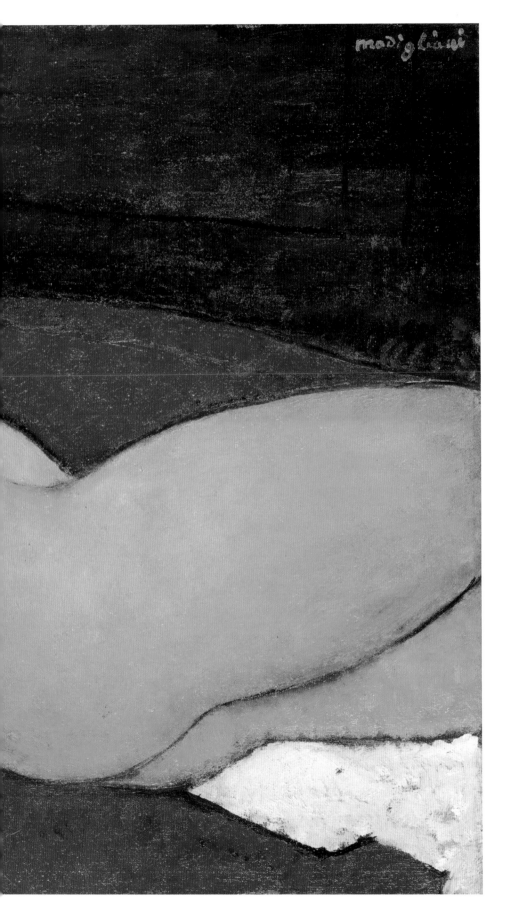

AMEDEO MODIGLIANI
Italian, 1884–1920

130. *Reclining Nude*

1917
Oil on canvas
23⅞ x 36½ in. (60.6 x 92.7 cm)
Signed (upper right): modigliani
The Mr. and Mrs. Klaus G. Perls Collection, 1997
1997.149.9

Modigliani's celebrated series of paintings of female nudes continues the tradition of depictions of the nude Venus established in the Renaissance and prevailing up to the nineteenth century, yet with one large difference. Unlike Modigliani's frank portrayals of nude women, which appear unabashedly provocative, the eroticism of the earlier nudes was always softened by a mythological or anecdotal context. He never depicted his mistresses or friends in these poses, but used professional models.

The paintings that comprise Modigliani's great series of thirty reclining nudes, begun in 1916, share several characteristics. As here—one of the artist's most famous works— they recline on dark bed coverings that accentuate the glow of their skin, and they are always seen close up and usually from above. Their stylized bodies span the entire width of the canvases, and their feet and hands remain mostly outside the picture frames. Sometimes they are asleep, but usually they face the viewer, as does this gracefully proportioned nude, with her small, high-set breasts, although the hips are turned slightly away from the spectator. SR

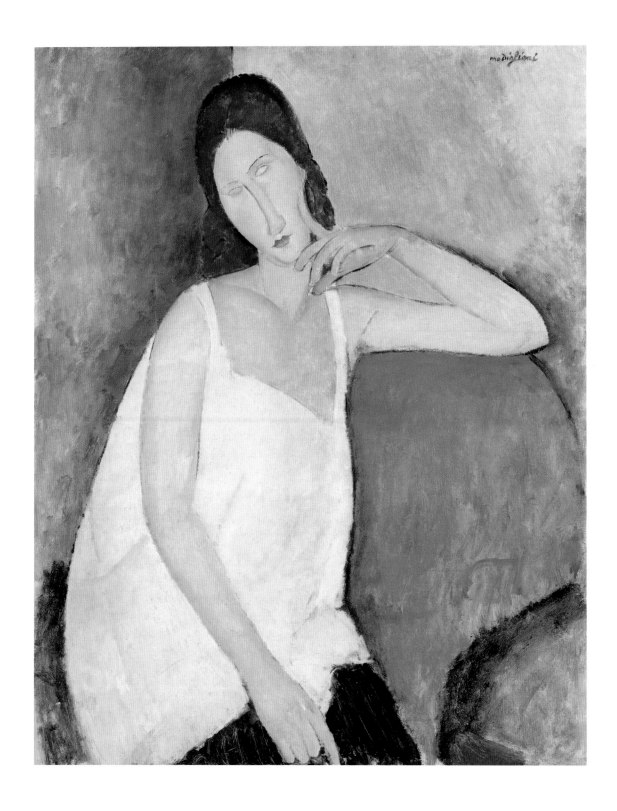

AMEDEO MODIGLIANI
Italian, 1884–1920

131. *Jeanne Hébuterne*

1919
Oil on canvas
36 x 28¾ in. (91.4 x 73 cm)
Signed (upper right): modigliani
Gift of Mr. and Mrs. Nate B. Spingold, 1956
56.184.2

Modigliani met Jeanne Hébuterne in 1917, when she was a nineteen-year-old art student. She became the artist's mistress and bore him a daughter, also named Jeanne, in November 1918. Hébuterne was small and attractive, quiet and docile, and always can be recognized by her clear and intense blue eyes. It has been suggested that the present painting shows Hébuterne during a second pregnancy in later 1919. Among the twenty-some-odd portraits Modigliani painted of his always properly attired mistress, this is the only instance where she is shown scantily dressed. The loose white chemise seems to underline her expectant condition, while at the same time implying modesty and chastity.

Typical of Modigliani's style are the elongated and elegantly linear forms, reminiscent of Italian Renaissance and Mannerist art. The oval head, with its incised features, calls to mind the sculpture of Brancusi, who inspired the young Modigliani when, early in his career, he worked as a sculptor.

One day after Modigliani died of tuberculosis in January 1920, the pregnant Hébuterne committed suicide by flinging herself from the roof of her parents' house. S R

AMEDEO MODIGLIANI
Italian, 1884–1920

132. *Flower Vendor*
1919
Oil on canvas
45⅞ x 28⅞ in. (116.5 x 73.3 cm)
Signed (upper right): modigliani
Bequest of Florene M. Schoenborn, 1995
1996.403.9

Modigliani's career as an artist coincided with his arrival in Paris in the winter of 1906. In the remaining fourteen years of his life, he would create an oeuvre comprising some 420 paintings—of which only about fourteen are dated—and innumerable drawings. Except for four landscapes painted in 1919 in the South of France, his main subject matter consisted of portraits. By 1916, he had found his own style, aptly described as one of elegant "mannerist elongation." This particular mode of reducing the features of his sitters to their essentials was largely provoked by Modigliani's previous activity as a sculptor, from 1906 to 1916—a period when he hardly painted at all.

Here, and as in most of Modigliani's close-up or half-length portraits, there is little indication of the surroundings. Nothing identifies the sullen young woman in her dark, sober dress with her profession as a vendor of flowers. Modigliani painted this work when he lived, mainly in Nice—with Jeanne Hébuterne, his mistress and the mother of his child—from March 1918 until May 1919. Lacking his usual coterie of friends, the artist employed local servants, shopgirls, and children as his models. SR

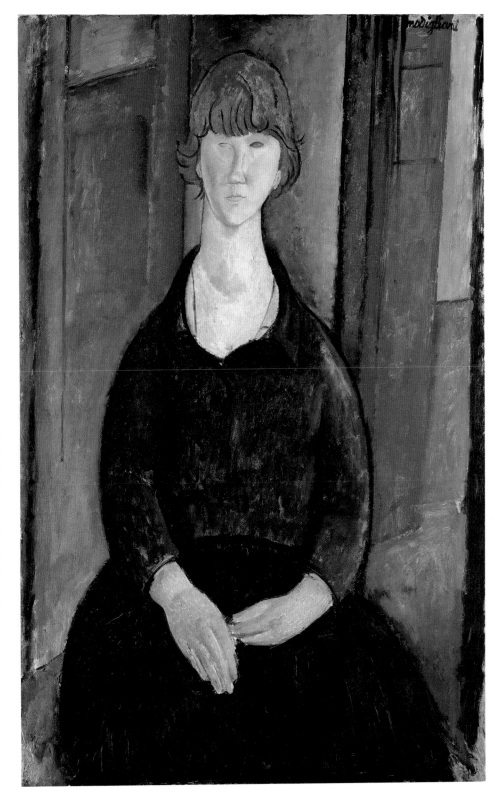

Overleaf: Édouard Manet. *Boating* (detail). See no. 62

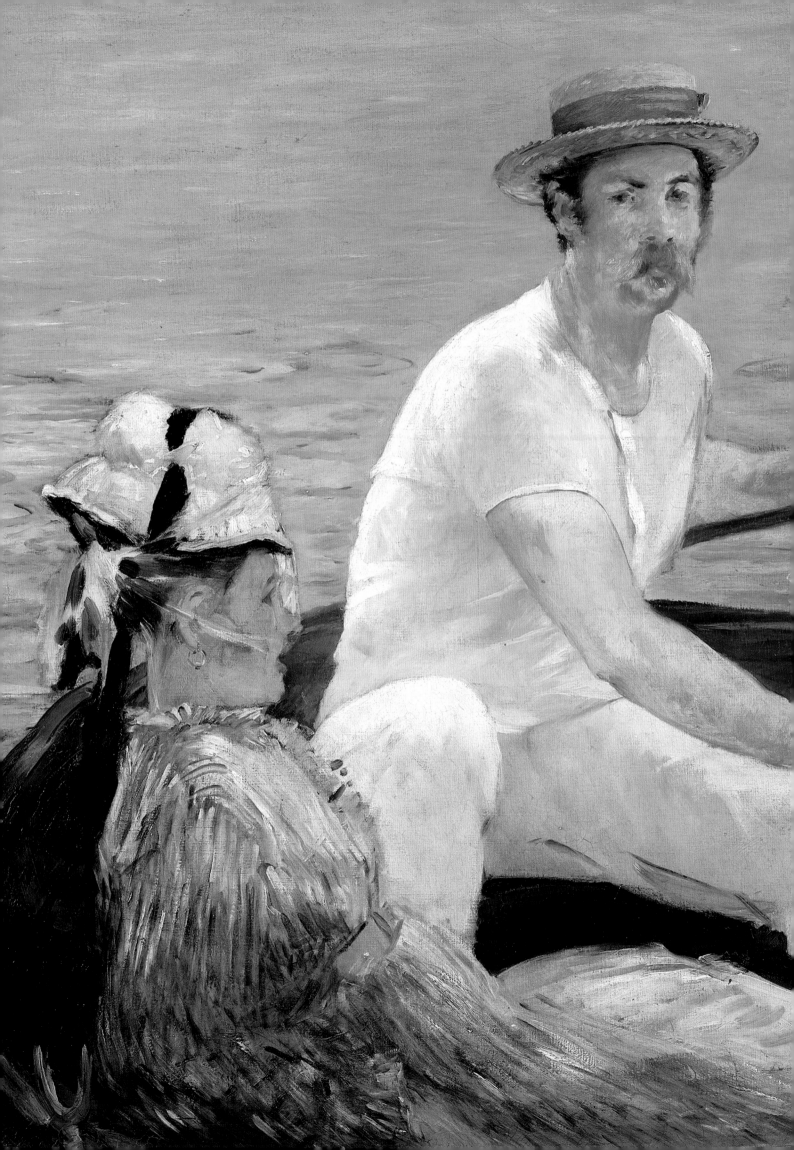

ILLUSTRATED CHECKLIST

Jules Bastien-Lepage
French, 1848–1884

Joan of Arc
1879
Oil on canvas
100 x 110 in. (254 x 279.4 cm)
Signed, dated, and inscribed (lower right): J.BASTIEN-
LEPAGE / DAMVILLERS Meuse / 1879
Gift of Erwin Davis, 1889
89.21.1
See no. 103

PROVENANCE
Erwin Davis, New York (1880–89; bought from the
artist for $4,000; his sale, Ortgies, New York, March
19–20, 1889, no. 145, for $23,700, bought in)

EXHIBITIONS
Salon, Paris, 1880, no. 177; "Tentoonstelling,"
Casino, Ghent, 1880, no. 27; "Fourth Annual
Exhibition," Society of American Artists, New York,
March 28–April 29, 1881, no. 26; "Second Annual
Exhibition Fair," New England Manufacturers' and
Mechanics' Institute, September 6–November ?,
1882, no catalogue number; "Exposition des oeuvres
de Jules Bastien-Lepage," École des Beaux-Arts, Paris,
March–April 1885, no. 112; "Exposition universelle
internationale de 1889: Exposition centennale de l'art
français (1789–1889), Paris, May–November 1889,
no. 18, (lent by M. Davis); "Jeanne d'Arc: Les
tableaux de l'Histoire," Musée des Beaux-Arts,
Rouen, May 30–September 1, 2003, no. 68

SELECTED REFERENCES
Philippe de Chennevières, "Le Salon de 1880,"
Gazette des beaux-arts 21, 1880, pp. 511–12;
Olivier Merson, *Le Monde illustré* 47, July 3, 1880,
p. 10; Henri Olleris, *Mémento du Salon de peinture
de gravure et de sculpture en 1880*, Paris, 1880,
pp. 22–23; Roger-Ballu, *La peinture au Salon de
1880*, Paris, 1880, pp. 13–16, 101; Maurice du
Seigneur, *L'Art et les artistes au Salon de 1880*, Paris,
1880, pp. 6–8; Frédéric de Syène, "Salon de 1880,"
L'Artiste 52, May–June 1880, p. 344; W. C. Brownell,
"Bastien-Lepage: Painter and Psychologist," *Magazine
of Art* 6, 1883, pp. 269–70; J.-K. Huysmans, "Le
Salon officiel de 1880," *L'Art moderne*, 1883,
pp. 132–34, 145; L. de Fourcaud, "Artistes contempo-
rains: Jules Bastien-Lepage," *Gazette des beaux-arts*
31, pér. 2, February 1885, pp. 108, 115–16;
L. de Fourcaud, "Exposition des oeuvres de Bastien-
Lepage," *Gazette des beaux-arts* 31, pér. 2, March
1885, pp. 259–64, 267; William Howe Downes,
"Boston Painters and Paintings," *Atlantic Monthly* 62,
October 1888, pp. 507–8; Prince Bojidar
Karageorgevitch, "Personal Reminiscences of Jules
Bastien-Lepage," *Magazine of Art* 13, 1890, pp. 86–
88; André Theuriet, George Clausen, Walter Richard

Sickert, *Jules Bastien-Lepage and His Art: A Memoir,*
London, 1892, pp. 53–58, 60, 99, 123, 125, 142, ill.
p. 55 (detail); Arthur Hoeber, *The Treasures of the
Metropolitan Museum of Art of New York,* 1899,
pp. 76–78, ill.; F[lorence] N. L[evy], "The Children's
Favorite Pictures," *Metropolitan Museum of Art
Bulletin* 5, September 1910, p. 208; B[ryson]
B[urroughs], "Nineteenth-Century French Painting,"
Metropolitan Museum of Art Bulletin 13, August
1918, p. 180; *Journal de Marie Bashkirtseff,* 2 vols.,
Paris, 1928, vol. 2, pp. 184–85; Harry B. Wehle,
"Seventy-five Years Ago," *Metropolitan Museum of Art
Bulletin* 4, April 1946, p. 202; Charles Sterling and
Margaretta M. Salinger, *French Paintings: A Catalogue
of the Collection of The Metropolitan Museum of Art,*
3 vols., New York, 1955–67, vol. 2, pp. 207–10, ill.;
Émile Zola, *Salons,* 1959, pp. 246–48; E. Haverkamp-
Begemann and Anne-Marie S. Logan, *European
Drawings and Watercolors in the Yale University Art
Gallery, 1500–1900,* vol. 1, 1970,
p. 44; William Steven Feldman, "The Life and Work
of Jules Bastien-Lepage (1848–1884)," unpublished
Ph.D. dissertation, New York University, 1973,
pp. 33–37, 84, 98, 115–142, 158, 164, 225, 228,
230–31, 256, 258–59, 261, 265, 271, 306, 310,
fig. 41; Gabriel P. Weisberg, *The Realist Tradition:
French Painting and Drawing, 1830–1900,* exh. cat.,
Cleveland Museum of Art, 1980, pp. 205–7, 211
n. 1, p. 268; Kenneth McConkey, "Listening to the
Voices: A Study of Some Aspects of Jules Bastien-
Lepage's 'Joan of Arc Listening to the Voices,'" *Arts
Magazine* 56, January 1982, pp. 154–60, ill.; Marie-
Madeleine Aubrun, *Jules Bastien-Lepage 1848–1884,
Catalogue raisonné de l'oeuvre,* Paris, 1985, pp. 14–
15, 22–23, 29, 57, 172–80, no. 249, ill.; Dorine
Cardyn-Oomen and Nathalie Monteyne, *Tranches de
vie: Le naturalisme en Europe, 1875–1915,* exh. cat.,
Koninklijk Museum voor Schone Kunsten, Antwerp,
Ghent, 1996, pp. 63–64, 66, 86, 206, 254; L. de
Fourcaud, *Bastien-Lepage: Sa vie et ses oeuvres,
1848–1884,* [1885], pp. 26–28, 30–31, ill.; Caroline
Igra, "Measuring the Temper of Her Time: Joan of Arc
in the 1870s and 1880s," *Konsthistorisk Tidskrift* 68,
1999, pp. 122–23, fig. 7

Pierre Bonnard
French, 1867–1947

From the Balcony
1909
Oil on canvas
49 x 39⅛ in. (124.5 x 99.4 cm)
Signed (upper right): Bonnard
Bequest of Charles Goldman, 1966
66.65.1
See no. 120

PROVENANCE
[Bernheim-Jeune, Paris; 1909–January 8, 1910;
bought from the artist; sold to Bernstein]; Henry
Bernstein, Paris (from 1910); [reportedly Ambroise
Vollard, Paris]; [Sam Salz, New York, in 1955; sold
to Goldman]; Charles Goldman, New York (1955–
d. 1966; his bequest to the Metropolitan Museum
pending life interest of his widow, d. 2001)

EXHIBITION
"Bonnard," Galerie Bernheim-Jeune, Paris,
March 7–26, 1910, no. 26

SELECTED REFERENCE
Jean Dauberville and Henry Dauberville, *Bonnard:
Catalogue raisonné de l'oeuvre peint,* 4 vols., Paris,
1968, vol. 2, p. 153, no. 543, ill.

View of The Old Port, Saint-Tropez
1911
Oil on canvas
33 x 34 in. (83.8 x 86.4 cm)
Signed (lower left): Bonnard
Bequest of Scofield Thayer, 1982
1984.433.1
See no. 121

PROVENANCE
[Galerie Bernheim-Jeune, Paris, from 1911; bought from the artist; Aurelien Lugné-Poë, Paris; [Galerie Bernheim-Jeune, Paris, until July 6, 1923; sold to Thayer for $1,500]; Scofield Thayer, New York (1923–d. 1982; on view at the Worcester Art Museum as part of the Dial Collection, 1936–82)

EXHIBITIONS
"Bonnard: Oeuvres récentes," Galerie Bernheim-Jeune, Paris, June 17–July 6, 1912, no. 5; "Original Paintings, Drawings, and Engravings being Exhibited with the Dial Folio 'Living Art,'" Montross Gallery, New York, January 26–February 14, 1924, no. 4; "Exhibition of the Dial Collection of Paintings, Engravings, and Drawings by Contemporary Artists," Worcester Art Museum, Mass., March 5–30, 1924, no. 3; ["The Dial Collection"], Hillyer Art Gallery, Smith College, Northampton, Mass., spring 1924; "Loan Exhibition of Paintings and Prints by Pierre Bonnard and Édouard Vuillard," Art Institute of Chicago, December 15, 1938–January 15, 1939, no. 23; "Pierre Bonnard," Museum of Modern Art, New York, May 10–September 6, 1948, Cleveland Museum of Art, 1948, no. 51; "The Dial and the Dial Collection," Worcester Art Museum, April 30–September 8, 1959, no. 3; "Selections from the Dial Collection," Worcester Art Museum, November 13–30, 1965; "The Dial Revisited," Worcester Art Museum, June 29–August 22, 1971; "Selection Two: 20th Century Art," Metropolitan Museum of Art, New York, June–August 1985; "Selection Three: 20th Century Art," Metropolitan Museum of Art, New York, October 22, 1985–January 26, 1986; "20th Century Masters from The Metropolitan Museum of Art," Australian National Gallery, Canberra, March 1–April 27, 1986, Queensland Art Gallery, Brisbane, May 7–July 1, 1986, no. 26; "Pierre Bonnard," Louisiana Museum, Humlebaek, September 12–January 10, 1993, no. 27; "Pierre Bonnard: Das Glück zu malen," Kunstsammlung Nordrhein-Westfalen, Düsseldorf, January 23–April 12, 1993, no. 13; "Painters in Paris, 1895-1950," Metropolitan Museum of Art, March 8–December 31, 2000; "Mediterranée, de Courbet à Matisse: 1850–1925," Galeries Nationales du Grand Palais, Paris, September 19, 2000–January 15, 2001, no. 4; "Picasso and the School of Paris, Paintings from The Metropolitan Museum of Art," Kyoto Municipal Museum of Art, September 14–November 24, 2002, Bunkamura Museum of Art, Tokyo, December 7, 2002–March 9, 2003

SELECTED REFERENCES
François Fosca, Bonnard: Vingt-cinq phototypies, Paris, 1919, pl. 22; The Dial 79, July 1925, color frontis.; André Fontainas, Bonnard [Les albums d'art Druet, vol. 20], Paris [1928] n.p., ill.; François-Joachim Beer, Pierre Bonnard, Marseilles, 1947, pp. 105, [167], no. 85, ill.; Rolf Söderberg, Pierre Bonnard, Stockholm, 1949, p. 45, ill.; Jean Dauberville and Henry Dauberville, Bonnard: Catalogue raisonné de l'oeuvre peint, 4 vols., Paris, 1968, vol. 2, p. 235, no. 660, ill.; Nicholas Joost, "The Dial Collection: Tastes and Trends of the Twenties," Apollo, December 1971, pp. 488–89, pl. 10; Sasha M. Newman et al., Bonnard: The Late Paintings, exh. cat, Phillips Collection, Washington, D.C., 1984, fig. 5; Lisa M. Messinger, "Twentieth-Century Art: The Scofield Thayer Bequest," Notable Acquisitions (Metropolitan Museum of Art) 1984–1985, 1984–85, pp. 44–46, ill. (color); Gary Tinterow et al., The Metropolitan Museum of Art: Modern Europe, New York, 1987, p. 83, fig. 60, ill. (color); Michel Terrasse, Bonnard et Le Cannet, Paris, 1987, p. 10, ill.

The Dressing Room
1914
Oil on canvas
28⅜ x 34¾ in. (72.1 x 88.3 cm)
Signed and dated (upper left): Bonnard / 1914
Bequest of Scofield Thayer, 1982
1984.433.3
See no. 122

PROVENANCE
[Galerie Bernheim-Jeune, Paris, until ca. 1923]; Scofield Thayer, New York (ca. 1923–d. 1982; on view at the Worcester Art Museum as part of the Dial Collection, 1936–82)

EXHIBITIONS
"La tredicesima esposizione d'arte a Venezia, 1922," no. 235, not in catalogue; "Original Paintings, Drawings, and Engravings being Exhibited with the Dial Folio 'Living Art,'" Montross Gallery, New York, January 26–February 14, 1924, no. 3; "Exhibition of the Dial Collection of Paintings, Engravings, and Drawings by Contemporary Artists," Worcester Art Museum, Mass., March 5–30, 1924, no. 1; "[The Dial Collection]," Hillyer Art Gallery, Smith College, Northampton, Mass., spring 1924; "The Dial and the Dial Collection," Worcester Art Museum, April 30–September 8, 1959, no. 4; "Selections from the Dial Collection," Worcester Art Museum, November 13–30, 1965; "The Dial: Arts and Letters in the 1920s," Worcester Art Museum, March 7–May 10, 1981, no. 8; "Selection Two: 20th Century Art," Metropolitan Museum of Art, New York, June–August 1985; "20th Century Masters from The Metropolitan Museum of Art," Australian National Gallery, Canberra, March 1–April 27, 1986, Queensland Art Gallery, Brisbane, May 7–July 1, 1986; "Pierre Bonnard," Louisiana Museum, Humlebaek, September 12–January 10, 1993, no. 38; "Pierre Bonnard: Das Glück zu malen," Kunstsammlung Nordrhein-Westfalen, Düsseldorf, January 23–April 12, 1993, no. 17; "Bonnard," Kunsthalle der Hypo Kulturstiftung, Munich, January 28–April 24, 1994, no. 67; "Painters in Paris, 1895–1950," Metropolitan Museum of Art, New York, March 8–December 31, 2000; "Picasso and the School of Paris, Paintings from The Metropolitan Museum of Art," Kyoto Municipal Museum of Art, September 14–November 24, 2002, Bunkamura Museum of Art, Tokyo, December 7, 2002–March 9, 2003

SELECTED REFERENCES
The Dial 80, March 1926, p. 179, ill. (color); Jean Dauberville and Henry Dauberville, Bonnard: Catalogue raisonné de l'oeuvre peint, 4 vols., Paris, 1968, vol. 2, p. 343, no. 811, ill.; Nicholas Joost, Scofield Thayer and The Dial, An Illustrated History, Carbondale and Edwardsville, Ill., 1964, plate section, n.p., ill.; Lisa M. Messinger, "Twentieth-

Century Art: The Scofield Thayer Bequest," Notable Acquisitions (Metropolitan Museum of Art) 1984–1985, 1984–85, pp. 44–46, ill. (color); John Richardson, "Rediscovering an Early Modern Vision: The Dial Collection Recalls the Life and Times of Scofield Thayer," House and Garden 159, no. 2, February 1987, p. 161, ill.

The Green Blouse
1919
Oil on canvas
40⅛ x 26⅞ in. (101.9 x 68.3 cm)
Signed (lower left): Bonnard
The Mr. and Mrs. Henry Ittleson Jr. Purchase Fund, 1963
63.64
See no. 123

PROVENANCE
Gaston Bernheim de Villers, Paris; bought from the artist February 1920–d. 1953); Mme Gaston Bernheim de Villers, Paris; her great-nephew Abbé Phillippe de la Chapelle, Paris (until 1962); [Sam Salz, Inc., New York, 1962–63]

EXHIBITIONS
"23rd Annual International Exhibition of Paintings," Carnegie Institute, Pittsburgh, 1924, no. 26; "Exhibition of Paintings by Bonnard," Wildenstein and Co., Inc., New York, March 1–24, 1934, no. 25; "Changes in Perspective: 1880–1925," Grey Art Gallery and Study Center, New York University, New York, May 2–June 2, 1978; "Profil du Metropolitan Museum of Art de New York: De Ramsès à Picasso," Galerie des Beaux-Arts, Bordeaux, May 15–September 1, 1981, no. 219; "5,000 Years of Art from the Collection of The Metropolitan Museum of Art," San Diego Museum of Art, October 11–December 6, 1981, Krannert Museum of Art, University of Illinois at Urbana-Champaign, January 3–February 28, 1982, Fine Arts Museum of the South, Mobile, Ala., March 28–May 9, 1982, Midland Art Center, Midland, Mich., June 6–August 22, 1982, Arkansas Art Center, Little Rock, September 19–November 11, 1982; "Bonnard," Kunsthaus Zürich, December 14, 1984–March 10, 1985, Städtische Galerie im Städelschen Kunstinstitut, Frankfurt-am-Main, 1985, no. 92; "20th Century Masters from The Metropolitan Museum of Art," Australian National Gallery, Canberra, March 1–April 27, 1986, Queensland Art Gallery, Brisbane, May 7–July 1, 1986; "Treasures from The Metropolitan

Museum of Art: French Art from the Middle Ages to the Twentieth Century," Yokohama Museum of Art, March 25–June 4, 1989; "Pierre Bonnard," Louisiana Museum, Humlebaek, September 12–January 10, 1993, no. 52; "Pierre Bonnard: Das Glück zu malen," Kunstsammlung Nordrhein-Westfalen, Düsseldorf, January 23–April 12, 1993, no. 23; "Bonnard," Kunsthalle der Hypo-Kulturstiftung, Munich, January 28–April 24, 1994, no. 80; "Pierre Bonnard," Aichi Prefectural Museum of Art, Nagoya, March 28–May 18, 1997, Bunkamura Museum of Art, Tokyo, May 24–July 21, 1997, no. 59; "Painters in Paris, 1895–1950," Metropolitan Museum of Art, New York, March 8–December 31, 2000; "Picasso and the School of Paris, Paintings from The Metropolitan Museum of Art," Kyoto Municipal Museum of Art, September 14–November 24, 2002, Bunkamura Museum of Art, Tokyo, December 7, 2002–March 9, 2003; "Pierre Bonnard: L'Oeuvre d'art, un arrêt du temps," Musée d'Art Moderne de la Ville de Paris, February 2–May 7, 2006, no. 52

SELECTED REFERENCES
Claude Roger-Marx, *Pierre Bonnard*, Paris, 1924, p. 37, ill.; Maurice Denis, "L'Époque du Symbolisme," *Gazette des beaux-arts*, 6e sér., vol. 76, t. 11, 1st semester 1934, p. 176, fig. 11; Charles Sterling and Margaretta M. Salinger, *French Paintings: A Catalogue of the Collection of the Metropolitan Museum of Art*, 3 vols., New York, 1955–67, vol. 3, p. 208, ill.; Theodore Rousseau, "Reports of the Departments–European Paintings," *Metropolitan Museum of Art Bulletin*, n.s., vol. 22, no. 2, October 1963, pp. 66–67, ill.; Jean Dauberville and Henry Dauberville, *Bonnard: Catalogue raisonné de l'oeuvre peint*, 4 vols., Paris, 1968, vol. 2, p. 460, no. 979, ill.

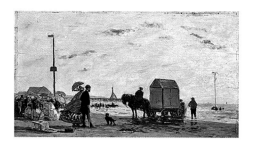

Eugène Boudin
French, 1824–1898

On the Beach at Trouville
1863
Oil on wood
10 x 18 in. (25.4 x 45.7 cm)
Signed and dated (lower right): E. Boudin.63
Bequest of Amelia B. Lazarus, 1907
07.88.4
See no. 33

PROVENANCE
[Tempelaere, Paris, by 1899–at least 1900]; Amelia B. Lazarus, New York (by 1902–d. 1907)

EXHIBITIONS
Salon, Paris, May 1, 1864–?, possibly no. 214; "Works in Oil and Pastel by the Impressionists of Paris," American Art Association, New York, April 10–28, 1886, possibly no. 74; National Academy of Design, New York, American Art Association, New York, May 25–June 30, 1886, no. 74; "Exposition des oeuvres d'Eugène Boudin," École des Beaux-Arts, Paris, January 9–30, 1899, no. 122; "Exposition Eugène Boudin," Bernheim-Jeune, Paris, November 12–30, 1900, no. 103; "Loan Exhibition of Paintings by Eugène Boudin," Art Institute of Chicago, December 19, 1935–January 19, 1936, no. 2; "Exhibition of French Impressionist Landscape Painting," William Rockhill Nelson Gallery, Kansas City, November 29–December 30, 1936, no. 11; "Impressionism: A Centenary Exhibition," Metropolitan Museum of Art, New York, December 12, 1974–February 10, 1975, not in catalogue

SELECTED REFERENCES
G. Jean-Aubry, *Eugène Boudin d'après des documents inédits: L'Homme et l'oeuvre*, Paris, 1922, p. 57; Charles Sterling and Margaretta M. Salinger, *French Paintings: A Catalogue of the Collection of The Metropolitan Museum of Art*, 3 vols., New York, 1955–67, vol. 2, pp. 135–36, ill.; Margaretta M. Salinger, "Windows Open to Nature," *Metropolitan Museum of Art Bulletin* 27, summer 1968, n.s., unpaginated, ill.; Robert Schmit, *Eugène Boudin, 1824–1898*, 3 vols., Paris, 1973, vol. 1, p. 86, no. 271, ill., cf. *Supplément*, 2 vols., Paris, 1984–93, vol. 1, 1984, p. 134, no. 271, vol. 2, 1993, p. 197, no. 271; Charles S. Moffett, *Impressionist and Post-Impressionist Paintings in The Metropolitan Museum of Art*, New York, 1985, pp. 10, 16–17, ill.

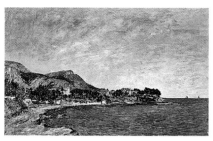

Beaulieu: The Bay of Fourmis
1892
Oil on canvas
21⅝ x 35½ in. (54.9 x 90.2 cm)
Signed, dated, and inscribed (lower left): [E].Boudin 92. / Beaulieu - Mars
Bequest of Jacob Ruppert, 1939
39.65.2
See no. 34

PROVENANCE
[Durand-Ruel, Paris, 1892; bought from the artist, May 10, stock no. 2152; sold November 8 to Durand-Ruel]; [Durand-Ruel, New York, 1892–94; sold on May 12 to Spencer]; Spencer, New York (from 1894); [Durand-Ruel, New York, by 1905, stock no. 998; sold to Canfield]; Richard A. Canfield, New York (until d. 1916; sale, American Art Association, New York, January 27–28, 1916, no. 151, for $5,000, to Otto Bernet for Ruppert); Jacob Ruppert, New York (1916–d. 1939)

EXHIBITIONS
Salon, Paris, 1892, no. 141; "Pictures by Boudin, Cézanne, Degas, Manet . . . ," Grafton Galleries, London, Durand-Ruel, Paris, January–February 1905, no. 7; "Selected Pictures by Eugène Boudin (1824–1898)," Arthur Tooth and Sons, London, October 25–November 17, 1934, possibly no. 11; "Five Centuries of European Painting," Arkansas Arts Center, Little Rock, May 16–October 26, 1963, p. 44; "Impressionism and Its Roots," University of Iowa Gallery of Art, Iowa City, November 8–December 6, 1964, no. 21; "Impressionism: A Centenary Exhibition," Metropolitan Museum of Art, New York, December 12, 1974–February 10, 1975, not in catalogue; "Louis Eugène Boudin: Precursor of Impressionism," Santa Barbara Museum of Art, October 8–November 21, 1976, Art Museum of South Texas, Corpus Christi, December 2, 1976–January 9, 1977, Columbus Gallery of Fine Arts, March 10–April 24, 1977, Fine Arts Gallery of San Diego, May 5–June 12, 1977, Museum of Fine Arts, St. Petersburg, Fla., January 18–February 27, 1977, no. 30

SELECTED REFERENCES
G. Jean-Aubry, *Eugène Boudin d'après des documents inédits: L'Homme et l'oeuvre*, Paris, 1922, p. 174; Hermann Warner Williams Jr., "The Bequest of Jacob Ruppert," *Metropolitan Museum of Art Bulletin* 34, July 1939, p. 169; Charles Sterling and Margaretta M. Salinger, *French Paintings: A Catalogue of the Collection of The Metropolitan Museum of Art*, 3 vols., New York, 1955–67, vol. 2, pp. 136–37, ill.; Robert Schmit, *Eugène Boudin, 1824–1898*, 3 vols., Paris, 1973, vol. 3, p. 118, no. 2885, ill.

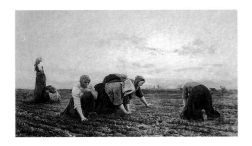

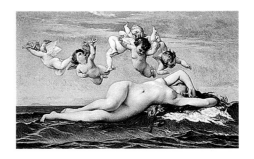

the *Nineteenth Century,* London, 1971, p. 107, fig. 73; Jean Bouret, *L'École de Barbizon et le paysage français au XIXe siècle,* Neuchatel, 1972, p. 265, ill. p. 248; Albert Boime, *The Art of the Macchia and the Risorgimento: Representing Culture and Nationalism in Nineteenth-Century Italy,* Chicago, 1993, p. 110, fig. 3.21

Jules Breton
French, 1827–1906

The Weeders
1868
Oil on canvas
28⅛ x 50¼ in. (71.4 x 127.6 cm)
Signed, dated, and inscribed (lower right): Jules Breton / Courrières 1868
Bequest of Collis P. Huntington, 1900
25.110.66
See no. 48

PROVENANCE
Henry Probasco, Cincinnati (until 1887); sale, American Art Association, New York, April 18, 1887, no. 96, ill.; Collis P. Huntington, New York (by 1893–d. 1900; life interest to his widow, Arabella D. Huntington, later [from 1913] Mrs. Henry E. Huntington, 1900–d. 1924; life interest to their son, Archer Milton Huntington, 1924–terminated in 1925)

EXHIBITIONS
"World's Columbian Exhibition: Fine Arts," Chicago World's Fair, May 1–October 26, 1893, no. 2876; "French Pre-Impressionist Painters of the Nineteenth Century," Winnipeg Art Gallery, April 10–May 9, 1954, no. 69; "Van Gogh as Critic and Self-Critic," Metropolitan Museum of Art, New York, October 30, 1973–January 6, 1974, no. 30; "Impressionism: A Centenary Exhibition," Metropolitan Museum of Art, New York, December 12, 1974–February 10, 1975, not in catalogue; "Jules et Emile Breton, peintres de l'Artois," Musée d'Arras, October 16, 1976–January 3, 1977; "Millet's Gleaners," Minneapolis Institute of Arts, April 2–June 4, 1978, no. 22; "Courbet und Deutschland," Hamburger Kunsthalle, October 19–December 17, 1978, Städtische Galerie im Städelschen Kunstinstitut, Frankfurt am Main, January 17–March 18, 1979, no. 477; "Jules Breton and the French Rural Tradition," Joslyn Art Museum, Omaha, November 6, 1982–January 2, 1983, Dixon Gallery and Gardens, Memphis, Tenn., January 16–March 6, 1983, Sterling and Francine Clark Art Institute, Williamstown, Mass., April 2–June 5, 1983, no. 14; "Franse meesters uit het Metropolitan Museum of Art: Realisten en Impressionisten," Rijksmuseum Vincent Van Gogh, Amsterdam, March 15–May 31, 1987, no. 7; "Corot to Cézanne: 19th Century French Paintings from The Metropolitan Museum of Art," Museum of Art, Fort Lauderdale, December 22, 1992–April 11, 1993, no catalogue

SELECTED REFERENCES
Jules Breton, *Un peintre paysan: Souvenirs et impressions,* Paris, 1896, pp. 110–11; Walter Rowlands, "Art Sales in America," *The Art Journal,* 1887, p. 295; Jules Breton, trans. Mary J. Serrano, *The Life of an Artist,* New York, 1891, ill.; Charles Sterling and Margaretta M. Salinger, *French Paintings: A Catalogue of the Collection of The Metropolitan Museum of Art,* 3 vols., New York, 1955–67, vol. 2, pp. 180–81, ill.; Albert Boime, *The Academy and French Painting in*

Alexandre Cabanel
French, 1823–1889

The Birth of Venus
1875
Oil on canvas
41¾ x 71⅞ in. (106 x 182.6 cm)
Signed (lower left): ALEX CABANEL
Gift of John Wolfe, 1893
94.24.1
See no. 29

PROVENANCE
John Wolfe, New York (1875–d. 1894; commissioned from the artist; sale, Leavitt's, April 5–6, 1882, bought in)

EXHIBITIONS
"The Taste of the Seventies," Metropolitan Museum of Art, New York, 1946, no. 70; "The Spirit of Modern France," Toledo Museum of Art, November–December 1946, Art Gallery of Toronto, January–February 1947, no. 38; "Muse or Ego: Salon and Independent Artists of the 1880's," Pomona College Gallery, Claremont, Calif., April 16–May 12, 1963, no. 14; "Artists of the Paris Salon," Cummer Gallery of Art, Jacksonville, Fla., January 7–February 3, 1964, no. 8; "Impressionism: A Centenary Exhibition," Metropolitan Museum of Art, New York, December 12, 1974–February 10, 1975, not in catalogue; "Courbet und Deutschland," Hamburger Kunsthalle, October 19–December 17, 1978, Städtische Galerie im Städelschen Kunstinstitut, Frankfurt am Main, January 17–March 18, 1979, no. 479; "Treasures from The Metropolitan Museum of Art: French Art from the Middle Ages to the Twentieth Century," Yokohama Museum of Art, March 25–June 4, 1989, no. 84

SELECTED REFERENCES
Edward Strahan (Earl Shinn), ed., *The Art Treasures of America,* 3 vols., New York, 1879, reprint ed. 1977, vol. 1, pp. 64, 67; Bryson Burroughs, *Catalogue of Paintings,* New York, 1914, pp. 35–36, no. C11–4; Charles Sterling and Margaretta M. Salinger, *French Paintings: A Catalogue of the Collection of The Metropolitan Museum of Art,* 3 vols., New York, 1955–67, vol. 2, pp. 166–67, ill.; Rebecca A. Rabinow, "Catharine Lorillard Wolfe: The First Woman Benefactor of the Metropolitan Museum," *Apollo* 147, March 1998, pp. 51, 54 n. 22; T. J. Clark, *The Painting of Modern Life: Paris in the Art of Manet and His Followers,* New York, 1999, rev. ed. [1st ed., 1984], pp. xii, 122, fig. 145; Patricia Mainardi, "The 19th-Century Art Trade: Copies, Variations, Replicas," *The Van Gogh Museum Journal,* 2000, p. 67, fig. 6

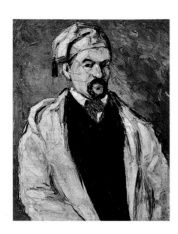

Paul Cézanne
French, 1839–1906

Antoine Dominique Sauveur Aubert
(born 1817), the Artist's Uncle
1866
Oil on canvas
31⅜ x 25¼ in. (79.7 x 64.1 cm)
Wolfe Fund, 1951; acquired from The Museum of
Modern Art, Lillie P. Bliss Collection
53.140.1
See no. 72

PROVENANCE
[Ambroise Vollard, Paris, until 1899; sold July 10,
1899 to Rosenberg]; [Alexandre Rosenberg, Paris,
1899]; Auguste Pellerin, Paris (about 1899–until
1916); [Jos Hessel, Paris, 1916–20]; Marius de Zayas,
New York (1920–about 1921); Lizzie (Lillie) P. Bliss,
New York (about 1921–d. 1931; bequeathed to the
Museum of Modern Art, New York); Museum of
Modern Art, New York (1931–51; sold to the
Metropolitan Museum)

EXHIBITIONS
"Salon d'automne," Grand Palais des Champs-
Élysées, Paris, October 1–22, 1907, no. 2 (possibly
this picture); "Loan Exhibition of Impressionist and
Post-Impressionist Paintings," Metropolitan Museum
of Art, New York, May 3–September 15, 1921, no. 4;
[group exhibition], Modern Gallery, New York, 1921,
unnumbered cat.; "Summer Exhibition of Modern
French and American Painters," Brooklyn Museum,
June 12–October 14, 1926, no catalogue; "First Loan
Exhibition: Cézanne, Gauguin, Seurat, van Gogh,"
Museum of Modern Art, New York, November 8–
December 7, 1929, no. 1; "Memorial Exhibition: The
Collection of the Late Miss Lizzie P. Bliss, Vice-
President of the Museum," Museum of Modern Art,
New York, May 17–September 27, 1931, no. 1;
"The Collection of Miss Lizzie P. Bliss: Fourth Loan
Exhibition," Addison Gallery of American Art,
Andover, Mass., October 17–December 15, 1931, no.
1; "Modern Masters from the Collection of Miss
Lizzie P. Bliss," John Herron Art Institute, Indianapolis,
January 1932, no. 1; "The Lillie P. Bliss Collection,"
Museum of Modern Art, New York, 1934, no. 1;
"Modern Works of Art," Museum of Modern Art, New
York, November 20, 1934–January 20, 1935, no. 1;
"Art in Our Time," Museum of Modern Art, New York,
May 10–September 30, 1939, no. 56; "Cézanne:
Paintings, Watercolors and Drawings," Art Institute of
Chicago, February 7–March 16, 1952, Metropolitan
Museum of Art, New York, April 4–May 18, 1952,
no. 5; "Cézanne: The Early Years, 1859–1872," Royal
Academy of Arts, London, April 22–August 21, 1988,
Musée d'Orsay, Paris, September 19, 1988–January 1,

1989, National Gallery of Art, Washington, D.C.,
January 29–April 30, 1989, no. 22; "Origins of
Impressionism," Metropolitan Museum of Art, New
York, September 27, 1994–January 8, 1995, no. 25;
"Cézanne," Philadelphia Museum of Art, May 30–
September 1, 1996, no. 7

SELECTED REFERENCES
Eliot Clark, "Considerations on Modernistic
Aesthetics," *Art in America* 9, August 1921, ill.
p. 213; Georges Rivière, *Le maître Paul Cézanne,*
Paris, 1923, p. 204, ill. opp. p. 10; Roger Fry, "New
Laurels for the Scorned Cézanne," *New York Times
Magazine,* May 1, 1927, p. 6, ill.; Kurt Pfister,
Cézanne: Gestalt/Werk/Mythos, Potsdam, 1927,
fig. 33; R. H. Wile[n]ski, *French Painting,* Boston,
1931, p. 309; James Johnson Sweeney, "The Bliss
Collection," *Creative Art* 8, May 1931, p. 357;
Georges Rivière, *Cézanne: Le peintre solitaire,* Paris,
1933, ill. p. 21; Lionello Venturi, *Cézanne: Son art—
son oeuvre,* 2 vols., Paris, 1936, vol. 1, pp. 21, 82,
no. 73, vol. 2, pl. 19, no. 73; René Huyghe, *Cézanne,*
Paris, 1936, pp. 12, 32, 67, fig. 11; Robert J.
Goldwater, "Cézanne in America: The Master's
Paintings in American Collections," *Art News* 36,
March 26, 1938, section I (The 1938 Annual),
p. 136; R. H. Wilenski, *Modern French Painters,* New
York [1940], p. 10, pl. 3; Sheldon Cheney, *The Story
of Modern Art,* New York, 1941 [4th reprint, 1947],
pp. 210–12, ill.; Alfred H. Barr Jr., ed., *New York
Painting and Sculpture in the Museum of Modern Art,*
New York, 1942, p. 30, no. 83, ill.; Bernard Dorival,
Cézanne, Paris, 1948, French. ed. [English. ed., 1948,
p. 128], pp. 29, 133, 142; John Rewald, *Paul
Cézanne: A Biography,* New York, 1948, p. x,
fig. 17; Bernard Dorival, trans. H. H. A. Thackthwaite,
Cézanne, New York, 1948, pp. 25, 128, 138; Liliane
Guerry, *Cézanne et l'expression de l'espace,* Paris,
1950, p. 28; John Rewald, *The Ordeal of Paul
Cézanne,* London, 1950, pp. vii, 36–37, pl. 4;
Lawrence Gowing, ed., *An Exhibition of Paintings by
Cézanne,* exh. cat., Royal Scottish Academy Building,
Edinburgh, 1954, unpaginated, under no. 2; Maurice
Raynal, trans. James Emmons, *Cézanne,* Lausanne,
1954, pp. 23, 30, color ill.; Josephine L. Allen and
Elizabeth E. Gardner, *A Concise Catalogue of the
European Paintings in The Metropolitan Museum of
Art,* New York, 1954, p. 17; Charles Sterling and
Margaretta M. Salinger, *French Paintings: A Catalogue
of the Collection of The Metropolitan Museum of Art,*
3 vols., New York, 1955–67, vol. 3, pp. 96–97, ill.;
Yvon Taillandier, trans. Graham Snell, *P. Cézanne,*
New York [196–], pp. 9, 15, 28, color ill.; Melvin
Waldfogel, unpublished Ph.D. dissertation, *The
Bathers of Paul Cézanne,* Harvard University,
Cambridge, Mass., 2 vols., 1961, vol. 1, p. 30; Wayne
V. Andersen, "A Cézanne Self-Portrait Drawing
Reidentified," *Burlington Magazine* 106, June 1964,
p. 285; Nello Ponente, *Cézanne,* [Milan, ca. 1966],
unpaginated, black and white and color ill.;
Margaretta M. Salinger, "Windows Open to Nature,"
Metropolitan Museum of Art Bulletin 27, summer
1968, n.s., p. 35, ill.; Richard W. Murphy et al., *The
World of Cézanne: 1839–1906,* New York, 1968, p.
27, color ill.; Sandra Orienti, *L'Opera completa di
Cézanne,* Milan, 1970 [French ed., 1975; English ed.,
1985], pp. 88–89, no. 56, ill.; Marcel Brion, trans.
Maria Paola De Benedetti, *Paul Cézanne,* Milan,
1972, p. 14, fig. 2 (color); Nicholas Wadley, *Cézanne
and His Art,* London, 1975, pp. 14–15, 19, pl. 11
(color); Judith Wechsler, ed., *Cézanne in Perspective,*
Englewood Cliffs, N.J., 1975, fig. 1; Lionello Venturi,
trans. R. Skira, *Cézanne,* Geneva, 1978, pp. 52–53,
color ill.; Howard Hibbard, *The Metropolitan
Museum of Art,* New York, 1980,
pp. 429, 440–41, fig. 788 (color); Richard Shiff,

Cézanne and the End of Impressionism, Chicago,
1984, pp. 204–5, 266 n. 30, fig. 45; Charles S.
Moffett, *Impressionist and Post-Impressionist Paintings
in The Metropolitan Museum of Art,* New York, 1985,
pp. 176–77, 253, color ill.; Gary Neil Wells,
*Metaphorical Relevance and Thematic Continuity in
the Early Paintings of Paul Cézanne, 1865–1877,*
unpublished Ph.D. dissertation, Ohio State University,
Columbus, 1987, pp. 71– 73, 76–81, 106 n. 53,
p. 276, pl. XVIII; Richard Shone, "London, Royal
Academy: Early Cézanne," *Burlington Magazine* 130,
June 1988, pp. 480–81, fig. 75; John Rewald with the
research assistance of Frances Weitzenhoffer,
*Cézanne and America: Dealers, Collectors, Artists,
and Critics, 1891–1921, 1979,* Princeton, 1989,
pp. 325, 327, 349, figs. 170– 71; Nina Athanassoglou-
Kallmyer, "Museum News: National Gallery of Art,
Washington, D.C., 'Cézanne: The Early Years,
1859–1872,'" *Art Journal* 49, spring 1990, pp. 72–74,
fig. 2; Hajo Düchting, *Paul Cézanne 1839–1906:
Natur wird Kunst,* Cologne, 1990 [English ed., 1999],
pp. 34–35, 37, color ill.; Maria Teresa Benedetti,
trans. Marie-Christine Gamberini, *Cézanne,* Paris,
1995 [Italian ed., 1995], p. 52, color ill.; John Rewald
in collaboration with Walter Feilchenfeldt and Jayne
Warman, *The Paintings of Paul Cézanne: A Catalogue
Raisonné,* 2 vols., New York, 1996, vol. 1, pp. 102,
563, 566–67, 570, 572–73, no. 107, vol. 2, p. 36,
fig. 107; Karen Wilkin, "Monsieur Pellerin's
Collection," *New Criterion* 14, April 1996, p. 22;
James H. Rubin, *Courbet,* London, 1997, pp. 318–19,
fig. 208 (color); Sona Johnston, John House et al.,
*Faces of Impressionism: Portraits from American
Collections,* exh. cat., Baltimore Museum of Art, New
York, 1999, pp. 22–23, fig. 11 (color)

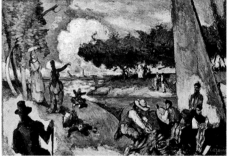

The Fishermen (Fantastic Scene)
ca. 1875
Oil on canvas
21¾ x 32¼ in. (55.2 x 81.9 cm)
Gift of Heather Daniels and Katharine Whild,
Promised Gift of Katharine Whild, and Purchase,
The Annenberg Foundation Gift, Gift of Joanne Toor
Cummings, by exchange, Wolfe Fund, and Ellen
Lichtenstein and Joanne Toor Cummings Bequests,
Mr. and Mrs. Richard J. Bernhard Gift, Gift of Mr. and
Mrs. Richard Rodgers, and Wolfe Fund, by exchange,
and funds from various donors, 2001
2001.473
See no. 73

PROVENANCE
Victor Chocquet, Paris (bought from the artist–
d. 1891; his widow, Marie Chocquet, Paris (1891–
d. 1899; her sale, Galerie Georges Petit, Paris, July 1,
3–4, 1899, no. 22, for Fr 2,350 to Hessel); [Jos Hessel,
Paris, from 1899]; [Bernheim-Jeune, Paris, until 1907;

sold in July to Cassirer]; [Paul Cassirer, 1907–9; sale on January 4, 1908, to Nationalgalerie, Berlin, for DM 16,310, purchase never completed; returned to dealer March 21, 1908 and sold January 26, 1909, for DM 13,200 to Liebermann]; Max Liebermann, Berlin (1909–d. 1935); Mrs. Max Liebermann (1935–38); her daughter, Käthe Liebermann (later Mrs. Kurt Riezler), Berlin and New York (1938–d. 1952); her daughter, Mrs. Howard B.White (Maria Riezler), Northport, New York (1952–d. 1995); her daughters, Heather Daniels and Katharine Whild (1995–2001)

EXHIBITIONS
"3e exposition de peinture [3rd Impressionist exhibition]," 6, rue le Peletier, Paris, April 1877, not in catalogue; [title not known], Paul Cassirer, Berlin, April–June 1904; "Fünfzehnten Ausstellung der Berliner Secession," Paul Cassirer, Berlin, 1908, no. 38; "III. Ausstellung," Paul Cassirer, Berlin, November 17–December 12, 1909, no. 27; "Cézanne-Ausstellung," Paul Cassirer, Berlin, November–December 1921, no. 3; "Paul Cézanne," Kunsthalle Basel, August 30–October 12, 1936, no. 12; "Honderd Jaar Fransche Kunst," Stedelijk Museum, Amsterdam, July 2–September 25, 1938, no. 9; "Cézanne," Wildenstein and Co., Inc., New York, March 27–April 26, 1947, no. 7; "Cézanne: Paintings, Watercolors, and Drawings," Art Institute of Chicago, February 7–March 16, 1952, Metropolitan Museum of Art, New York, April 4–May 18, 1952, no. 33; "Cézanne," Wildenstein and Co., Inc., New York, November 5–December 5, 1959, no. 10; "Paintings from Private Collections: Summer Loan Exhibition," Metropolitan Museum of Art, New York, July 12–September 2, 1963, no. 4; "Exposition Cézanne," National Museum of Western Art, Tokyo, March 30–May 19, 1974, Museum of the City of Kyoto, June 1–July 17, 1974, Cultural Center of Fukuoka, July 24–August 18, 1974, no. 9; "The New Painting: Impressionism 1874–1886," National Gallery of Art, Washington, D.C., January 17–April 6, 1986, M. H. de Young Memorial Museum, San Francisco, April 19–July 6, 1986, no. 42; "Cezanne: Gemälde," Kunsthalle Tübingen, January 16–May 2, 1993, no. 16

SELECTED REFERENCES
Georges Rivière, "L'Exposition des impressionistes," L'Impressionniste: Journal d'art 2, April 14; Hans Rosenhagen, "Von Ausstellungen und Sammlungen," Die Kunst für Alle 19, June 1, 1904, p. 403; Julius Meier-Graefe, trans. Florence Simmonds and George W. Chrystal, Modern Art, Being a Contribution to a New System of Aesthetics, London, 1908, ill. opp. p. 264; Julius Meier-Graefe, Paul Cézanne, Munich, 1910, 3rd ed., rev. and expanded, ill. p. 17; Cézanne, Paris, 1914, p. 63, pl. X; Ambroise Vollard, Paul Cézanne, Paris, 1914 [English ed., 1923], p. 34 n. 1, pl. 8; Julius Meier-Graefe, Entwicklungsgeschichte der modernen Kunst, 3 vols., 1914–15, Munich, vol. 3, 1915, 2nd ed. [English ed. "Cézanne," 1927], pp. 565–66, pl. 489; Gustave Coquiot, Paul Cézanne, Paris [1919], pp. 68, 211, 245; Julius Meier-Graefe, Cézanne und sein Kreis: Ein Beitrag zur Entwicklungsgeschichte, Munich, 1920, 3rd ed. [1st ed., 1918], p. 74 n. 4, p. 79, ill. opp. p. 96; Max J. Friedländer, "Über Paul Cézanne," Die Kunst für Alle 45, February 1922, ill. opp. p. 136; Julius Meier-Graefe, trans. J. Holroyd-Reece, Cézanne, London, 1927, pp. 25, 35–36, pl. XII; Rudolf Grossmann, "Liebermann as Collector," Formes 4, April 1930, p. 18, ill. opp. p. 19; Lionello Venturi, "Cézanne," L'Arte 6, July 1935, pp. 317, 323, 324, ill.; Lionello Venturi, Cézanne: son art—Son oeuvre, 2 vols., Paris, 1936, vol. 1, pp. 37–38, 119, 298, no. 243, vol. 2,

pl. 65, no. 243, René Huyghe, Cézanne, Paris, 1936, pp. 21, 34, 53, fig. 17; R. H. Wilenski, Modern French Painters, New York [1940], p. 39; Erle Loran, Cézanne's Composition: Analysis of His Form with Diagrams and Photographs of His Motifs, Berkeley, 1943 [2nd ed., 1946], p. 57; Liliane Guerry, Cézanne et l'expression de l'espace, Paris, 1950, p. 27; Theodore Reff, "Cézanne: The Enigma of the Nude," Art News 58, November 1959, p. 29, ill.; Theodore Reff. "Cézanne's Constructive Stroke," Art Quarterly 25, autumn 1962, pp. 220–21, 225 nn. 16–17; Adrien Chappuis, Les dessins de Paul Cézanne au Cabinet des estampes du Musée des Beaux-Arts de Bâle, 2 vols., Olten, Switzerland, 1962, vol. 1, pp. 15, 61, 118, fig. 27; Kurt Badt, trans. Sheila Ann Ogilvie, The Art of Cézanne, Berkeley, 1965 [German ed., 1956], p. 191 n. 17; Wayne V. Andersen, "Cézanne, Tanguy, Chocquet," Art Bulletin 49, June 1967, p. 137; John Rewald, "Chocquet and Cézanne," Gazette des beaux-arts 74, July–August 1969, 6e pér., pp. 47, 49, 75, 83, no. 22, fig. 9; Sandra Orienti, L'Opera completa di Cézanne, Milan, 1970 [French ed., 1975; English ed., 1985], pp. 98–99, no. 261, ill.; Wayne Andersen, Cézanne's Portrait Drawings, Cambridge, Mass., 1970, p. 138; Adrien Chappuis, The Drawings of Paul Cézanne: A Catalogue Raisonné, 2 vols., Greenwich, Conn., 1973, vol. 1, pp. 117, 122; Karl-Heinz Janda and Annegret Janda, "Max Liebermann als Kunstsammler," Forschungen und Berichte 15, 1973, pp. 106, 116, 123, no. 4, pl. 14, fig. 4; John Rewald, "Some Entries for a New Catalogue Raisonné of Cézanne's Paintings," Gazette des beaux-arts 86, November 1975, 6e pér., pp. 158–59, ill.; T. J. Clark, The Painting of Modern Life, New York, 1984, pp. x, 19, fig. 7; Mary Tompkins Lewis, Cézanne's Early Imagery, Berkeley, 1989, pp. x, 204–5, 262 n. 21, pl. XVII (color); Mary Louise Krumrine et al., Paul Cézanne: The Bathers, exh. cat., Kunstmuseum Basel, 1990 [German ed., 1989], pp. 288, 294, fig. 230, p. 244, 288, 294, fig. 230; Ruth Berson, ed., The New Painting: Impressionism, 1874–1886: Documentation, 2 vols., San Francisco, 1996, vol. 1, p. 182; John Rewald in collaboration with Walter Feilchenfeldt and Jayne Warman, The Paintings of Paul Cézanne: A Catalogue Raisonné, 2 vols., New York, 1996, vol. 1, pp. 169–70, 197, 563, 566, 568–72, no. 237, vol. 2, p. 78, fig. 237, Gary Tinterow et al., "Recent Acquisitions, A Selection: 2001–2002," Metropolitan Museum of Art Bulletin 60, fall 2002, p. 31, color ill.

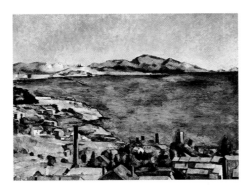

The Gulf of Marseilles Seen from L'Estaque
ca. 1885
Oil on canvas
28¾ x 39½ in. (73 x 100.3 cm)
H. O. Havemeyer Collection, Bequest of Mrs. H. O. Havemeyer, 1929
29.100.67
See no. 77

PROVENANCE
[Ambroise Vollard, Paris; sold to Havemeyer in June 1901]; Mr. and Mrs. H. O. Havemeyer, New York (1901–until his d. 1907); Mrs. H. O. (Louisine W.) Havemeyer, New York (1907–d. 1929)

EXHIBITIONS
"The H. O. Havemeyer Collection," Metropolitan Museum of Art, New York, March 10–November 2, 1930, no. 5; "Cézanne," Musée de l'Orangerie, Paris, May–October 1936, no. 43; "Cézanne: Paintings, Watercolors, and Drawings," Art Institute of Chicago, February 7–March 16, 1952, no. 49, Metropolitan Museum of Art, New York, April 4–May 18, 1952; "Metropolitan Museum Masterpieces," Hofstra College, Hempstead, N.Y., June 29–September 1, 1952, no. 32; "Masterpieces of Fifty Centuries," Metropolitan Museum of Art, New York, November 15, 1970–February 15, 1971, no. 383; "Impressionism: A Centenary Exhibition," Galeries Nationales du Grand Palais, Paris, September 21–November 24, 1974, Metropolitan Museum of Art, New York, December 12, 1974–February 10, 1975, no. 8; "A Day in the Country: Impressionism and the French Landscape," Los Angeles County Museum of Art, June 28–September 16, 1984, Art Institute of Chicago, October 23, 1984–January 6, 1985, Galeries Nationales du Grand Palais, Paris, February 4–April 22, 1985, no. 128; "Splendid Legacy: The Havemeyer Collection," Metropolitan Museum of Art, New York, March 27–June 20, 1993, no. A75; "Cézanne: Il padre dei moderni," Complesso del Vittoriano, Rome, March 7–July 21, 2002, unnumbered cat.

SELECTED REFERENCES
H. Kessler, Deutsche und französische Kunst, Leipzig [1913], p. 122; Frank Jewett Mather Jr., "The Havemeyer Pictures," The Arts 16, March 1930, pp. 450, 483; ill.; Harry B. Wehle, "The Exhibition of the H. O. Havemeyer Collection," Metropolitan Museum of Art Bulletin 25, March 1930, p. 58; H. O. Havemeyer Collection, Catalogue of Paintings, Prints, Sculpture, and Objects of Art, 1931, pp. 56–57, ill.; Lionello Venturi, "Cézanne," L'Arte 6, July 1935, pp. 302, 386, 391, fig. 15; Lionello Venturi, Cézanne: Son art—son oeuvre, 2 vols., Paris, 1936, vol. 1, pp. 53–54, 157, no. 429, vol. 2, pl. 122, no. 429; Douglas Lord, "Paul Cézanne," Burlington Magazine 69, July 1936, p. 35; Fritz Novotny, Cézanne, Vienna, 1937, pl. 37; "Cézanne après inventaire," Almanach des Arts, August 1937, p. 249, ill.; Fritz Novotny, Cézanne und das Ende der Wissenschaftlichen Perspektive, Vienna, 1938, p. 44 n. 38, p. 193; Robert J. Goldwater, "Cézanne in America: The Master's Paintings in American Collections," Art News 36, March 26, 1938, section I (The 1938 Annual), p. 154; Albert C. Barnes and Violette De Mazia, The Art of Cézanne, New York, 1939, pp. 342–43, 412, no. 101; Thomas Craven, ed., A Treasury of Art Masterpieces, from the Renaissance to the Present Day, New York, 1939, pp. 529–31, colorpl. 129; R. H. Wilenski, Modern French Painters, New York [1940], p. 76, pl. 20B; Erle Loran, Cézanne's Composition: Analysis of His Form with Diagrams and Photographs of His Motifs, Berkeley, 1943 [2nd ed., 1946], p. 58; Bryan Holme, ed., Masterpieces in Color at The Metropolitan Museum of Art, New York, 1945, p. 15, colorpl. LVII; Lionello Venturi, Painting and Painters: How to Look at a Picture, from Giotto to Chagall, New York, 1945, p. 185, fig. 42; Bernard Dorival, Cézanne, Paris, 1948, Fr. ed. [English ed., 1948], pp. 52–54, 72, 156–57, pl. 75; Fritz Novotny, Cézanne, New York, 1948, pl. 35; Liliane Guerry, Cézanne et l'expression de l'espace, Paris, 1950, pp. 88–92, 95–96, 102, fig. 17; Lionello Venturi,

trans. Francis Steegmuller, *Impressionists and Symbolists,* 2 vols., New York, 1947–50, vol. 2, 1950, pp. 132–33, fig. 130, ill.; Charles Sterling and Margaretta M. Salinger, *French Paintings: A Catalogue of the Collection of The Metropolitan Museum of Art,* 3 vols., New York, 1955–67, vol. 3, pp. 105–6, ill.; Lionello Venturi, *Four Steps Toward Modern Art: Giorgione, Caravaggio, Manet, Cézanne,* New York, 1956, pp. 70–72, ill. (frontis.); Robert William Ratcliffe, *Cézanne's Working Methods and Their Theoretical Background,* unpublished Ph.D. dissertation, Courtauld Institute of Art, London, 1960, p. 44; Lorenz Dittmann, "Zur Kunst Cézannes," *Festschrift Kurt Badt zum siebzigsten Geburtstage,* Berlin, 1961, p. 207, fig. 6; Jay M. Kloner, Theodore Reff, eds., *Cézanne Watercolors,* exh. cat., M. Knoedler and Co., New York, 1963, p. 29, under no. 15; Liliane Brion-Guerry, *Cézanne et l'expression de l'espace,* Paris, 1966, 2nd ed., pp. 112–17, 120–21, 130, 145, 216, pl. 24; Nello Ponente, *Cézanne,* [Milan, 1966], unpaginated, ill., colorpl. V; George Heard Hamilton, *Painting and Sculpture in Europe: 1880 to 1940,* Baltimore, 1967, pp. 20–21, pl. 8B; Margaretta M. Salinger, "Windows Open to Nature," *Metropolitan Museum of Art Bulletin* 27, summer 1968, n.s., p. 36, ill.; Richard W. Murphy et al., *The World of Cézanne: 1839–1906,* New York, 1968, pp. 127, 152, color ill.; Sandra Orienti, *L'Opera completa di Cézanne.* Milan, 1970 [French ed., 1975; English ed., 1985], p. 105, no. 422, ill.; Adrien Chappuis, *The Drawings of Paul Cézanne: A Catalogue Raisonné,* 2 vols., Greenwich, Conn., 1973, vol. 1, p. 120, under no. 338; John Rewald, "The Impressionist Brush," *Metropolitan Museum of Art Bulletin* 32, no. 3, 1973–74, pp. 37–38, 41, no. 24, ill.; William Gaunt, *Marine Painting: An Historical Survey,* Amsterdam, 1975, p. 204, fig. 225; William Rubin, ed., *Cézanne: The Late Work,* exh. cat., Museum of Modern Art, New York, 1977, p. 76; Howard Hibbard, *The Metropolitan Museum of Art,* New York, 1980, p. 430, fig. 787 (color); Judith Wechsler, *The Interpretation of Cézanne,* Ann Arbor, Mich., 1981, p. 50; John Rewald, *Paul Cézanne: The Watercolors, A Catalogue Raisonné,* Boston, 1983, p. 112, under no. 116; Richard Shiff, *Cézanne and the End of Impressionism,* Chicago, 1984, pp. 116–17, 119, 121, fig. 27; Charles S. Moffett, *Impressionist and Post-Impressionist Paintings in The Metropolitan Museum of Art,* New York, 1985, pp. 10, 188–89, 253, color ill.; John Rewald, *Cézanne: A Biography,* New York, 1986, pp. 155, 276, no. 155, ill.; Frances Weitzenhoffer, *The Havemeyers: Impressionism Comes to America,* New York, 1986, p. 256; Gary Tinterow et al., *The Metropolitan Museum of Art: Modern Europe,* New York, 1987, pp. 6, 49, colorpl. 30; Richard Kendall, ed., *Cézanne by Himself: Drawings, Paintings, Writings,* London, 1988, ill. p. 134 (color); Sidney Geist, *Interpreting Cézanne,* Cambridge, Mass., 1988, pp. 121–22, 248, 283, pl. 104; John Rewald with the research assistance of Frances Weitzenhoffer, *Cézanne and America: Dealers, Collectors, Artists, and Critics, 1891–1921,* Princeton, 1989, pp. 125, 128 n. 44, pp. 311, 347, fig. 69; Richard Verdi, *Cézanne and Poussin: The Classical Vision of Landscape,* exh. cat., National Gallery of Scotland, Edinburgh, 1990, p. 153; Hajo Düchting, *Paul Cézanne, 1839–1906: Natur wird Kunst,* Cologne, 1990 [English ed., 1999], pp. 12, 104, color ill.; Maria Teresa Benedetti, trans. Marie-Christine Gamberini, *Cézanne,* Paris, 1995 [Italian ed., 1995], pp. 124, 149, color ill.; Françoise Cachin et al., *Cézanne,* exh. cat., Philadelphia Museum of Art, 1996 [French ed., 1995], pp. 225, 574, fig. 1; John Rewald in collaboration with Walter Feilchenfeldt and Jayne Warman, *The Paintings of Paul Cézanne: A Catalogue Raisonné,* 2 vols., New York, 1996, vol. 1,

pp. 17, 412, 568, 570–72, no. 625, colorpl. 50, vol. 2, p. 211, fig. 625; A. G. Kostenevich, *Pol Sezann i russkii avangard nachala XX veka: Katalog,* exh. cat., State Hermitage Museum, St. Petersburg, 1998, p. 72

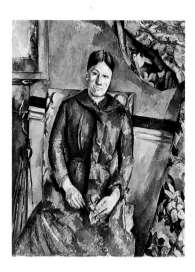

Madame Cézanne (Hortense Fiquet, 1850–1922) *in a Red Dress*
1888–90
Oil on canvas
45⅞ x 35¼ in. (116.5 x 89.5 cm)
The Mr. and Mrs. Henry Ittleson Jr. Purchase Fund, 1962
62.45
See no. 79

PROVENANCE
[Ambroise Vollard, Paris (about 1899–until 1904); bought from the artist, Stockbook A, no. 4175; transferred April 8, 1904, to Bernheim-Jeune, Paris; inv. no. 13621, sold to Pellerin on July 7, 1904]; Auguste Pellerin, Paris (1904–d. 1929); his son, Jean-Victor Pellerin, Paris (1929–62; sold to the Metropolitan Museum)

EXHIBITIONS
"Salon d'automne," Grand Palais des Champs-Élysées, Paris, October 1–22, 1907, no. 18; "Cézanne," Musée de l'Orangerie, Paris, spring 1936, no. 76; "Impressionism: A Centenary Exhibition," Metropolitan Museum of Art, New York, December 12, 1974–February 10, 1975, not in catalogue; "Cezanne: Gemälde," Kunsthalle Tübingen, January 16–May 2, 1993, no. 41; "Cézanne," Galeries Nationales du Grand Palais, Paris, September 25, 1995–January 7, 1996, Tate Gallery, London, February 8–April 28, 1996, Philadelphia Museum of Art, May 30–September 1, 1996, no. 167

SELECTED REFERENCES
[Ambroise Vollard], *Cézanne,* n.p. [191?], ill.; Julius Meier-Graefe, *Cézanne und sein Kreis,* Munich, 1918, p. 167, ill.; Gustave Coquiot, *Paul Cézanne,* Paris [1919], p. 238, ill. opp. p. 238; Julius Meier-Graefe, *Cézanne und sein Kreis: Ein Beitrag zur Entwicklungsgeschichte,* Munich, 1920, 3rd ed. [1st ed., 1918], ill. p. 167; Georges Rivière, *Le maître Paul Cézanne,* Paris, 1923, p. 216; Roger Fry, "Le développement de Cézanne," *L'Amour de l'art* 7, 1926, p. 408, ill.; Roger Fry, *Cézanne: A Study of His Development,*

New York, 1927, pp. 68–69, fig. 34, pl. XXIII; Julius Meier-Graefe, trans. John Holroyd-Reece, *Cézanne,* London, 1927, pl. LXVIII; Frantz Jourdain and Robert Rey, *Le Salon d'Automne,* Paris, 1928, rev. ed., p. 59; Roger Fry, "Cézannes Udvikling," *Samleren* 6, September 1929, ill. p. 131; Georges Rivière, *Cézanne: Le peintre solitaire,* Paris, 1933, p. 139, ill. p. 111; Gerstle Mack, *Paul Cézanne,* New York, 1935, pl. 17; Lionello Venturi, *Cézanne: Son art—son oeuvre,* 2 vols., Paris, 1936, vol. 1, p. 188, no. 570, vol. 2, pl. 182, no. 570; René Huyghe, *Cézanne,* Paris, 1936, pp. 44, 56, 59, fig. 28; Maurice Raynal, *Cézanne,* Paris, 1936, pl. LXX; Otto Benesch, "Cézanne: Zur 30.Wiederkehr seines Todestages am 22.Oktober," *Die Kunst* 75, December 1936, ill. p. 70; Fritz Novotny, *Cézanne,* Vienna, 1937, p. 8, pl. 63; Fritz Novotny, *Cézanne und das Ende der Wissenschaftlichen Perspektive,* Vienna, 1938, p. 87 n. 82; Albert C. Barnes and Violette De Mazia, *The Art of Cézanne,* New York, 1939, pp. 217, 373–74, 415, no. 133, ill.; Raymond Cogniat, *Cézanne,* Paris, 1939, pl. 87; Erle Loran, *Cézanne's Composition: Analysis of His Form with Diagrams and Photographs of His Motifs,* Berkeley, 1943 [2nd ed., 1946], pp. 85, 91; Liliane Guerry, *Cézanne et l'expression de l'espace,* Paris, 1950, pp. 10, 35, 67, 76, 93, 97, 103, 105–6, 110–11, 115–16, 171–74, fig. 20; Charles Sterling and Margaretta M. Salinger, *French Paintings: A Catalogue of the Collection of The Metropolitan Museum of Art,* 3 vols., New York, 1955–67, vol. 3, pp. 100, 109–11, ill.; Robert William Ratcliffe, *Cézanne's Working Methods and Their Theoretical Background,* unpublished Ph.D. dissertation, Courtauld Institute of Art, London, 1960, p. 18; Jean de Beucken, trans. Lothian Small, *Cézanne: A Pictorial Biography,* New York, 1962 [German ed., 1960], pp. 93, 137, ill.; Kurt Badt, trans. Sheila Ann Ogilvie, *The Art of Cézanne,* Berkeley, 1965 [German ed., 1956], p. 153; Anne H. van Buren, "Madame Cézanne's Fashions and the Dates of her Portraits," *Art Quarterly* 29, 1966, pp. 119, 121, 123; Jean Paris, "Espaces de Cézanne," *Cézanne,* n.p., 1966, pp. 167, 215, fig. 121; Sandra Orienti et al., *L'Opera completa di Cézanne,* Milan, 1970 [French ed., 1975; English ed., 1985], p. 112, no. 573, ill.; Wayne Andersen, *Cézanne's Portrait Drawings,* Cambridge, Mass., 1970, p. 43 n. 7; René Huyghe, *La relève du réel: La peinture française au XIXe siècle, impressionnisme, symbolisme,* Paris, 1974, p. 225; John Rewald, "Some Entries for a New Catalogue Raisonné of Cézanne's Paintings," *Gazette des beaux-arts* 86, November 1975, 6e pér., p. 166; William Rubin, ed., *Cézanne: The Late Work,* exh. cat., Museum of Modern Art, New York, 1977, pp. 77, 81, ill. [French ed., 1978, pp. 19, 22, ill.]; Judith Wechsler, *The Interpretation of Cézanne,* Ann Arbor, Mich., 1981, p. 39; John Rewald, *Paul Cézanne: The Watercolors, A Catalogue Raisonné,* Boston, 1983, pp. 26, 157, under no. 296, p. 174, under no. 375; Charles S. Moffett, *Impressionist and Post-Impressionist Paintings in The Metropolitan Museum of Art,* New York, 1985, pp. 11, 194–95, 254, color ill.; Rainer Maria Rilke, ed., trans. Joel Agee, *Letters on Cézanne,* New York, 1985, pp. 57–58; Ronald Pickvance et al., *Cézanne,* exh. cat., Isetan Museum of Art, Tokyo, 1986, p. 66, ill.; Richard R. Brettell, *Post-Impressionists,* Chicago, 1987, p. 65; Bob Kirsch, "Paul Cézanne: 'Jeune fille au piano' and Some Portraits of His Wife, An Investigation of His Painting of the Late 1870s," *Gazette des beaux-arts* 110, July–August 1987, 6e pér., p. 24; Richard Kendall, ed., *Cézanne by Himself: Drawings, Paintings, Writings,* London, 1988, pp. 171, 314, color ill.; Ettore Camesasca, *The São Paulo Collection: From Manet to Matisse,* Rijksmuseum Vincent van Gogh, Amsterdam, Milan, 1989, English ed., pp. 112, 116, ill.; Richard Verdi, "Tübingen:

Cézanne," *Burlington Magazine* 135, 1993, p. 296, fig. 53; Michael Kimmelman, "At the Met with Elizabeth Murray: Looking for the Magic in Painting," *New York Times,* October 21, 1994, p. C28, ill.; Isabelle Cahn, *Paul Cézanne,* Paris, 1995 [English ed., 1995], p. 81, color ill.; Françoise Cachin, "Un génie indéfinissable," *Connaissance des arts* 521, 1995, pp. 48–49, color ill.; John Rewald in collaboration with Walter Feilchenfeldt and Jayne Warman, *The Paintings of Paul Cézanne: A Catalogue Raisonné,* 2 vols., New York, 1996, vol. 1, pp. 17, 338, 340, 423, 427, 563, 568, 573, no. 655, colorpl. 25, vol. 2, p. 221, fig. 655; Richard Shone, "Cézanne," *Burlington Magazine* 138, May 1996, pp. 340, 342, fig. 39 (color); Michael Kimmelman, "At the Met with Wayne Thiebaud: A Little Weirdness Can Help an Artist Gain Cachet," *New York Times,* August 23, 1996, p. C25; John Golding, "Under Cézanne's Spell," *New York Review of Books* 43, January 11, 1996, pp. 46–47, color ill.; Görel Cavalli-Björkman et al., *Cézanne,* exh. cat., Nationalmuseum, Stockholm, 1997, p. 41, ill.; Richard Shiff, "La touche de Cézanne: Entre vision impressionniste et vision symboliste," *Cézanne aujourd'hui,* Musée d'Orsay, Paris, 1997, p. 119, fig. 30 (color); Katharina Schmidt et al., *Cézanne, Picasso, Braque: Der Beginn des kubistischen Stillebens,* exh. cat., Kunstmuseum Basel, Ostfildern-Ruit, 1998, p. 33, n. 36; Furuta Hirotoshi and Hidenori Kurita et al., *Cézanne and Japan,* exh. cat., Yokohama Museum of Art, Tokyo, 1999, p. 203 n. 15, pp. 209–11, n. 17; Felix Baumann et al., *Cézanne: Finished, Unfinished,* exh. cat., Kunstforum Wien, Ostfildern-Ruit, 2000, p. 168, fig. 2; Eliza E. Rathbone and George T. M. Shackelford, eds., *Impressionist Still Life,* exh. cat., Phillips Collection, New York, 2001, p. 36, ill.

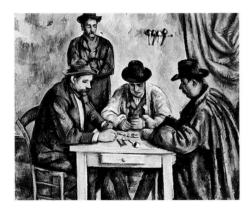

The Card Players
1890–92
Oil on canvas
25¾ x 32¼ in. (65.4 x 81.9 cm)
Bequest of Stephen C. Clark, 1960
61.101.1
See no. 80

PROVENANCE
[Ambroise Vollard, Paris (about 1899–until 1900); bought from the artist for 250 francs, Stockbook A, no. 3488; sold on February 19, 1900, for 4,500 francs to Bernheim-Jeune]; private collection of Josse and Gaston Bernheim-Jeune, Paris (1900–until 1930, when brothers divided collection); [Étienne Bignou,

Paris, 1931]; [Knoedler, New York, 1931, stock no. A1377; sold in August for $85,000 to Clark]; Stephen C. Clark, New York (1931–d. 1960)

EXHIBITIONS
"Exposition Cézanne," Bernheim-Jeune, Paris, January 10–22, 1910, no. 47; "Modern French Art," Grosvenor Gallery, London, 1914, no. 7; "Exposition de peinture moderne," Bernheim-Jeune, Paris, June 14–23, 1917, no. 4; "Französische Kunst des XIX. und XX. Jahrhunderts," Kunsthaus Zürich, October 5–November 14, 1917, no. 34; "Exposition Cézanne," Bernheim-Jeune, Paris, December 1–18, 1920, no. 14; "Rétrospective Paul Cézanne (1839–1906)," Bernheim-Jeune, Paris, June 1–30, 1926, no. 39; "Erste Sonderausstellung in Berlin," Galerien Thannhauser, Berliner Künstlerhaus, January 9–mid-February 1927, no. 29; "Cent ans de peinture française," Galerie Georges Petit, Paris, June 15–30, 1930, no. 28; "A Century of Progress," Art Institute of Chicago, June 1–November 1, 1933, no. 307; "Exhibition of French Painting from the Fifteenth Century to the Present Day," California Palace of the Legion of Honor, San Francisco, June 8–July 8, 1934, no. 68; "Modern Works of Art," Museum of Modern Art, New York, November 20, 1934–January 20, 1935, no. 6; "Cézanne," Musée de l'Orangerie, Paris, spring 1936, no. 83; "Exhibition of Masterpieces by Cézanne," Durand-Ruel, New York, March 29–April 16, 1938, no. 17; "Art in Our Time," Museum of Modern Art, New York, May 10–September 30, 1939, no. 62; "Modern Masters from European and American Collections," Museum of Modern Art, New York, January 26–March 24, 1940, no. 9; "Masterpieces of Art: European and American Paintings, 1500–1900," World's Fair, New York, May–October 1940, no. 340; "Paintings by Cézanne (1839–1906)," Paul Rosenberg and Co., New York, November 19–December 19, 1942, no. 14; "Art in Progress," Museum of Modern Art, New York, 1944, unnumbered cat.; "Paintings from the Stephen C. Clark Collection," Century Association, New York, June 6–September 28, 1946, unnumbered checklist; "Cézanne," Wildenstein and Co., Inc., New York, March 27–April 26, 1947, no. 45; "Cézanne: Paintings, Watercolors and Drawings," Art Institute of Chicago, February 7–March 16, 1952, Metropolitan Museum of Art, New York, April 4–May 18, 1952, no. 79; "A Collector's Taste: Selections from the Collection of Mr. and Mrs. Stephen C. Clark," M. Knoedler and Co., New York, January 12–30, 1954, no. 11; "Paintings from Private Collections," Museum of Modern Art, New York, May 31–September 5, 1955, unnumbered cat.; "Pictures Collected by Yale Alumni," Yale University Art Gallery, New Haven, May 8–June 18, 1956, no. 111; "Paintings from Private Collections: Summer Loan Exhibition," Metropolitan Museum of Art, New York, July 1– September 1, 1958, no. 14; "Paintings from Private Collections: Summer Loan Exhibition," Metropolitan Museum of Art, New York, July 7–September 7, 1959, no. 8; "Paintings from Private Collections: Summer Loan Exhibition," Metropolitan Museum of Art, New York, July 6–September 4, 1960, no. 13; "Cézanne," Phillips Collection, Washington, February 27–March 28, 1971, Art Institute of Chicago, April 17–May 16, 1971, Museum of Fine Arts, Boston, June 1–July 3, 1971, no. 18; "Paul Cézanne," Museo Español de Arte Contemporáneo, Madrid, March 8–April 30, 1984, no. 40; "From Delacroix to Matisse," State Hermitage Museum, Leningrad [St. Petersburg], March 15–May 10, 1988, Pushkin State Museum of Fine Arts, Moscow, June 10–July 30, 1988, no. 35; "The Clark Brothers Collect: Impressionist and Early Modern Paintings," Sterling and Francine Clark Art Institute, Williamstown, Mass., June 4–September 4, 2006,

Metropolitan Museum of Art, New York, May 22–August 19, 2007, unnumbered cat., fig. 181

SELECTED REFERENCES
Guillaume Apollinaire, "The Cézanne Exhibition," *Paris-Journal,* January 20, 1910; Marius-Ary Leblond, *Apollon* 1, no. 6, 1910, part 1, p. 99, ill. opp. p. 89; Fritz Burger, *Cézanne und Hodler: Einführung in die Probleme der Malerei der Gegenwart,* 2 vols., Munich, 1913, vol. 1, pp. 90–91, vol. 2, pl. 72; Charles Louis Borgmeyer, *The Master Impressionists,* Chicago, 1913, ill. p. 272; *Cézanne,* Paris, 1914, p. 71, pl. XLIII; Julius Meier-Graefe, *Entwicklungsgeschichte der modernen Kunst,* 3 vols., 1914–15, Munich, 2nd ed. [English ed., *Cézanne,* 1927], vol. 3, pl. 502; Ambroise Vollard, *Paul Cézanne,* Paris, 1919, p. 66; Jacques E. Blanche, *Quatre-vingts ans de peinture libre, 1880–1885,* Paris, 1920, p. 15, no. 3, ill.; André Fontainas, Louis Vauxcelles, Waldemar George et al., *Histoire générale de l'art français de la révolution à nos jours,* Paris, 1922, pp. 234–36, ill.; Georges Rivière, *Le maître Paul Cézanne,* Paris, 1923, p. 218, ill. opp. p. 168; Tristan-L. Klingsor [pseud. Léon Leclère], *Cézanne,* Paris, 1924, 2nd ed. [1st ed. 1923], p. 38, pl. 32; Lionello Venturi, *Il gusto dei primitivi,* Bologna, 1926, pp. 324–25, pl. 90; Roger Fry, *Cézanne: A Study of His Development,* New York, 1927, pp. 26, 71–72, fig. 36, pl. XXVI; Julius Meier-Graefe, "Die Franzosen in Berlin," *Der Cicerone* 19, January 1927, pp. 44, 56, ill.; Julius Meier-Graefe, trans. John Holroyd-Reece, *Cézanne,* London, 1927, p. 63, pl. XCVI; Max Osborn, "Klassiker der französischen Moderne die Galerien Thannhauser im Berliner Künstlerhaus," *Deutsche Kunst und Dekoration* 59, March 1927, pp. 336, 339, ill.; Emil Waldmann, *Die Kunst des Realismus und des Impressionismus im 19. Jahrhundert,* Berlin, 1927, pp. 105, 499, ill.; D. H. Lawrence, *The Paintings of D. H. Lawrence,* London [1929], unpaginated; Joachim Gasquet, *Cézanne,* Berlin, 1930, ill. opp. p. 12; C. J. Bulliet, *Art Masterpieces in a Century of Progress Fine Arts Exhibition at the Art Institute of Chicago,* 2 vols., Chicago, 1933, vol. 2, no. 62, ill.; Georges Rivière, *Cézanne: Le peintre solitaire,* Paris, 1933, pp. 137, 140, 145, ill.; "The Century of Progress Exhibition of the Fine Arts," *Bulletin of the Art Institute of Chicago* 27, April–May 1933, pp. 66, 68, ill.; Alfred M. Frankfurter, "Art in the Century of Progress," *Fine Arts* 20, June 1933, ill. p. 36; Lionello Venturi, "Cézanne," *L'Arte* 6, September 1935, n.s., p. 394, fig. 21; Lionello Venturi, *Cézanne: Son art—son oeuvre,* 2 vols., Paris, 1936, vol. 1, pp. 59, 185–86, no. 559, vol. 2, pl. 177, no. 559, René Huyghe, "Cézanne et son oeuvre," *L'Amour de l'art* 17, May 1936, fig. 65; Jacques de Laprade, "L'Exposition Cézanne à l'Orangerie," *Beaux-arts* 177, May 22, 1936, pp. 1–2, ill.; René Huyghe, *Cézanne,* Paris, 1936, pp. 44, 57–58, fig. 41; Ambroise Vollard, trans. Harold L. Van Doren, *Paul Cézanne: His Life and Art,* New York, 1937 [2nd English ed.], p. 47, pl. 6; Robert J. Goldwater, "Cézanne in America: The Master's Paintings in American Collections," *Art News* 36, March 26, 1938, section I (The 1938 Annual), pp. 145, 156, ill.; Alfred M. Frankfurter, "Cézanne: Intimate Exhibition," *Art News* 36, March 26, 1938, no. 26, section II, pp. 16, 30, ill.; Ambroise Vollard, *En écoutant Cézanne, Degas, Renoir,* Paris, 1938, p. 35; Alfred M. Frankfurter, "Cézanne in New York," *Burlington Magazine* 72, May 1938, p. 243; Albert C. Barnes and Violette De Mazia, *The Art of Cézanne,* New York, 1939, p. 87 n. 76, pp. 271, 364, 415, no. 125, ill.; James W. Lane, "Thirty-three Masterpieces in a Modern Collection: Mr. Stephen C. Clark's Paintings by American and European Masters," *Art News Annual* 37, 1939, pp. 133, 143, ill.; Erle Loran,

Cézanne's Composition: Analysis of His Form with Diagrams and Photographs of His Motifs, Berkeley, 1943 [2nd ed., 1946], p. 93; Edward Alden Jewell, Aimée Crane et al., French Impressionists and Their Contemporaries Represented in American Collections, New York, 1944, ill. p. 116; Edward Alden Jewell, Paul Cézanne, New York, 1944, ill. p. 46; Lionello Venturi, Paul Cézanne Water Colours, Oxford, 1944, 2nd ed. [1st ed., 1943], p. 19; John Rewald, The History of Impressionism, New York, 1946, ill. p. 410; Robert Witt et al., The Brothers Le Nain, exh. cat., Toledo Museum of Art, Toledo, 1947, unpaginated, ill.; Bernard Dorival, Cézanne, Paris, 1948, French ed. [English ed., New York, 1948], pp. 62–65, 166–67, pl. 125; John Rewald, Paul Cézanne: A Biography, New York, 1948, colorpl. III; Liliane Guerry, Cézanne et l'expression de l'espace, Paris, 1950, p. 196 n. 61; James M. Carpenter, "Cézanne and Tradition," Art Bulletin 33, September 1951, p. 179, fig. 6; ill.; Dora Panofsky, "Gilles or Pierrot? Iconographic Notes on Watteau," Gazette des beaux-arts 39, May–June 1952, 6e pér., p. 339, fig. 13; Theodore Rousseau Jr., "Cézanne as an Old Master," Art News 51, April 1952, pp. 29, 33, ill.; Theodore Rousseau Jr., The Metropolitan Museum of Art Miniatures: Paintings by Paul Cézanne, New York, vol. 35, 1952, unpaginated, color ill.; Bernard Berenson, Caravaggio: His Incongruity and His Fame, London, 1953, pp. 23–24, pl. 37; Lawrence Gowing, ed., An Exhibition of Paintings by Cézanne, exh. cat., Royal Scottish Academy Building, Edinburgh, 1954, unpaginated, under no. 52; Maurice Raynal, trans. James Emmons, Cézanne, Lausanne, 1954, pp. 9, 91, 99–100, color ill.; Douglas Cooper, "Two Cézanne Exhibitions—II," Burlington Magazine 96, December 1954, p. 380; Albert Châtelet, Hommage à Cézanne, exh. cat., Musée de l'Orangerie, Paris, 1954, pp. 21–22, under no. 55; Charles Sterling and Margaretta M. Salinger, French Paintings: A Catalogue of the Collection of The Metropolitan Museum of Art, 3 vols., New York, 1955–67, vol. 3, pp. 112–15, ill.; Henri Perruchot and Librairie Hachette, La vie de Cézanne, Paris, 1958, pp. 317–19; ill.; John Rewald, Cézanne, Geffroy et Gasquet suivi de souvenirs sur Cézanne de Louis Aurenche et de lettres inédites, Paris, 1959, p. 34, fig. 11; Alfred Frankfurter, "Midas on Parnassus," Art News Annual 28, 1959, p. 39, ill.; Yvon Taillandier, trans. Graham Snell, P. Cézanne, New York [196-], pp. 38, 54, 72, color ill.; Frank Elgar, Cézanne, New York [196-], pp. 136, 246, 279, fig. 87 (color); "Ninety-first Annual Report: Additions to the Collections," Metropolitan Museum of Art Bulletin 20, October 1961, pp. 42, 64, ill.; Klaus Demus et al., Paul Cézanne, 1839–1906, exh. cat., Österreichische Galerie, Oberes Belvedere, Vienna, 1961, p. 27, under no. 33; Michael Levey, A Concise History of Painting from Giotto to Cézanne, London, 1962, p. 310, colorpl. 548; Peter H. Feist, Paul Cézanne, Leipzig, 1963, pp. 33, 76, pl. 55; W. G. Constable, Art Collecting in the United States of America, London, 1964, p. 171, fig. 32; Kurt Badt, trans. Sheila Ann Ogilvie, The Art of Cézanne, Berkeley, 1965 [German ed., 1956], pp. 89, 93, 118–19, pl. 9; Pierre Cabanne et al., Cézanne, [Paris], 1966, pp. 238–39, 270, fig. 164; Margaretta M. Salinger, "Windows Open to Nature," Metropolitan Museum of Art Bulletin 27, summer 1968, n.s., p. 37, ill.; Richard W. Murphy et al., The World of Cézanne: 1839–1906, New York, 1968, pp. 110–11, color ill.; H. H. Arnason, History of Modern Art: Painting, Sculpture, Architecture, New York [1968], p. 46, fig. 44; Jack Lindsay, Cézanne: His Life and Art, Greenwich, Conn., 1969, pp. 246, 350, colorpl. II; Sandra Orienti, L'Opera completa di Cézanne, Milan, 1970 [French ed., 1975; English ed., 1985], p. 115, no. 634, ill.; Wayne Andersen, Cézanne's Portrait

Drawings, Cambridge, Mass., 1970, pp. 37, 39, 43 n. 2, pp. 229–30, fig. 31; Troels Andersen, ed., trans. Xenia Glowacki-Prus and Arnold McMillin, Essays on Art, 1915–33 [by] K.S. Malevich, New York, 1971, fig. 1; Leroy C. Breunig, ed., Apollinaire on Art: Essays and Reviews 1902–1918 by Guillaume Apollinaire, New York, 1972, p. 57; Adrien Chappuis, The Drawings of Paul Cézanne: A Catalogue Raisonné, 2 vols., Greenwich, Conn., 1973, vol. 1, p. 61, under no. 37, pp. 248–50, under nos. 1083, 1091–92; Fritz Erpel, Paul Cézanne, Berlin, 1973, pp. 42–43, no. 14, color ill.; René Huyghe, La relève du réel: La peinture française au XIXe siècle: Impressionnisme, symbolisme, Paris, 1974, fig. 185; Judith Wechsler, ed., "Cézanne in Perspective," Englewood Cliffs, N.J., 1975, pp. 91– 92; William Rubin, ed., Cézanne: The Late Work, exh. cat., Museum of Modern Art, New York, 1977, pp. 17, 30; Alan C. Birnholz, "On the Meaning of Kazimir Malevich's 'White on White,'" Art International 21, January 1977, p. 10, ill.; Bram Dijkstra, ed., A Recognizable Image: William Carlos Williams on Art and Artists, New York, 1978, p. 180, fig. 28; Howard Hibbard, The Metropolitan Museum of Art, New York, 1980, p. 430, fig. 795 (color); Theodore Reff, "Cézanne's 'Cardplayers' and Their Sources," Arts Magazine 55, November 1980, p. 106, fig. 4; Jean Arrouye, La Provence de Cézanne, Aix-en-Provence, 1982, pp. 68, 75, color ill.; John Rewald, Paul Cézanne: The Watercolors, A Catalogue Raisonné, Boston, 1983, pp. 175–77, under nos. 377–79; Bruno Ely et al., Cézanne au Musée d'Aix, Aix-en-Provence, 1984, p. 192, ill.; Charles S. Moffett, Impressionist and Post-Impressionist Paintings in The Metropolitan Museum of Art, New York, 1985, pp. 11, 198–99, 254, color ill.; John Rewald, Cézanne: A Biography, New York, 1986, pp. 200, 277, no. 200, color ill.; Ronald Pickvance et al., Cézanne, exh. cat., Isetan Museum of Art, Tokyo, 1986, p. 68, ill.; Gary Tinterow et al., The Metropolitan Museum of Art: Modern Europe, New York, 1987, p. 53, colorpl. 33; Dennis Farr and John House et al., Impressionist & Post-Impressionist Masterpieces: The Courtauld Collection, exh. cat., Cleveland Museum of Art, New Haven, 1987, unpaginated, under no. 26; Richard Kendall, ed., Cézanne by Himself: Drawings, Paintings, Writings, London, 1988, pp. 177, 315, color ill.; Fritz Erpel, Paul Cézanne, Berlin, 1988, p. 52, ill.; Hugo Düchting, Paul Cézanne 1839–1906: Natur wird Kunst, Cologne, 1990 [English ed., 1999], pp. 42, 156, 160, 222, color ill.; Mary Louise Krumrine et al., Paul Cézanne: The Bathers, exh. cat., Kunstmuseum Basel, Basel, 1990 [German ed., 1989], p. 258 n. 76, p. 259 n. 9, p. 260 n. 31, p. 265 n. 9; Seven Cézanne Paintings from the Auguste Pellerin Collection, Christie's, London, November 30, 1992, p. 46, fig. 1 (color); Götz Adriani and Walter Feilchenfeldt, Cézanne: Gemälde, exh. cat., Kunsthalle Tübingen, Cologne, 1993 [English ed., 1995], p. 201 n. 1; Charles Harrison et al., "Impressionism, Modernism and Originality," Modernity and Modernism: French Painting in the Nineteenth Century, New Haven, 1993, p. 155, pl. 146; Maria Teresa Benedetti, trans. Marie-Christine Gamberini, Cézanne, Paris, 1995 [Italian ed., 1995], pp. 171, 189, color ill.; Jean-Jacques Lévêque, Paul Cézanne: Le précurseur de la modernité, 1839–1906, Paris, 1995, p. 155, color ill.; Ulrike Becks-Malorny, Paul Cézanne 1839–1906: Wegbereiter der Moderne, Cologne, 1995, pp. 62–63, color ill.; Joyce Medina, Cézanne and Modernism: The Poetics of Painting, Albany, 1995, pp. 153–54, 158, 161, 228 n. 8; Stéphane Melchior-Durand, L'ABCdaire de Cézanne, Paris, 1995, p. 76; Françoise Cachin et al., Cézanne, exh. cat., Philadelphia Museum of Art, Philadelphia, 1996, pp. 335, 338, 345 [French ed., 1995]; John Rewald in collaboration with Walter Feilchenfeldt

and Jayne Warman, The Paintings of Paul Cézanne: A Catalogue Raisonné, 2 vols., New York, 1996, vol. 1, pp. 10, 369, 409, 444–45, 491, 495, 563, 566–72, no. 707, vol. 2, p. 243, fig. 707; Linda Nochlin, Cézanne's Portraits, Lincoln, Neb., 1996, p. 20; Ann Dumas et al., The Private Collection of Edgar Degas, exh. cat., Metropolitan Museum of Art, New York, 1997, pp. 213–14, fig. 291; Ten Paintings by Paul Cézanne formerly in the Auguste Pellerin Collection, Sotheby's, New York, November 13, 1997, pp. 13–14; Theodore Reff, "Cézanne et Chardin," Cézanne aujourd'hui, Musée d'Orsay, Paris, 1997, p. 18; Mary Louise Krumrine, "Les 'Joueurs de cartes' de Cézanne: Un jeu de la vie," Cézanne aujourd'hui, Musée d'Orsay, Paris, 1997, pp. 65–66, fig. 24 (color); Katharina Schmidt, ed., Cézanne, Picasso, Braque: Der Beginn des kubistischen Stillebens, exh. cat., Kunstmuseum Basel, Ostfildern-Ruit, 1998, p. 85, fig. 19, p. 149; Sylvie Patin, "Une étude peinte de Cézanne: 'Le joueur de cartes,' 1890–1892, donnée au Musée d'Orsay," Revue du Louvre et des musées de France 48, February 1998, p. 22; Nina Maria Athanassoglou-Kallmyer, Cézanne and Provence: The Painter in His Culture, Chicago, 2003, p. 210

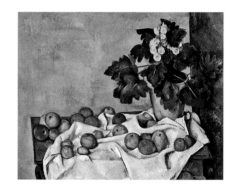

Still Life with Apples and a Pot of Primroses
ca. 1890
Oil on canvas
28¾ x 36⅜ in. (73 x 92.4 cm)
Bequest of Sam A. Lewisohn, 1951
51.112.1
See no. 76

PROVENANCE
[Julien (père) Tanguy, Paris]; Paul Helleu, Paris (until 1894; gift sent in late March via Durand-Ruel to Monet); Claude Monet, Giverny (1894–d. 1926); his son, Michel Monet, Giverny; [Paul Rosenberg, Paris]; [Bernheim-Jeune, Paris, and Knoedler Galleries, Paris and New York]; Adolph Lewisohn, New York (by 1929–d. 1938); his son, Sam A. Lewisohn, New York (1938–d. 1951)

EXHIBITIONS
"Cinquante ans de peinture française, 1875–1925," Musée des Arts Décoratifs, Paris, May 28–July 12, 1925, no. 12; "First Loan Exhibition: Cézanne, Gauguin, Seurat, van Gogh," Museum of Modern Art, New York, November 8–December 7, 1929, no. 29; "Cézanne, Gauguin," Toledo Museum of Art, June–

August 1935, unnumbered cat.; "Cézanne," Musée de l'Orangerie, Paris, May–October 1936, no. 70; "Exhibition of Masters of French 19th Century Painting," New Burlington Galleries, London, October 1–31, 1936, no. 89; "Chefs-d'oeuvre de l'art français," Palais National des Arts, Paris, July–September 1937, no. 253; "Exhibition of Masterpieces by Cézanne," Durand-Ruel, New York, March 29–April 16, 1938, no. 18; "Masterpieces of Art: European and American Paintings, 1500–1900," World's Fair, New York, May–October 1940, no. 346; "Art in Progress," Museum of Modern Art, New York, 1944, unnumbered cat. (ill. p. 24); "Cézanne," Wildenstein and Co., Inc., New York, March 27–April 26, 1947, no. 51; "The Lewisohn Collection," The Metropolitan Museum of Art, New York, November 2–December 2, 1951, no. 13; "Cézanne: Paintings, Watercolors, and Drawings; Art Institute of Chicago, February 7–March 16, 1952," Metropolitan Museum of Art, New York, April 4–May 18, 1952, no. 83; "Vier Eeuwen Stilleven in Frankrijk," Museum Boymans, Rotterdam, July 10–September 20, 1954, no. 109; "Masterpieces of Fifty Centuries," Metropolitan Museum of Art, New York, November 15, 1970–February 15, 1971, not in catalogue; "Corot to Cézanne: 19th Century French Paintings from The Metropolitan Museum of Art," Museum of Art, Fort Lauderdale, December 22, 1992–April 11, 1993, no catalogue

SELECTED REFERENCES

Paul Cézanne = Mappe, Munich, 1912, pl. 10; Stephan Bourgeois and Waldemar George, "The French Paintings of the XIXth and XXth Centuries in the Adolph and Samuel Lewisohn Collection," *Formes,* nos. 28–29, 1932, p. 301, ill. after p. 304; Lionello Venturi, *Cézanne: Son art—son oeuvre,* 2 vols., Paris, 1936, vol. 1, pp. 57, 194, no. 599; vol. 2, pl. 194, no. 599; Élie Faure, *Cézanne,* Paris [1936], fig. 40; Jacques de Laprade, "L'Exposition Cézanne à l'Orangerie," *Beaux-arts* 177, May 22, 1936, p. 2, ill. p. 10; René Huyghe, *Cézanne,* Paris, 1936, pp. 44, 48, 66, fig. 36; John Rewald, "Cézanne et son oeuvre," *L'Art sacré,* special number, May 1936, p. 8, fig. 15; ill.; Sam A. Lewisohn, *Painters and Personality: A Collector's View of Modern Art,* [New York], 1937, p. 37, pl. 18; Fritz Novotny, *Cézanne,* Vienna, 1937, pl. 74; Fritz Novotny, *Cézanne und das Ende der Wissenschaftlichen Perspektive,* Vienna, 1938, pp. 71–72 n. 64; Robert J. Goldwater, "Cézanne in America: The Master's Paintings in American Collections," *Art News* 36, March 26, 1938, section I (The 1938 Annual), p. 160, ill. p. 143; Alfred M. Frankfurter, "Cézanne: Intimate Exhibition," *Art News* 36, March 26, 1938, no. 26, section II, pp. 17, 30, ill.; Alfred M. Frankfurter, "Cézanne in New York," *Burlington Magazine* 72, May 1938, p. 243; Albert C. Barnes and Violette De Mazia, *The Art of Cézanne,* New York, 1939, pp. 72, 313 n. 23, pp. 363, 414, no. 121; Raymond Cogniat, *Cézanne,* Paris, 1939, pl. 78; Sam A. Lewisohn, "Personalities Past and Present," *Art News* 37, February 25, 1939, section I (The 1939 Annual), ill. p. 69; Alfred M. Frankfurter, "383 Masterpieces of Art," *Art News* 38, May 25, 1940 (The 1940 Annual), p. 66; ill.; Walt Kuhn, "Cézanne: Delayed Finale," *Art News* 46, April 1947, pp. 15–16, ill.; Bernard Dorival, *Cézanne,* Paris, 1948, French ed. [English ed., 1948], pp. 57, 161, pl. 98; Fritz Novotny, *Cézanne,* New York, 1948, pl. 68; Liliane Guerry, *Cézanne et l'expression de l'espace,* Paris, 1950, pp. 70, 99; Theodore Rousseau Jr. et al., *The Lewisohn Collection,* exh. cat., Metropolitan Museum of Art, New York, 1951, pp. 7–8, 13, 43, no. 13, ill.; Theodore Rousseau Jr., "Notes on the Cover," *Metropolitan Museum of Art Bulletin* 10, May 1952, inside front cover, ill. on

cover (color); Theodore Rousseau Jr., *The Metropolitan Museum of Art Miniatures: Paintings by Paul Cézanne,* New York, vol. 35, 1952, unpaginated, color ill.; Bernard Berenson, *Caravaggio: His Incongruity and His Fame,* London, 1953, pp. 23–24; Theodore Rousseau Jr., "A Guide to the Picture Galleries," *Metropolitan Museum of Art Bulletin* 12, January 1954, n.s., part 2, ill. p. 53; Lawrence Gowing, ed., *An Exhibition of Paintings by Cézanne,* exh. cat., Royal Scottish Academy Building, Edinburgh, 1954, unpaginated, under no. 40; Maurice Raynal, trans. James Emmons, *Cézanne,* Lausanne, 1954, p. 85, color ill.; Charles Sterling and Margaretta M. Salinger, *French Paintings: A Catalogue of the Collection of The Metropolitan Museum of Art,* 3 vols., New York, 1955–67, vol. 3, pp. 102–4, ill.; Howard Fussiner, "Organic Integration in Cézanne's Painting," *College Art Journal* 15, summer 1956, pp. 304–8, 310–11, fig. 2; Michel Faré, *La nature morte en France,* 2 vols., Geneva, 1962, vol. 2, fig. 499; Margaretta M. Salinger, "Windows Open to Nature," *Metropolitan Museum of Art Bulletin* 27, summer 1968, n.s., p. 40, color ill.; Richard W. Murphy et al., *The World of Cézanne: 1839–1906,* New York, 1968, p. 134, color ill.; Paulette Howard-Johnston "Une visite à Giverny en 1924," *L'Oeil* 171, March 1969, p. 30, color ill.; Sandra Orienti, *L'Opera completa di Cézanne,* Milan, 1970 [French ed., 1975; English ed., 1985], pp. 123–24, no. 822, ill.; Bernard Dunstan, *Painting Methods of the Impressionists,* New York, 1976, p. 94, color ill. [rev. ed. 1983, pp. 94–95]; John Rewald, *Paul Cézanne: The Watercolors, A Catalogue Raisonné,* Boston, 1983, p. 221, under no. 542; Charles S. Moffett, *Impressionist and Post-Impressionist Paintings in The Metropolitan Museum of Art,* New York, 1985, pp. 11, 184–85, 253, color ill.; Mary Louise Krumrine, et al., *Paul Cézanne: The Bathers,* exh. cat., Kunstmuseum Basel, Basel, 1990 [German ed., 1989], p. 302 n. 63; Götz Adriani and Walter Feilchenfeldt, *Cézanne: Gemälde,* exh. cat., Kunsthalle Tübingen, Cologne, 1993 [English ed., 1995], pp. 114 n. 2, 178 n. 1; Jean-Marie Baron and Pascal Bonafoux, *Cézanne: Les natures mortes,* Paris, 1993, pp. 38–39, color ill.; Charles F. Stuckey, *Claude Monet, 1840–1926,* exh. cat., Art Institute of Chicago, 1995, p. 225; Françoise Cachin et al., *Cézanne,* Philadelphia Museum of Art, exh. cat., Philadelphia, 1996 [French ed., 1995], pp. 99, n. 2, 567, 571; John Rewald in collaboration with Walter Feilchenfeldt and Jayne Warman, *The Paintings of Paul Cézanne: A Catalogue Raisonné,* 2 vols., New York, 1996, vol. 1, pp. 434, 567–70, no. 680, vol. 2, p. 233, fig. 680

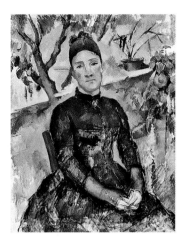

Madame Cézanne (Hortense Fiquet, 1850–1922) *in the Conservatory*
1891
Oil on canvas
36¼ x 28¾ in. (92.1 x 73 cm)
Bequest of Stephen C. Clark, 1960
61.101.2
See no. 78

PROVENANCE
[Ambroise Vollard, Paris]; Auguste Pellerin, Paris (probably by 1899, until at least 1907); [Ambroise Vollard, Paris (by 1911); sold with another Cézanne for 50,000 francs on April 28, 1911 to Morozov]; Ivan Abramovich Morozov, Moscow (1911–18); Museum of Modern Western Art, Moscow (1918–33); [sold c/o Knoedler to Clark on May 9, 1933]; Stephen C. Clark, New York (1933–d. 1960)

EXHIBITIONS
"Exposition Paul Cézanne," Galerie Vollard, Paris, November–December 1895, no catalogue; "Salon d'automne," Grand Palais des Champs-Élysées, Paris, October 1–22, 1907, no. 25; "III. Ausstellung," Paul Cassirer, Berlin, November 17–December 12, 1909, no. 17; "Paul Cézanne (1839–1906), Vincent van Gogh (1853–1890)," Museum of Modern Western Art, Moscow, 1926, no. 15; "A Century of Progress," Art Institute of Chicago, June 1–November 1, 1934, no. 296; "Modern Works of Art," Museum of Modern Art, New York, November 20, 1934–January 20, 1935, no. 5; "French Masterpieces of the Nineteenth Century," Century Club, New York, January 11–February 10, 1936, no. 17; "Twentieth Anniversary Exhibition," Cleveland Museum of Art, June 26–October 4, 1936, no. 254; "Paul Cézanne: Exhibition of Paintings, Water-colors, Drawings, and Prints," San Francisco Museum of Art, September 1–October 4, 1937, no. 27; "Exhibition of Masterpieces by Cézanne," Durand-Ruel, New York, March 29–April 16, 1938, no. 16; "Art in Our Time," Museum of Modern Art, New York, May 10–September 30, 1939, no. 60; "Masterpieces of Art: European and American Paintings, 1500–1900," World's Fair, New York, May–October 1940, no. 341; "Paintings by Cézanne (1839–1906)," Paul Rosenberg and Co., New York, November 19–December 19, 1942, no. 15; "Paintings from the Stephen C. Clark Collection," Century Association, New York, June 6–September 28, 1946, unnumbered checklist; "Cézanne," Wildenstein and Co., Inc., New York, March 27–April 26, 1947, no. 48; "To Honor Henry McBride: An Exhibition of Paintings, Drawings, and Water Colors," M. Knoedler Galleries, New York, November 29–December 17, 1949, no. 2; "Cézanne: Paintings, Watercolors, and Drawings," Art Institute of Chicago, February 7–March 16, 1952, Metropolitan Museum

of Art, New York, April 4–May 18, 1952, no. 68; "A Collector's Taste: Selections from the Collection of Mr. and Mrs. Stephen C. Clark," M. Knoedler and Co., New York, January 12–30, 1954, no. 12; "Paintings from Private Collections," Museum of Modern Art, New York, May 31–September 5, 1955, unnumbered cat.; "Paintings from Private Collections: Summer Loan Exhibition," Metropolitan Museum of Art, New York, July 1–September 1, 1958, no. 16; "Paintings from Private Collections: Summer Loan Exhibition," Metropolitan Museum of Art, New York, July 7–September 7, 1959, no. 9; "Paintings, Drawings, and Sculpture Collected by Yale Alumni," Yale University Art Gallery, New Haven, May 19–June 26, 1960, no. 76; "Paintings from Private Collections: Summer Loan Exhibition," Metropolitan Museum of Art, New York, July 6–September 4, 1960, no. 9; "Masterpieces of Painting in Metropolitan Museum of Art," Museum of Fine Arts, Boston, September 16– November 1, 1970, unnumbered cat. (p. 82); "Masterpieces of Fifty Centuries," Metropolitan Museum of Art, New York, November 15, 1970– February 15, 1971, not in catalogue; "Impressionism: A Centenary Exhibition," Metropolitan Museum of Art, New York, December 12, 1974–February 10, 1975, not in catalogue; "Capolavori impressionisti dei musei americani," Museo di Capodimonte, Naples, December 3, 1986–February 1, 1987, Pinacoteca di Brera, Milan, March 4–May 3, 1987, no. 7; "Treasures from The Metropolitan Museum of Art: French Art from the Middle Ages to the Twentieth Century," Yokohama Museum of Art, March 25–June 4, 1989, no. 92; "Morozov and Shchukin—The Russian Collectors: Monet to Picasso," Museum Folkwang, Essen, June 25–October 31, 1993, Pushkin State Museum of Fine Arts, Moscow, November 30, 1993–January 30, 1994, State Hermitage Museum, St. Petersburg [Leningrad], February 16–April 16, 1994, no. 34; "Cézanne," Nationalmuseum, Stockholm, October 17, 1997– January 11, 1998, no. 7; "The Clark Brothers Collect: Impressionist and Early Modern Paintings," Metropolitan Museum of Art, New York, May 22–August 19, 2007, unnumbered cat., fig. 182

SELECTED REFERENCES

Julius Meier-Graefe, *Impressionisten,* Munich, 1907, 2nd ed., ill. p. 201; Julius Meier-Graefe, *Paul Cézanne,* Munich, 1910, 3rd ed., rev. and expanded, ill. p. 46; Sergei Makovskii, "French Artists in the Morosoff Collection," *Apollon* 1, nos. 3–4, 1912, part 1, p. 23, ill. after p. 28; Jean Royère, "Paul Cézanne, Erinnerungen," *Kunst und Künstler* 10, July 1912, ill. p. 479; Fritz Burger, *Cézanne und Hodler: Einführung in die Probleme der Malerei der Gegenwart,* 2 vols., Munich, 1913, vol. 1, pp. 86–87; vol. 2, pl. 69; Ambroise Vollard, *Paul Cézanne,* Paris, 1914 [English ed., 1923], p. 58, pl. 24; Julius Meier-Graefe, *Entwicklungsgeschichte der modernen Kunst,* 3 vols., 1914–15, Munich, 1915, vol. 3, 2nd ed. [English ed., *Cézanne,* 1927], pl. 497; Roger Fry, "'Paul Cézanne' by Ambroise Vollard," *Burlington Magazine* 31, August 1917, p. 61, pl. 3; Max Deri, *Die Malerei im XIX. Jahrhundert,* 2 vols., Berlin, 1920, vol. 1, pp. 201–3, vol. 2, pl. 46; Georges Rivière, *Le maître Paul Cézanne,* Paris, 1923, p. 218; [Boris Nikolaevich] Ternovietz, "Le Musée d'Art Moderne de Moscou," *L'Amour de l'art* 6, 1925, p. 470, ill. p. 473; Paul Ettinger, "Die modernen Franzosen in den Kunstsammlungen Moskaus," *Der Cicerone* 18, no. 4, 1926, p. 111, ill. p. 114; Julius Meier-Graefe, trans. John Holroyd-Reece, *Cézanne,* London, 1927, p. 63, pl. XCIII; Christian Zervos, "Idéalisme et Naturalisme dans la peinture moderne, II.—Cézanne, Gauguin, Van Gogh," *Cahiers d'art* 2, 1927, ill. p. 333; *Musée d'Art Moderne de Moscou: Catalogue illustré,* Moscow, 1928, p. 98, no. 560, pl. 25; Louis

Réau, *Catalogue de l'art français dans les musées russes,* Paris, 1929, p. 100, no. 742; Joachim Gasquet, *Cézanne,* Berlin, 1930, ill. opp. p. 148; John Becker, "The Museum of Modern Western Painting in Moscow—Part I," *Creative Art* 10, March 1932, pp. 195, 200, ill.; Georges Rivière, *Cézanne: Le peintre solitaire,* Paris, 1933, p. 145; *Art News* 32, May 12, 1934, ill. p. 3; *Bulletin of the Art Institute of Chicago* 28, April–May 1934, pp. 51–52, ill.; Gerstle Mack, *Paul Cézanne,* New York, 1935, p. 341; Lionello Venturi, "Cézanne," *L'Arte* 6, September 1935, n.s., pp. 393– 94, pl. IX, fig. 19; Lionello Venturi, *Cézanne: Son art—son oeuvre,* 2 vols., Paris, 1936, vol. 1, pp. 60–61, 188, no. 569, vol. 2, pl. 181, no. 569, Charles Sterling, *Cézanne,* exh. cat., Musée de l'Orangerie, Paris, 1936, p. 146, under no. 160; Alfred M. Frankfurter, "French Masterpieces, 1850–1900: An Important Loan Exhibition of Painting Current at the Century Club," *Art News* 34, February 1, 1936, p. 6, ill. on cover; Robert J. Goldwater, "Cézanne in America: The Master's Paintings in American Collections," *Art News* 36, March 26, 1938, section I (The 1938 Annual), p. 156, ill. on cover (color); Alfred M. Frankfurter, "Cézanne: Intimate Exhibition," *Art News* 36, March 26, 1938, no. 26, section II, p. 17, ill. p. 15; Alfred M. Frankfurter, "Cézanne in New York," *Burlington Magazine* 72, May 1938, p. 243; Thomas Craven, ed., *A Treasury of Art Masterpieces, from the Renaissance to the Present Day,* New York, 1939, pp. 533–35, colorpl. 130; James W. Lane, "Thirty-three Masterpieces in a Modern Collection: Mr. Stephen C. Clark's Paintings by American and European Masters," *Art News Annual* 37, 1939, pp. 133, 138, ill.; John Rewald, *Cézanne: Sa vie, son oeuvre, son amitié pour Zola,* Paris, 1939, p. 346; R. H. Wilenski, *Modern French Painters,* New York [1940], p. 346; Alfred M. Frankfurter, "383 Masterpieces of Art," *Art News* 38, May 25, 1940 (The 1940 Annual), pp. 39, 64, color ill.; Lionello Venturi, "Cézanne, Fighter for Freedom," *Art News* 41, November 15–30, 1942, pp. 18–19, color ill.; Evelyn Marie Stuart, "Editor's Letters," *Art News* 41, January 15–31, 1943, p. 4; Edward Alden Jewell, Aimée Crane et al., *French Impressionists and Their Contemporaries Represented in American Collections,* New York, 1944, ill. p. 135 (color); Göran Schildt, *Cézanne,* Stockholm, 1946, fig. 24; Bernard Dorival, *Cézanne,* Paris, 1948, French ed. [English ed., New York, 1948], pp. 59, 61, 163–64, pl. 112; Alonzo Lansford, "Clark Collection Shown for Charity," *Art Digest* 22, March 15, 1948, p. 9; ill.; Lionello Venturi, trans. Francis Steegmuller, *Impressionists and Symbolists,* 2 vols., 1947–50, New York, vol. 2, pp. 134–35, fig. 134; "L'Art moderne français dans les collections des musées étrangers—I. Musée d'Art Moderne Occidental à Moscou," *Cahiers d'art* 25, no. 2, 1950, p. 338, no. 16; Marion Downer, *Paul Cézanne,* New York, 1951, unpaginated, ill.; James M. Carpenter, "Cézanne and Tradition," *Art Bulletin* 33, September 1951, p. 182; Meyer Schapiro, *Paul Cézanne,* New York, 1952, pp. 82–83, ill.; Theodore Rousseau Jr., *The Metropolitan Museum of Art Miniatures: Paintings by Paul Cézanne,* New York, vol. 35, 1952, unpaginated, color ill.; Theodore Rousseau Jr., *Paul Cézanne (1839–1906),* New York, 1953, unpaginated, colorpl. 21; Maurice Raynal, trans. James Emmons, *Cézanne,* Lausanne, 1954, ill. p. 87 (color); Charles Sterling and Margaretta M. Salinger, *French Paintings: A Catalogue of the Collection of The Metropolitan Museum of Art,* 3 vols., New York, 1955–67, vol. 3, pp. 100–102, 109, ill.; Lionello Venturi, *Four Steps Toward Modern Art: Giorgione, Caravaggio, Manet, Cézanne,* New York, 1956, p. 72, fig. 29; Frank Elgar, *Cézanne,* New York [196–], pp. 152, 158, 279, fig. 91; "Ninety-first Annual Report: Additions to the

Collections," *Metropolitan Museum of Art Bulletin* 20, October 1961, p. 64, frontis. (color); Peter H. Feist, *Paul Cézanne,* Leipzig, 1963, pp. 17, 32, 76, pl. 47; Kurt Badt, trans. Sheila Ann Ogilvie, *The Art of Cézanne,* Berkeley, 1965 [German ed., 1956], p. 187; Anne H. van Buren, "Madame Cézanne's Fashions and the Dates of Her Portraits," *Art Quarterly* 29, 1966, pp. 118–21, 123–24 nn. 5, 17, 18, p. 127 n. 18, fig. 12; Margaretta M. Salinger, "Windows Open to Nature," *Metropolitan Museum of Art Bulletin* 27, summer 1968, n.s., pp. 38–39, ill.; Richard W. Murphy et al., *The World of Cézanne: 1839–1906,* New York, 1968, pp. 104–5, color ill. and ill. on slipcase; Jack Lindsay, *Cézanne: His Life and Art,* Greenwich, Conn., 1969, p. 351, fig. 76; Sandra Orienti, *L'Opera completa di Cézanne,* Milan, 1970 [French ed., 1975; English ed., 1985], p. 112, no. 569, ill.; Wayne Andersen, *Cézanne's Portrait Drawings,* Cambridge, Mass., 1970, p. 98, under no. 70; Leland Bell et al., "The Metropolitan Museum, 1870–1970– 2001," *Art News* 68, January 1970, pp. 38–39, color ill.; Marcel Brion, trans. Maria Paola De Benedetti, *Paul Cézanne,* Milan, 1972, p. 49, color ill.; Adrien Chappuis, *The Drawings of Paul Cézanne: A Catalogue Raisonné,* 2 vols., Greenwich, Conn., 1973, vol. 1, p. 246, under no. 1068; John Rewald, "The Impressionist Brush," *Metropolitan Museum of Art Bulletin* 32, no. 3, 1973–74, pp. 40– 41, 46, no. 26, ill.; René Huyghe, *La relève du réel: La peinture française au XIXe siècle, Impressionnisme, symbolisme,* Paris, 1974, p. 435; Judith Wechsler, ed., *Cézanne in Perspective,* Englewood Cliffs, N.J., 1975, fig. 11; Sidney Geist, "The Secret Life of Paul Cézanne," *Art International* 19, November 20, 1975, pp. 13–14, ill.; Bernard Dunstan, "Notes on Painting from the Model," *American Artist* 39, 1975, p. 37, color ill.; Alice Bellony-Rewald, *The Lost World of the Impressionists,* London, 1976, p. 227; Vivian Endicott Barnett, *The Guggenheim Museum: Justin K. Thannhauser Collection,* New York, 1978, p. 33; Lionello Venturi, trans. R. Skira, *Cézanne,* Geneva, 1978, pp. 113, 115, color ill.; Joyce E. Brodsky, "Cézanne and the Image of Confrontation," *Gazette des beaux-arts* 92, September 1978, 6e pér., p. 85; Howard Hibbard, *The Metropolitan Museum of Art,* New York, 1980, pp. 429–30, fig. 789 (color); Albert Elsen, *Purposes of Art,* New York, 1981, 4th ed. [1st ed., 1962], p. 326, ill.; John Rewald, *Paul Cézanne: The Watercolors, A Catalogue Raisonné,* Boston, 1983, p. 132, under no. 194; Bruno Ely et al., *Cézanne au Musée d'Aix,* Aix-en-Provence, 1984, pp. 192, 195, 221, ill.; Charles S. Moffett, *Impressionist and Post-Impressionist Paintings in The Metropolitan Museum of Art,* New York, 1985, pp. 11, 182–83, 253, color ill.; John Rewald, *Cézanne: A Biography,* New York, 1986, pp. 191, 277, no. 191, color ill.; Gary Tinterow et al., *The Metropolitan Museum of Art: Modern Europe,* New York, 1987, p. 53, colorpl. 32; Sidney Geist, *Interpreting Cézanne,* Cambridge, Mass., 1988, p. 164, pl. 134; Ettore Camesasca, *The São Paulo Collection: From Manet to Matisse,* exh. cat., Rijksmuseum Vincent van Gogh, Amsterdam, Milan, 1989 [English ed.], p. 112, ill.; Hugo Düchting, *Paul Cézanne 1839–1906: Natur wird Kunst,* Cologne, 1990 [English ed., 1999], pp. 155, 157, color ill.; Mary Louise Krumrine, Christian Geelhaar et al., *Paul Cézanne: The Bathers,* exh. cat., Kunstmuseum Basel, Basel, 1990 [German ed., 1989], p. 258 n. 85, p. 302 n. 113; Götz Adriani and Walter Feilchenfeldt, *Cézanne: Gemälde,* exh. cat., Kunsthalle Tübingen, Cologne, 1993 [English ed., 1995], p. 310 n. 35; Maria Teresa Benedetti, trans. Marie-Christine Gamberini, *Cézanne,* Paris, 1995 [Italian ed., 1995], pp. 170, 187, color ill.; Jean-Jacques Lévêque, *Paul Cézanne: Le précurseur de la modernité, 1839–1906,*

Paris, 1995, p. 115, color ill.; Françoise Cachin et al., *Cézanne*, exh. cat., Philadelphia Museum of Art, Philadelphia, 1996, pp. 272, 575, fig. 2 [French ed., 1995]; Linda Nochlin, "Cézanne: Studies in Contrast," *Art in America* 84, June 1996, p. 66; John Rewald in collaboration with Walter Feilchenfeldt and Jayne Warman, *The Paintings of Paul Cézanne: A Catalogue Raisonné*, 2 vols., New York, 1996, vol. 1, pp. 441–42, 562–63, 567–72, no. 703, vol. 2, p. 241, fig. 703; Linda Nochlin, *Cézanne's Portraits*, Lincoln, Neb., 1996, p. 19; Görel Cavalli-Björkman, "Cézanne i blickpunkten: Focus on Cézanne," *Art Bulletin of Nationalmuseum Stockholm* 4, 1997, pp. 53–54, ill.; Mary Tompkins Lewis, *Cézanne*, London, 2000, pp. 240, 242–243, 252, fig. 149 (color); Felix Baumann et al., *Cézanne: Finished, Unfinished*, exh. cat., Kunstforum Wien, Ostfildern-Ruit, 2000, pp. 52–54, 156, fig. 18; Albert Kostenewitsch et al., *Die russische Avantgarde und Paul Cézanne*, exh. cat., Gustav-Lübcke-Museum, Bönen, 2002, pp. 16, 25; Philippe Cros, *Paul Cézanne*, Paris, 2002, pp. 157, 164, color ill.; Nina Maria Athanassoglou-Kallmyer, *Cézanne and Provence: The Painter in His Culture*, Chicago, 2003, pp. 48–50, fig. 1.37 (color)

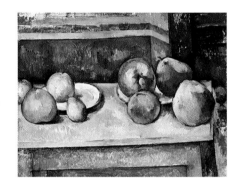

Still Life with Apples and Pears
ca. 1891–92
Oil on canvas
17⅝ x 23⅛ in. (44.8 x 58.7 cm)
Bequest of Stephen C. Clark, 1960
61.101.3
See no. 74

PROVENANCE
[Ambroise Vollard, Paris (about 1899–until 1900), bought from the artist for 150 francs, Stockbook A, no. 3361; sold for 2,000 francs on April 14, 1900, to Emil Heilbuth, Berlin for Cassirer]; [Bruno and Paul Cassirer, Berlin, 1900–1901]; [Paul Cassirer, Berlin, 1901–2]; his ex-wife, Lucie Ceconi, Berlin (1902–12; sold March 22, 1912, to Bernheim-Jeune]; private collection of J. and G. Bernheim-Jeune, Paris (1912–until at least 1926]; [Galerie E. Bignou, Paris]; [Reid & Lefevre, London, until 1929]; [Knoedler, New York, 1929; sold December 26 to Clark]; Stephen C. Clark, New York (1929–d. 1960)

EXHIBITIONS
"Group exhibition," Bruno and Paul Cassirer, Berlin, November 2–December 1, 1900, no. 12; "Exposition Cézanne," Bernheim-Jeune, Paris, December 1–18, 1920, no. 17; "Exposition d'oeuvres des XIXe et XXe siècles," Bernheim-Jeune, Paris, June–July 1925,

no. 14; "Trente ans d'art indépendant: 1884–1914," Société des Artistes Indépendants, Grand Palais des Champs-Elysées, Paris, February 20–March 21, 1926, no. 2875; "Rétrospective Paul Cézanne (1839–1906)," Bernheim-Jeune, Paris, June 1–30, 1926, no. 47 (probably this work); "Peintures des écoles impressionniste et néo-impressionniste," location unknown, Lucerne, February 1929, no. 1; "Masterpieces by Nineteenth Century French Painters," Lefevre Fine Art Ltd., London, June 1929, no. 1; "Ten Masterpieces by Nineteenth Century French Painters," Lefevre Gallery, Glasgow, 1929, no. 1; "Summer Exhibition, Retrospective," Museum of Modern Art, New York, June 15–late September, 1930, no. 22; "Chardin and the Modern Still Life," Marie Harriman Gallery, New York, November 1936, no. 13; "Summer Exhibition," Museum of Modern Art, New York, June–November 1937, no catalogue; "Cézanne: Centennial Exhibition, 1839–1939," Marie Harriman Gallery, New York, November 7–December 2, 1939, no. 11; "Jardin d'été," Coordinating Council of French Relief Societies, New York, May 3–31, 1944, unnumbered checklist; "Paintings from the Stephen C. Clark Collection," Century Association, New York, June 6–September 28, 1946, unnumbered checklist; "A Collector's Taste: Selections from the Collection of Mr. and Mrs. Stephen C. Clark," M. Knoedler and Co., New York, January 12–30, 1954, no. 9; "Pictures Collected by Yale Alumni," Yale University Art Gallery, New Haven, May 8–June 18, 1956, no. 109; "Paintings from Private Collections: Summer Loan Exhibition," Metropolitan Museum of Art, New York, July 1–September 1, 1958, no. 15; "Paintings from Private Collections: Summer Loan Exhibition," Metropolitan Museum of Art, New York, July 7–September 7, 1959, no. 12; "Paintings from Private Collections: Summer Loan Exhibition," Metropolitan Museum of Art, New York, July 6–September 4, 1960, no. 12; "Impressionism: A Centenary Exhibition," Metropolitan Museum of Art, New York, December 12, 1974–February 10, 1975, not in catalogue; "Franse meesters uit het Metropolitan Museum of Art: Realisten en Impressionisten," Rijksmuseum Vincent van Gogh, Amsterdam, March 15–May 31, 1987, no. 24; "The Clark Brothers Collect: Impressionist and Early Modern Paintings," Sterling and Francine Clark Art Institute, Williamstown, Mass., June 4–September 4, 2006, Metropolitan Museum of Art, New York, May 22–August 19, 2007, unnumbered cat., fig. 123

SELECTED REFERENCES
L'Art moderne et quelques aspects de l'art d'autrefois: Cent-soixante-treize planches d'après la collection privée de MM. J. and G. Bernheim-Jeune, 2 vols., Paris, 1919, vol. 1, pl. 29; *Bulletin de la vie artistique* 7, March 15, 1926, ill. (frontis.); Lionello Venturi, *Cézanne: Son art—son oeuvre*, 2 vols., Paris, 1936, vol. 1, p. 173, no. 502, vol. 2, pl. 155, no. 502; Robert J. Goldwater, "Cézanne in America: The Master's Paintings in American Collections," *Art News* 36, March 26, 1938, section I (The 1938 Annual), p. 158; James W. Lane, "Thirty-three Masterpieces in a Modern Collection: Mr. Stephen C. Clark's Paintings by American and European Masters," *Art News Annual* 37, 1939, p. 133; Erle Loran, *Cézanne's Composition: Analysis of His Form with Diagrams and Photographs of His Motifs*, Berkeley, 1943 [2nd ed., 1946], p. 93; Liliane Guerry, *Cézanne et l'expression de l'espace*, Paris, 1950, p. 95; Charles Sterling and Margaretta M. Salinger, *French Paintings: A Catalogue of the Collection of The Metropolitan Museum of Art*, 3 vols., New York, 1955–67, vol. 3, p. 109, ill.; "Ninety-first Annual Report: Additions to the Collections," *Metropolitan Museum of Art Bulletin* 20, October 1961, p. 64; Sandra Orienti, *L'Opera completa di Cézanne*, Milan, 1970 [French ed., 1975;

English ed., 1985], pp. 108–9, no. 482, ill.; Margit Rowell, "On Albers' Color," *Artforum* 10, January 1972, p. 31, fig. 7; Theodore Reff, "The Pictures within Cézanne's Pictures," *Arts Magazine* 53, June 1979, pp. 97, 104 n. 37, fig. 22; John Rewald, *Paul Cézanne: The Watercolors, A Catalogue Raisonné*, Boston, 1983, p. 154, under no. 289; Charles S. Moffett, *Impressionist and Post-Impressionist Paintings in The Metropolitan Museum of Art*, New York, 1985, pp. 11, 200, 254, color ill.; Richard Kendall, ed., *Cézanne by Himself: Drawings, Paintings, Writings*, London, 1988, p. 98, 313, color ill.; Christoph Jamme, "The Loss of Things: Cézanne— Rilke— Heidegger," *Kunst & Museumjournaal* 2, no. 1, 1990, ill. p. 41; Götz Adriani and Walter Feilchenfeldt, *Cézanne: Gemälde*, exh. cat., Kunsthalle Tübingen, Cologne, 1993 [English ed., 1995], pp. 299, 309 n. 22; Michael Kimmelman, "At the Met with Roy Lichtenstein: Disciple of Color and Line, Master of Irony," *New York Times*, March 31, 1995, p. C27, ill.; Philippe Dagen, *Cézanne*, Paris, 1995, p. 108, color ill.; Françoise Cachin et al., *Cézanne*, exh. cat., Philadelphia Museum of Art, Philadelphia, 1996 [French ed., 1995], p. 575; John Rewald in collaboration with Walter Feilchenfeldt and Jayne Warman, *The Paintings of Paul Cézanne: A Catalogue Raisonné*, 2 vols., New York, 1996, vol. 1, pp. 441, 562, 566–67, 569, 571, no. 701, vol. 2, p. 240, fig. 701

Still Life with a Ginger Jar and Eggplants
1893–94
Oil on canvas
28½ x 36 in. (72.4 x 91.4 cm)
Bequest of Stephen C. Clark, 1960
61.101.4
See no. 75

PROVENANCE
[Ambroise Vollard, Paris (about 1899–until 1906; bought from the artist for 400 francs, Stockbook A, no. 3559A; sold May 4, 1906, to Havemeyer for 15,000 francs); through Mary Cassatt; deposited by Cassatt with Durand-Ruel on May 7, shipped on May 11 to Havemeyer]; Mr. and Mrs. H. O. Havemeyer, New York (until his d. 1907); Mrs. H. O. Havemeyer, New York (1907–d. 1929); her son, Horace Havemeyer, New York (1929–48; consigned September 20, 1948 to Knoedler); [Knoedler, New York, on consignment from Havemeyer, 1948; no. CA-3141, sold in November to Clark]; Stephen C. Clark, New York (1948–d. 1960)

EXHIBITIONS
"Loan Exhibition of French Masterpieces of the Late
XIX Century," Durand-Ruel, New York, March
20–April 10, 1928, no. 4; "Trends in European
Painting, 1880–1930," Century Association, New
York, February 2–March 31, 1949, no. 6; "A
Collector's Taste: Selections from the Collection of Mr.
and Mrs. Stephen C. Clark," M. Knoedler & Co., New
York, January 12–30, 1954, no. 13; "Great French
Paintings: An Exhibition in Memory of Chauncey
McCormick," Art Institute of Chicago, January
20–February 20, 1955, no. 4; "Paintings from Private
Collections," Museum of Modern Art, New York, May
31–September 5, 1955, unnumbered cat.; "Paintings
from Private Collections: Summer Loan Exhibition,"
Metropolitan Museum of Art, New York, July
1–September 1, 1958, no. 18; "Paintings from Private
Collections: Summer Loan Exhibition," Metropolitan
Museum of Art, New York, July 7– September 7,
1959, no. 11; "Paintings, Drawings, and Sculpture
Collected by Yale Alumni," Yale University Art Gallery,
New Haven, May 19–June 26, 1960, no. 78;
"Paintings from Private Collections: Summer Loan
Exhibition," Metropolitan Museum of Art, New York,
July 6–September 4, 1960, no. 11; "Impressionism: A
Centenary Exhibition," Metropolitan Museum of Art,
New York, December 12, 1974– February 10, 1975,
not in catalogue; "100 Paintings from the
Metropolitan Museum," State Hermitage Museum,
Leningrad [St. Petersburg], May 15–June 20, 1975,
Pushkin State Museum of Fine Arts, Moscow, August
28–November 2, 1975, no. 72 ; "Cezanne:
Gemälde," Kunsthalle Tübingen, January 16–May 2,
1993, no. 59; "Objects of Desire: The Modern Still
Life," Museum of Modern Art, New York, May 21–
August 26, 1997, Hayward Gallery, London, October
7, 1997–January 4, 1998, unnumbered checklist;
"Impressionist Still Life," Phillips Collection,
Washington, D.C., September 22, 2001–January 13,
2002, Museum of Fine Arts, Boston, February 17–
June 9, 2002, unnumbered cat., pl. 83; "The Clark
Brothers Collect: Impressionist and Early Modern
Paintings," Sterling and Francine Clark Art Institute,
Williamstown, Mass., June 4–September 4, 2006,
Metropolitan Museum of Art, New York, May 22–
August 19, 2007, unnumbered cat., fig. 184

SELECTED REFERENCES
"French Masters Shown at Durand-Ruel's," Art News
26, March 24, 1928, p. 8, ill.; H. O. Havemeyer
Collection: Catalogue of Paintings, Prints, Sculpture,
and Objects of Art, 1931, p. 329; Lionello Venturi,
Cézanne: Son art—son oeuvre, 2 vols., Paris, 1936,
vol. 1, pp. 57, 194, no. 597, vol. 2, pl. 193, no. 597;
Robert J. Goldwater, "Cézanne in America: The
Master's Paintings in American Collections," Art News
36, March 26, 1938, section I (The 1938 Annual), pp.
140, 160, ill.; Charles Sterling and Margaretta M.
Salinger, French Paintings: A Catalogue of the
Collection of The Metropolitan Museum of Art, 3
vols., New York, 1955–67, vol. 3, pp. 111–12, ill.;
"Ninety-first Annual Report: Additions to the
Collections," Metropolitan Museum of Art Bulletin 20,
October 1961, pp. 42, 64, ill.; Sandra Orienti,
L'Opera completa di Cézanne, Milan, 1970 [French
ed., 1975; English ed., 1985], pp. 122–23, no. 793,
ill.; John Rewald, Paul Cézanne: The Watercolors,
A Catalogue Raisonné, Boston, 1983, pp. 134, 230,
under nos. 204 and 563; Götz Adriani, trans. Russell
M. Stockman, Cézanne Watercolors, New York, 1983
[German ed., 1981], p. 280, under no. 88; Charles S.
Moffett, Impressionist and Post-Impressionist Paintings
in The Metropolitan Museum of Art, New York, 1985,
pp. 11, 196–97, 254, color ill.; John Rewald,
Cézanne: A Biography, New York, 1986, pp. 210,
277, no. 210, color ill.; Frances Weitzenhoffer, The

Havemeyers: Impressionism Comes to America, New
York, 1986, p. 142, pl. 107; Gary Tinterow et al.,
"Modern Europe," The Metropolitan Museum of Art,
12 vols., New York, 1987–89, vol. 8, pp. 9, 50–51,
colorpl. 31; Richard Kendall, ed., Cézanne by
Himself: Drawings, Paintings, Writings, London, 1988,
pp. 188, 315, color ill.; Sidney Geist, Interpreting
Cézanne, Cambridge, Mass., 1988, pp. 23–24, 278,
pls. 25–26; John Rewald with the research assistance
of Frances Weitzenhoffer, Cézanne and America:
Dealers, Collectors, Artists, and Critics, 1891–1921,
Princeton, 1989, p. 128 n. 44; Steven Henry Madoff,
"Looking at Art, Paul Cézanne: Still Life with a Ginger
Jar and Eggplants," Arts News 89, May 1990, pp. 125–
26, color ill.; Susan Alyson Stein, Gary Tinterow,
Gretchen Wold et al., Splendid Legacy: The
Havemeyer Collection, exh. cat., Metropolitan
Museum of Art, New York, 1993, pp. 47, 230, 246,
colorpl. 243, 302–4, A78 ill.; Jean-Marie Baron and
Pascal Bonafoux, Cézanne: Les natures mortes, Paris,
1993, pp. 36–37, color ill.; Maria Teresa Benedetti,
trans. Marie-Christine Gamberini, Cézanne, Paris,
1995 [Italian ed., 1995], p. 210, color ill.; Evmarie
Schmitt, trans. John William Gabriel, Cézanne in
Provence, Munich, 1995 [German ed., 1995], pp. 57,
115, color ill.; Philippe Dagen, Cézanne, Paris, 1995,
pp. 82, 107, ill.; Stéphane Melchior-Durand,
L'ABCdaire de Cézanne, Paris, 1995, p. 98; John
Rewald in collaboration with Walter Feilchenfeldt
and Jayne Warman, The Paintings of Paul Cézanne:
A Catalogue Raisonné, 2 vols., New York, 1996,
vol. 1, pp. 466– 67, 571, no. 769, vol. 2, p. 264,
fig. 769; Françoise Cachin et. al., Cézanne, exh. cat.,
Philadelphia Museum of Art, Philadelphia, 1996,
p. 387 n. 3, pp. 573–74 [French ed., 1995]; Elaine
Levin, "Ceramic Still Life, The Common Object,"
Ceramics: Art and Perception, 1998, p. 56; Nina
Maria Athanassoglou-Kallmyer, Cézanne and
Provence: The Painter in His Culture, Chicago, 2003,
pp. 125, 127, fig. 3.26 (color)

Théodore Chassériau
French, 1819–1856

Scene in the Jewish Quarter of Constantine
1851
Oil on canvas
22⅜ x 18½ in. (56.8 x 47 cm)
Signed and dated (lower right): Th^re Chassériau 1851
Purchase, The Annenberg Foundation Gift, 1996
1996.285
See no. 35

PROVENANCE
Christofle collection, Paris (by 1893–1931); Georges
Lefébvre (in 1931); Rex Ingram, Hollywood and Nice
(in 1933); sale, Sotheby's, Los Angeles, March 12,
1979, no. 57; Joseph Tanenbaum, Toronto (by
1982–90); sale, Sotheby's, New York, October 23,
1990, no. 38, bought in; sold to Stair Sainty); [Stair
Sainty Matthiesen, New York, 1990–96]

EXHIBITIONS
"Les peintres orientalistes français, 3e Exposition.
Exposition rétrospective: Chassériau (1819–1856),"
Paris, 1896, no. 9; [unknown exhibition], Durand-
Ruel, Paris, 1897, no. 9; "Exposition coloniale inter-
nationale de Paris," May–November 1931,
unnumbered cat.; "Éxposition Chassériau, 1819–
1856," Musée de l'Orangerie, Paris, 1933, no. 59;
"Orientalism: The Near East in French Painting
1800–1880," Memorial Art Gallery of the University
of Rochester, August 27–October 17, 1982,
Neuberger Museum, SUNY College at Purchase,
November 14–December 23, 1982, no. 10;
"Théodore Chassériau (1819–1856): The Unknown
Romantic," Galeries Nationales du Grand Palais,
Paris, February 26–May 27, 2002, Musée des Beaux-
Arts, Strasbourg, June 19–September 21, 2002,
Metropolitan Museum of Art, New York, October 22,
2002–January 5, 2003, no. 154

SELECTED REFERENCES
Valbert Chevillard, Un peintre romantique: Théodore
Chassériau, Paris, 1893, p. 284, no. 118; Léandre
Vaillat, "Chasseriau," L'Art et les artistes 5, 1907, ill.
p. 181; Henry Marcel and Jean Laran, Chassériau,
Paris, 1911, pp. 83–85, no. 34, fig. xxxiv; Léandre
Vaillat, "L'Oeuvre de Théodore Chassériau," Les arts
140, August 1913, p. 22; Raymond Escholier,
"L'Orientalisme de Chassériau," Gazette des beaux-
arts 3, 1921, 5e pér., pp. 99, 102, ill.; Lloyd
Goodrich, "Theodore Chassériau," The Arts 14,
August 1928, ill. p. 91; Henri Focillon, "Chassériau
ou les deux romantismes," Le romantisme et l'art,
Paris, 1928, p. 169; Léonce Bénédite and André
Dezarrois, Théodore Chassériau, Sa vie et son

oeuvre, 2 vols., Paris, 1931, vol. 2, p. 298, pl. XXIV; Marc Sandoz, *Théodore Chassériau, 1819–1856*, Paris, 1974, pp. 59, 348, no. 214, pl. CLXXX; Lynne Thornton, *Les orientalistes: Peintres voyageurs, 1828–1908*, Paris, 1983, p. 74, color ill.; Bruno Foucart, *Le renouveau de la peinture religieuse en France (1800–1860)*, Paris, 1987, p. 322; Louis-Antoine Prat, *Inventaire général des dessins école française: Dessins de Théodore Chassériau*, 2 vols., Paris, 1988, vol. 1, p. 281, under no. 607, ill.; Gary Tinterow, "Recent Acquisitions, A Selection: 1996–1997," *Metropolitan Museum of Art Bulletin* 55, fall 1997, pp. 46–47, color ill.; Christine Peltre, *Théodore Chassériau*, Paris, 2001, p. 135, fig. 151 (color)

Camille Corot
French, 1796–1875

Fontainebleau: Oak Trees at Bas-Bréau
1832 or 1833
Oil on paper, laid down on wood
15⅝ x 19½ in. (39.7 x 49.5 cm)
Inscribed (verso): Cette étude de mon maître Corot peinte vers 1830 / qui lui a servi pour son tableau d'Hagar dans le désert / fut donné [par lui à?] Célestin Nanteuil en 183[5?] / Je l'ai retrouvé en fort mauvais état en 1884 / à Ma . . . lle [Marseille?] Je l'ai net-toyée et fait mettre / sur Panneau dans l'état où elle se trouve / Corot l'estimait comme une de ses meilleurs. / Français (This study by my master Corot painted about 1830 / which he used for his painting of Hagar in the desert / was given [by him to?] Célestin Nanteuil in 183[5?] / I rediscovered it in very bad condition in 1884 / at Ma . . . lle [Marseille?] I cleaned it and had it put / on panel, its present state. / Corot considered it one of his best. / Français)
Catharine Lorillard Wolfe Collection, Wolfe Fund, 1979
1979.404
See no. 7

PROVENANCE
Célestin Nanteuil (from 183[5?]; given to him by the artist); M. and Mme Larrieu; Mme Larrieu; François Louis Français (1884–at least 1896); sale, William Doyle Galleries, New York, May 16, 1979, no. 1; Simon Parks, New York (1979); sale, Sotheby's, New York, October 12, 1979, no. 222; [E. V. Thaw, New York, 1979; sold to the Metropolitan Museum]

EXHIBITIONS
"Exposition universelle internationale de 1889: Exposition centennale de l'art français (1789–1889)," Paris, May–November 1889, no. 148; "Landscapes by French Artists, 1780–1880," Metropolitan Museum of Art, New York, November 17, 1987– February 7, 1988; "Barbizon: French Landscapes of the Nineteenth Century," Metropolitan Museum of Art, New York, February 4–May 10, 1992; "Corot 1796–1875," Galeries Nationales du Grand Palais, Paris, February 27–May 27, 1996, National Gallery of Canada, Ottawa, June 21–September 22, 1996, no. 35, Metropolitan Museum of Art, New York, October 29, 1996–January 19, 1997, no. 35; "French Painters of Nature: The Barbizon School, Landscapes from The Metropolitan Museum of Art," New York State Museum, Albany, May 22–August 22, 2004

SELECTED REFERENCES
L. Roger-Milès, "Corot," *Les artistes célèbres*, Paris, vol. 32, [1891], p. 84; Alfred Robaut, *L'Oeuvre de Corot: Catalogue raisonné et illustré*, 5 vols. in 4, Paris, 1905 (reprinted 1965), vol. 2, pp. 98–99, no. 278, ill., vol. 4, p. 286; C[harles] S. M[offett], A[nne] W[agner] et al., *The Metropolitan Museum of*

Art: Notable Acquisitions, 1979–1980, New York, 1980, p. 43, ill.; Peter Galassi, Margaret Smith et al., "The Nineteenth Century: Valenciennes to Corot," *Claude to Corot: The Development of Landscape Painting in France*, exh. cat., Colnaghi, New York, 1990, pp. 246–47, fig. 17; Peter Galassi, *Corot in Italy: Open-Air Painting and the Classical-Landscape Tradition*, New Haven and London, 1991, p. 81, pl. 95

Study for "The Destruction of Sodom"
1843
Oil on canvas
14⅛ x 19⅝ in. (35.9 x 49.8 cm)
Catharine Lorillard Wolfe Collection, Wolfe Fund, 1984
1984.75
See no. 9

PROVENANCE
Jean Parédés, Paris; Prévost (in 1897; sale, Paris, June 10, 1897, no. 50, withdrawn); [Nat Leeb, Paris, until 1968]; [Hirschl & Adler, New York, 1968–74; sale, Christie's, London, July 6, 1971, no. 4, bought in; sale, Hôtel George V, Paris, March 13–14, 1974, no. 6, bought in]; [Galerie Dr. Bühler, Munich, 1974–at least 1980]; sale, Sotheby's, New York, February 29, 1984, no. 14; sold to the Metropolitan Museum

EXHIBITIONS
"Selections from the European Collection," Hirschl and Adler, New York, February 1970, no. 14; "Millet, Corot, and the School of Barbizon," Seibu Museum, Tokyo, March 15–April 14, 1980, Museum of Modern Art, Hyogo, Kobe, April 19–May 18, 1980, Hokkaido Prefectural Museum of Modern Art, Sapporo, May 24–June 15, 1980, Hiroshima Prefectural Museum, June 21–July 13, 1980, Kitakyushu Municipal Museum, July 19–August 10, 1980, no. T23; "Barbizon: French Landscapes of the Nineteenth Century," Metropolitan Museum of Art, New York, February 4–May 10, 1992

SELECTED REFERENCES
Alfred Robaut, *L'Oeuvre de Corot: Catalogue raisonné et illustré*, 5 vols. in 4, Paris, 1905 (reprinted 1965), vol. 2, p. 168, no. 460 bis, ill. p. 169; Étienne Moreau-Nélaton, *Corot raconté par lui-même* [2nd ed., rev., of *Histoire de Corot et de ses oeuvres, d'après les documents receuillis par Alfred Robaut*, 1905], 2 vols., Paris, 1924, vol. 1, fig. 79; Charles Sterling and Margaretta M. Salinger, *French Paintings: A Catalogue of the Collection of The Metropolitan Museum of Art*, 3 vols., New York, 1955–67, vol. 2, p. 52; Hans-Peter Bühler, *Die Schule von Barbizon: Französische Landschaftmalerei im 19. Jahrhundert,*

Munich, 1979, pp. 38, 63, ill. p. 44 (color), fig. 29; Fronia E. Wissman, *Corot's Salon Paintings: Sources from French Classicism to Contemporary Theater Design,* unpublished Ph.D. dissertation, Yale University, 2 vols., 1989, p. 88, fig. 38; Michael Pantazzi et al., *Corot,* exh. cat., Metropolitan Museum of Art, New York, 1996, p. 253, under no. 114, fig. 106 [French ed., *Corot 1796–1875,* Paris, 1996, p. 316, under no. 114]

The Burning of Sodom (formerly, *The Destruction of Sodom*)

1843 and 1857
Oil on canvas
36⅜ x 71⅜ in. (92.4 x 181.3 cm)
Signed (lower right): COROT.
H. O. Havemeyer Collection, Bequest of Mrs. H. O. Havemeyer, 1929
29.100.18
See no. 10

PROVENANCE

[Durand-Ruel, Paris, purchased in 1868 for Fr 15,000; sold in 1873 to Camondo for Fr 20,000]; comte Abram de Camondo, Paris (1873–d.1889); his son, comte Isaac de Camondo, Paris (1889; sold to Durand-Ruel for Fr 100,000); [Durand-Ruel, Paris, 1889; sold to Havemeyer for Fr 125,000]; Mr. and Mrs. H. O. Havemeyer, New York (1889–his d. 1907); Mrs. H. O. (Louisine W.) Havemeyer, New York (1907–d. 1929)

EXHIBITIONS

Salon, Paris, March 15–?, 1844, no. 399 (this canvas before being cut down); Salon, Paris, 1857, no. 593; "Exposition de l'oeuvre de Corot," École Nationale des Beaux-Arts, Paris, 1875, no. 209; "Loan Collection of Paintings," Metropolitan Museum of Art, New York, November 1890–April 1891, no. 6; "World's Columbian Exhibition: Fine Arts," Chicago World's Fair, May 1–October 26, 1893, no. 2886; "The H. O. Havemeyer Collection," Metropolitan Museum of Art, New York, March 10–November 2, 1930, no. 12; "19th-Century French and American Paintings from the Collection of The Metropolitan Museum of Art," Newark Museum, April 9–May 15, 1946, no. 4; "Barbizon Revisited," California Palace of the Legion of Honor, San Francisco, September 27–November 4, 1962, Toledo Museum of Art, November 20–December 27, 1962, Cleveland Museum of Art, January 15–February 24, 1963, Museum of Fine Arts, Boston, March 14–April 28, 1963, no. 9; "Corot," Edinburgh International Festival, August 14–September 12, 1965, National Gallery, London, October 1–November 7, 1965, no. 75; "From Delacroix to Matisse," State Hermitage Museum, Leningrad [St. Petersburg], March 15–May 10, 1988, Pushkin State Museum of Fine Arts, Moscow, June 10–July 30, 1988, no. 4; "Barbizon: French Landscapes of the Nineteenth Century," Metropolitan Museum of Art,

New York, February 4–May 10, 1992, no catalogue; "Splendid Legacy: The Havemeyer Collection," The Metropolitan Museum of Art, New York, March 27–June 20, 1993, no. A100; "Corot 1796–1875," Galeries Nationales du Grand Palais, Paris, February 27–May 27, 1996, National Gallery of Canada, Ottawa, June 21–September 22, 1996, Metropolitan Museum of Art, New York, October 29, 1996–January 19, 1997, no. 114; "La collection Havemeyer: Quand l'Amérique découvrait l'impressionnisme . . . ," Musée d'Orsay, Paris, October 20, 1997–January 18, 1998, no. 9

SELECTED REFERENCES

Arsène Houssaye, "Le Salon de 1843," *Revue de Paris* 16, April 1843, p. 35; Louis Peisse, "Le Salon de 1843," *Revue des deux mondes* 2, April 15, 1843, nouvelle pér., p. 283; Alphonse Karr, *Les guêpes* 28, April 1843, p. 28; Arsène Houssaye, "Salon de 1843," *L'Artiste,* vol. 3, 1843, 3e sér., p. 178; Théophile Gautier, *La presse,* March 30, 1844; Arsène Houssaye, "Le Salon," *L'Artiste* 5, 1844, 3e sér., p. 258; *Journal des artistes* 1, April 21, 1844, p. 30; A. A., "Salon de 1844," *Les beaux-arts* 3, 1844, pp. 2–3; "Salon de 1844," *L'Illustration* 3, March 16, 1844, p. 56, ill.; Étienne-Joseph-Théophile Thoré, *Salon de 1844,* Paris, 1844, pp. 30, 32–33; "Diderot au Salon de 1844," *La chronique* 5, 1844, 3e année, pp. 104–5; Désiré Laverdant, *La démocratie pacifique,* May 16, 1844; Théophile Silvestre, *Histoire des artistes vivants: Français et étrangers,* Paris, 1856, pp. 102–4; A. J. du Pays, "Salon de 1857," *L'Illustration* 30, September 26, 1857, pp. 202–3; Charles Perrier, *L'Art français au Salon de 1857,* Paris, 1857, p. 138; Bertall, *Journal amusant,* September 19, 1857; Paul Mantz, "Artistes contemporains: Corot," *Gazette des beaux-arts* 11, November 1, 1861, pp. 427–28; Henri Dumesnil, *Corot: Souvenirs intimes,* Paris, 1875, pp. 46, 125, 127; Jules Claretie, *Peintres et sculpteurs contemporains,* 2 vols., 1882–1884, Paris, 1882, vol. 1, p. 103 n. 1, p. 112; Paul Cornu, *Corot,* Paris, 1889, pp. 84, 87, ill.; L. Roger-Milès, "Corot," *Les artistes célèbres,* Paris, vol. 32 [1891], pp. 38, 48, 50, 83; L. Roger-Milès, *Album classique des chefs-d'oeuvre de Corot,* Paris [1895], p. 38, fig. 14.797; David Croal Thomson, *The Barbizon School of Painters: Corot, Rousseau, Diaz, Millet, Daubigny et al.,* London, 1902, pp. 40, 66, ill. opp. p. 47; Gustave Geffroy, Charles Geoffrey Holme, eds., "Jean-Baptiste Camille Corot?," *Corot and Millet,* New York, 1903, pp. cxvi, cxvii, cxx; Ethel Birnstingl and Alice Pollard, *Corot,* London, 1904, pp. 164, 167, 178; Alfred Robaut, *L'Oeuvre de Corot: Catalogue raisonné et illustré,* 5 vols. in 4, Paris, 1905 (reprinted 1965), vol. 1, pp. 104, 106, vol. 2, pp. 108, 168, 178, 344–45, no. 1097, ill., vol. 4, pp. 168, 169, 177, 276, 358–60, 366; Maurice Hamel, *Corot et son oeuvre,* 2 vols., Paris, 1905, vol. 1, pp. 22, 28, pl. 23; Julius Meier-Graefe, *Corot und Courbet: Ein Beitrag zur Entwicklungsgeschichte der Modernen Malerei,* Leipzig, 1905, pp. 49–50, 64; Émile Michel, *Corot,* Paris [1905], p. 30; Loys Delteil, *Le peintre-graveur illustré (XIX et XX siècles),* 31 vols., Paris, 1906–26, vol. 5, *Corot,* unpaginated ("Corot" [p. 3], as "L'Incendie de Sodene"); Étienne Moreau-Nélaton, *Corot,* Paris, 1913, p. 59; Julius Meier-Graefe, *Camille Corot,* Munich, 1913, 3rd ed., pp. 54–55, 77, ill.; Étienne Moreau-Nélaton, *Corot raconté par lui-même* [2nd ed., rev., of *Histoire de Corot et de ses oeuvres, d'après les documents receuillis par Alfred Robaut,* 1905], 2 vols., Paris, 1924, vol. 1, pp. 55–56, 58–59, 108, figs. 79, 138, 140; C. Bernheim de Villers, *Corot: Peintre de figures,* Paris, 1930, p. 32, no. 173, ill.; Charles Chassé, "Corot en Bretagne," *L'Art et les artistes* 20, July 1930, pp. 334–35; Julius Meier-Graefe, *Corot,* Berlin, 1930, pp. 54, 75–76; *H. O.*

Havemeyer Collection, Catalogue of Paintings, Prints, Sculpture and Objects of Art, 1931, pp. 72–73, ill.; Lionello Venturi, *Les archives de l'impressionnisme,* 2 vols., Paris, 1939, vol. 1, p. 19, vol. 2, p. 185; Charles Sterling and Margaretta M. Salinger, *French Paintings: A Catalogue of the Collection of The Metropolitan Museum of Art,* 3 vols., New York, 1955–67, vol. 2, pp. 52–54, ill.; Daniel Baud-Bovy and Alexandre Jullien, *Corot,* Geneva, 1957, pp. 38, 86, 187, 210–12, 230–31, pl. XLII; François Fosca, *Corot, Sa vie et son oeuvre,* Brussels, 1958, pp. 24, 32, 146, 190; André Coquis, *Corot et la critique contemporaine,* Paris, 1959, pp. 34–36, 72, 77, 80; A. Tabarant, *La vie artistique au temps de Baudelaire* [Paris], 1963, 2nd ed. [1st ed. 1942], pp. 61, 71, 242; Jean Leymarie, trans. Stuart Gilbert, *Corot,* Geneva, 1966 [English ed., 1979; French ed., 1992], p. 68 [English ed., *Corot,* 1979, p. 78, ill.]; Germain Bazin, *Corot,* Paris, 1973, rev. 3rd ed. [1st ed., 1942], pp. 47, 265, 268–69; Pierre Miquel, "1824–1874," *L'École de la nature: Le paysage français au XIXe siècle, 1824–1874,* 6 vols., Maurs-la-Jolie, 1975–87, vol. 2, pp. 27, 38–39; Hélène Toussaint et al., *Hommage à Corot: Peintures et dessins des collections françaises,* exh. cat., Orangerie des Tuileries, Paris, 1975, p. 48, 112, 181, 182; René Huyghe, *La relève de l'imaginaire: La peinture français au XIXe siècle, Réalisme, romantisme,* Paris, 1976, p. 438; Denise Delouche, *Peintres de la Bretagne* [Paris], 1977, pp. 266–67, 292 n. 302, ill.; Jean Leymarie, trans. Stuart Gilbert, *Corot,* New York, 1979 [2nd ed., 1992; French ed., 1966], p. 78, ill. [French ed., *Corot,* 1966, p. 68]; Sarah Symmons, *Daumier,* London, 1979, pp. 12–13, 94, fig. 9; Frances Renée Weitzenhoffer, *The Creation of the Havemeyer Collection, 1875–1900,* unpublished Ph.D. dissertation, City University of New York, 1982, pp. 112, 115, 132, 188, fig. 20; John Ingamells, "French Nineteenth Century," *The Wallace Collection: Catalogue of Pictures,* 4 vols., London, 1985–92, vol. 2, p. 46; Frances Weitzenhoffer, *The Havemeyers: Impressionism Comes to America,* New York, 1986, pp. 60, 66, 89, 255, pl. 18, ill. p. 74; Fronia E. Wissman, *Corot's Salon Paintings: Sources from French Classicism to Contemporary Theater Design,* unpublished Ph.D. dissertation, Yale University, 2 vols., 1989, vol. 1, pp. viii, 88–92, 173, 203, vol. 2, fig. 39; Peter Galassi, *Corot in Italy: Open-Air Painting and the Classical-Landscape Tradition,* New Haven and London, 1991, pp. 60, 235 n. 76; Josine M. Eikelenboom Smits, *The Architectural Landscapes of Jean-Baptiste-Camille Corot,* unpublished Ph.D. dissertation, Stanford University, 2 vols., 1991, pp. 268–70, fig. 250; Michael Clarke, *Corot and the Art of Landscape,* London, 1991, pp. 67, 69, fig. 74; Fronia E. Wissman, Kermit S. Champa, et al., *The Rise of Landscape Painting in France: Corot to Monet,* exh. cat., Currier Gallery of Art, Manchester, N.H., 1991, p. 76 n. 14; Iain Gale, *Corot,* London, 1994, pp. 26–27, 36, 39; Vincent Pomarède, ed., *Corot: Naturaleza, emoción, recuerdo,* exh. cat., Museo Thyssen-Bornemisza, Madrid, 2005, pp. 43, 275, 308, 338, 312, 390, 400, 402, fig. 8.2 (color)

A Village Street: Dardagny
1852, 1857, or 1863
Oil on canvas
13½ x 9½ in. (34.3 x 24.1 cm)
Signed and inscribed: (lower left) COROT; (center right, on wall) 48
Bequest of Collis P. Huntington, 1900
25.110.17
See no. 8

PROVENANCE
Sale, Paris, April 15, 1873, for Fr 605 to Fréret; Louis Fréret (from 1873); Albert Wolff, Paris (in 1875); T. Bascle, Paris (until 1883; sale, Hôtel Drouot, Paris, April 12–14, 1883, no. 19, for Fr 4,400); Collis P. Huntington, New York (until d. 1900; life interest to his widow, Arabella D. Huntington, later [from 1913] Mrs. Henry E. Huntington, 1900–d. 1924; life interest to their son, Archer Milton Huntington, 1924– terminated in 1925)

EXHIBITIONS
"Exposition de l'oeuvre de Corot," École Nationale des Beaux-Arts, Paris, 1875, no. 18; "19th-Century French and American Paintings from the Collection of The Metropolitan Museum of Art," Newark Museum, April 9–May 15, 1946, no. 2; "Barbizon Revisited," California Palace of the Legion of Honor, San Francisco, September 27–November 4, 1962, Toledo Museum of Art, November 20–December 27, 1962, Cleveland Museum of Art, January 15– February 24, 1963, Museum of Fine Arts, Boston, March 14–April 28, 1963, no. 11; "Capolavori impressionisti dei musei americani," Museo di Capodimonte, Naples, December 3, 1986–February 1, 1987, Pinacoteca di Brera, Milan, March 4–May 3, 1987, no. 9; "Barbizon: French Landscapes of the Nineteenth Century," Metropolitan Museum of Art, New York, February 4– May 10, 1992; "Corot 1796–1875," Galeries Nationales du Grand Palais, Paris, February 27–May 27, 1996, National Gallery of Canada, Ottawa, June 21–September 22, 1996, Metropolitan Museum of Art, New York, October 29, 1996–January 19, 1997, no. 111

SELECTED REFERENCES
Alfred Robaut, *L'Oeuvre de Corot: Catalogue raisonné et illustré*, 5 vols. in 4, Paris, 1905 (reprinted 1965), vol. 2, p. 242, no. 718, ill. p. 243; Charles Sterling and Margaretta M. Salinger, *French Paintings: A Catalogue of the Collection of The Metropolitan Museum of Art*, 3 vols., New York, 1955–67, vol. 2, pp. 51–52, ill.; Germain Bazin, *Corot*, Paris, 1973, rev. 3rd ed., [1st ed., 1942], p. 267; Josine M. Eikelenboom Smits, *The Architectural Landscapes of Jean-Baptiste-Camille Corot*, unpublished Ph.D. dissertation, Stanford University, 2 vols., 1991, vol. 1, pp. 347–48, vol. 2, p. xxxii, fig. 332

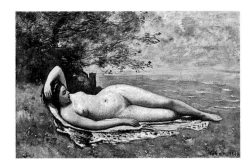

Bacchante by the Sea
1865
Oil on wood
15¼ x 23⅜ in. (38.7 x 59.4 cm)
Signed and dated (lower right): COROT 1865
H. O. Havemeyer Collection, Bequest of Mrs. H. O. Havemeyer, 1929
29.100.19
See no. 11

PROVENANCE
"M. Senateur du Midi" (received from the artist); Armand Frères (sold March 1891 to Bernheim-Jeune & Cie.); [Bernheim-Jeune & Cie., Paris, 1891]; possibly comte de Camondo, Paris; Henri Vever, Paris (by 1895–97; his sale, Galerie Georges Petit, Paris, February 1–2, 1897, no. 23, for Fr 30,750, to Durand-Ruel); [Durand-Ruel, Paris, 1897; sold to Havemeyer on February 3, 1897, for Fr 31,500, stock no. 4037]; Mr. and Mrs. H. O. Havemeyer, New York (1897–his d. 1907; consigned to Durand-Ruel, New York, January 19–February 14, 1898, deposit no. 5657); Mrs. H. O. (Louisine W.) Havemeyer, New York (1907–d. 1929)

EXHIBITIONS
"Centenaire de Corot," Palais Galliéra, Paris, May–June 1895, no. 139; "The H. O. Havemeyer Collection," Metropolitan Museum of Art, New York, March 10–November 2, 1930, no. 16; "Corot," Musée de l'Orangerie, Paris, 1936, no. 77; "Exposition Corot," Musée de Lyon, May 24–June 28, 1936, no. 82; "Corot, 1796–1875," Philadelphia Museum of Art, 1946, no. 42; "La femme dans l'art français," Musée de Peinture Moderne, Brussels, March 13–May 24, 1953; "Corot, 1796–1875," Art Institute of Chicago, October 6–November 13, 1960, no. 96; "Corot," Wildenstein and Co., Inc., New York, October 30–December 6, 1969, no. 58; "Nudes in Landscapes: Four Centuries of a Tradition," Metropolitan Museum of Art, New York, May 18– August 5, 1973; "Barbizon: French Landscapes of the Nineteenth Century," Metropolitan Museum of Art, New York, February 4–May 10, 1992; "Splendid Legacy: The Havemeyer Collection," Metropolitan Museum of Art, New York, March 27–June 20, 1993, no. A106; "Corot 1796–1875," Galeries Nationales du Grand Palais, Paris, February 27–May 27, 1996, National Gallery of Canada, Ottawa, June 21–September 22, 1996, Metropolitan Museum of Art, New York, October 29, 1996–January 19, 1997, no. 119

SELECTED REFERENCES
Paul Cornu, *Corot*, Paris, 1889, p. 71; Ethel Birnstingl and Alice Pollard, *Corot*, London, 1904, p. 170; Alfred Robaut, *L'Oeuvre de Corot: Catalogue raisonné et illustré*, 5 vols. in 4, Paris, 1905 (reprinted 1965), vol. 3, pp. 48–49, no. 1376, ill., vol. 4, p. 293; Julius Meier-Graefe, *Corot und Courbet: Ein Beitrag zur*

Entwicklungsgeschichte der Modernen Malerei, Leipzig, 1905, p. 41; Émile Michel, *Corot*, Paris [1905], p. 28; Walther Gensel, *Corot und Troyon*, Leipzig, 1906, p. 47, fig. 40; Julius Meier-Graefe, trans. Florence Simmonds and George W. Chrystal, *Modern Art, Being a Contribution to a New System of Aesthetics*, 2 vols., 1908–?, London, 1908, vol. 1, p. 171; Raymond Bouyer, "Corot, peintre de figures," *Revue de l'art ancien et moderne* 26, July–December 1909, p. 302, ill.; Julius Meier-Graefe, *Camille Corot*, Munich, 1913, 3rd ed., p. 46, ill. p. 127; Karl Madsen, *Corot og Hans Billeder, I Nordisk Eie*, Copenhagen, 1920, pp. 64, 84, ill.; Étienne Moreau-Nélaton, *Corot raconté par lui-même* [2nd ed., rev., of *Histoire de Corot et de ses oeuvres, d'après les documents receuillis par Alfred Robaut*, 1905], 2 vols., Paris, 1924, vol. 2, p. 35, fig. 207; Arsène Alexandre, "La collection Havemeyer: Courbet et Corot," *La renaissance* 12, June 1929, pp. 278, 281, ill.; Harry B. Wehle, "The Exhibition of the H. O. Havemeyer Collection," *Metropolitan Museum of Art Bulletin* 25, March 1930, p. 56, ill.; C. Bernheim de Villers, *Corot: Peintre de figures*, Paris, 1930, p. 59, no. 208, ill.; Julius Meier-Graefe, *Corot*, Berlin, 1930, pl. CIII; *H. O. Havemeyer Collection, Catalogue of Paintings, Prints, Sculpture, and Objects of Art*, 1931, pp. 70–71, ill.; Paul Jamot, *Corot*, Paris, 1936, ill. p. 26; Germain Bazin, "Corot et son oeuvre," *L'Amour de l'art* 17, February 1936, p. 60, fig. 62; Élie Faure, *Corot* [1936?], fig. 44; Jean Alazard, *Corot*, Milan, 1952, fig. 94; Charles Sterling and Margaretta M. Salinger, *French Paintings: A Catalogue of the Collection of The Metropolitan Museum of Art*, 3 vols., New York, 1955–67, vol. 2, p. 59, ill.; François Fosca, *Corot, Sa vie et son oeuvre*, Brussels, 1958, ill. p. 134; Germain Bazin, *Corot* Paris, 1973, 3rd ed., rev., [1st ed., 1942], p. 270; René Huyghe, *La relève de l'imaginaire: La peinture français au XIXe siècle, Réalisme, romantisme*, Paris, 1976, p. 271, fig. 286; Frances Renée Weitzenhoffer, *The Creation of the Havemeyer Collection, 1875– 1900*, unpublished Ph.D. dissertation, City University of New York, 1982, pp. xiv, 291, no. 99, fig. 99; Frances Weitzenhoffer, *The Havemeyers: Impressionism Comes to America*, New York, 1986, pp. 126, 176, pl. 78; Antje Zimmermann, *Studien zum Figurenbild bei Corot*, unpublished Ph.D. dissertation, Universität Köln, 1986, pp. 109, 367, no. 120; Jean Selz, *La vie et l'oeuvre de Camille Corot*, Paris, 1988, pp. 226, 281, color ill.; Jean Leymarie, trans. Stuart Gilbert, *Corot* [Geneva], 1992, 2nd ed. [1st ed. in French, 1966], pp. 144, 147, color ill.

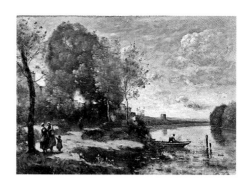

River with a Distant Tower
1865
Oil on canvas
21½ x 30⅞ in. (54.6 x 78.4 cm)
Signed (lower left): C. COROT
Bequest of Robert Graham Dun, 1900
11.45.4
See no. 14

PROVENANCE
Société Artésienne des Amis des Arts (until 1866);
Philippe Ledieu, France (from 1866); Robert Graham
Dun, New York (until d. 1900; life interest to his
widow, Mary D. Bradford Dun, 1900–d. 1910)

EXHIBITIONS
"Trees in Art," Guild Hall, East Hampton, N.Y.,
July 18–August 13, 1957, no. 11; "Barbizon: French
Landscapes of the Nineteenth Century," Metropolitan
Museum of Art, New York, February 4– May 10, 1992;
"French Painters of Nature: The Barbizon School,
Landscapes from The Metropolitan Museum of Art,"
New York State Museum, Albany, May 22–August 22,
2004

SELECTED REFERENCES
Gustave Geffroy, Charles Geoffrey Holme et al.,
"Jean-Baptiste Camille Corot," *Corot and Millet*, New
York, 1903, p. cxxxii; Alfred Robaut, *L'Oeuvre de
Corot: Catalogue raisonné et illustré*, 5 vols. in 4,
Paris, 1905 (reprinted 1965), vol. 3, pp. 170–71,
no. 1700, ill.; B[ryson] B[urroughs], "Recent
Accessions," *Metropolitan Museum of Art Bulletin* 6,
no. 4, April 1911, pp. 98, 99 (ill.); B[ryson]
B[urroughs], "Modern Paintings in the Altman
Bequest," *Metropolitan Museum of Art Bulletin* 9,
no. 12, December 1914, p. 252; Charles Sterling and
Margaretta M. Salinger, *French Paintings: A Catalogue
of the Collection of The Metropolitan Museum of Art*,
3 vols., New York, 1955–67, vol. 2, pp. 58–59, ill.

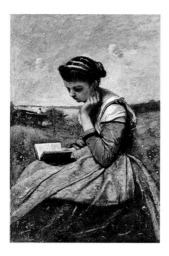

A Woman Reading
1869 and 1870
Oil on canvas
21⅜ x 14¾ in. (54.3 x 37.5 cm)
Signed (lower left): [COR]OT
Gift of Louise Senff Cameron, in memory of her
uncle, Charles H. Senff, 1928
28.90
See no. 12

PROVENANCE
Oscar Simon, Dinard; [Boussod-Valadon, Paris, in
1894]; [Knoedler, New York, in 1895]; Charles H.
Senff, New York (until 1911; his estate sale, Anderson
Galleries, New York, March 28–29, 1928, no. 61,
bought in); his niece, Louise Senff Cameron, New
Windsor, N.Y. (1928)

EXHIBITIONS
Salon, Paris, 1869, no. 550; "The Taste of Today in
Masterpieces of Painting before 1900," Metropolitan
Museum of Art, New York, July 10– October 2, 1932;
"Corot," Musée de l'Orangerie, Paris, 1936, no. 90;
"Exposition Corot," Musée de Lyon, May 24–June 28,
1936, no. 94; "Corot, 1796–1875," Philadelphia
Museum of Art, 1946, no. 56; "Art Treasures of the
Metropolitan," Metropolitan Museum of Art, New
York, November 7, 1952–September 7, 1953,
no. 144; "Corot, 1796–1875," Art Institute of
Chicago, October 6–November 13, 1960, no. 111;
"Masterpieces of Fifty Centuries," Metropolitan
Museum of Art, New York, November 15, 1970–
February 15, 1971, no. 365; "Impressionism: A
Centenary Exhibition," Metropolitan Museum of Art,
New York, December 12, 1974–February 10,
1975, not in catalogue; "100 Paintings from the
Metropolitan Museum," State Hermitage Museum,
Leningrad [St. Petersburg], May 15–June 20, 1975,
Pushkin State Museum of Fine Arts, Moscow, August
28–November 2, 1975, no. 58; "Capolavori impres-
sionisti dei musei americani," Museo di Capodimonte,
Naples, December 3, 1986–February 1, 1987,
Pinacoteca di Brera, Milan, March 4–May 3, 1987,
no. 10; "Corot to Cézanne: 19th Century French
Paintings from The Metropolitan Museum of Art,"
Museum of Art, Fort Lauderdale, December 22,
1992–April 11, 1993, no catalogue; "Barbizon:
French Landscapes of the Nineteenth Century,"
Metropolitan Museum of Art, New York, February 4–
May 10, 1992, no catalogue; "Corot 1796–1875,"
Galeries Nationales du Grand Palais, Paris, February
27–May 27, 1996, National Gallery of Canada,
Ottawa, June 21–September 22, 1996, Metropolitan
Museum of Art, New York, October 29, 1996–
January 19, 1997, no. 141

SELECTED REFERENCES
Ernest Hache, "Salon de 1869," *Les merveilles de l'art
et de l'industrie: Antiquité, moyen age, renaissance,
temps moderne (1869–1870)* [Paris, 1870?], p. 298;
Théophile Gautier, *L'Illustration* 53, June 5, 1869
[repr. in *Tableaux à la plume*, Paris, 1880, p. 312];
Exposition de l'oeuvre de Corot, exh. cat., École
Nationale des Beaux-Arts, Paris, 1875, p. 30;
L. Roger-Milès, "Corot," *Les artistes célèbres*, Paris,
vol. 32 [1891], p. 84, no. 550; Ethel Birnstingl and
Alice Pollard, *Corot*, London, 1904, pp. 168, 179;
Alfred Robaut, *L'Oeuvre de Corot: Catalogue raisonné
et illustré*, 5 vols. in 4, Paris, 1905 (reprinted 1965),
vol. 3, pp. 114–15, no. 1563, ill., vol. 4, pp. 170,
375; Étienne Moreau-Nélaton, *Corot*, Paris, 1913,
p. 84; Étienne Moreau-Nélaton, *Corot raconté par lui-
même* [2nd ed., rev., of *Histoire de Corot et de ses
oeuvres, d'après les documents receuillis par Alfred
Robaut*, 1905], 2 vols., Paris, 1924, vol. 2, p. 35,
fig. 212; Bryson Burroughs, "Woman Reading in the
Fields, by Corot," *Metropolitan Museum of Art
Bulletin* 23, June 1928, pp. 154–56, figs 1–2; Léon
Arnoult, *Turner, Wagner, Corot*, Paris, 1930, p. 59;
C. Bernheim de Villers, *Corot: Peintre de figures*,
Paris, 1930, p. 34, no. 262, ill.; Paul Jamot, *Corot*,
Paris, 1936, p. 21, ill. on title page; *Metropolitan
Museum of Art Bulletin* 13, October 1954, color ill.
on cover (detail); Charles Sterling and Margaretta M.
Salinger, *French Paintings: A Catalogue of the
Collection of The Metropolitan Museum of Art*, 3
vols., New York, 1955–67, vol. 2, pp. 63–65, ill.;
François Fosca, *Corot, Sa vie et son oeuvre*, Brussels,
1958, p. 221, ill. p. 155; André Coquis, *Corot et la
critique contemporaine*, Paris, 1959, pp. 117–19;
*Great Paintings from The Metropolitan Museum of
Art*, New York, 1959, unpaginated, no. 52, color ill.;
Robert L. Herbert, *Barbizon Revisited*, exh. cat.,
California Palace of the Legion of Honor, Boston,
1962, p. 53; Sylvie Béguin et al., *Figures de Corot*,
exh. cat., Musée du Louvre, Paris, 1962, p. 172,
under no. 75; Germain Bazin, *Corot*, Paris, 1973, rev.
3rd ed. [1st ed., 1942], p. 271; Pierre Miquel,
"1824–1874," *L'École de la nature: Le paysage français
au XIXe siècle, 1824–1874*, 6 vols., Maurs-la-Jolie,
1975–87, vol. 2, pp. 51–52; Hélène Toussaint et al.,
*Hommage à Corot: Peintures et dessins des collec-
tions françaises*, exh. cat., Orangerie des Tuileries,
Paris, 1975, p. 184; Anne L. Poulet, *Corot to Braque:
French Paintings from the Museum of Fine Arts,
Boston*, exh. cat., Museum of Fine Arts, Boston, 1979,
p. 4 under no. 2; Antje Zimmermann, *Studien zum
Figurenbild bei Corot*, unpublished Ph.D. dissertation,
Universität Köln, 1986, pp. 51, 57, 139, 240 n. 4,
p. 245 n. 32, p. 352, no. 46, fig. 46; Fronia E.
Wissman, *Corot's Salon Paintings: Sources from
French Classicism to Contemporary Theater Design*,
unpublished Ph.D. dissertation, Yale University, 2
vols., 1989, vol. 1, pp. ix, 107–10, 205, no. 117,
vol. 2, fig. 53; Joseph J. Rishel et al., *Masterpieces of
Impressionism and Post-Impressionism: The Annenberg
Collection*, exh. cat., Philadelphia Museum of Art,
Philadelphia, 1991, rev. ed. [1st ed., 1989], pp. 2,
130 n. 2, fig. 1; Michael Clarke, *Corot and the Art of
Landscape*, London, 1991, p. 139; Jean Leymarie,
Corot [Geneva], 1992, 2nd ed., pp. 148–49, color ill.;
Vincent Pomarède, ed., *Corot: Naturaleza, emoción,
recuerdo*, exh. cat., Museo Thyssen-Bornemisza,
Madrid, 2005, pp. 238, 251–52, 315, 383, 387, 404,
fig. 7.6 (color)

Ville-d'Avray
1870
Oil on canvas
21⅝ x 31½ in. (54.9 x 80 cm)
Signed (lower right): COROT
Catharine Lorillard Wolfe Collection, Bequest of
Catharine Lorillard Wolfe, 1887
87.15.141
See no. 15

PROVENANCE
[Knoedler, New York, until 1881; sold to Wolfe on
January 11 for $2,700]; Catharine Lorillard Wolfe,
New York (1881–d. 1887)

EXHIBITIONS
Salon, Paris, May 1–June 20, 1870, no. 649; "Pedestal
Fund Art Loan Exhibition," National Academy of
Design, New York, December 3, 1883–?, no. 13;
"Landscape Painting in the East and West," Shizuoka
Prefectural Museum of Art, April 19–June 1, 1986,
Kobe City Museum, June 7–July 13, 1986, no. 9; "In
Support of Liberty: European Paintings at the 1883
Pedestal Fund Art Loan Exhibition," Parrish Art
Museum, Southampton, N.Y., June 29–September 1,
1986 (this painting not exhibited until August 1),
National Academy of Design, New York, September
18–December 7, 1986, no. 13; "The Rise of
Landscape Painting in France: Corot to Monet," IBM
Gallery of Science and Art, New York, July 30–
September 28, 1991, no. 37; "Barbizon: French
Landscapes of the Nineteenth Century," Metropolitan
Museum of Art, New York, February 4–May 10, 1992;
"Corot 1796–1875," Galeries Nationales du Grand
Palais, Paris, February 27–May 27, 1996, National
Gallery of Canada, Ottawa, June 21–September 22,
1996, Metropolitan Museum of Art, New York,
October 29, 1996–January 19, 1997, no. 148;
"French Painters of Nature: The Barbizon School,
Landscapes from The Metropolitan Museum of Art,"
New York State Museum, Albany, May 22–August 22,
2004

SELECTED REFERENCES
Ph[illipe] Burty, *Le Rappel,* May 20, 1870; Marius
Chaumelin, "Le Salon de 1870," *La Presse* [June 27,
1870] [reprinted in *L'Art contemporain,* Paris, 1873,
p. 436]; Camille Lemonnier, *Salon de Paris, 1870,*
Paris, 1870, pp. 176, 178–79; A[lfred] de L[ostalot],
"Le Salon de 1870: Oeuvres reproduites par
'L'Illustration,'" *L'Illustration* 55, no. 1419, May 7,
1870, p. 335, ill. p. 333 (zinc engraving by Pirodon);
René Ménard, "Le Salon de 1870 (2e et dernier
article)," *Gazette des beaux-arts* 4, July 1870, 2e pér.,
p. 54; "Envois de Corot aux Salons," *Exposition de
l'oeuvre de Corot,* exh. cat., Paris, 1875, p. 30;
Theodore Robinson, John C. van Dyke et al.,
"Camille Corot," *Modern French Masters: A Series of
Biographical and Critical Reviews by American Artists,*
New York, 1889 [reprinted 1896], p. 115; L. Roger-
Milès, "Corot," *Les artistes célèbres,* Paris, vol. 32

[1891], p. 84 (no. 649); Alfred Robaut, *L'Oeuvre de
Corot: Catalogue raisonné et illustré,* 5 vols. in 4,
Paris, 1905 [reprinted 1965], vol. 1, p. 247, vol. 3,
p. 244, no. 2003, ill. p. 245, vol. 4, pp. 170, 375;
Maurice Hamel, *Corot et son oeuvre,* 2 vols., Paris,
1905, vol. 2, pl. 65; W[illiam] M. I[vins] Jr., "The Mr.
and Mrs. Isaac D. Fletcher Collection," *Metropolitan
Museum of Art Bulletin* 13, no. 3, March 1918, p. 60;
Étienne Moreau-Nélaton, *Corot raconté par lui-même*
[2nd ed., rev., of *Histoire de Corot et de ses oeuvres,
d'après les documents receuillis par Alfred Robaut,*
1905], 2 vols., Paris, 1924, vol. 2, p. 37, fig. 217;
Charles Sterling and Margaretta M. Salinger, *French
Paintings: A Catalogue of the Collection of The
Metropolitan Museum of Art,* 3 vols., New York,
1955–67, vol. 2, p. 67, ill. p. 66; André Coquis, *Corot
et la critique contemporaine,* Paris, 1959, pp. 120–21;
James Merrill, "Notes on Corot," *Corot, 1796–1875,*
exh. cat., Chicago, 1960, p. 15; Victor Carlson et al.,
The Forest of Fontainbleau [sic], *Refuge of Reality:
French Landscape 1800 to 1870,* exh. cat., New York,
1972, unpaginated, under no. 17; Germain Bazin,
Corot, Paris, 1973, rev. 3rd ed. [1st ed., 1942],
p. 272; Pierre Miquel, *Le paysage français au XIXe
siècle, 1824–1874: L'École de la Nature,* 6 vols.,
Maurs-la-Jolie, 1975–87, vol. 2, p. 52; Hélène
Toussaint et al., *Hommage à Corot: Peintures et
dessins des collections françaises,* exh. cat., Orangerie
des Tuileries, Paris, 1975, p. 184; Mahonri Sharp
Young, "Letter from the USA: The Pedestal," *Apollo*
124, no. 293, n.s., July 1986, pp. 50, 51 (pl. IX);
Geneviève Matheron, *Corot à Ville-d'Avray,* exh. cat.,
Musée de Ville-d'Avray, Ville-d'Avray, 1987, colorpl.
25; Fronia E. Wissman, *Corot's Salon Paintings:
Sources from French Classicism to Contemporary
Theater Design,* unpublished Ph.D. dissertation, Yale
University, 2 vols., 1989, vol. 1, pp. 188, 205 (no.
119); Jean Leymarie, *Corot* [Geneva], 1992, 2nd ed.
[1st ed., 1966], p. 197, ill. p. 162 (color); Rebecca A.
Rabinow, "Catharine Lorillard Wolfe: The First
Woman Benefactor of The Metropolitan Museum,"
Apollo 147, no. 433, March 1998, pp. 52, 55 n. 28;
Vincent Pomarède, ed., *Corot: Naturaleza, emoción,
recuerdo,* exh. cat., Museo Thyssen-Bornemisza,
Madrid, 2005, pp. 315, 404

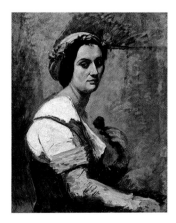

Sibylle
ca. 1870
Oil on canvas
32¼ x 25½ in. (81.9 x 64.8 cm)
H. O. Havemeyer Collection, Bequest of Mrs. H. O.
Havemeyer, 1929
29.100.565
See no. 13

PROVENANCE
Alfred Robaut, Paris (until 1899; sold on February 21
to Durand-Ruel for Fr 6,000); [Durand-Ruel, Paris,
1899, stock no. 5026; sold on December 8, 1899,
or January 25, 1900, to Durand-Ruel, New York];
[Durand-Ruel, New York, 1899/1900–1903, stock no.
2286; sold on February 7, 1903, to Havemeyer for
$6,000]; Mr. and Mrs. H. O. Havemeyer, New York
(1903–7); Mrs. H. O. (Louisine W.) Havemeyer, New
York (1907–d. 1929)

EXHIBITIONS
"The H. O. Havemeyer Collection," Metropolitan
Museum of Art, New York, March 10–November 2,
1930, no. 18; "The Spirit of Modern France," Toledo
Museum of Art, November–December 1946, Art
Gallery of Toronto, January–February 1947, no. 35;
"Homer, Eakins, Ryder, Inness, and Their French
Contemporaries: A Loan Exhibition . . . ," Fort
Worth Art Association, March 11–April 15, 1949,
no. 2; "Figures de Corot," Musée du Louvre, Paris,
June–September 1962, no. 69; "Corot," Wildenstein
and Co., Inc., New York, October 30–December 6,
1969, no. 64; "Masterpieces of Painting in The
Metropolitan Museum of Art," Museum of Fine Arts,
Boston, September 16–November 1, 1970; "Barbizon:
French Landscapes of the Nineteenth Century,"
Metropolitan Museum of Art, New York, February
4–May 10, 1992, no catalogue; "Splendid Legacy:
The Havemeyer Collection," Metropolitan Museum of
Art, New York, March 27–June 20, 1993, no. A114;
"Corot, 1796–1875," Galeries Nationales du Grand
Palais, Paris, February 27–May 27, 1996, National
Gallery of Canada, Ottawa, June 21–September 22,
1996, Metropolitan Museum of Art, New York,
October 29, 1996–January 19, 1997, no. 142; "La
collection Havemeyer: Quand l'Amérique découvrait
l'impressionnisme . . . ," Musée d'Orsay, Paris,
October 20, 1997–January 18, 1998, no. 10; "Corot:
Naturaleza, emoción, recuerdo," Museo Thyssen-
Bornemisza, Madrid, June 7– September 11, 2005,
Palazzo dei Diamanti, Ferrara, October 9, 2005–
January 8, 2006, no. 65

SELECTED REFERENCES
Alfred Robaut, *L'Oeuvre de Corot: Catalogue raisonné
et illustré,* 5 vols. in 4, Paris, 1905 [reprinted 1965],
vol. 3, pp. 292–93, no. 2130, ill.; Julius Meier-Graefe,
Camille Corot, Munich, 1913, 3rd ed., ill. p. 153;
Étienne Moreau-Nélaton, *Corot raconté par lui-même*
[2nd ed., rev., of *Histoire de Corot et de ses oeuvres,
d'après les documents receuillis par Alfred Robaut,*
1905], 2 vols., Paris, 1924, vol. 1, p. 115, fig. 143;
Arsène Alexandre, "La collection Havemeyer:
Courbet et Corot," *La renaissance* 12, June 1929,
pp. 277, 281, ill.; C. Bernheim de Villers, *Corot:
Peintre de figures,* Paris, 1930, p. 62, no. 303, ill.;
Julius Meier-Graefe, *Corot,* Berlin, 1930, p. 102,
pl. CXXVIII [128]; *H. O. Havemeyer Collection,
Catalogue of Paintings, Prints, Sculpture, and Objects
of Art,* 1931, pp. 64–65, ill.; David Rosen and Henri
Marceau, "A Study in the Use of Photographs in the
Identification of Paintings," *Technical Studies in the
Field of the Fine Arts,* October 1937, p. 86, figs. 16,
17; Charles Sterling and Margaretta M. Salinger,
*French Paintings: A Catalogue of the Collection of
The Metropolitan Museum of Art,* 3 vols., New York,
1955–67, vol. 2, pp. 65–67, ill.; François Fosca,
Corot, Sa vie et son oeuvre, Brussels, 1958, pp. 138,
145; Madeleine Hours, *Jean-Baptiste-Camille Corot,*
New York [1972], pp. 152–53, color ill.; Germain
Bazin, *Corot,* Paris, 1973, rev. 3rd ed. [1st ed., 1942],
pp. 65, 272; Anthony F. Janson, "Corot: Tradition and
the Muse," *Art Quarterly* 1, no. 4, 1978, n.s.,
pp. 308–10, 313, fig. 8; Antje Zimmermann, *Studien
zum Figurenbild bei Corot,* unpublished Ph.D.

dissertation, Universität Köln, 1986, pp. 127 n. 10, 171–73, 177, 293 n. 68, 377, fig. 164; Fronia E. Wissman, *Corot's Salon Paintings: Sources from French Classicism to Contemporary Theater Design,* unpublished Ph.D. dissertation, Yale University, 2 vols., 1989, p. 127; Iain Gale, *Corot,* London, 1994, pp. 124–25, 144, no. 125, ill. (color)

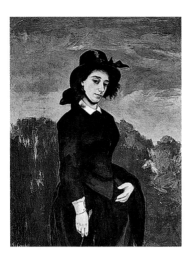

Gustave Courbet
French, 1819–1877

Woman in a Riding Habit (L'Amazone)
1856
Oil on canvas
45½ x 35⅛ in. (115.6 x 89.2 cm)
Signed (lower left): G. Courbet.
H. O. Havemeyer Collection, Bequest of Mrs. H. O. Havemeyer, 1929
29.100.59
See no. 24

PROVENANCE
Théodore Duret, Paris (until 1906; sold to Havemeyer for Fr 15,000); Mr. and Mrs. H. O. Havemeyer, New York (spring 1906–7); Mrs. H. O. (Louisine W.) Havemeyer, New York (1907–d. 1929)

EXHIBITIONS
"Loan Exhibition of the Works of Gustave Courbet," Metropolitan Museum of Art, New York, April 7– May 18, 1919, no. 6; "The H. O. Havemeyer Collection," Metropolitan Museum of Art, New York, March 10–November 2, 1930, no. 24; "Loan Exhibition of Paintings," Art Gallery of Toronto, November 1–December 1, 1935, no. 168; "A Loan Exhibition of Gustave Courbet," Wildenstein and Co., Inc., New York, December 2, 1948–January 8, 1949, no. 14; "Four Centuries of European Painting," Honolulu Academy of Arts, December 8, 1949– January 29, 1950, no. 22; "Fifty Paintings by Old Masters," Art Gallery of Toronto, April 21–May 21, 1950, no. 5; "Diamond Jubilee Exhibition: Masterpieces of Painting," Philadelphia Museum of Art, November 4, 1950–February 11, 1951, no. 58; "Gustave Courbet, 1819–1877," Philadelphia Museum of Art, December 17, 1959–February 14, 1960, Museum of Fine Arts, Boston, February 26– April 14, 1960, no. 24; "Style, Truth, and the Portrait," Cleveland Museum of Art, October 1–November 10, 1963, no. 75; "From Delacroix to Matisse," State Hermitage Museum, Leningrad [St. Petersburg], March 15–May 10, 1988, Pushkin State Museum of Fine Arts, Moscow, June 10–July 30, 1988, no. 8; "Splendid Legacy: The Havemeyer Collection," Metropolitan Museum of Art, New York, March 27– June 20, 1993, no. A127; "La collection Havemeyer: Quand l'Amérique découvrait l'impressionnisme . . . ," Musée d'Orsay, Paris, October 20, 1997–January 18, 1998, no. 17

SELECTED REFERENCES
Zacharie Astruc, *Les 14 Stations du Salon,* Paris, 1859, pp. 390–91; Georges Riat, *Gustave Courbet, peintre,*

Paris, 1906, pp. 171–72; Harry B. Wehle, "The Exhibition of the H. O. Havemeyer Collection," *Metropolitan Museum of Art Bulletin* 25, March 1930, p. 55; *H. O. Havemeyer Collection, Catalogue of Paintings, Prints, Sculpture, and Objects of Art,* 1931, pp. 92–93, ill.; Charles Léger, "Un Portrait inconnu de Louise Colet par Gustave Courbet," *Nouvelles littéraires, artistiques et scientifiques,* September 1, 1934, ill.; Joseph F. Jackson, *Louise Colet et ses amis littéraires,* New Haven, 1937, p. 348 n. 29; Charles Sterling and Margaretta M. Salinger, *French Paintings: A Catalogue of the Collection of The Metropolitan Museum of Art,* 3 vols., New York, 1955–67, vol. 2, pp. 113–15, ill.; Marie-Thérèse de Forges, Hélène Toussaint et al., *Gustave Courbet (1819–1877),* exh. cat., Villa Medici, Rome, 1969, p. 69; Charles Scott Chetham, *Modern Painting, Drawing, and Sculpture Collected by Louise and Joseph Pulitzer, Jr.,* exh. cat., Fogg Art Museum, 4 vols., Cambridge, Mass., 1957–88, vol. 3, 1971, pp. 382–84, ill.; Robert Fernier, *La vie et l'oeuvre de Gustave Courbet,* 2 vols., Lausanne, 1977–78, vol. 1, p. 122–23, no. 202, ill.; Pierre Courthion, trans. Marina Anzil Robertini, *L'Opera completa di Courbet,* Milan, 1985, pp. 83–85, no. 190, ill.; Frances Weitzenhoffer, *The Havemeyers: Impressionism Comes to America,* New York, 1986, pp. 164–65, 180, 256, pl. 127; Sarah Faunce, Linda Nochlin et al., *Courbet Reconsidered,* exh. cat., Brooklyn Museum, 1988, pp. 119–20; Louisine W. Havemeyer, *Sixteen to Sixty: Memoirs of a Collector,* New York, 1993, 3rd ed. with notes by Susan Alyson Stein [1st ed., 1930; repr. 1961], pp. 188–89, 201–3, 302, 329 n. 262, p. 331 n. 287

Louis Gueymard (1822–1880) *as Robert le Diable*
1857
Oil on canvas
58½ x 42 in. (148.6 x 106.7 cm)
Signed (lower left): G. Courbet.
Gift of Elizabeth Milbank Anderson, 1919
19.84
See no. 22

PROVENANCE
Possibly Louis Gueymard, Paris (until 1867); possibly Gauthier Villars, Paris (from 1867); private collection (until 1872; sale, Hôtel Drouot, Paris, January 19,

1872, no. 23); Adolphe Reignard, Paris (by 1878–at least 1896); Elizabeth Milbank Anderson, New York (until 1919)

EXHIBITIONS
Salon, Paris, 1857, no. 624; "Exposition rétrospective de tableaux et dessins des maîtres modernes," Durand-Ruel, Paris, 1878, no. 35; "Exposition des œuvres de Gustave Courbet," École des Beaux-Arts, Paris, May 1882, no. 18; "Loan Exhibition of the Works of Gustave Courbet," Metropolitan Museum of Art, New York, April 7–May 18, 1919, no. 8; "An Exhibition of Paintings by Courbet," Baltimore Museum of Art, May 3–29, 1938, no. 3; "Gustave Courbet, 1819–1877," Galeries Nationales du Grand Palais, Paris, September 30, 1977–January 2, 1978, no. 54, Royal Academy of Arts, London, January 19–March 19, 1978, no. 51

SELECTED REFERENCES
Théophile Silvestre, Histoire des artistes vivants: Français et étrangers, Paris, 1856, p. 278; B[ryson] B[urroughs], "The Gift of a Courbet," Metropolitan Museum of Art Bulletin 14, May 1919, pp. 112–13, ill.; Charles Léger, Courbet et son temps (Lettres et documents inédits), Paris, 1948, pp. 62–63; Charles Sterling and Margaretta M. Salinger, French Paintings: A Catalogue of the Collection of The Metropolitan Museum of Art, 3 vols., New York, 1955–67, vol. 2, p. 113, ill.; Robert Fernier, La vie et l'oeuvre de Gustave Courbet, 2 vols., Lausanne, 1977–78, vol. 1, pp. 132–33, no. 213, ill.; Pierre Courthion, trans. Marina Anzil Robertini, L'Opera completa di Courbet, Milan, 1985, pp. 84–85, no. 205, ill.; Sarah Faunce, Linda Nochlin, Ann Dumas et al., Courbet Reconsidered, exh. cat., Brooklyn Museum, 1988, pp. 109, 215; Klaus Herding, trans. John William Gabriel, Courbet: To Venture Independence, New Haven, 1991, pp. 241–42 n. 13; Petra Ten-Doesschate Chu, ed. and trans., Letters of Gustave Courbet, Chicago and London, 1992, pp. 153, 155 n. 4, fig. 30

Madame de Brayer
1858
Oil on canvas
36 x 28⅝ in. (91.4 x 72.7 cm)
Signed and dated (lower right): G. Courbet..58
H. O. Havemeyer Collection, Bequest of Mrs. H. O. Havemeyer, 1929
29.100.118
See no. 25

PROVENANCE
Family of the sitter, Brussels (until 1907; sold spring 1907 to Havemeyer through Théodore Duret and Mary Cassatt); Mr. and Mrs. H. O. Havemeyer, New York (until his d. 1907; shipped to them by Durand-Ruel, May 11, 1907, deposit no. 11181); Mrs. H. O. (Louisine W.) Havemeyer, New York (1907–d. 1929)

EXHIBITIONS
"14 tableaux de Gustave Courbet exposés appartenant à des collectionneurs belges," Cercle Artistique et Littéraire, Brussels, 1878; "Portraits du siècle (1789–1889)," location unknown, Brussels, 1889, no. 51; "Loan Exhibition of Impressionist and Post-Impressionist Paintings," Metropolitan Museum of Art, New York, May 3–September 15, 1921, no. 25; "The H. O. Havemeyer Collection," Metropolitan Museum of Art, New York, March 10–November 2, 1930, no. 26; "A Century of Progress," Art Institute of Chicago, June 1–November 1, 1934, no. 178; "Chefs-d'œuvre de l'art français," Palais National des Arts, Paris, July–September 1937, no. 278; "Thirty-eight Great Paintings from The Metropolitan Museum of Art," Detroit Institute of Arts, October 1–October 29, 1951, no catalogue; "Gustave Courbet, 1819– 1877," Philadelphia Museum of Art, December 17, 1959–February 14, 1960, Museum of Fine Arts, Boston, February 26–April 14, 1960, no. 34; "Masterpieces of Painting in The Metropolitan Museum of Art," Museum of Fine Arts, Boston, September 16–November 1, 1970, unnumbered cat. (p. 75); "Gustave Courbet, 1819–1877," Galeries Nationales du Grand Palais, Paris, September 30, 1977–January 2, 1978, no. 56, Royal Academy of Arts, London, January 19–March 19, 1978, no. 53; "Courbet Reconsidered," Brooklyn Museum, November 4, 1988–January 16, 1989, Minneapolis Institute of Arts, February 18–April 30, 1989, no. 31; "Splendid Legacy: The Havemeyer Collection," Metropolitan Museum of Art, New York, March 27–June 20, 1993, no. A129; "Courbet: Artiste et promoteur de son oeuvre," Musée Cantonal des Beaux-Arts de Lausanne, November 21, 1998–March 7, 1999, Nationalmuseum, Stockholm, March 26–May 30, 1999, no. 11; "Bruxelles: Carrefour de cultures," Palais des Beaux-Arts, Brussels, September 8– November 5, 2000, no cat. number

SELECTED REFERENCES
Camille Lemonnier, G. Courbet et son oeuvre, Paris [1878], p. 72; J. Krexpel, "L'Exposition des portraits de maîtres du siècle, à Bruxelles," Revue blanche 2, May 1890, Série Belge, 3; H[arry] B. W[ehle], "Loan Exhibition of Modern French Paintings," Metropolitan Museum of Art Bulletin 16, May 1921, p. 94; Harry B. Wehle, "The Exhibition of the H. O. Havemeyer Collection," Metropolitan Museum of Art Bulletin 25, March 1930, p. 55; H. O. Havemeyer Collection, Catalogue of Paintings, Prints, Sculpture, and Objects of Art, 1931, pp. 90–91, ill.; Charles Sterling and Margaretta M. Salinger, French Paintings: A Catalogue of the Collection of The Metropolitan Museum of Art, 3 vols., New York, 1955–67, vol. 2, pp. 118–19, ill.; Robert Fernier, La vie et l'oeuvre de Gustave Courbet, 2 vols., Lausanne, 1977–78, vol. 1, pp. 144–45, no. 232, ill.; Pierre Courthion, trans. Marina Anzil Robertini, L'Opera completa di Courbet, Milan, 1985, pp. 85–86, no. 224, ill.; Frances Weitzenhoffer, The Havemeyers: Impressionism Comes to America, New York, 1986, pp. 178, 180, 245, 257, pl. 137; Petra Ten-Doesschate Chu, ed. and trans., Letters of Gustave Courbet, Chicago and London, 1992, pp. 158, 160 n. 2; Louisine W. Havemeyer, Sixteen to Sixty: Memoirs of a Collector, New York, 1993, 3rd ed. with notes by Susan Alyson Stein [1st ed., 1930; repr. 1961], pp. 188, 202, 329 n. 261

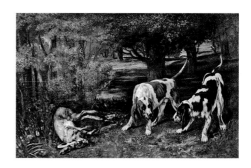

Hunting Dogs with Dead Hare
ca. 1858–59
Oil on canvas
36½ x 58½ in. (92.7 x 148.6 cm)
Signed (lower right): G. Courbet.
H. O. Havemeyer Collection, Gift of Horace Havemeyer, 1933
33.77
See no. 23

PROVENANCE
[Brame, Paris, until 1892; sold on June 23 for Fr 12,000 to Durand-Ruel]; [Durand-Ruel, Paris, 1892, stock no. 2334; sold on September 26 for Fr 40,000 to Durand-Ruel]; [Durand-Ruel, New York, 1892; sold to Havemeyer]; Mr. and Mrs. H. O. Havemeyer, New York (1892–his d. 1907); Mrs. H. O. (Louisine W.) Havemeyer, New York (1907–d. 1929); her son, Horace Havemeyer, New York (1929–33)

EXHIBITIONS
"Exposition Universelle de 1867," Champ-de-Mars, Paris, 1867, probably no. 171; "14 tableaux de Gustave Courbet exposés appartenant à des collectionneurs belges," Cercle Artistique et Littéraire, Brussels, 1878; "World's Columbian Exhibition: Fine Arts," Chicago World's Fair of 1893, May 1–October 26, 1893, no. 2898; "Loan Exhibition of the Works of Gustave Courbet," Metropolitan Museum of Art, New York, April 7–May 18, 1919, no. 7; "Animals in Art," Philbrook Museum of Art, Tulsa, October 3–December 4, 1944, no. 11; "Capolavori impressionisti dei musei americani," Museo di Capodimonte, Naples, December 3, 1986–February 1, 1987, Pinacoteca di Brera, Milan, March 4–May 3, 1987, no. 12; "Splendid Legacy: The Havemeyer Collection," Metropolitan Museum of Art, New York, March 27–June 20, 1993, no. A128; "La collection Havemeyer: Quand l'Amérique découvrait l'impressionnisme . . . ," Musée d'Orsay, Paris, October 20, 1997–January 18, 1998, no. 15

SELECTED REFERENCES
Charles Beauquier, Revue littéraire de la Franche-Comté, May 1, 1867, p. 332; Camille Lemonnier, G. Courbet et son oeuvre, Paris [1878], pp. 74–75 [reprinted in Les Peintres de la vie, Paris, 1888, pp. 52–53]; [Jules] Castagnary, "Fragments d'un livre sur Courbet (deuxième article)," Gazette des beaux-arts 6, 1911, p. 488, ill.; Léonce Bénédite, Courbet, Paris [1912], pp. 77–78, pl. XXXI; André Fontainas, Courbet, Paris, 1921, p. 68; H. O. Havemeyer Collection, Catalogue of Paintings, Prints, Sculpture, and Objects of Art, 1931, pp. 352–53, ill.; Charles Léger, Courbet et son temps (Lettres et documents inédits), Paris, 1948, pp. 66, 69; Charles Sterling and Margaretta M. Salinger, French Paintings: A Catalogue of the Collection of The Metropolitan Museum of Art, 3 vols., New York, 1955–67, vol. 2, pp. 116–17, ill.; Bruce K. MacDonald, "The Quarry by Gustave

Courbet," *Bulletin of the Museum of Fine Arts,* Boston, vol. 67, no. 348, 1969, pp. 60–62, 67–68 n. 16, fig. 8; Robert Fernier, *La vie et l'oeuvre de Gustave Courbet,* 2 vols., Lausanne, 1977–78, vol. 2, pp. 50–51, no. 620, ill.; Marie-Thérèse de Forges, Hélène Toussaint et al., *Gustave Courbet, 1819–1877,* exh. cat., Royal Academy of Arts, London, 1978, p. 131 [French ed., 1977, p. 144]; Pierre Courthion, trans. Marina Anzil Robertini, *L'Opera completa di Courbet,* Milan, 1985, p. 107, no. 602, ill.; Frances Weitzenhoffer, *The Havemeyers: Impressionism Comes to America,* New York, 1986, pp. 80, 89, pl. 31; Petra Ten-Doesschate Chu, ed. and trans., *Letters of Gustave Courbet,* Chicago, 1992, pp. 304, 309, 525, 551; Louisine W. Havemeyer, *Sixteen to Sixty: Memoirs of a Collector,* New York, 1993, 3rd ed. with notes by Susan Alyson Stein [1st ed., 1930; repr. 1961], pp. 194, 330 n. 272

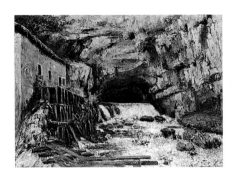

The Source of the Loue
1864
Oil on canvas
39¼ x 56 in. (99.7 x 142.2 cm)
Signed (bottom center): G. Courbet
H. O. Havemeyer Collection, Bequest of Mrs. H. O. Havemeyer, 1929
29.100.122
See no. 26

PROVENANCE
[Félix Gérard, père, Paris]; [Durand-Ruel, Paris, until 1872; sold to Schnabacher]; M. Schnabacher (from 1872); M. Darlu, Paris (until 1889; deposited at Durand-Ruel, Paris, May 16 deposit no. 6746; sold on August 21 for Fr 7,000 to Durand-Ruel); [Durand-Ruel, Paris, 1889, stock no. 2448; sold on August 21 for Fr 15,000 to Havemeyer]; Mr. and Mrs. H. O. Havemeyer, New York (1889–his d. 1907); Mrs. H. O. (Louisine W.) Havemeyer, New York (1907–d. 1929)

EXHIBITIONS
"Exposition des œuvres de M. G. Courbet," Rond-Point du Pont de l'Alma, Paris, 1867, possibly no. 22; "Exposition rétrospective des oeuvres de G. Courbet aux artistes Franc-Comtois," Durand-Ruel, Paris, 1897; "Loan Exhibition of the Works of Gustave Courbet," Metropolitan Museum of Art, New York, April 7–May 18, 1919, no. 16; "The H. O. Havemeyer Collection," Metropolitan Museum of Art, New York, March 10–November 2, 1930, no. 30; "An Exhibition of Paintings by Courbet," Baltimore Museum of Art, May 3–29, 1938, no. 12; "Masterpieces of Art: European and American Paintings, 1500–1900," World's Fair, New York, May–October 1940, no. 263; "Six Centuries of Landscape," Montreal Museum of Fine Arts, March 7– April 13, 1952, no. 46; "Splendid Legacy: The Havemeyer Collection," Metropolitan Museum of Art, New York, March 27–June 20, 1993,

no. A140; "Body," Art Gallery of New South Wales, Sydney, September 12–November 16, 1997, no. 34; "Gustave Courbet et la Franche-Comté," Musée des Beaux-Arts et d'Archéologie, Bensançon, September 23– December 31, 2000, no. 62; "Courbet and the Modern Landscape," J. Paul Getty Museum, Los Angeles, February 21–May 14, 2006, Museum of Fine Arts, Houston, June 18–September 10, 2006, Walters Art Museum, Baltimore, October 15, 2006–January 7, 2007, no. 23

SELECTED REFERENCES
Georges Riat, *Gustave Courbet, peintre,* Paris, 1906, pp. 217, 253, 386, ill. p. 97; *H. O. Havemeyer Collection, Catalogue of Paintings, Prints, Sculpture, and Objects of Art,* 1931, pp. 86–87, ill.; Charles Sterling and Margaretta M. Salinger, *French Paintings: A Catalogue of the Collection of The Metropolitan Museum of Art,* 3 vols., New York, 1955–67, vol. 2, p. 122, ill.; Robert Fernier, *La vie et l'oeuvre de Gustave Courbet,* 2 vols., Lausanne, 1977–78, vol. 1, p. 216, no. 387, ill. p. 217; Pierre Courthion, trans. Marina Anzil Robertini, *L'Opera completa di Courbet,* Milan, 1985, p. 94, no. 368, ill.; Frances Weitzenhoffer, *The Havemeyers: Impressionism Comes to America,* New York, 1986, pp. 117, 257, pl. 72; Sarah Faunce, Linda Nochlin, Ann Dumas et al., *Courbet Reconsidered,* exh. cat., Brooklyn Museum, 1988, pp. 74, 85, 153, 189; Petra Ten-Doesschate Chu, ed. and trans., *Letters of Gustave Courbet,* Chicago, 1992, pp. 243, 551; Louisine W. Havemeyer, *Sixteen to Sixty: Memoirs of a Collector,* New York, 1993, 3rd ed. with notes by Susan Alyson Stein [1st ed., 1930; repr. 1961], pp. 186, 194, 329 n. 259, p. 330 n. 272, p. 342 n. 425

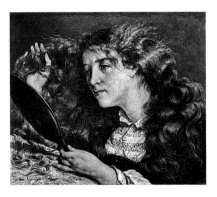

Jo, La Belle Irlandaise
1866
Oil on canvas
22 x 26 in. (55.9 x 66 cm)
Signed and dated (lower left): . . 66 / Gustave.Courbet.
H. O. Havemeyer Collection, Bequest of Mrs. H. O. Havemeyer, 1929
29.100.63
See no. 30

PROVENANCE
[Félix Gérard, père, Paris, until 1896; sale, Hôtel Drouot, Paris, February 25, 1896, no. 13, for Fr 2,020, to M. Gérard, fils]; [his son, M. Gérard, Paris, 1896]; [Hector-Gustave Brame, Paris, until 1898; deposited at Durand-Ruel, Paris, June 15, 1898, deposit no. 9360; sold September 9 for Fr 4,000 to Durand-Ruel]; [Durand-Ruel, Paris, 1898,

stock no. 4762; sold October 12 (Paris stock book) or 27 for Fr 12,000 to Durand-Ruel]; [Durand-Ruel, New York, 1898; New York stock book no. 2042; sold December 31 for $2,800 to Havemeyer]; Mr. and Mrs. H. O. Havemeyer, New York (1898–his d. 1907); Mrs. H. O. (Louisine W.) Havemeyer, New York (1907–d. 1929)

EXHIBITIONS
"Old Master and Modern Paintings," Union League Club, New York, November 1898, no. 15; "Loan Exhibition of the Works of Gustave Courbet," Metropolitan Museum of Art, New York, April 7–May 18, 1919, no. 23; "The H. O. Havemeyer Collection," Metropolitan Museum of Art, New York, March 10–November 2, 1930, no. 32 [2nd ed., 1958, no. 81]; "La femme dans l'art français," Musée de Peinture Moderne, Brussels, March 13–May 24, 1953; "Gustave Courbet, 1819–1877," Philadelphia Museum of Art, December 17, 1959–February 14, 1960, Museum of Fine Arts, Boston, February 26–April 14, 1960, no. 55; "100 Paintings from the Metropolitan Museum," State Hermitage Museum, Leningrad [St. Petersburg], May 15–June 20, 1975, Pushkin State Museum of Fine Arts, Moscow, August 28– November 2, 1975, no. 60; "Gustave Courbet, 1819–1877," Galeries Nationales du Grand Palais, Paris, September 30, 1977–January 2, 1978, no. 90, Royal Academy of Arts, London, January 19–March 19, 1978, no. 87; "A Magic Mirror: The Portrait in France, 1700–1900," Museum of Fine Arts, Houston, October 12, 1986–January 25, 1987, no. 34; "Franse meesters uit het Metropolitan Museum of Art: Realisten en Impressionisten," Rijksmuseum Vincent Van Gogh, Amsterdam, March 15–May 31, 1987, no. 10; "Courbet Reconsidered," Brooklyn Museum, November 4, 1988–January 16, 1989, Minneapolis Institute of Arts, February 18–April 30, 1989, no. 54; "Splendid Legacy: The Havemeyer Collection," Metropolitan Museum of Art, New York, March 27–June 20, 1993, no. A147; "La collection Havemeyer: Quand l'Amérique découvrait l'impressionnisme . . . ," Musée d'Orsay, Paris, October 20, 1997–January 18, 1998, no. 14

SELECTED REFERENCES
Georges Riat, *Gustave Courbet, peintre,* Paris, 1906, pp. 228–29, 254, 259, 262, 360; Harry B. Wehle, "The Exhibition of the H. O. Havemeyer Collection," *Metropolitan Museum of Art Bulletin* 25, March 1930, p. 55; *H. O. Havemeyer Collection, Catalogue of Paintings, Prints, Sculpture, and Objects of Art,* 1931, pp. 74–75, ill.; Charles Sterling and Margaretta M. Salinger, *French Paintings: A Catalogue of the Collection of The Metropolitan Museum of Art,* 3 vols., New York, 1955–67, vol. 2, pp. 128–29, ill.; Robert Fernier, *La vie et l'oeuvre de Gustave Courbet,* 2 vols., Lausanne, 1977–78, vol. 1, p. 244, vol. 2, p. 12, no. 538, ill. p. 13; Pierre Courthion, trans. Marina Anzil Robertini, *L'Opera completa di Courbet,* Milan, 1985, p. 102, no. 515, ill. pl. XXVIII; Frances Weitzenhoffer, *The Havemeyers: Impressionism Comes to America,* New York, 1986, pp. 136, 256, pl. 99; Michael Fried, *Courbet's Realism,* Chicago, 1990, pp. 198–200, 205, 220, 228, 272–73, 289, 319 n. 41, pp. 337–38 nn. 25–26, p. 339 n. 32, pl. 11; Louisine W. Havemeyer, *Sixteen to Sixty: Memoirs of a Collector,* New York, 1993, 3rd ed. with notes by Susan Alyson Stein [1st ed., 1930; repr. 1961], pp. 187–88, 212, 301, 329 n. 260, p. 332 n. 303; Sarah Faunce, *Gustave Courbet,* New York, 1993, pp. 108–9, no. 31, ill.

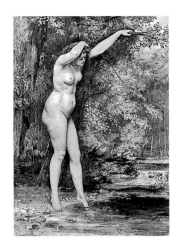

The Young Bather
1866
Oil on canvas
51¼ x 38¼ in. (130.2 x 97.2 cm)
Signed and dated (lower left): 66 / G. Courbet.
H. O. Havemeyer Collection, Bequest of Mrs. H. O.
Havemeyer, 1929
29.100.124
See no. 27

PROVENANCE
Khalil-Bey, Paris (until 1868; his sale, Hôtel Drouot,
Paris, January 16–18, 1868, no. 10, for Fr 3,700, to
Belling); Belling (from 1868); Sainctelette, Brussels (in
1878); Mrs. H. O. (Louisine W.) Havemeyer, New
York (1920–d. 1929; bought through Théodore Duret,
probably for Fr 60,000; first offered to her by Duret,
January 16, 1917; received by her, February 10, 1920)

EXHIBITIONS
"14 tableaux de Gustave Courbet exposés appar-
tenant à des collectionneurs belges," Cercle Artistique
et Littéraire, Brussels, 1878; "The H. O. Havemeyer
Collection," Metropolitan Museum of Art, New York,
March 10–November 2, 1930, no. 31; "A Loan
Exhibition of Gustave Courbet," Wildenstein and Co.,
Inc., New York, December 2, 1948–January 8, 1949,
no. 29; "Nudes in Landscapes: Four Centuries of a
Tradition," Metropolitan Museum of Art, New York,
May 18–August 5, 1973, no catalogue; "100 Paintings
from the Metropolitan Museum," State Hermitage
Museum, Leningrad [St. Petersburg], May 15–June 20,
1975, Pushkin State Museum of Fine Arts, Moscow,
August 28–November 2, 1975, no. 61; "The Cult of
Images," University of California Santa Barbara Art
Museum, April 6–May 8, 1977, no. 1; "Splendid
Legacy: The Havemeyer Collection," Metropolitan
Museum of Art, New York, March 27–June 20, 1993,
no. A146

SELECTED REFERENCES
Théophile Gautier, "Variétés: Beaux-arts: Collection
Khalil-Bey," *Le moniteur universel*, December 14,
1867, p. 1557; Le Hir, *Journal des amateurs*, 1868,
p. 10; Paul Mantz, "Gustave Courbet—Part 3,"
Gazette des beaux-arts 18, 1878, pér. 2, pp. 375–78,
ill.; Camille Lemonnier, *G. Courbet et son oeuvre*,
Paris [1878], pp. 72–73 [reprinted in *Les peintres de
la vie*, Paris, 1888, pp. 50–51]; J[oséphin] Péladan,
"Gustave Courbet," *L'Artiste* 2, 1884, p. 411; Gustave
Cahen, *Eugène Boudin: Sa vie et son oeuvre*, Paris,
1900, p. 193; Georges Riat, *Gustave Courbet, peintre*,
Paris, 1906, pp. 245–46, 259, 387, ill. p. 247; Arsène
Alexandre, "La collection Havemeyer: Courbet et
Corot," *La renaissance* 12, June 1929, p. 278, ill.
p. 274; Harry B. Wehle, "The Exhibition of the H. O.

Havemeyer Collection," *Metropolitan Museum of Art
Bulletin* 25, March 1930, p. 55; *H. O. Havemeyer
Collection, Catalogue of Paintings, Prints, Sculpture,
and Objects of Art*, 1931, pp. 82–83, ill.; Charles
Sterling and Margaretta M. Salinger, *French Paintings:
A Catalogue of the Collection of The Metropolitan
Museum of Art*, 3 vols., New York, 1955–67, vol. 2,
pp. 127–28, ill.; Robert Fernier, *La vie et l'oeuvre de
Gustave Courbet*, 2 vols., Lausanne, 1977–78, vol. 2,
p. 10, no. 535, ill. p. 11; Pierre Courthion, trans.
Marina Anzil Robertini, *L'Opera completa di Courbet*,
Milan, 1985, p. 103, no. 525, ill. (black and white,
colorpl. XXVI); Frances Weitzenhoffer, *The
Havemeyers: Impressionism Comes to America*, New
York, 1986, pp. 239, 257, pl. 161; Jörg Zutter and
Petra Ten-Doesschate Chu, eds., *Courbet: Artiste et
promoteur de son oeuvre*, exh. cat., Musée Cantonal
des Beaux-Arts de Lausanne, Paris, 1998, French ed.
[Swedish ed., 1999], pp. 15, 31, 81, fig. 86

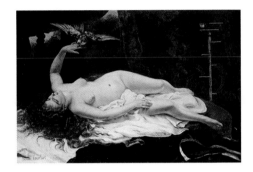

Woman with a Parrot
1866
Oil on canvas
51 x 77 in. (129.5 x 195.6 cm)
Signed and dated (lower left): .66 / Gustave.Courbet.
H. O. Havemeyer Collection, Bequest of Mrs. H. O.
Havemeyer, 1929
29.100.57
See no. 28

PROVENANCE
Jules Bordet, Dijon (1870–at least 1889; bought from
the artist in spring 1870 for Fr 15,000); [possibly
Haro, Paris]; [Durand-Ruel, Paris; received on deposit
from Boudet (or Bordet) on February 2, 1895, deposit
no. 8623; deposited at Durand-Ruel, New York, on
November 4, 1895, deposit no. 5358; sold on April
30, 1898, for Fr 20,000 to Durand-Ruel]; [Durand-
Ruel, New York, 1898, stock no. 1994; sold on April
30, 1898, for $12,000 to Havemeyer]; Mr. and Mrs.
H. O. Havemeyer, New York (1898–his d. 1907);
Mrs. H. O. (Louisine W.) Havemeyer, New York
(1907–d. 1929)

EXHIBITIONS
Salon, Paris, 1866, no. 463; "Exposition générale des
beaux-arts," location unknown, Brussels, 1866,
no. 144; "Exposition des œuvres de M. G. Courbet,"
Rond-Point du Pont de l'Alma, Paris, 1867, no. 10;
"Première exposition internationale des beaux-arts
dans le Palais de l'Industrie à Munich," Glaspalast,
Munich, July 20–October 31, 1869; unidentified
exhibition, Antwerp, 1870; "Exposition des œuvres
de Gustave Courbet," École des Beaux-Arts, Paris,

May 1882, no. 13; "Exposition universelle interna-
tionale de 1889: Exposition centennale de l'art
français (1789–1889)," Paris, May–November 1889,
no. 210; "Loan Exhibition of the Works of Gustave
Courbet," Metropolitan Museum of Art, New York,
April 7–May 18, 1919, no. 24; "The H. O. Havemeyer
Collection," Metropolitan Museum of Art, New York,
March 10–November 2, 1930, no. 21; "Exhibition of
French Art: 1200–1900," Royal Academy of Arts,
London, January 4–March 12, 1932, no. 436; "Art
Treasures of the Metropolitan," Metropolitan Museum
of Art, New York, November 7, 1952–September 7,
1953, no. 141; "Venetian Tradition," Cleveland
Museum of Art, November 9, 1956–January 1, 1957,
no. 8; "Gustave Courbet, 1819–1877," Philadelphia
Museum of Art, December 17, 1959–February 14,
1960, Museum of Fine Arts, Boston, February 26–April
14, 1960, no. 60; "Impressionism: A Centenary
Exhibition," Metropolitan Museum of Art, New York,
December 12, 1974– February 10, 1975, not in cata-
logue; "Gustave Courbet, 1819–1877," Galeries
Nationales du Grand Palais, Paris, September 30,
1977–January 2, 1978, no. 96, Royal Academy of
Arts, London, January 19–March 19, 1978, no. 91;
"The Second Empire, 1852–1870: Art in France under
Napoleon III," Philadelphia Museum of Art, October
1–November 26, 1978, no. VI-30, Detroit Institute of
Arts, January 15–March 18, 1979, no. VI-30, Galeries
Nationales du Grand Palais, Paris, May 11–August 13,
1979, no. 198; "From Delacroix to Matisse," State
Hermitage Museum, Leningrad [St. Petersburg], March
15–May 10, 1988, Pushkin State Museum of Fine
Arts, Moscow, June 10–July 30, 1988, no. 10; "Courbet
Reconsidered," Brooklyn Museum, November 4,
1988–January 16, 1989, not in catalogue; "Splendid
Legacy: The Havemeyer Collection," Metropolitan
Museum of Art, New York, March 27–June 20, 1993,
no. A145; "Origins of Impressionism," Galeries
Nationales du Grand Palais, Paris, April 19–August 8,
1994, Metropolitan Museum of Art, New York,
September 27, 1994–January 8, 1995, no. 45

SELECTED REFERENCES
A. Baignères, "Journal du Salon de 1866," *Revue con-
temporaine* 51, 1866, pp. 347–48; Charles Beauquier,
Revue littéraire de la Franche-Comté, August 1, 1866;
Charles Beaurin, "Le salon de 1866," *Revue du XIXe
siècle* 1, June 1, 1866, p. 454; Charles Blanc, "Salon
de 1866," *Gazette des beaux-arts* 20, 1866, p. 510;
Maxime du Camp, *Revue des deux mondes* 63, 1866,
pp. 711–12; Jules Castagnary, *La liberté*, May 1866;
P. Challemel-Lacour, "Le salon de 1866," *La revue
moderne*, 1866, pp. 534–35; Cham, "Promenade au
salon," *Le charivari*, May 1866; Just Durgy, "La femme
au perroquet," 1866; Louis Enault, *Revue illustrée des
eaux minérales, des bains de mer, de stations hiver-
nales*, May 27, 1866, p. 162; Théophile Gautier,
Journal officiel, July 4, 1866; Léon Lagrange, "Le
salon de 1866," *Le correspondant* 32, 1866, p. 196;
Paul de Saint-Victor, *La presse*, June 10, 1866; C. de
Sault, "Salon de 1866," *Le temps*, May 18, 1866,
p. 2; Jules Vallès, *L'Événement*, March 11, 1866;
Émile Zola, *Mon salon*, Paris, 1866, pp. 57–58, 60;
[J. Castagnary], *Le nain jaune*, August 14 and 29,
1866; *Le chevalier*, 1866; Felix Jahyer, *Deuxième
étude sur les beaux-arts: Salon de 1866*, Paris, 1866,
pp. 81, 86–87; Edmond About, *Salon de 1866*, Paris,
1867, pp. 47–49; L. Petit, "G. Courbet," *Le hanneton*,
June 13, 1867; Arnaud, *Le Salon pour rire*, 1868;
Étienne-Joseph-Théophile Thoré, "Salon de 1866,"
Salons de W. Bürger, 1861 à 1868, Paris, 1870, vol. 2,
pp. 277, 283–84; comte H[enry] d' Ideville, *Gustave
Courbet*, Paris, 1878, pp. 30, 32–33, 62–64; Paul
Mantz, "Gustave Courbet—Part 3," *Gazette des
beaux-arts* 18, 1878, pér. 2, pp. 375–76, 378–79;
J. Troubat, *Plume et pinceau*, 1878, p. 254; Émile

Durand-Gréville, *Entretiens avec J.-J. Henner,* May 1882; J.-K. Huysmans, "Le Salon officiel de 1880," *L'Art moderne,* Paris, 1883, p. 238; Victor Fournel, *Les artistes français contemporains: peintures— sculpteurs,* Tours, 1884, p. 363; Georges Riat, *Gustave Courbet, peintre,* Paris, 1906, pp. 234–42, 252, 256, 270, 276, 387, no. 56, ill.; [Jules] Castagnary, "Fragments d'un livre sur Courbet," *Gazette des beaux-arts* 7, January 1912, pér. 4, p. 24; Théodore Duret, *Courbet,* Paris, 1918, pp. 75–76, 149, pl. 26; Charles Léger, *Courbet selon les carica- tures et les images,* Paris, 1920, pp. 61, 66, 77; Harry B. Wehle, "The Exhibition of the H. O. Havemeyer Collection," *Metropolitan Museum of Art Bulletin* 25, March 1930, p. 55; *H. O. Havemeyer Collection, Catalogue of Paintings, Prints, Sculpture, and Objects of Art,* 1931, pp. 76–77, ill.; Ludovic Halévy, *Carnets,* Paris, 1935, vol. 1, pp. 109–10; Charles Léger, *Courbet et son temps (Lettres et documents inédits),* Paris, 1948, pp. 112–13, 196–97, fig. 32; Pierre Courthion, ed., *Courbet raconté par lui-même et par ses amis,* 2 vols., Geneva, 1948–50, vol. 1, pp. 130, 212, 214–15, 220–22, vol. 2, pp. 231, 301, fig. 7; Theodore Rousseau Jr., "A Guide to the Picture Galleries," *Metropolitan Museum of Art Bulletin* 12, January 1954, n.s., part 2, ill. p. 48; Charles Sterling and Margaretta M. Salinger, *French Paintings: A Catalogue of the Collection of The Metropolitan Museum of Art,* 3 vols., New York, 1955–67, vol. 2, pp. 124–27, ill.; Edmond de Goncourt, *Journal: Mémoires de la vie littéraire,* Paris, 1956, vol. 2, p. 376; Lucie Chamson Mazauric, "Comment on perd un tableau," *La revue du Louvre* 18 (1968), pp. 28, 30–31; Robert Fernier, *La vie et l'oeuvre de Gustave Courbet,* 2 vols., Lausanne, 1977–78, vol. 2, pp. 4–5, no. 526, ill.; Prof. Dr. Peter-Klaus Schuster et al., *Courbet und Deutschland,* exh. cat., Hamburger Kunsthalle, Cologne, 1978, pp. 240–42, ill.; Denise Delouche et al., *L'Image par l'image,* Rennes, 1983, unpaginated; Pierre Courthion, trans. Marina Anzil Robertini, *L'Opera completa di Courbet,* Milan, 1985, pp. 102–3, no. 518, ill.; Frances Weitzenhoffer, *The Havemeyers: Impressionism Comes to America,* New York, 1986, pp. 56, 110, 193, 239, 256, 262 n. 9, pl. 143; Michael Fried, *Courbet's Realism,* Chicago, 1990, pp. 189, 200–201, 203–5, 207, 209, 220, 247, 289, 338–39 nn. 31–34, fig. 75; Petra Ten-Doesschate Chu, ed. and trans., *Letters of Gustave Courbet,* Chicago, 1992, pp. 275–79, 282–91, 293–98, 303, 373, 374 n. 1, 530; Louisine W. Havemeyer, *Sixteen to Sixty: Memoirs of a Collector,* New York, 1993, 3rd ed. with notes by Susan Alyson Stein [1st ed., 1930; repr. 1961], pp. 184–85, 195–97, 301, 328 n. 253, p. 330 nn. 278–79, p. 340 n. 400; James H. Rubin, *Courbet,* London, 1997, pp. 204–5, 207, 212, 251, 325, fig. 126; Jörg Zutter and Petra Ten-Doesschate Chu, eds., *Courbet: Artiste et promoteur de son oeuvre,* exh. cat., Musée Cantonal des Beaux-Arts de Lausanne, Paris, 1998 [Swedish ed., 1999], pp. 25, 31, 34, 75, 81, 104, fig. 22

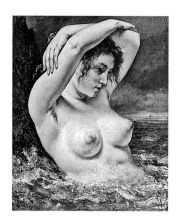

The Woman in the Waves
1868
Oil on canvas
25¾ x 21¼ in. (65.4 x 54 cm)
Signed and dated (lower left): 68 / G. Courbet
H. O. Havemeyer Collection, Bequest of Mrs. H. O. Havemeyer, 1929
29.100.62
See no. 31

PROVENANCE
[Durand-Ruel, Paris from 1873; purchased from the artist for Fr 50,000 or Fr 45,000 in bonds]; Jean-Baptiste Faure, Paris (by 1882–93; sold January 9 for Fr 13,000 to Durand-Ruel); [Durand-Ruel, Paris, 1893, stock no. 2580, as "Femme à la vague"; sold January 18 for Fr 20,000 to Durand-Ruel]; [Durand-Ruel, New York, 1893; sold January 30 for $5,000 to Havemeyer]; Mr. and Mrs. H. O. Havemeyer, New York (1893–his d.1907); Mrs. H. O. (Louisine W.) Havemeyer, New York (1907–d. 1929)

EXHIBITIONS
"Salon de Gand," Casino, Ghent, September 13– November 15, 1868, no. 1031; "Première exposition internationale des beaux-arts dans le Palais de l'Industrie à Munich," Glaspalast, Munich, July 20– October 31, 1869; "Exposition générale des beaux-arts," location unknown, Brussels, August 15– October 15, 1872, no. 143; "Exposition des œuvres de Gustave Courbet," École des Beaux-Arts, Paris, May 1882, no. 24; "Loan Exhibition of the Works of Gustave Courbet," Metropolitan Museum of Art, New York, April 7–May 18, 1919, no. 31; "The H. O. Havemeyer Collection," Metropolitan Museum of Art, New York, March 10–November 2, 1930, no. 33; "Metropolitan Museum Masterpieces," Hofstra College, Hempstead, N.Y., June 29–September 1, 1952, no. 34; "München 1869–1958: Aufbruch zur Modernen Kunst," Haus der Kunst, Munich, June 21– October 5, 1958, no. 26; "Gustave Courbet, 1819– 1877," Philadelphia Museum of Art, December 17, 1959–February 14, 1960, Museum of Fine Arts, Boston, February 26–April 14, 1960, no. 67; "Gustave Courbet, 1819–1877," Galeries Nationales du Grand Palais, Paris, September 30, 1977–January 2, 1978, no. 109, Royal Academy of Arts, London, January 19– March 19, 1978, no. 106; "Courbet und Deutschland," Hamburger Kunsthalle, October 19– December 17, 1978, Städtische Galerie im Städelschen Kunstinstitut, Frankfurt am Main, January 17–March 18, 1979, no. 277A; "Capolavori impressionisti dei musei americani," Museo di Capodimonte, Naples, December 3, 1986–February 1, 1987, Pinacoteca di Brera, Milan, March 4–May 3, 1987, no. 14; "Courbet Reconsidered," Brooklyn Museum, November 4, 1988–January 16, 1989, Minneapolis Institute of Arts, February 18–April 30, 1989, no. 68; "Splendid

Legacy: The Havemeyer Collection," Metropolitan Museum of Art, New York, March 27–June 20, 1993, no. A148; "La collection Havemeyer: Quand l'Amérique découvrait l'impressionnisme . . . ," Musée d'Orsay, Paris, October 20, 1997–January 18, 1998, no. 11; "Courbet: Artiste et promoteur de son oeuvre," Musée Cantonal des Beaux-Arts de Lausanne, November 21, 1998–March 7, 1999, Stockholm, March 26–May 30, 1999, no. 53; "Faszination Venus: Bilder einer Göttin von Cranach bis Cabanel," Wallraf-Richartz-Museum, Cologne, October 14, 2000–January 7, 2001, Alte Pinakothek, Munich, February 1, 2001–April 2, 2001, Koninklijk Museum voor Schone Kunsten, Antwerp, May 20, 2001–August 15, 2001, no. 75

SELECTED REFERENCES
Exhibition review, *Journal de Gand,* September 16, 1868; Georges Riat, *Gustave Courbet, peintre,* Paris, 1906, pp. 264–65, ill.; Harry B. Wehle, "The Exhibition of the H. O. Havemeyer Collection," *Metropolitan Museum of Art Bulletin* 25, March 1930, p. 55; *H. O. Havemeyer Collection, Catalogue of Paintings, Prints, Sculpture, and Objects of Art,* 1931, pp. 78–79, ill.; Charles Sterling and Margaretta M. Salinger, *French Paintings: A Catalogue of the Collection of The Metropolitan Museum of Art,* 3 vols., New York, 1955–67, vol. 2, pp. 130–31, ill.; Robert Fernier, *Gustave Courbet: Peintre de l'art vivant,* Paris, 1969, fig. 51; Anthea Callen, *Jean-Baptiste Faure, 1830–1914: A Study of a Patron and Collector of the Impressionists and Their Contemporaries,* master's thesis, University of Leicester, 1971, p. 146, no. 163; Robert Fernier, *La vie et l'oeuvre de Gustave Courbet,* 2 vols., Lausanne, 1977–78, vol. 2, p. 56, no. 628, ill. p. 57; Pierre Courthion, trans. Marina Anzil Robertini, *L'Opera completa di Courbet,* Milan, 1985, p. 108, no. 612, ill., pl. XXXV; Frances Weitzenhoffer, *The Havemeyers: Impressionism Comes to America,* New York, 1986, pp. 112–13, 256, pl. 65; R. Hoozee, "Gustave Courbet op het Gentse Salon van 1868," *De Wagenmenner en Andere Verhaln,* symposium proceedings, Claire van Damme and Paul van Calster, eds., Ghent, 1986, pp. 83, 85, 87; Petra Ten-Doesschate Chu, ed. and trans., *Letters of Gustave Courbet,* Chicago, 1992, pp. 481, 488, 560; Louisine W. Havemeyer, *Sixteen to Sixty: Memoirs of a Collector,* New York, 1993, 3rd ed. with notes by Susan Alyson Stein [1st ed., 1930; repr. 1961], pp. 196–97, 330 n. 280

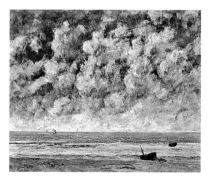

The Calm Sea
1869
Oil on canvas
23½ x 28¾ in. (59.7 x 73 cm)
Signed and dated (lower left): .69 / G.Courbet.
H. O. Havemeyer Collection, Bequest of Mrs. H. O. Havemeyer, 1929
29.100.566
See no. 32

Thomas Couture
French, 1815–1879

Soap Bubbles
ca. 1859
Oil on canvas
51½ x 38⅝ in. (130.8 x 98.1 cm)
Signed and inscribed: (lower left) T.C.; (on paper)
immortalité de l'un . . . (one's immortality . . .)
Catharine Lorillard Wolfe Collection, Bequest of
Catharine Lorillard Wolfe, 1887
87.15.22
See no. 36

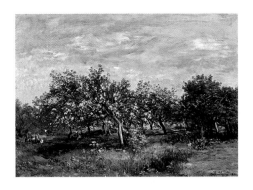

Charles-François Daubigny
French, 1817–1878

Apple Blossoms
1873
Oil on canvas
23⅛ x 33⅜ in. (58.7 x 84.8 cm)
Signed and dated (lower right): Daubigny 1873
Bequest of Collis P. Huntington, 1900
25.110.3
See no. 46

203

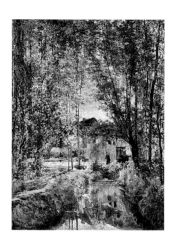

Landscape with a Sunlit Stream
ca. 1877
Oil on canvas
25⅛ x 18⅞ in. (63.8 x 47.9 cm)
Signed (lower left): Daubigny.
Bequest of Martha T. Fiske Collord, in memory of her
first husband, Josiah M. Fiske, 1908
08.136.4
See no. 47

PROVENANCE
Mrs. A. B. Blodgett, Philadelphia (in 1904); Martha T.
Fiske Collord, New York (until d. 1908)

EXHIBITIONS
"Trees in Art," Guild Hall, East Hampton, N.Y.,
July 18–August 13, 1957, no. 13; "Barbizon
Revisited," California Palace of the Legion of Honor,
San Francisco, September 27–November 4, 1962,
Toledo Museum of Art, November 20–December 27,
1962, Cleveland Museum of Art, January 15–
February 24, 1963, Museum of Fine Arts, Boston,
March 14–April 28, 1963, no. 36; "Charles François
Daubigny," Paine Art Center and Arboretum,
Oshkosh, Wisc., May 1–31, 1964, no. 73; "Charles
François Daubigny," Gallery of Modern Art, New York,
June 16–August 2, 1964, no. 73

SELECTED REFERENCES
B[ryson] B[urroughs], "Bequest of the Late Mrs.
Martha T. Fiske Collord," *Metropolitan Museum of Art
Bulletin* 3, November 1908, p. 200, ill.; Charles
Sterling and Margaretta M. Salinger, *French Paintings:
A Catalogue of the Collection of The Metropolitan
Museum of Art,* 3 vols., New York, 1955–67, vol. 2,
p. 101, ill.; Madeleine Fidell-Beaufort and Janine
Bailly-Herzberg, trans. Judith Schub, *Daubigny,* Paris,
1975, pp. 138–39, no. 64, ill.; Robert Hellebranth,
Charles-François Daubigny, Morges, Switzerland,
1976, p. 79, no. 211, ill.

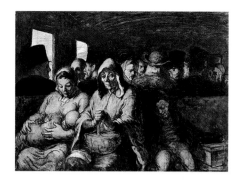

Honoré Daumier
French, 1808–1879

The Third-Class Carriage
ca. 1862–64
Oil on canvas
25¾ x 35½ in. (65.4 x 90.2 cm)
H. O. Havemeyer Collection, Bequest of Mrs. H. O.
Havemeyer, 1929
29.100.129
See no. 19

PROVENANCE
Duz, Paris (by 1878–92; sold on June 8, 1892, to
Durand-Ruel); [Durand-Ruel, Paris, 1892–93, possi-
bly stock no. 2316; sold on April 19, 1893, to
Durand-Ruel, New York]; [Durand-Ruel, New York,
1893–96, stock no. 1048, sold on February 24, 1896,
to Borden]; Matthew Chaloner Durfee Borden,
New York (1896–1913; his sale, American Art
Association, New York, February 13–14, 1913,
no. 76, for $40,000 to Durand-Ruel for Havemeyer);
Mrs. H. O. (Louisine W.) Havemeyer, New York
(1913–d. 1929)

EXHIBITIONS
"Exposition des peintures, aquarelles, dessins et litho-
graphies des maîtres français de la caricature et de la
peinture," École des Beaux-Arts, Paris, 1888, no. 361;
"The H. O. Havemeyer Collection," Metropolitan
Museum of Art, New York, March 10–November 2,
1930, no. 42; "Daumier: Peintures, aquarelles,
dessins," Musée de l'Orangerie, Paris, 1934, no. 6;
"Daumier 1808–1879," Pennsylvania Museum of Art,
Philadelphia, 1937, no. 5; "Chefs-d'oeuvre de l'art
français," Palais National des Arts, Paris, July–
September 1937, no. 288; "Diamond Jubilee
Exhibition: Masterpieces of Painting," Philadelphia
Museum of Art, November 4, 1950–February 11,
1951, no. 57; "Art Treasures of the Metropolitan,"
Metropolitan Museum of Art, New York, November 7,
1952–September 7, 1953, no. 142; "De David à
Toulouse-Lautrec: Chefs-d'œuvre des collections
américaines," Musée de l'Orangerie, Paris, spring
1955, no. 16; "Van Gogh as Critic and Self-Critic,"
Metropolitan Museum of Art, New York, October 30,
1973–January 6, 1974, no. 38; "Franse meesters uit
het Metropolitan Museum of Art: Realisten en
Impressionisten," Rijksmuseum Vincent Van Gogh,
Amsterdam, March 15–May 31, 1987, no. 8; "From
Delacroix to Matisse," State Hermitage Museum,
Leningrad [St. Petersburg], March 15–May 10, 1988,
Pushkin State Museum of Fine Arts, Moscow, June 10–
July 30, 1988, no. 3; "Daumier Drawings,"
Metropolitan Museum of Art, New York, February 26–
May 2, 1993, no cat. number; "Daumier 1808–1879,"
Musée des Beaux-Arts du Canada, Ottawa, June 11–
September 6, 1999, Galeries Nationales du Grand
Palais, Paris, October 5, 1999–January 3, 2000,
Phillips Collection, Washington, D.C., February 19–
May 14, 2000, no. 271

SELECTED REFERENCES
Paul Sébillot, *Le bien public,* April 23, 1878; Camille
Pelletan, "Sur l'ouverture de l'exposition Daumier;
Exposition Daumier," *Le rappel,* May 31, 1878, p. 2;
Arsène Alexandre, *Honoré Daumier,* Paris, 1888,
p. 375, ill. p. 257; E. Klossowski, *Honoré Daumier,*
Munich, 1908, p. 18, no. 253, pl. 58; Harry B.
Wehle, "The Exhibition of the H. O. Havemeyer
Collection," *Metropolitan Museum of Art Bulletin* 25,
March 1930, pp. 56, 58, ill.; Raymond Escholier,
Daumier, Paris, 1930, pp. 130, 262, no. 55, ill.;
*H. O. Havemeyer Collection, Catalogue of Paintings,
Prints, Sculpture, and Objects of Art,* 1931, pp. 102,
103, ill.; Jean Adhémar, "Sur la date des tableaux de
Daumier," *Bulletin de la Société de l'Histoire de l'Art
Français,* 1935, pp. [152], 154, [155]; Josephine L.
Allen, "Notes on the Cover," *Metropolitan Museum of
Art Bulletin* 5, October 1946, opp. p. 49, ill. on cover
and opp. p. 49; Theodore Rousseau Jr., "A Guide to
the Picture Galleries," *Metropolitan Museum of Art
Bulletin* 12, January 1954, part 2, ill. p. 52; Jean
Adhémar, *Honoré Daumier,* Paris [1954], pp. 52, 53,
128, no. 147, ill. after p. 50 and pl. 147; Charles
Sterling and Margaretta M. Salinger, *French Paintings:
A Catalogue of the Collection of The Metropolitan
Museum of Art,* 3 vols., New York, 1955–67, vol. 2,
pp. 37–39, ill.; K. E. Maison, "Further Daumier
Studies—I: The Tracings," *Burlington Magazine* 98,
May 1956, p. 166; K. E. Maison, *Honoré Daumier:
Catalogue Raisonné of the Paintings, Watercolours,
and Drawings,* 2 vols., Greenwich, Conn., 1967–68,
vol. 1, pp. 141–43, no. I-165, pl. 61; Gabriele
Mandel et al., *L'Opera pittorica completa di Daumier,*
Milan, 1971, p. 107, no. 215, ill., pl. 52–53; Frances
Weitzenhoffer, *The Havemeyers: Impressionism
Comes to America,* New York, 1986, pp. 56, 80–81,
209, 258, 262 n. 9, pl. 149; Louisine W. Havemeyer,
Sixteen to Sixty: Memoirs of a Collector, New York,
1993, 3rd ed. with notes by Susan Alyson Stein [1st
ed., 1930; repr. 1961], pp. 7, 303, 308 n. 13; Susan
Alyson Stein et al., *Splendid Legacy: The Havemeyer
Collection,* exh. cat., Metropolitan Museum of Art,
New York, 1993, pp. 214, 262–63, 284–85, 322, no.
A177, pl. 261; Bruce Laughton, *Honoré Daumier,*
New Haven, 1996, pp. 113, 114, 116, 184 n. 12,
pl. 139

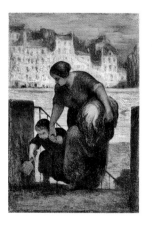

The Laundress
1863
Oil on wood
19¼ x 13 in. (48.9 x 33 cm)
Signed and dated (lower left): h. Daumier / 186[3?]
Bequest of Lillie P. Bliss, 1931
47.122
See no. 18

PROVENANCE

Geoffroy-Dechaume, Paris (by 1878–93; sale, Hôtel Drouot, Paris, April 14–15, 1893, no. 24, for Fr 5,400); Paul Gallimard, Paris (by 1900–26); [Hodebert, Paris, 1926]; [Alex Reid and Lefevre, London, possibly 1927]; [Knoedler, London and New York, 1927]; Lillie P. Bliss, New York (1927– d. 1931; bequeathed to the Museum of Modern Art); Museum of Modern Art, New York (1931–47; transferred to the Metropolitan Museum on September 15, 1947)

EXHIBITIONS

"Daumier," Durand-Ruel, Paris, April 17–June 17, 1878, no. 37; "Centennale de l'art français (1800–1889)," Exposition Internationale Universelle, Paris, May–November 1900, no. 180; "Exposition Daumier," Palais de l'École des Beaux-Arts, Paris, May 1901, no. 42; "Daumier," Galerie Eugène Blot, Paris, 1908, no. 6; "Exposition d'art français du XIXe siècle," Royal Museum, Copenhagen, May 15– June 30, 1914, no. 61; "Corot–Daumier," Museum of Modern Art, New York, October 16–November 23, 1930, no. 80; "Memorial Exhibition: The Collection of the Late Miss Lizzie [Lillie] P. Bliss, Vice-President of the Museum," Museum of Modern Art, New York, May 17–September 27, 1931, "The Collection of Miss Lizzie [Lillie] P. Bliss: Fourth Loan Exhibition," Addison Gallery of American Art, Andover, Mass., October 17–December 15, 1931; "Modern Masters from the Collection of Miss Lizzie [Lillie] P. Bliss," John Herron Art Institute, Indianapolis, January 1932, no. 23; "The Lillie P. Bliss Collection," Museum of Modern Art, New York, 1934, no. 22; "Independent Painters of Nineteenth-Century Paris," Museum of Fine Arts, Boston, March 15–April 28, 1935, no. 3; "Masterpieces of Art: European Paintings and Sculpture from 1300–1800," World's Fair, New York, May–October 1939, no. 258; "The Development of Impressionism," Los Angeles Museum, January 12– February 28, 1940, no. 13; "From Paris to the Sea Down the River Seine," Wildenstein, New York, January 28–February 27, 1943, no. 6; "The Spirit of Modern France," Toledo Museum of Art, November– December 1946, Art Gallery of Toronto, January– February 1947, no. 28; "Daumier, 1808–1879," Phillips Collection, Washington, D.C., February 19– May 14, 2000, no. 163

SELECTED REFERENCES

Duranty, "Daumier," *Gazette des beaux-arts* 18, no. 1, 1878, pp. 538, 544; G. Puissant, *La lanterne,* April 20, 1878, p. 2; G. Puissant, *La petite république française,* April 26, 1878, p. 2; Arsène Alexandre, *Honoré Daumier,* Paris, 1888, pp. 352, 375; Julius Meier-Graefe, *Entwicklungsgeschichte der Modernen Kunst,* 3 vols., Stuttgart, 1904, p. 97; Raymond Escholier, *Daumier,* Paris, 1923, p. 152; Jean Adhémar, *Honoré Daumier,* Paris [1954], p. 124, under no. 114; Charles Sterling and Margaretta M. Salinger, *French Paintings: A Catalogue of the Collection of The Metropolitan Museum of Art,* 3 vols., New York, 1955–67, vol. 2, pp. 40–43, ill.; K. E. M[aison], "Daumier's Painted Replicas," *Gazette des beaux-arts* 57, 1961, 6e pér., pp. 370–71, 377, no. 1; K. E. Maison, *Honoré Daumier: Catalogue Raisonné of the Paintings, Watercolours, and Drawings,* 2 vols., 1967–68, Greenwich, Conn., vol. 1, pp. 136–37, no. I-159, pl. 42; Gabriele Mandel et al., *L'Opera pittorica completa di Daumier,* Milan, 1971, p. 106, no. 207, ill.; Michael Pantazzi, Henri Loyrette et al., *Daumier, 1808–1879,* exh. cat., National Gallery of Canada, Ottawa, 1999, pp. 231, 303, 313, 314, 348, 491, no. 163, ill. [French ed., pp. 231, 303, 313, 314, 348, 491, no. 163, ill.]

Edgar Degas
French, 1834–1917

Self-Portrait
ca. 1854
Oil on paper, laid down on canvas
16 x 13½ in. (40.6 x 34.3 cm)
Bequest of Stephen C. Clark, 1960
61.101.6
See no. 63

PROVENANCE

The artist, Paris (until d. 1917); his brother, René de Gas, Paris (1917–d. 1926); his stepdaughter, Odile Olivier de Gas, possibly Paris (1926–after 1946); [Sam Salz, New York; until 1950, sold to Clark]; Stephen C. Clark, New York (1950–d. 1960)

EXHIBITIONS

"Degas: Portraitiste, sculpteur," Musée de l'Orangerie, Paris, July 19–October 1, 1931, no. 1; "Scènes et figures parisiennes," Galerie Charpentier, Paris, 1943, no. 70; "A Collector's Taste: Selections from the Collection of Mr. and Mrs. Stephen C. Clark," M. Knoedler and Co., New York, January 12– 30, 1954, no. 7; "Paintings from Private Collections: Summer Loan Exhibition," Metropolitan Museum of Art, New York, July 7–September 7, 1959, no. 28; "Paintings, Drawings, and Sculpture Collected by Yale Alumni," Yale University Art Gallery, New Haven, May 19–June 26, 1960, no. 49; "Degas in the Metropolitan," Metropolitan Museum of Art, New York, February 26–September 4, 1977, no. 1; "Degas," Virginia Museum, Richmond, May 23– July 9, 1978, no. 1; "Treasures from The Metropolitan Museum of Art: French Art from the Middle Ages to the Twentieth Century," Yokohama Museum of Art, March 25–June 4, 1989, no. 89; "Corot to Cézanne: 19th Century French Paintings from The Metropolitan Museum of Art," Fort Lauderdale Museum of Art, December 22, 1992–April 11, 1993; "Degas Portraits," Kunsthaus Zürich, December 2, 1994– March 5, 1995, no. 16; "The Clark Brothers Collect: Impressionist and Early Modern Painting," Sterling and Francine Clark Art Institute, Williamstown, Mass., June 4–September 4, 2006, no. 77

SELECTED REFERENCES

Paul-André Lemoisne, *Degas et son œuvre,* 4 vols., Paris, [1946–49, reprint 1984], vol. 1, pp. 14, 20, vol. 2, opp. p. 1, under no. 2, p. 2, under no. 5, p. 4, under no. 11, pp. 6–7, no. 12, ill.; Charles Sterling and Margaretta M. Salinger, *French Paintings: A Catalogue of the Collection of The Metropolitan Museum of Art,* 3 vols., New York, 1955–67, vol. 3, pp. 56–57, ill.; Jean Sutherland Boggs, *Portraits by Degas,* Berkeley and Los Angeles, 1962, pp. 9, 87

n. 36, 105; Fiorella Minervino, *L'Opera completa di Degas,* Milan, 1970, p. 91, no. 117; Charles S. Moffett, *Degas: Paintings in The Metropolitan Museum of Art,* New York, 1979, p. 5, colorpl. 1; Ronald Pickvance, *Edgar Degas: 1834–1917,* exh. cat., David Carritt, London, 1983, unpaginated, under no. 1; Philippe Brame and Theodore Reff, *Degas et son oeuvre: A Supplement,* New York, 1984, p. 32, under no. 29; Charles S. Moffett, *Impressionist and Post-Impressionist Paintings in The Metropolitan Museum of Art,* New York, 1985, pp. 11, 50–51, 250, ill. (color); Götz Adriani, *Degas: Pastels, Oil Sketches, Drawings,* exh. cat., Kunsthalle Tübingen, English ed., New York, 1985 [German ed., 1984], p. 105 n. 70, p. 343 under no. 29

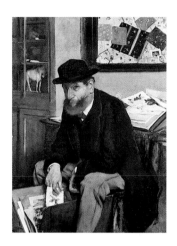

The Collector of Prints
1866
Oil on canvas
20⅞ x 15¾ in. (53 x 40 cm)
Signed and dated (lower left): Degas / 1866
H. O. Havemeyer Collection, Bequest of Mrs. H. O. Havemeyer, 1929
29.100.44
See no. 65

PROVENANCE

Mr. and Mrs. H. O. Havemeyer, New York (probably 1891–his d. 1907; bought from the artist for Fr 3,000 or 5,000; sent to them by Durand-Ruel on December 13, 1894; probably arrived in New York on February 12, 1895); Mrs. H. O. (Louisine W.) Havemeyer, New York (1907–d. 1929)

EXHIBITIONS

"The H. O. Havemeyer Collection," Metropolitan Museum of Art, New York, March 10–November 2, 1930, no. 47; "Thirty-eight Great Paintings from The Metropolitan Museum of Art," Detroit Institute of Arts, October 1–October 29, 1951, Art Gallery of Toronto, November 14–December 12, 1951, City Art Museum of St. Louis, January 6–February 4, 1952, Seattle Art Museum, March 1–June 30, 1952, no catalogue; "Impressionism: A Centenary Exhibition," Metropolitan Museum of Art, New York, December 12, 1974–February 10, 1975, not in catalogue; "Degas in the Metropolitan," Metropolitan Museum of Art, New York, February 26–September 4, 1977, no. 5 (of paintings); "Degas," Virginia Museum, Richmond, May 23–July 9, 1978, no. 2; "Edgar Degas," Acquavella Galleries, Inc., New York, November 1–December 3, 1978, no. 4; "Degas," Galeries Nationales du Grand Palais, Paris, February 9–May 16, 1988, National Gallery of Canada,

Ottawa, June 16–August 28, 1988, Metropolitan Museum of Art, New York, September 27, 1988–January 8, 1989, no. 66; "Splendid Legacy: The Havemeyer Collection," Metropolitan Museum of Art, New York, March 27–June 20, 1993, no. A197; "Origins of Impressionism," Galeries Nationales du Grand Palais, Paris, April 19–August 8, 1994, Metropolitan Museum of Art, New York, September 27, 1994–January 8, 1995, no. 58; "In Perfect Harmony: Picture + Frame, 1850–1920," Van Gogh Museum, Amsterdam, March 31–June 25, 1995, no. 118; "La collection Havemeyer: Quand l'Amérique découvrait l'impressionnisme . . . ," Musée d'Orsay, Paris, October 20, 1997–January 18, 1998, no. 33

SELECTED REFERENCES

"The H. O. Havemeyer Collection," *Parnassus* 2, March 1930, p. 7; *H. O. Havemeyer Collection, Catalogue of Paintings, Prints, Sculpture, and Objects of Art,* 1931, pp. 112–13, ill.; Louise Burroughs, "A Portrait of James Tissot by Degas," *Metropolitan Museum of Art Bulletin* 36, 1941, p. 37; Paul-André Lemoisne, *Degas et son oeuvre,* 4 vols., Paris [1946–49, reprint 1984], vol. 2, pp. 70–71, no. 138, ill.; Jean S[utherland] Boggs, "Edgar Degas and the Bellellis," *Art Bulletin* 37, June 1955, p. 134 n. 45; Charles Sterling and Margaretta M. Salinger, *French Paintings: A Catalogue of the Collection of The Metropolitan Museum of Art,* 3 vols., New York, 1955–67, vol. 3, p. 61, ill.; Margaretta M. Salinger, "Windows Open to Nature," *Metropolitan Museum of Art Bulletin* 27, summer 1968, n.s., unpaginated, ill.; Theodore Reff, "The Pictures within Degas's Pictures," *Metropolitan Museum Journal* 1, 1968, pp. 125, 127, 131–33, 164–66, figs. 7, 8 (detail); Fiorella Minervino, *L'Opera completa di Degas,* Milan, 1970, p. 96, no. 219, ill.; Theodore Reff, "Manet's Portrait of Zola," *Burlington Magazine* 117, 1975, p. 39, fig. 30; Alice Bellony-Rewald, *The Lost World of the Impressionists,* London, 1976, pp. 170–71, ill.; Theodore Reff, *Degas, The Artist's Mind* [New York], 1976, pp. 90, 94, 98–101, 106, 138, 144–45, 307 n. 44, fig. 65; Theodore Reff, "Degas: A Master among Masters," *Metropolitan Museum of Art Bulletin* 34, spring 1977, n.s., pp. [14–15], fig. 26 (color) and color detail inside front cover; Charles S. Moffett and Elizabeth Streicher, "Mr. and Mrs. H. O. Havemeyer as Collectors of Degas," *Nineteenth Century* 3, spring 1977, pp. 25–27, ill.; Charles S. Moffett, *Degas: Paintings in The Metropolitan Museum of Art,* New York, 1979, pp. 7–8, colorpl. 12; Gabriel P. Weisberg et al., *The Realist Tradition: French Painting and Drawing, 1830–1900,* exh. cat., Cleveland Museum of Art, 1980, p. 175 under no. 149; Jacques Dufwa, *Winds from the East: A Study in the Art of Manet, Degas, Monet and Whistler 1856–86,* Stockholm, 1981, pp. 90, 201 n. 40, fig. 69; Frances Renée Weitzenhoffer, *The Creation of the Havemeyer Collection, 1875–1900,* unpublished Ph.D. dissertation, City University of New York, 1982, pp. 164–65, 169 n. 40, 198 n. 45, fig. 48; Françoise Cachin and Charles S. Moffett, eds., *Manet, 1832–1883,* exh. cat., Metropolitan Museum of Art, New York, 1983, pp. 282, 284, ill.; Hanne Finsen, *Degas et la famille Bellelli,* exh. cat., Ordrupgaard, Copenhagen, 1983, p. 94, under appendix D; Roy McMullen, *Degas: His Life, Times, and Work,* Boston, 1984, pp. 134, 145, 434; Charles F. Stuckey, *Degas: Form and Space,* exh. cat., Centre Culturel du Marais, Paris, 1984, p. 62 n. 128, fig. 64 (color); Philippe Brame and Theodore Reff, *Degas et son oeuvre: A Supplement,* New York, 1984, p. 46, under no. 44; Charles S. Moffett, *Impressionist and Post-Impressionist Paintings in The Metropolitan Museum of Art,* New York, 1985, pp. 56–57, 250, color ill.; Frances Weitzenhoffer, *The*

Havemeyers: Impressionism Comes to America, New York, 1986, pp. 81, 255, fig. 34; Robert L. Herbert, *Impressionism: Art, Leisure, and Parisian Society,* New Haven, 1988, colorpl. 54; Henri Loyrette, "Degas entre Gustave Moreau et Duranty, Notes sur les portraits 1859–1876," *Revue de l'art* 86, 1989, p. 19; Carol Armstrong, *Odd Man Out: Readings of the Work and Reputation of Edgar Degas,* Chicago, 1991, p. 104, fig. 49; Henri Loyrette, trans. I. Mark Paris, *Degas: The Man and His Art,* New York, 1993, pp. 14–15, ill.; Louisine W. Havemeyer, *Sixteen to Sixty: Memoirs of a Collector,* New York, 1993, 3rd ed. with notes by Susan Alyson Stein [1st ed., 1930; repr. 1961], pp. 252–53, 288, 337 nn. 371, 376, p. 344 n. 450; Felix Baumann and Marianne Karabelnik, eds., *Degas Portraits,* exh. cat., Kunsthaus Zürich, London, 1994, pp. 105, 261; Richard Thomson, *Edgar Degas: Waiting,* Malibu, 1995, p. 73, fig. 48; Ann Dumas et al., *The Private Collection of Edgar Degas,* exh. cat., Metropolitan Museum of Art, New York, 1997, p. 111, fig. 128; Rebecca A. Rabinow, *Degas and America: The Early Collectors,* High Museum of Art, Atlanta, 2000, p. 37, fig. 4 (color)

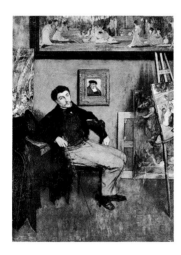

James-Jacques-Joseph Tissot (1836–1902)
ca. 1867–68
Oil on canvas
59⅜ x 44 in. (151.4 x 111.8 cm)
Stamped (lower right): Degas
Rogers Fund, 1939
39.161
See no. 66

PROVENANCE

Edgar Degas, Paris (until d. 1917; his estate sale, Galerie Georges Petit, Paris, May 6–8, 1918, no. 37, as "Portrait d'homme dans un atelier de peintre," for Fr 25,700 to Hessel); [Jos Hessel, Paris, 1918–21; deposited on March 14, 1921, with Durand-Ruel, Paris; sold on April 28, 1921, to Durand Ruel, New York]; [Durand-Ruel, New York, 1921–22, sold on April 6, 1922, for $1,400 to Lewisohn]; Adolph Lewisohn, New York (1922–d. 1938); [Jacques Seligmann, New York, until 1939]

EXHIBITIONS

"Degas: Loan Exhibition Arranged by Students," Fogg Art Museum, Cambridge, Mass., May 9–30, 1931, no. 3; "Degas," Marie Harriman Gallery, New York,

November 5–December 1, 1934, no. 5; "Masterpieces by Degas," Durand-Ruel, New York, March 22–April 10, 1937, no. 2; "Great Portraits from Impressionism to Modernism," Wildenstein and Co., Inc., New York, March 1–29, 1938, no. 9; "French Painting from David to Toulouse-Lautrec," Metropolitan Museum of Art, New York, February 6–March 26, 1941, no. 34; "The Lewisohn Collection," Metropolitan Museum of Art, New York, November 2–December 2, 1951, no. 22; "Loan Exhibition: Degas for the Benefit of The Citizens' Committee for Children of New York, Inc.," Wildenstein, New York, April 7–May 7, 1960, no. 14; "James Jacques Joseph Tissot, 1836–1902: A Retrospective Exhibition," Museum of Art, Rhode Island School of Design, Providence, February 28–March 29, 1968, Art Gallery of Ontario, Toronto, April 6–May 5, 1968, no cat. number; "Portrait of the Artist," Metropolitan Museum of Art, New York, January 18–March 7, 1972, no. 22; "Impressionism: A Centenary Exhibition," Galeries Nationales du Grand Palais, Paris, September 21–November 24, 1974, Metropolitan Museum of Art, New York, December 12, 1974–February 10, 1975, no. 11; "Degas in the Metropolitan," Metropolitan Museum of Art, New York, February 26–September 4, 1977, no. 6 (of paintings); "Degas," Galeries Nationales du Grand Palais, Paris, February 9–May 16, 1988, National Gallery of Canada, Ottawa, June 16–August 28, 1988, Metropolitan Museum of Art, New York, September 27, 1988–January 8, 1989, no. 75; "Origins of Impressionism," Galeries Nationales du Grand Palais, Paris, April 19–August 8, 1994, Metropolitan Museum of Art, New York, September 27, 1994–January 8, 1995, no. 62; "The Private Collection of Edgar Degas," Metropolitan Museum of Art, New York, October 1, 1997–January 11, 1998, no cat. number; "Faces of Impressionism: Portraits from American Collections," Baltimore Museum of Art, October 10, 1999–January 30, 2000, Museum of Fine Arts, Houston, March 25–May 7, 2000, Cleveland Museum of Art, May 28–July 30, 2000, no. 25; "Degas and America: The Early Collectors," High Museum of Art, Atlanta, March 3–May 27, 2001, Minneapolis Institute of Arts, June 16–September 9, 2001, no. 22; "Manet/Velázquez: The French Taste for Spanish Painting," Metropolitan Museum of Art, New York, March 4–June 8, 2003, no. 105; "Rebels and Martyrs: The Image of the Artist in the Nineteenth Century," National Gallery, London, June 28–August 28, 2006, no. 43

SELECTED REFERENCES

Paul Lafond, *Degas,* Paris, 1918–19, vol. 2, p. 15; James Laver, *"Vulgar Society": The Romantic Career of James Tissot, 1836–1902,* London, 1936, pp. 11–13; Louise Burroughs, "A Portrait of James Tissot by Degas," *Metropolitan Museum of Art Bulletin* 36, 1941, pp. 35–38, ill. cover; John Rewald, *The History of Impressionism,* New York, 1946, 1st ed., p. 155, ill. [1961 and 1973 eds., p. 207, ill. p. 176]; Paul-André Lemoisne, *Degas et son oeuvre,* 4 vols., Paris [1946–49, reprint 1984], vol. 1, pp. 56, 239 n. 117, vol. 2, pp. 90–91, no. 175, ill.; Lillian Browse, *Degas Dancers,* New York [1949], p. 21; Meyer Schapiro, *Vincent van Gogh,* New York, 1950, p. 44; Charles Sterling and Margaretta M. Salinger, *French Paintings: A Catalogue of the Collection of The Metropolitan Museum of Art,* 3 vols., New York, 1955–67, vol. 3, pp. 62–64, ill.; Jean Sutherland Boggs, "Degas Notebooks at the Bibliothèque Nationale III: Group C (1863–1886)," *Burlington Magazine* 100, July 1958, p. 243; Jean Sutherland Boggs, *Portraits by Degas,* Berkeley and Los Angeles, 1962, pp. 23, 32, 57, 59, 131, pl. 46; Margaretta M. Salinger, "Windows Open to Nature," *Metropolitan Museum of Art Bulletin* 27,

1968, n.s., unpaginated, ill.; Theodore Reff, "The Pictures within Degas's Pictures," *Metropolitan Museum Journal* 1, 1968, pp. 125, 127, 131, 133–40, 150, 152 n. 97, 161–62, 164–66, figs. 10, 11, 13, 15, 17 (overall and details); Fiorella Minervino, *L'Opera completa di Degas,* Milan, 1970, pp. 96–97, no. 240, ill.; Theodore Reff, "Degas's 'Tableau de Genre,'" *Art Bulletin* 54, September 1972, p. 331; Theodore Reff, *Degas, The Artist's Mind* [New York] 1976, pp. 28, 90, 98, 101, 103–7, 110, 138, 140, 144–45, 223–24, figs. 68, 69, 71, 73, 75 (overall and details); Theodore Reff, *The Notebooks of Edgar Degas: A Catalogue of the Thirty-eight Notebooks in the Bibliothèque Nationale and Other Collections,* 2 vols., Oxford, 1976, vol. 1, p. 108 (notebook 21, p. 6v), pp. 110–11 (notebook 22, p. 31); Theodore Reff, "Degas: A Master among Masters," *Metropolitan Museum of Art Bulletin* 34, spring 1977, n.s., p. [11], fig. 15; Charles S. Moffett, *Degas: Paintings in The Metropolitan Museum of Art,* New York, 1979, pp. 7–8, colorpl. 9; Ian Thomson, "Tissot and Oxford," *Oxford Art Journal* 2, April 1979, pp. 54–55; Gabriel P. Weisberg, ed., *The Realist Tradition: French Painting and Drawing, 1830–1900,* exh. cat., Cleveland Museum of Art, 1980, p. 175; Jacques Dufwa, *Winds from the East: A Study in the Art of Manet, Degas, Monet and Whistler 1856–86,* Stockholm, 1981, pp. 89–95, 104, 115, 187, fig. 70; Susan Koslow, "Two Sources for Vincent van Gogh's 'Portrait of Armand Roulin': A Character Likeness and a Portrait Schema," *Arts Magazine* 56, September 1981, p. 159, fig. 4; Roy McMullen, *Degas: His Life, Times, and Work,* Boston, 1984, pp. 134, 145; Michael Wentworth, Krystyna Matyjaszkiewicz, ed., *James Tissot,* exh. cat., Barbican Art Gallery, Oxford, 1984, pp. 12–14, 16–17, 100, fig. 1; Michael Wentworth, *James Tissot,* Oxford, 1984, pp. 49, 59, pl. 37; Charles S. Moffett, *Impressionist and Post-Impressionist Paintings in The Metropolitan Museum of Art,* New York, 1985, pp. 56, 58–59, 250, ill. in color (overall and detail); Richard Thomson, *The Private Degas,* exh. cat., Whitworth Art Gallery, Manchester, London, 1987, pp. 26–27, fig. 23; John Milner, *The Studios of Paris: The Capital of Art in the Late Nineteenth Century,* New Haven, 1988, p. 33, pl. 35; Henri Loyrette, "Degas entre Gustave Moreau et Duranty, Notes sur les portraits 1859–1876," *Revue de l'art* 86, 1989, pp. 20, 22–23, fig. 16; Carol Armstrong, *Odd Man Out: Readings of the Work and Reputation of Edgar Degas,* Chicago, 1991, pp. 103–4, 140, fig. 50; Anne Higonet, *Berthe Morisot's Images of Women,* Cambridge, Mass., 1992, pp. 125–27, 292, fig. 42; Henri Loyrette, trans. I. Mark Paris, *Degas: The Man and His Art,* New York, 1993, pp. 38–39, ill. (details); Felix Baumann and Marianne Karabelnik, eds., *Degas Portraits,* exh. cat., Kunsthaus Zürich, London, 1994, pp. 24, 100, 106, 141, 255, ill. p. 107; Colin B. Bailey, ed., *Renoir's Portraits: Impressions of an Age,* exh. cat., National Gallery of Canada, Ottawa, New Haven, 1997, pp. 60–62, 100; Petra Buschhoff-Leineweber, *Edouard Manet und die Impressionisten,* exh. cat., Staatsgalerie Stuttgart, 2002, pp. 167–68, fig. 201

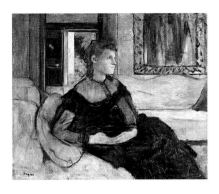

Madame Théodore Gobillard (Yves Morisot, 1838–1893)

1869
Oil on canvas
21¾ x 25⅝ in. (55.2 x 65.1 cm)
Signed (lower left): Degas
H. O. Havemeyer Collection, Bequest of Mrs. H. O. Havemeyer, 1929
29.100.45
See no. 67

PROVENANCE

[Michel Manzi, Paris, until d. 1915; sold on December 5, 1916, by Manzi's widow, Charlotte Manzi, through Mary Cassatt to Havemeyer]; Mrs. H. O. (Louisine W.) Havemeyer, New York (1916–d. 1929)

EXHIBITIONS

"2e exposition de peinture [2nd Impressionist exhibition]," 11, rue Le Peletier, Paris, April 1876, no. 39, possibly this work; "The H. O. Havemeyer Collection," Metropolitan Museum of Art, New York, March 10–November 2, 1930, no. 52; "Degas's Portraits of his Family and Friends," Minneapolis Institute of Arts, March 6–28, 1948; "Berthe Morisot and Her Circle: Paintings from the Rouart Collection, Paris," Art Gallery of Toronto, September 20–October 26, 1952, not in catalogue; "Degas in the Metropolitan," Metropolitan Museum of Art, New York, February 26–September 4, 1977, no. 9 (of paintings); "Degas," Virginia Museum, Richmond, May 23–July 9, 1978, no. 5; "Edgar Degas," Acquavella Galleries, Inc., New York, November 1–December 3, 1978, no. 8; "Franse meesters uit het Metropolitan Museum of Art: Realisten en Impressionisten," Rijksmuseum Vincent Van Gogh, Amsterdam, March 15–May 31, 1987, no. 26; "Degas," Galeries Nationales du Grand Palais, Paris, February 9–May 16, 1988, National Gallery of Canada, Ottawa, June 16–August 28, 1988, Metropolitan Museum of Art, New York, September 27, 1988–January 8, 1989, no. 87; "Splendid Legacy: The Havemeyer Collection," Metropolitan Museum of Art, New York, March 27–June 20, 1993, no. A200; "Degas, o Universo de um Artista," Museu de Arte de São Paulo, May 17–August 20, 2006, no cat. number

SELECTED REFERENCES

Harry B. Wehle, "The Exhibition of the H. O. Havemeyer Collection," *Metropolitan Museum of Art Bulletin* 25, March 1930, p. 55; *H. O. Havemeyer Collection, Catalogue of Paintings, Prints, Sculpture, and Objects of Art,* 1931, pp. 114–15, ill.; John Rewald, *The History of Impressionism,* New York, 1946, 1st ed. [1961 ed., p. 222, ill. p. 226, 1973 ed.], p. 188, ill. p. 182; Paul-André Lemoisne, *Degas et son oeuvre,* 4 vols., Paris [1946–49, reprint 1984], vol. 1, p. 58; vol. 2, pp. 110–11, no. 213, ill.; Charles

Sterling and Margaretta M. Salinger, *French Paintings: A Catalogue of the Collection of The Metropolitan Museum of Art,* 3 vols., New York, 1955–67, vol. 3, pp. 65–66, ill.; Denis Rouart, ed., trans. Betty W. Hubbard, *The Correspondence of Berthe Morisot,* New York, 1957, pp. 33, 35–36; Jean Sutherland Boggs, *Portraits by Degas,* Berkeley and Los Angeles, 1962, pp. 27, 31, 119, pl. 64; Louise Burroughs, "Degas Paints a Portrait," *Metropolitan Museum of Art Bulletin* 21, January 1963, pp. 169–72, ill. inside cover; Eugenia Parry Janis, "The Role of the Monotype in the Working Method of Degas—I," *Burlington Magazine* 109, January 1967, p. 25; Theodore Reff, "The Pictures within Degas's Pictures," *Metropolitan Museum Journal* 1, 1968, p. 125; Fiorella Minervino, *L'Opera completa di Degas,* Milan, 1970, p. 97, no. 249, ill.; Charles S. Moffett and Elizabeth Streicher, "Mr. and Mrs. H. O. Havemeyer as Collectors of Degas," *Nineteenth Century* 3, spring 1977, pp. 26, 28–29, fig. 7; Jacob Bean et al., *The Metropolitan Museum of Art: Notable Acquisitions, 1975–1979,* New York, 1979, p. 57; Ira M. Horowitz, "Whistler's Frames," *Art Journal* 39, winter 1979–80, p. 130; Charles S. Moffett, *Degas: Paintings in The Metropolitan Museum of Art,* New York, 1979, pp. 6–9, colorpl. 5; Jacob Bean, *The Metropolitan Museum of Art: Notable Acquisitions, 1983–1984,* New York, 1984, p. 73; Roy McMullen, *Degas: His Life, Times, and Work,* Boston, 1984, pp. 167–69, ill.; Charles S. Moffett, *Impressionist and Post-Impressionist Paintings in The Metropolitan Museum of Art,* New York, 1985, pp. 12, 61–63, 250, ill. in color (overall and detail); Gary Tinterow, *The Metropolitan Museum of Art: Notable Acquisitions, 1984–1985,* New York, 1985, p. 30; Frances Weitzenhoffer, *The Havemeyers: Impressionism Comes to America,* New York, 1986, pp. 230–31, 255, pl. 156; Anne Higonet, *Berthe Morisot's Images of Women,* Cambridge, Mass., 1992, pp. 67, 290, fig. 17; Henri Loyrette, trans. I. Mark Paris, *Degas: The Man and His Art,* New York, 1993, p. 56, ill.; Louisine W. Havemeyer, *Sixteen to Sixty: Memoirs of a Collector,* New York, 1993, 3rd ed. with notes by Susan Alyson Stein, [1st ed., 1930; repr. 1961], pp. 264–67, 337 n. 376, p. 339 n. 396; Gary Tinterow and Henri Loyrette, *Origins of Impressionism,* exh. cat., Metropolitan Museum of Art, New York, 1994, p. 323, fig. 392; Felix Baumann and Marianne Karabelnik, eds., *Degas Portraits,* exh. cat., Kunsthaus Zürich, London, 1994, pp. 24, 89; Isabelle Cahn et al., *In Perfect Harmony: Picture + Frame, 1850–1920,* exh. cat., Van Gogh Museum, Amsterdam, 1995, pp. 132, 134, fig. 119 (color); Jean Sutherland Boggs, *Degas et la Nouvelle-Orléans,* exh. cat., Ordrupgaard, Copenhagen, 1999, p. 20, fig. 12; Richard R. Brettell, *Impressionism: Painting Quickly in France, 1860–1890,* exh. cat., National Gallery, London, New Haven, 2000, p. 203, fig. 144 (color)

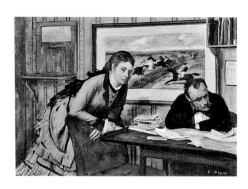

Sulking
ca. 1870
Oil on canvas
12¾ x 18¼ in. (32.4 x 46.4 cm)
Signed (lower right): E. Degas
H. O. Havemeyer Collection, Bequest of Mrs. H. O.
Havemeyer, 1929
29.100.43
See no. 64

PROVENANCE
[Durand-Ruel, Paris; received on deposit from the
artist on December 27, 1895, deposit no. 8848;
bought from the artist on April 28, 1897, for
Fr 13,500, stock no. 4191; sold to Durand-Ruel,
New York, for Havemeyer]; [Durand-Ruel, New York,
1896, stock no. 1646; sold on December 15, 1896,
for $4,500 to Havemeyer]; Mrs. H. O. (Louisine W.)
Havemeyer, New York (1896–d. 1929)

EXHIBITIONS
"Degas," Durand-Ruel, Paris, 1896; "Loan Exhibition
of Masterpieces by Old and Modern Painters,"
M. Knoedler and Co., New York, April 6–24, 1915,
no. 25; "The H. O. Havemeyer Collection,"
Metropolitan Museum of Art, New York, March
10–November 2, 1930, no. 46; "Degas, 1834–1917,"
Pennsylvania Museum of Art, Philadelphia, 1936,
no. 19; "Degas," Musée de l'Orangerie, Paris,
March–April 1937, no. 11; "Degas's Portraits of His
Family and Friends," Minneapolis Institute of Arts,
March 6–28, 1948, unnumbered checklist; "A Loan
Exhibition of Degas," Wildenstein, New York, April
7–May 14, 1949, no. 28; "Degas's Racing World,"
Wildenstein and Co., Inc., New York, March 21–April
27, 1968, no. 6; "From Realism to Symbolism:
Whistler and His World," Wildenstein, New York,
March 4–April 3, 1971, Philadelphia Museum of Art,
April 15–May 23, 1971, no. 64; "Degas in the
Metropolitan," Metropolitan Museum of Art, New
York, February 26–September 4, 1977, no. 10 (of
paintings); "Degas," Virginia Museum, Richmond,
May 23–July 9, 1978, no. 6; "Degas 1879," National
Gallery of Scotland, Edinburgh, August 13–September
30, 1979, no. 38; "Degas," Galeries Nationales du
Grand Palais, Paris, February 9–May 16, 1988,
National Gallery of Canada, Ottawa, June 16–August
28, 1988, Metropolitan Museum of Art, New York,
September 27, 1988–January 8, 1989, no. 85;
"Splendid Legacy: The Havemeyer Collection,"
Metropolitan Museum of Art, New York, March 27–
June 20, 1993, no. A201; "Origins of Impressionism,"
Galeries Nationales du Grand Palais, Paris, April
19–August 8, 1994, Metropolitan Museum of Art,
New York, September 27, 1994–January 8, 1995,
no. 67; "Degas at the Races," National Gallery of Art,
Washington, D.C., April 12– July 12, 1998, no. 25;
"Edgar Degas, Photographer," Metropolitan Museum
of Art, New York, October 9, 1998–January 3, 1999, J.
Paul Getty Museum, Los Angeles, February 2–March

28, 1999, Bibliothèque Nationale de France, Paris,
May 11–July 31, 1999, no cat. number; "Degas, o
Universo de um Artista," Museu de Arte de São Paulo,
May 17–August 20, 2006, no cat. number

SELECTED REFERENCES
Charles Saunier, "Beaux-arts petites expositions,"
Revue encyclopédique 149, July 11, 1896, p. 481;
George Moore, "Degas," *Kunst und Künstler* 6, 1908,
ill. p. 142; Georges Lecomte, "La crise de la peinture
française," *L'Art et les artistes* 12, October 1910, ill. p.
27; Paul Lafond, *Degas,* 2 vols., 1918–29, vol. 1, ill.
p. 37, vol. 2, p. 5; Paul Jamot, "Degas (1834–1917),"
Gazette des beaux-arts 14, April–June 1918, 4e pér.,
pp. 130, 132, ill.; Julius Meier-Graefe, *Degas,*
Munich, 1920, p. 14, pl. 18 [English ed., 1923, p. 28,
pl. 18]; Paul Jamot, *Degas,* Paris, 1924, pp. 71–73,
138–39, pl. 26; Arsène Alexandre, "La collection
Havemeyer, 2e étude: Degas," *La Renaissance* 12,
October 1929, p. 485, ill.; *H. O. Havemeyer
Collection, Catalogue of Paintings, Prints, Sculpture,
and Objects of Art,* 1931, pp. 110–11, ill.; Marcel
Guérin, "Degas (1834–1917)," *L'Amour de l'art* 7,
July 1931, p. 268, fig. 7; Louise Burroughs, "Degas in
the Havemeyer Collection," *Metropolitan Museum of
Art Bulletin* 27, May 1932, pp. 143–44, ill.; Bryson
Burroughs, "Changes in the Picture Galleries,"
Metropolitan Museum of Art Bulletin 27, January
1932, p. 19; *The Metropolitan Museum of Art: A
Guide to the Collections,* 2 parts, New York, 1934,
part 2, p. 129, ill.; Arsène Alexandre, "Degas:
Nouveaux aperçus," *L'Art et les artistes* 29, February
1935, n.s., ill. p. 151; Paul-André Lemoisne, *Degas et
son oeuvre,* 4 vols., Paris [1946–49, reprint 1984],
vol. 1, p. 83, vol. 2, pp. 174–75, no. 335, ill. vol. 3,
p. 500, under no. 864; Lillian Browse, *Degas
Dancers,* New York [1949], p. 27; Daniel Catton Rich,
Degas, New York, 1951, pp. 62–63, color ill.;
Theodore Rousseau Jr., "A Guide to the Picture
Galleries," *Metropolitan Museum of Art Bulletin* 12,
January 1954, n.s., part 2, p. 7; Charles Sterling and
Margaretta M. Salinger, *French Paintings: A Catalogue
of the Collection of The Metropolitan Museum of Art,*
3 vols., New York, 1955–67, vol. 3, pp. 71–73, ill.;
Pierre Cabanne, *Edgar Degas,* Paris, 1957 [English
ed., 1958, pp. 29, 97, 111, under no. 49]; Jean
Sutherland Boggs, "Degas Notebooks at the
Bibliothèque Nationale III: Group C (1863–1886),"
Burlington Magazine 100, July 1958, p. 244; Ronald
Pickvance, "The Drawings of Edgar Degas; Degas,"
book review, *Burlington Magazine* 106, June 1964,
p. 295; Quentin Bell, *Degas: Le viol,* Newcastle upon
Tyne, 1965, pp. 10–11; Theodore Reff, "The Pictures
within Degas's Pictures," *Metropolitan Museum
Journal* 1, 1968, pp. 125, 127, 143–45, 147, 164–66,
figs. 24, 26 (overall and detail); Theodore Reff, "Some
Unpublished Letters of Degas," *Art Bulletin* 50, March
1968, p. 91 n. 49; Aaron Scharf, *Art and Photography,*
Baltimore, 1969, pp. 144–46, 301, fig. 127; Theodore
Reff, "More Unpublished Letters of Degas," *Art
Bulletin* 51, September 1969, p. 287 n. 66; Fiorella
Minervino, *L'Opera completa di Degas,* Milan, 1970,
p. 104, no. 386, ill. p. 104 and colorpl. 20; Ronald
Pickvance, "Degas as a Photographer," *Lithopinion* 5,
spring 1970, p. 74, ill.; Theodore Reff, "Degas and
the Literature of His Time–I," *Burlington Magazine*
112, September 1970, pp. 583–84, fig. 10 (detail);
Anthea Callen, *Jean-Baptiste Faure, 1830–1914: A
Study of a Patron and Collector of the Impressionists
and Their Contemporaries,* master's thesis, University
of Leicester, 1971, p. 160, no. 193; Theodore Reff,
"The Technical Aspects of Degas's Art," *Metropolitan
Museum Journal* 4, 1971, p. 142, fig. 1 (detail);
Eugenia Parry Janis, "Degas and the 'Master of
Chiaroscuro,'" *Museum Studies* 7, 1972, p. 71 n. 29;
Theodore Reff, "Degas's 'Tableau de Genre,'" *Art

Bulletin 54, September 1972, pp. 326, 333–34;
Theodore Reff, *Degas, The Artist's Mind* [New York],
1976, pp. 10, 90, 93, 116–20, 144–45, 162–64, 216,
228, 232, 272, 315 nn. 73, 74, 80, figs. 83 (color)
and 85 (detail); Theodore Reff, *The Notebooks of
Edgar Degas: A Catalogue of the Thirty-eight
Notebooks in the Bibliothèque Nationale and Other
Collections,* 2 vols., Oxford, 1976, vol. 1, pp. 20, 21
n. 1, 110–11 (notebook 22, p. 43), 122 (notebook 25,
pp. 36–37, 39), 151; Theodore Reff, "Degas: A Master
among Masters," *Metropolitan Museum of Art Bulletin*
34, spring 1977, n.s., p. [23], fig. 39 (color); Norma
Broude, "Degas's 'Misogyny,'" *Art Bulletin* 59, March
1977, pp. 95–96, fig. 1; Charles S. Moffett, *Degas:
Paintings in The Metropolitan Museum of Art,* New
York, 1979, p. 10, colorpl. 14; Ian Dunlop, *Degas,*
New York, 1979, pp. 81, 83, 229 n. 67, colorpl. 63;
Richard Thomson, "Degas in Edinburgh," exhibition
review, *Burlington Magazine* 121, October 1979,
p. 674; Carol A. Nathanson and Edward J. Olszewski,
"Degas's Angel of the Apocalypse," *Bulletin of the
Cleveland Museum of Art* 67, October 1980, p. 251;
Eugénie De Keyser, *Degas: Réalité et métaphore,*
Louvain-la-Neuve, 1981, p. 55; Theodore Reff,
"Degas and De Valernes in 1872," *Arts Magazine* 56,
September 1981, p. 126; Roy McMullen, *Degas: His
Life, Times, and Work,* Boston, 1984, pp. 161–63,
180, 270, 431, ill.; Suzanne Folds McCullagh, *Degas
in The Art Institute of Chicago,* exh. cat., Art Institute
of Chicago, 1984, p. 13; Weston J. Naef et al., *The
Metropolitan Museum of Art: Notable Acquisitions,
1983–1984,* New York, 1984, p. 80; Charles S.
Moffett, *Impressionist and Post-Impressionist Paintings
in The Metropolitan Museum of Art,* New York, 1985,
pp. 64–65, 250, ill. (color, overall and detail); Bradley
Collins, "Manet's 'In the Conservatory' and 'Chez le
Père Lathuille,'" *Art Journal* 45, spring 1985, p. 61,
fig. 4; Frances Weitzenhoffer, *The Havemeyers:
Impressionism Comes to America,* New York, 1986,
p. 255; Gary Tinterow et al., "Modern Europe," *The
Metropolitan Museum of Art,* 12 vols., New York,
1987–89, vol. 8, pp. 26–27, colorpl. 12; Horst Keller,
Edgar Degas, Munich, 1988, pp. 65, 174, fig. 40;
Richard Thomson, "The Degas Exhibition at the Grand
Palais," *Burlington Magazine* 130, April 1988, p. 297;
Robert Gordon and Andrew Forge, *Degas,* New York,
1988, pp. 74, 119, ill. p. 112; Robert L. Herbert,
Impressionism: Art, Leisure, and Parisian Society,
New Haven, 1988, pp. 56, 155, 162, 308 nn. 25, 55,
colorpl. 58; Eugenia Parry Janis, "Degas: The Nudes,"
review, *Burlington Magazine* 132, April 1990, p. 280;
Richard Kendall, Griselda Pollock, eds., *Dealing with
Degas: Representations of Women and the Politics of
Vision,* London, 1992, pp. 46, 81, 83–84, 87, 89–90,
92 n. 5, p. 93 n. 22, fig. 16; Louisine W. Havemeyer,
Sixteen to Sixty: Memoirs of a Collector, New York,
1993, 3rd ed. with notes by Susan Alyson Stein [1st
ed., 1930; repr. 1961], p. 337 n. 376; Henri Loyrette,
trans. I. Mark Paris, *Degas: The Man and His Art,*
New York, 1993, pp. 52–53, ill.; Susan Sidlauskas,
"Resisting Narrative: The Problem of Edgar Degas's
Interior," *Art Bulletin* 75, December 1993, p. 694
n. 96; Felix Baumann and Marianne Karabelnik, eds.,
Degas Portraits, exh. cat., Kunsthaus Zürich, London,
1994, pp. 90, 302, 309; Marilyn R. Brown, *Degas
and the Business of Art: A Cotton Office in New
Orleans,* University Park, 1994, p. 122, fig. 35;
Anthea Callen, *The Spectacular Body: Science,
Method and Meaning in the Work of Degas,* New
Haven, 1995, p. 175, pl. 112; Norma Broude, book
review, "Dealing with Degas: Representations of
Women and the Politics of Vision," *Woman's Art
Journal* 16, autumn 1995–winter 1996, p. 36; Richard
Kendall, *Degas, Beyond Impressionism,* exh. cat.,
National Gallery, London, 1996, p. 45; Colin B.
Bailey, ed., *Renoir's Portraits: Impressions of an Age,*

exh. cat., National Gallery of Canada, Ottawa, New Haven, 1997, p. 55; Ann Dumas et al., *The Private Collection of Edgar Degas*, exh. cat., Metropolitan Museum of Art, New York, 1997, p. 60; Gary Tinterow et al., *La collection Havemeyer: Quand l'Amérique découvrait l'impressionnisme*, exh. cat., Musée d'Orsay, Paris, 1997, pp. 71, 108, fig. 29; Rebecca A. Rabinow, *Degas and America: The Early Collectors*, exh. cat., High Museum of Art, Atlanta, 2000, p. 38, ill. p. 35 (color detail), fig. 5 (color); Anne Hollander, *Fabric of Vision: Dress and Drapery in Painting*, exh. cat., National Gallery, London, 2002, pp. 146–47, 168, fig. 108 (color); Aruna D'Souza, Jennifer R. Gross, ed., *Edgar Degas: Defining the Modernist Edge*, exh. cat., Yale University Art Gallery, New Haven, 2003, pp. 38, 40–41, fig. 13 (color); Susan Sidlauskas, "Emotion, Color, Cézanne (The Portraits of Hortense)," electronic resource, *Nineteenth-Century Art Worldwide* 3, Autumn 2004, p. 27 n. 27 (http://www.19thc-artworldwide.org/autumn_04/articles/sidl.html)

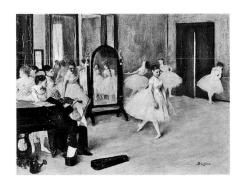

The Dancing Class
ca. 1870
Oil on wood
7¾ x 10⅝ in. (19.7 x 27 cm)
Signed (lower right): Degas
H. O. Havemeyer Collection, Bequest of Mrs. H. O. Havemeyer, 1929
29.100.184
See no. 68

PROVENANCE
[Durand-Ruel, Paris, bought from the artist in January 1872, stock no. 943; sold on January 16, 1872, with a painting by Henry Levy and one by Héreau in exchange for two paintings by Zamacoïs, two by Richet, and Fr 1,500 to Premsel]; Premsel, possibly Paris (1872; sold on January 30, 1872, for Fr 7,000 in exchange for a painting by Corot to Durand-Ruel); [Durand-Ruel, Paris, 1872, stock no. 979; sold on February 6, 1872, in exchange for a painting by Puvis de Chavannes, one by Brandon, and Fr 500 to Brandon]; Jacques-Émile-Édouard Brandon, Paris (1872–at least 1874); [Durand-Ruel, Paris and London, 1876]; Captain Henry Hill, Brighton (from 1875 or 1876–1889; his estate sale, Christie's, London, May 25, 1889, no. 26, for gns 41 or 111 to Wallis); [Wallis & Son, London, from 1889]; Michel Manzi, Paris (until d. 1915); his widow, Charlotte Manzi, Paris (1915–16, sold on December 5, 1916 through Mary Cassatt to Havemeyer); Mrs. H. O. (Louisine W.) Havemeyer, New York (1916–d. 1929)

EXHIBITIONS
"Première exposition, 1874 [1st Impressionist exhibition]," boulevard des Capucines, 35, Paris, April 15–May 15, 1874, no. 55; "Twelfth Exhibition of Pictures by Modern French Artists," Deschamps Gallery, London, spring 1876, no. 2; "Loan Exhibition of French Masterpieces of the Late XIX Century," Durand-Ruel, New York, March 20–April 10, 1928, no. 6; "The H. O. Havemeyer Collection," Metropolitan Museum of Art, New York, March 10–November 2, 1930, no. 48; "Impressionism: A Centenary Exhibition," Galeries Nationales du Grand Palais, Paris, September 21–November 24, 1974, Metropolitan Museum of Art, New York, December 12, 1974–February 10, 1975, no. 15; "100 Paintings from the Metropolitan Museum," State Hermitage Museum, Leningrad [St. Petersburg], May 15–June 20, 1975, Pushkin State Museum of Fine Arts, Moscow, August 28–November 2, 1975, no. 66; "Degas in the Metropolitan," Metropolitan Museum of Art, New York, February 26–September 4, 1977, no. 11 (of paintings); "Degas," Metropolitan Museum of Art, New York, September 27, 1988–January 8, 1989, no. 106; "Splendid Legacy: The Havemeyer Collection," Metropolitan Museum of Art, New York, March 27–June 20, 1993, no. A203

SELECTED REFERENCES
Etienne Carjat, "L'Exposition du boulevard des Capucines," *Le patriote français*, April 27, 1874, p. 3; Ernest Chesneau, "A côté du Salon: II. Le Plein Air: Exposition du boulevard des Capucines," *Paris-Journal*, May 7, 1874, p. 2; E. d'H., "L'Exposition du boulevard des Capucines," *Le rappel*, April 17, 1874, p. 2; [Philippe Burty], "Exposition de la société anonyme des artistes," *La republique française*, April 25, 1874, p. 2; Marc de Montifaud, "Exposition du boulevard des Capucines," *L'Artiste* 9, May 1, 1874, p. 309; *Art Journal* 38, 1876, p. 211; *The Antheneum*, 1876, p. 571; *H. O. Havemeyer Collection, Catalogue of Paintings, Prints, Sculpture, and Objects of Art*, 1931, p. 117, ill.; Louise Burroughs, "Degas in the Havemeyer Collection," *Metropolitan Museum of Art Bulletin* 27, May 1932, p. 144; John Rewald, *The History of Impressionism*, New York, 1946, ill. p. 232 and opp. p. 232 (color detail); [1961 and 1973 eds., ill. p. 279 (color)]; Paul-André Lemoisne, *Degas et son oeuvre*, 4 vols., Paris [1946–49, reprint 1984], vol. 1, pp. 69, 71, vol. 2, pp. 148–49, no. 297, ill.; Lillian Browse, *Degas Dancers*, New York [1949], pp. 53, 60, 338, 341, pl. 17, colorpl. 2; Charles Sterling and Margaretta M. Salinger, *French Paintings: A Catalogue of the Collection of The Metropolitan Museum of Art*, 3 vols., New York, 1955–67, vol. 3, pp. 69–71, ill.; Ronald Pickvance, "Degas's Dancers: 1872–76," *Burlington Magazine* 105, June 1963, pp. 256–59, 265–66; Theodore Reff, "The Pictures within Degas's Pictures," *Metropolitan Museum Journal* 1, 1968, p. 126; Fiorella Minervino, *L'Opera completa di Degas*, Milan, 1970, p. 99, no. 296, ill.; John Rewald, "The Impressionist Brush," *Metropolitan Museum of Art Bulletin* 32, no. 3, 1973–74, p. [24], fig. 13; Theodore Reff, *The Notebooks of Edgar Degas: A Catalogue of the Thirty-eight Notebooks in the Bibliothèque Nationale and Other Collections*, 2 vols., Oxford, 1976, vol. 1, p. 7 n. 2, pp. 9, 21, 115 (notebook 22, p. 203), 120 (notebook 24, pp. 22–23, 34); Charles S. Moffett, *Degas: Paintings in The Metropolitan Museum of Art*, New York, 1979, pp. 10–11, colorpl. 17; Ian Dunlop, *Degas*, New York, 1979, pp. 95, 117, 125, pl. 86; Eugénie De Keyser, *Degas: Réalité et métaphore*, Louvain-la-Neuve, 1981, pp. 19, 26–27, 60–61, 66, 95, p. 24; Theodore Reff, "Degas and De Valernes in 1872," *Arts Magazine* 56, September 1981, p. 126; Roy McMullen, *Degas: His Life, Times, and Work*, Boston,

1984, pp. 209–10, 214, 220, 223, 225, 246, 248–49, ill. p. 208; George T. M. Shackelford, *Degas: The Dancers*, exh. cat., National Gallery of Art, Washington, D.C., 1984, pp. 27–28, 43, 45, fig. 1.4; Charles S. Moffett, *Impressionist and Post-Impressionist Paintings in The Metropolitan Museum of Art*, New York, 1985, pp. 66–67, 250, ill. in color (overall and detail); Eunice Lipton, *Looking into Degas: Uneasy Images of Women and Modern Life*, Berkeley, 1986, pp. 86, 97, 99–100, 207 n. 12, fig. 53; Frances Weitzenhoffer, *The Havemeyers: Impressionism Comes to America*, New York, 1986, p. 231, pl. 157; Richard Thomson, *The Private Degas*, exh. cat., Whitworth Art Gallery, Manchester, London, 1987, p. 46; Mari Kálmán Meller, "Exercises in and around Degas's Classrooms: Part I," *Burlington Magazine* 130, March 1988, pp. 208–10, 212, fig. 25 (color); Carol Armstrong, *Odd Man Out: Readings of the Work and Reputation of Edgar Degas*, Chicago, 1991, pp. 9, 50, 52–53, fig. 1; Richard Kendall, Griselda Pollock, eds., *Dealing with Degas: Representations of Women and the Politics of Vision*, London, 1992, pp. 186–87, 189–91, 193, fig. 42; Louisine W. Havemeyer, *Sixteen to Sixty: Memoirs of a Collector*, New York, 1993, 3rd ed. with notes by Susan Alyson Stein, [1st ed., 1930; repr. 1961], pp. 265–66, 337 n. 376, pp. 339–40 n. 397; Henri Loyrette, trans. I. Mark Paris, *Degas: The Man and His Art*, New York, 1993, pp. 67–69, ill.; Felix Baumann and Marianne Karabelnik, eds., *Degas Portraits*, exh. cat., Kunsthaus Zürich, London, 1994, pp. 49–50, ill.; Richard Kendall, *Degas and the Little Dancer*, exh. cat., Joslyn Art Museum, Omaha, New Haven, 1998, pp. 5–6, fig. 1; Jill DeVonyar and Richard Kendall, *Degas and the Dance*, exh. cat., Detroit Institute of Arts, New York, 2002, pp. 79, 135, 287 n. 29, colorpl. 143; Madeleine Korn, "Exhibitions of Modern French Art and Their Influence on Collectors in Britain 1870–1918: The Davies Sisters in Context," *Journal of the History of Collections* 16, no. 2, 2004, pp. 196, 208, 213; Anna Gruetzner Robins and Richard Thomson, *Degas, Sickert, and Toulouse-Lautrec: London and Paris, 1870–1910*, exh. cat., Tate Britain, London, 2005, pp. 26, 29, fig. 8 (color)

Dancers in the Rehearsal Room with a Double Bass
ca. 1882–85
Oil on canvas
15⅜ x 35¼ in. (39.1 x 89.5 cm)
Signed (lower left): Degas
H. O. Havemeyer Collection, Bequest of Mrs. H. O. Havemeyer, 1929
29.100.127
See no. 69

PROVENANCE
Alexander Reid, Glasgow (by 1891–92; sold to Kay); Arthur Kay, Glasgow (1892–at least 1893); [Martin et Camentron, Paris, until 1895; sold on May 28, 1895,

for Fr 8,000 to Durand-Ruel]; [Durand-Ruel, Paris, 1895, stock no. 3318; sold on November 20, 1895, for Fr 20,000 to Durand-Ruel, New York]; [Durand-Ruel, New York, 1895–96, stock no. 1445; sold on March 23, 1896, for $ 6,000 to Milliken]; E. F. Milliken, New York (1896–1902; his sale, American Art Association, New York, February 14, 1902, no. 11, for $ 6,100 to Durand-Ruel for Havemeyer); Mr. and Mrs. H. O. Havemeyer, New York (1902–his d. 1907); Mrs. H. O. (Louisine W.) Havemeyer, New York (1907–d. 1929)

EXHIBITIONS
"A Small Collection of Pictures by Degas and Others," Mr. Collie's Rooms, Société des Beaux-Arts, London, December 18, 1891–January 8, 1892, no. 20; "A Small Collection of Pictures by Degas and Others," Société des Beaux-Arts, Glasgow, February 1892, no catalogue; "First Exhibition, consisting of Paintings and Sculpture, by British and Foreign Artists of the Present Day," Grafton Galleries, London, February 18–?, 1893, no. 301A; "First Annual Exhibition," Carnegie Art Galleries, Pittsburgh, November 5, 1896–January 1, 1897, no. 86; "The H. O. Havemeyer Collection," Metropolitan Museum of Art, New York, March 10–November 2, 1930, no. 54; "19th-Century French and American Paintings from the Collection of The Metropolitan Museum of Art," Newark Museum, April 9–May 15, 1946, no. 13; "A Man of Influence: Alex Reid, 1854–1928," Scottish Arts Council, Edinburgh, October 20–November 11, 1967, no. 23; "Degas in the Metropolitan," Metropolitan Museum of Art, New York, February 26–September 4, 1977, no. 16 (of paintings); "Degas," Virginia Museum, Richmond, May 23–July 9, 1978, no. 12; "Edgar Degas," Acquavella Galleries, Inc., New York, November 1–December 3, 1978, no. 40; "Degas 1879," National Gallery of Scotland, Edinburgh, August 13–September 30, 1979, no. 26; "Degas: The Dancers," National Gallery of Art, Washington, D.C., November 22, 1984–March 10, 1985, no. 30; "The Private Degas," Whitworth Art Gallery, Manchester, January 20–February 28, 1987, Fitzwilliam Museum, Cambridge, March 17–May 3, 1987, no. 75; "Degas," Galeries Nationales du Grand Palais, Paris, February 9–May 16, 1988, National Gallery of Canada, Ottawa, June 16–August 28, 1988, Metropolitan Museum of Art, New York, September 27, 1988–January 8, 1989, no. 239; "Splendid Legacy: The Havemeyer Collection," Metropolitan Museum of Art, New York, March 27–June 20, 1993, no. A238; "Hokusai: Il vecchio pazzo per la pittura," Palazzo Reale, Milan, October 6, 1999–January 9, 2000, no. VII.12; "Degas: Classico e moderno," Complesso del Vittoriano, Rome, October 1, 2004–February 1, 2005, no. 57; "Degas, Sickert, and Toulouse-Lautrec: London and Paris, 1870–1910," Tate Britain, London, October 5, 2005–January 15, 2006, Phillips Collection, Washington, D.C., February 18–May 14, 2006, no. 43

SELECTED REFERENCES
George Moore, "Degas in Bond Street," *Speaker*, January 2, 1892, p. 19; "Grafton Gallery," *Westminster Gazette*, February 17, 1893, p. 3; "The Grafton Gallery," *Globe*, February 25, 1893, p. 3; "The Grafton Gallery," *Artist*, March 1, 1893, p. 86; *H. O. Havemeyer Collection, Catalogue of Paintings, Prints, Sculpture and Objects of Art*, 1931, p. 119; E. Tietze-Conrat, "What Degas Learned from Mantegna," *Gazette des beaux-arts* 26, July–December 1944, 6e sér., pp. 416–17, fig. 1; Paul-André Lemoisne, *Degas et son oeuvre*, 4 vols., Paris [1946–49, reprint 1984], vol. 3, pp. 528–29, no. 905, ill.; Lillian Browse, *Degas Dancers*, New York [1949], pp. 67, 377–79, pl. 118; Charles Sterling and

Margaretta M. Salinger, *French Paintings: A Catalogue of the Collection of The Metropolitan Museum of Art*, 3 vols., New York, 1955–67, vol. 3, pp. 84–85, ill.; Fiorella Minervino, *L'Opera completa di Degas*, Milan, 1970, p. 124, no. 836, ill.; Theodore Reff, *The Notebooks of Edgar Degas: A Catalogue of the Thirty-eight Notebooks in the Bibliothèque Nationale and Other Collections*, 2 vols., Oxford, 1976, vol. 1, p. 21 n. 8, p. 137 (notebook 31, p. 70), p. 151; Theodore Reff, "Degas: A Master among Masters," *Metropolitan Museum of Art Bulletin* 34, spring 1977, n.s., p. [39], fig. 70 (color); Charles S. Moffett, *Degas: Paintings in The Metropolitan Museum of Art*, New York, 1979, p. 12, colorpl. 18; Theodore Reff, "Degas, Lautrec, and Japanese Art," *Japonisme in Art: An International Symposium*, December 18–22, 1979, Tokyo, 1980, pp. 198–99; Kate Flint, ed., "Impressionism in England: The Critical Reception," London, 1984, pp. 279–80, 282; Suzanne Folds McCullagh, et al., *Degas in The Art Institute of Chicago*, Art Institute of Chicago, 1984, pp. 62, 146, 149; Sue Welsh Reed, Barbara Stern Shapiro et al., *Edgar Degas: The Painter as Printmaker*, exh. cat., Boston, 1984, p. lviii, fig. 37 (anonymous lithograph after the painting); Götz Adriani, *Degas: Pastels, Oil Sketches, Drawings*, exh. cat., Kunsthalle Tübingen, New York, 1985, English ed. [German ed., 1984], p. 383, under no. 162, p. 385, under no. 172; Frances Weitzenhoffer, *The Havemeyers: Impressionism Comes to America*, New York, 1986, p. 257; Colin B. Bailey, Joseph J. Rishel, and Mark Rosenthal, *Masterpieces of Impressionism and Post-Impressionism: The Annenberg Collection*, exh. cat., Philadelphia Museum of Art, 1991, rev. ed. [1st ed., 1989], p. 14; Mari Kálmán Meller, "Exercises in and around Degas's Classrooms: Part II," *Burlington Magazine* 132, April 1990, pp. 253, 255, 257–58, fig. 21; Mari Kálmán Meller, "Exercises in and around Degas's Classrooms: Part III," *Burlington Magazine* 135, July 1993, pp. 452, 458 n. 43; Louisine W. Havemeyer, *Sixteen to Sixty: Memoirs of a Collector*, New York, 1993, 3rd ed. with notes by Susan Alyson Stein [1st ed., 1930; repr. 1961], pp. 259, 337 n. 376, p. 338 n. 385; Richard Thomson, *Edgar Degas: Waiting*, Malibu, 1995, pp. 19, 21, fig. 12; Ann Dumas et al. *The Private Collection of Edgar Degas*, exh. cat., Metropolitan Museum of Art, New York, 1997, p. 252, fig. 335 (color); Richard Shone, *The Janice H. Levin Collection of French Art*, exh. cat., Metropolitan Museum of Art, New York, 2002, p. 39, fig. 18; Jill DeVonyar and Richard Kendall, *Degas and the Dance*, exh. cat., Detroit Institute of Arts, New York, 2002, p. 111; Madeleine Korn, "Exhibitions of Modern French Art and Their Influence on Collectors in Britain 1870–1918: The Davies Sisters in Context," *Journal of the History of Collections* 16, no. 2, 2004, pp. 209, 213

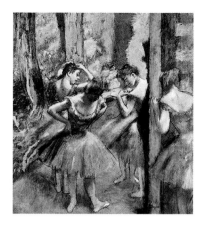

Dancers, Pink and Green
ca. 1890
Oil on canvas
32⅜ x 29¾ in. (82.2 x 75.6 cm)
Signed (lower right): Degas
H. O. Havemeyer Collection, Bequest of Mrs. H. O. Havemeyer, 1929
29.100.42
See no. 70

PROVENANCE
Mrs. H. O. (Louisine W.) Havemeyer, New York (by 1917–d. 1929; deposited with Durand-Ruel, New York, January 8–December 21, 1917, deposit no. 7844)

EXHIBITIONS
"Loan Exhibition of French Masterpieces of the Late XIX Century," Durand-Ruel, New York, March 20–April 10, 1928, no. 7; "The H. O. Havemeyer Collection," Metropolitan Museum of Art, New York, March 10–November 2, 1930, no. 55; "Metropolitan Museum Masterpieces," Hofstra College, Hempstead, N.Y., June 29–September 1, 1952, no. 35; "Treasured Masterpieces of The Metropolitan Museum of Art," Tokyo National Museum, August 10–October 1, 1972, Kyoto Municipal Museum of Art, October 8–November 26, 1972, no. 97; "Impressionism: A Centenary Exhibition," Metropolitan Museum of Art, New York, December 12, 1974–February 10, 1975, not in catalogue; "Degas in the Metropolitan," Metropolitan Museum of Art, New York, February 26–September 4, 1977, no. 18 (of paintings); "Degas," Virginia Museum, Richmond, May 23–July 9, 1978, no. 18; "Edgar Degas," Acquavella Galleries, Inc., New York, November 1–December 3, 1978, no. 45; "Capolavori impressionisti dei musei americani," Museo di Capodimonte, Naples, December 3, 1986–February 1, 1987, Pinacoteca di Brera, Milan, March 4–May 3, 1987, no. 17; "Degas," Galeries Nationales du Grand Palais, Paris, February 9–May 16, 1988, National Gallery of Canada, Ottawa, June 16–August 28, 1988, Metropolitan Museum of Art, New York, September 27, 1988–January 8, 1989, no. 293; "Treasures from The Metropolitan Museum of Art: French Art from the Middle Ages to the Twentieth Century," Yokohama Museum of Art, March 25–June 4, 1989, no. 90; "Splendid Legacy: The Havemeyer Collection," The Metropolitan Museum of Art, New York, March 27–June 20, 1993, no. A252; "Edgar Degas: The Many Dimensions of a Master French Impressionist," Dayton Art Institute, August 13–October 9, 1994, no. 96; "Degas, Beyond Impressionism," National Gallery, London, May 22–August 26, 1996, Art Institute of Chicago, September 28, 1996–January 5, 1997, no. 31; "La collection Havemeyer: Quand

l'Amérique découvrait l'impressionnisme . . . ,"
Musée d'Orsay, Paris, October 20, 1997–January 18,
1998, no. 1; "The Artist and the Camera: Degas to
Picasso," San Francisco Museum of Modern Art,
October 2, 1999–January 4, 2000, Dallas Museum of
Art, February 1–May 7, 2000, no. 20; "Edgar Degas:
Figures in Motion," Memorial Art Gallery of the
University of Rochester, October 13, 2002–January 5,
2003, no catalogue; "Degas: Classico e moderno,"
Complesso del Vittoriano, Rome, October 1, 2004–
February 1, 2005, no. 71

SELECTED REFERENCES
"Havemeyer Collection at Metropolitan Museum:
Havemeyers Paid Small Sums for Masterpieces," *Art
News* 28, March 15, 1930, ill. p. 40; *H. O.
Havemeyer Collection, Catalogue of Paintings, Prints,
Sculpture, and Objects of Art,* 1931, p. 118, ill.; Paul-
André Lemoisne, *Degas et son œuvre,* 4 vols., Paris
[1946–49, reprint 1984], vol. 3, pp. 590–91, no. 1013,
ill.; Lillian Browse, *Degas Dancers,* New York [1949],
p. 396, pl. 180; Theodore Rousseau Jr., "A Guide to
the Picture Galleries," *Metropolitan Museum of Art
Bulletin* 12, January 1954, n.s., part 2, p. 7; Charles
Sterling and Margaretta M. Salinger, *French Paintings:
A Catalogue of the Collection of The Metropolitan
Museum of Art,* 3 vols., New York, 1955–67, vol. 3,
pp. 85–86, ill.; Fiorella Minervino, *L'Opera completa
di Degas,* Milan, 1970, p. 125, no. 855, ill.; René
Huyghe, *La relève du réel: La peinture française au
XIXe siècle, Impressionnisme, symbolisme,* Paris,
1974, colorpl. 9; Bernard Dunstan, *Painting Methods
of the Impressionists,* New York, 1976, ill. p. 80; Janet
F. Buerger, "Degas' Solarized and Negative
Photographs: A Look at Unorthodox Classicism,"
Image 21, June 1978, p. 21; Theodore Reff, "Edgar
Degas and the Dance," *Arts Magazine* 53, November
1978, pp. 145, 147, fig. 2; Charles S. Moffett, *Degas:
Paintings in The Metropolitan Museum of Art,* New
York, 1979, pp. 12–13, colorpl. 26; Roy McMullen,
Degas: His Life, Times, and Work, Boston, 1984,
p. 417; Charles S. Moffett, *Impressionist and Post-
Impressionist Paintings in The Metropolitan Museum
of Art,* New York, 1985, pp. 82, 251, ill. p. 83 (color);
Frances Weitzenhoffer, *The Havemeyers:
Impressionism Comes to America,* New York, 1986,
p. 255; Denys Sutton, *Edgar Degas: Life and Work,*
New York, 1986, colorpl. 186; Richard Kendall,
Griselda Pollock, eds., *Dealing with Degas:
Representations of Women and the Politics of Vision,*
London, 1992, p. 199 n. 13; Louisine W. Havemeyer,
Sixteen to Sixty: Memoirs of a Collector, New York,
1993, 3rd ed. with notes by Susan Alyson Stein [1st
ed., 1930; repr. 1961], pp. 259, 337 n. 376, p. 338
n. 386; Mari Kálmán Meller, "Late Degas: London
and Chicago," exhibition review, *Burlington
Magazine* 138, September 1996, p. 616

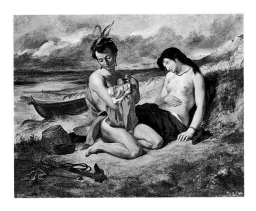

Eugène Delacroix
French, 1798–1863

The Natchez
1835
Oil on canvas
35½ x 46 in. (90.2 x 116.8 cm)
Signed (lower right): EugDelacroix
Purchase, Gifts of George N. and Helen M. Richard
and Mr. and Mrs. Charles S. McVeigh and Bequest of
Emma A. Sheafer, by exchange, 1989
1989.328
See no. 16

PROVENANCE
The artist, Paris (until 1837; possibly sold to baron
Charles Rivet for Fr 1,200; lottery, Lyons, 1837 or
1838, possibly won by Paturle); Monsieur Paturle
(until 1872; his sale, Hôtel Drouot, Paris, February
28, 1872, no. 7, for Fr 19,000 to Febvre); [Alexis
Joseph Febvre, Paris, from 1872]; Charles Sedelmeyer,
Paris (until 1877; his sale, Hôtel Drouot, Paris, April
30, 1877, no. 25, for Fr 7,100); Paul Demidoff,
principe di San Donato, Florence and St. Petersburg
(in 1878); Monsieur Perreau (until 1881; sold October
1881 for Fr 6,000 to Boussod, Valadon); [Boussod-
Valadon, Paris, 1881–at least 1885]; [Goupil, Paris, in
1887; sale, Hôtel Drouot, Paris, May 25, 1887, no. 44,
sold for Fr 5,000 to Escribe acting for Boussod,
Valadon, probably bought in, and sold for the same
price to Guillot]; Edmond Guillot, Paris (until 1888;
sold on December 31, 1888, for Fr 6,560 to Boussod,
Valadon); [Boussod, Valadon, Paris, 1888; sold on
December 31, 1888, for Fr 8,400 to Michel]; F. Michel
(from 1888); Philippe George, Ay, France (until 1891;
his sale, Galerie Georges Petit, Paris, June 2, 1891,
no. 17, for Fr 15,600); [Durand-Ruel, Paris, in 1900];
Monsieur Bessonneau, Angers (by 1916); his son-in-
law(?), Monsieur Frappier (by 1923); Mme Frappier
(by 1925–at least 1930); sale, former collection
Bessonneau d'Angers, Galerie Charpentier, Paris, June
15, 1954, no. 31, for Fr 3,700,000 to Reid & Lefevre;
[Reid & Lefevre, London, 1954–at least 1956]; Lord
and Lady Walston, Thriplow, Cambridge (by 1959–89;
on loan to National Gallery, London, April 1988–May
1989; sale, Christie's, New York, November 14, 1989,
no. 31)

EXHIBITIONS
Salon, Paris, March 1–?, 1835, no. 556; "Exposition
de 1836," Société Centrale des Amis des Arts en
Province, Moulins, 1836, supp. no. 266; "Exposition
de la Société des Amis des Arts de Lyon," location
unknown, Lyons, 1837, no. 72; "Exposition rétrospec-
tive de tableaux et dessins des maîtres modernes,"
Durand-Ruel, Paris, 1878, no. 156; "Exposition
Eugène Delacroix au profit de la souscription des-
tinée à élever à Paris un monument à sa memoire,"
École Nationale des Beaux-Arts, Paris, March 6–April

15, 1885, no. 32; "Exposition d'oeuvres d'Eugène
Delacroix (1798–1863) au profit de la Société des
Amis du Louvre," Paul Rosenberg, Paris, January
16–February 18, 1928, no. 5; "Centenaire du roman-
tisme: Exposition E. Delacroix," Musée du Louvre,
Paris, June–September 1930, no. 20; "Eugène
Delacroix," Biennale, Venice, June–September 1956,
no. 4; "Centenaire d'Eugène Delacroix, 1798–1863,"
Musée du Louvre, Paris, May–September 1963,
no. 220; "Delacroix," Royal Scottish Academy,
Edinburgh, August 15–September 13, 1964, Royal
Academy of Arts, London, October 1–November 8,
1964, no. 7; "Chateaubriand, Le voyageur et
l'homme politique," Bibliothèque Nationale de
France, Paris, 1969, no. 77; "Eugène Delacroix,"
Kunsthaus Zürich, June 5–August 23, 1987, Städtische
Galerie im Städelschen Kunstinstitut, Frankfurt am
Main, September 24, 1987–January 10, 1988, no. 7;
"Eugène Delacroix (1798–1863): Paintings, Drawings,
and Prints from North American Collections,"
Metropolitan Museum of Art, New York, April 10–
June 16, 1991, no. 3; "Delacroix: La naissance d'un
nouveau romantisme," Musée des Beaux-Arts, Rouen,
April 4–July 15, 1998, no. 52

SELECTED REFERENCES
Charles Lenormant, "De l'école française en 1835:
Salon annuel," *Revue des deux mondes* 2, April 1,
1835, 4e sér., p. 197; Victor Schoelcher, "Salon de
1835," *Revue de Paris* 17, May 1835, pp. 58–59;
A., *Le constitutionnel,* April 26, 1835; G[uyot] de
F[ère], *Journal spécial des lettres et des beaux-arts,*
vol. 1, 1835, p. 204; F. P., *Moniteur universel,* April
13, 1835; "Les peintres et les poètes," *L'Artiste* 9,
1835, 8e livraison, p. 90; L[ouis] P[eiss]e, *Le temps,*
April 30, 1835; E. S., *La tribune politique et littéraire,*
April 6, 1835; A. T[ardieu], *Le courrier français,*
March 30, 1835; W., *Le réformateur,* March 15, 1835;
L'Artiste 12, 1836, p. 24; *L'Artiste* 14, 1837, p. 212;
T. Thoré, "M. Eugène Delacroix," *Le siècle,* February
25, 1837; Théophile Silvestre, *Delacroix,* Paris, 1855,
p. 80; A[rnould] de Vienne, "La galerie de M.
Paturle," *L'Artiste* 2, 1856, 6e sér., p. 76; [Achille
Piron], *Eugène Delacroix: Sa vie et ses oeuvres,* Paris,
1865, p. 107; Adolphe Moreau, *E. Delacroix et son
œuvre,* Paris, 1873, pp. 160, 175–76, 252; Alfred
Robaut, *L'Oeuvre complet de Eugène Delacroix,* Paris,
1885 [repr. 1969], pp. 29, 35, 398, no. 108, ill.
(engraving); Henry Houssaye, "L'Exposition des
oeuvres d'Eugène Delacroix à l'Ecole des beaux-arts,"
Revue des deux mondes 68, April 1, 1885, 3e sér.,
p. 668; Maurice Tourneux, *Eugène Delacroix devant
ses contemporains,* Paris, 1886, pp. 61–63; Adolphe-
Étienne Moreau-Nélaton, *Delacroix raconté par lui-
même,* 2 vols., Paris, 1916, vol. 1, pp. 154, 163,
fig. 121; Julius Meier-Graefe, *Eugène Delacroix:
Beiträge su einer Analyse,* Munich, 1922, ill. p. 99;
Raymond Escholier, *Delacroix: Peintre, graveur,
écrivain,* 3 vols., Paris, 1926–29, vol. 1, ill. p. 131;
Louis Hourticq, *Delacroix: L'Oeuvre du maître,* Paris,
1930, pp. 183, 191, ill. p. 7; André Joubin, ed.,
Journal de Eugène Delacroix, 3 vols., Paris, 1932,
vol. 1, pp. 15 n. 2, 39, vol. 3, p. 375 n. 6, pp. 521–
22; André Joubin, *Correspondance générale d'Eugène
Delacroix,* 5 vols., Paris, 1935–38, vol. 1, p. 409,
vol. 2, pp. 3–4 n. 5; Lee Johnson, "Delacroix at the
Biennale," *Burlington Magazine* 98, September 1956,
p. 327; Lee Johnson, "The Early Drawings of
Delacroix," book review, *Burlington Magazine* 98,
January 1956, p. 23; René Huyghe, *Delacroix,* New
York, 1963, pp. 187, 282, 302, pl. 216 (detail);
Maurice Sérullaz, *Mémorial de l'exposition Eugène
Delacroix,* Paris, 1963, pp. 163–65, no. 217, ill.;
Louis Hautecoeur, *Littérature et peinture en France du
XVIIe au XXe siècle,* Paris, 1963, p. 35; Lee Johnson,
Delacroix, exh. cat., Royal Academy of Arts, London,

1964, pp. 11, 17, 43, no. 7, pl. 5; Maurice Sérullaz, "A Comment on the Delacroix Exhibition organized in England," *Burlington Magazine* 107, July 1965, p. 366; Lee Johnson, "Eugène Delacroix et les Salons," *Revue du Louvre*, 16, nos. 4 and 5, 1966, p. 223; Frank Anderson Trapp, *The Attainment of Delacroix*, Baltimore [1970], p. 194 n. 33; Luigina Rossi Bortolatto, *L'Opera pittorica completa di Delacroix*, Milan, 1972, p. 92, no. 98, ill.; Hugh Honour, *L'Amérique vue par l'Europe*, exh. cat., Grand Palais, Paris, 1976, p. XXXV, 247, 256–57; David Wakefield, "Chateaubriand's 'Atala' as a Source of Inspiration in Nineteenth-Century Art," *Burlington Magazine* 120, January 1978, p. 21, fig. 21; Sara Lichtenstein, published Ph.D. dissertation, *Delacroix and Raphael*, Courtauld Institute of Art, 1973, New York, 1979, pp. 93–95, fig. 48; Lee Johnson, *The Paintings of Eugène Delacroix: A Critical Catalogue*, 6 vols., Oxford, 1981–89, vol. 1, pp. viii, xxi, 53, 78–80, 90, 244, no. 101, vol. 2, pl. 88, vol. 3, pp. xxii, 287 (see also *Fourth Supplement and Reprint of Third Supplement*, 2002 [3rd supplement, pub. 1993], pp. 323–24, no. 101); Maurice Sérullaz, *Delacroix*, Paris, 1981, pp. 178–79, no. 35, ill.; Maurice Sérullaz et al., *Musée du Louvre, Cabinet des Dessins, Inventaire général des dessins, École française, Dessins d'Eugène Delacroix*, 2 vols., Paris, 1984, vol. 1, p. 89, under no. 88; Gary Tinterow et al., "Recent Acquisitions, A Selection: 1989–1990," *Metropolitan Museum of Art Bulletin* 48, fall 1990, pp. 5, 41–42, color ill. on cover (detail) and p. 42 (overall); Everett Fahy, "Selected Acquisitions of European Paintings at the Metropolitan Museum of Art, 1987–1991," *Burlington Magazine* 133, November 1991, pp. 801, 807, colorpl. XII; Barthélémy Jobert, *Delacroix*, Paris, 1997, pp. 50, 58, 102, 104, colorpl. 65 [English ed., 1998]; Peter Brooks, *History Painting and Narrative Delacroix's 'Moments*,' Oxford, 1998, pp. 13, 15, fig. 7; Richard Thomson, *Theo van Gogh: Marchand de tableaux, collectionneur, frère de Vincent*, exh. cat., Van Gogh Museum, Amsterdam, Paris, 1999, pp. 71, 75, 78, 200 n. 64, fig. 58 (color); John F. Moffitt, "The Native American 'Sauvage' as Pictured by French Romantic Artists and Writers," *Gazette des beaux-arts* 134, September 1999, pp. 124–26, 129 n. 21, fig. 4

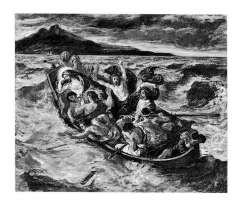

Christ Asleep during the Tempest
ca. 1853
Oil on canvas
20 x 24 in. (50.8 x 61 cm)
Signed (lower left): Eug. Delacroix
H. O. Havemeyer Collection, Bequest of Mrs. H. O. Havemeyer, 1929
29.100.131
See no. 17

PROVENANCE

[Possibly Francis Petit, Paris, from 1853]; possibly Bouruet-Aubertot, Paris (by 1860); possibly Monsieur R.-L. L. (until 1876; his sale, Paris, April 22, 1876, no. II); John Saulnier, Bordeaux (possibly by 1873–d. 1886; his estate sale, Hôtel Drouot, Paris, June 5, 1886, no. 35, for Fr 14,000, bought in; his estate sale, Galerie Charles Sedelmeyer, Paris, March 25, 1892, no. 8, for Fr 26,000 to Durand-Ruel); [Durand-Ruel, Paris, 1892, stock no. 2066; sold on December 13, 1892, for Fr 40,000 to Durand-Ruel, New York]; [Durand-Ruel, New York, 1892–94, sold on January 16, 1894, to Havemeyer]; Mr. and Mrs. H. O. Havemeyer, New York (1894–his d. 1907); Mrs. H. O. (Louisine W.) Havemeyer, New York (1907–d. 1929)

EXHIBITIONS

"Tableaux de l'école moderne tirés de collections d'amateurs . . . ," 26, boulevard des Italiens, Paris, 1860, no. 349 (possibly this work); "Exposition des œuvres d'Eugène Delacroix," 26, boulevard des Italiens, Paris, 1864, no. 125 (possibly this work); "Exposition Eugène Delacroix au profit de la souscription destinée à élever à Paris un monument à sa memoire," École Nationale des Beaux-Arts, Paris, March 6–April 15, 1885, no. 201; "Maîtres du Siècle," 3, rue Bayard (former studio of Gustave Doré), Paris, April–May 1886, no. 78; "The H. O. Havemeyer Collection," Metropolitan Museum of Art, New York, March 10–November 2, 1930, no. 59; "The Development of Impressionism," Los Angeles Museum, January 12–February 28, 1940, no. 23; "Metropolitan Museum Masterpieces," Hofstra College, Hempstead, N.Y., June 29–September 1, 1952, no. 36; "Painting: School of France," Atlanta Art Association Galleries, September 20–October 4, 1955, Birmingham Museum of Art, October 16–November 5, 1955, no. 6; "Impressionism," Columbia Museum of Art, Columbia, S.C., April 3–May 8, 1960, no. 14; "Treasured Masterpieces of The Metropolitan Museum of Art," Tokyo National Museum, August 10–October 1, 1972, Kyoto Municipal Museum of Art, October 8–November 26, 1972, no. 91; "Van Gogh as Critic and Self-Critic," Metropolitan Museum of Art, New York, October 30, 1973–January 6, 1974, no. 37; "Franse meesters uit het Metropolitan Museum of Art: Realisten en Impressionisten," Rijksmuseum Vincent Van Gogh, Amsterdam, March

15–May 31, 1987, no. 1; "Eugène Delacroix," Kunsthaus Zürich, June 5–August 23, 1987, Städtische Galerie im Städelschen Kunstinstitut, Frankfurt am Main, September 24, 1987–January 10, 1988, no. 95; "Treasures from The Metropolitan Museum of Art: French Art from the Middle Ages to the Twentieth Century," Yokohama Museum of Art, March 25–June 4, 1989, no. 81; "Eugène Delacroix (1798–1863): Paintings, Drawings, and Prints from North American Collections," Metropolitan Museum of Art, New York, April 10–June 16, 1991, no. 9; "Splendid Legacy: The Havemeyer Collection," Metropolitan Museum of Art, New York, March 27–June 20, 1993, no. A261; "Delacroix: The Late Work," Galeries Nationales du Grand Palais, Paris, April 7–July 20, 1998, Philadelphia Museum of Art, September 15, 1998–January 3, 1999, no. 115; "Eugène Delacroix," Staatliche Kunsthalle Karlsruhe, November 1, 2003–February 1, 2004, no. 172; "Vincent's Choice: Van Gogh's *Musée Imaginaire*," Van Gogh Museum, Amsterdam, February 14–June 15, 2003, unnumbered cat. (pl. 124)

SELECTED REFERENCES

Théophile Silvestre, *Delacroix*, Paris, 1855, p. 81; Théophile Gautier, "Exposition de tableux modernes," *Gazette des beaux-arts* 5, 1860, p. 202 (possibly this work); Amédée Cantaloube, *Eugène Delacroix*, Paris, 1864, p. 98; H. de la Madelène, *Eugène Delacroix à l'exposition du Boulevard des Italiens*, Paris, 1864, p. 17 (possibly this work); Adolphe Moreau, *E. Delacroix et son œuvre*, Paris, 1873, p. 262; Alfred Robaut, catalogue raisonné, *L'Oeuvre complet de Eugène Delacroix*, Paris, 1885 [repr. 1969], p. 326, no. 1215, ill. (engraving); Paul Mantz, "La collection John Saulnier," *Le temps*, June 3, 1886; *The Complete Letters of Vincent van Gogh*, 3 vols., Greenwich, Conn., 1958, vol. 2, p. 597, no. 503, vol. 3, p. 24, no. 531, p. 29, no. 533, pp. 495, 497, no. B8; Julius Meier-Graefe, *Manet und sein Kreis*, Berlin, 1902, ill. opp. p. 10; Adolphe-Étienne Moreau-Nélaton, *Delacroix raconté par lui-même*, 2 vols., Paris, 1916, vol. 2, p. 115, fig. 335; Julius Meier-Graefe, *Eugène Delacroix: Beiträge su einer Analyse*, Munich, 1922, ill. p. 199; Frank Jewett Mather Jr., "The Havemeyer Pictures," *The Arts* 16, March 1930, p. 469, ill. p. 461; Andre Joubin, ed., *Journal de Delacroix* 2, 1932, pp. 77, 82–83, 88; Edward S. King, "Delacroix's Paintings in the Walters Art Gallery," *Journal of the Walters Art Gallery* 1, 1938, pp. 90, 92–93, 109 n. 14, p. 110 nn. 30 and 36, fig. 6; Walter Friedlaender, trans. Robert Goldwater, *David to Delacroix*, New York, 1952, pp. 125, 133, fig. 81; Charles Sterling and Margaretta M. Salinger, *French Paintings: A Catalogue of the Collection of The Metropolitan Museum of Art*, 3 vols., New York, 1955–67, vol. 2, pp. 27–30, ill.; Lee Johnson, "Delacroix at the Biennale," *Burlington Magazine* 98, September 1956, p. 329 nn. 9 and 10; Lee Johnson, "The Etruscan Sources of Delacroix's 'Death of Sardanapalus,'" *Art Bulletin* 42, December 1960, p. 300; Lee Johnson, *Delacroix*, exh. cat., Art Gallery of Toronto, 1962, pp. 45–46, under no. 18; René Huyghe, *Delacroix*, New York, 1963, pp. 469, 537; Felix Baumann and Hugo Wagner, *Eugène Delacroix*, exh. cat., Kunstmuseum Bern, Bern, 1963, unpaginated, under no. 78; Maurice Sérullaz, *Mémorial de l'exposition Eugène Delacroix*, Paris, 1963, pp. 340–41, under nos. 448 and 449; Luigina Rossi Bortolatto, *L'Opera pittorica completa di Delacroix*, Milan, 1972, p. 125, no. 655, ill.; Charles S. Moffett, "'Ah! that lovely picture by Delacroix': Van Gogh as Critic and Self-Critic," exhibition review, *Art News* 72, December 1973, p. 40, ill. p. 38; Susan Elizabeth Strauber, *The Religious Paintings of Eugène Delacroix*, unpublished Ph.D. dissertation, Brown University,

1980, pp. 239, 258–59, 267–79, 344–45 nn. 100, 105, p. 346 n. 112, fig. 56; Maurice Sérullaz, *Delacroix*, Paris, 1981, p. 195, no. 386, ill.; Lee Johnson, *The Paintings of Eugène Delacroix, A Critical Catalogue*, 6 vols., Oxford, 1981–89, vol. 1, p. 118, vol. 3, pp. 232–33, 235 n. 1, pp. 236, 348, 354, no. 454, vol. 4, pl. 263; William R. Johnston, *The Nineteenth Century Paintings in the Walters Art Gallery*, Baltimore, 1982, p. 49; Ronald Pickvance, *Van Gogh in Arles*, exh. cat., Metropolitan Museum of Art, New York, 1984, p. 103; Frances Weitzenhoffer, *The Havemeyers: Impressionism Comes to America*, New York, 1986, pp. 98, 258, pl. 45; Judy Sund, "The Sower and the Sheaf: Biblical Metaphor in the Art of Vincent van Gogh," *Art Bulletin* 70, December 1988, pp. 666–68 n. 53, fig. 5; Evert van Uitert et al., *Vincent van Gogh: Paintings*, exh. cat., Rijksmuseum Vincent van Gogh, Amsterdam, Milan, 1990, p. 118, fig. 44b; Debora Silverman, *Lost Paradise: Symbolist Europe*, exh. cat., Montreal Museum of Fine Arts, 1995, pp. 107, 112, ill.; Peter Rautmann, trans. Denis-Armand Canal and Lydie Échasseriaud, *Delacroix*, Paris, 1997, p. 292, fig. 284 (color); Naomi Margolis Maurer, *The Pursuit of Spiritual Wisdom: The Thought and Art of Vincent van Gogh and Paul Gauguin*, Madison, N.J., 1998, p. 7, fig. 10 (color); Louis van Tilborgh et al., *Millet/Van Gogh*, exh. cat., Musée d'Orsay, Paris, 1998, p. 105 n. 33; Arlette Sérullaz and Annick Doutriaux, *Delacroix: "Une fête pour l'oeil,"* Paris, 1998, p. 123, ill. p. 122 (color); Kathleen Powers Erickson, *At Eternity's Gate: The Spiritual Vision of Vincent van Gogh*, Grand Rapids, Mich., 1998, pp. 97–100, 155, fig. 9

Henri Fantin-Latour
French, 1836–1904

Still Life with Flowers and Fruit
1866
Oil on canvas
28¾ x 23⅝ in. (73 x 60 cm)
Signed and dated (upper left): Fantin. 1866.
Purchase, Mr. and Mrs. Richard J. Bernhard Gift, by exchange, 1980
1980.3
See no. 71

PROVENANCE
Michael Spartali, London (1866–67); Michael Spartali or Stavros Dilberoglou, London (from 1867); [Gustave Tempelaere, Paris]; [Lefevre, London]; sale, Galerie Georges Petit, Paris, May 22, 1919, no. 16, for Fr 34,000, to Graat et Madoulé for Gulbenkian; Calouste Gulbenkian, Paris (1919–48; gift to Cayrol); M. Cayrol, Paris (from 1948); possibly by descent to Mme Joel Hardion, Paris (until 1979); [Robert Schmit, Paris, David Carritt, London, Artemis, New York, and Lefevre, London, 1979–80]

EXHIBITIONS
"La fleur: Peinture, sculpture et arts appliqués du XVe au XIXe siècle," Hôtel Jean Charpentier, Paris, June 16–July 12, 1930, no. 21; "Fantin-Latour," Galeries Nationales du Grand Palais, Paris, November 9, 1982–February 7, 1983, National Gallery of Canada, Ottawa, March 17–May 22, 1983, California Palace of the Legion of Honor, San Francisco, June 18–September 6, 1983, no. 36; "Origins of Impressionism," Galeries Nationales du Grand Palais, Paris, April 19–August 8, 1994, Metropolitan Museum of Art, New York, September 27, 1994–January 8, 1995, no. 72

SELECTED REFERENCES
Madame Fantin-Latour [Victoria Dubourg], *Catalogue de l'oeuvre complet (1849–1904) de Fantin-Latour*, Paris, 1911 [reprint 2000], p. 40, no. 288; C[harles] S. M[offett], A[nne] W[agner] et al., *The Metropolitan Museum of Art: Notable Acquisitions, 1979–1980*, New York, 1980, pp. 43–44, color ill.; Denys Sutton, "Cross-Currents in Nineteenth-Century French Painting," *Apollo* 113, no. 230, April 1981, p. 248, color ill. on cover; Charles S. Moffett, *Impressionist and Post-Impressionist Paintings in The Metropolitan Museum of Art*, New York, 1985, pp. 20–21, color ill.; Jean-Jacques Lévêque, *Henri Fantin-Latour: Un peintre intimiste, 1836–1904*, Paris, 1996, color ill. p. 131

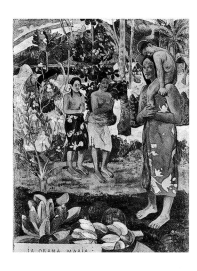

Paul Gauguin
French, 1848–1903

Ia Orana Maria (Hail Mary)
1891
Oil on canvas
44¾ x 34½ in. (113.7 x 87.6 cm)
Signed, dated, and inscribed: (lower right) P Gauguin 91; (lower left) IA ORANA MARIA
Bequest of Sam A. Lewisohn, 1951
51.112.2
See no. 106

PROVENANCE
Michel Manzi, Paris (1893–1915; bought for Fr 2,000 from the Durand-Ruel exhibition, November 1893–d. 1915; his estate, 1915–19; his estate sale, Galerie Manzi et Joyant, Paris, March 13–14, 1919, no. 56, for Fr 58,000 to Knoedler); [Knoedler, New York, 1919]; Adolph Lewisohn, New York (1919–d. 1938); his son, Sam A. Lewisohn, New York (1938–d. 1951)

EXHIBITIONS
"Exposition d'oeuvres récentes de Paul Gauguin," Durand-Ruel, Paris, November 1893, no. 1; "Fiftieth Anniversary Exhibition," Metropolitan Museum of Art, New York, May 8–August 1920, unnumbered cat.; "Loan Exhibition of Impressionist and Post-Impressionist Paintings," Metropolitan Museum of Art, New York, May 3–September 15, 1921, no. 47; "Exhibition of 'Modern' Pictures Representing Impressionist, Post-Impressionist, Expressionist, and Cubist Painters," Union League Club, New York, April 8–10, 1924, no. 16; "Loan Exhibition of French Masterpieces of the Late XIX Century," Durand-Ruel, New York, March 20–April 10, 1928, no. 8; "A Century of French Painting," M. Knoedler and Co., New York, November 12–December 8, 1928, no. 29; "Summer Exhibition, Retrospective," Museum of Modern Art, New York, June 15–late September, 1930, no. 39; "Exhibition of French Art: 1200–1900," Royal Academy of Arts, London, January 4–March 12, 1932, no. 540; "A Century of Progress," Art Institute of Chicago, June 1–November 1, 1933, no. 366; "Cézanne, Gauguin," Toledo Museum of Art, June–August 1935, unnumbered cat.; "Paul Gauguin: 1848–1903," Wildenstein and Co., Inc., New York, March 20–April 18, 1936, no. 17; "Twentieth Anniversary Exhibition," Cleveland Museum of Art, June 26–October 4, 1936, no. 276; "Chefs-d'œuvre de l'art français," Palais National des Arts, Paris, July–September 1937, no. 326; "Art in Our Time," Museum of Modern Art, New York, May 10–September 30, 1939, no. 67; "Masterpieces of Art:

European and American Paintings, 1500–1900," World's Fair, New York, May–October 1940, no. 355; "A Loan Exhibition of Paul Gauguin," Wildenstein and Co., Inc., New York, April 3–May 4, 1946, no. 19; "Gauguin: Exposition du centenaire," Orangerie des Tuileries, Paris, 1949, no. 25; "The 19th Century Heritage," Paul Rosenberg, New York, March 7–April 1, 1950, no. 8; "The Lewisohn Collection," Metropolitan Museum of Art, New York, November 2–December 2, 1951, no. 34; "L'Oeuvre du XXe siècle: Peintures- sculptures," Musée National d'Art Moderne, Paris, May–June 1952, no. 31; "Gauguin: Paintings, Drawings, Prints, Sculpture," Art Institute of Chicago, February 12–March 29, 1959, no. 28, Metropolitan Museum of Art, New York, April 23–May 31, 1959, no. 28; "Masterpieces of Fifty Centuries," Metropolitan Museum of Art, New York, November 15, 1970–February 15, 1971, no. 384; "The Art of Paul Gauguin," National Gallery of Art, Washington, D.C., May 1–July 31, 1988, Art Institute of Chicago, September 17–December 11, 1988, Galeries Nationales du Grand Palais, Paris, January 10–April 20, 1989, no. 135; "Gauguin," Pushkin State Museum of Fine Arts, Moscow, May 20–July 20, 1989, State Hermitage Museum, Leningrad [St. Petersburg], July 30–October 4, 1989, no. 22; "The Lure of the Exotic: Gauguin in New York Collections," Metropolitan Museum of Art, New York, June 18–October 20, 2002, no. 55; "Gauguin Tahiti," Galeries Nationales du Grand Palais, Paris, September 30, 2003–January 19, 2004, Museum of Fine Arts, Boston, February 29, 2004–June 20, 2004, no. 74

SELECTED REFERENCES

Paul Gauguin and Charles Morice, Noa Noa, Paris, 1901, p. 19; Charles Morice, Paul Gauguin, Paris, 1919, 1st ed. [new ed., 1920], p. 171 n. 1, pp. 183, 201; Hamilton Easter Field, "Art New and Old in Current Shows," Arts and Decoration 12, no. 11, December 15, 1919, p. 109; Pola Gauguin, "Paul Gauguin," Kunst og Kultur 9, 1921, p. 248; Achille Delaroche, trans. Van Wyck Brooks, "Concerning the Painter Paul Gauguin, from an Aesthetic Point of View," Paul Gauguin's Intimate Journals, New York, 1921, p. 41; Charles Chassé, Gauguin et le groupe de Pont-Aven, Paris, 1921, pp. 50–52; Stephen Bourgeois, "A Notable Group of French Modernists," Arts and Decoration, November 1922, pp. 25, 74, ill.; Gustave Kahn, "Paul Gauguin," L'Art et les artistes 12, October 1925–February 1926, p. 61; Stephan Bourgeois, The Adolph Lewisohn Collection of Modern French Paintings and Sculpture, New York, 1928, pp. 160–61, ill.; Stephan Bourgeois, "The Passion of Collecting: Notes on the Adolph Lewisohn Collection," Art News, April 14, 1928, pp. 64, 67, ill.; A. Alexandre, Paul Gauguin, Sa vie et le sens de son oeuvre, Paris, 1930, pp. 133, 135–40, 157, 161, 263–64, ill.; R. H. Wile[n]ski, French Painting, Boston, 1931, pp. 289, 294, pl. 120; Stephan Bourgeois and Waldemar George, "The French Paintings of the XIXth and XXth Centuries in the Adolph and Samuel Lewisohn Collection," Formes, nos. 28–29, 1932, pp. 301–2; "The Century of Progress Exhibition of the Fine Arts," Bulletin of the Art Institute of Chicago 27, April–May 1933, p. 67; Daniel Catton Rich, "The Exhibition of French Art 'Art Institute of Chicago,'" Formes, no. 33, 1933, p. 383; Charles Kunstler and Librairie Floury, Gauguin: Peintre maudit, Paris, 1934, p. 170; Beril Becker, Paul Gauguin: The Calm Madman, New York, 1935, pp. 195–96; Sam A. Lewisohn, Painters and Personality: A Collector's View of Modern Art [New York], 1937, pp. 61–63, ill.; Pola Gauguin, trans. Arthur G. Chater, My Father Paul Gauguin, New York, 1937, 1st American ed., pp. 171–72; Martin Tow,

Tainted Paradise: A Study of the Life and Art of Paul Gauguin, New York, 1937, pp. 107, 153; René Huyghe, La peinture française: XVIIIme et XIXme siècles (figures et portraits), Paris, 1937, unpaginated, no. 46, ill. (detail); Sam A. Lewisohn, "Personalities Past and Present," Art News 37, February 25, 1939, section I (The 1939 Annual), pp. 70, 154, ill.; Mary H. Piexotto, "Famous Art Collections: The Lewisohn Collection," Studio 117, March 1939, pp. 95, 101, ill.; R. H. Wilenski, Modern French Painters, New York [1940], p. 131; Maurice Malingue, Gauguin, Monaco, 1943, pp. 30, 89, ill.; John Rewald, ed., Paul Gauguin: Letters to Ambroise Vollard and André Fontainas, San Francisco, 1943, p. 39; Henry La Farge, "John La Farge and the South Sea Idyll," Journal of the Warburg and Courtauld Institutes 7, 1944, p. 38; Hans Graber, Paul Gauguin nach eigenen und fremden Zeugnissen, Basel, 1946, pp. 351–52, 377, ill. between pp. 284 and 285; Raymond Cogniat, Gauguin, Paris, 1947, p. 33, pl. 63; Henri Perruchot, Gauguin: Sa vie ardente et misérable, Paris, 1948, pp. 188, 190–91, ill. opp. p. 97; Jean Leymarie, "Musée de l'Orangerie: Exposition Gauguin," Musées de France, June 1949, p. 110; Frank Elgar, Gauguin, Paris, 1949, unpaginated, no. 16, pl. 16; Denys Sutton, "The Paul Gauguin Exhibition," Burlington Magazine 91, no. 559, October 1949, p. 284 n. 9; Alexander Watt, "The Centenary Exhibition of the Work of Gauguin," Apollo 50, October 1949, p. 98; Gilberte Martin-Méry, "Gauguin et le groupe de Pont-Aven," exh. cat., Musée des Beaux-Arts de Quimper, 1950, pp. 25, 61; Annie Joly-Segalen, ed., Lettres de Gauguin à Daniel de Monfreid, Paris, 1950, pp. 54, 145, 158; Georg Schmidt, Gauguin, Bern, 1950, p. 28, ill. p. 49; Bernard Dorival, "Sources of the Art of Gauguin from Java, Egypt and Ancient Greece," Burlington Magazine 93, April 1951, pp. 118–19, fig. 16; Henri Dorra, "Ia Orana Maria," Metropolitan Museum of Art Bulletin 10, May 1952, pp. 254–60, ill.; Henri Dorra, "The First Eves in Gauguin's Eden," Gazette des beaux-arts 151, March 1953, 6e pér., p. 189, fig. 2; Paul Gauguin, Bernard Dorival, ed., Carnet de Tahiti, 2 vols., Paris, 1954, pp. 17, 26, 29, 36, 58 n. 3, p. 60 n. 3, p. 61 n. 2, p. 62 n. 1 to p. 39; John Rewald, Paul Gauguin (1848–1903), New York, 1954, unpaginated, colorpl. 14; Charles Sterling and Margaretta M. Salinger, French Paintings: A Catalogue of the Collection of The Metropolitan Museum of Art, 3 vols., New York, 1955–67, vol. 3, pp. 170–74, ill.; Robert J. Goldwater, Paul Gauguin, New York [1957, concise ed. 1983], p. 100, colorpl. missing; John Rewald, Gauguin Drawings, New York, 1958, p. 30; Alfred Frankfurter, "Midas on Parnassus," Art News Annual 28, 1959, p. 43; Maurice Denis, Journal, vol. 3, Paris, 1959, p. 83; René Huyghe et al., eds., Gauguin, Paris, 1961, pp. 34, 87, 90, 122, 234, ill.; Henri Perruchot, La vie de Gauguin, 1961, pp. 271, 275; John Rewald, Post-Impressionism: From Van Gogh to Gauguin, New York, 1962, pp. 502, 506, 509, ill.; Georges Wildenstein, Gauguin, Paris, 1964, French ed. [English ed., 1965], p. 167, no. 428, ill.; Georges Boudaille, trans. Alisa Jaffa, Gauguin, New York, 1964, pp. 121, 179–80, 190, 194, 207, ill. in color; Bengt Danielsson, trans. Reginald Spink, Gauguin in the South Seas, London, 1965, English ed. [Swedish ed., 1964], pp. 90–91, 142, 144–45, 190; Patrick O'Reilly, Catalogue du Musée Gauguin, Paris, 1965, p. 61 under nos. 210–11; Paul C. Nicholls, Gauguin, New York, 1967, pp. 13, 25, no. 34, ill. in color; Margaretta M. Salinger, "Windows Open to Nature," Metropolitan Museum of Art Bulletin 27, summer 1968, n.s., unpaginated, ill.; Bengt Danielsson, "The Exotic Sources of Gauguin's Art," Expedition 11, summer 1969, pp. 22–23, ill.; Patrik Reuterswärd et al., Gauguin i

Söderhavet [Gauguin in the South Sea Islands], exh. cat., Etnografiska Museet and Nationalmuseum, Stockholm, 1970, pp. 47, 55; John Russell, Gauguin, Paris, 1970, pp. 36–37, no. 14, colorpl. 14; Alan Bowness, Gauguin, New York, 1971, pp. 11–12, colorpl. 32; G. M. Sugana, L'Opera completa di Gauguin, Milan, 1972, p. 102, no. 263, ill.; Dieuwke de Hoop Scheffer, "Ia Orana Maria (Ik groet U, Maria)," Bulletin van het Rijksmuseum 20, December 1972, pp. 171–76, ill.; Linnea Stonesifer Dietrich, A Study of Symbolism in the Tahitian Painting of Paul Gauguin: 1891–1893, unpublished Ph.D. dissertation, University of Delaware, Newark, 1973, pp. 13, 67, 95–99, 103, 203–4, 207; Richard S. Field, Paul Gauguin: Monotypes, exh. cat., Philadelphia, 1973, under no. 65; René Huyghe, La relève du réel: La peinture française au XIXe siècle, Impressionnisme, symbolisme, Paris, 1974, pp. 350–51, 443, ill.; Pierre Leprohon, Paul Gauguin, Paris, 1975, pp. 210, 330, 338, 346; Bengt Danielsson, Gauguin à Tahiti et aux îles Marquises, Papeete, 1975, p. 91; Richard S. Field, Paul Gauguin: The Paintings of the First Voyage to Tahiti, New York, 1977, pp. 54, 57–74, 78, 301, 306, 315, 360, no. 17; Vojtech Jirat-Wasiutynski, Paul Gauguin in the Context of Symbolism, New York, 1978, pp. 187 n. 2, pp. 276, 358 n. 2; Ziva Amishai-Maisels, "Gauguin's Early Tahitian Idols," Art Bulletin, June 1978, p. 331 n. 4; Mary Lynn Zink, "Gauguin's 'Poèmes barbares' and the Tahitian Chant of Creation," Art Journal 38, Fall 1978, p. 21 n. 17; Susan Wise, Paul Gauguin: His Life and His Paintings, Chicago, 1980, p. 13, colorpl. 15; Robert Goldwater, Paul Gauguin, New York, 1983, concise ed. [1st ed., 1957], p. 74, color ill. opp. p. 74; Jehanne Teilhet-Fisk, Paradise Reviewed: An Interpretation of Gauguin's Polynesian Symbolism, Ann Arbor, Mich., no. 31, 1983, pp. 1, 48, 171, 185 n. 34; Mary Lynn Zink Vance, Gauguin's Polynesian Pantheon as a Visual Language, unpublished Ph.D. dissertation, University of California, Santa Barbara, 1983, pp. 29, 134, 348, 386, no. 5, pl. 5; Robert Rosenblum and H. W. Janson, 19th-Century Art, New York, 1984, pp. 426, 453, colorpl. 77; William Rubin, ed., "Primitivism" in 20th Century Art: Affinity of the Tribal and the Modern, 2 vols., New York, 1984, vol. 1, pp. 178, 187, 189, 191, ill.; Ziva Amishai-Maisels, Gauguin's Religious Themes, New York, 1985, pp. 1, 56–57, 190, 288–98, 304–5, 307, 316, 325, 327 nn. 9, 11, 16, p. 328 nn. 19, 21–23, 26–27, p. 334 n. 78, p. 329 n. 37, pp. 358, 383, 485, fig. 126; Paul Gauguin, trans. Jonathan Griffin, Noa Noa: Gauguin's Tahiti, Oxford, 1985, pp. 86–87; Robert Goldwater, Primitivism in Modern Art, Cambridge, Mass., 1986, enlarged ed. [1st ed., 1938; revised ed., 1967], pp. 75–76, ill.; Gary Tinterow et al., The Metropolitan Museum of Art: Modern Europe, New York, 1987, pp. 5, 11, 76–78, colorpl. 54; Michel Hoog, trans. Constance Devanthéry-Lewis, Paul Gauguin: Life and Work, New York, 1987, [French ed., 1987], pp. 158–59, 163, 166, 198, 209, 306 n. 10, colorpl. 109; Maurice Malingue, La vie prodigieuse de Gauguin, Paris, 1987, pp. 112, 177, 183, 195; Yann le Pichon, trans. I. Mark Paris, Gauguin: Life, Art, Inspiration, New York, 1987, pp. 156–57, colorpl. 293; Marla Prather and Charles F. Stuckey, eds., Gauguin: A Retrospective, New York, 1987, pp. 180, 185, 218, 225, 229, colorpl. 57; Belinda Thomson, Gauguin, London, 1987, pp. 141, 145–47, 167, 171, 182, ill.; Frédérique de Gravelaine, Paul Gauguin: La vie, la technique, l'oeuvre peint, Lausanne, 1988, pp. 58, 104–5, color ill.; Colta Ives, "French Prints in the Era of Impressionism and Symbolism," Metropolitan Museum of Art Bulletin 46, summer 1988, p. 30, ill.; Elizabeth Mongan, Eberhard W. Kornfeld, and Harold Joachim, Paul Gauguin: Catalogue Raisonné of His Prints,

Bern, 1988, p. 131; Françoise Cachin, *Gauguin*, Paris, 1988, pp. 155, 160–61, 164, 169, ill.; Isabelle Cahn et al., *Gauguin*, Paris, 1988, pp. 60–61, no. 33, ill.; John Rewald with the research assistance of Frances Weitzenhoffer, *Cézanne and America: Dealers, Collectors, Artists, and Critics, 1891–1921*, Princeton, 1989, pp. 325, 330; Günter Metken, "Die erste Reise, Gemälde 1891–1893," *Gauguin in Tahiti*, Munich, 1989, unpaginated, colorpl. 8; Pierre Daix, *Paul Gauguin* [Paris], 1989, pp. 234–35, 239, 253, 257, 400 n. 21; Pascale Bertrand, "Exposition Gauguin," *Beaux-arts* 64, January 1989, pp. 42–43, ill.; Françoise Cachin, *Gauguin: "Ce malgré moi de sauvage,"* Paris, 1989, pp. 75–76, 94, ill.; Hans H. Hofstätter, "Christliche Thematik im Werk von Paul Gauguin," *Das Münster* 42, 1989, p. 304, ill.; U. Stake et al., *Gauguin*, exh. cat., Pushkin State Museum of Fine Arts, Moscow, 1989, pp. 149, 167–71, 195, ill.; Lesley Stevenson, *Gauguin*, London, 1990, pp. 126–27, 155, ill.; Gary Tinterow, "Miracle au Met," *Connaissance des arts* no. 472, June 1991, p. 39; Pierre-Francis Schneeberger, *Gauguin—Tahiti*, Paris, 1991, pp. 24, 36, 40, 91, colorpl. 4; Michel Hoog et al., *Gauguin: Actes du colloque Gauguin*, Paris, 1991, p. 152; Fereshteh Daftari, *The Influence of Persian Art on Gauguin, Matisse, and Kandinsky*, New York, 1991, pp. 101–4, no. 49, ill.; Ingo F. Walther, trans. Michael Hulse, *Paul Gauguin, 1848–1903: The Primitive Sophisticate*, Cologne, 1993, pp. 38–39, 42, ill.; Caroline Boyle-Turner et al., *Le cercle de Gauguin en Bretagne: L'Impressionisme s'installe devant le motif et fait ce qu'il voit . . .*, exh. cat., Musée de Pont-Aven, 1994, pp. 12, 14; Françoise Dumont, ed., *Gauguin: Les XX et la libre Esthétique*, exh. cat., Musée d'Art Moderne et d'Art Contemporaine, Liège, 1994, p. 40, ill.; Michael Kimmelman, "At the Met with Roy Lichtenstein: Disciple of Color and Line, Master of Irony," *New York Times*, March 31, 1995, p. C27; Asya Kantor-Gukovskaya et al., trans. Ashkhen Mikoyan, *Paul Gauguin, Mysterious Affinities*, Bournemouth, England, 1995, [Russian ed., 1995], p. 61; Claudia Beltramo and Ceppi Zevi, eds., *Paul Gauguin e l'avanguardia russa*, exh. cat., Palazzo dei Diamanti, Ferrara, 1995, pp. 108, 177 n. 4, ill.; David Sweetman, *Paul Gauguin: A Complete Life*, London, 1995, pp. 304–6, 309, 315, 318, 361–62, 392, 436; Eckhard Hollmann, *Paul Gauguin: Images from the South Seas*, New York, 1996, pp. 34–35, 52, 62, ill; Hermann Fillitz, ed., *Der Traum vom Glück: Die Kunst des Historismus in Europa*, 2 vols., Vienna, 1996, pp. 150, 157, colorpl. 1; Anna Maria Damigella, *Paul Gauguin, La vita e l'opera*, Milan, 1997, pp. 25, 168, 170–71, ill.; George W. Költzch et al., *Paul Gauguin: Das verlorene Paradies*, exh. cat., Museum Folkwang, Essen, Cologne, 1998, pp. 83, 85 n. 26, pp. 97, 243–44, ill.; Naomi Margolis Maurer, *The Pursuit of Spiritual Wisdom: The Thought and Art of Vincent van Gogh and Paul Gauguin*, Madison, N.J., 1998, pp. 145–46, 166, 293, ill.; Christoph Becker, ed., trans. John Southard, *Paul Gauguin, Tahiti*, exh. cat., Staatsgalerie Stuttgart, Ostfildern-Ruit, 1998, English ed. [German ed., 1998], pp. 41, 82 n. 45, p. 136; Belinda Thomson, "Exhibition review: Stuttgart. Paul Gauguin," *Burlington Magazine* 140, May 1998, p. 350

Tahitian Landscape
1892
Oil on canvas
25⅜ x 18⅝ in. (64.5 x 47.3 cm)
Inscribed (lower left): PGauguin–9[2]
Anonymous Gift, 1939
39.182
See no. 105

PROVENANCE
Private collection, France (from 1897, purchased from the artist); [Étienne Bignou, Paris and New York, until 1935; sold to Marshall Field, Chicago]; Marshall Field, Chicago (1935–39)

EXHIBITIONS
"Three Centuries of French Painting," Wichita Art Museum, May 9–23, 1954, no. 20; "Painting: School of France," Atlanta Art Association Galleries, September 20–October 4, 1955, Birmingham Museum of Art, October 16–November 5, 1955, no. 31; "Gauguin: Paintings, Drawings, Prints, Sculpture," Art Institute of Chicago, February 12–March 29, 1959, Metropolitan Museum of Art, New York, April 23–May 31, 1959, no. 32; "Changes in Perspective, 1880–1925," Grey Art Gallery and Study Center, New York University, New York, May 2–June 2, 1978, unnumbered cat. (p. 10); "The Lure of the Exotic: Gauguin in New York Collections," Metropolitan Museum of Art, New York, June 18–October 20, 2002, no. 119

SELECTED REFERENCES
Harry B. Wehle, "A Landscape by Paul Gauguin," *Metropolitan Museum of Art Bulletin* 35, March 1940, pp. 56–57, ill.; Virginia N. Whitehill, *Stepping-Stones in French Nineteenth-Century Painting*, New York, 1941, p. 40, fig. 16; Maurice Malingue, *Gauguin: Le peintre et son oeuvre*, Paris, 1948, unpaginated, no. 175, ill.; Lee van Dovski [Herbert Lewandowski], *Paul Gauguin oder die Flucht vor der Zivilisatio*, Delphi, 1950, p. 348, no. 259; Paul Gauguin, Bernard Dorival, eds., *Carnet de Tahiti*, 2 vols., Paris, 1954, vol. 1, pp. 12, 23–24; Charles Sterling and Margaretta M. Salinger, *French Paintings: A Catalogue of the Collection of The Metropolitan Museum of Art*, 3 vols., New York, 1955–67, vol. 3, pp. 174–75, ill.; Georges Wildenstein, *Gauguin*, Paris, 1964, French ed. [English ed., 1965], p. 175, no. 442, ill.; Paul Gauguin, Ronald Pickvance, *The Drawings of Paul Gauguin*, London, 1970, p. 34; Pierre Leprohon, *Paul Gauguin*, Paris, 1975, p. 330; Richard S. Field, *Paul Gauguin: The Paintings of the First Voyage to Tahiti*, New York, 1977, pp. 163–64, 325, 329–30, no. 47; Vivian Endicott Barnett, *The Guggenheim Museum: Justin K. Thannhauser Collection*, New York, 1978, p. 59; Sjraar van Heutgen et al., *Franse meesters uit het Metropolitan Museum of Art: Realisten en Impressionisten*, exh. cat., Rijksmuseum Vincent Van Gogh, Amsterdam, Zwolle, the Netherlands, 1987, p. 15; Asya Kantor-Gukovskaya et al., trans. Ashkhen Mikoyan, *Paul Gauguin, Mysterious Affinities*, Bournemouth, England, 1995 [Russian ed., 1995], p. 48

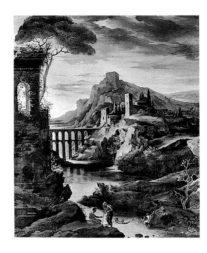

Théodore Gericault
French, 1791–1824

Evening: Landscape with an Aqueduct
1818
Oil on canvas
98½ x 86½ in. (250.2 x 219.7 cm)
Purchase, Gift of James A. Moffett 2nd, in memory of
George M. Moffett, by exchange, 1989
1989.183
See no. 6

PROVENANCE
René Petit-Le Roy, Paris (until 1903; sale, Hôtel
Drouot, Paris, May 30, 1903, no. 23, together with
no. 22 for Fr 1,205 to Lavillé); possibly comte de
Saint-Léon, château de Jeurre (until 1937); possibly
[Nat Leeb, Paris, 1937–49; sold to Ujlaky]; possibly
[Alexandre Ujlaky, Paris, from 1949]; [Paul Brame
and César de Hauke, Paris, 1952–54; sold to
Chrysler]; Walter P. Chrysler Jr., New York (1954–
d. 1988; on loan to The Chrysler Museum, Norfolk,
from 1971; his estate sale, Sotheby's, New York,
June 1, 1989, no. 110)

EXHIBITIONS
"Théodore Géricault 1791–1824," Kunstmuseum,
Winterthur, August 30–November 8, 1953, no. 70;
"Paintings from the Collection of Walter P. Chrysler,
Jr.," California Palace of the Legion of Honor, San
Francisco, City Art Museum of St. Louis, William
Rockhill Nelson Gallery of Art, Kansas City, Seattle
Art Museum, Los Angeles County Museum,
Minneapolis Institute of Arts, Detroit Institute of Arts,
Museum of Fine Arts, Boston, Portland Art Museum,
March 2, 1956–April 14, 1957 (inclusive dates),
no. 73; "Paintings from Private Collections: Summer
Loan Exhibition," Metropolitan Museum of Art, New
York, July 1–September 1, 1958, no. 64; "French
Paintings 1789–1929 from the Collection of Walter P.
Chrysler, Jr.," Dayton Art Institute, March 25–May 22,
1960, no. 15; "French Landscape Painters from Four
Centuries," Finch College Museum of Art, New York,
October 20, 1965–January 9, 1966, no. 14;
"Gericault," Los Angeles County Museum of Art,
October 12–December 12, 1971, Detroit Institute of
Arts, January 23–March 7, 1972, Philadelphia
Museum of Art, March 30–May 14, 1972, no. 31;
"French Paintings from the Chrysler Museum,"
Birmingham Museum of Art, November 6, 1986–
January 18, 1987, North Carolina Museum of Art,
Raleigh, May 31–September 14, 1986, no. 19;
"Gericault's Heroic Landscapes: The Times of Day,"
Metropolitan Museum of Art, New York, November 6,
1990–January 13, 1991, no. 11; "Géricault," Galeries
Nationales du Grand Palais, Paris, October 10,
1991–January 6, 1992, no. 161

SELECTED REFERENCES
Charles Clément, "Gericault (4e article)," *Gazette des
beaux-arts* 22, March 1867, p. 235; Charles Clément,
"Catalogue de l'œuvre de Gericault—Peinture,"
Gazette des beaux-arts 23, September 1867, p. 275,
under no. 13; Charles Clément, *Gericault, Étude
biographique et critique avec le catalogue raisonné de
l'œuvre du maitre*, Paris, 1879, 2nd ed. [repr. New
York, 1974, with notes by Lorenz Eitner; 1st ed.,
1868]; Lorenz Eitner, "Two Rediscovered Landscapes
by Gericault and the Chronology of His Early Work,"
Art Bulletin 36, June 1954, pp. 131–42, fig. 2; Lorenz
Eitner, "Gericault at Winterthur," *Burlington Magazine*
96, August 1954, p. 258; Max Huggler, "Two
Unknown Landscapes by Gericault," *Burlington
Magazine* 96, August 1954, pp. 234, 237, figs. 2–3
(overall and detail); Denise Aimé-Azam, *Mazeppa:
Gericault et son temps*, Paris, 1956, p. 126; Lorenz
Eitner, "The Sale of Gericault's Studio in 1824,"
Gazette des beaux-arts 53, February 1959,
pp. 119–21; Robert Lebel, "Gericault, Ses ambitions
monumentales et l'inspiration italienne," *L'Arte* 25,
October–December 1960 [reprinted as book, 1960],
pp. 328–335, 340 nn. 8–9, p. 341 nn. 16, 22, 24,
fig. 2; Lorenz Eitner, *Gericault: An Album of Drawings
in the Art Institute of Chicago*, Chicago, 1960, p. 35,
under folio 43; Antonio del Guercio, *Gericault*, Milan,
1963, pp. 33–34, 142, no. 27, ill.; Lorenz Eitner,
"Gericault's 'Dying Paris' and the Meaning of His
Romantic Classicism," *Master Drawings* 1, spring
1963, pp. 22–23, 32–33 nn. 5, 12, 13; Denise Aimé-
Azam, *Gericault: L'Énigme du peintre de la "Méduse,"*
Paris, 1970, pp. 152, 375; Joanna Szczepinska-Tramer,
"Recherches sur les paysages de Gericault," *Bulletin de
la Société de l'Histoire de l'Art Français*, année 1973,
1974, pp. 299–300, 303, 306–7, 310–11, 313; Serge
Lemoine, *Donation Granville: Catalogue des peintures,
dessins, estampes et sculptures œuvres réalisées avant
1900*, 3 vols., Dijon, 1976, vol. 1, p. 139; Philippe
Grunchec, *L'Opera completa di Gericault*, Milan,
1978, pp. 106–7, no. 129, colorpl. XXVI and fig. 129;
Philippe Grunchec, *Gericault*, exh. cat., Villa Medici,
Rome, 1979, pp. 218–21, fig. A; Hélène Toussaint,
*French Painting: The Revolutionary Decades,
1760–1830*, exh. cat., Art Gallery of New South
Wales, Sydney, 1980, pp. 106–7, ill.; Donald A.
Rosenthal, "Gericault's Expenses for 'The Raft of the
Medusa,'" *Art Bulletin* 62, December 1980, p. 638
n. 6; Lorenz Eitner, "The Literature of Art," *Burlington
Magazine* 122, March 1980, p. 210; Lorenz E. A.
Eitner, *Gericault, His Life and Work*, London, 1983,
pp. 142–45, 340 nn. 24–27, colorpl. 120; Germain
Bazin, "Le retour à Paris: Synthèse d'expériences plas-
tiques," *Théodore Gericault, Étude critique, documents
et catalogue raisonné*, 7 vols., Paris, 1987–97, vol. 5,
pp. 8–10, 13, 123, no. 1426, ill. (color, opp. p. 14,
and black and white), Scott Schaefer, *Sotheby's Art at
Auction 1988–89*, 1989, pp. 26, 28–29, fig. 1 (color);
Peter Galassi, Margaret Smith et al., *Claude to Corot:
The Development of Landscape Painting in France*,
exh. cat., Colnaghi, New York, 1990, pp. 240–41,
fig. 8; Gary Tinterow et al., "Recent Acquisitions, A
Selection: 1989–1990," *Metropolitan Museum of Art
Bulletin* 48, fall 1990, pp. 5, 40–41, color ill.; Gary
Tinterow, *Gericault's Heroic Landscapes: The Times of
Day*, exh. cat., Metropolitan Museum of Art, New York,
1990 [*Metropolitan Museum of Art Bulletin*, vol. 48,
winter 1990/91], pp. 3, 7, 10, 14–26, 28–33, 35–38,
41, 44, 47, 49, 51–56, 58–61, 70, no. 11, ill. on cover
and inside front cover, fig. 6 and p. 52 (the whole
and details, all in color); Everett Fahy, "Selected
Acquisitions of European Paintings at the Metropolitan
Museum of Art, 1987–1991," *Burlington Magazine*
133, November 1991, p. 806, fig. IX (color); Bernard
Noël, *Gericault*, Paris, 1991, pp. 40, 43–44, ill. (color)

Jean-Léon Gérôme
French, 1824–1904

Prayer in the Mosque
1871
Oil on canvas
35 x 29½ in. (88.9 x 74.9 cm)
Signed (upper right, on beam): J.L. GEROME
Catharine Lorillard Wolfe Collection, Bequest of
Catharine Lorillard Wolfe, 1887
87.15.130
See no. 38

PROVENANCE
[Goupil, Paris, 1871; possibly bought from the artist
in September for Fr 6,000; sold for Fr 12,000 or
22,000 to Knoedler]; [Knoedler, New York, 1871–74,
possibly stock no. 5695, sold for $10,670; (Fr 49,500)
to Wolfe]; Catharine Lorillard Wolfe, New York
(1874–d. 1887)

EXHIBITIONS
"The Taste of the Seventies," Metropolitan Museum of
Art, New York, 1946, no. 109; "The Orientalists:
Delacroix to Matisse, European Painters in North
Africa and the Near East," Royal Academy of Arts,
London, March 24–May 27, 1984, no. 32, National
Gallery of Art, Washington, D.C., July 1–October 28,
1984, no. 34; "The Lure of Egypt: Land of the
Pharoahs Revisited," Museum of Fine Arts, St.
Petersburg, Fla., January 10–June 9, 1996, no. 19;
"Gérôme and Goupil: Art et Entreprise," Musée
Goupil, Bordeaux, October 12, 2000–January 14,
2001, Dahesh Museum of Art, New York, February
6–May 5, 2001, Frick Art and Historical Center,
Pittsburgh, June 7–August 12, 2001, no. 72

SELECTED REFERENCES
Edward Strahan, ed., *Gérôme: A Collection of the
Works of Gérôme in One Hundred Photogravures*,
2 vols., New York, 1881, vol. 2, unpaginated, ill.;
C. H. Stranahan, *A History of French Painting from
Its Earliest to Its Latest Practice*, New York, 1888,
p. 319; Fanny Field Hering, *Gérôme*, New York,
1892, p. 126; Arthur Hoeber, *The Treasures of The
Metropolitan Museum of Art of New York*, New York,
1899, pp. 80–81; Gustave Haller, *Nos grands pein-
tres: Catalogue de leurs œuvres et opinions de la
presse*, Paris, 1899, p. 101; Charles Sterling and
Margaretta M. Salinger, *French Paintings: A
Catalogue of the Collection of The Metropolitan
Museum of Art*, 3 vols., New York, 1955–67, vol. 2,
p. 171, ill.; Richard Ettinghausen, *Jean-Léon Gérôme,
1824–1904*, exh. cat., Dayton Art Institute, Dayton,
Ohio, 1972, pp. 22–23, fig. 12; Donald A. Rosenthal,
Orientalism: The Near East in French Painting,

1800–1880, exh. cat., Memorial Art Gallery of the University of Rochester, Rochester, N.Y., 1982, p. 78; Gerald M. Ackerman, *The Life and Work of Jean-Léon Gérôme, with a Catalogue Raisonné*, London, 1986, pp. 93, 228, no. 200, ill.; Christine Peltre, *L'Atelier du voyage: Les peintres en Orient au XIXe siècle*, Paris, 1995, p. 61; Gerald M. Ackerman, catalogue raisonné, *Jean-Léon Gérôme: Monographie révisée, mis à jour*, Paris, 2000, pp. 105, 274, ill.

Pygmalion and Galatea
ca. 1890
Oil on canvas
35 x 27 in. (88.9 x 68.6 cm)
Signed (on base of statue): J.L. GEROME.
Gift of Louis C. Raegner, 1927
27.200
See no. 40

PROVENANCE
[Boussod-Valadon, Paris, 1892; purchased from the artist in March, sold to Yerkes]; Charles Tyson Yerkes, Chicago (1892–d. 1905; his estate 1905–10; his estate sale, Mendelssohn Hall, New York, April 5–8, 1910, no. 21, sold for $4,000 to Dugro); Judge P. H. Dugro, New York (from 1910); Louis C. Raegner, New York (until 1927)

EXHIBITIONS
"The Taste of the Seventies," Metropolitan Museum of Art, New York, 1946, no. 110; "The Classical Contribution to Western Civilization," Art Gallery of Toronto, December 15, 1948–January 31, 1949, Metropolitan Museum of Art, New York, April 1949, not in catalogue; "Perennial Pygmalion," Museum of the City of New York, January 20–May 1958; "In the Studio: The Making of Art in Nineteenth-Century France," Sterling and Francine Clark Art Institute, Williamstown, Mass., September 12–October 25, 1981, no. 26; "Adam and Eve," Museum of Modern Art, Saitama, Japan, October 10–December 6, 1992, no. 3; "Paris in the Late 19th Century," National Gallery of Australia, Canberra, November 30, 1996–February 23, 1997, unnumbered cat.; "Rings: Five Passions in World Art," High Museum of Art, Atlanta, June 24–September 29, 1996, unnumbered cat.; "Paris in the Late 19th Century," Queensland Art Gallery, Brisbane, March 15–May 22, 1997, unnumbered cat.; "Pygmalions Werkstatt," Städtische Galerie im Lenbachhaus, Munich, September 8– November 25, 2001, Wallraf-Richartz-Museum, Cologne, May 24–August 25, 2002, no. 79

SELECTED REFERENCES
Fanny Field Hering, *The Life and Works of Jean Léon Gérôme*, New York, 1892, pp. 283, 285–86; F. G. Stephens, "Mr. Yerkes' Collection at Chicago.—III. The Modern Masters," *Magazine of Art* 18, 1895, p. 168; Charles Sterling and Margaretta M. Salinger, *French Paintings: A Catalogue of the Collection of The Metropolitan Museum of Art*, 3 vols., New York, 1955–67, vol. 2, pp. 172–73, ill.; Richard Ettinghausen, *Jean-Léon Gérôme, 1824–1904*, exh. cat., Dayton Art Institute, Dayton, Ohio, 1972, p. 95; Gerald M. Ackerman, *The Life and Work of Jean-Léon Gérôme, with a Catalogue Raisonné*,

London, 1986, pp. 134–36, 145, 268–69, 318, no. 385, ill.; Gary Tinterow et al., *The Metropolitan Museum of Art: Modern Europe*, New York, 1987, p. 78, ill.; Sunanda K. Sanyal, "Allegorizing Representation: Gérôme's Final Phase," *Athanor* 15, 1997, pp. 38–40, fig. 3; Gerald M. Ackerman, *Jean-Léon Gérôme: Monographie révisée, catalogue raisonné mis à jour*, Paris, 2000, pp. 159, 330, no. 385, ill.; Hélène Lafont-Couturier et al., *Gérôme and Goupil: Art and Enterprise*, exh. cat., Dahesh Museum of Art, New York, 2000, p. 21

Tiger and Cubs
ca. 1884
Oil on canvas
29 x 36 in. (73.7 x 91.4 cm)
Signed (lower left): J.L. GEROME
Bequest of Susan P. Colgate, in memory of her husband, Romulus R. Colgate, 1936
36.162.4
See no. 39

PROVENANCE
Susan P. Colgate, Sharon, Conn. (by 1934–d. 1936)

EXHIBITION
"The Artist's Menagerie: Five Millennia of Animals in Art," Queens Museum, New York, June 29–August 25, 1974, no. 73

SELECTED REFERENCES
Charles Sterling and Margaretta M. Salinger, *French Paintings: A Catalogue of the Collection of The Metropolitan Museum of Art*, 3 vols., New York, 1955–67, vol. 2, p. 172, ill.; Gerald M. Ackerman, *The Life and Work of Jean-Léon Gérôme, with a Catalogue Raisonné*, London, 1986, pp. 120, 256–57, no. 331, ill.; Gerald M. Ackerman, *Jean-Léon Gérôme: Monographie révisée, catalogue raisonné mis à jour*, Paris, 2000, pp. 124, 312–13, no. 331, ill.

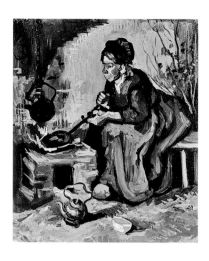

Vincent van Gogh
Dutch, 1853–1890

Peasant Woman Cooking by a Fireplace
1885
Oil on canvas
17⅜ x 15 in. (44.1 x 38.1 cm)
Gift of Mr. and Mrs. Mortimer Hays, 1984
1984.393
See no. 107

PROVENANCE
Amédée Schuffenecker, Paris and Clamart (1901–5); Auguste Pellerin, Paris; [Eugène Blot, Paris, by 1933–37]; his sale, Hôtel Drouot, Paris, June 2, 1933, no. 49, bought in; his sale, Hôtel Drouot, Paris, April 23, 1937, no. 69; Levy-Hermanos, Paris (by 1939–at least 1947); Mr. and Mrs. Mortimer Hays, Norwalk, Conn. (by 1955–84)

EXHIBITIONS
"Exposition Vincent van Gogh," Galerie Bernheim-Jeune, Paris, March 15–31, 1901, no. 44; "Exposition rétrospective Vincent van Gogh," Société des Artistes Indépendants, Grands Serres de la Ville de Paris, March 24–April 30, 1905, no. 41; "Jubiläums-Ausstellung Mannheim: Internationale Kunst-und Grosse Gautenbau-Ausstellung," Städtische Kunsthalle, Mannheim, May 1–October 20, 1907, no. 1076; "Gauguin, ses amis: L'École de Pont-Aven et l'Académie Julian," Galerie Beaux-Arts, Paris, February–March 1934, no. 143; "The Art and Life of Vincent van Gogh," Wildenstein and Co., Inc., New York, October 6–November 7, 1943, no. 5; "Van Gogh," Wildenstein and Co., Inc., New York, March 24–April 30, 1955, no. 8; "Vincent van Gogh," Los Angeles Municipal Art Gallery, July 3–August 4, 1957, no. 3

SELECTED REFERENCES
Van Gogh—Mappe, Munich, 1912, pl. 7; Louis Piérard, trans. Herbert Garland, *The Tragic Life of Vincent van Gogh,* London, 1925, ill. opp. p. 31; Paul Colin, trans. Beatrice Moggridge, *Van Gogh,* London, 1926, pl. 4; J.-B. de La Faille, *L'Oeuvre de Vincent van Gogh: Catalogue raisonné,* 4 vols., Paris, 1928, vol. 1, p. 55, no. 176, vol. 2, pl. 43; Walther Vanbeselaere, *De Hollandsche Periode (1880–1885) in het Werk van Vincent van Gogh (1853–1890),* Antwerp, 1937, pp. 300, 416, no. 176; J.-B. de La Faille, trans. Prudence Montagu-Pollock, *Vincent van Gogh,* London [1939], pp. 146, 568, 575, 586, no. 174, ill.; Georg Schmidt, *Van Gogh,* Bern, 1947, pl. 3; Paul Gachet, *Vincent van Gogh aux "Indépendants,"* Paris, 1953, unpaginated; J.-B. de La Faille, *The Works of Vincent van Gogh: His*

Paintings and Drawings, Amsterdam, 1970, pp. 95, 99, 435–36, 453–54, 618, no. 176, ill.; Paolo Lecaldano, *L'Opera pittorica completa di Van Gogh e i suoi nessi grafici,* 2 vols., Milan, 1977, repr. [1st ed., 1966], vol. 1, pp. 104–5, no. 174, ill.; Jan Hulsker, *The Complete Van Gogh: Paintings, Drawings, Sketches,* New York, 1980 [1st ed., Amsterdam, 1977], pp. 178–79, no. 799, ill.; Gary Tinterow et al., *The Metropolitan Museum of Art: Notable Acquisitions, 1984–1985,* New York, 1985, p. 27, ill.; Roland Scotti, "Die 'Internationale Kunst-Ausstellung' 1907 in Mannheim," *Kunst + Dokumentation 9,* Mannheim Städtische Kunsthalle, 1985, pp. 37, 42; Walter Feilchenfeldt, *Vincent van Gogh and Paul Cassirer, Berlin: The Reception of Van Gogh in Germany from 1901 to 1914,* Zwolle, the Netherlands, 1988, pp. 84, 145; Jan Hulsker, *The New Complete Van Gogh: Paintings, Drawings, Sketches,* Amsterdam, 1996, rev. ed., pp. 178, 182, no. 799, ill. p. 179; Sjraar van Heugten, *Vincent van Gogh Drawings, Volume 2: Nuenen 1883–1885,* Van Gogh Museum, Amsterdam, 1997, p. 268 n. 3

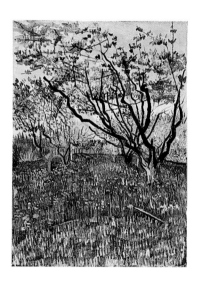

The Flowering Orchard
1888
Oil on canvas
28½ x 21 in. (72.4 x 53.3 cm)
Signed (lower left): Vincent
The Mr. and Mrs. Henry Ittleson Jr. Purchase Fund, 1956
56.13
See no. 108

PROVENANCE
Presumably the artist's brother, Theo van Gogh, Paris (1888/89–d. 1891; sent to him by the artist in 1888/89), and in turn, his widow, Johanna van Gogh-Bonger, Amsterdam (from 1891); [Kunstzalen Oldenzeel, Rotterdam, 1904]; H. P. Bremmer, The Hague (1904–55; on loan to the Gemeentemuseum, The Hague, from 1924); [E. J. van Wisselingh and Co., Amsterdam, 1955]; [Wildenstein, New York, 1955–56; sold to the Metropolitan Museum]

EXHIBITIONS
"Vincent van Gogh," Kunstzalen Oldenzeel, Rotterdam, November 10–December 15, 1904, no. 65; "Internationale Kunstausstellung des Sonderbundes Westdeutscher Kunstfreunde und Künstler," Städtische Ausstellungshalle, Cologne, May 25–September 30, 1912, no. 20; "Verzameling

H. P. Bremmer," Gemeentemuseum, The Hague, March 9–April 23, 1950, no. 35; "Van Gogh: Dip inti e disegni," Palazzo Reale, Milan, February–April, 1952, no. 94; "Maîtres français: XIXme et XXme siècles," E. J. van Wisselingh and Co., Amsterdam, October 10–November 12, 1955, no. 14; "Impressionism: A Centenary Exhibition," The Metropolitan Museum of Art, New York, December 12, 1974–February 10, 1975, not in catalogue; "Van Gogh in Arles," The Metropolitan Museum of Art, New York, October 18–December 30, 1984, no. 9; "Treasures from The Metropolitan Museum of Art: French Art from the Middle Ages to the Twentieth Century," Yokohama Museum of Art, March 25–June 4, 1989, no. 98; "Corot to Cézanne: 19th Century French Paintings from The Metropolitan Museum of Art," Museum of Art, Fort Lauderdale, December 22, 1992–April 11, 1993, no catalogue

SELECTED REFERENCES
J.-B. de La Faille, *L'Oeuvre de Vincent van Gogh: Catalogue raisonné,* 4 vols., Paris, 1928, vol. 1, p. 157, no. 552, vol. 2, pl. 151; W. Scherjon and Jos. De Gruyter, *Vincent van Gogh's Great Period: Arles, St. Rémy, and Auvers sur Oise (Complete Catalogue),* Amsterdam, 1937, p. 54, Arles no. 22, ill.; J.-B. de La Faille, trans. Prudence Montagu-Pollock, *Vincent van Gogh,* London [1939], pp. 401, 565, 578, 588, 591, no. 577, ill.; W. Uhde and Ludwig Goldscheider, *Vincent van Gogh,* New York, 1941, pl. 19; Charles Sterling and Margaretta M. Salinger, *French Paintings: A Catalogue of the Collection of The Metropolitan Museum of Art,* 3 vols., New York, 1955–67, vol. 3, pp. 182–83, ill.; Theodore Rousseau Jr., "New Accessions of Paintings," *Metropolitan Museum of Art Bulletin* 14, April 1956, n.s., p. 198, ill. p. 203; August Kuhn-Foelix, *Vincent van Gogh: Eine Psychographie,* Bergen, Germany, 1958, p. 140, pl. 34; Frank Elgar, *Van Gogh,* New York, 1958, p. 110, no. 105, ill.; J.-B. de La Faille, *The Works of Vincent van Gogh: His Paintings and Drawings,* Amsterdam, 1970, pp. 232, 525, 633, no. 552, ill.; Paolo Lecaldano, *L'Opera pittorica completa di Van Gogh e i suoi nessi grafici,* 2 vols., Milan, 1977 [1st ed., 1966], vol. 2, p. 205, no. 488, ill.; Jan Hulsker, *The Complete Van Gogh: Paintings, Drawings, Sketches,* New York, 1980 [1st ed., Amsterdam, 1977], pp. 310, 313, no. 1381, ill.; Walter Feilchenfeldt, *Vincent van Gogh and Paul Cassirer, Berlin: The Reception of Van Gogh in Germany from 1901 to 1914,* Zwolle, the Netherlands, 1988, pp. 103, 149; Matthias Arnold, *Vincent van Gogh: Werk und Wirkung,* Munich, 1995, pp. 408–9; Jan Hulsker, *The New Complete Van Gogh: Paintings, Drawings, Sketches,* Amsterdam, 1996, rev. ed. p. 313, no. 1381, ill.; Walter Feilchenfeldt, *By Appointment Only: Cézanne, Van Gogh, and Some Secrets of Art Dealing—Essays and Lectures,* New York and London, 2006 [German ed., 2005], pp. 298–99, color ill.

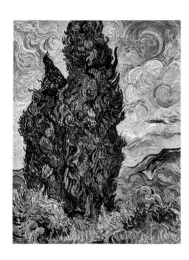

Cypresses
1889
Oil on canvas
36¾ x 29⅛ in. (93.4 x 74 cm)
Rogers Fund, 1949
49.30
See no. 109

PROVENANCE

The artist's brother, Theo van Gogh, Paris (1889–d. 1891; sent to him by the artist on September 28, 1889); his widow, Johanna van Gogh-Bonger, Amsterdam (1891–95; sold with six other paintings for fl. 384 to Moline); [Lucien Moline, Paris, from 1895]; Julien Leclercq, Paris (purchased in 1901, d. 1901); Maurice Fabre, Paris and Gasparets (until 1908); [E. Druet, Paris, 1908]; sale, Hôtel Drouot, Paris, May 16, 1908, no. 25; Fritz Meyer-Fierz, Zürich (bought in Paris, May 1908–1923/24; [Justin K. Thannhauser, Berlin, 1923/24–at least 1929; sold to Schocken]; Salman Schocken, Berlin, later New York (until 1949; sold to Thannhauser); [Justin K. Thannhauser, New York, 1949; sold to the Metropolitan Museum]

EXHIBITIONS

"Salon des Indépendants (6e exposition)," Société des Artistes Indépendants, Pavillon de la Ville de Paris, March 20–April 27, 1890, no. 832 (probably this picture); "Salon des Indépendants (7e exposition)," Société des Artistes Indépendants, Pavillon de la Ville de Paris, March 20–April 27, 1891, no. 1195 (possibly this picture); "Exposition Vincent van Gogh," Galerie Bernheim-Jeune, Paris, March 15–31, 1901, no. 35; "Van Gogh," Galerien Thannhauser, Munich, 1907, no. 43; "Vincent van Gogh," Galerie E. Druet, Paris, January 6–18, 1908, no. 4; "Internationale Kunstausstellung des Sonderbundes Westdeutscher Kunstfreunde und Künstler," Städtische Ausstellungshalle, Cologne, May 25–September 30, 1912, no. 108; "Vincent van Gogh," Kunsthalle Basel, March 27–April 21, 1924, no. 60; "Erste Sonderausstellung in Berlin," Galerien Thannhauser, Berlin, January 9–mid-February 1927, no. 119; "Vincent van Gogh: L'Époque française," Bernheim-Jeune, Paris, June 20–July 2, 1927, no catalogue; "First Loan Exhibition: Cézanne, Gauguin, Seurat, van Gogh," Museum of Modern Art, New York, November 8–December 7, 1929, no. 85; "Work by Vincent van Gogh," Cleveland Museum of Art, November 3–December 12, 1948, no. 18; "Van Gogh: Paintings and Drawings," Metropolitan Museum of Art, New York, October 21, 1949–January 15, 1950, Art Institute of Chicago, February 1–April 15, 1950, no. 112; "Metropolitan Museum Masterpieces," Hofstra College, Hempstead, N.Y.,

June 29–September 1, 1952, no. 15; "French Painting—David to Cézanne," Norton Gallery and School of Art, West Palm Beach, Fla., February 4–March 1, 1953, Lowe Gallery, Coral Gables, Fla., March 11–31, 1953, no. 26; "Directors' Choice," John and Mable Ringling Museum of Art, Sarasota, Fla., February 6–March 4, 1955, no. 26; "Paintings from the Metropolitan / Pinturas del Metropolitano," Bronx County Courthouse, New York, May 12–June 13, 1971, no. 18; "Van Gogh as Critic and Self-Critic," Metropolitan Museum of Art, New York, October 30, 1973–January 6, 1974, no. 7; "Impressionism: A Centenary Exhibition," Metropolitan Museum of Art, New York, December 12, 1974–February 10, 1975, not in catalogue; "Van Gogh in Saint-Rémy and Auvers," Metropolitan Museum of Art, New York, November 25, 1986–March 22, 1987, no. 15; "Vincent van Gogh: Paintings," Rijksmuseum Vincent van Gogh, Amsterdam, March 30–July 29, 1990, no. 90; "Van Gogh and Gauguin: The Studio of the South," Art Institute of Chicago, September 22, 2001–January 13, 2002, Van Gogh Museum, Amsterdam, February 9–June 2, 2002, no. 117; "Vincent van Gogh: The Drawings," Metropolitan Museum of Art, New York, October 12–December 31, 2005, no. 109

SELECTED REFERENCES

R. Meyer-Riefstahl, "Vincent van Gogh—I," *Burlington Magazine* 18, November 1910, ill. p. 96; Max Deri, *Die Malerei im XIX. Jahrhundert*, 2 vols., Berlin, 1920, vol. 1, p. 227, vol. 2, pl. 57; Curt Glaser, *Vincent van Gogh*, Leipzig, 1921, pl. 16; Roch Grey, *Vincent van Gogh*, Rome, 1924, ill.; Max Osborn, "Klassiker der französischen Moderne die Galerien Thannhauser im Berliner Künstlerhaus," *Deutsche Kunst und Dekoration* 59, March 1927, ill. p. 336; Julius Meier-Graefe, "Die Franzosen in Berlin," *Der Cicerone* 19, January 1927, ill. p. 54; J.-B. de La Faille, "Vincent van Gogh," *L'Art vivant* 3, August 1, 1927, ill. p. 626; Florent Fels, *Vincent van Gogh*, Paris, 1928, color ill. frontispiece; J.-B. de La Faille, *L'Oeuvre de Vincent van Gogh: Catalogue raisonné*, 4 vols., Paris, 1928, vol. 1, pp. 172–73, no. 613, vol. 2, pl. 171; J.B. de la Faille, *Les faux Van Gogh*, Paris, 1930, pp. 7–8, 44, pl. 6; W. Scherjon, *Catalogue des tableaux par Vincent van Gogh décrits dans ses lettres. Périodes: St. Rémy, et Auvers sur Oise*, Utrecht, 1932, p. 22, no. 10, ill.; Alfred Bader, *Künstler-Tragik: Karl Stauffer, Vincent van Gogh*, Basel, 1932, pp. 89–90, pl. 47; W. Scherjon and Jos. De Gruyter, *Vincent van Gogh's Great Period: Arles, St. Rémy, and Auvers sur Oise (Complete Catalogue)*, Amsterdam 1937, p. 212, St. Rémy no. 10, ill.; Jean de Beucken, *Vincent van Gogh: Un portrait* [Brussels, 1938], p. 94, color ill. p. 103; J.-B. de La Faille, trans. Prudence Montagu-Pollock, *Vincent van Gogh*, London [1939], pp. 425, 559, 574, 588, no. 616, ill.; Georg Schmidt, *Van Gogh*, Bern, 1947, pp. 26– 27, pl. 38; M. M. van Dantzig, *Vincent?: A New Method of Identifying the Artist and His Work and of Unmasking the Forger and His Products*, Amsterdam [1947], pp. 89–90, 95–96, pl. 6; "Notes on the Cover," *Metropolitan Museum of Art Bulletin* 8, October 1949, n.s., opp. p. 49, color ill. (cover); Murray Pease, "The Hand and the Brush," *Art News Annual* 19, 1950, pp. 90–96, ill.; Jean Leymarie, *Van Gogh* [Paris], 1951, pp. 91, 125, no. 116, ill.; Charles Sterling and Margaretta M. Salinger, *French Paintings: A Catalogue of the Collection of The Metropolitan Museum of Art*, 3 vols., New York, 1955–67, vol. 3, pp. 188–89, ill.; John Rewald, *Post-Impressionism: From Van Gogh to Gauguin*, New York, 1956, p. 334, color ill. p. 335 [3rd, rev. ed., 1978, p. 311, color ill. p. 314]; Vincent van Gogh, *The Complete Letters of Vincent van Gogh*, 3 vols., Greenwich, Conn., 1958, vol. 3, pp. 184–86, letter

no. 596, p. 219, letter no. 608; August Kuhn-Foelix, *Vincent van Gogh: Eine Psychographie*, Bergen, Germany, 1958, p. 146, pl. 37; Margaretta M. Salinger, "Windows Open to Nature," *Metropolitan Museum of Art Bulletin* 27, summer 1968, n.s., unpaginated, ill.; J.-B. de La Faille, *The Works of Vincent van Gogh: His Paintings and Drawings*, Amsterdam, 1970, pp. 246–47, 528, 635, no. 613, ill.; Jean Leymarie, trans. James Emmons, *Van Gogh*, New York, 1977 [1st ed., 1968], pp. 152, 164, 209, color ill. p. 153; Paolo Lecaldano, *L'Opera pittorica completa di Van Gogh e i suoi nessi grafici*, 2 vols., Milan, vol. 2, 1977, repr. [1st ed., 1966], p. 220, no. 668, ill. p. 218; Jan Hulsker, *The Complete Van Gogh: Paintings, Drawings, Sketches*, New York, 1980 [Dutch ed., 1977], pp. 398, 404, no. 1746, ill.; Patricia Mathews, "Aurier and Van Gogh: Criticism and Response," *Art Bulletin* 68, March 1986, p. 95, fig. 3; Gary Tinterow et al., *The Metropolitan Museum of Art: Modern Europe*, New York, 1987, pp. 64–65, colorpl. 43; John Leighton et al., "Vincent van Gogh's 'A Cornfield, with Cypresses,'" *National Gallery Technical Bulletin* 11, 1987, pp. 44–45 n. 8; Walter Feilchenfeldt, *Vincent van Gogh and Paul Cassirer, Berlin: The Reception of Van Gogh in Germany from 1901 to 1914*, Zwolle, the Netherlands, 1988, pp. 107, 149, 158, ill.; Marja Supinen, "Julien Leclercq–Vincent van Gogh in varhainen puolustaja," *Taidehistoriallisia Tutkimuksia Konsthistoriska Studier* 11, 1988, pp. 82, 87–89, 92, 109, fig. 8; Fritz Erpel, *Vincent van Gogh: Lebensbilder, Lebenszeichen*, Munich, 1989, colorpl. 440; Margit Ingold-Hahnloser and Charles S. Moffett et al., *The Passionate Eye: Impressionist and Other Master Paintings from the Collection of Emil G. Bührle, Zürich*, exh cat., National Gallery of Art, Washington, D.C., Zürich, 1990, p. 176; Roland Dorn et al, *Vincent van Gogh and the Modern Movement: 1890–1914*, exh. cat., Museum Folkwang, Essen, 1990, pp. 44, 170, 172; Ronald Pickvance et al., *Vincent van Gogh: Drawings*, exh. cat., Rijksmuseum Kröller-Müller, Otterlo, Milan, 1990, p. 286; Jan Hulsker, *Vincent van Gogh: A Guide to His Work and Letters*, Amsterdam, 1993, pp. 41, 54–55, 61, 76; Gary Tinterow et al., "Recent Acquisitions, A Selection: 1992–1993," *Metropolitan Museum of Art Bulletin* 51, fall 1993, p. 51; Vojtech Jirat-Wasiutyński, "Vincent van Gogh's Paintings of Olive Trees and Cypresses from St.-Rémy," *Art Bulletin* 75, December 1993, pp. 656–58, 667, fig. 11; Louis van Tilborgh et al., *In Perfect Harmony: Picture + Frame, 1850–1920*, exh. cat., Van Gogh Museum, Amsterdam, 1995, p. 172; Matthias Arnold, *Vincent van Gogh: Werk und Wirkung*, Munich, 1995, pp. 485, 494, colorpl. 277; Jan Hulsker, *The New Complete Van Gogh: Paintings, Drawings, Sketches*, Amsterdam, 1996, rev. ed., pp. 398, 496, no. 1746, ill. p. 404; Naomi Margolis Maurer, *The Pursuit of Spiritual Wisdom: The Thought and Art of Vincent van Gogh and Paul Gauguin*, Madison, N.J., 1998, p. 92, fig. 154; Bogomila Welsh-Ovcharov, *Van Gogh in Provence and Auvers* [New York], 1999, pp. 235, 238, color ill. p. 240; *The Berggruen Collection*, sale catalogue, Phillips, New York, May 7, 2001, p. 54, fig. 7; Chris Stolwijk and Han Veenenbos, *The Account Book of Theo van Gogh and Jo van Gogh-Bonger*, Amsterdam, 2002, pp. 47, 105, 142, 181, 183, ill.; Sjraar van Heugten, *Van Gogh Draughtsman: The Masterpieces*, Van Gogh Museum, Amsterdam, 2005, pp. 163, 167, 191, fig. 147; Walter Feilchenfeldt, *By Appointment Only, Cézanne, Van Gogh, and Some Secrets of Art Dealing*, London and New York, 2006 [German ed., 2005], p. 72

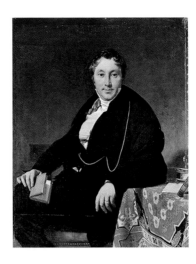

Jean-Auguste-Dominique Ingres
French, 1780–1867

Jacques-Louis Leblanc (1774–1846)
1823
Oil on canvas
47⅝ x 37⅝ in. (121 x 95.6 cm)
Signed (at the right, on the paper): Ingres Pinx.
Catharine Lorillard Wolfe Collection, Wolfe Fund,
1918
19.77.1
See no. 3

PROVENANCE
M. and Mme Jacques-Louis Leblanc, Florence, later
Paris (1823–39); Jacques-Louis Leblanc, Paris, later
Tours (1839–d. 1846); his daughter, Mme Jean-Henri
Place, *née* Isaure Juliette-Joséphine Leblanc, Paris
(1846–d. 1895; posthumous sale, Hôtel Drouot,
Paris, January 23, 1896, no. 48, for Fr 3,500 to
Durand-Ruel for Degas); Edgar Degas, Paris (1896–
d. 1917; posthumous sale, Galerie Georges Petit,
March 26–27, 1918, no. 54, sold to the Metropolitan
Museum)

EXHIBITIONS
"Great Portraits by Famous Painters," Minneapolis
Institute of Arts, November 13–December 21, 1952;
"Ingres," Musée du Petit Palais, Paris, October 27,
1967–January 29, 1968, no. 127; "Ingres at the
Metropolitan," Metropolitan Museum of Art, New
York, December 13, 1988–March 19, 1989; "The
Private Collection of Edgar Degas," Metropolitan
Museum of Art, New York, October 1, 1997–January
11, 1998, no. 619; "Portraits by Ingres: Image of an
Epoch," National Gallery, London, January 27–April
25, 1999, National Gallery of Art, Washington, May
23–August 22, 1999, Metropolitan Museum of Art,
New York, October 5, 1999–January 2, 2000, no. 89

SELECTED REFERENCES
Théophile Silvestre, *Histoire des artistes vivants:
Français et étrangers*, Paris, 1856, p. 36; Olivier
Merson, *Ingres: Sa vie et ses oeuvres*, Paris, 1867,
p. 109; Henri Delaborde, *Ingres: Sa vie, ses travaux,
sa doctrine*, Paris, 1870, p. 253, no. 134; Charles
Blanc, *Ingres: Sa vie et ses ouvrages*, Paris, 1870,
pp. 82–83, 232; "Nouvelles," *La chronique des arts
et de la curiosité, supplément à la Gazette des beaux-
arts* 5, February 1, 1896, p. 38; Arsène Alexandre,
*Jean-Dominique Ingres: Master of Pure Draughts-
manship*, London, 1905, pp. 15–16; J[ules]
Momméja, *Ingres*, Paris [1907], p. 71; Augustin Boyer
D'Agen, *Ingres d'après une correspondence inédite*,
1909, p. 60; A. J. Finberg, *Ingres*, London [?1910],
p. 45; Henry Lapauze, *Ingres Sa vie et son oeuvre*

(1780–1867), d'après des documents inédits, Paris,
1911, pp. 212–14; Paul Lafond, *Degas*, 2 vols., Paris,
1918–19, vol. 1, pp. 117–21; Henry Lapauze, "Ingres
chez Degas: La famille de Lucien Bonaparte," *La re-
naissance* 1, March 1918, pp. 10–11, ill.; B[ryson]
B[urroughs], "Two Ingres Portraits," *Metropolitan
Museum of Art Bulletin* 13, May 1918, p. 119;
Bryson Burroughs, "Portraits of M. and Mme Leblanc
by Ingres," *Metropolitan Museum of Art Bulletin* 14,
June 1919, pp. 133–35, ill.; "Portraits by Ingres,"
American Magazine of Art 11, no. 1, November
1919, pp. 15, 17, ill.; Morton D. Zabel, "Ingres in
America," *The Arts* 16, no. 6, February 1930, pp.
372, 374–75, 377, ill.; Paul-André Lemoisne, *Degas
et son oeuvre*, 4 vols., Paris [1946–49, reprint 1984],
p. 175, ill. opp. p. 176; Jean Alazard, *Ingres et
l'Ingrisme*, Paris, 1950, pp. 66, 148 n. 31, pl. XLVIII;
Theodore Rousseau Jr. "A Guide to the Picture
Galleries," *Metropolitan Museum of Art Bulletin* 12,
January 1954, n.s., part 2, p. 6; Charles Sterling and
Margaretta M. Salinger, *French Paintings: A
Catalogue of the Collection of The Metropolitan
Museum of Art*, 3 vols., New York, 1955–67, vol. 2,
pp. 9–10, ill.; Georges Wildenstein, *The Paintings of
J. A. D. Ingres*, New York, 1956 [1st ed., 1954],
p. 194, no. 153, pl. 59; Daniel Halévy, trans. Mina
Curtiss, *My Friend Degas*, Middletown, Conn., 1964,
pp. 85–86; Hans Naef, "Ingres und die Familie
Leblanc," *Du-atlantis* 26, February 1966, pp. 121–34,
colorpl. 5; Robert Rosenblum, *Jean-Auguste-
Dominique Ingres*, New York, 1967, pp. 124–25,
colorpl. 32; Emilio Radius, Ettore Camesasca,
L'Opera completa di Ingres, Milan, 1968, pp. 100–
101, no. 110, ill.; Hans Naef, "Ingres to M. Leblanc:
An Unpublished Letter," *Metropolitan Museum of Art
Bulletin* 29, December 1970, pp. 178–84, fig. 2;
Theodore Reff, *Degas, The Artist's Mind* [New York],
1976, pp. 54, 88–89, 309 n. 53, p. 312 nn. 140,
144, 145; Hans Naef, "Degas acheteur des portraits
de M. et Mme Leblanc," *Bulletin du Musée Ingres* 39,
July 1976, pp. 11–14, ill.; Hans Naef, *Die
Bildniszeichnungen von J.-A.-D. Ingres*, 5 vols., Bern,
1977–80, vol. 2, pp. 438–48, fig. 2; Daniel Ternois,
Ingres, Milan, 1980, pp. 65, 94–95, 179–80, no. 164,
ill. (black and white and color); Jean Sutherland
Boggs, ed., *Degas*, exh. cat., National Gallery of
Canada, Ottawa, New York, 1988, p. 491, fig. 279;
Georges Vigne, trans. John Goodman, *Ingres*, New
York, 1995 [French ed., 1995], pp. 157–60, 266,
328, 333, no. 106, colorpl. 132; Colin B. Bailey, ed.,
Renoir's Portraits: Impressions of an Age, exh. cat.,
National Gallery of Canada, New Haven, 1997,
p. 106; Rebecca A. Rabinow, "Catharine Lorillard
Wolfe: The First Woman Benefactor of the
Metropolitan Museum," *Apollo* 147, March 1998,
p. 54; Valérie Bajou, *Monsieur Ingres*, Paris, 1999,
pp. 184, 186–87, 359 n. 22, colorpl. 134; Gary
Tinterow, "'Portraits by Ingres: Image of an Epoch':
Reflections, Technical Observations, Addenda, and
Corrigenda," *Metropolitan Museum Journal* 35, 2000,
p. 195

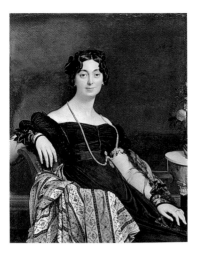

Madame Jacques-Louis Leblanc (Françoise
Poncelle, 1788–1839)
1823
Oil on canvas
47 x 36½ in. (119.4 x 92.7 cm)
Signed, dated, and inscribed (lower left): Ingres P.
flor. 1823
Catharine Lorillard Wolfe Collection, Wolfe Fund,
1918
19.77.2
See no. 2

PROVENANCE
M. and Mme Jacques-Louis Leblanc, Florence, later
Paris (1823–39); Jacques-Louis Leblanc, Paris, later
Tours (1839–d. 1846); his daughter, Mme Jean-Henri
Place, *née* Isaure Juliette-Josephine Leblanc, Paris
(1886–d. 1895; posthumous sale, Hôtel Drouot,
Paris, January 23, 1896, no. 47, for Fr 7,500 to
Durand-Ruel for Degas); Edgar Degas (1896–d. 1917;
posthumous sale, Galerie Georges Petit, Paris, March
26–27, 1918, no. 55, sold to the Metropolitan
Museum)

EXHIBITIONS
Salon, Paris, March 1, 1834–?, no. 999; "Exposition
universelle de 1855," Palais des Beaux-Arts, Paris,
May 15, 1855–?, no. 3368; "Art Treasures of the
Metropolitan," Metropolitan Museum of Art, New
York, November 7, 1952–September 7, 1953, no. 140;
"Ingres," Musée du Petit Palais, Paris, October 27,
1967–January 29, 1968, no. 128; "French Painting
1774–1830: The Age of Revolution," Grand Palais,
Paris, November 16, 1974–February 3, 1975, Detroit
Institute of Arts, March 5–May 4, 1975, Metropolitan
Museum of Art, New York, June 12–September 7,
1975, no. 110; "From Delacroix to Matisse," State
Hermitage Museum, Leningrad [St. Petersburg],
March 15–May 10, 1988, Pushkin State Museum of
Fine Arts, Moscow, June 10–July 30, 1988, no. 2;
"Ingres at the Metropolitan," Metropolitan Museum
of Art, New York, December 13, 1988–March 19,
1989; "The Private Collection of Edgar Degas,"
Metropolitan Museum of Art, New York, October 1,
1997–January 11, 1998, no. 620; "Portraits by Ingres:
Image of an Epoch," Metropolitan Museum of Art,
New York, October 5, 1999–January 2, 2000,
National Gallery of Art, Washington, D.C., May 23–
August 22, 1999, National Gallery, London,
January 27–April 25, 1999, no. 88

SELECTED REFERENCES
Gabriel Laviron, *Le Salon de 1834*, Paris, 1834,
p. 316; *Lettres sur le Salon de 1834*, Paris, March 6,
1834, letter II, pp. 19–21; Louis Peisse, "Beaux-Arts

Salon de 1834," *Le national,* May 3, 1834, p. 316; A.-D. Vergnaud, *Examen du Salon de 1834,* Paris, 1834, p. 316; Maxime du Camp, *Les beaux-arts à l'exposition universelle de 1855,* Paris, 1855; Charles Perrier, "Exposition universelle des beaux-arts: II, La peinture française—M. Ingres," *L'Artiste* 15, May 27, 1855, 5th series, p. 45; Théophile Silvestre, *Histoire des artistes vivants: Français et étrangers,* Paris, 1856, pp. 36, 39; Théodore Duret, *Les peintres français en 1867,* Paris, 1867; Olivier Merson, *Ingres: Sa vie et ses oeuvres,* Paris, 1867, p. 109; Henri Delaborde, *Ingres: Sa vie, ses travaux, sa doctrine,* Paris, 1870, pp. 40, 253–54, no. 135; Charles Blanc, *Ingres, Sa vie et ses ouvrages,* Paris, 1870, pp. 33, 82–83, 232; "Nouvelles," *La chronique des arts et de la curiosité, supplément à la Gazette des beaux-arts* 5, February 1, 1896, p. 38; Arsène Alexandre, *Jean-Dominique Ingres: Master of Pure Draughtsmanship,* London, 1905, pp. 15–16; J[ules] Momméja, *Ingres,* Paris [1907], p. 71; A. J. Finberg, *Ingres,* London [?1910], p. 45; Henry Lapauze, *Ingres: Sa vie et son oeuvre (1780–1867), d'après des documents inédits,* Paris, 1911, pp. 212–14, 316; Paul Lafond, *Degas,* 2 vols., Paris, 1918–19, vol. 1, 1918, pp. 117–21; Henry Lapauze, "Ingres chez Degas: La famille de Lucien Bonaparte," *La renaissance* 1, March 1918, pp. 10–11, ill.; B[ryson] B[urroughs], "Two Ingres Portraits," *Metropolitan Museum of Art Bulletin* 13, May 1918, p. 119; Bryson Burroughs, "Portraits of M. and Mme Leblanc by Ingres," *Metropolitan Museum of Art Bulletin* 14, June 1919, pp. 133–34, ill.; "Portraits by Ingres," *American Magazine of Art* 11, no. 1, November 1919, pp. 15–16, ill.; Morton D. Zabel, "Ingres in America," *The Arts* 16, no. 6, February 1930, pp. 372, 374–76, ill.; Walter Pach, *Ingres,* New York, 1939, pp. 51–52, 100, 266, ill. opp. p. 115; Paul-André Lemoisne, *Degas et son oeuvre,* 4 vols., Paris [1946–49, reprint 1984], p. 175, ill. opp. p. 176; Jean Alazard, *Ingres et l'Ingrisme,* Paris, 1950, pp. 66, 148 n. 31, pl. L; Theodore Rousseau Jr., "A Guide to the Picture Galleries," *Metropolitan Museum of Art Bulletin* 12, January 1954, n.s., part 2, p. 6; Charles Sterling and Margaretta M. Salinger, *French Paintings: A Catalogue of the Collection of The Metropolitan Museum of Art,* 3 vols., New York, 1955–67, vol. 2, pp. 10–11, ill.; Norman Schlenoff, *Ingres: Ses sources littéraires,* Paris, 1956, p. 140; Georges Wildenstein, *The Paintings of J. A. D. Ingres,* New York, 1956 [1st ed., 1954], p. 193, no. 152, pls. 58, 60, 61 (the whole and details); John Canaday, "Four Women," *Philadelphia Museum of Art Bulletin* 52, no. 253, 1957, pp. 43–44, 46, 48–49, ill.; Daniel Halévy, trans. Mina Curtiss, *My Friend Degas,* Middletown, Conn., 1964, pp. 85–86; Hans Naef, "Ingres und die Familie Leblanc," *Du-atlantis* 26, February 1966, pp. 121–34, colorpl. 4; Robert Rosenblum, *Jean-Auguste-Dominique Ingres,* New York, 1967, pp. 122–23, colorpl. 31; Emilio Radius, Ettore Camesasca, *L'Opera completa di Ingres,* Milan, 1968, p. 101, no. 109, ill. (black and white and colorpl. 32); Hans Naef, "Ingres to M. Leblanc: An Unpublished Letter," *Metropolitan Museum of Art Bulletin* 29, December 1970, pp. 178–84, fig. 3; Kenneth Clark, "Ingres: Peintre de la vie moderne," *Apollo* 93, no. 111, May 1971, n.s., p. 358, no. 5, ill.; René Huyghe, *La relève de l'imaginaire: La peinture français au XIXe siècle, Réalisme, romantisme,* Paris, 1976, p. 463; Theodore Reff, *Degas, The Artist's Mind,* [New York], 1976, pp. 54, 88–89, 309 n. 53, p. 312 nn. 139–40, 144–45; Hans Naef, "Degas acheteur des portraits de M. et Mme Leblanc," *Bulletin du Musée Ingres* 39, July 1976, pp. 11–14, ill.; Hans Naef, *Die Bildniszeichnungen von J.-A.-D. Ingres,* 5 vols., Bern, 1977–80, vol. 2,

pp. 438–48, fig. 1; Daniel Ternois, *Ingres,* Milan, 1980, pp. 65, 94, 179, no. 163, ill. (black and white and color); Jean Sutherland Boggs, ed., *Degas,* exh. cat., National Gallery of Canada, Ottawa, New York, 1988, p. 491, fig. 280; Georges Vigne, trans. John Goodman, *Ingres,* New York, 1995 [French ed., 1995], pp. 157, 159–60 197, 328, 333, no. 107, colorpl. 133; Paul de Roux, *Ingres,* Paris, 1996, pp. 59–61, ill. in color (the whole and two details); Colin B. Bailey, ed., *Renoir's Portraits: Impressions of an Age,* exh. cat., National Gallery of Canada, New Haven, 1997, p. 106; Rebecca A. Rabinow, "Catharine Lorillard Wolfe: The First Woman Benefactor of the Metropolitan Museum," *Apollo* 147, March 1998, p. 54; Valérie Bajou, *Monsieur Ingres,* Paris, 1999, pp. 184–85, 187, 224, 359 n. 22, colorpl. 133; Gary Tinterow, "'Portraits by Ingres: Image of an Epoch': Reflections, Technical Observations, Addenda, and Corrigenda," *Metropolitan Museum Journal* 35, 2000, p. 195

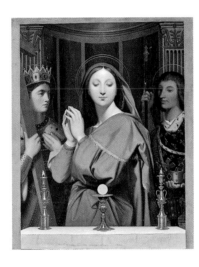

The Virgin Adoring the Host
1852
Oil on canvas
15⅞ x 12⅞ in. (40.3 x 32.7 cm)
Inscribed (at the bottom): Ingres à Madame Louise Marcotte, 1852
Gift of Lila and Herman Shickman, 2005
2005.186
See no. 5

PROVENANCE
Mme Charles Marie Jean-Baptiste François Marcotte (1852–d. 1862, gift of the artist); her widower and uncle, Charles Marie Jean-Baptiste François Marcotte, called Marcotte d'Argenteuil (1862–d. 1864); his son, Louis Marie Joseph Marcotte (1864–d. 1893); his widow, Mme Louis Marie Joseph Marcotte (1893–d. 1922); her daughter, Mme Eugène Marie Marcel Pougin de la Maisonnneuve (from 1922–[d. 1955]); private collection, London (by 1954); Mrs. Deane F. Johnson (Anne Ford), New York (apparently ca. 1985; sold to Shickman); Lila and Herman Shickman, New York (ca. 1985–2005)

EXHIBITION
"Exposition Ingres . . . organisée au profit du Musée Ingres," Galerie Georges Petit, Paris, April 26–May 14, 1911, no. 52

SELECTED REFERENCES
Arnould de Vienne, "Galerie de M. Marcotte," *L'Artiste,* 6e sér., 2, August 24, 1856, p. 102; Henry Lapauze, *Les dessins de J.-A.-D. Ingres du Musée de Montauban,* Paris, 1901, pp. 236 under "Cahier IX," 250 under "Cahier X"; Henry Lapauze, *Ingres: Sa Vie et son oeuvre (1780–1867), d'après des documents inédits,* Paris, 1911, p. 465; Georges Wildenstein, *The Paintings of J. A. D. Ingres,* New York, 1956 [1st ed., 1954], p. 220, no. 268, pl. 99; Michel Laclotte, ed., *Ingres,* exh. cat., Paris, 1968, p. 320, under no. 249; Emilio Radius and Ettore Camesasca, *L'Opera completa di Ingres,* Milan, 1968, p. 108 (no. 131b, ill.); Hans Naef, *Die Bildniszeichnungen von J.-A.-D. Ingres,* 5 vols., Bern, 1977–80, vol. 2, p. 519; Debra Edelstein, ed., *In Pursuit of Perfection: The Art of J.-A.-D. Ingres,* exh. cat., J. B. Speed Art Museum, Louisville, 1983–84, pp. 136, 245, 246, 248, 251, 253; Georges Vigne, *Dessins d'Ingres: Catalogue raisonné des dessins du Musée de Montauban,* Paris, 1995, p. 63, under nos. 269, 270 (ill.); Daniel Ternois, "Lettres d'Ingres à Marcotte d'Argenteuil," *Société de l'Histoire de l'Art Français, Archives de l'Art Français,* 35, 1999, pp. 30, 32 n. 13, 154 n. 6 under no. 87, 249; Gary Tinterow, Philip Conisbee, eds., *Portraits by Ingres: Image of an Epoch,* exh. cat., New York, 1999, p. 375 n. 29; Daniel Ternois, "Lettres d'Ingres à Marcotte d'Argenteuil: Dictionnaire," *Société de l'Histoire de l'Art Français, Archives de l'Art Français,* 36, 2001, pp. 230, 231 nn. 28–34, fig. 40, cf. p. 83; Stephan Wolohojian, *A Private Passion: 19th-Century Paintings and Drawings from the Grenville L. Winthrop Collection, Harvard University,* exh. cat., Metropolitan Museum of Art, New York, 2003, p. 196, under no. 76; Vincent Pomarède, Stéphane Guéguan, Louis-Antoine Prat, Éric Bertin, eds., *Ingres, 1780–1867,* exh. cat., Musée du Louvre, Paris, 2006, p. 332

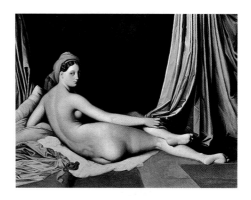

Jean-Auguste-Dominique Ingres and Workshop
French, 1780–1867

Odalisque in Grisaille
ca. 1824–34
Oil on canvas
32¾ x 43 in. (83.2 x 109.2 cm)
Catharine Lorillard Wolfe Collection, Wolfe Fund,
1938
38.65
See no. 4

PROVENANCE
Jean-Auguste-Dominique Ingres, Paris (until d. 1867;
his estate sale, Hôtel Drouot, Paris, April 27, 1867,
no. 7, to Ingres); Mme Jean-Auguste-Dominique
Ingres, *née* Ramel, Paris (1867–at least 1870); her
brother, Albert Ramel, Paris; Mme Albert Ramel, Paris
(by 1921); her daughter, Mme Emmanuel Riant, née
Ramel, Paris (until 1937); [Jacques Seligmann, Paris
and New York, 1937–38; sold to the Metropolitan
Museum]

EXHIBITIONS
"Exposition Ingres," Hôtel de la Chambre Syndicale
de la Curiosité et des Beaux-Arts, Paris, May 8–June
5, 1921, no. 24; "Masterpieces of Art: European and
American Paintings, 1500–1900," World's Fair, New
York, May–October 1940, no. 236; "The Classical
Contribution to Western Civilization," Art Gallery of
Toronto, December 15, 1948–January 31, 1949,
Metropolitan Museum of Art, New York, April 1949;
"Gray Is the Color," Rice Museum, October 19,
1973–January 19, 1974, no. 62; "Treasures from The
Metropolitan Museum of Art, New York: Memories
and Revivals of the Classical Spirit," National Gallery,
Alexander Soutzos Museum, Athens, August
15–November 15, 1979, no. 85; "Orientalism: The
Near East in French Painting 1800–1880," Memorial
Art Gallery of the University of Rochester, August
27–October 17, 1982, Neuberger Museum, SUNY
College at Purchase, November 14–December 23,
1982, no. 54; "Ingres, In Pursuit of Perfection: The
Art of J.-A.-D. Ingres," J. B. Speed Art Museum,
Louisville, December 6, 1983–January 29, 1984,
Kimbell Art Museum, Fort Worth, March 3,
1984–May 6, 1984, no. 51; "Treasures from The
Metropolitan Museum of Art: French Art from the
Middle Ages to the Twentieth Century," Yokohama
Museum of Art, March 25–June 4, 1989, no. 77;
"From El Greco to Cézanne: Masterpieces of
European Painting from the National Gallery of Art,
Washington, D.C. and The Metropolitan Museum of
Art, New York," National Gallery, Alexandros Soutzos
Museum, Athens, December 13, 1992–April 11, 1993,
no. 37; "Fantasme Ingres: Variations autour de la
Grande Odalisque," Musée de Cambrai, June 26–
October 30, 2004, no. 2

SELECTED REFERENCES
Henri Delaborde, *Ingres: Sa vie, ses travaux, sa doc-
trine*, Paris, 1870, p. 236, under no. 75; Henry
Lapauze, *Les dessins de J.-A.-D. Ingres du Musée de
Montauban*, Paris, 1901, pp. 235, 248–49; James W.
Lane, "Notes from New York," *Apollo* 28, December
1938, pp. 301–2; Louise Burroughs, "Odalisque en
Grisaille by Ingres," *Metropolitan Museum of Art
Bulletin* 33, October 1938, pp. 222–25, ill.; Walter
Pach, *Ingres*, New York, 1939, pp. 49, ill. opp. p. 67;
Charles Sterling and Margaretta M. Salinger, *French
Paintings: A Catalogue of the Collection of The
Metropolitan Museum of Art*, 3 vols., New York,
1955–67, vol. 2, pp. 7–9, ill.; Georges Wildenstein,
Ingres, New York, 1956 [1st ed., 1954], p. 210,
no. 226, fig. 56; Daniel Ternois, *Ingres*, exh. cat.,
Musée du Petit Palais, Paris, 1967, pp. 103–4, ill.;
Anne Poulet, "Turquerie," *Metropolitan Museum of
Art Bulletin* 26, January 1968, p. 236, no. 65, ill.;
Emilio Radius, Ettore Camesasca, *L'Opera completa
di Ingres*, Milan, 1968, p. 97, no. 82d, ill.; John L.
Connolly Jr., "Ingres and the Erotic Intellect," *Art
News Annual* 38 [Linda Nochlin and Thomas B.
Hess, eds., *Woman as Sex Object, Studies in Erotic
Art, 1730–1970*], 1972, pp. 21, 24 ill.; John L.
Connolly Jr., *Ingres Studies: Antiochus and
Stratonice, The Bather and Odalisque Themes*,
unpublished Ph.D. dissertation, University of
Pennsylvania, 1974, p. 44, pl. XII; Everett Fahy, ed.,
The Wrightsman Pictures, New York, 2005, p. 293,
under no. 78; Vincent Pomarède, Stéphane Guéguan,
Louis-Antoine Prat, Éric Bertin, eds., *Ingres 1780–
1867*, exh. cat., Musée du Louvre, Paris, 2006,
pp. 176, 180, fig. 137 (color)

Maximilien Luce
French, 1858–1941

Morning, Interior
1890
Oil on canvas
25½ x 31⅞ in. (64.8 x 81 cm)
Signed and dated (lower right): Luce 90
Bequest of Miss Adelaide Milton de Groot
(1876–1967), 1967
67.187.80
See no. 112

PROVENANCE
Purportedly [Julien (père) Tanguy, Paris, until
d. 1894]; his widow (1894; her sale, Hôtel Drouot,
Paris, June 2, 1894, not in catalogue, to Vollard);
[Ambroise Vollard, Paris]; [Jacques Rodrigues-
Henriques, Paris] (the foregoing per an inscription on
the stretcher); Adelaide Milton de Groot, New York
(by 1938–d. 1967)

EXHIBITIONS
"Tableaux de M. Luce et Aquarelles de Paul Signac,"
Galerie des Néo-Impressionistes, Paris, November 22–
December 6 or 8, 1894, no. 14; "Renoir to Picasso
1914," Joe and Emily Lowe Art Gallery of the
University of Miami, Coral Gables, February 8–
March 10, 1963, no. 78

SELECTED REFERENCES
Jean Sutter, ed., trans. Chantal Deliss, *The Neo-
Impressionists*, Greenwich, Conn., 1970 [French ed.,
1970], p. 174; Jean Bouin-Luce and Denise
Bazetoux, trans. Denis Mahaffey, *Maximilien Luce:
Catalogue raisonné de l'oeuvre peint*, 2 vols., Paris,
1986, vol. 1, p. 199, vol. 2, p. 141, no. 563, ill.

Édouard Manet
French, 1832–1883

Copy after Delacroix's "Bark of Dante"
ca. 1859
Oil on canvas
13 x 16⅛ in. (33 x 41 cm)
H. O. Havemeyer Collection, Bequest of Mrs. H. O.
Havemeyer, 1929
29.100.114
See no. 54

PROVENANCE
The artist's widow, Suzanne Manet, Paris (until 1894;
sold on October 30, 1894, for Fr 150 to Vollard);
[Ambroise Vollard, Paris, 1894–95; sold on August
27, 1895, for Fr 350 to Durand-Ruel]; [Durand-Ruel,
Paris, 1895, stock no. 3392; sold on August 27, 1895,
for Fr 400 to Havemeyer]; Mr. and Mrs. H. O.
Havemeyer, New York (1895–his d. 1907); Mrs. H.
O. (Louisine W.) Havemeyer, New York (1907–
d. 1929)

EXHIBITIONS
Displayed at Galerie Vollard, Paris, winter 1895; "The
H. O. Havemeyer Collection," Metropolitan Museum
of Art, New York, March 10–November 2, 1930,
no. 80; "Manet," Wildenstein, New York, February
26–April 3, 1948, no. 1; "Delacroix, Ses maîtres, ses
amis, ses élèves," Musée des Beaux-Arts de
Bordeaux, May 17–September 30, 1963, no. 363;
"Édouard Manet, 1832–1883," Philadelphia Museum
of Art, November 3–December 11, 1966, Art Institute
of Chicago, January 13–February 19, 1967, no. 3;
"French Nineteenth-Century Oil Sketches: David to
Degas," William Hayes Ackland Memorial Art Center,
Chapel Hill, March 5–April 16, 1978, no. 47;
"Manet, 1832–1883," Metropolitan Museum of Art,
New York, September 10–November 27, 1983, not
in catalogue; "Splendid Legacy: The Havemeyer
Collection," Metropolitan Museum of Art, New York,
March 27–June 20, 1993, no. A343; "Impression:
Painting Quickly in France, 1860–1890," National
Gallery, London, November 1, 2000–January 28,
2001, Van Gogh Museum, Amsterdam, March 2–
May 20, 2001, Sterling and Francine Clark Art
Institute, Williamstown, Mass., June 16–September 9,
2001, unnumbered cat. (fig. 14)

SELECTED REFERENCES
Théodore Duret, *Histoire d'Édouard Manet et de son
oeuvre*, Paris, 1902, p. 192, no. 5; Camille de Sainte-
Croix, "Édouard Manet," *Portraits d'hier*, December
15, 1909, p. 20; Julius Meier-Graefe, *Édouard Manet*,
Munich, 1912, pp. 18–19; Théodore Duret, trans. J. E.
Crawford Flitch, *Manet and the French Impressionists*,
London, 1912 [1st ed., 1910], p. 221, no. 5; Antonin
Proust, *Édouard Manet*, Paris, 1913, pp. 23–24;
Étienne Moreau-Nélaton, *Manet raconté par lui-même*,

2 vols., Paris, 1926, vol. 1, p. 24, fig. 9; A. Tabarant,
"Les Manet de la collection Havemeyer," *La renais-
sance* 13, February 1930, pp. 58–60; A. Tabarant,
Manet, Histoire catalographique, Paris, 1931, pp. 31–
32, no. 8; Paul Jamot and Georges Wildenstein,
Manet, 2 vols., Paris, 1932, vol. 1, pp. 20, 74, 114,
no. 1, vol. 2, fig. 485; Paul Colin, *Édouard Manet*,
Paris, 1932, pp. 16–17, 73; Beaumont Newhall,
"After Delacroix," *American Magazine of Art* 29,
September 1936, p. 581, ill.; Wilhelm Uhde, *The
Impressionists*, Vienna, 1937, p. 11; Gotthard
Jedlicka, *Édouard Manet*, Zurich, 1941, pp. 133–34;
John Rewald, *The History of Impressionism*, New
York, 1946, 1st ed. [1961 ed., rev., enlarged, p. 25,
ill.], pp. 23–24, ill.; A. Tabarant, *Manet et ses
oeuvres*, 4th ed., Paris, 1947 (1st. ed., 1942), pp. 19,
533, no. 7; Michel Florisoone, *Manet*, Monaco,
1947, p. XVII; George Heard Hamilton, *Manet and
His Critics*, New Haven, 1954, p. 22 n. 5; Georges
Bataille, trans. Austryn Wainhouse and James
Emmons, *Manet: Biographical and Critical Study*,
New York, 1955, p. 6; Charles Sterling and
Margaretta M. Salinger, *French Paintings: A
Catalogue of the Collection of The Metropolitan
Museum of Art*, 3 vols., New York, 1955–67, vol. 3,
pp. 24–25, ill.; Theodore Reff, "Copyists in the
Louvre, 1850–1870," *Art Bulletin* 46, December
1964, p. 556; Sandra Orienti et al., *The Complete
Paintings of Manet*, New York, 1967, p. 87, no. 4B;
Albert Boime, *The Academy and French Painting in
the Nineteenth Century*, London, 1971, p. 130,
fig. 112; Denis Rouart and Daniel Wildenstein,
Édouard Manet, Catalogue raisonné, 2 vols., Paris,
1975, vol. 1, pp. 32–33, no. 3, ill.; Peter Gay, *Art
and Act, On Causes in History—Manet, Gropius,
Mondrian*, New York, 1976, fig. 41; Anne Coffin
Hanson, *Manet and the Modern Tradition*, New
Haven, 1977, p. 155, fig. 99; Albert Boime, *Thomas
Couture and the Eclectic Vision*, New Haven, 1980,
p. 456, fig. XII.5; Frances Renée Weitzenhoffer, *The
Creation of the Havemeyer Collection, 1875–1900*,
unpublished Ph.D. dissertation, City University of
New York, 1982, p. 240, fig. 72; Françoise Cachin
and Charles S. Moffett, eds., *Manet, 1832–1883*,
exh. cat., Metropolitan Museum of Art, New York,
1983, pp. 45–46, under no. 1, fig. a [French ed.,
1983]; Frances Weitzenhoffer, *The Havemeyers:
Impressionism Comes to America*, New York, 1986,
pp. 105, 257; Françoise Cachin, *Manet* [Paris], 1990,
p. 148, fig. 3; Éric Darragon, *Manet*, Paris, 1991,
p. 32; Juliet Wilson-Bareau, *Manet by Himself,
Correspondence and Conversation: Paintings, Pastels,
Prints, and Drawings*, Boston, 1991, p. 307, no. 31,
fig. 31; Jean-Pierre Cuzin and Marie-Anne Dupuy,
*Copier Créer, De Turner à Picasso: 300 oeuvres
inspirées par les maîtres du Louvre*, exh. cat., Musée
du Louvre, Paris, 1993, p. 258, under no. 168,
fig. 168a; Ronald Pickvance, *Manet*, exh. cat.,
Fondation Pierre Gianadda, Martigny, Switzerland,
1996, p. 216; Rebecca A. Rabinow, ed., *Cézanne to
Picasso: Ambroise Vollard, Patron of the Avant-Garde*,
Metropolitan Museum of Art, New York, p. 276

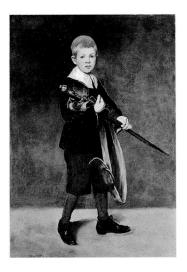

Boy with a Sword
1861
Oil on canvas
51⅝ x 36¾ in. (131.1 x 93.4 cm)
Signed (lower left): Manet
Gift of Erwin Davis, 1889
89.21.2
See no. 56

PROVENANCE
Placed on deposit with Théodore Duret by the artist
(September 1870–71; sold before January 1872,
[artist's tabbed notebook] for Fr 1,200, to Febvre);
[Febvre, Paris, 1872; sold January 8 for Fr 1,500 to
Durand-Ruel]; [Durand-Ruel, Paris, from 1872, stock
no. 930; on deposit with Edwards]; Alfred Edwards,
Paris (until 1881; sale, Hôtel Drouot, February 24,
no. 39, for Fr 9,100 to Feder); Jules Feder, Paris
(1881; on deposit with Durand-Ruel, February 25,
deposit no. 3080; sold, June 28, to Durand-Ruel);
[Durand-Ruel, Paris, 1881, stock no. 1880–84: 1135;
sold June 28 for Fr 10,000 to J. Alden Weir for
Davis]; Erwin Davis, New York (1881–89; his sale,
Ortgies, New York, March 19–20, no. 141, bought in
at $6,700)

EXHIBITIONS
Unidentified exhibition, Rue de Choiseul, Paris,
1861–62; "Salon des amis des arts de Bordeaux,"
Galerie de la Société des Amis des Arts, Bordeaux,
1862, no. 438; "Exposition de tableaux anciens et
modernes," Galerie Martinet, Paris, March 1–April
1863; "Exposition générale des beaux-arts, salon tri-
ennale," location unknown, Brussels, July 29–
September 28, 1863, no. 755; "Tableaux de M.
Édouard Manet," Avenue de l'Alma, Paris, May 1867,
no. 4; unidentified exhibition, Société Artistique des
Bouches-du-Rhône, Marseilles, December 1868–?;
"Pedestal Fund Art Loan Exhibition," National
Academy of Design, New York, December 3, 1883–?,
no. 153; "Works in Oil and Pastel by the
Impressionists of Paris," American Art Association,
New York, April 10–28, 1886, National Academy of
Design, New York, May 25–June 30, 1886, no. 303;
"Temporary Exhibition," Metropolitan Museum of Art,
New York, April 1906, no. 20; "Manet and Renoir,"
Pennsylvania Museum of Art, Philadelphia,
November 29, 1933–January 1, 1934, no catalogue;
"Metropolitan Museum Masterpieces," Hofstra
College, Hempstead, N.Y., June 29–September 1,
1952, no. 39; "München 1869–1958: Aufbruch zur
modernen Kunst," Haus der Kunst München, June 21–
October 5, 1958, no. 79; "One Hundred Years
of Impressionism: A Tribute to Durand-Ruel,"
Wildenstein and Co., Inc., New York, April 2–May 9,

1970, no. 1; "Treasures from the Metropolitan," Indianapolis Museum of Art, October 25, 1970–January 3, 1971, no. 67; "Treasured Masterpieces of The Metropolitan Museum of Art," Tokyo National Museum, August 10–October 1, 1972, Kyoto Municipal Museum of Art, October 8–November 26, 1972, no. 92; "Modern Masters: Manet to Matisse," Art Gallery of New South Wales, Sydney, April 10–May 11, 1975, National Gallery of Victoria, Melbourne, May 28–June 22, 1975, no. 59; "Modern Masters: Manet to Matisse," Museum of Modern Art, New York, August 4–September 1, 1975, no. 59; "Manet, 1832–1883," Galeries Nationales du Grand Palais, Paris, April 22–August 1, 1983, Metropolitan Museum of Art, New York, September 10–November 27, 1983, no. 14; "Manet i närbild," Nationalmuseum, Stockholm, February 7–June 11, 1985, no. 59; "In Support of Liberty: European Paintings at the 1883 Pedestal Fund Art Loan Exhibition," Parrish Art Museum, Southampton, N.Y., June 29–September 1, 1986, National Academy of Design, New York, September 18–December 7, 1986, no. 47; "Capolavori impressionisti dei musei americani," Museo di Capodimonte, Naples, December 3, 1986– February 1, 1987, Pinacoteca di Brera, Milan, March 4–May 3, 1987, no. 22; "From Delacroix to Matisse," State Hermitage Museum, Leningrad [St. Petersburg], March 15–May 10, 1988, Pushkin State Museum of Fine Arts, Moscow, June 10–July 30, 1988, no. 12; "Corot to Cézanne: 19th Century French Paintings from The Metropolitan Museum of Art," Museum of Art, Fort Lauderdale, December 22, 1992–April 11, 1993; "Manet/ Velázquez: La manière espagnole au XIXe siècle," Musée d'Orsay, Paris, September 16, 2002–January 12, 2003, no. 73, "Manet/Velázquez: The French Taste for Spanish Painting," Metropolitan Museum of Art, New York, March 4–June 8, 2003, no. 133; "Manet en el Prado," Museo Nacional del Prado, Madrid, October 13, 2003–February 8, 2004, no. 24

SELECTED REFERENCES
Ernest Chesneau, "L'Art contemporain," L'Artiste 1, April 1, 1863, p. 149; Zacharie Astruc, Le Salon de 1863, May 20, 1863; Ernest Chesneau, "Le Salon de 1865," Le constitutionnel, May 16, 1865; Émile Zola, "Une nouvelle manière en peinture: Édouard Manet," Revue du XIXe siècle 4, January 1, 1867, 8e sér.; E. Spuller, "M. Édouard Manet et sa peinture," Le nain jaune, June 9, 1867; Paul Mantz, "Salon de 1868, II," L'Illustration, June 6, 1868, p. 362; A. Maire, "Revue de l'exposition de la société artistique. À Madame . . . troisième lettre," Courrier de Marseille, January 21, 1869, p. 2; Armand Silvestre, La renaissance litteraire 1, 1872, p. 179; Armand Silvestre, Galerie Durand-Ruel, Recueil d'estampes, Paris, 1873, pp. 24–25, pl. LVI (engraved by Braquemond); Junius, "M. Édouard Manet," Le gaulois, April 25, 1876; Albert Wolff, "Salons," Le figaro, May 1, 1883; Edmond Bazire, Manet, Paris, 1884, pp. 54–56, 139; Jacques de Biez, Édouard Manet, January 22, 1884, Paris, 1884, pp. 34, 57; Albert Wolff, La capitale de l'art, Paris, 1886, pp. 220, 227; É[mile] Durand-Gréville, "La peinture aux États-Unis: Les galeries privées," Gazette des beaux-arts 36, July 1887, 2e pér., p. 74; Antonin Proust, "Édouard Manet inédit," La revue blanche 12, February 15, 1897, p. 174; Arthur J. Eddy, "Édouard Manet, Painter," Brush and Pencil 1, February 1898, pp. 137–38, 140; Théodore Duret, Histoire d'É-douard Manet et de son oeuvre, Paris, 1902, pp. 19, 203, no. 41; Frank Fowler, "The Field of Art: Modern Foreign Paintings at the Metropolitan Museum, Some Examples of the French School," Scribner's Magazine 44, September 1908, pp. 381–82, ill.; Emil Waldmann, "Französische Bilder in Amerikanischem

Privatbesitz, Part 1," Kunst und Künstler 9, November 1910, pp. 91, 96, ill.; Jean Laran and Georges Le Bas, Manet, Paris, 1912, pp. 23–24, pl. IV; Julius Meier-Graefe, Édouard Manet, Munich, 1912, p. 64 n. 1, p. 131 n. 4, p. 202 n. 1, pp. 313, 313, fig. 194; Théodore Duret, trans. J. E. Crawford Flitch, Manet and the French Impressionists, London, 1912 [1st ed., 1910], pp. 28, 214, 224, no. 41; Antonin Proust, Édouard Manet, Paris, 1913, pp. 120, 136, 152, 154; Paul Jamot, "La collection Camondo au Musée du Louvre: Les peintures et les dessins (deuxième article)," Gazette des beaux-arts 11, June 1914, pér. 4, pp. 442, 444; Katharine Metcalf Roof, The Life and Art of William Merritt Chase, New York, 1917, p. 94; Duncan Phillips, Julian Alden Weir: An Appreciation of His Life and Works, New York, 1921, p. 21; Léon Rosenthal, "Manet et l'Espagne," Gazette des beaux-arts 12, 1925, pér. 5, p. 212; J[acques]-É[mile] Blanche, trans. F. C. de Sumichrast, Manet, London, 1925, pp. 31, 42, fig. 4; Étienne Moreau-Nélaton, Manet raconté par lui-même, 2 vols., Paris, 1926, vol. 1, pp. 45, 51–53, fig. 48; vol. 2, p. 90; Paul Jamot, "Manet, 'Le fifre' et Victorine Meurend," Revue de l'art ancien et moderne 51, January–May 1927, pp. 33–34; A. Tabarant, Manet, Histoire catalographique, Paris, 1931, pp. 68–69, no. 42; Charles Léger, Édouard Manet, Paris, 1931, p. 7; Paul Jamot and Georges Wildenstein, Manet, 2 vols., Paris, 1932, vol. 1, pp. 35–36, 119, no. 42; vol. 2, fig. 35; Germain Bazin, "Manet et la tradition," L'Amour de l'art, May 1932, pp. 155, 160; Paul Colin, Édouard Manet, Paris, 1932, p. 21; E. Lambert, "Manet et l'Espagne," Gazette des beaux-arts 9, June 1933, 6 pér., p. 372; Helen Comstock, "The Connoisseur in America: A Child Portrait by Manet," Connoisseur 97, May 1936, p. 282; Walter Pach, Queer Thing, Painting: Forty Years in the World of Art, New York, 1938, pp. 9–10; Lionello Venturi, Les archives de l'impressionnisme, 2 vols., Paris, 1939, vol. 2, pp. 166, 192, 211; Hans Graber, Édouard Manet nach Eigenen und Fremden Zeugnissen, Basel, 1941, pp. 82, 297, 309; A. Tabarant, La vie artistique au temps de Baudelaire, Paris, 1942, pp. 367, 488; Marcel Guérin, L'Oeuvre gravé de Manet, Paris, 1944, unpaginated, under no. 11; Hans Huth, "Impressionism Comes to America," Gazette des beaux-arts 29, April 1946, sér. 6, pp. 232–33, fig. 6; A. Tabarant, Manet et ses oeuvres, 4th ed., Paris, 1947 [1st. ed., 1942], pp. 45, 136, 182–83, 534, no. 44, fig. 37; Michel Benisovich, "Une lettre de Manet," Beaux-arts, August 25–31, 1954; George Heard Hamilton, Manet and His Critics, New Haven, 1954, pp. 38–39, 81 n. 2, pp. 96, 98, 111, 120, 130 n. 6, pp. 155, 161, 260, 265, 266; Nils Gösta Sandblad, trans. Walter Nash, Manet: Three Studies in Artistic Conception, Lund, 1954, pp. 31, 87; J.-L. Vaudoyer, E. Manet, Paris [1955], unpaginated, ill. (overall and detail); Charles Sterling and Margaretta M. Salinger, French Paintings: A Catalogue of the Collection of The Metropolitan Museum of Art, 3 vols., New York, 1955–67, vol. 3, pp. 30–33, ill.; Henri Perruchot, La vie de Manet, Paris, 1959, pp. 109–10, color ill. opp. p. 96; Theodore Reff, "The Symbolism of Manet's Frontispiece Etchings," Burlington Magazine 104, May 1962, pp. 183–85, fig. 2; Anne Coffin Hanson, Édouard Manet, 1832–1883, exh. cat., Philadelphia Museum of Art, Philadelphia, 1966, pp. 56–57, 147; Joel Isaacson, The Early Paintings of Claude Monet, unpublished Ph.D. dissertation, University of California, Berkeley, 1967, pp. 140, 310 n. 9; Sandra Orienti et al., The Complete Paintings of Manet, New York, 1967, p. 90, no. 37, ill.; Margaretta M. Salinger, "Windows Open to Nature," Metropolitan Museum of Art Bulletin 27, summer 1968, n.s., p. 6, ill.; Beatrice Farwell, "Manet's 'Espada' and Marcantonio,"

Metropolitan Museum Journal 2, 1969, p. 206; Joel Isaacson, Manet and Spain, Prints and Drawings, exh. cat., Museum of Art, University of Michigan, Ann Arbor, Mich., 1969, pp. 19, 26; Alain de Leiris, The Drawings of Édouard Manet, Berkeley, 1969, pp. 10, 56, 105, no. 156, fig. 7 (tracing); Roger Fry, Denys Sutton, ed., Letters of Roger Fry, 2 vols., New York, 1972, vol. 1, pp. 24, 255 n. 1 to letter 177, p. 265 n. 1 to letter 191; Steven Kovács, "Manet and His Son in 'Déjeuner dans l'atelier,'" The Connoisseur 181, November 1972, pp. 196, 198, 200, fig. 1; Richard J. Boyle, American Impressionism, Boston, 1974, p. 160; George Mauner, Manet, Peintre-Philosophe: A Study of the Painter's Themes, University Park, Pa., 1975, p. 177 n. 20; Denis Rouart and Daniel Wildenstein, Édouard Manet, Catalogue raisonné, 2 vols., Paris, 1975, vol. 1, pp. 12, 24, 54–55, no. 37, ill., vol. 2, p. 166; David H. Solkin, "Philibert Rouvière: Édouard Manet's 'L'Acteur tragique,'" Burlington Magazine, November 1975, p. 705; Anne Coffin Hanson, Manet and the Modern Tradition, New Haven, 1977, pp. 71, 79, colorpl. 48; Bradford R. Collins, "Manet's Luncheon in the Studio: An Homage to Baudelaire," Art Journal 38, winter 1978–79, p. 109; Albert Boime, Thomas Couture and the Eclectic Vision, New Haven, 1980, pp. 461, 463; Alain de Leiris, "Manet and El Greco: 'The Opera Ball,'" Arts Magazine 55, September 1980, p. 97; Frances Weitzenhoffer, "First Manet Paintings to Enter an American Museum," Gazette des beaux-arts 97, March 1981, 6e pér., pp. 125–29; Charles S. Moffett, Impressionist and Post-Impressionist Paintings in The Metropolitan Museum of Art, New York, 1985, pp. 26–27, color ill.; Frances Weitzenhoffer, The Havemeyers: Impressionism Comes to America, New York, 1986, pp. 35, 44, pl. 6; Kathleen Adler, Manet, Oxford, 1986, pp. 54, 77, 101, fig. 38; Sjraar van Heutgen et al. Franse meesters uit het Metropolitan Museum of Art: Realisten en Impressionisten, exh. cat., Rijksmuseum Vincent van Gogh, Amsterdam, Zwolle, the Netherlands, 1987, pp. 13, 24–25, fig. 16; Éric Darragon, Manet, Paris, 1989, pp. 58–60, 71, 137; Horst Keller, Edouard Manet, Munich, 1989, pp. 14, 17, fig. 11; Anne Distel, trans. Barbara Perroud-Benson, Impressionism: The First Collectors, New York, 1990, pp. 24, 242; Françoise Cachin, Manet [Paris], 1990, pp. 74–75, 156, colorpl. 3; T. A. Gronberg, Manet: A Retrospective, New York, 1990, pp. 22, 30, 71–72, 168, 189, 228, 323, 339, colorpl. 6; Éric Darragon, Manet, Paris, 1991, pp. 69, 79, 80–81, 90, 115, 188, 289, 372–73, fig. 41 (color); Sarah Carr-Gomm, Manet, London, 1992, pp. 46–47, color ill.; Louisine W. Havemeyer, Sixteen to Sixty: Memoirs of a Collector, New York, 1993, 3rd ed. with notes by Susan Alyson Stein [1st ed., 1930; repr. 1961], pp. 221, 237, 333 n. 315, p. 335 n. 345; Susan Alyson Stein, Gary Tinterow, H. Barbara Weinberg et al., Splendid Legacy: The Havemeyer Collection, exh. cat., Metropolitan Museum of Art, New York, 1993, pp. 8, 27, 31, 76, 206 fig. 1; Vivien Perutz, Édouard Manet, Lewisburg, Pa., 1993, p. 127; Ronald Pickvance, Manet, exh. cat., Fondation Pierre Gianadda, Martigny, Switzerland, 1996, p. 221 under no. 18; Hans Körner, Édouard Manet: Dandy, flaneur, maler, Munich, 1996, pp. 27, 29, colorpl. 19; Beth Archer Brombert, Édouard Manet: Rebel in a Frock Coat, Boston, 1996, pp. 81, 85–86, 185–86, 255, 419, fig. 4; Gary Tinterow et al., La collection Havemeyer: Quand l'Amérique découvrait l'impressionnisme, exh. cat., Musée d'Orsay, Paris, 1997, pp. 32, 107, fig. 10; Madeleine Fidell-Beaufort, "The American Art Trade and French Painting at the End of the 19th century," The Van Gogh Museum Journal, 2000, p. 107; George Mauner and Henri Loyrette, Manet: The Still-

Life Paintings, exh. cat., Musée d'Orsay, New York, 2000, pp. 21, 33–34, 66 [French ed., "Manet: Les natures mortes," Paris, 2000, pp. 36, 48, 78]; Nancy Locke, *Manet and the Family Romance,* Princeton, 2001, pp. 73–74, 120–23, 131, fig. 33; Peter Meller, "Manet in Italy: Some Newly Identified Sources for his Early Sketchbooks," *Burlington Magazine* 144, February 2002, pp. 92–93; Carol Armstrong, *Manet Manette,* New Haven, 2002, pp. 11, 16–17, 27–28, 39–40, 47, 72, 101, 104, 114, 160, 178, ill. (no. 4 and fig. 46)

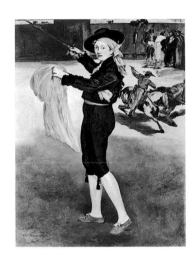

Mademoiselle V . . . in the Costume of an Espada
1862
Oil on canvas
65 x 50¼ in. (165.1 x 127.6 cm)
Signed and dated (lower left): éd. Manet. / 1862
H. O. Havemeyer Collection, Bequest of Mrs. H. O. Havemeyer, 1929
29.100.53
See no. 57

PROVENANCE
The artist, Paris (1862–72; sold in January 1872 for Fr 3,000 to Durand-Ruel); [Durand-Ruel, Paris, 1872–74; sold on February 16, 1874 for Fr 5,000 to Faure]; Jean-Baptiste Faure, Paris (1874–98; deposited with Durand-Ruel, November 11, 1896– January 9, 1897 [deposit no. 9021], and September 11, 1897–August 30, 1898 [deposit no. 9182]; sold on December 22, 1898, for Fr 45,000 to Durand-Ruel); [Durand-Ruel, Paris, 1898; sold on December 28, 1898 (Paris stock book), or January 21, 1899 (New York stock book), stock no. 4906, to Durand-Ruel]; [Durand-Ruel, New York, 1898; sold on December 31, 1898, for $15,000, stock no. 2095, to Havemeyer]; Mr. and Mrs. H. O. Havemeyer, New York (1898–his d. 1907); Mrs. H. O. (Louisine W.) Havemeyer, New York (1907–d. 1929)

EXHIBITIONS
"Salon des 'refusés,'" Palais des Champs-Élysées, Paris, May 15–?, 1863, no. 365; "Tableaux de M. Édouard Manet," Avenue de l'Alma, Paris, May 1867, no. 12; "Exposition des oeuvres de Édouard Manet," École Nationale des Beaux-Arts, Paris, January 6–28, 1884, no. 15; unidentified exhibition, Durand-Ruel,

Paris, September 1896, no catalogue; unidentified exhibition, Durand-Ruel, Paris, March 1898; "The H. O. Havemeyer Collection," Metropolitan Museum of Art, New York, March 10– November 2, 1930, no. 76; "One Hundred Years: French Painting, 1820–1920," William Rockhill Nelson Gallery of Art, Kansas City, Mo., March 31–April 28, 1935, no. 31; "Honderd Jaar Fransche Kunst," Stedelijk Museum, Amsterdam, July 2–September 25, 1938, no. 139; "Art Treasures of the Metropolitan," Metropolitan Museum of Art, New York, November 7, 1952–September 7, 1953, no. 145; "Édouard Manet, 1832–1883," Philadelphia Museum of Art, November 3–December 11, 1966, Art Institute of Chicago, January 13–February 19, 1967, no. 50; "Old Mistresses: Women Artists of the Past," Walters Art Gallery, Baltimore, April 17–June 18, 1972; "Impressionism: A Centenary Exhibition," Metropolitan Museum of Art, New York, December 12, 1974–February 10, 1975, not in catalogue; "Manet, 1832–1883," Galeries Nationales du Grand Palais, Paris, April 22–August 1, 1983, Metropolitan Museum of Art, New York, September 10–November 27, 1983, no. 33; "From Delacroix to Matisse," State Hermitage Museum, Leningrad [St. Petersburg], March 15–May 10, 1988, Pushkin State Museum of Fine Arts, Moscow, June 10–July 30, 1988, no. 13; "Splendid Legacy: The Havemeyer Collection," Metropolitan Museum of Art, New York, March 27–June 20, 1993, no. A344; "Origins of Impressionism," Galeries Nationales du Grand Palais, Paris, April 19–August 8, 1994, Metropolitan Museum of Art, New York, September 27, 1994–January 8, 1995, no. 90; "Manet/Velázquez: La manière espagnole au XIXe siècle," Musée d'Orsay, Paris, September 16, 2002–January 12, 2003, no. 78, "Manet/Velázquez: The French Taste for Spanish Painting," Metropolitan Museum of Art, New York, March 4–June 8, 2003, no. 139; "Manet en el Prado," Museo Nacional del Prado, Madrid, October 13, 2003–February 8, 2004, no. 39

SELECTED REFERENCES
Zacharie Astruc, *Le Salon de 1863,* May 20, 1863, p. 16; Castagnary, "Salon des refusés," *L'Artiste* 2, August 15, 1863, p. 76; Fernand Desnoyers, ed., *Salon des refusés: La peinture en 1863,* Paris, 1863, pp. 41–42; Théophile Thoré, *Salon de 1863: Les réprouvés,* 1863; W. Bürger [Théophile Thoré], "Salon de 1863," *L'Independance belge,* June 11, 1863, p. 424; J[ohn] Graham, "Un étranger au salon," *Le figaro,* July 16, 1863; A. Paul, "Le Salon de 1863, les refusés," *Le siècle,* July 19, 1863; H. de la Madelène, *Le Salon des Refusés,* Paris, 1863, p. 41; A. Stevens, *Le Salon de 1863,* Paris, 1866, p. 196; Émile Zola, "Une nouvelle manière en peinture: Édouard Manet," *Revue du XIXe siècle* 4, January 1, 1867, 8 sér., pp. 53, 56; Émile Zola, *Éd. Manet: Étude biographique et critique, accompagnée d'un portrait d'Éd. Manet par Bracquemond, et d'une eau-forte d'Éd. Manet, d'après "Olympia,"* Paris, 1867, p. 32; Jules Claretie, "Salon de 1872," *Le soir,* May 25, 1872; Émile Zola, *Mes haines,* Paris, 1880; Edmond Bazire, *Manet,* Paris, 1884, p. 71; Jacques de Biez, Colloquium/Symposium, *Édouard Manet,* January 22, 1884, Paris, 1884, p. 30; Joséphin Péladan, "Le procédé de Manet d'après l'exposition de l'École des Beaux-Arts," *L'Artiste* 1, February 1884, 54 année, pp. 106–8, 116; Paul Mantz, "The Works of Manet," *Le temps,* January 16, 1884; Thadée Natanson, "A propos de Mm C. Cottet, Gauguin, E. Vuillard, et E. Manet," *La revue blanche,* 1896, p. 518; Théodore Duret, *Histoire d'Édouard Manet et de son oeuvre,* Paris, 1902, pp. 200, 202, no. 37 [German ed., *Édouard Manet: Sein Leben und Seine Kunst,* Berlin, 1910, pp. 254, 255–56,

no. 37, ill. p. 65]; Emil Waldmann, "Französische Bilder in Amerikanischem Privatbesitz, Part 1," *Kunst und Künstler* 9, November 1910, ill. p. 92, "Französische Bilder in Amerikanischem Privatbesitz, Part 2" [December] 1910, p. 134; Julius Meier-Graefe, *Édouard Manet,* Munich, 1912, pp. 64, 313, fig. 43; Théodore Duret, trans. J. E. Crawford Flitch, *Manet and the French Impressionists,* London, 1912 [1st ed., 1910], p. 224, no. 37; Antonin Proust, *Édouard Manet,* Paris, 1913, p. 163, no. 15; Jacques-Émile Blanche, *De David à Degas,* Paris, 1919, p. 151; [A.] Tabarant, "Celle que fu 'l'Olympia,'" *Bulletin de la vie artistique* 2, May 15, 1921, p. 298, ill. p. 297; Emil Waldmann, *Édouard Manet,* Berlin, 1923, pp. 17–18, 29–32, 43, 45–46, ill.; J.-E. Blanche, trans. F. C. de Sumichrast, *Manet,* London, 1925, p. 26; Étienne Moreau-Nélaton, *Manet raconté par lui-même,* 2 vols., Paris, 1926, vol. 1, pp. 48, 132, fig. 53, vol. 2, p. 127, no. 15, fig. 341; Paul Jamot, "Manet, 'Le fifre' et Victorine Meurend," *Revue de l'art ancien et moderne* 51, January–May 1927, pp. 36–38; Frank Jewett Mather Jr., "The Havemeyer Pictures," *The Arts* 16, March 1930, pp. 473, 477–78, ill.; A. Tabarant, "Les Manet de la collection Havemeyer," *La Renaissance* 13, February 1930, pp. 58, 63–64, ill.; Charles V. Wheeler, *Manet, An Essay,* Washington, 1930, pp. 14–15, ill.; L. E. Rowe, "A Study for the Havemeyer Picture," *Bulletin of the Rhode Island School of Design* 18, 1930, p. 26, ill. p. 27; A. Tabarant, *Manet, Histoire catalographique,* Paris, 1931, pp. 85–86, no. 54; Paul Jamot and Georges Wildenstein, *Manet,* 2 vols., Paris, 1932, vol. 1, p. 121, no. 51, vol. 2, fig. 40; Paul Colin, *Édouard Manet,* Paris, 1932, p. 73, fig. VII; E. Lambert, "Manet et l'Espagne," *Gazette des beaux-arts* 9, June 1933, 6 pér., p. 375, fig. 11; Lionello Venturi, *Les archives de l'impressionnisme,* Paris, 1939, vol. 2, p. 191; Gotthard Jedlicka, *Édouard Manet,* Zurich, 1941, p. 78; Marcel Guérin, *L'Oeuvre gravé de Manet,* Paris, 1944, unpaginated, under no. 32; John Rewald, *The History of Impressionism,* New York, 1946 [1961 ed., pp. 83, 85, 272, ill.], pp. 72, 75, 225–26, ill.; A. Tabarant, *Manet et ses oeuvres,* 4th ed. Paris, 1947 [1st. ed., 1942], pp. 54–55, 62, 69, 73, 136, 491, 534, no. 55, fig. 55; Michel Florisoone, *Manet,* Monaco, 1947, pp. XXIII, 20, ill.; Joseph C. Sloane, *French Painting between the Past and the Present: Artists, Critics, and Traditions from 1848 to 1870,* Princeton, 1951, reprinted 1973, pp. 186, 194 n. 10, p. 196, fig. 60; George Heard Hamilton, *Manet and His Critics,* New Haven, 1954, pp. 155, 157, pl. 5; Nils Gösta Sandblad, trans. Walter Nash, *Manet: Three Studies in Artistic Conception,* Lund, 1954, p. 83; Charles Sterling and Margaretta M. Salinger, *French Paintings: A Catalogue of the Collection of The Metropolitan Museum of Art,* 3 vols., New York, 1955–67, vol. 3, pp. 33–35, ill.; J.-L. Vaudoyer, *E. Manet,* Paris [1955], unpaginated, no. 13, ill. (overall and detail); Georges Bataille, trans. Austryn Wainhouse and James Emmons, *Manet: Biographical and Critical Study,* New York, 1955, pp. 8, 10, 46, color ill.; John Richardson, *Édouard Manet: Paintings and Drawings,* London, 1958, pp. 14, 119, no. 10, pl. 10; *Great Paintings from The Metropolitan Museum of Art,* New York, 1959, unpaginated, no. 53, color ill.; Jacques Lethève, *Impressionnistes et symbolistes devant la presse,* Paris, 1959, p. 24; Henri Perruchot, *La vie de Manet,* Paris, 1959, pp. 118, 121, ill.; François Daulte, "Le marchand des impressionnistes," *L'Oeil,* no. 66, June 1960, p. 58; Alan Bowness, "A Note on 'Manet's Compositional Difficulties,'" *Burlington Magazine* 103, June 1961, p. 277; Theodore Reff, "The Symbolism of Manet's Frontispiece Etchings," *Burlington Magazine* 104, May 1962, p. 183; A. Tabarant, *La vie artistique au*

temps de Baudelaire [Paris], 1963, 2nd ed. [1st ed., 1942], pp. 312, 415; Joel Isaacson, unpublished Ph.D. dissertation, *The Early Paintings of Claude Monet,* University of California, Berkeley, 1967, pp. 136, 140, 290 n. 14, p. 310 n. 9; Sandra Orienti et al., *The Complete Paintings of Manet,* New York, 1967, p. 91, no. 51, ill. p. 91 and colorpl. VII; Alan Bowness, "Manet and Mallarmé," *Philadelphia Museum of Art Bulletin* 62, April–June 1967, pp. 213, 216, ill.; Martha Schmierer and Richard Verdi, "Thoughts Arising from the Philadelphia-Chicago Manet Exhibition," *The Art Quarterly* 30, fall–winter 1967, pp. 240–41; René Thomsen, "Note concernant la composition du tableau: 'Victorine Meurent en costume d'espada,'" *Bulletin de la Société d'Études pour la Connaissance d'Édouard Manet,* no. 2, January 1968, p. 28, ill.; Beatrice Farwell, "Manet's 'Espada' and Marcantonio," *Metropolitan Museum Journal* 2, 1969, pp. 197–207, ill.; Joel Isaacson, *Manet and Spain, Prints and Drawings,* exh. cat., Museum of Art, University of Michigan, Ann Arbor, 1969, pp. 3, 9, 11, 14, 30–31, under nos. 15 and 16; Alain de Leiris, *The Drawings of Édouard Manet,* Berkeley, 1969, pp. 12, 107, under no. 181, fig. 9; Michael Fried, "Manet's Sources," *Artforum* 7, March 1969, pp. 52–53, 66, 69 nn. 19, 27, p. 71 n. 69, p. 75 nn. 146–47, 149, ill.; Theodore Reff, "'Manet's Sources': A Critical Evaluation," *Artforum* 8, September 1969, pp. 40, 45–47, ill. p. 41; E[gbert] Haverkamp-Begemann and Anne-Marie S. Logan, *European Drawings and Watercolors in the Yale University Art Gallery, 1500–1900,* 2 vols., New Haven, 1970, vol. 1, p. 81, under no. 141; Jean C. Harris, *Édouard Manet: Graphic Works, A Definitive Catalogue Raisonné,* New York, 1970, p. 112, under no. 35; Anthea Callen, *Jean-Baptiste Faure, 1830–1914: A Study of a Patron and Collector of the Impressionists and Their Contemporaries,* master's thesis, University of Leicester, 1971, pp. 233–34, 624, no. 361; Julián Gállego, "Goya en el arte moderno," *Goya,* January–February 1971, p. 256; Joel Isaacson, *Monet: Le déjeuner sur l'herbe,* New York, 1972, p. 80; Germain Bazin, trans. Maria Paola de Benedetti, *Édouard Manet,* Milan, 1972, pp. 8, 76, ill. [French ed., 1974]; Kermit Swiler Champa, *Studies in Early Impressionism,* New Haven, 1973, pp. 4, 52, fig. 4; John Rewald, "The Impressionist Brush," *Metropolitan Museum of Art Bulletin* 32, no. 3, 1973–74, pp. 4, 6–7, no. 2, ill. (overall [black and white] and detail [color]); Anthea Callen, "Faure and Manet," *Gazette des beaux-arts* 83, March 1974, 6 pér., p. 163; Denis Rouart and Daniel Wildenstein, *Édouard Manet, Catalogue raisonné,* 2 vols., Paris, 1975, vol. 1, pp. 4, 12, 17, 66–67, no. 58, ill.; vol. 2, p. 140, under no. 372; S[usan] A. D[enker] et al., *Selection V: French Watercolors and Drawings from the Museum's Collection, ca. 1800–1910,* exh. cat., Museum of Art, Rhode Island School of Design, Providence, 1975, pp. 106–8, under no. 47; Theodore Reff [review of *Édouard Manet, Catalogue raisonné*] *Art Bulletin* 58, December 1976, p. 637; Anne Coffin Hanson, *Manet and the Modern Tradition,* New Haven, 1977, pp. 79–82, 85, 87, 163, 170, 175, 188–89, 191, 200, pl. 49; Seymour Howard, "Early Manet and Artful Error: Foundations of Anti-Illusion in Modern Painting," *Art Journal* 37, fall 1977, p. 16, fig. 4; Nigel Glendinning, *Goya and His Critics,* New Haven, 1977, pp. 119, 279, 320 n. 5, fig. 33; Sharon Flescher, *Zacharie Astruc: Critic, Artist and Japoniste,* published Ph.D. dissertation, Columbia University, 1977, New York, 1978, p. 101; Julie Manet, *Journal (1893–1899): Sa jeunesse parmi les peintres impressionnistes et les hommes de lettres,* Paris, 1979, p. 157; Joel Isaacson, *The Crisis of Impressionism, 1878–1882,* exh. cat., University of Michigan

Museum of Art, Ann Arbor, 1979, p. 36; Alain de Leiris, "Edouard Manet's 'Mlle V. in the Costume of an Espada': Form-Ideas in Manet's Stylistic Repertory; Their Sources in Early Drawing Copies," *Arts Magazine* 53, January 1979, pp. 112–17, ill. (fig. 1 [black and white] and cover [color]); Alain de Leiris, "Manet and El Greco: 'The Opera Ball,'" *Arts Magazine* 55, September 1980, p. 99; Sandra Orienti, trans. Claude Lauriol, *Tout Manet, 1853–1873: La peinture,* 2 vols., Paris, 1981, vol. 1, pp. 25, 33, 30, no. 45, ill. (color and black and white); Charles F. Stuckey, "What's Wrong with this Picture?," *Art in America* 69, September 1981, p. 100; Joel Isaacson, "Impressionism and Journalistic Illustration," *Arts Magazine* 56, June 1982, p. 114 n. 56; Pierre Daix, *La vie de peintre d'Édouard Manet,* Paris, 1983, pp. 87, 124; Charles F. Stuckey, *Manet,* Mount Vernon, N.Y., 1983, p. 9, colorpl. 5; Barbara Ehrlich White, *Renoir: His Life, Art, and Letters,* New York, 1984, p. 30; Charles S. Moffett, *Impressionist and Post-Impressionist Paintings in The Metropolitan Museum of Art,* New York, 1985, pp. 28–29, ill. in color (overall and detail); Elizabeth Anne McCauley, *A. A. E. Disdéri and the Carte de visite Portrait Photograph,* New Haven, 1985, pp. 181, 185, 190, fig. 177; Frances Weitzenhoffer, *The Havemeyers: Impressionism Comes to America,* New York, 1986, pp. 212, 255, colorpl. 82; Eunice Lipton, *Looking into Degas: Uneasy Images of Women and Modern Life,* Berkeley, 1986, pp. 35–36, fig. 23; Kathleen Adler, *Manet,* Oxford, 1986, pp. 45, 52, 54–55, 77, 182, colorpl. 53; Gary Tinterow, *The Metropolitan Museum of Art: Modern Europe,* New York, 1987, pp. 6, 12–13, color ill.; Larry L. Ligo, "Baudelaire's *Mistress Reclining* and *Young Woman Reclining in Spanish Costume:* Manet's Pendant Portraits of his Acknowledged 'Mistresses,' Baudelairian Aesthetics and Photography," *Arts Magazine* 62, January 1988, pp. 76, 83, fig. 19; Éric Darragon, *Manet,* Paris, 1989, pp. 70, 76, 84–85, 88–89, 137; Horst Keller, *Edouard Manet,* Munich, 1989, pp. 34, 40, colorpl. 25; Mikael Wivel, Juliet Wilson-Bareau, Hanne Finsen, *Manet,* exh. cat., Ordrupgaard, Copenhagen, 1989, pp. 49, 82, 89, 92; Anne Distel, trans. Barbara Perroud-Benson, *Impressionism: The First Collectors,* New York, 1990, p. 241, colorpl. 58; Françoise Cachin, *Manet* [Paris], 1990, pp. 14–15, 38, fig. 2 (color); Martine Bacherich, *Je regarde Manet,* Paris, 1990, pp. 13, 100–1, 118–19, 130, pl. 7; Paul Hayes Tucker, *Monet in the '90s: The Series Paintings,* exh. cat., Museum of Fine Arts, Boston, Boston, 1990, p. 131, fig. 55; Juliet Wilson-Bareau, *Manet by Himself, Correspondence and Conversation: Paintings, Pastels, Prints, and Drawings,* Boston, 1991, p. 163; Klaus Herding, trans. John William Gabriel, *Courbet: To Venture Independence,* New Haven, 1991, pp. 17, 202 n. 27; Éric Darragon, *Manet,* Paris, 1991, pp. 96, 102, 104, 119, 130, 132–33, 212, 377, fig. 66 (color); Sarah Carr-Gomm, *Manet,* London, 1992, pp. 14, 56–57, color ill.; Louisine W. Havemeyer, *Sixteen to Sixty: Memoirs of a Collector,* New York, 1993, 3rd ed. with notes by Susan Alyson Stein [1st ed., 1930; repr. 1961], pp. 7, 224–25, 307 n. 10, p. 333 n. 323; Vivien Perutz, *Édouard Manet,* Lewisburg, Pa., 1993, pp. 28, 84, 86, colorpl. 11; Nigel Blake, Francis Frascina et al., *Modernity and Modernism: French Painting in the Nineteenth Century,* New Haven, 1993, p. 87, pl. 74; Françoise Cachin, *Manet: "J'ai fait ce que j'ai vu,"* Paris, 1994, pp. 43, 48, 49–51, ill. in color (overall and detail) [English ed., 1995, pp. 3, 43, 49–51, 116, ill. in color (overall and detail)]; Gary Tinterow et al., *Corot,* exh. cat., Metropolitan Museum of Art, New York, 1996, p. 329, fig. 143, under no. 140 [French ed., 1996, p. 390, ill.]; Michael Fried, *Manet's Modernism: or, The Face of Painting in the 1860s,*

Chicago, 1996, pp. 1, 88, 145–46, 284, 295, 324, 326, 334, 338, 468 n. 18, p. 469 n. 26, pp. 491–92 nn. 144–45, 147, colorpl. 5; Hans Körner, *Édouard Manet: Dandy, flaneur, maler,* Munich, 1996, pp. 42, 44, colorpl. 32; Beth Archer Brombert, *Édouard Manet: Rebel in a Frock Coat,* Boston, 1996, pp. 117, 119–20, 130, 433; Alan Krell, *Manet and the Painters of Contemporary Life,* London, 1996, pp. 42–43, 49, 107, fig. 35; Colin B. Bailey, ed., *Renoir's Portraits: Impressions of an Age,* exh. cat., National Gallery of Canada, New Haven, 1997, pp. 27–28, 64–65; Fred Licht, *Manet,* Milan, 1998, pp. 33–35, pl. 11; Paul Hayes Tucker, ed., *Manet's "Le déjeuner sur l'herbe,"* Cambridge, 1998, pp. 17–18, fig. 10, 119–20, 136, 138; George Mauner and Henri Loyrette, *Manet: The Still-Life Paintings,* exh. cat., Musée d'Orsay, New York, 2000, p. 14, fig. 3 (color) [French ed., 2000, pp. 30–31, fig. 3 (color)]; Richard R. Brettell, *Impression: Painting Quickly in France, 1860–1890,* exh. cat., National Gallery, London, New Haven, 2000, pp. 78, 80, fig. 39 (detail in color); Nancy Locke, *Manet and the Family Romance,* Princeton, 2001, pp. 56, 62, 81, 100, 104, 119, 128, 194 n. 168, fig. 23; Peter Meller, "Manet in Italy: Some Newly Identified Sources for his Early Sketchbooks," *Burlington Magazine* 144, February 2002, p. 81 n. 67; Carol Armstrong, *Manet Manette,* New Haven, 2002, pp. 11, 15–16, 20, 40, 72, 82–83, 94, 99, 112–14, 139, 149–50, 157, 160, 162, 344 nn. 2 and 4, p. 353 n. 9, ill. pp. 27, 134 (color detail), and colorpl. 66

Fishing
ca. 1862–63
Oil on canvas
30¼ x 48½ in. (76.8 x 123.2 cm)
Signed (lower left, on raft): éd.Manet
Purchase, Mr. and Mrs. Richard J. Bernhard Gift, 1957
57.10
See no. 55

PROVENANCE
The artist, Paris (until d. 1883; or the artist's mother, Mme Eugénie-Désirée Manet, Paris [in 1883]; possibly the artist's brother, Eugène Manet, Paris [by 1885; exchanged with Suzanne Manet for "Mme Manet à jardin, Bellevue"]; possibly the artist's widow, Suzanne Manet, Paris [1883 or 1885–97; sold 1897 for Fr 3,500 to Camentron]); [Camentron, Paris, 1897; sold April 4, 1897, to Durand-Ruel]; [Durand-Ruel, Paris, 1897–1950, stock no. D-R 4145, Depot no. 8968; sold June 20, 1950, to Société Artistique George V]; [Société Artistique George V, Paris, 1950–about 1956]; [Sam Salz, New York, about 1956–57; sold to the Metropolitan Museum]

EXHIBITIONS
"Tableaux de M. Édouard Manet,"Avenue de l'Alma, Paris, May 1867, no. 50; "Édouard Manet, 1832–1883," Galerie Matthiesen, Berlin, February 6–March 18, 1928, no. 5; "Exposition d'oeuvres de Manet au profit des 'Amis du Luxembourg,'" Bernheim-Jeune, Paris, April 14–May 4, 1928, no. 15 (possibly this picture); "Exposition Manet, 1832–1883," Musée de l'Orangerie, Paris, June–July 1932, no. 14; "XIXe Biennale internazionale d'arte," Biennale, Venice, 1934, no. 1; "Golden Gate International Exposition," Palace of Fine Arts, San Francisco, 1940, no. 274; "Manet, 1832–1883," Galeries Nationales du Grand Palais, Paris, April 22–August 1, 1983, Metropolitan Museum of Art, New York, September 10–November 27, 1983, no. 12; "Copier créer, de Turner à Picasso: 200 oeuvres inspirées par les maîtres du Louvre," Musée du Louvre, Paris, April 26–July 26, 1993, no. 316; "Manet," Fondation Pierre Gianadda, Martigny, Switzerland, June 5–November 11, 1996, no. 8; "Manet en el Prado," Museo Nacional del Prado, Madrid, October 13, 2003–February 8, 2004, no. 28

SELECTED REFERENCES
Théodore Duret, Histoire d'Édouard Manet et de son oeuvre, Paris, 1902, pp. 100–101, 201, no. 33 [German ed., "Édouard Manet: Sein Leben und Seine Kunst," Berlin, 1910, pp. 134, 255, no. 33]; Julius Meier-Graefe, Édouard Manet, Munich, 1912, pp. 123–24, fig. 59; Théodore Duret, trans. J. E. Crawford Flitch, Manet and the French Impressionists, London, 1912 [1st ed., 1910], p. 224, no. 33; Étienne Moreau-Nélaton, Manet raconté par lui-même, 2 vols., Paris, 1926, vol. 1, pp. 29–30, fig. 16; Paul Jamot, "Études sur Manet," Gazette des beaux-arts 15, 1927, pér. 5, pp. 38–40, 42, ill.; A. Tabarant, Manet, Histoire catalographique, Paris, 1931, pp. 60–61, no. 35; Paul Jamot and Georges Wildenstein, Manet, 2 vols., Paris, 1932, vol. 1, pp. 57, 106, 108, 117, no. 30; vol. 2, fig. 13; Germain Bazin, "Manet et la tradition," L'Amour de l'art, May 1932, pp. 153–55, figs. 18 and 21 (overall and detail); Marcel Guérin, L'Oeuvre gravé de Manet, Paris, 1944, unpaginated, under no. 1; A. Tabarant, Manet et ses oeuvres, 4th ed., Paris, 1947 [1st ed., 1942], pp. 34–36, 61–62, 524, 534, no. 29, fig. 29; Michel Florisoone, Manet, Monaco, 1947, pp. XV, XVII, pl. 11; Nils Gösta Sandblad, trans. Walter Nash, Manet: Three Studies in Artistic Conception, Lund, 1954, pp. 42–45, 89–90, 170 n. 46, p. 171 n. 47, fig. 3; Charles Sterling and Margaretta M. Salinger, French Paintings: A Catalogue of the Collection of The Metropolitan Museum of Art, 3 vols., New York, 1955–67, vol. 3, pp. 25–27, ill.; James J. Rorimer and Dudley T. Easby Jr., "Review of the Year 1956–1957," Metropolitan Museum of Art Bulletin 16, October 1957, n.s., p. 38, ill. p. 44; Alain de Leiris, "Manet's 'Christ Scourged' and the Problem of His Religious Paintings," Art Bulletin 61, March 1959, p. 199 n. 6; Theodore Reff, "The Meaning of Manet's Olympia," Gazette des beaux-arts 63, February 1964, pér. 6, p. 116; Anne Coffin Hanson, Édouard Manet, 1832–1883, exh. cat., Philadelphia Museum of Art, Philadelphia, 1966, pp. 46–47, 49, no. 11, ill.; Sandra Orienti et al., The Complete Paintings of Manet, New York, 1967, p. 90, no. 34, ill.; Alan Bowness, "Manet and Mallarmé," Philadelphia Museum of Art Bulletin 62, April–June 1967, p. 213; Alan Bowness, "Manet at Philadelphia," Burlington Magazine 109, March 1967, p. 189, fig. 114; Beatrice Farwell, "Manet's 'Espada' and Marcantonio," Metropolitan Museum Journal 2, 1969, p. 206; Michael Fried, "Manet's Sources," Artforum 7, March 1969, pp. 28–29, 33–34, 50, 52, 69 nn. 35, 36d, p. 71 n. 69, ill.;

Theodore Reff, "'Manet's Sources': A Critical Evaluation," Artforum 8, September 1969, p. 46; Theodore Reff, "Manet and Blanc's 'Histoire des peintres,'" Burlington Magazine 112, July 1970, pp. 456–57; Jean C. Harris, Édouard Manet: Graphic Works, A Definitive Catalogue Raisonné, New York, 1970, p. 30, under no. 4; Germain Bazin, trans. Maria Paola de Benedetti, Édouard Manet, Milan, 1972, p. 85, fig. 1 [French ed., 1974]; George Mauner, Manet, Peintre-Philosophe: A Study of the Painter's Themes, University Park, Pa., 1975, pp. 21–22, 24–27, 149, figs. 11, 16, 17 (overall and details); Denis Rouart and Daniel Wildenstein, Édouard Manet, Catalogue raisonné, 2 vols., Paris, 1975, vol. 1, pp. 52, no. 36, ill. p. 53, vol. 2, pp. 96, 136; Theodore Reff, "Review of Ref. Rouart and Wildenstein 1975," Art Bulletin 58, December 1976, p. 635–36; Anne Coffin Hanson, Manet and the Modern Tradition, New Haven, 1977, pp. 56, 94, 161, pl. 65; Denys Sutton, Romance and Reality: Aspects of Landscape Painting, exh. cat., Wildenstein and Co., Inc., New York, 1978, p. 7; Theodore Reff, Manet and Modern Paris, exh. cat., National Gallery of Art, Washington, D.C., 1982, pp. 16–17, fig. 5; Pierre Daix, La vie de peintre d'Édouard Manet, Paris, 1983, pp. 64–65; Jay McKean Fisher, The Prints of Édouard Manet, exh. cat., Detroit Institute of Arts, Washington, D.C., 1985, pp. 38–39, under no. 7; Kathleen Adler, Manet, Oxford, 1986, pp. 31–32, 51, fig. 18; Éric Darragon, Manet, Paris, 1989, pp. 56–57, 65; Françoise Cachin, Manet [Paris], 1990, p. 30, fig. 2 (color); T. A. Gronberg, Manet: A Retrospective, New York, 1990, colorpl. 5; Éric Darragon, Manet, Paris, 1991, pp. 68–69, 72, 298, fig. 34 (color); Peter C. Sutton, The Age of Rubens, exh. cat., Museum of Fine Arts, Boston, Boston, 1993, pp. 94–95, fig. 120; Vivien Perutz, Édouard Manet, Lewisburg, Pa., 1993, pp. 66, 97–98, fig. 37; Henri Loyrette et al., in Origins of Impressionism, exh. cat., Metropolitan Museum of Art, New York, 1994, pp. 120, 402, fig. 157 [French ed., 1994, pp. 120, 399, fig. 157]; Michael Fried, Manet's Modernism: or, The Face of Painting in the 1860s, Chicago, 1996, pp. 25–26, 37, 40, 82, 86–87, 470–71 nn. 33–34, p. 488 n. 127, p. 491 n. 143, p. 513 n. 37, fig. 2; Hans Körner, Édouard Manet: Dandy, flaneur, maler, Munich, 1996, pp. 29–32, 35, fig. 21 (color); Beth Archer Brombert, Édouard Manet: Rebel in a Frock Coat, Boston, 1996, pp. 75, 80–81, 85, 110–11, 143, 186, 209, 400; Alan Krell, Manet and the Painters of Contemporary Life, London, 1996, pp. 14–18, 39, fig. 7; Paul Hayes Tucker, ed., Manet's "Le déjeuner sur l'herbe," Cambridge, 1998, pp. 23, 34 n. 32, 35 n. 33, 137, fig. 14; Joanna Szczepinska-Tramer, "Manet et 'Le déjeuner sur l'herbe,'" Artibus et historiae 19, no. 38, 1998, pp. 183–187, 189 nn. 31, 33, 42, fig. 4; Nancy Locke, Manet and the Family Romance, Princeton, 2001, pp. 65, 71–72, 74, 78–79, 81–83, 121, 145, 192 n. 114, p. 194 nn. 155, 157, fig. 30, ill. (book jacket in color); Carol Armstrong, Manet Manette, New Haven, 2002, pp. 11, 15, 26–27, 305, 326 n. 35, ill. p. 29

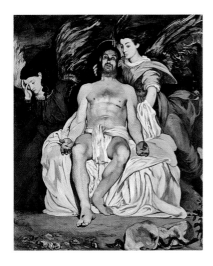

The Dead Christ with Angels
1864
Oil on canvas
70⅝ x 59 in. (179.4 x 149.9 cm)
Signed and inscribed: (lower left) Manet; (lower right, on rock) évang[ile]. sel[on]. St. Jean / chap[ître]. XX v. XII (Gospel according to Saint John, chapter 20, verse 12)
H. O. Havemeyer Collection, Bequest of Mrs. H. O. Havemeyer, 1929
29.100.51
See no. 58

PROVENANCE
The artist, Paris (1864–72; sold in January for Fr 3,000 to Durand-Ruel); [Durand-Ruel, Paris, from 1872, stock no. 959]; private collection, possibly Paris (in 1877; sold for Fr 7,000 to Durand-Ruel); [Durand-Ruel, from 1877, stock no. 1046]; private collection, possibly Paris (until 1881; sold June 4 to Durand-Ruel); [Durand-Ruel, Paris, 1881–1900, stock no. 19); deposited at Durand-Ruel, New York, on February 27, 1895 (deposit no. 5253); sold on November 16 (Paris stock book), or November 17 (New York stock book, no. 2411), for Fr 4,050 to Durand-Ruel]; [Durand-Ruel, New York, 1900–1903; sold, February 7 for $17,000 to Havemeyer]; Mr. and Mrs. H. O. Havemeyer, New York (1903–his d. 1907); Mrs. H. O. (Louisine W.) Havemeyer, New York (1907–d. 1929)

EXHIBITIONS
Salon, Paris, May 1, 1864–?, no. 1281; "Tableaux de M. Édouard Manet," avenue de l'Alma, Paris, May 1867, no. 7; "Fourth Exhibition of the Society of French Artists," Durand-Ruel, London, summer 1872, no. 91; "Catalogue of the Art Department Foreign Exhibition," location unknown, Boston, 1883, no. 1; "Paintings by Édouard Manet," Durand-Ruel, New York, 1895, no. 8; "Loan Exhibition of Paintings at the Carnegie Institute," Carnegie Institute, Pittsburgh, November 6, 1902–January 1, 1903, no. 94; "The H. O. Havemeyer Collection," Metropolitan Museum of Art, New York, March 10–November 2, 1930, no. 75; "Exposition Manet, 1832–1883," Musée de l'Orangerie, Paris, June–July 1932, no. 20; "Twentieth Anniversary Exhibition," Cleveland Museum of Art, June 26–October 4, 1936, no. 285; "Masterpieces of Art: European and American Paintings, 1500–1900," World's Fair, New York, May–October 1940, no. 281; "'What They Said'—Postscript to Art Criticism," Durand-Ruel, New York, November 28–December 17, 1949, no. 2; "Baudelaire," Petit Palais, Paris, November 23, 1968–March 17, 1969, no. 581; "Manet, 1832–1883," Galeries Nationales du Grand

Palais, Paris, April 22–August 1, 1983, Metropolitan Museum of Art, New York, September 10–November 27, 1983, no. 74; "Splendid Legacy: The Havemeyer Collection," Metropolitan Museum of Art, New York, March 27–June 20, 1993, no. A346; "Origins of Impressionism," Galeries Nationales du Grand Palais, Paris, April 19–August 8, 1994, Metropolitan Museum of Art, New York, September 27, 1994–January 8, 1995, no. 96; "Manet/Velázquez: La manière espagnole au XIXe siècle," Musée d'Orsay, Paris, September 16, 2002–January 12, 2003, no. 85, "Manet/Velázquez: The French Taste for Spanish Painting," Metropolitan Museum of Art, New York, March 4–June 8, 2003, no. 142; "Manet en el Prado," Museo Nacional del Prado, Madrid, October 13, 2003–February 8, 2004, no. 63

SELECTED REFERENCES

Léon Lagrange, "Le Salon de 1864," *Gazette des beaux-arts* 16, 1864, p. 515; *Vie parisienne,* May 1, 1864; G. de Sault, *Le temps,* May 12, 1864; Hector de Callias, "Salon de 1864," *L'Artiste* 1, June 1, 1864, p. 242; Edmond About, *Le petit journal,* June 3, 1864; Raoul de Navery, "Salon de 1864," *La gazette des étrangers,* June 7, 1864; Étienne-Joseph-Théophile Thoré, "Au Salon de 1864," *L'Indépendance belge,* June 15, 1864; Paul de Saint-Victor, "Salon de 1864," *La presse,* June 19, 1864, p. 3; Théophile Gautier, *Le moniteur universel,* June 25, 1864, p. 876; Georges Barral, *Salon de 1864, Vingt-sept pages d'arret!!!,* Paris, 1864; Le Hanneton, *Journal des Toques,* June 26, 1864; J. du Pays, "Salon de 1864," *L'Illustration,* July 1, 1864; Émile Zola, "Une nouvelle manière en peinture: Édouard Manet," *Revue du XIXe siècle* 4, January 1, 1867, 8 sér., p. 57; Émile Zola, *Éd. Manet: Étude biographique et critique, accompagnée d'un portrait d'Éd. Manet par Bracquemond, et d'une eau-forte d'Éd. Manet, d'après "Olympia,"* Paris, 1867, p. 34; Jules-Michel Godet, *Oeuvres de M. Ed. Manet (24 photographies),* Paris, April 20, 1872, no. 20, ill.; Junius, "M. Édouard Manet," *Le gaulois,* April 25, 1876; Philippe de Chennevières, "Le comte Clément de Ris et les expositions du temps de l'empire," *L'Artiste* 1, May 1883, p. 323; Edmond Bazire, *Manet,* Paris, 1884, pp. 40–41; *L'Art français,* November 15, 1890, ill.; Théodore Duret, *Histoire d'Édouard Manet et de son oeuvre,* Paris, 1902, pp. 27, 206, no 56; Hugo v. Tschudi, *Édouard Manet,* Berlin, 1902, p. 19; Charles Baudelaire, *Lettres 1846–1866,* Paris, 1907, pp. 361–62; Jean Laran and Georges Le Bas, *Manet,* Paris, 1912, pp. 37–38, pl. XI; Julius Meier-Graefe, *Édouard Manet,* Munich, 1912, pp. 71–76, 312, fig. 39; Théodore Duret, trans. J. E. Crawford Flitch, *Manet and the French Impressionists,* London, 1912 [1st ed., 1910], pp. 35, 225, no. 56; Kenyon Cox, "Academicism and the National Academy of Design," *The Art World* 2, August 1917, p. 427, fig. 3; F. Wellington Ruckstuhl, "Remarks by the Editors on Illustrations," *The Art World* 2, August 1917, p. 430, ill.; Ambroise Vollard, *Auguste Renoir (1841–1919),* Paris, 1920, 5th ed., p. 44; Emil Waldmann, *Édouard Manet,* Berlin, 1923, pp. 27, 37, ill.; [A.] Tabarant, "Manet, Peintre religieux, "*Bulletin de la vie artistique,* 4e année, no. 12, June 15, 1923, pp. 247, 249–50, ill.; Arsène Alexandre, "Manet, académicien sans fauteuil," *La renaissance* 6 année, no. 9, September 1923, p. 489, ill.; Camille Mauclair, *Les maitres de l'impressionnisme, Leur histoire, leur esthétique, Leurs oeuvres,* 1923 [1st ed., 1903; 2nd ed., 1904]; J[acques]-É[mile] Blanche, trans. F. C. de Sumichrast, *Manet,* London, 1925, pp. 35–36, pl. 12; Étienne Moreau-Nélaton, *Manet raconté par lui-même,* 2 vols., Paris, 1926, vol. 1, pp. 56–59, 133, fig. 58; Ambroise Vollard, trans. Randolph T. Weaver, *Degas, An Intimate Portrait,* New York, 1927, pp. 99–100; Frank Jewett Mather Jr., "The Havemeyer

Pictures," *The Arts* 16, March 1930, pp. 444, 478, ill.; A. Tabarant, "Les Manet de la collection Havemeyer," *La renaissance* 13, February 1930, pp. 59, 64, 66, ill.; A. Tabarant, *Manet, Histoire catalographique,* Paris, 1931, pp. 116–19, 577, no. 72; Paul Jamot and Georges Wildenstein, *Manet,* 2 vols., Paris, 1932, vol. 1, pp. 27, 126–27, no. 85, vol. 2, fig. 22; Germain Bazin, "Manet et la tradition," *L'Amour de l'art,* May 1932, p. 155; Paul Colin, *Édouard Manet,* Paris, 1932, pp. 24, 28, 74; Daniel Catton Rich, "The Spanish Background for Manet's Early Work," *Parnassus* 4, February 1932, p. 4; Michel Florisoone, "Manet inspiré par Venise," *L'Amour de l'art* 18, January 1937, pp. 26–27, ill.; Lionello Venturi, *Les archives de l'impressionnisme,* Paris, 1939, vol. 2, p. 191, no. 54; Gotthard Jedlicka, *Édouard Manet,* Zurich, 1941, pp. 86–87, 313, 360, 397 n. 9; Marcel Guérin, *L'Oeuvre gravé de Manet,* Paris, 1944, unpaginated, under no. 34; Louis Piérard, *Manet l'incompris,* Paris, 1944, pp. 75–76, 80; Ima N. Ebin, "Manet and Zola," *Gazette des beaux-arts* 27, June 1945, p. 362, fig. 2; Hans Huth, "Impressionism Comes to America," *Gazette des beaux-arts* 29, April 1946, sér. 6, pp. 230–31, fig. 5; A. Tabarant, *Manet et ses oeuvres,* Paris, 1947, 4th ed. (1st. ed., 1942), pp. 81–84, 87, 136, 173, 195, 535, no. 71, fig. 71; Edgar Wind, "Traditional Religion and Modern Art," *Art News* 52, May 1953, pp. 19–20, ill.; George Heard Hamilton, *Manet and His Critics,* New Haven, 1954, pp. 55–63, pl. 12; Nils Gösta Sandblad, trans. Walter Nash, *Manet: Three Studies in Artistic Conception,* Lund, 1954, pp. 101–2, 150, 157; Charles Sterling and Margaretta M. Salinger, *French Paintings: A Catalogue of the Collection of The Metropolitan Museum of Art,* 3 vols., New York, 1955–67, vol. 3, pp. 36–40, ill.; Vladimir Gurewich, "Observations on the Iconography of the Wound in Christ's Side, with Special Reference to its Position," *Journal of the Warburg and Courtauld Institutes* 20, July 1957, pp. 358, 362, pl. 26-a; John Richardson, *Édouard Manet: Paintings and Drawings,* London, 1958, p. 121, no. 22, colorpl. 22; Alain de Leiris, "Manet's 'Christ Scourged' and the Problem of His Religious Paintings," *Art Bulletin* 61, March 1959, pp. 198–99 n. 7; François Daulte, "Le marchand des impression-nistes," *L'Oeil,* no. 66, June 1960, p. 58; John Rewald, *The History of Impressionism,* New York, 1961, rev., enlarged ed. [1st ed., 1946, p. 92], pp. 106, 136 n. 22; Pierre Courthion, *Édouard Manet,* New York, 1962, pp. 34, 78–79, color ill.; A. Tabarant, *La vie artistique au temps de Baudelaire* [Paris], 1963, 2nd ed. [1st ed., 1942], pp. 335–36, 345, 415; Anne Coffin Hanson, *Édouard Manet, 1832–1883,* exh. cat., Philadelphia Museum of Art, 1966, pp. 88–89, 91, under no. 70; Sandra Orienti et al., *The Complete Paintings of Manet,* New York, 1967, p. 93, no. 64, ill.; Robert Caby, "Études inédites de Manet pour le 'Christ aux anges,'" *Bulletin de la Société d'Études pour la Connaissance d'Édouard Manet,* no. 1, June 1967, pp. 22–24, figs. 1–5 (related studies); Joel Isaacson, *Manet and Spain, Prints and Drawings,* exh. cat., Museum of Art, University of Michigan, Ann Arbor, 1969, pp. 12, 36–37, under no. 26; Alain de Leiris, *The Drawings of Édouard Manet,* Berkeley, 1969, p. 64; Michael Fried, "Manet's Sources," *Artforum* 7, March 1969, pp. 29, 54–57, 64, 66–67, 69 n. 19, p. 76 nn. 163–64a, ill.; Theodore Reff, "'Manet's Sources': A Critical Evaluation," *Artforum* 8, September 1969, pp. 42, 47; Anne Coffin Hanson, "Édouard Manet, 'Les Gitanos,' and the Cut Canvas," *Burlington Magazine* 112, March 1970, p. 158; Theodore Reff, "Manet and Blanc's 'Histoire des peintres,'" *Burlington Magazine* 112, July 1970, p. 457; Jean C. Harris, *Édouard Manet: Graphic Works, A Definitive Catalogue*

Raisonné, New York, 1970, p. 145; George Mauner, *Manet, Peintre-Philosophe: A Study of the Painter's Themes,* University Park, Pa., 1975, pp. 111–15, 140, 146, 159, figs. 58–59 (overall and detail); Denis Rouart and Daniel Wildenstein, *Édouard Manet, Catalogue raisonné,* 2 vols., Paris, 1975, vol. 1, pp. 13, 17, 82–83, no. 74, ill., vol. 2, p. 74; Bernard Dorival, "Quelques sources méconnues de divers ouvrages de Manet: De la sculpture gothique à la photographie," *Bulletin de la Société de l'Histoire de l'Art Français* (1976), 1975, pp. 320, 339, fig. 10; Theodore Reff [review of *Édouard Manet, Catalogue raisonné*] *Art Bulletin* 58, December 1976, p. 637; Theodore Reff, *Manet: Olympia,* New York, 1976, p. 45; Anne Coffin Hanson, *Manet and the Modern Tradition,* New Haven, 1977, pp. 22–23, 25, 83 n. 133, pp. 104–10, 167, pl. 75; Seymour Howard, "Early Manet and Artful Error: Foundations of Anti-Illusion in Modern Painting, "*Art Journal* 37, fall 1977, p. 15; Sharon Flescher, *Zacharie Astruc: Critic, Artist and Japoniste,* published Ph.D. dissertation, Columbia University, 1977, New York, 1978, pp. 169–70; William Hauptman, "Manet's Portrait of Baudelaire: An Emblem of Melancholy," *Art Quarterly* 1, 1978, p. 232 figs. 14–15 (overall and detail); Piero Dini and Alba del Soldato, *Diego Martelli,* Florence, 1978, p. 175; Albert Boime, *Thomas Couture and the Eclectic Vision,* New Haven, 1980, p. 463; Alain de Leiris, "Manet and El Greco: 'The Opera Ball,'" *Arts Magazine* 55, September 1980, pp. 97, 99 n. 17; Klaus Kertess, "Figuring it Out," *Artforum* 19, November 1980, pp. 30–31, ill.; Jennifer M. Sheppard, "The Inscription in Manet's 'The Dead Christ, with Angels,'" *Metropolitan Museum Journal* 16, 1981, pp. 199–200, ill. (overall and detail); Beatrice Farwell, published Ph.D. disser-tation, *Manet and the Nude: A Study in Iconography in the Second Empire* (1973), New York, 1981, pp. viii, 128–30, 309 n. 138, fig. 74; Pierre Daix, *La vie de peintre d'Édouard Manet,* Paris, 1983, pp. 123, 125–26, 137; Charles F. Stuckey, *Manet,* Mount Vernon, N.Y., 1983, pp. 9–10, colorpl. 6; Jane Mayo Roos, "Édouard Manet's 'Angels at the Tomb of Christ': A Matter of Interpretation," *Arts Magazine* 58, April 1984, pp. 83–91, figs. 1, 5–6 (overall and details); Charles S. Moffett, *Impressionist and Post-Impressionist Paintings in The Metropolitan Museum of Art,* New York, 1985, pp. 31–32, color ill.; Ziva Amishai-Maisels, *Gauguin's Religious Themes,* pub-lished Ph.D. dissertation, Hebrew University, 1969, New York, 1985, p. 103; Michael Paul Driskel, "Manet, Naturalism, and the Politics of Christian Art," *Arts Magazine* 60, November 1985, pp. 44–45, fig. 3; Gabriel P. Weisberg, "From the Real to the Unreal: Religious Painting and Photography at the Salons of the Third Republic,' *Arts Magazine* 60, December 1985, pp. 58–59, 63, fig. 1; Frances Weitzenhoffer, *The Havemeyers: Impressionism Comes to America,* New York, 1986, pp. 102, 147, 255, pl. 118; Kathleen Adler, *Manet,* Oxford, 1986, pp. 65, 67–68, colorpl. 54; Richard R. Brettell, *French Salon Artists: 1800–1900,* Chicago, 1987, pp. 55, 59; Ekkehard Mai, *Triomphe et mort du héros: La peinture d'histoire en Europe de Rubens à Manet,* exh. cat., Musée des Beaux-Arts de Lyon, Milan, 1988, pp. 141, 260, 262, fig. 102; Éric Darragon, *Manet,* Paris, 1989, pp. 96–98, 109; Juliet Wilson-Bareau, *Manet by Himself, Correspondence and Conversation: Paintings, Pastels, Prints, and Drawings,* London, 1991, p. 32; Éric Darragon, *Manet,* Paris, 1991, pp. 136, 142–46, 212, 372, colorpl. 75; Richard Wrigley, *Édouard Manet,* London, 1991, pp. 16–17, 23, colorpl. 7; Sarah Carr-Gomm, *Manet,* London, 1992, pp. 70–71, 140, color ill.; Louisine W. Havemeyer, *Sixteen to Sixty: Memoirs of a Collector,* New York, 1993, 3rd ed. with notes by Susan Alyson

Stein [1st ed., 1930; repr. 1961], pp. 220, 236–37, 333 n. 316, p. 335 n. 343; Vivien Perutz, *Édouard Manet*, Lewisburg, Pa., 1993, pp. 80, 112–16, colorpl. 19; Kermit Swiler Champa, *'Masterpiece' Studies: Manet, Zola, Van Gogh, and Monet*, University Park, Pa., 1994, pp. 41–42, 46; Dolores Mitchell, "Manet's 'Olympia': If Looks could Kill," *Source* 13, spring 1994, pp. 39, 41–46 n. 22, fig. 2; Françoise Cachin, *Manet: "J'ai fait ce que j'ai vu,"* Paris, 1994, pp. 62– 63, 65, color ill. [English ed., 1995, pp. 62–63, 65, color ill.]; Michael Fried, *Manet's Modernism: or, The Face of Painting in the 1860s*, Chicago, 1996, pp. 1, 91–95, 100, 122–23, 132, 157–60, 164, 175, 281–82, 308, 310–18, 357, 494–95 nn. 160, 162, p. 518 n. 77, p. 578 n. 134, p. 579 n. 135, p. 580 n. 145, colorpl. 6, fig. 148 (overall and detail); Hans Körner, *Édouard Manet: Dandy, flaneur, maler*, Munich, 1996, pp. 83–86, colorpl. 67; Beth Archer Brombert, *Édouard Manet: Rebel in a Frock Coat*, Boston, 1996, pp. 148, 150–53, 158, 170–71, 220, fig. 17; Gary Tinterow et al., *La collection Havemeyer: Quand l'Amérique découvrait l'impressionnisme*, exh. cat., Musée d'Orsay, Paris, 1997, pp. 56–57, 108, fig. 24; Fred Licht, *Manet*, Milan, 1998, p. 45, fig. 23; Richard R. Brettell, *Impression: Painting Quickly in France, 1860–1890*, exh. cat., National Gallery (London), New Haven, 2000, p. 80, colorpl. 41 (detail); Nancy Locke, *Manet and the Family Romance*, Princeton, 2001, pp. 3, 137–39, fig. 69; Peter Meller, "Manet in Italy: Some Newly Identified Sources for His Early Sketchbooks," *Burlington Magazine* 144, February 2002, pp. 74–75, fig. 28 (color); Carol Armstrong, *Manet Manette*, New Haven, 2002, pp. 11, 14, 17, 28, 40, 41, 99, 157–58, 271, 355 n. 23, p. 362 n. 4, ill. (no. 7 and fig. 70); Arden Reed, *Manet, Flaubert, and the Emergence of Modernism: Blurring Genre Boundaries*, Cambridge, 2003, pp. 5, 7, fig. 1 (detail)

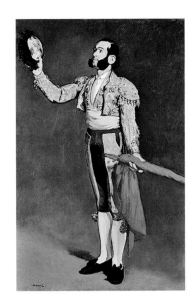

A Matador
ca. 1866–67
Oil on canvas
67⅜ x 44½ in. (171.1 x 113 cm)
Signed (lower left): Manet
H. O. Havemeyer Collection, Bequest of Mrs. H. O. Havemeyer, 1929
29.100.52
See no. 59

PROVENANCE
The artist, Paris (until 1870; sold, possibly September for Fr 1,200 to Duret); Théodore Duret, Paris (1870–94; his sale, Galerie Georges Petit, Paris, March 19, no. 20, for Fr 10,500 to Durand-Ruel and Faure); [Durand-Ruel, Paris, and Jean-Baptiste Faure, owned jointly until Faure sold his half share to Durand-Ruel on December 21, 1898, stock no. 2965, sold, October 25, 1894, to Durand-Ruel]; [Durand-Ruel, New York, 1894–95, stock no. 1223, sold, August 31 to Durand-Ruel]; [Durand-Ruel, Paris, 1895–98; on deposit with Durand-Ruel, New York, August 31, 1895–December 31 (deposit no. 5350); New York stock no. 2073, sold, December 21 (Paris stock book) or December 31, 1898 (New York stock book), for Fr 20,000 to Durand-Ruel]; [Durand-Ruel, New York, 1898; sold, December 31 for $8,000 to Havemeyer]; Mr. and Mrs. H. O. Havemeyer, New York (1898–his d. 1907); Mrs. H. O. (Louisine W.) Havemeyer, New York (1907–d. 1929)

EXHIBITIONS
The artist's studio, spring 1866, no catalogue; "Tableaux de M. Édouard Manet," avenue de l'Alma, Paris, May 1867, no. 16; "Salon des amis des arts de Bordeaux," Galerie de la Société des Amis des Arts, Bordeaux, 1869, no. 409; "Exposition des oeuvres de Édouard Manet," École Nationale des Beaux-Arts, Paris, January 6–28, 1884, no. 34; "Paintings by Édouard Manet," Durand-Ruel, New York, 1895, no. 24; "Buffalo Society of Artists Fifth Annual Exhibition," Buffalo Society of Artists, 1896, no. 56; "Second Annual Exhibition," Carnegie Institute, Pittsburgh, November 4, 1897–January 1, 1898, no. 139; "Loan Exhibition of Pictures by Modern Artists," Copley Hall and Allston Hall, Boston, March 7–28, 1898, no. 58; "The H. O. Havemeyer Collection," Metropolitan Museum of Art, New York, March 10–November 2, 1930, no. 78; "Manet and Renoir," Pennsylvania Museum of Art, Philadelphia, November 29, 1933–January 1, 1934, no catalogue;

"Thirty-eight Great Paintings from the Metropolitan Museum of Art," Detroit Institute of Arts, October 1–October 29, 1951, Art Gallery of Toronto, November 14–December 12, 1951, City Art Museum of St. Louis, January 6–February 4, 1952, Seattle Art Museum, March 1–June 30, 1952, no catalogue; "Masterpieces of Painting in The Metropolitan Museum of Art," Museum of Fine Arts, Boston, September 16–November 1, 1970; "Manet, 1832–1883," Metropolitan Museum of Art, New York, September 10–November 27, 1983, no. 92; "Treasures from The Metropolitan Museum of Art: French Art from the Middle Ages to the Twentieth Century," Yokohama Museum of Art, March 25–June 4, 1989, no. 88; "Splendid Legacy: The Havemeyer Collection," Metropolitan Museum of Art, New York, March 27–June 20, 1993, no. A348; "Manet/Velázquez: La manière espagnole au XIXe siècle," Musée d'Orsay, Paris, September 16, 2002–January 12, 2003, no. 94, "Manet/Velázquez: The French Taste for Spanish Painting," Metropolitan Museum of Art, New York, March 4–June 8, 2003, no. 149

SELECTED REFERENCES
Émile Vallet, *Courrier de la Gironde*, 1869; Edmond Bazire, *Manet*, Paris, 1884, pp. 21, 139, ill. (engraving by Guérard); Louis Gonse, "Manet," *Gazette des beaux-arts* 29, February 1884, pér. 2 , p. 142; Joséphin Péladan, "Le procédé de Manet d'après l'exposition de l'École des Beaux-Arts," *L'Artiste* 1, February 1884, 54 année, p. 110; Théodore Duret, *Histoire d'Édouard Manet et de son oeuvre*, Paris, 1902, pp. 179, 212, no. 78; Emil Waldmann, "Französische Bilder in Amerikanischem Privatbesitz, Part 1," *Kunst und Künstler* 9, November 1910, p. 93, ill., "Französische Bilder in Amerikanischem Privatbesitz, Part 2," [December] 1910, p. 134; Julius Meier-Graefe, *Édouard Manet*, Munich, 1912, pp. 153–54 n. 1, 316, fig. 72; Théodore Duret, trans. J. E. Crawford Flitch, *Manet and the French Impressionists*, London, 1912 [1st ed. 1910], p. 227, no. 78; Emil Waldmann, *Édouard Manet*, Berlin, 1923, pp. 32, 39, 46, ill.; J[acques]-É[mile] Blanche, trans. F. C. de Sumichrast, *Manet*, London, 1925, p. 42; Étienne Moreau-Nélaton, *Manet raconté par lui-même*, 2 vols., Paris, 1926, vol. 1, pp. 76, 137, fig. 76, vol. 2, 128, no. 34, fig. 342; A. Tabarant, "Autour de Manet," *L'Art vivant* 4, May 4, 1928, p. 349; A. Tabarant, "Les Manet de la collection Havemeyer," *La renaissance* 13, February 1930, pp. 61, 69, ill.; A. Tabarant, *Manet, histoire catalographique*, Paris, 1931, pp. 152–54, no. 113; Paul Jamot and Georges Wildenstein, *Manet*, 2 vols., Paris, 1932, vol. 1, pp. 131–32, no. 124, vol. 2, fig. 44; Paul Colin, *Édouard Manet*, Paris, 1932, p. 74; J[ulius] Meier-Graefe, "The Manet Centenary," *Formes*, no. 24, April 1932, ill.; E. Lambert, "Manet et l'Espagne," *Gazette des beaux-arts* 9, June 1933, pér. 6, p. 375; Robert Rey, trans. Eveline Byam Shaw, *Manet*, New York, 1938, p. 21; Gotthard Jedlicka, *Édouard Manet*, Zurich, 1941, pp. 85, 104, 397 n. 7; A. Tabarant, *Manet et ses oeuvres*, Paris, 1947, 4th ed. (1st. ed., 1942), pp. 121, 124, 137, 183, 491, 512, 536, no. 121, fig. 121; Michel Florisoone, *Manet*, Monaco, 1947, p. XXI; George Heard Hamilton, *Manet and His Critics*, New Haven, 1954, p. 155; Georges Bataille, trans. Austryn Wainhouse and James Emmons, *Manet: Biographical and Critical Study*, New York, 1955, pp. 10, 47, color ill.; Charles Sterling and Margaretta M. Salinger, *French Paintings: A Catalogue of the Collection of The Metropolitan Museum of Art*, 3 vols., New York, 1955–67, vol. 3, pp. 43–44, ill.; Henri Perruchot, *La vie de Manet*, Paris, 1959, pp. 188, 213; A. Tabarant, *La vie artistique au temps de Baudelaire* [Paris], 1963, 2nd ed. [1st ed., 1942], p. 376; Joel Isaacson, *The Early*

Paintings of Claude Monet, unpublished Ph.D. dissertation, University of California, Berkeley, 1967, p. 311 n. 11, p. 313 n. 22; Sandra Orienti et al., *The Complete Paintings of Manet*, New York, 1967, p. 96, no. 102, ill.; Margaretta M. Salinger, "Windows Open to Nature," *Metropolitan Museum of Art Bulletin* 27, Summer 1968, n.s., p. 9, ill.; Merete Bodelsen, "Early Impressionist Sales 1874–94 in the Light of Some Unpublished 'procès verbaux,'" *Burlington Magazine* 110, June 1968, pp. 341, 345; Anthea Callen, "Faure and Manet," *Gazette des beaux-arts* 83, March 1974, pér. 6, pp. 171, 178 nn. 93–94; Denis Rouart and Daniel Wildenstein, *Édouard Manet, Catalogue raisonné*, 2 vols., Paris, 1975, vol. 1, pp. 5, 18, 25, 108–9, no. 111, ill.; Marc Saul Gerstein, *Impressionist and Post-Impressionist Fans*, unpublished Ph.D. dissertation, Harvard University, Cambridge, Mass., 1978, p. 48; Julie Manet, *Journal (1893–1899), Sa jeunesse parmi les peintres impressionnistes et les hommes de lettres*, Paris, 1979, p. 30; Pierre Daix, *La vie de peintre d'Édouard Manet*, Paris, 1983, pp. 150–51; Frances Weitzenhoffer, *The Havemeyers: Impressionism Comes to America*, New York, 1986, pp. 102, 128–29, 255, fig. 81; Kathleen Adler, *Manet*, Oxford, 1986, p. 181; Anne Distel, trans. Barbara Perroud-Benson, *Impressionism: The First Collectors*, New York, 1990, pp. 58, 241, colorpl. 39; Françoise Cachin, *Manet* [Paris], 1990, pp. 62, 158, fig. 2 (color); Éric Darragon, *Manet*, Paris, 1991, pp. 377, 392, colorpl. 85; Louisine W. Havemeyer, *Sixteen to Sixty: Memoirs of a Collector*, New York, 1993, 3rd ed. with notes by Susan Alyson Stein [1st ed., 1930; repr. 1961], pp. 223–24, 307–8 n. 10, p. 333 n. 321; Beth Archer Brombert, *Édouard Manet: Rebel in a Frock Coat*, Boston, 1996, p. 305; Dominique Dussol, *Art et bourgeoisie: La Société des Amis des Arts de Bordeaux (1851–1939)*, Bordeaux, 1997, pp. 218–19, 229, 267, ill. in color (overall and detail); Fred Licht, *Manet*, Milan, 1998, p. 55, fig. 32; Carol Armstrong, *Manet Manette*, New Haven, 2002, pp. 11, 15, 28, 102–3, 344 n. 4, no. 16, figs. 16 and 49; Manuela B. Mena Marqués, ed., *Manet en el Prado*, exh. cat., Museo Nacional del Prado, Madrid, 2003, pp. 54, 63 n. 103, 67, 71–72, 79, 82 n. 49, 190, 225, 354, 387, 393 n. 103, 396, 400, 401 n. 49, 443, 455, 496, fig. 22 (color)

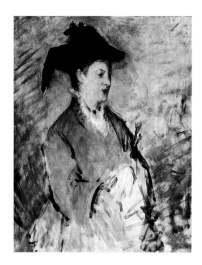

Madame Édouard Manet (Suzanne Leenhoff, 1830–1906)

ca. 1866–69
Oil on canvas
39½ x 30⅞ in. (100.3 x 78.4 cm)
Bequest of Miss Adelaide Milton de Groot
(1876–1967), 1967
67.187.81
See no. 60

PROVENANCE

M. Paul François Marie Antoine Ménard-Dorian, Paris (in 1902); Mme Louise Aline Ménard-Dorian, Paris (by 1910–d. 1929; her sale, Galerie Georges Petit, Paris, December 2, 1929, no. 12, for Fr 155,000 to Durand-Ruel); [Durand-Ruel, Paris, 1929–at least 1933]; Adelaide Milton de Groot, New York (by 1936–d. 1967)

EXHIBITIONS

"Exhibition of French Art: 19th–20th Centuries," Spolku Výtvarných Umelcu, Prague, May–June 1923, no. 84; "Exposition rétrospective de l'art français," Rijksmuseum, Amsterdam, July 3–October 3, 1926, no. 67; "Modern French Painting, From Manet to Matisse," Art Gallery of Toronto, January 1933, no. 22; "Exhibition of Paintings by the Master Impressionists," Durand-Ruel, New York, October 15–November 10, 1934, no. 8 (probably this picture); "Masterpieces from the Collection of Adelaide Milton de Groot," Perls Galleries, New York, April 14–May 3, 1958, no. 2; "Masterpieces from the Adelaide Milton de Groot Collection," Columbus Gallery of Fine Arts, Columbus, Ohio, December 2, 1958–March 1, 1959, no. 23; "Impressionism," Columbia Museum of Art, Columbia, S.C., April 3–May 8, 1960, no. 18; "Manet, 1832–1883," Metropolitan Museum of Art, New York, September 10–November 27, 1983, not in catalogue; "Capolavori impressionisti dei musei americani," Museo di Capodimonte, Naples, December 3, 1986–February 1, 1987, Pinacoteca di Brera, Milan, March 4–May 3, 1987, no. 24; "Corot to Cézanne: 19th Century French Paintings from The Metropolitan Museum of Art," Museum of Art, Fort Lauderdale, December 22, 1992–April 11, 1993, no catalogue

SELECTED REFERENCES

Théodore Duret, *Histoire d'Édouard Manet et de son oeuvre*, Paris, 1902, p. 219, no. 106; Théodore Duret, trans. J. E. Crawford Flitch, *Manet and the French Impressionists*, London, 1912 [1st ed., 1910], p. 229, no. 106; Étienne Moreau-Nélaton, *Manet raconté par lui-même*, 2 vols., Paris, 1926, vol. 1,

p. 109, fig. 118; A. Tabarant, *Manet, Histoire catalographique*, Paris, 1931, pp. 161–62, no. 121; Paul Jamot and Georges Wildenstein, *Manet*, 2 vols., Paris, 1932, vol. 1, pp. 133–34, no. 135, vol. 2, fig. 55; Robert Rey, trans. Eveline Byam Shaw, *Manet*, New York, 1938, English ed. [French ed., 1938], p. 162, no. 62, ill.; A. Tabarant, *Manet et ses oeuvres*, Paris, 1947, 4th ed. (1st ed., 1942), pp. 129–30, 536, no. 124, fig. 124; Harry B. Wehle, "The de Groot Collection," *Metropolitan Museum of Art Bulletin* 6, June 1948, n.s., p. 270, ill.; Sandra Orienti et al., *The Complete Paintings of Manet*, New York, 1967, p. 96, no. 108, ill.; Denis Rouart and Daniel Wildenstein, *Édouard Manet, Catalogue raisonné*, 2 vols., Paris, 1975, vol. 1, pp. 112–13, no. 117, ill.; Françoise Cachin and Charles S. Moffett, eds., *Manet, 1832–1883*, exh. cat., Metropolitan Museum of Art, New York, 1983, pp. 331, 426, 441 [French ed., 1983, pp. 331, 442]; Charles S. Moffett, *Impressionist and Post-Impressionist Paintings in The Metropolitan Museum of Art*, New York, 1985, pp. 38–39, color ill.; Vivien Perutz, *Édouard Manet*, Lewisburg, Pa., 1993, p. 79; Beth Archer Brombert, *Édouard Manet: Rebel in a Frock Coat*, Boston, 1996, pp. 143, 207–9, 296

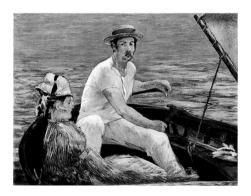

Boating

1874
Oil on canvas
38¼ x 51¼ in. (97.2 x 130.2 cm)
Signed (lower right): Manet
H. O. Havemeyer Collection, Bequest of Mrs. H. O. Havemeyer, 1929
29.100.115
See no. 62

PROVENANCE

The artist, Paris (1874–79; sold at the Salon of 1879, for Fr 1,500 to Desfossés); Victor Desfossés, Paris (1879–95; sold on May 7 for Fr 25,000, to Durand-Ruel); [Durand-Ruel, Paris, 1895, stock no. 3267; sold on September 19, for Fr 55,000, to Havemeyer]; Mr. and Mrs. H. O. Havemeyer, New York (1895–his d. 1907); Mrs. H. O. (Louisine W.) Havemeyer, New York (1907–d. 1929)

EXHIBITIONS

Unidentified exhibition, Paris, 1876; Salon, Paris, May 12, 1879–?, no. 2011; "Exposition des oeuvres de Édouard Manet," École Nationale des Beaux-Arts, Paris, January 6–28, 1884, no. 76; Exposition centennale de l'art français (1789–1889)," Exposition Universelle Internationale de 1889, Paris, May–

November 1889, no. 498; "Loan Exhibition: Paintings by Édouard Manet, 1832–1883," Durand-Ruel, New York, November 29–December 13, 1913, no. 13; "The H. O. Havemeyer Collection," Metropolitan Museum of Art, New York, March 10–November 2, 1930, no. 79; "Manet and Renoir," Pennsylvania Museum of Art, Philadelphia, November 29, 1933–January 1, 1934, no catalogue; "Édouard Manet, 1832–1883," Philadelphia Museum of Art, November 3–December 11, 1966, Art Institute of Chicago, January 13–February 19, 1967, no. 125; "Masterpieces of Painting in The Metropolitan Museum of Art," Museum of Fine Arts, Boston, September 16–November 1, 1970, unnumbered cat. (p. 78); "Masterpieces of Fifty Centuries," Metropolitan Museum of Art, New York, November 15, 1970–February 15, 1971, no. 374; "Impressionism: A Centenary Exhibition," Galeries Nationales du Grand Palais, Paris, September 21–November 24, 1974, Metropolitan Museum of Art, New York, December 12, 1974–February 10, 1975, no. 22; "Manet, 1832–1883," Galeries Nationales du Grand Palais, Paris, April 22–August 1, 1983, Metropolitan Museum of Art, New York, September 10–November 27, 1983, no. 140; "From Delacroix to Matisse," State Hermitage Museum, Leningrad [St. Petersburg], March 15–May 10, 1988, Pushkin State Museum of Fine Arts, Moscow, June 10–July 30, 1988, no. 14; "Splendid Legacy: The Havemeyer Collection," Metropolitan Museum of Art, New York, March 27–June 20, 1993, no. A358; "Impressionists on the Seine: A Celebration of Renoir's 'Luncheon of the Boating Party,'" Phillips Collection, Washington, D.C., September 21, 1996–February 9, 1997; "La collection Havemeyer: Quand l'Amérique découvrait l'impressionnisme . . . ," Musée d'Orsay, Paris, October 20, 1997–January 18, 1998, no. 20; "The Impressionists at Argenteuil," National Gallery of Art, Washington, D.C., May 28–August 20, 2000, Wadsworth Atheneum Museum of Art, Hartford, September 6–December 3, 2000, no. 40; "Manet en el Prado," Museo Nacional del Prado, Madrid, October 13, 2003–February 8, 2004, no. 93

SELECTED REFERENCES
Stéphane Mallarmé, "The Impressionists and Édouard Manet," *The Art Monthly Review and Photographic Portfolio* 1, no. 9, September 30, 1876; Bertall, "L'Exposition de M. Manet," *Paris-Journal,* April 30, 1876 [p. 9]; Arthur Baignères, "Le Salon de 1879 (Premier article)," *Gazette des beaux-arts* 19, June 1879, p. 564; F. C. de Syène, "Salon de 1879. II," *L'Artiste* 50, July 1879, p. 7; Jules Castagnary, *Siècle,* June 28, 1879; Stop, *Le journal amusant,* June 14, 1879, no. 204; Louis de Fourcaud, *Gaulois,* June 18, 1879; H[enri] Guérard, "Manet's Decoration by the State," *Le carillon,* July 16, 1881; J.-K. Huysmans, "Le Salon officiel de 1879," *L'Art moderne,* 1883, pp. 35–36; Louis Gonse, "Manet," *Gazette des beaux-arts* 29, February 1884, pér. 2, p. 146; Joséphin Péladan, "Le procédé de Manet d'après l'exposition de l'École des Beaux-Arts," *L'Artiste* 1, February 1884, année 54, pp. 114–15; L. de Fourcaud and F.-G. Dumas, eds., "Exposition centennale de l'art français, IV," *Revue de l'exposition universelle de 1889,* 2 vols., Paris, 1889, p. 51; J. Meier-Graefe, "Die Stellung Eduard Manet's," *Die Kunst für Alle* 15, October 15, 1899, p. 67, ill.; Antonin Proust, "The Art of Édouard Manet," *The International Studio* 12, February 1901, p. 228, ill.; Théodore Duret, *Histoire d'Édouard Manet et de son oeuvre,* Paris, 1902, pp. 108, 117–18, 237, no. 181; Hugo v. Tschudi, *Édouard Manet,* Berlin, 1902, p. 29, ill.; Adolf Hölzel, "Über Künstlerische Ausdrucksmittel und Deren Verhältniz zu Natur und Bild," *Die Kunst für Alle* 20, December 15, 1904, p. 129, ill.; Théodore

Duret and François Benoit, "Édouard Manet et les impressionistes," *Histoire du paysage en France,* Paris, 1908, p. 310; Rudolf Adelbert Meyer, "Manet und Monet," *Die Kunst Unserer Zeit* 19, 1908, p. 51, ill.; Jean Laran and Georges Le Bas, *Manet,* Paris, 1912, pp. 95–96, pl. XI; Julius Meier-Graefe, *Édouard Manet,* Munich, 1912, p. 231 n. 3, p. 232, fig. 133; Théodore Duret, trans. J. E. Crawford Flitch, *Manet and the French Impressionists,* London, 1912 [1st ed., 1910], pp. 96, 235, no. 181, ill. opp. p. 96; Antonin Proust, *Édouard Manet,* Paris, 1913, p. 93; Achille Ségard, *Mary Cassatt: Un peintre des enfants et des mères,* Paris, 1913, pp. 61–62; Antonin Proust, "Erinnerungen an Édouard Manet," *Kunst und Künstler* 11, March 1913, p. 323, ill.; Emil Waldmann, *Édouard Manet,* Berlin, 1923, pp. 78, 81, 129, ill.; Étienne Moreau-Nélaton, *Manet raconté par lui-même,* 2 vols., Paris, 1926, vol. 2, pp. 24, 57, 129, no. 76, figs. 195 and 352; Frank Jewett Mather Jr., "The Havemeyer Pictures," *The Arts* 16, March 1930, p. 479; A. Tabarant, "Les Manet de la collection Havemeyer," *La renaissance* 13, February 1930, pp. 68, 72, ill.; A. Tabarant, *Manet, Histoire catalographique,* Paris, 1931, pp. 264–65, no. 215; Paul Jamot and Georges Wildenstein, *Manet,* 2 vols., Paris, 1932, vol. 1, pp. 96, 149, no. 244, vol. 2, fig. 176; Paul Colin, *Édouard Manet,* Paris, 1932, pp. 42, 74; Jacques-Émile Blanche, trans. Walter Clement, *Portraits of a Lifetime: The Late Victorian Era, The Edwardian Pageant, 1870–1914,* London, 1938 [reprint; 1st ed., 1937], p. 39; Gotthard Jedlicka, *Édouard Manet,* Zurich, 1941, pp. 173–74, 404 n. 5; A. Tabarant, *Manet et ses oeuvres,* Paris, 1947, 4th ed. [1st. ed., 1942], pp. 246–47, 345–49, 492, 512, 539, no. 226, fig. 226; Margaretta M. Salinger, "Notes," *Metropolitan Museum of Art Bulletin* 5, March 1947, p. 172, ill. (overall and detail on cover); Lionello Venturi, trans. Francis Steegmuller, *Modern Painters,* 2 vols., New York, 1947–50, vol. 2, pp. 23–24, fig. 20; Fiske Kimball and Lionello Venturi, *Great Paintings in America,* New York, 1948, pp. 180–81, no. 83, color ill.; Theodore Rousseau Jr., "A Guide to the Picture Galleries," *Metropolitan Museum of Art Bulletin* 12, January 1954, n.s., part 2, p. 52, ill.; George Heard Hamilton, *Manet and His Critics,* New Haven, 1954, pp. 211–12, 232, 265, pl. 31; Jean Leymarie, trans. James Emmons, *Impressionism,* 2 vols., Lausanne, 1955, vol. 2, p. 35; Georges Bataille, trans. Austryn Wainhouse and James Emmons, *Manet: Biographical and Critical Study,* New York, 1955, pp. 94, 109, color ill.; Charles Sterling and Margaretta M. Salinger, *French Paintings: A Catalogue of the Collection of The Metropolitan Museum of Art,* 3 vols., New York, 1955–67, vol. 3, pp. 45–47, ill.; Lionello Venturi, *Four Steps Toward Modern Art: Giorgione, Caravaggio, Manet, Cézanne,* New York, 1956, p. 57, fig. 23; John Richardson, *Édouard Manet: Paintings and Drawings,* London, 1958, p. 126, no. 48, fig. 48; Jacques Lethève, *Impressionnistes et symbolistes devant la presse,* Paris, 1959, p. 105; Henri Perruchot, *La vie de Manet,* Paris, 1959, pp. 250–51, 280; J. Mathey, *Graphisme de Manet: Essai de catalogue raisonné des dessins,* 3 vols., Paris, 1961–63, vol. 1, p. 33 under no. 135; Henri Perruchot, *Édouard Manet,* New York, 1962, pp. 14, 87, no. 60, colorpl. 60; Denys Sutton, "The Discerning Eye of Louisine Havemeyer," *Apollo* 82, September 1965, pp. 232, fig. 5; George Heard Hamilton, "Is Manet Still 'Modern'?," *Art News Annual* 31, 1966, p. 162; Sandra Orienti et al., *The Complete Paintings of Manet,* New York, 1967, p. 103, no. 194, ill. (colorpl. XXXII and black and white); Margaretta M. Salinger, "Windows Open to Nature," *Metropolitan Museum of Art Bulletin* 27, summer 1968, n.s., p. 10, ill. (color and black and white; overall and detail); Alain

de Leiris, *The Drawings of Édouard Manet,* Berkeley, 1969, p. 125, under no. 429; John Rewald, "The Impressionist Brush," *Metropolitan Museum of Art Bulletin* 32, no. 3, 1973–74, pp. 30–31, no. 19, ill. (color detail and b and w); Denis Rouart and Daniel Wildenstein, *Édouard Manet, Catalogue raisonné,* 2 vols., Paris, 1975, vol. 1, pp. 6, 20, 24, 186–87, no. 223, ill., vol. 2, p. 148, under nos. 400–401; J. Kirk T. Varnedoe, *Gustave Caillebotte,* exh. cat., Museum of Fine Arts, Houston, Houston, 1976 [2nd ed., 1987], p. 122, fig. 1; Chisaburoh F. Yamada, ed., "Ukiyo-e and European Painting," *Dialogue in Art: Japan and the West,* New York, 1976, p. 36, fig. 18 (color); Anne Coffin Hanson, *Manet and the Modern Tradition,* New Haven, 1977, pp. 77, 165, 190, fig. 109; Michael Justin Wentworth, *James Tissot: Catalogue Raisonné of His Prints,* Minneapolis Institute of Arts, 1978, pp. 98, 231, under no. 20, fig. 20d; Anne Distel, *Hommage à Claude Monet (1840–1926),* exh. cat., Galeries Nationales du Grand Palais, Paris, 1980, p. 111; Raymond Cogniat and Michel Hoog, *Manet,* Paris, 1982, pp. 23, 27, 38, no. 26, colorpl. 26; Charles S. Moffett, *Impressionist and Post-Impressionist Paintings in The Metropolitan Museum of Art,* New York, 1985, pp. 40–41, color ill.; Frances Weitzenhoffer, *The Havemeyers: Impressionism Comes to America,* New York, 1986, pp. 56, 107, 117, 177, 257, 262 n. 9, colorpl. 60; Kathleen Adler, *Manet,* Oxford, 1986, pp. 172–73, 176, 213, colorpl. 161; Gary Tinterow et al., *The Metropolitan Museum of Art: Modern Europe,* New York, 1987, pp. 18–20, colorpl. 6; Charles F. Stuckey et al., *Berthe Morisot, Impressionist,* exh. cat., National Gallery of Art, Washington, D.C., New York, 1987, p. 82, fig. 54; Juliet Wilson-Bareau, "L'Année impressionniste de Manet: Argenteuil et Venise en 1874," *Revue de l'art* 86, 1989, pp. 29, 32, 34 n. 24, fig. 4; Françoise Cachin, *Manet* [Paris], 1990, pp. 116, 158, color ill.; T. A. Gronberg, *Manet: A Retrospective,* New York, 1990, p. 15, colorpl. 66; Norma Broude, ed., *World Impressionism: The International Movement, 1860–1920,* New York, 1990, p. 28, colorpl. 26; Sabine Rewald, ed., *The Romantic Vision of Caspar David Friedrich: Paintings and Drawings from the U.S.S.R.,* New York, 1990, pp. 12–13, fig. 13; Juliet Wilson-Bareau, *Manet by Himself, Correspondence and Conversation: Paintings, Pastels, Prints, and Drawings,* Boston, 1991, p. 186; Éric Darragon, *Manet,* Paris, 1991, pp. 260, 286, 377, 381, colorpl. 204; Louisine W. Havemeyer, *Sixteen to Sixty: Memoirs of a Collector,* New York, 1993, 3rd ed. with notes by Susan Alyson Stein [1st ed., 1930; repr. 1961], pp. 225, 334 n. 325, p. 340 n. 400; Vivien Perutz, *Édouard Manet,* Lewisburg, Pa., 1993, pp. 164–65, 175, 220 n. 20, colorpl. 45; Nigel Blake, Francis Frascina et al., "Modern Practices of Art and Modernity," *Modernity and Modernism: French Painting in the Nineteenth Century,* New Haven, 1993, pp. 115, 118, pl. 106; Anne Distel, *Gustave Caillebotte, 1848–1894,* exh. cat., Galeries Nationales du Grand Palais, Paris, 1994, p. 116, under no. 23, fig. 2; Hans Körner, *Édouard Manet: Dandy, flaneur, maler,* Munich, 1996, pp. 149, 151, 154, colorpl. 121; Beth Archer Brombert, *Édouard Manet: Rebel in a Frock Coat,* Boston, 1996, pp. 361, 395–96; Alan Krell, *Manet and the Painters of Contemporary Life,* London, 1996, pp. 134, 179, colorpl. 122; Colin B. Bailey, ed., *Renoir's Portraits: Impressions of an Age,* exh. cat., National Gallery of Canada, Ottawa, New Haven, 1997, p. 130; Fred Licht, *Manet,* Milan, 1998, p. 62, fig. 38; Carol Armstrong, *Manet Manette,* New Haven, 2002, pp. 203, 212, 218, 220–23, fig. 106

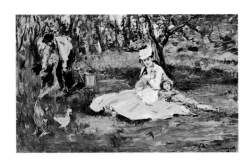

The Monet Family in Their Garden at Argenteuil
1874
Oil on canvas
24 x 39¼ in. (61 x 99.7 cm)
Signed (lower right): Manet
Bequest of Joan Whitney Payson, 1975
1976.201.14
See no. 61

PROVENANCE
Claude Monet, Argenteuil (1874–78; returned to Manet); Édouard Manet, Paris (1878; sold for Fr 750 to Toul); [Toul, Paris, from 1878]; Auguste Pellerin, Paris (by 1902–10; sold to Bernheim-Jeune, Cassirer, and Durand-Ruel); [Bernheim-Jeune, Paul Cassirer, and Durand-Ruel, Paris, 1910; sold for Fr 300,000 with Manet's "Portrait of the Artist, Marcellin Desboutin" (Museu de Arte Moderna, São Paulo) to Arnhold]; Eduard Arnhold, Berlin (1910–d. 1925); his widow, Johanna Arnhold, Berlin (1925–at least 1935); ?her daughter, Else Arnhold (?later Mrs. Kuhnheim), Berlin; ?her children, a daughter and two sons, Berlin; Alberto Ulrich, Zurich (until 1964; sold on February 19, through the Alfred Daber Gallery, Paris to Knoedler); [Knoedler, New York, 1964; sold on February 26 for $605,000 to Payson]; Joan Whitney Payson, New York and Manhasset (1964–d. 1975)

EXHIBITIONS
"Centennale de l'art français (1800–1889)," Exposition Internationale Universelle, Paris, May–November 1900, no. 451; "Trente-cinq tableaux de la collection Pellerin," Bernheim-Jeune, Paris, June 1910, no. 6; "Sammlung Pellerin," Paul Cassirer, Berlin, 1910; "Édouard Manet (Aus der Sammlung Pellerin)," Moderne Galerie, Munich, 1910, no. 8; "L'Impressionnisme," Palais des Beaux-Arts, Brussels, June 15–September 29, 1935, no. 33; "Impressionist Treasures," M. Knoedler and Co., New York, January 12–29, 1966, no. 14; "Manet, 1832–1883," Galeries Nationales du Grand Palais, Paris, April 22–August 1, 1983, Metropolitan Museum of Art, New York, September 10–November 27, 1983, no. 141; "Faces of Impressionism: Portraits from American Collections," Baltimore Museum of Art, October 10, 1999–January 30, 2000, Museum of Fine Arts, Houston, March 25–May 7, 2000, Cleveland Museum of Art, May 28–July 30, 2000, no. 36; "Édouard Manet und die Impressionisten," Staatsgalerie Stuttgart, September 21, 2002–February 9, 2003, no. 40; "Monet et ses amis," Musée des Beaux-Arts de Budapest, December 1, 2003–March 15, 2004, no. 63

SELECTED REFERENCES
Hugo von Tschudi, "Die Jahrhundert-Ausstellung der Französischen Kunst," *Die Kunst für Alle* 16, October 15, 1900, pp. 42, 49, ill.; Théodore Duret, *Histoire d'Édouard Manet et de son oeuvre,* Paris, 1902, pp. 100, 236, no. 176; Hugo v. Tschudi, *Édouard Manet,* Berlin, 1902, p. 24; George Moore, *Reminiscences of the Impressionist Painters,* Dublin, 1906; "L'Exode en Allemagne des maîtres de l'impressionnisme," *L'Art et les artistes* 11, April 1910, p. 45; G. J. W., "Von Ausstellungen und Sammlungen," *Die Kunst für Alle* 25, May 15, 1910, p. 378; Emil Waldmann, "Édouard Manet in der Sammlung Pellerin," *Kunst und Künstler* 8, May 1910, pp. 392, 395, ill.; Werner Weisbach, *Impressionismus: Ein Problem der Malerei in der Antike und Neuzeit,* 2 vols., Berlin, 1910–11, vol. 2, p. 115, color ill. opp. p. 114; G. J. Wolf, "Édouard Manet," *Die Kunst für Alle* 26, January 1, 1911, p. 145, ill.; Jean Laran and Georges Le Bas, *Manet,* Paris, 1912, p. 71, pl. XXVIII; Julius Meier-Graefe, *Édouard Manet,* Munich, 1912, p. 316, pl. 129; Carl Gebhardt, "Die Neuerwerbungen Französicher Malerei im Städelschen Kunstinstitut zu Frankfurt am Main," *Der Cicerone* 4, October 15, 1912, p. 765; Max Deri, *Die Malerei im XIX. Jahrhundert,* 2 vols., Berlin, 1920, vol. 1, p. 149, vol. 2, pl. 26; Ambroise Vollard, *Auguste Renoir (1841–1919),* Paris, 1920, 5th ed., p. 74; Emil Waldmann, *Édouard Manet,* Berlin, 1923, pp. 66– 67, ill.; Marc Elder, *À Giverny, chez Claude Monet,* Paris, 1924, pp. 70–71; Ambroise Vollard, trans. Harold L. Van Doren and Randolph T. Weaver, *Renoir, An Intimate Record,* New York, 1925, p. 70; Marie Dormoy, "La collection Arnhold," *L'Amour de l'art* 7, July 1926, pp. 242, 244, ill.; Étienne Moreau-Nélaton, *Manet raconté par lui-même,* 2 vols., Paris, 1926, vol. 2, pp. 24–25, 40–41, 116, fig. 190; Karl Scheffler, "Vergleichende Kunstanschauung in der Frühjahrsausstellung der Akademie der Künste," *Kunst und Künstler* 24, 1926, p. 344; A. Tabarant, *Manet, Histoire catalographique,* Paris, 1931, p. 270, no. 222; Gaston Poulain, *Bazille et ses amis,* Paris, 1932, p. 103 n. 1; Paul Jamot and Georges Wildenstein, *Manet,* 2 vols., Paris, 1932, vol. 1, pp. 22, 93, 149, no. 245, vol. 2, pl. 357; "Notes biographiques," *L'Amour de l'art,* no. 5, May 1932, p. 147; Paul Colin, *Édouard Manet,* Paris, 1932, pl. XLVI; René Huyghe, "Manet, Peintre," *L'Amour de l'art,* no. 5, May 1932, p. 184, fig. 79; A. Tabarant, "Manet (A propos de son centenaire)," *Revue de l'art ancien et moderne* 61, 1932, p. 23, ill.; Ambroise Vollard, trans. Violet M. Macdonald, *Recollections of a Picture Dealer,* London, 1936, p. 169; Helen Comstock, "The Connoisseur in America: A Child Portrait by Manet," *Connoisseur* 97, May 1936, p. 282; Gotthard Jedlicka, *Édouard Manet,* Zurich, 1941, ill. opp. p. 177; John Rewald, *The History of Impressionism,* New York, 1946, 1st ed. [4th rev. ed., 1973, pp. 341–43, ill.], pp. 276–77, ill.; A. Tabarant, *Manet et ses oeuvres,* Paris, 1947, 4th ed. (1st. ed., 1942), pp. 250, 252, 254, 288, 513, 539, no. 233, fig. 233; Michel Florisoone, *Manet,* Monaco, 1947, p. 64, ill.; George Heard Hamilton, *Manet and His Critics,* New Haven, 1954, p. 176 n. 3; Jean Leymarie, trans. James Emmons, *Impressionism,* 2 vols., Lausanne, 1955, vol. 2, p. 32; Georges Bataille, trans. Austryn Wainhouse and James Emmons, *Manet: Biographical and Critical Study,* New York, 1955, p. 12; F. W. J. Hemmings and Robert J. Niess, eds., *Émile Zola, Salons,* Paris, 1959, p. 25; Maurice Sérullaz, *Les peintres impressionistes,* Paris, 1959, p. 102; Theodore Rousseau Jr., "Ninety-fifth Annual Report of the Trustees, for the Fiscal Year 1964–1965," *Metropolitan Museum of Art Bulletin* 24, October 1965, p. 58; Franz Winzinger, "Madame Monet als Modell: Ein unbekanntes Bild von Manet," *Die Kunst und das schöne Heim* 63, September 1965, p. 513; Charles Merrill Mount, *Monet, a Biography,* New York, 1966, pp. 252–53; F. N., "Durchbruch der Impressionisten," *Weltkunst* 36, February 15, 1966, p. 129, ill.; John Rewald, "How New York Became the Capital of 19th-Century Paris," *Art News* 64, January 1966, pp. 34, 36, color ill.; Sandra Orienti et al., *The Complete Paintings of Manet,* New York, 1967, p. 104, no. 198, ill.; Paulette Howard-Johnston, "Une visite à Giverny en 1924," *L'Oeil,* no. 171, March 1969, pp. 30, 32–33, ill.; J. Salomon, "Chez Monet avec Vuillard et Roussel," *L'Oeil,* no. 197, May 1971, p. 24; Germain Bazin, trans. Maria Paola de Benedetti, *Édouard Manet,* Milan, 1972, p. 79, ill. [French ed., 1974]; Denis Rouart and Daniel Wildenstein, *Édouard Manet, Catalogue raisonné,* 2 vols., Paris, 1975, vol. 1, pp. 6, 19, 190–91, no. 227, ill.; Anne Distel, *Hommage à Claude Monet (1840–1926),* exh. cat., Galeries Nationales du Grand Palais, Paris, 1980, p. 111; Pierre Daix, *La vie de peintre d'Édouard Manet,* Paris, 1983, p. 256, fig. 32; Charles S. Moffett, *Impressionist and Post-Impressionist Paintings in The Metropolitan Museum of Art,* New York, 1985, pp. 46–47, ill. in color (overall and detail); Anne Distel et al., *Renoir,* exh. cat., Hayward Gallery, London, 1985, pp. 205–6, under no. 30, fig. a [French ed., 1985, p. 126, under no. 29, fig. 31]; Kathleen Adler, *Manet,* Oxford, 1986, pp. 168–69, fig. 158 (color); Nicolaas Teeuwisse, *Vom Salon zur Secession: Berliner Kunstleben zwischen Tradition und Aufbruch zur Moderne, 1871–1900,* Berlin, 1986, pp. 223, 306 n. 527; Barbara Paul, "Drei Sammlungen französischer impressionister Kunst im kaiserlichen Berlin—Bernstein, Liebermann, Arnhold," *Zietschrift des Deutschen Vereins für Kunstwissenschaft* 42, 1988, pp. 23, 29, n. 88, fig. 8; Juliet Wilson-Bareau, "L'Année impressionniste de Manet: Argenteuil et Venise en 1874," *Revue de l'art* 86, 1989, p. 34 n. 24; Éric Darragon, *Manet,* Paris, 1991, pp. 246, 286, colorpl. 169; Juliet Wilson-Bareau, *Manet by Himself, Correspondence and Conversation: Paintings, Pastels, Prints, and Drawings,* Boston, 1991, p. 311, no. 160, colorpl. 160; Sarah Carr-Gomm, *Manet,* London, 1992, pp. 112–13, color ill.; Vivien Perutz, *Édouard Manet,* Lewisburg, Pa., 1993, p. 162, fig. 177; Kermit Swiler Champa, *"Masterpiece" Studies: Manet, Zola, Van Gogh, and Monet,* University Park, Pa., 1994, p. 142, ill. pp. 17–19; Charles F. Stuckey, *Claude Monet, 1840–1926,* exh. cat., Art Institute of Chicago, 1995, p. 199; Hans Körner, *Édouard Manet: Dandy, flaneur, maler,* Munich, 1996, p. 147, fig. 118; Alan Krell, *Manet and the Painters of Contemporary Life,* London, 1996, pp. 129, 131, fig. 120; Barbara Ehrlich White, *Impressionists Side by Side: Their Friendships, Rivalries, and Artistic Exchanges,* New York, 1996, p. 72, color ill.; Colin B. Bailey, ed., *Renoir's Portraits: Impressions of an Age,* exh. cat., National Gallery of Canada, Ottawa, New Haven, 1997, pp. 57, 130–31, fig. 144; Richard R. Brettell, *Impression: Painting Quickly in France, 1860–1890,* exh. cat., National Gallery, London, Ottawa, New Haven, 2000, pp. 87–88, 162, fig. 46 (color); Carol Armstrong, *Manet Manette,* New Haven, 2002, p. 213, fig. 102; Manuela B. Mena Marqués, ed., *Manet en el Prado,* exh. cat., Museo Nacional del Prado, Madrid, 2003, pp. 121, 296, 420, 478, fig. 140 (color)

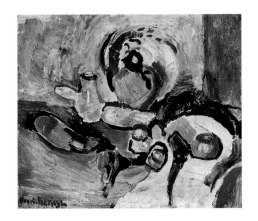

Henri Matisse
French, 1869–1954

Still Life with Vegetables
1905
Oil on canvas
15⅛ x 18⅛ in. (38.4 x 46 cm)
Signed (lower left): Henri-Matisse
Jacques and Natasha Gelman Collection, 1998
1999.363.38
See no. 127

PROVENANCE
[Possibly Bernheim-Jeune, Paris]; Professor Heinz Braun, Breslau (probably by 1922–no later than 1926; to Thannhauser); [Galerien Thannhauser, Munich and Lucerne; not before 1926–August 19, 1927; sold to Reinhardt]; [Paul Reinhardt, New York; 1927–at least 1930]; Carl Hamilton, United States (by 1934; his sale, Rains Auction Room, New York, April 6, 1934, no. 64, ill.); Josef von Sternberg, Los Angeles and Weehawken, N.J. (by 1943–49; his sale, Parke Bernet Galleries, London, November 22, 1949, no. 87, ill., to Miller); Mr. and Mrs. Max Miller, United States (from 1949–at least 1953); Mrs. Geoffrey Bennett, New York (until 1970; sale, Sotheby's, London, April 15, 1970, no. 49, ill.); private collection, San Diego (1970–77; sale, Sotheby's, London, June 27, 1977, no. 26, ill.; to Gelman); Jacques and Natasha Gelman, New York (1977–98)

EXHIBITIONS
"Erste Sonderausstellung in Berlin," Galerie Thannhauser, Berlin, January 9–mid-February, 1927, no. 152; "Modern French Art," Rhode Island School of Design Museum, Providence, March 11–31, 1930, no. 23; "The Collection of Josef von Sternberg," Los Angeles County Museum, May 17– September 5, 1943, no. 26; "Exhibition of Paintings and Drawings from the Josef von Sternberg Collection," Arts Club of Chicago, November 1–27, 1946, no. 10; "Les Fauves," Sidney Janis Gallery, New York, November 13–December 23, 1950, no. 31; "Matisse," Society of the Four Arts, Palm Beach, February 6–March 1, 1953, no. 6; "The UCSD Collection," University of California San Diego Art Gallery, April 24–May 16, 1973; "Twentieth-Century Modern Masters: The Jacques and Natasha Gelman Collection," Metropolitan Museum of Art, New York, December 12, 1989–April 1, 1990, Royal Academy, London, April 19–July 15, 1990, unnumbered cat.; "Henri Matisse: 1904–1917," Centre Georges Pompidou, Paris, February 23–June 21, 1993, no. 29; "De Matisse à Picasso: Collection Jacques et Natasha Gelman," Fondation Pierre Gianadda, Martigny, June 18–November 1, 1994, unnumbered cat.

SELECTED REFERENCES
Roland Schacht, *Henri Matisse*, Dresden, 1922, p. 59 (ill.); Adolphe Basler, *Henri Matisse*, Junge Kunst series, vol. 46, Leipzig, 1924 (ill.); Adolphe Basler, "Henri Matisse," *Der Cicerone* 16, no. 21, November 6, 1924, p. 1003 (ill.); *Art at Auction: The Year at Sotheby's and Park Bernet, 1969–70*, New York, 1971, pp. 152, 168 (color ill.); Mario Luzi and Massimo Carrà, *L'Opera di Matisse dall rivolta 'fauve' all'intimismo, 1904–1928*, Milan, 1971, pp. 89–90, no. 94 (ill.); *Art at Auction: The Year at Sotheby's and Park Bernet, 1976–77*, London and Totowa, N.J., 1977, p. 147 (ill.); Lode Seghers, "Mercado de las artes en el extranjero," *Goya*, nos. 140–141, 1977, p. 171 (ill.); Massimo Carrà and Xavier Deryng, *Tout l'oeuvre peint de Matisse, 1904–1928* [French ed. of Luzi and Carrà 1971], trans. Simone Darses, Paris, 1982, pp. 89–90, no. 94, ill.; Pierre Schneider, trans. Michael Taylor and Bridget Strevens Romer, *Matisse*, New York, 1984, p. 231 (ill.)

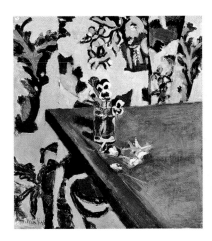

Pansies
1918–19
Oil on paper mounted on wood
19¾ x 17¾ in. (48.9 x 45.1 cm)
Signed (lower left): H. Matisse
Bequest of Joan Whitney Payson, 1975
1976.201.22
See no. 129

PROVENANCE
Sainsère collection, Paris (Mme Olivier Sainsère, d. 1947, possibly with her husband, d. 1923); presumably Sainsère heirs (by 1960; deposited with Durand-Ruel); [Durand-Ruel, Paris; in 1960; sold to Payson on June 14 for $45,000]; Joan Whitney Payson, New York and Manhasset (1960–d. 1975)

EXHIBITIONS
"An Ode to Gardens and Flowers," Nassau County Museum of Art, Roslyn Harbor, N.Y., May 10–August 9, 1992, unnumbered cat.; "Matisse, His Art and His Textiles: The Fabric of Dreams," Musée Matisse, Le Cateau-Cambrésis, October 23, 2004–January 25, 2005, Royal Academy of Arts, London, March 5–May 30, 2005, Metropolitan Museum of Art, New York, June 23–September 25, 2005, no. 16

SELECTED REFERENCE
Gary Tinterow et al., *The Metropolitan Museum of Art: Modern Europe*, New York, 1987, p. 104, fig. 80 (color ill.)

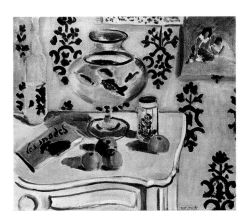

The Goldfish Bowl
Winter 1921–22
Oil on canvas
21⅜ x 25¾ in. (54.3 x 65.4 cm)
Signed (lower right): Henri Matisse
Bequest of Scofield Thayer, 1982
1984.433.19
See no. 128

PROVENANCE
Gaston Bernheim de Villers, Paris (by April 23, 1923; sold to Bernheim); [Galerie Bernheim-Jeune, Paris, April 23–July 20, 1923, stock no. 23355; sold for $1,000 to Thayer]; Scofield Thayer, New York (1923–d. 1982; on view at the Worcester Art Museum as part of the Dial Collection, 1931–82)

EXHIBITIONS
"Exposition Henri-Matisse," Galerie Bernheim-Jeune, Paris, February 23–March 15, 1922, no. 22; "Original Paintings, Drawings, and Engravings being Exhibited with the Dial Folio 'Living Art,'" Montross Gallery, New York, January 26–February 14, 1924, no. 23; "Exhibition of the Dial Collection of Paintings, Engravings and Drawings by Contemporary Artists," Worcester Art Museum, March 15–30, 1924, no. 22; ["The Dial Collection"], Hillyer Art Gallery, Smith College, Northampton, Mass., spring 1924, no catalogue; "Henri-Matisse Retrospective Exhibition," Museum of Modern Art, New York, November 3–December 6, 1931, no. 63; "Modern French Masters," Columbus [Ohio] Gallery of Fine Arts, November 28–December 31, 1952, Akron [Ohio] Art Institute, January 13–February 16, 1953, Worcester Art Museum, March 5–April 12, 1953, no. 20; "Matisse: A Museum Course Exhibition," Busch-Reisinger Museum, Harvard University, Cambridge, Mass., May 9–June 8, 1955, no. 8; "The Dial and the Dial Collection," Worcester Art Museum, April 30–September 8, 1959, no. 64; "Selections From The Dial Collection," Worcester Art Museum, November 13–30, 1965, no catalogue; "The Dial Revisited," Worcester Art Museum, June 29–August 22, 1971, no catalogue; "The Dial: Arts and Letters in the 1920s," Worcester Art Museum, March 7–May 10, 1981, no. 85; "20th Century Masters from The Metropolitan Museum of Art," National Gallery of Australia, Canberra, March 1–April 27, 1986, Queensland Art Gallery, Brisbane, May 7–July 1, 1986, cat. p. 25; "Matisse," Queensland Art Gallery, Brisbane, March 29–May 16, 1995, National Gallery of Australia, Canberra, May 27–July 9, 1995, National Gallery of Victoria, Melbourne, July 19–September 3, 1995, no. 95; "Painters in Paris, 1895–1950," Metropolitan Museum of Art, March 8–December 31, 2000, cat. p. 123; "Picasso and the School of Paris, Paintings from The Metropolitan Museum of Art," Kyoto Municipal Museum of Art,

September 14–November 24, 2002, Bunkamura Museum of Art, Tokyo, December 7, 2002–March 9, 2003, pl. 47

SELECTED REFERENCES
Elie Faure, Jules Romains, Charles Vildrac, and Léon Werth, *Henri Matisse,* Paris, 1923, pl. 29; *The Dial* 80, 1926, p. 447, ill. (color); F[rancis] H[enry] T[aylor], "Modern French Paintings in the Museum," *Bulletin of The Worcester Art Museum,* 22, no. 4, January 1932, pp. 69–70 (ill.); William Wasserstrom, ed., *A Dial Miscellany,* Syracuse, N.Y., 1963, fig. 64; Alfred H. Barr, Jr., *Matisse: His Art and His Public* [1951], rev. ed., New York, 1974, p. 559; Pierre Schneider, *Henri Matisse,* trans. Michael Taylor and Bridget Strevens Romer, New York, 1984, pp. 419–24, 456 n. 1; Lisa M. Messinger, "Notable Acquisitions 1984–85; Twentieth-Century Art: The Scofield Thayer Bequest," *Metropolitan Museum of Art Bulletin* 42, 1984–85, pp. 46–47 (color ill.); Jack Cowart and Dominique Fourcade, *Henri Matisse, The Early Years in Nice, 1916–1930,* National Gallery of Art, Washington, D.C., 1986, p. 273, n. 60; Gary Tinterow et al., *The Metropolitan Museum of Art: Modern Europe,* New York, 1987, p. 105, fig. 81, ill. (color); John Richardson, "Rediscovering an Early Modern Vision: The Dial Collection Recalls the Life and Times of Scofield Thayer," *House and Garden* 159, no. 2, February 1987, color detail on cover; Guy-Patrice Dauberville and Michel Dauberville, *Henri Matisse chez Bernheim-Jeune,* 2 vols., Paris, 1995, vol. 1, p. 110, no. 22, vol. 2, pp. 1066–67 no. 516 (ill.), 1440, 1460, 1465

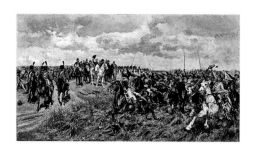

Ernest Meissonier
French, 1815–1891

1807, Friedland
1875
Oil on canvas
53½ x 95½ in. (135.9 x 242.6 cm)
Signed and dated (lower left): EMeissonier [initials in monogram] / 1875
Gift of Henry Hilton, 1887
87.20.1
See no. 37

PROVENANCE
Alexander T. Stewart, New York (1876; bought from the artist for $60,000); his widow, Cornelia M. Stewart, New York (1876–d. 1886; her husband's estate sale, American Art Association, New York, March 23–25, 1887, no. 210, for $66,000 to Hilton); Henry Hilton, New York (1887)

EXHIBITIONS
"Welt-Ausstellung 1873 in Wien," Vienna, 1873, no. 479; "Exposition annuelle du cercle de l'union artistique," Galerie Georges Petit, Paris, December 1875; "Eadweard Muybridge, 1872–1882," New York Cultural Center, May 16–July 29, 1973

SELECTED REFERENCES
Gustave Larroumet et al., *Meissonier,* Paris, n.d., p. 37, ill. p. 40; Roger Ballu, "1807: Le Meissonier de M. Alexander T. Stewart," *L'Art* 4, 1875, pp. 14–18, 356; Henry Houssaye, "La Peinture des batailles: Le Nouveau tableau de M. Meissonier—L'Exposition des oeuvres de Pils," *Revue des deux mondes* 13, 3e ser., February 15, 1876, pp. 882–83; Edward Strahan [Earl Shinn], *The Art Treasures of America,* New York, 1879 [repr. 1977], vol. 1, pp. 27–30, ill.; Alice Meynell, "Our Living Artists: Jean Louis Ernest Meissonier," *Magazine of Art* 4, 1881, p. 137; John W. Mollett, *Meissonier,* London, 1882, pp. 42, 53–55, 65, 72; Philippe Burty in F.-G. Dumas, ed., trans. Clara Bell, "Jean-Louis-Ernest Meissonier," *Illustrated Biographies of Modern Artists,* 4 vols., Paris, 1882, vol. 4, section 12, pp. 282, 287; Jules Claretie, *Peintres et sculpteurs contemporains,* 2 vols., Paris, 1882–84, vol. 2, pp. 23–25, 27–28; John Oldcastle, "An American Millionaire's Gallery," *Art-Journal,* 1887, p. 156; Walter Rowlands, "Art Sales in America," *Art-Journal,* 1887, p. 294; Marius Chaumelin, *Portraits d'artistes: E. Meissonier, J. Breton,* Paris, 1887, pp. 26–28, 53, no. 168; Lionel Robinson, *J. L. E. Meissonier, Hon. R. A.,* London, 1887, pp. 14, 21, ill. pp. 2, 17, 18; Clarence Cook, *Art and Artists of Our Time,* 6 vols., New York, 1888, vol. 1, pp. 67, 69; Louis Gonse, "Meissonier," *Gazette des beaux-arts* 5, 3e per., March 1891, p. 180; "Jean-Louis-Ernest Meissonier," exh. cat., École des Beaux-Arts, Paris, 1893, pp. 45–48, under no. 93; Claude Phillips, "The Meissonier Exhibition," *Magazine of Art* 16, 1893, pp. 282–84; John C. van Dyke, ed., *Modern French Masters: A Series of Biographical and Critical Reviews by American*

Artists, 1896, pp. 95, 98, ill. opp. p. 94; Vallery C. O. Gréard, *Meissonier: His Life and His Art,* New York, 1897, pp. 44, 74, 118, 199, 212–13, 242–43, 245, 247–55, ill. opp. p. 250; Arthur Hoeber, *The Treasures of The Metropolitan Museum of Art of New York,* New York, 1899, pp. 78–79, ill.; Frank Fowler, "The Field of Art: Modern Foreign Paintings at the Metropolitan Museum, Some Examples of the French School," *Scribner's Magazine* 44, September 1908, p. 382; Charles Sterling and Margaretta M. Salinger, *French Paintings: A Catalogue of the Collection of The Metropolitan Museum of Art,* 3 vols., New York, 1955–67, vol. 2, pp. 152–54, ill.; Henry James, *The Painter's Eye,* Cambridge, Mass., 1956, pp. 108–12; Dominique Brachlianoff et. al, *Ernest Meissonier: Rétrospective,* exh. cat., Lyon, 1993, pp. 27, 35, 45–46, 48, 61, 75, 77, 80–81, 107, 148, 188, 194–97, 205, 207, 220–26, 228, 231, 235, 238, fig. 1; Marc J. Gotlieb, *The Plight of Emulation: Ernest Meissonier and French Salon Painting,* Princeton, 1996, pp. 50, 87–89, 155, 162, 170, 173–74, 181, 183, 242, n. 1, fig. 18; Constance Cain Hungerford, *Ernest Meissonier: Master in His Genre,* Cambridge, 1999, pp. 3, 30, 157–60, 166–77, 180, 185–86, 189, 196, 201, 208, 219–20, 227, fig. 64

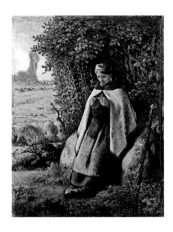

Jean-François Millet
French, 1814–1875

Shepherdess Seated on a Rock
1856
Oil on wood
14⅛ x 11⅛ in. (35.9 x 28.3 cm)
Gift of Douglas Dillon, 1983
1983.446
See no. 20

PROVENANCE
[Knoedler, New York, until 1879; sold in October to Raynor]; James A. Raynor, New York (October 1879–d. 1885); his daughter, Mrs. William Storrs; Wells, New York (until d. 1935; her estate, 1935–36; sale, American Art Association, New York, November 12, 1936, no. 42, for $3,700 to Dillon); Clarence Dillon, New York (1936–d. 1979); his son, Douglas Dillon, New York (1979–83; sale, Sotheby's, New York, October 26, 1983, no. 37, bought in)

EXHIBITION
"French Painters of Nature: The Barbizon School, Landscapes from The Metropolitan Museum of Art," New York State Museum, Albany, May 22–August 22, 2004, unnumbered brochure

SELECTED REFERENCES
Edward Wheelwright. "Personal Recollections of Jean François Millet," *Atlantic Monthly* 38, September 1876, pp. 273–74; Julia Cartwright, *Jean François Millet,* London and New York, 1902 [1st ed., 1896], pp. 166–67; Étienne Moreau-Nélaton, *Millet raconté par lui-même,* Paris, 1921, p. 30; Robert L. Herbert, *Jean-François Millet,* exh. cat., Grand Palais, Paris, 1975, p. 123, under no. 82; John House, *Monet, Nature into Art,* New Haven, 1986, p. 181

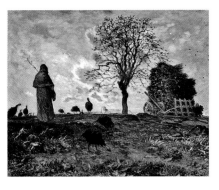

Autumn Landscape with a Flock of Turkeys
1872–73
Oil on canvas
31⅞ x 39 in. (81 x 99.1 cm)
Signed (lower right): J.F. Millet
Mr. and Mrs. Isaac D. Fletcher Collection, Bequest of Isaac D. Fletcher, 1917
17.120.209
See no. 21

PROVENANCE
[Durand-Ruel, Paris, from 1873]; "M. M*** de Marseilles" (until 1874; his sale, Hôtel Drouot, Paris, April 30, 1874, no. 49, sold for Fr 13,020); [M. Lannoy, Paris, 1874–75; sold for Fr 22,500 to Dupont]; J. Dupont, Antwerp (from 1875); Samuel P. Avery, New York (until about 1883; sold for $6,500 to Dana); Charles A. Dana, New York (by 1883–d. 1898; his estate sale, American Art Association, New York, February 24–26, 1898, no. 591, sold for $20,500 to Schaus); [Herman Schaus, New York, 1898]; Mr. and Mrs. Isaac D. Fletcher, New York (from 1898–his d. 1917)

EXHIBITIONS
"Exposition de tableaux modernes au profit de la caisse centrale des artistes belges," Galerie Ghémar, Brussels, 1876, no. 173; "Pedestal Fund Art Loan Exhibition," National Academy of Design, New York, December 3, 1883–?, no. 6; "Works of Antoine-Louis Barye Exhibited at the American Art Galleries under the Auspices of the Barye Monument Association, also of Paintings by J. F. Millet and Others, His Contemporaries and Friends," American Art Galleries, New York, November 15, 1889–January 15, 1890, no. 614; "Exhibition of French Painting of the Nineteenth and Twentieth Centuries," Fogg Art Museum, Cambridge, Mass., March 6–April 6, 1929, no. 63; "Landscape Paintings," Metropolitan Museum of Art, New York, May 14–September 30, 1934, no. 44; "19th-Century French and American Paintings from the Collection of The Metropolitan Museum of Art," Newark Museum, April 9–May 15, 1946, no. 21; "Jean-François Millet," Grand Palais, Paris, October 17, 1975–January 5, 1976, no. 242; "Jean-François Millet," Hayward Gallery, London, January 22–March 7, 1976, no. 145; "In Support of Liberty: European Paintings at the 1883 Pedestal Fund Art Loan Exhibition," Parrish Art Museum, Southampton, N.Y., June 29–September 1, 1986, National Academy of Design, New York, September 18–December 7, 1986, no. 64; "Capolavori impressionisti dei musei americani," Museo di Capodimonte, Naples, December 3, 1986–February 1, 1987, Pinacoteca di Brera, Milan, March 4–May 3, 1987, no. 27; "From Delacroix to Matisse," State Hermitage Museum, Leningrad [St. Petersburg], March 15–May 10, 1988, Pushkin State Museum of Fine Arts, Moscow, June 10–July 30, 1988, no. 11; "The Rise of Landscape Painting in France: Corot to Monet," IBM Gallery of Science and Art, New York, July 30–September 28, 1991, no. 90; "Barbizon: French Landscapes of the Nineteenth Century," Metropolitan Museum of Art, New York, February 4– May 10, 1992, no catalogue; "Corot to Cézanne: 19th Century French Paintings from The Metropolitan Museum of Art," Museum of Art, Fort Lauderdale, December 22, 1992–April 11, 1993, no catalogue

SELECTED REFERENCES
Alfred Sensier, *La vie et l'oeuvre de J.-F. Millet,* Paris, 1881, p. 356; E. Durand-Gréville, "La peinture aux Etats-Unis," *Gazette des beaux-arts* 36, July 1887, p. 73; W. J. Mollett, *The Painters of Barbizon,* London and New York, 1890, pp. 116, 119; J. M. Cartwright, *Jean-Francoise Millet, His Life and Letters,* London, 1896, p. 336; L. Soullié, *Les grands peintures aux ventes publiques, Jean-François Millet,* Paris, 1900, pp. 51–52; Lionello Venturi, *Les archives de l'impressionnisme,* Paris, 1939, vol. 2, p. 185; Charles Sterling and Margaretta M. Salinger, *French Paintings: A Catalogue of the Collection of The Metropolitan Museum of Art,* 3 vols., New York, 1955–67, vol. 2, pp. 91–93, ill.; A. Riverday, *L'École de Barbizon, L'Évolution du prix des tableaux de 1850 à 1960,* Paris and The Hague, 1973, p. 22; R. Huyghe, *La relève de l'imaginaire,* Paris, 1976, p. 467; A. Fermigier, *Jean-François Millet,* New York, 1977, pp. 127f., ill. p. 124; Sarah Burns, "A Study of the Life and Poetic Vision of Georges Fuller (1822–1884)," *American Art Journal* 13, no. 4, autumn 1981, p. 30

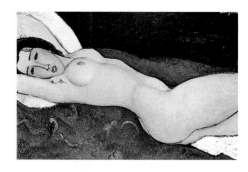

Amedeo Modigliani
Italian, 1884–1920

Reclining Nude
1917
Oil on canvas
23⅞ x 36½ in. (60.6 x 92.7 cm)
Signed (upper right): Modigliani
The Mr. and Mrs. Klaus G. Perls Collection, 1997
1997.149.9
See no. 130

PROVENANCE
Leopold Zborowski, Paris (1920–26); Georges Menier (d. 1933); his son, Claude Menier, Paris (until at least 1958); [Galerie Mouradian-Vallotton, Paris; until 1960]; [Perls Galleries (Klaus G. Perls), New York, by January 1960–97]

EXHIBITIONS
"Cent tableaux de Modigliani," Galerie Charpentier, Paris, April–May 1958, no. 48; "Modigliani," Musée Cantini, Marseilles, June 10–July 27, 1958, not in catalogue; "Major Recent Acquisitions," Perls Galleries, New York, January 19–March 5, 1960, no. 1; "Amedeo Modigliani (1884–1920)," Perls Galleries, New York, October 29–December 7, 1963, no. 17; "The Nudes of Modigliani [For the benefit of the Dance Collection of the New York Public Library]," Perls Galleries, New York, October 11–November 12, 1966, no. 1; "Amedeo Modigliani [Loan exhibition, for the benefit of the Museum of Modern Art, New York]," Acquavella Galleries, New York, October 14–November 13, 1971, no. 37; "Amedeo Modigliani, 1884–1920," Musée d'Art Moderne de la Ville de Paris, March 26–June 28, 1981, no. 51; "Modigliani, An Anniversary Exhibition," National Gallery of Art, Washington, D.C., December 11, 1983–April 22, 1984; "Painters in Paris 1895–1950," Metropolitan Museum of Art, New York, March 8–December 31, 2000, unnumbered cat.; "Picasso and the School of Paris, Paintings from The Metropolitan Museum of Art, New York," Kyoto Municipal Museum of Art, September 14–November 24, 2002, Bunkamura Museum of Art, Tokyo, December 7, 2002–March 9, 2003, no. 34; "Modigliani: Beyond the Myth," Art Gallery of Ontario, Toronto, October 23, 2004–January 23, 2005, Phillips Collection, Washington, D.C., February 19–May 29, 2005, not in catalogue

SELECTED REFERENCES
Deutsche Kunst und Dekoration 56, no. 28, July 1925, p. [208] (ill.); André Salmon, *Modigliani, Sa vie et son oeuvre*, Paris, [1926], pl. 8; Giovanni Scheiwiller, *Amedeo Modigliani*, Milan, 1927 pl. [4] (French ed., 1928, pl. 3); Arthur Pfannstiel, *Modigliani*, Paris [1929], opp. p. 98 (ill.), "catalogue présumé," pp. 20–21, under 1917 as "Nu couché"; Michel Georges-Michel, *Les Montparnos, Roman nouveau de la Bohème cosmopolite*, Paris, 1929, p. 223, ill.; Seigo Taguchi, *Modigliani*, Tokyo, 1936

[1st ed., 1930], pl. 9 ; Raffaele Carrieri, *Avant-Garde Painting and Sculpture (1890–1955) in Italy*, 2nd ed. including English trans., Milan, 1955, p. [92], fig. 102; Vincenzo Costantini, *Architettura, scultura, pittura contemporanea Europea in un secolo di materialismo*, Milan [1951], p. 259 (ill.); Arthur Pfannstiel, *Modigliani et son oeuvre: Étude critique et catalogue raisonné*, Paris, 1956, p. 98, no. 132; Ambrogio Ceroni, *Amedeo Modigliani, Peintre; Suivi des "Souvenirs" de Lunia Czechowska*, Milan, 1958, p. 64, fig. 130; Alfred Werner, *Modigliani*, New York [1966], p. 44, fig. 52; J. Lanthemann, *Modigliani, 1884–1920: Catalogue raisonné. Sa vie, son oeuvre complet, son art*, Barcelona, 1970, pp. 117, no. 153, 200 fig. 153; Ambrogio Ceroni, *Amedeo Modigliani*, Milan, 1970, colorpl. XXVIII–XXIX, pp. 98, no. 199 (ill.), 111 [French ed., 1972]; Claude Roy, trans. James Emmons and Stuart Gilbert, *Modigliani*, New York, 1985 [1st ed., Geneva, 1958], pp. 79 (color ill.), 103 (color detail), 156; Angela Ceroni, *Modigliani, Les nus*, Paris, 1989, pp. 82–83, no. 24 (color ill.); Christian Parisot, *Modigliani: Catalogue raisonné*, 2 vols., Livorno, 1990–91, vol. 2, pp. 176 (ill.), 316, no. 40/1917; Osvaldo Patani, *Amedeo Modigliani: Catalogo generale*, 3 vols., Milan, 1991, vol. 1, p. 219, no. 208 (color ill.)

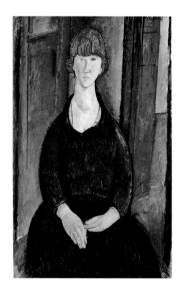

Flower Vendor
1919
Oil on canvas
45⅞ x 28⅞ in. (116.5 x 73.3 cm)
Signed (upper right): modigliani
Bequest of Florene M. Schoenborn, 1995
1996.403.9
See no. 132

PROVENANCE
[Louis Libaude, Paris (d. 1922)]; [Galerie Bing, Paris, by 1925–probably at least 1927]; [Jos Hessel, Paris]; [Constant Lepoutre, Paris (d. 1929)]; Lecomte-Durey, Paris (by 1929); Mme Lederlin, Paris (by 1933; her sale, Galerie Charpentier, Paris, March 23, no. 136); private collection, Zurich; Marquiset; Martinet (until May 1950; sold to Rosenberg); [Paul Rosenberg, New York (in 1950; sold to Marx)]; Mr. and Mrs. Samuel Abraham Marx, Chicago (1950–his d. 1964); Mrs. Florene Marx, later Mrs. Wolfgang Schoenborn (1964–95)

EXHIBITIONS
"Modigliani," Galerie Bing, Paris, October 24–November 15, 1925, no. 6; "Internationale Kunst Ausstellung: Jahresschau deutscher Arbeit," Dresden, June–September 1926, no. 196; "Modigliani," Palais des Beaux-Arts, Brussels, November 1933, no. 44; "Modigliani," Kunsthalle, Basel, January 7–February 4, 1934, no. 36; "20th Century French Paintings," Paul Rosenberg, New York, November 13–December 12, 1950, no. 8; "Amedeo Modigliani: Paintings, Drawings, Sculpture," Cleveland Museum of Art, January 30–March 18, 1951, Museum of Modern Art, New York, April 11–June 10, 1951, unnumbered cat.; "The School of Paris: Paintings from the Florene May Schoenborn and Samuel A. Marx Collection," Museum of Modern Art, New York, November 1, 1965–January 2, 1966, Art Institute of Chicago, February 11–March 27, 1966, City Art Museum of St. Louis, April 26–June 13, 1966, Museo de Arte Moderno, Mexico City, July 2–August 7, 1966, San Francisco Museum of Art, September 2–October 2, 1966, unnumbered cat.; "Painters in Paris: 1895–1950," Metropolitan Museum of Art, New York, March 8–December 31, 2000, unnumbered cat.; "Der Kühle Blick, Realismus der zwanziger Jahre," Kunsthalle der Hypo Kulturstiftung, Munich, June 1–September 2, 2001, unnumbered cat.

SELECTED REFERENCES
Waldemar George, "Modigliani," *L'Amour de l'art* 6, no. 10, October 1925, p. [383] (ill.); André Salmon, *Modigliani, Sa vie et son oeuvre*, Paris [1926], pl. 12; Giovanni Scheiwiller, *Amedeo Modigliani*, Milan, 1927 (and later editions), pl. [2]; Arthur Pfannstiel, *Modigliani*, Paris [1929], p. 18, ill. opp. p. 91, p. 106, "catalogue présumé," p. 36; Seigo Taguchi, *Modigliani*, Tokyo, 1936, pl. 13; Nietta Aprà, *Tormento di Modigliani*, Milan [1945], p. 81 (ill.); Arthur Pfannstiel, *Modigliani et son oeuvre: Étude critique et catalogue raisonné*, Paris, 1956, p. 126, no. 221; Ambrogio Ceroni, *Amedeo Modigliani, Dessins et sculptures, avec suite du catalogue illustré des peintures*, Milan, 1965, p. 50, no. 218, pl. 218; J. Lanthemann, *Modigliani, 1884–1920: Catalogue raisonné, Sa vie, son oeuvre complet, son art*, Barcelona, 1970, pp. 136, no. 417, 270 fig. 417; Ambrogio Ceroni, *I dipinti di Modigliani*, Milan, 1970, pp. [105] fig. 331, 111 [French ed., 1972]; Claude Roy, trans. James Emmons and Stuart Gilbert, *Modigliani*, New York, 1985 [1st ed., Geneva, 1958], pp. 139 (color ill.), 158 ; Christian Parisot, *Modigliani Catalogue Raisonné*, 2 vols., Livorno, 1990–91, vol. 2, pp. 241 (ill.), 341, no. 12/1919; Osvaldo Patani, *Amedeo Modigliani: Catalogo generale*, 3 vols., Milan, 1991, vol. 1, p. 333, no. 343 (color ill.)

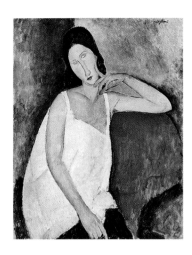

Jeanne Hébuterne
1919
Oil on canvas
36 x 28¾ in. (91.4 x 73 cm)
Signed (upper right): modigliani
Gift of Mr. and Mrs. Nate B. Spingold, 1956
56.184.2
See no. 131

PROVENANCE
Léopold Zborowski, Paris; [Louis Libaude, Paris (d. 1922)]; [possibly Galerie Bing (Henri Bing), Paris; by 1925]; Monsieur R. B. (by 1937; his sale, Hôtel Drouot, Paris, June 3, no. 18); Georges Hyordey, possibly Paris (1937–possibly 1951); [Galerie Bing, Paris; by 1951; sold to Lindon]; [Jacques Lindon, New York; in 1951; sold to Spingold]; Mr. and Mrs. Nate B. Spingold, New York (1951–56)

EXHIBITIONS
"Modigliani," Galerie Bing, Paris, October 24–November 15, 1925, no. 4 or 19; "Amedeo Modigliani," Arthur Tooth and Sons, London, March 17–April 9, 1938, no. 20; "Collector's Choice: Masterpieces of French Art from New York Private Collections [Loan exhibition, for the benefit of the Public Education Association]," Paul Rosenberg and Co., New York, March 17–April 18, 1953, no. 26; "The Nate and Frances Spingold Collection," Metropolitan Museum of Art, New York, March 23–June 19, 1960, unnumbered cat.; "Modigliani," Royal Scottish Academy, Edinburgh, August 17–September 16, 1963, Tate Gallery, London, September 28–November 3, 1963, no. 45; "Modigliani," National Museum of Modern Art, Tokyo, July 19–September 29, 1985, Aichi Prefectural Art Gallery, Nagoya, October 23–November 7, 1985, no. 124; "20th Century Masters from The Metropolitan Museum of Art," National Gallery of Australia, Canberra, March 1–April, 27, 1986, Queensland Art Gallery, Brisbane, May 7–July 1, 1986, unnumbered cat.; "Italian Art in the 20th Century: Painting and Sculpture, 1900–1988," Royal Academy of Arts, London, January 14–April 19, 1989, no. 64; "Amedeo Modigliani: Malerei, Skulpturen, Zeichnungen," Kunstsammlung Nordrhein-Westfalen, Düsseldorf, January 19–April 1, 1991, Kunsthaus Zürich, April 19–July 7, 1991, no. 88; "Painters in Paris 1895–1950," Metropolitan Museum of Art, New York, March 8–December 31, 2000, unnumbered cat.; "Modigliani e i suoi: Jeanne Hébuterne, André Hébuterne, Georges Dorignac, Amedeo Modigliani," Fondazione Giorgio Cini, Venice, October 8–December 24, 2000, no. 142; "Picasso and the School of Paris, Paintings from The Metropolitan Museum of Art," Kyoto Municipal Museum of Art, September 14–November 24, 2002,

Bunkamura Museum of Art, Tokyo, December 7, 2002–March 9, 2003, no. 35; "Modigliani: Beyond the Myth," Jewish Museum, New York, May 21–September 19, 2004, Phillips Collection, Washington, D.C., February 19–May 29, 2005, unnumbered cat.; "Modigliani and his Models," Royal Academy of Arts, London, July 8–October 15, 2006, unnumbered cat.

SELECTED REFERENCES
Jacques Lassaigne, *Panorama des arts*, Paris, 1946, p. 11, ill.; Pierre Descargues, *Amedeo Modigliani, 1884–1920*, Paris, 1951, pl. 42; Paolo d'Ancona, trans. Lucia Krasnik, *Modigliani, Chagall, Soutine, Pascin: Some Aspects of Expressionism*, Milan [1953], pp. 23–[24], [25] (color ill.), [91]; Alfred M. Frankfurter, "Collectors and Million-Dollar Taste," *ArtNews* 52, no. 1, March 1953, p. 25 (ill.); Charles Sterling and Margaretta M. Salinger, *French Paintings: A Catalogue of the Collection of the Metropolitan Museum of Art*, 3 vols., New York, 1955–67, vol. 3, p. 241, ill.; Arthur Pfannstiel, *Modigliani et son oeuvre: Étude critique et catalogue raisonné*, Paris, 1956, p. 153, no. 290; Ambrogio Ceroni, *Amedeo Modigliani, Peintre; Suivi des "souvenirs" de Lunia Czechowska*, Milan, 1958, p. 69, no. 152, colorpl. 152; J. Lanthemann, *Modigliani, 1884–1920: Catalogue raisonné, Sa vie, son oeuvre complet, son art*, Barcelona, 1970, pp. 131, no. 347, 251 fig. 347; Ambrogio Ceroni, *Amedeo Modigliani*, Milan, 1970, pp. 104–[105], no. 326 (ill.), 111 [French ed., 1972]; Bernard Zurcher, trans. Jane Brenton, *Modigliani*, London, 1981, pp. 23, 31, color pl. 69 [1st ed., Paris, 1980]; Claude Roy, trans. James Emmons and Stuart Gilbert, *Modigliani*, New York, 1985, pp. 126 (color ill.), 158 [1st ed., Geneva, 1958]; Thérèse Castieau-Barrielle, *La vie et l'oeuvre de Amedeo Modigliani*, Paris, 1987, p. 220 (color ill.); Gary Tinterow et al., *The Metropolitan Museum of Art: Modern Europe*, New York, 1987, pp. 124–25, fig. 103 (color ill.); Christian Parisot, *Modigliani: Catalogue raisonné*, 2 vols., Livorno, 1990–91, vol. 2, pp. 240 (ill.), 340–41, no. 11/1919; Osvaldo Patani, *Amedeo Modigliani: Catalogo generale*, 3 vols., Milan, 1991, vol. 1, p. 328, no. 338 (color ill.).

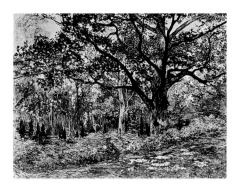

Claude Monet
French, 1840–1926

The Bodmer Oak, Fontainebleau Forest
1865
Oil on canvas
37⅞ x 50⅞ in. (96.2 x 129.2 cm)
Signed (lower right): Claude Monet.
Gift of Sam Salz and Bequest of Julia W. Emmons, by exchange, 1964
64.210
See no. 84

PROVENANCE
The artist, seized from his studio at Ville-d'Avray in 1866 or 1867; nephew of the dealer Martin; the artist (until 1873; sold to Durand-Ruel); [Durand-Ruel, Paris and New York, 1873–1900]; Chauncey J. Blair, Chicago (1900); [Durand-Ruel, New York, from 1900]; [Sam Salz, New York, by 1962–64]

EXHIBITIONS
"Exhibition of Paintings by Claude Monet," Durand-Ruel, New York, January 26–February 14, 1907, no. 23; "Claude Monet: Memorial Exhibition," Museum of Fine Arts, Boston, January 1927, no. 43; "Exposition Claude Monet: 1840–1926," Durand-Ruel, Paris, May 22–September 30, 1959, no. 4; "Barbizon Revisited," California Palace of the Legion of Honor, San Francisco, September 27–November 4, 1962, Toledo Museum of Art, November 20–December 27, 1962, Cleveland Museum of Art, January 15–February 24, 1963, Museum of Fine Arts, Boston, March 14–April 28, 1963, no. 109; "Impressionism: A Centenary Exhibition," Metropolitan Museum of Art, New York, December 12, 1974–February 10, 1975, not in catalogue; "Franse meesters uit het Metropolitan Museum of Art: Realisten en Impressionisten," Rijksmuseum Vincent Van Gogh, Amsterdam, March 15–May 31, 1987, no. 20; "Landschaft im Licht: Impressionistische Malerei in Europa und Nordamerika, 1860–1910," Wallraf-Richartz-Museum, Cologne, April 6–July 1, 1990, Kunsthaus Zürich, August 3–October 21, 1990, no. 118; "Origins of Impressionism," Galeries Nationales du Grand Palais, Paris, April 19–August 8, 1994, Metropolitan Museum of Art, New York, September 27, 1994–January 8, 1995, no. 120; "Claude Monet, 1840–1926," Art Institute of Chicago, July 22–November 26, 1995, no. 3; "Monet and Bazille: A Collaboration," High Museum of Art, Atlanta, February 23–May 16, 1999, no. 11; "L'École de Barbizon: Peindre en plein air avant l'impressionnisme," Musée des Beaux-Arts de Lyon, June 22–September 9, 2002, no. 84; "Monet's Garden," Kunsthaus Zürich, October 29, 2004–March 13, 2005, no. 6

SELECTED REFERENCES
Arsène Alexandre, *Claude Monet*, Paris, 1921, pp. 51–52; John Rewald, *The History of*

Impressionism, New York, 1946, 1st ed., ill. p. 85 [later eds., ill. p. 95]; Charles Sterling and Margaretta M. Salinger, *French Paintings: A Catalogue of the Collection of The Metropolitan Museum of Art*, 3 vols., New York, 1955–67, vol. 3, pp. 124–25, ill.; Charles Merrill Mount, *Monet, A Biography,* New York, 1966, pp. 89, 225–26, 414; Margaretta M. Salinger, "Windows Open to Nature," *Metropolitan Museum of Art Bulletin* 27, summer 1968, unpaginated, ill.; Douglas Cooper, "The Monets in the Metropolitan Museum," *Metropolitan Museum Journal* 3, 1970, pp. 281–84, 302, 305, fig. 3; Charles S. Moffett, *Impressionist and Post-Impressionist Paintings in The Metropolitan Museum of Art,* New York, 1985, pp. 106–7, 251, ill.; Daniel Wildenstein, trans. Chris Miller, Peter Snowdon et al., *Monet, or the Triumph of Impressionism,* 4 vols., Cologne, 1996, vol. 1, p. 58, ill. p. 31, vol. 2, pp. 30–31, no. 60, ill. [1st ed., 1974–91]; Joachim Pissarro, *Monet and the Mediterranean,* exh. cat., Kimbell Art Museum, Fort Worth, New York, 1997, pp. 88, 185 n. 3; Matthias Arnold, *Claude Monet,* Hamburg, 1998, p. 97

La Grenouillère

1869
Oil on canvas
29⅜ x 39¼ in. (74.6 x 99.7 cm)
Signed and inscribed: (lower right) Claude Monet
H. O. Havemeyer Collection, Bequest of Mrs. H. O. Havemeyer, 1929
29.100.112
See no. 85

PROVENANCE

Possibly Édouard Manet, Paris (until d. 1883); possibly his widow, Suzanne Manet, Paris (1883–86); [Durand-Ruel, Paris, possibly bought from Mme Manet in 1886, definitely by 1891, stock no. 1586; sold on September 27, 1897, for Fr 12,500 to Havemeyer]; Mr. and Mrs. H. O. Havemeyer, New York (1897–his d. 1907); Mrs. H. O. (Louisine W.) Havemeyer, New York (1907–d. 1929)

EXHIBITIONS

"2e exposition de peinture [2nd Impressionist exhibition]," Paris, April 1876, no. 164 (possibly this picture); "The H. O. Havemeyer Collection," Metropolitan Museum of Art, New York, March 10–November 2, 1930, no. 82; "From Paris to the Sea Down the River Seine," Wildenstein, New York, January 28–February 27, 1943, no. 36; "Monet and the Beginnings of Impressionism," Currier Gallery of Art, Manchester, N.H., October 8–November 6, 1949, no. 38; "Thirty-eight Great Paintings from The Metropolitan Museum of Art," Detroit Institute of

Arts, October 1–October 29, 1951, Art Gallery of Toronto, November 14–December 12, 1951, City Art Museum of St. Louis, January 6–February 4, 1952, Seattle Art Museum, March 1–June 30, 1952; "Claude Monet," Gemeentemuseum, The Hague, July 24–September 22, 1952, no. 14; "Claude Monet," Royal Scottish Academy Building, Edinburgh, August–September 1957, Tate Gallery, London, September 26–November 3, 1957, no. 16; "One Hundred Years of Impressionism: A Tribute to Durand-Ruel," Wildenstein and Co., Inc., New York, April 2–May 9, 1970, no. 7; "Masterpieces of Fifty Centuries," Metropolitan Museum of Art, New York, November 15, 1970–February 15, 1971, not in catalogue; "Impressionism: A Centenary Exhibition," Galeries Nationales du Grand Palais, Paris, September 21–November 24, 1974, Metropolitan Museum of Art, New York, December 12, 1974–February 10, 1975, no. 27; "Paintings by Monet," Art Institute of Chicago, March 15–May 11, 1975, no. 19; "Splendid Legacy: The Havemeyer Collection," Metropolitan Museum of Art, New York, March 27–June 20, 1993, no. A389; "Origins of Impressionism," Galeries Nationales du Grand Palais, Paris, April 19–August 8, 1994, Metropolitan Museum of Art, New York, September 27, 1994–January 8, 1995, no. 147; "Claude Monet, 1840–1926," Art Institute of Chicago, July 22–November 26, 1995, no. 18; "Impressionists on the Seine: A Celebration of Renoir's 'Luncheon of the Boating Party,'" Phillips Collection, Washington, D.C., September 21, 1996–February 9, 1997; "Impressionism and the North: Late 19th Century French Avant-Garde Art and the Art in the Nordic Countries 1870–1920," Nationalmuseum, Stockholm, September 25, 2002–January 19, 2003, Statens Museum for Kunst, Copenhagen, February 21–May 25, 2003, no. 139; "Monet et ses amis," Musée des Beaux-Arts de Budapest, December 1, 2003–March 15, 2004, no. 68

SELECTED REFERENCES

Wynford Dewhurst, *Impressionist Painting: Its Genesis and Development,* London, 1904, ill. opp. p. 40; Rudolf Adelbert Meyer, "Manet und Monet," *Die Kunst Unserer Zeit* 19, 1908, ill. p. 63; Georges Grappe, *Claude Monet,* Paris [1909], p. 28, ill. opp. p. 54; Georges Lecomte, "Claude Monet ou le vieux chêne de Giverny," *La renaissance de l'art français et des industries de luxe* 3, October 1920, ill. p. 405; Gustave Geffroy, "Claude Monet," *L'Art et les artistes* 2, October 1920–February 1921, ill. p. 56; André Fontainas and Louis Vauxcelles, *Histoire générale de l'art français de la Révolution à nos jours,* 3 vols., Paris, vol. 1, 1922, ill. p. 135; Gustave Geffroy, *Claude Monet: Sa vie, son temps, son oeuvre,* Paris, 1922, p. 262, ill. opp. p. 52; Louis Vauxcelles, "Claude Monet," *L'Amour de l'art* 3, 1922, ill. p. 236; Camille Mauclair, trans. J. Lewis May, *Claude Monet,* London [1925], p. 47, pl. 17 [French ed., Paris, 1924]; Florent Fels, *Claude Monet,* Paris, 1925, ill. p. 41; *L'Art vivant* 3, January 1, 1927, ill. pp. 20–21; Léon Werth, *Claude Monet;* Paris, 1928, pl. 9; Frank Jewett Mather Jr., "The Havemeyer Pictures," *The Arts* 16, March 1930, p. 479; *H. O. Havemeyer Collection: Catalogue of Paintings, Prints, Sculpture, and Objects of Art,* 1931, pp. 152–53, ill.; Paul Jamot and Georges Wildenstein, *Manet,* 2 vols., Paris, 1932, vol. 1, p. 106; Gaston Poulain, *Bazille et ses amis,* Paris, 1932, pp. 161–62; Stephen Gwynn, *Claude Monet and His Garden: The Story of an Artist's Paradise,* New York, 1934, p. 168; John Rewald, *The History of Impressionism,* New York, 1946, pp. 191–92, 196, ill. [4th rev. ed., 1973, pp. 227–32, ill.]; *The Metropolitan Museum of Art Miniatures, French Impressionists: Manet, Monet,*

Pissarro, Renoir, and Boudin, 97 vols. in 5, New York, 1947–57, vol. 27, Album LI, unpaginated, ill.; Charles Sterling and Margaretta M. Salinger, *French Paintings: A Catalogue of the Collection of The Metropolitan Museum of Art,* 3 vols., New York, 1955–67, vol. 3, pp. 126–27, ill.; William C. Seitz, *Claude Monet,* New York, [1960], pp. 23, 84–85, ill.; Luigina Rossi Bortolatto, *L'opera completa di Claude Monet, 1870–1889,* Milan, 1966, pp. 89–90, no. 25, ill.; Joel Isaacson, *The Early Paintings of Claude Monet,* unpublished Ph.D. dissertation, University of California, Berkeley, 1967, pp. xiii, 224–37, 326–27 n. 32, pl. 79; Margaretta M. Salinger, "Windows Open to Nature," *Metropolitan Museum of Art Bulletin* 27, summer 1968, unpaginated, ill.; Douglas Cooper, "The Monets in the Metropolitan Museum," *Metropolitan Museum Journal* 3, 1970, pp. 281–82, 286–87, 302– 5, fig. 6; Kermit Swiler Champa, *Studies in Early Impressionism,* New Haven, 1973, pp. 63–66, pl. 11; John Rewald, "The Impressionist Brush," *Metropolitan Museum of Art Bulletin* 32, no. 3, 1973–74, p. 21, fig. 12 and ill. p. 21; George Heard Hamilton, "The Philosophical Implications of Impressionist Landscape Painting," *Museum of Fine Arts, Houston Bulletin* 6, spring 1975, pp. 6–7, fig. 2; Alice Bellony-Rewald, *The Lost World of the Impressionists,* London, 1976, pp. 99, 102, 104–5, ill.; Anthea Callen, *Renoir,* London, 1978, pp. 11–12, fig. 5; Joel Isaacson, *Observation and Reflection: Claude Monet,* Oxford, 1978, pp. 17–19, 22, 77–78, 201–2, pl. 29, pl. 30; Brian Petrie, *Claude Monet, The First of the Impressionists,* Oxford, 1979, pp. 34–35, 37, pl. 28; Michael Wilson, "Monet's 'Bathers at La Grenouillère,' From Plein-air to Impressionism: Monet at La Grenouillère," *National Gallery Technical Bulletin* 5, 1981, p. 14, fig. 2; Joel Isaacson, "Impressionism and Journalistic Illustration," *Arts Magazine* 56, June 1982, pp. 97, 100, 102, 114 n. 38, p. 115 n. 93, fig. 3; Robert Gordon and Andrew Forge, *Monet,* New York, 1983, pp. 43–44, 289, ill.; John Rewald and Frances Weitzenhoffer, eds., *Aspects of Monet,* New York, 1984, pp. 36–51, ill.; Charles S. Moffett, *Impressionist and Post-Impressionist Paintings in The Metropolitan Museum of Art,* New York, 1985, pp. 10, 112–13, 251, color ill.; Frances Weitzenhoffer, *The Havemeyers: Impressionism Comes to America,* New York, 1986, pp. 117, 257, colorpl. 76; John House, *Monet: Nature into Art,* New Haven, 1986, pp. 51, 53, 59, 77, 136, 147, 161, 205, 235 n. 5, p. 242 n. 38, pl. 71; Charles S. Moffett, ed., *The New Painting: Impressionism 1874–1886,* exh. cat., National Gallery of Art, Washington, D.C., San Francisco, 1986, pp. 145, 147, 157, 163, 254, fig. 1; Robert L. Herbert, *Impressionism: Art, Leisure, and Parisian Society,* New Haven, 1988, pp. 212–15, pls. 211, 213; Karin Sagner-Düchting, *Claude Monet, 1840–1926: Ein Fest für die Augen,* Cologne, 1990, pp. 43, 45–47, 65, ill.; David Bomford et al., *Art in the Making: Impressionism,* exh. cat., National Gallery, London, 1990, p. 120, pl. 81; Virginia Spate, *Claude Monet: Life and Work,* New York, 1992, pp. 57–59, fig. 63 (color); Charles Harrison et al., *Modernity and Modernism: French Painting in the Nineteenth Century,* New Haven, 1993, pp. 160, 167, 170, 174–75, 258, colorpls. 153, 156; Jacques G. Laÿ and Monique Laÿ, "Rediscovering La Grenouillère: 'Ars longa, vita brevis,'" *Apollo* 137, May 1993, p. 282, pl. I.; Paul Hayes Tucker, *Claude Monet: Life and Art,* New Haven, 1995, pp. 42–44, pl. 52; Stephan Koja, trans. John Brownjohn, *Claude Monet,* exh. cat., Österreichische Galerie, Vienna, Munich, 1996, English ed., pp. 19, 22, 23, 54, 60, 185, ill.; Daniel Wildenstein, trans. Chris Miller, Peter Snowdon et al., *Monet, or the Triumph of Impressionism,* 4 vols., Cologne, 1996, vol. 1,

pp. 76–78, ill., vol. 2, p. 65, no. 134 [1st ed., 1974–91]; Ruth Berson, ed., *The New Painting: Impressionism 1874–1886. Documentation*, 2 vols., San Francisco, 1996, vol. 2, p. 41; Barbara Ehrlich White, *Impressionists Side by Side: Their Friendships, Rivalries, and Artistic Exchanges*, New York, 1996, pp. 64–65, ill.; Gary Tinterow et al., *La collection Havemeyer: Quand l'Amérique découvrait l'impressionnisme*, exh. cat., Musée d'Orsay, Paris, 1997, pp. 63, 108, fig. 25; Susanne Weiss, *Claude Monet: Ein distanzierter Blick auf Stadt und Land Werke, 1859–1889*, Berlin, 1997, pp. 128–29, fig. 32; Matthias Arnold, *Claude Monet*, Hamburg, 1998, pp. 38, 101–2, ill.; Richard R. Brettell, *Impression: Painting Quickly in France, 1860–1890*, exh. cat., National Gallery, London, New Haven, 2000, pp. 115–16, fig. 69

Jean Monet (1867–1913) on His Hobby Horse
1872
Oil on canvas
23⅞ x 29¼ in. (60.6 x 74.3 cm)
Signed and dated (lower right): Claude Monet- / 1872.
Gift of Sara Lee Corporation, 2000
2000.195
See no. 86

PROVENANCE
The artist, Argenteuil (1872–d. 1926); his daughter-in-law, Blanche Hoschedé-Monet [Mme Jean Monet], Giverny (1926–at least 1935); [Georges Bernheim, Paris, until 1938; sold on April 29, 1938 to Wildenstein]; [Wildenstein, London, 1938–43; sold to Rogers]; Mrs. Huttleson H. Rogers, New York (1943–at least 1948); Mr. and Mrs. Nathan Cummings, Chicago and New York (by 1952–at least 1982); [Colnaghi, New York, 1983]; private collection/foundation, United States (by 1986–94); [William Beadleston, New York, 1994; sold to Sara Lee]; Sara Lee Corporation, Chicago (1994–2000)

EXHIBITIONS
"Claude Monet: Exposition rétrospective," Musée de l'Orangerie, Paris, 1931, no. 20; "Claude Monet de 1865 à 1888," Durand-Ruel, Paris, 1935, no. 11; "Children of France," Wildenstein and Co., Inc., New York, 1942; "Claude Monet, 1840–1926," Kunsthaus Zürich, May 10–June 15, 1952, no. 27; "Claude Monet" [Fondation Wildenstein], Paris, June 19–

July 17, 1952, no. 21; "Claude Monet," Gemeentemuseum, The Hague, July 24–September 22, 1952, no. 23; "Collection Nathan Cummings d'art ancien du Pérou," Musée des Arts Décoratifs, Paris, March–May 1956, no. 3, Palazzo Venezia, Rome, June–July 1956; "Claude Monet," Royal Scottish Academy Building, Edinburgh, August–September 1957, Tate Gallery, London, September 26–November 3, 1957, no. 30; "Paintings by Claude Monet: Paintings from the Collection of Mrs. Mellon Bruce," Society of the Four Arts, Palm Beach, 1958, no. 7; "Paintings from the Cummings Collection," Minneapolis Institute of Arts, January 14–March 7, 1965, unnumbered cat.; "Olympia's Progeny," Wildenstein and Co., Inc., New York, October 28–November 27, 1965, no. 9; "Selections from the Nathan Cummings Collection," National Gallery of Art, Washington, D.C., June 28–September 11, 1970, no. 11; "Nathan Cummings Collection," Metropolitan Museum of Art, New York, July 1–September 7, 1971, no. 48; "Faces from the World of Impressionism and Post-Impressionism," Wildenstein and Co., Inc., New York, November 2–December 9, 1972, no. 47; "Major Works from the Collection of Nathan Cummings," Art Institute of Chicago, October 20–December 9, 1973, no. 3; "Paintings by Monet," Art Institute of Chicago, March 15–May 11, 1975, no. 30; "Claude Monet," Acquavella Galleries, Inc., New York, October 27–November 28, 1976, no. 14; "De Fiets," Museum Boymans-van Beuningen, Rotterdam, April 7–June 12, 1977, no. 76; "Prized Possessions: European Paintings from Private Collections of Friends of the Museum of Fine Arts, Boston," Museum of Fine Arts, Boston, June 17–August 16, 1992, no. 93; "Claude Monet, 1840–1926," Art Institute of Chicago, July 22–November 26, 1995, no. 27; "Monet to Moore: The Millennium Gift of Sara Lee Corporation," Singapore Museum of Art, April 1–May 30, 1999, National Gallery of Australia, Canberra, June 11–August 22, 1999, North Carolina Museum of Art, Raleigh, September 10–November 7, 1999, Portland Art Museum, November 19, 1999–January 23, 2000, Art Institute of Chicago, March 13–May 28, 2000, no. 31; "Monet's Garden," Kunsthaus Zürich, October 29, 2004–March 13, 2005, no. 8

SELECTED REFERENCES
Raymond Cogniat, *Monet and His World*, London, 1966, pp. 50, 135 n. 50, ill.; Paul Hayes Tucker, *Monet at Argenteuil*, New Haven, 1982, pp. 131, 134–35, 139, no. 104, ill.; John House, *Monet: Nature into Art*, New Haven, 1986, pp. 34–35, no. 44, ill.; Paul Hayes Tucker, *Monet: Life and Art*, New Haven, 1995, pp. 65–66, 68, fig. 74; Daniel Wildenstein, trans. Chris Miller, Peter Snowdon et al., *Monet, or the Triumph of Impressionism*, 4 vols., Cologne, 1996, vol. 2, pp. 104–5, no. 238, ill. [1st ed., 1974–91]; Gary Tinterow et al., "Recent Acquisitions, A Selection: 1999–2000," *Metropolitan Museum of Art Bulletin* 58, fall 2000, pp. 5, 45, ill.

Apples and Grapes
ca. 1879–80
Oil on canvas
26⅝ x 35¼ in. (67.6 x 89.5 cm)
Signed (upper right): Claude Monet
Gift of Henry R. Luce, 1957
57.183
See no. 89

PROVENANCE
[Possibly Georges Petit, Paris, from 1879; bought from the artist]; Victor Chocquet, Paris (until d. 1898); Mme Chocquet, Paris (1898–d. 1899; posthumous sale, Georges Petit, Paris, July 1, 3, and 4, 1899, no. 79, for Fr 6,000 to Durand-Ruel); [Durand-Ruel, Paris, from 1899]; Decap, Paris (in 1903); Mme Barret-Decap, Biarritz (in 1932); Barret-Decap collection, Paris (until at least 1941); Marcel Kapferer, Paris (by 1947–50); [Wildenstein, New York, 1950]; Henry R. Luce, New York (1950–57)

EXHIBITIONS
"Exhibition of Pictures by French Impressionists, Monet, Sisley, Pissarro, Renoir, and Other Masters," Hanover Gallery, London, January–February, 1901, no. 25; "Exhibition of French Art: 1200–1900," Royal Academy of Arts, London, January 4–March 12, 1932, no. 548; "La pintura francesa de David à nuestros días," Museo Nacional de Bellas Artes, Buenos Aires, October–December 1939, no. 99; "The Painting of France since the French Revolution," M. H. de Young Memorial Museum, San Francisco, December 1940–January 1941, no. 78; "French Painting from David to Toulouse-Lautrec," Metropolitan Museum of Art, New York, February 6–March 26, 1941, no. 93; "Pictures Collected by Yale Alumni," Yale University Art Gallery, New Haven, May 8–June 18, 1956, no. 83; "Claude Monet," Acquavella Galleries, Inc., New York, October 27–November 28, 1976, no. 33; "Monet at Vétheuil: The Turning Point," University of Michigan Museum of Art, Ann Arbor, January 25–March 15, 1998, Dallas Museum of Art, March 28–May 17, 1998, Minneapolis Institute of Arts, May 30–July 26, 1998, unnumbered cat.

SELECTED REFERENCES
New York Herald (Paris), June 29, 1899; Gustave Geffroy, *Claude Monet: Sa vie, son temps, son oeuvre*, Paris, 1922, p. 219; Charles Sterling and Margaretta M. Salinger, *French Paintings: A Catalogue of the Collection of The Metropolitan Museum of Art*, 3 vols., New York, 1955–67, vol. 3, pp. 129–30, ill.; C[laude] Richebé, "Claude Monet au Musée Marmottan," *Académie des Beaux-Arts*, année 1959–60, 1960, p. 122; Luigina Rossi Bortolatto, *L'Opera completa di Claude Monet, 1870–1889*, Milan, 1966, pp. 100–1, no. 187, ill.; John Rewald, *The History of Impressionism*, New York, 2nd ed., 1961, p. 434 [and later eds.]; Douglas Cooper, "The Monets in the Metropolitan Museum,"

Metropolitan Museum Journal 3, 1970, pp. 296–97, 303, 305, fig. 22; Charles S. Moffett, *Impressionist and Post-Impressionist Paintings in The Metropolitan Museum of Art*, New York, 1985, pp. 122–23, 252, ill.; John House, *Monet: Nature into Art*, New Haven, 1986, pp. 41–42, 236 n. 117, pl. 56; Daniel Wildenstein, trans. Chris Miller, Peter Snowdon et al., *Monet, or the Triumph of Impressionismt*, 4 vols., Cologne, 1996, vol. 1, p. 149, vol. 2, pp. 213–14, no. 545, ill. p. 212 (color) [1st ed., 1974–91]

View of Vétheuil
1880
Oil on canvas
31½ x 23¾ in. (80 x 60.3 cm)
Signed and dated (lower left): 1880 Claude Monet
Bequest of Julia W. Emmons, 1956
56.135.1
See no. 87

PROVENANCE
Probably Charles Ephrussi, Paris (from 1880; bought from the artist in July 1880 for Fr 400); Dr. X . . . [Paulin], Paris (until 1901; his sale, Hôtel Drouot, Paris, November 21, 1901, no. 52, for Fr 6,900 to Leclanché); Maurice Leclanché, Paris (from 1901); Josse and Gaston Bernheim-Jeune, Paris (until 1910; sold May 22, 1910, to Bernheim-Jeune); [Bernheim-Jeune, Paris, 1910, stock no. 18110; sold May 30, 1910, to Liacre]; Georges Liacre, Paris (1910–11; sold October 18, 1911, to Durand-Ruel); [Durand-Ruel, Paris, 1911, stock no. 9754; sold November 25, 1911, to Durand Ruel]; [Durand-Ruel, New York, 1911–12, stock no. 3503; sold April 30, 1912, to Emmons]; Arthur B. Emmons, New York and Newport (1912–20; sale, American Art Association, New York, January 14, 1920, no. 27, for $7,000 to Durand-Ruel [possibly bought in for Emmons]); his widow, Julia W. Emmons, New York and Newport (until d. 1956)

EXHIBITIONS
"7me exposition des artistes indépendants," Salons du Panorama de Reischoffen, Paris, ?March 1–31, 1882, no. 89 (possibly); "Paintings by the Impressionists of Paris: Claude Monet, Camille Pisarro, Alfred Sisley, from the Galleries of Durand-Ruel, Paris and New York," Chase's Gallery, Boston, March 17–28, 1891, no. 12 (possibly); "Exhibition of Paintings by Claude Monet," Durand-Ruel, New York,

February 11–25, 1902, no. 10 (possibly); "Monet," Durand-Ruel, New York, 1911, no. 10 (possibly); "Paintings of different periods by Monet," Durand-Ruel, New York, February 8–25, 1911, no. 11; "Paintings by Corot . . . ," Brooks Reed Gallery, Boston, 1912, no. 50; "Four Masters of Impressionism," Acquavella Galleries, Inc., New York, October 24–November 30, 1968, no. 26; "Claude Monet, Painter of Light," Auckland City Art Gallery, April 9–May 28, 1985, Art Gallery of New South Wales, Sydney, June 11–July 23, 1985, National Gallery of Victoria, Melbourne, August 6–September 17, 1985, no. 7; "The New Painting: Impressionism, 1874–1886," National Gallery of Art, Washington, D.C., January 17–April 6, 1986, no. 124; M. H. de Young Memorial Museum, San Francisco, April 19–July 6, 1986, "Monet: Il maestro della luce," Complesso del Vittoriano, Rome, March 4–June 25, 2000, no. 18

SELECTED REFERENCES
Charles Sterling and Margaretta M. Salinger, *French Paintings: A Catalogue of the Collection of The Metropolitan Museum of Art*, 3 vols., New York, 1955–67, vol. 3, p. 132, ill.; James J. Rorimer and Dudley T. Easby Jr., "Review of the Year 1956–1957," *Metropolitan Museum of Art Bulletin* 16, October 1957, n.s., pp. 38, 63, ill. p. 46; Luigina Rossi Bortolatto, *L'Opera completa di Claude Monet, 1870–1889*, Milan, 1966, p. 101, no. 199, ill.; Douglas Cooper, "The Monets in the Metropolitan Museum," *Metropolitan Museum Journal* 3, 1970, pp. 302–5, fig. 34; Charles S. Moffett, *Impressionist and Post-Impressionist Paintings in The Metropolitan Museum of Art*, New York, 1985, pp. 124–25, 252, ill.; John House, *Monet: Nature into Art*, New Haven, 1986, pp. 59, 117–18, 120, 167, colorpl. 149; Daniel Wildenstein, trans. Chris Miller, Peter Snowdon et al., *Monet, or the Triumph of Impressionism*, 4 vols., Cologne, 1996, vol. 1, p. 163, vol. 2, p. 229, no. 592, ill. (color) [1st ed., 1974–91]

Chrysanthemums
1882
Oil on canvas
39½ x 32¼ in. (100.3 x 81.9 cm)
Signed and dated (lower left): Claude Monet 82
H. O. Havemeyer Collection, Bequest of Mrs. H. O. Havemeyer, 1929
29.100.106
See no. 88

PROVENANCE
[Durand-Ruel, Paris, bought from the artist in December 1883]; Alden Wyman Kingman, New York (1886–92; sold to Durand-Ruel); [Durand-Ruel, New York, 1892; sold to Lambert]; Catholina Lambert, Paterson, N.J. (1892–99; sold on February 28, 1899, to Durand-Ruel); [Durand-Ruel, New York, 1899, stock no. 2121; sold on March 10, 1899, to Havemeyer]; Mr. and Mrs. H. O. Havemeyer, New York (1899–his d. 1907); Mrs. H. O. (Louisine W.) Havemeyer, New York (1907–d. 1929)

EXHIBITIONS
"Exposition des Oeuvres de Claude Monet," Durand-Ruel, Paris, March 1–25, 1883, no. 18; "Troisième exposition annuelle des XX," Palais des Beaux-Arts, Brussels, February 6–March 7, 1886, no. 6; "Works in Oil and Pastel by the Impressionists of Paris," American Art Association, New York, April 10–28, 1886, "Works in Oil and Pastel by the Impressionists of Paris," National Academy of Design, New York, American Art Association, New York, May 25–June 30, 1886, no. 294; "Paintings by Old Masters, and Modern Foreign and American Painters, Together with an Exhibition of the Work of Claude Monet the Impressionist," Union League Club, New York, February 12–14, 1891, no. 50; "The H. O. Havemeyer Collection," Metropolitan Museum of Art, New York, March 10–November 2, 1930, no. 84; "Flower Paintings in Your Home," Toledo Museum of Art, Toledo, Ohio, October 2–30, 1949, no. 20; "Metropolitan Museum Masterpieces," Hofstra College, Hempstead, N.Y., June 29–September 1, 1952, no. 40; "Claude Monet," Richard L. Feigen and Co., New York, October 15–November 15, 1969, no. 18; "Splendid Legacy: The Havemeyer Collection," Metropolitan Museum of Art, New York, March 27–June 20, 1993, no. A400; "Monet: The Seine and the Sea, 1878–1883," Royal Scottish Academy, Edinburgh, August 6–October 26, 2003, no. 22

SELECTED REFERENCES
Gustave Geffroy, "Chronique—Cl. Monet," *La justice*, March 15, 1883, p. 2; "The French Impressionist Pictures," *New York Mail and Express*, May 24, 1886; P. H., "L'Exposition de Monet à l'Union League Club, New York," *L'Art dans les deux mondes*, Paris, no. 15, February 28, 1891, p. 173; Madeleine Octave Maus, *Trente années de lutte pour l'art: 1884–1914*, Brussels, 1926, p. 43 n. 2; Frank Jewett Mather Jr., "The Havemeyer Pictures," *The Arts* 16, March 1930, p. 481; Harry B. Wehle, "The Exhibition of the H. O. Havemeyer Collection," *Metropolitan Museum of Art Bulletin* 25, March 1930, p. 56; *H. O. Havemeyer Collection, Catalogue of Paintings, Prints, Sculpture, and Objects of Art*, 1931, pp. 154–55, ill.; *The Metropolitan Museum of Art Miniatures, French Impressionists: Manet, Monet, Pissarro, Renoir, and Boudin*, 97 vols. in 5, New York, 1947–57, vol. 27, Album LI, 1951, unpaginated, color ill.; Charles Sterling and Margaretta M. Salinger, *French Paintings: A Catalogue of the Collection of The Metropolitan Museum of Art*, 3 vols., New York, 1955–67, vol. 3, p. 133, ill.; Luigina Rossi Bortolatto, *L'Opera completa di Claude Monet, 1870–1889*, Milan, 1966, pp. 104, 112, no. 251, ill.; Douglas Cooper, "The Monets in the Metropolitan Museum," *Metropolitan Museum Journal* 3, 1970, pp. 296–97, 303 n. 2, pp. 304–5, fig. 23; Grace Seiberling, *Monet's Series*, published Ph.D. dissertation, Yale University, 1976, New York, 1981, pp. 188–89, 335 n. 2; Charles S. Moffett, *Impressionist and Post-Impressionist Paintings in The Metropolitan Museum of Art*, New York, 1985, pp. 132–33, 252, ill.; Frances Weitzenhoffer, *The Havemeyers: Impressionism*

Comes to America, New York, 1986, pp. 135, 256; Daniel Wildenstein, trans. Chris Miller, Peter Snowdon et al., Monet, or the Triumph of Impressionism, 4 vols., Cologne, 1996, vol. 2, p. 241, no. 634, ill. (color) [1st ed., 1974–91]

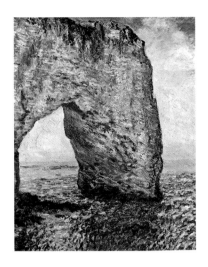

The Manneporte near Étretat
1886
Oil on canvas
32 x 25¾ in. (81.3 x 65.4 cm)
Signed and dated (lower left): Claude Monet 86
Bequest of Lillie P. Bliss, 1931
31.67.11
See no. 90

PROVENANCE
[Durand-Ruel, Paris and New York, 1887–92; bought from the artist]; Potter Palmer, Chicago (1892–93); [Durand-Ruel, New York, 1893–1909]; Cornelius Newton Bliss, New York (1909–d. 1911); Lillie P. Bliss, New York (1911–d. 1931)

EXHIBITIONS
"Monet," Durand-Ruel, New York, January 12–27, 1895, no. 31; "Monet," St. Botolph's Club, Boston, February 1895, no. 10; "Loan Exhibition of Impressionist and Post-Impressionist Paintings," Metropolitan Museum of Art, New York, May 3–September 15, 1921, no. 77; "Summer Exhibition of Modern French and American Painters," Brooklyn Museum, June 12–October 14, 1926, no catalogue; "Memorial Exhibition: The Collection of the Late Miss Lizzie P. Bliss, Vice-President of the Museum," Museum of Modern Art, New York, May 17–September 27, 1931, no. 99; "Landscape Paintings," Metropolitan Museum of Art, New York, May 14–September 30, 1934, no. 51; "Claude Monet, 1840–1926," Kunsthaus Zürich, May 10–June 15, 1952, no. 67; "Claude Monet," Gemeentemuseum, The Hague, July 24–September 22, 1952, no. 52; "Paintings from the Metropolitan / Pinturas del Metropolitano," Bronx County Courthouse, May 12–June 13, 1971, no. 22; "Normandy and Its Artists Remembered," Nassau County Museum of Art, Roslyn Harbor, N.Y., June 12–September 11, 1994, unnumbered cat.

SELECTED REFERENCES
Bryson Burroughs, "The Bequest of Lillie P. Bliss," *Metropolitan Museum of Art Bulletin* 26, November

1931, pp. 262, 264 n. 2, ill.; John Rewald, *The History of Impressionism*, New York, 1946, ill. p. 397; Charles Sterling and Margaretta M. Salinger, *French Paintings: A Catalogue of the Collection of The Metropolitan Museum of Art*, 3 vols., New York, 1955–67, vol. 3, p. 136, ill.; Luigina Rossi Bortolatto, *L'Opera completa di Claude Monet, 1870–1889*, Milan, 1966, pp. 107–8, no. 296, ill.; Margaretta M. Salinger, "Windows Open to Nature," *Metropolitan Museum of Art Bulletin* 27, summer 1968, n.s., unpaginated, ill.; Douglas Cooper, "The Monets in the Metropolitan Museum," *Metropolitan Museum Journal* 3, 1970, pp. 291–92, 294, 302, 304–5, fig. 15; Joel Isaacson, *Observation and Reflection: Claude Monet*, Oxford, 1978, pp. 37–38, 217, pl. 84; Grace Seiberling, *Monet's Series*, published Ph.D. dissertation, Yale University, 1976, New York, 1981, pp. 65–68, 271, fig. 5; Charles S. Moffett, *Impressionist and Post-Impressionist Paintings in The Metropolitan Museum of Art*, New York, 1985, pp. 135, 252, color ill.; John House, *Monet: Nature into Art*, New Haven, 1986, pp. 59–60, 67, 86, 125, 150, 184, 195, 241 n. 20, colorpl. 130, fig. 225 (diagram); Virginia Spate, *Claude Monet: Life and Work*, New York, 1992, p. 171; Robert L. Herbert, *Monet on the Normandy Coast: Tourism and Painting, 1867–1886*, New Haven, 1994, pp. 115–16, fig. 129 (color); Daniel Wildenstein, trans. Chris Miller, Peter Snowdon et al., *Monet, or the Triumph of Impressionism*, 4 vols., Cologne, 1996, vol. 1, pp. 210–11, color ill., vol. 3, p. 398, no. 1052, ill. (color) [1st ed., 1974–91]

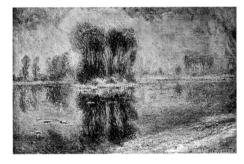

Ice Floes
1893
Oil on canvas
26 x 39½ in. (66 x 100.3 cm)
Signed and dated (lower right): Claude Monet 93
H. O. Havemeyer Collection, Bequest of Mrs. H. O. Havemeyer, 1929
29.100.108
See no. 91

PROVENANCE
[Durand-Ruel, Paris, bought from the artist, with I. Montaignac, on February 3, 1897, for Fr 11,400, stock no. 4067; sold to Havemeyer the same day]; Mr. and Mrs. H. O. Havemeyer, New York (1897–his d. 1907); Mrs. H. O. (Louisine W.) Havemeyer, New York (1907–d. 1929)

EXHIBITIONS
"The H. O. Havemeyer Collection," Metropolitan Museum of Art, New York, March 10–November 2, 1930, no. 87; "Claude Monet," Richard L. Feigen and Co., New York, October 15–November 15, 1969,

no. 32; "Monet's Years at Giverny: Beyond Impressionism," Metropolitan Museum of Art, New York, April 19–July 9, 1978, Saint Louis Art Museum, August 1–October 8, 1978, no. 23; "Splendid Legacy: The Havemeyer Collection," Metropolitan Museum of Art, New York, March 27–June 20, 1993, no. A408; "Impressionists in Winter: Effets de neige," Phillips Collection, Washington, D.C., September 19, 1998–January 3, 1999, Yerba Buena Center for the Arts, San Francisco, January 30–May 2, 1999, Brooklyn Museum, May 27–August 29, 1999, no. 27

SELECTED REFERENCES
Harry B. Wehle, "The Exhibition of the H. O. Havemeyer Collection," *Metropolitan Museum of Art Bulletin* 25, March 1930, p. 56; *H. O. Havemeyer Collection, Catalogue of Paintings, Prints, Sculpture, and Objects of Art*, 1931, pp. 158–59, ill.; Charles Sterling and Margaretta M. Salinger, *French Paintings: A Catalogue of the Collection of The Metropolitan Museum of Art*, 3 vols., New York, 1955–67, vol. 3, p. 138, ill.; Douglas Cooper, "The Monets in the Metropolitan Museum," *Metropolitan Museum Journal* 3, 1970, pp. 295, 304–5, fig. 16; Charles S. Moffett, *Impressionist and Post-Impressionist Paintings in The Metropolitan Museum of Art*, New York, 1985, pp. 142–43, 252, color ill.; Frances Weitzenhoffer, *The Havemeyers: Impressionism Comes to America*, New York, 1986, p. 257; John House, *Monet: Nature into Art*, New Haven, 1986, pp. 27, 57, 65, 69, 100, 128, 173–74, colorpl. 213; Daniel Wildenstein, trans. Chris Miller, Peter Snowdon et al., *Monet or the Triumph of Impressionism*, 4 vols., Cologne, 1996, vol. 1, p. 288, vol. 3, pp. 542–43, no. 1335, ill. (color) [1st ed., 1974–91]

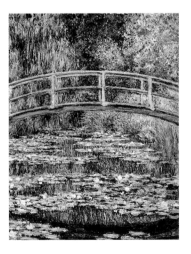

Bridge over a Pond of Water Lilies
1899
Oil on canvas
36½ x 29 in. (92.7 x 73.7 cm)
Signed and dated (lower right): Claude Monet / 99
H. O. Havemeyer Collection, Bequest of Mrs. H. O. Havemeyer, 1929
29.100.113
See no. 92

PROVENANCE
[Durand-Ruel, Paris, 1900–1901; bought from the artist on January 25, 1900, stock no. 5632; sold on

January 9, 1901, to Durand-Ruel, New York];
[Durand-Ruel, New York, 1901; stock no. 2458; sold
on January 26, 1901, to Havemeyer]; Mr. and Mrs.
H. O. Havemeyer, New York (1901–his d. 1907; on
deposit with Durand-Ruel, January 26–July 10, 1901);
Mrs. H. O. (Louisine W.) Havemeyer, New York
(1907–d. 1929; on deposit with Durand-Ruel,
November 30, 1908–August 20, 1909)

EXHIBITIONS
"Oeuvres récentes de Claude Monet," Durand-Ruel,
Paris, November 22–December 15, 1900, no. 12;
"The H. O. Havemeyer Collection," Metropolitan
Museum of Art, New York, March 10–November 2,
1930, no. 88; "World Cultures and Modern Art,"
Haus der Kunst, Munich, June 16–September 30,
1972, no. 682; "Impressionism: A Centenary
Exhibition," Metropolitan Museum of Art, New York,
December 12, 1974–February 10, 1975, not in cata-
logue; "Monet's Years at Giverny: Beyond
Impressionism," Metropolitan Museum of Art, New
York, April 19–July 9, 1978, Saint Louis Art Museum,
August 1–October 8, 1978, no. 31; "Claude Monet:
Nymphéas," Kunstmuseum Basel, July 20–October
19, 1986, no. 9; "Monet in the 90s: The Series
Paintings," Museum of Fine Arts, Boston, February 7–
April 29, 1990, Art Institute of Chicago, May 19–
August 24, 1990, Royal Academy of Arts, London,
September 7–December 9, 1990, no. 90; "Splendid
Legacy: The Havemeyer Collection," Metropolitan
Museum of Art, New York, March 27–June 20, 1993,
no. A414; "Monet: Le cycle des Nymphéas," Musée
National de l'Orangerie, Paris, May 6–August 2,
1999, no. 5; "Monet's Garden," Kunsthaus Zürich,
October 29, 2004–March 13, 2005, no. 38

SELECTED REFERENCES
Julien Leclercq, "'Le Bassin aux nymphéas' de
Claude Monet," Chronique des arts et de la curiosité,
December 1, 1900, pp. 363–64; H. O. Havemeyer
Collection, Catalogue of Paintings, Prints, Sculpture
and Objects of Art, 1931, pp. 156–57, ill.; Charles
Sterling and Margaretta M. Salinger, French Paintings:
A Catalogue of the Collection of The Metropolitan
Museum of Art, 3 vols., New York, 1955–67, vol. 3,
pp. 141–42, ill.; Douglas Cooper, "The Monets in
the Metropolitan Museum," Metropolitan Museum
Journal 3, 1970, pp. 297–300, 302, 304–5, fig. 28;
Charles S. Moffett, Impressionist and Post-
Impressionist Paintings in The Metropolitan Museum
of Art, New York, 1985, pp. 148–49, 253, color ill.;
Frances Weitzenhoffer, The Havemeyers: Impres-
sionism Comes to America, New York, 1986,
pp. 143, 257, pl. 113; Gary Tinterow et al., The
Metropolitan Museum of Art: Modern Europe, New
York, 1987, p. 37, colorpl. 21; Gary Tinterow,
"Miracle au Met," Connaissance des arts, no. 472,
June 1991, p. 36; Daniel Wildenstein, trans. Chris
Miller, Peter Snowdon et al., Monet, or the Triumph
of Impressionism, 4 vols., Cologne, 1996, vol. 1,
p. 338, ill. p. 337 (color), vol. 3, pp. 647–49,
no. 1518, ill. (color, overall and detail) [1st ed.,
1974–91]

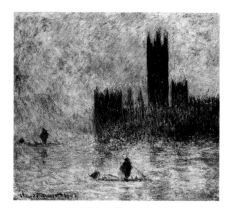

The Houses of Parliament (Effect of Fog)
1903–4
Oil on canvas
32 x 36⅜ in. (81.3 x 92.4 cm)
Signed and dated (lower left): Claude Monet 1903
Bequest of Julia W. Emmons, 1956
56.135.6
See no. 93

PROVENANCE
[Bernheim-Jeune, Paris, 1909–11, bought from the
artist in July 1909; sold on March 24, 1911, to
Durand-Ruel]; [Durand-Ruel, Paris, 1911, stock no.
9549; sold on April 1, 1911, to Durand-Ruel, New
York]; [Durand-Ruel, New York, 1911, stock no.
3438; sold on May 24, 1911, to Emmons]; Arthur B.
Emmons, New York and Newport (1911–d. 1922); his
widow, Julia W. Emmons, New York and Newport
(1922–d. 1956)

EXHIBITIONS
"Vues de la Tamise à Londres (1902–1904)," Durand-
Ruel, Paris, May 9–June 4, 1904, no. 32; "[Tableaux
Durand-Ruel]," Noonan-Kocian Gallery, St. Louis,
April 1911; "Man's Concept of Outer Space,"
Milwaukee Art Center, October 1, 1958–February 15,
1959; "The Metropolitan Museum of Art Loan
Collection: 'The River and the Sea,'" Phoenix Art
Museum, February 15, 1967–February 15, 1968,
no. 14; "Claude Monet," Holyoke Museum of
Natural History and Art, Holyoke, Mass., April–
May 1968, no catalogue; "The Impressionists in
London," Hayward Gallery, London, January 3–
March 11, 1973, no. 25; "Capolavori impressionisti
dei musei americani," Museo di Capodimonte,
Naples, December 3, 1986–February 1, 1987,
Pinacoteca di Brera, Milan, March 4–May 3, 1987,
no. 33; "Corot to Cézanne: 19th Century French
Paintings from The Metropolitan," Museum of Art,
Fort Lauderdale, December 22, 1992–April 11, 1993,
no catalogue; "Claude Monet," Österreichische
Galerie–Belvedere, Vienna, March 14–June 16, 1996,
no. 76; "Painters in Paris: 1895–1950," Metropolitan
Museum of Art, New York, March 8–December 31,
2000, unnumbered cat.; "Claude Monet: A Hymn to
Light," Hiroshima Prefectural Art Museum, August 3–
September 23, 2004, Nara Prefectural Museum of
Art, October 2–December 5, 2004, no. 43; "Monet's
London: Artists' Reflections on the Thames 1859–
1914," Museum of Fine Arts, St. Petersburg, Fla.,
January 16–April 24, 2005, Brooklyn Museum, May
27–September 4, 2005, Baltimore Museum of Art,
October 2–December 31, 2005, no. 36

SELECTED REFERENCES
Arsène Alexandre, Claude Monet, Paris, 1921, ill.
opp. p. 104; L. Venturi, Les archives de l'impression-
nisme, 1939, vol. 1, p. 393; Charles Sterling and
Margaretta M. Salinger, French Paintings: A

Catalogue of the Collection of The Metropolitan
Museum of Art, 3 vols., New York, 1955–67,
pp. 142–43, ill.; Douglas Cooper, "The Monets in the
Metropolitan Museum," Metropolitan Museum
Journal 3, 1970, pp. 299, 301–2, 304–5, fig. 29; John
House, "The Impressionists in London," Burlington
Magazine 115, March 1973, p. 197; John Elderfield,
"Monet's Series," Art International 18, November 15,
1974, ill. p. 28; Grace Seiberling, Monet's Series,
Yale University, 1976, New York, 1981, p. 375,
no. 41; Charles S. Moffett, Impressionist and Post-
Impressionist Paintings in The Metropolitan Museum
of Art, New York, 1985, pp. 150–51, 253, color ill.;
John House, Monet: Nature into Art, New Haven,
1986, pp. 58–59, 204, pl. 89; Gary Tinterow et al.,
The Metropolitan Museum of Art: Modern Europe,
New York, 1987, pp. 8, 34, colorpl. 18; Grace
Seiberling, Monet in London, exh. cat., High Museum
of Art, Seattle, 1988, pp. 84, 86 n. 87, p. 93 n. 32,
color ill. fig. 43; Daniel Wildenstein, trans. Chris
Miller, Peter Snowdon et al., Monet, or the Triumph
of Impressionism, 4 vols., Cologne, 1996, vol. 1,
color ill. p. 346, vol. 4, pp. 716–17, no. 1609, color
ill. [1st ed., 1974–91]; C[aroline] D[urand]-R[uel],
"Quand les Havemeyers aimaient la peinture
française," Connaissance des arts, no. 544,
November 1997, p. 108

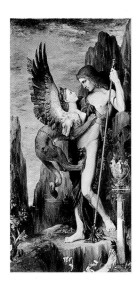

Gustave Moreau
French, 1826–1898

Oedipus and the Sphinx
1864
Oil on canvas
81¼ x 41¼ in. (206.4 x 104.8 cm)
Signed and dated (lower left): .Gustave Moreau .64.
Bequest of William H. Herriman, 1920
21.134.1
See no. 45

PROVENANCE
Prince Napoleon, Paris (1864–68; purchased from the artist May 1, 1864, for Fr 8,000; sold on February 3, 1868, no. 10709, Fr 14,000 to Durand-Ruel); [Durand-Ruel, Paris, in partnership with Brame, Paris, 1868; sold on March 6, for Fr 15,000 (to be paid in October 1868) to Herriman]; William H. Herriman, Rome (1868–d. 1921; installed at 93, Piazza di Spagna, Rome, by January 18, 1869)

EXHIBITIONS
Salon, Paris, 1864, no. 1388; "Salon des amis des arts de Bordeaux," Galerie de la Société des Amis des Arts de Bordeaux, 1865, no. 395; "Gustave Moreau," Galerie Mollien, Musée du Louvre, Paris, June 1–September 30, 1961, no. 10; "Odilon Redon, Gustave Moreau, Rodolphe Bresdin," Museum of Modern Art, New York, December 4, 1961–February 4, 1962, Art Institute of Chicago, March 2–April 15, 1962, no. 175; "Gustave Moreau," Los Angeles County Museum of Art, July 16–September 1, 1974, California Palace of the Legion of Honor, San Francisco, September 14–November 3, 1974, no. 28; "The Second Empire, 1852–1870: Art in France under Napoleon III," Philadelphia Museum of Art, October 1–November 26, 1978, no. VI-93, Detroit Institute of Arts, January 15–March 18, 1979, no. VI-93, Galeries Nationales du Grand Palais, Paris, May 11–August 13, 1979, no. 261; "Gustave Moreau: Symboliste," Kunsthaus Zürich, March 14–May 25, 1986, no. 19; "Gustave Moreau: Between Epic and Dream," Galeries Nationales du Grand Palais, Paris, September 29, 1998–January 4, 1999, Art Institute of Chicago, February 13–April 25, 1999, Metropolitan Museum of Art, New York, June 1–August 22, 1999, no. 28

SELECTED REFERENCES
Léon Lagrange, "Le Salon de 1864," *Gazette des beaux-arts* 16, 1864, pp. 506–8, ill.; F. Aubert, *Le pays*, 1864; Edmond About, *Salon de 1864*, Paris, 1864, pp. 137–42; Charles Clément, "Exposition de

1864 (troisième article)," *Journal des débats politiques et littéraires,* May 12, 1864, pp. 1ff.; Hector de Callias, "Salon de 1864: Les quarante médailles," *L'Artiste* 1, May 15, 1864, p. 219; *L'Artiste* 1, June 10, 1864, pp. 24–25; Jules Claretie, "Salon de 1864: Le salon des refusés,' *L'Artiste* 2, June 30, 1864, p. 4; Cham, "Une promenade au salon," *Le charivari,* 1864; Louis Auvray, *Exposition des beaux-arts: Salon de 1864,* Paris, 1864, pp. 54–57; Théophile Gautier, *La presse,* May 5, 1864; Théophile Gautier, *Le moniteur universel,* May 27, 1864, p. 766; Paul de Saint-Victor, *La presse,* May 7, 1864; A. Cantaloube, "Salon de 1864: La peinture," *Nouvelle revue de Paris* 3, June 15, 1864, pp. 602–7; Théophile Gautier, "Salon," *Le moniteur universel,* July 9, 1865; Maxime du Camp, *Les beaux-arts à l'exposition universelle et aux salons de 1863, 1864, 1865, 1866 and 1867,* Paris, 1867, pp. 109–19; Paul Mantz, "Les beaux-arts à l'exposition universelle," *Gazette des beaux-arts,* October 1867, p. 330; Ernest Chesneau, *Les nations rivales dans l'art,* Paris, 1868, pp. 181–99, 203, 206–7; Théophile Gautier, *Journal officiel* 53, June 20, 1869; T[héophile] Thoré, *Salons de W. Bürger 1861 à 1868,* 2 vols., Paris, 1870, vol. 2, pp. 14–19; Jules Castagnary, *Salons (1857–1870),* 2 vols., Paris, 1892, vol. 1, pp. 196–202; Ary Renan, *Gustave Moreau, 1826–1898,* Paris, 1900, pp. 27, 45, 49–52, 131, 133, ill. opp. p. 40; *Lettres d'Odilon Redon, 1878–1916, Publiées par sa famille,* Paris, 1923, p. 38; Joseph C. Sloane, *French Painting Between the Past and the Present: Artists, Critics, and Traditions from 1848 to 1870,* Princeton, 1951 [repr. 1973], pp. xii, 171–72, 174–76, fig. 68; Charles Sterling and Margaretta M. Salinger, *French Paintings: A Catalogue of the Collection of The Metropolitan Museum of Art,* 3 vols., New York, 1955–67, vol. 3, pp. 1–5, ill.; Henri Dorra, "The Guesser Guessed: Gustave Moreau's Œdipus," *Gazette des beaux-arts* 81, March 1973, pp. 129–140, ill.; René Huyghe, *La relève du réel: La peinture française au XIXe siècle, Impressionnisme, symbolisme,* Paris, 1974, pp. 267, 297, 452, ill.; Pierre-Louis Mathieu, *Gustave Moreau, with a Catalogue of Finished Paintings, Watercolors, and Drawings,* Boston, 1976, pp. 14, 18, 28, 70, 81–85, 94, 110–11, 128, 130, 197, 241, 257, 269 n. 312, pp. 284, 305, no. 64, ill.; Monique Halm-Tisserant, "La sphinx amoureuse: Un schéma grec dans l'œuvre de G. Moreau," *Revue des archéologues et historiens d'art de Louvain* 14, 1981, pp. 30–68, fig. 2; Pierre-Louis Mathieu, *Tout l'œuvre peint de Gustave Moreau,* Paris, 1991, pp. 5, 8–9, 68, 87, no. 105, fig. 105, colorpl. VIII; Pierre-Louis Mathieu, *Gustave Moreau,* Paris, 1994, pp. 9, 48, 72–79, 81, 83, 90, 110–11, 132, 139, 191, 264–65, 269, 277 nn. 5–6, p. 278 nn. 24–30, p. 280 n. 60, p. 287 n. 63, p. 288 n. 15, 292, color ill.; Michael Fried, *Manet's Modernism: or, The Face of Painting in the 1860s,* Chicago, 1996, pp. 10, 164, 308–12, 314–17, 577 nn. 125–26, p. 578 nn. 129, 133, colorpl. 14; Pierre-Louis Mathieu, *Gustave Moreau: Monographie et nouveau catalogue de l'œuvre achevé,* Paris, 1998, pp. 50–51, 150, 190, 238, 294, no. 75, ill.

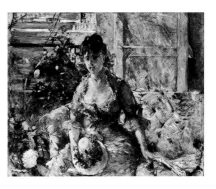

Berthe Morisot
French, 1841–1895

Young Woman Seated on a Sofa
ca. 1879
Oil on canvas
31¾ x 39¼ in. (80.6 x 99.7 cm)
Signed (lower left): Berthe Morisot
Partial and Promised Gift of Mr. and Mrs. Douglas Dillon, 1992
1992.103.2
See no. 96

PROVENANCE
Mme Léon-Marie Clapisson, Paris (by 1896); [Durand-Ruel, Paris, by 1905–at least 1959]; [Sam Salz, New York]; Mr. and Mrs. Douglas Dillon, New York (by 1976)

EXHIBITIONS
"Exposition Berthe Morisot." Durand-Ruel, Paris, April 23–May 10, 1902, no. 58 (possibly this picture); "Pictures by Boudin, Cézanne, Degas, Manet . . . ," Grafton Galleries, London, Durand-Ruel, Paris, January–February 1905, no. 158; "Salon d'automne," Grand Palais des Champs-Élysées, Paris, October 1–22, 1907, no. 161; "Réunion d'oeuvres par Berthe Morisot (1841–1895)," Galerie Marcel Bernheim, Paris, June 20–July 8, 1922, no. 43; "Exposition d'oeuvres de Berthe Morisot," Bernheim-Jeune, Paris, May 6–24, 1929, no. 18, "L'Impressionnisme," Palais des Beaux-Arts, Brussels, June 15–September 29, 1935, no. 48; "La peinture française au XIXe siècle," Musée du Prince Paul, Belgrade, 1939, no. 85; "Berthe Morisot (1841–1895)," Musée de l'Orangerie, Paris, summer 1941, no. 25; "Exposition de la femme, 1800–1930," Bernheim-Jeune, Paris, April–June 1948, no. 65; "Berthe Morisot, 1841–1895," Ny Carlsberg Glyptothek, Copenhagen, August 20–September 18, 1949, no. 16; "Berthe Morisot: An Exhibition of Paintings and Drawings," Matthiesen Gallery, London, 1950, no. 17; "Exposition Berthe Morisot," Musée de Dieppe, July 5–September 30, 1957, no. 16; "Exposition Berthe Morisot (1841–1895)," Musée Toulouse-Lautrec, Albi, July 1–September 15, 1958, no. 14; "Berthe Morisot," Wildenstein and Co., Inc., New York, November 3–December 10, 1960, no. 18; "Berthe Morisot," Musée Jacquemart-André, Paris, 1961, no. 25; "Berthe Morisot, 1841–1895," Wildenstein and Co., Inc., London, January 18–February 11, 1961, no. 14; "Berthe Morisot," Musée Jenisch, Vevey, Switzerland, June 24–September 3, 1961, no. 18

SELECTED REFERENCES
Camille Mauclair, *The French Impressionists (1860–1900),* London, [1903], p. 153, ill.; Roger Marx, "Les femmes peintres et l'impressionnisme—Berthe Morisot," *Gazette des beaux-arts* 38, December 1, 1907, p. 503, ill.; Vittorio Pica, "Artisti contemporanei: Berthe Morisot—Mary Cassatt,"

Emporium 26, July 1907, p. 11, ill.; Vittorio Pica, *L'impressionisti francesi*, Bergamo, 1908, p. 163, ill.; Charles Louis Borgmeyer, *The Master Impressionists*, Chicago, 1913, p. 236, ill.; Denis Rouart, *Berthe Morisot, 1841–1895*, Paris, 1948, unpaginated, no. 28., ill.; Jerome Mellquist, "Berthe Morisot," *Apollo* 70, December 1959, p. 158, fig. 1; M[arie]-L[ouise] Bataille and G[eorges] Wildenstein, *Berthe Morisot: Catalogue des peintures, pastels, et aquarelles*, Paris, 1961, pp. 9, 28, no. 78, pl. 44; Charles F. Stuckey et al., *Berthe Morisot, Impressionist*, exh. cat., National Gallery of Art, Washington, D.C., New York, 1987, pp. 78, 80, fig. 51; Gary Tinterow et al., "Recent Acquisitions, A Selection: 1991–1992," *Metropolitan Museum of Art Bulletin* 50, fall 1992, p. 49, color ill.; Alain Clairet, Delphine Montalant, and Yves Rouart, *Berthe Morisot, 1841–1895: Catalogue raisonné de l'œuvre peint*, Montolivet, 1997, p. 151, no. 78, ill.

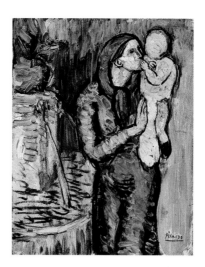

Pablo Picasso
Spanish, 1881–1973

Mother and Child by a Fountain
1901
Oil on canvas
16 x 12¾ in. (40.6 x 32.4 cm)
Signed (bottom right): Picasso
Bequest of Scofield Thayer, 1982
1984.433.23
See no. 124

PROVENANCE
Baron Napoléon Gourgaud, Paris; Scofield Thayer, New York (by 1924–d. 1982; on view at the Worcester Art Museum as part of the Dial Collection, 1931–82)

EXHIBITIONS
"Original Paintings, Drawings and Engravings being exhibited with the Dial Folio 'Living Art,'" Montross Gallery, New York, January 26–February 14, 1924, no. 24; "Exhibition of the Dial Collection of Paintings, Engravings, and Drawings by Contemporary Artists," Worcester Art Museum, Mass., March 5–30, 1924, no. 29; ["The Dial Collection"], Hillyer Art Gallery, Smith College, Northampton, Mass., spring 1924, no catalogue; "Picasso: 'Blue' and 'Rose' Periods, 1901–1906," Jacques Seligmann and Co., New York, November 2–26, 1936, no. 6; "The Dial and the Dial Collection," Worcester Art Museum, Mass., April 30–September 8, 1959, no. 74; "Selections from the Dial Collection," Worcester Art Museum, Mass., November 13–30, 1965, no catalogue; "The Dial: Arts and Letters in the 1920s," Worcester Art Museum, Mass., March 7–May 10, 1981, no. 114; "Treasures from The Metropolitan Museum of Art: French Art from the Middle Ages to the Twentieth Century," Yokohama Museum of Art, Yokohama, March 25–June 4, 1989, no. 160; "Picasso: The Early Years, 1892–1906," National Gallery of Art, Washington, D.C., March 30–July 27, 1997, Museum of Fine Arts, Boston, September 10, 1997–January 4, 1998, colorpl. 72; "Picasso, 1901–1909: Chefs-d'oeuvre du Metropolitan Museum of Art, New York," Musée Picasso, Paris, October 22, 1998–January 25, 1999, fig. 26; "Picasso's World of Children," National Museum of Western Art, Tokyo, March 14–June 18, 2000, no. 19; "Picasso: Die Umarmung," Spanischer Pavillion auf der Expo 2000 Hannover, Neue Nationalgalerie, Berlin, October 3–December 10, 2000, no. 1

SELECTED REFERENCES
Maurice Raynal, *Picasso* [Munich, 1921], Paris, 1922, pl. 2; *The Dial*, 80, May 1926, p. 357, ill. (color); F[rancis] H[enry] T[aylor], "Modern French Paintings in the Museum," *Bulletin of The Worcester Art Museum* 22, no. 4, January 1932, p. 70; Christian Zervos, *Pablo Picasso*, 33 vols., Paris and New York, 1932–78, vol. 1, p. 54 (ill.), no. 107; Alexandre Cirici Pellicer, *Picasso antes de Picasso*, Barcelona, 1946, pl. 52, ill.; Denys Sutton, *Picasso, Peintures, époques bleue et rose*, 2nd ed., Paris, 1955, p. [4], no. 2; Anthony Blunt and Phoebe Pool, *Picasso, The Formative Years*, New York, 1963, fig. 107; Helen Kay, *Picasso's World of Children*, New York, 1965, p. [48], ill.; Pierre Daix and Georges Boudaille, *Picasso: The Blue and Rose Periods, A Catalogue Raisonné of the Paintings, 1900–1906* [Neuchâtel, 1966], trans. Phoebe Pool, Greenwich, Conn., 1967, p. 195 no. VI.9, ill.; Pierre Cabanne, *Le siècle de Picasso: La jeunesse, le cubisme, le théâtre, l'amour (1881–1937)*, Paris, 1975, p. 117; Josep Palau i Fabre, *Picasso: The Early Years, 1881–1907* [Barcelona, 1980], trans. Kenneth Lyons, New York, 1981, pp. 277, no. 698, ill., 537, no. 698; Michael Leja, "'Le Vieux Marcheur' and 'Les Deux Risques': Picasso, Prostitution, Venereal Disease, and Maternity, 1899–1907," *Art History* 8, no. 1, March 1985, p. 72

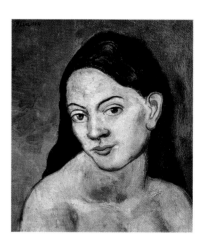

Head of a Woman
1903
Oil on canvas
15⅞ x 14 in. (40.3 x 35.6 cm)
Signed (upper left): Picasso
Bequest of Miss Adelaide Milton de Groot, 1967
67.187.91
See no. 125

PROVENANCE
Baron S. Fukushima, Paris; Adelaide Milton de Groot, New York (probably by 1933–d. 1967)

EXHIBITIONS
"Masterpieces from the Collection of Adelaide Milton de Groot," Perls Galleries, New York, April 14–May 3, 1958, no. 21; "From Impressionism to École de Paris: Its Passion and Struggle," Museum of Modern Art, Saitama, November 3–December 12, 1982, no. 76; "Der junge Picasso: Frühwerk und blaue Periode," Kunstmuseum Bern, December 8, 1984–February 17, 1985, no. 198; "Treasures from The Metropolitan Museum of Art: French Art from the Middle Ages to the Twentieth Century," Yokohama Museum of Art, March 25–June 4, 1989, no. 162;

"Picasso, 1901–1909: Chefs-d'oeuvre du Metropolitan Museum of Art, New York," Musée Picasso, Paris, October 22, 1998–January 25, 1999, fig. 34

SELECTED REFERENCES
Christian Zervos, *Pablo Picasso*, 33 vols., Paris and New York, 1932–78, vol. 6, p. 67, no. 548, ill.; Pierre Daix and Georges Boudaille, *Picasso: The Blue and Rose Periods, A Catalogue Raisonné of the Paintings, 1900–1906* [Neuchatel, 1966], trans. Phoebe Pool, Greenwich, Conn., 1967, p. 224, no. IX.16, ill.; Josep Palau i Fabre, *Picasso: The Early Years, 1881–1907* [Barcelona, 1980], trans. Kenneth Lyons, New York, 1981, pp. 349, no. 906, ill., 542, no. 906; Laszlo Gloser, *Picasso: Les chefs-d'oeuvre de la Période bleue,* Munich, 1988, pl. 31, ill.

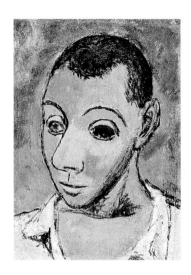

Self-Portrait
1906
Oil on canvas mounted on wood
10½ x 7¾ in. (26.7 x 19.7 cm)
Jacques and Natasha Gelman Collection, 1998
1999.363.59
See no. 126

PROVENANCE
Gertrude Stein, Paris (until d. 1946; acquired from the artist); Alice B. Toklas, Paris (ca. 1946–d. 1967); heirs of Gertrude Stein (children of her nephew Allan Stein, d. 1951), Paris and San Francisco (1967–68; sold to Meyer); André Meyer, New York (1968–at least 1970 or 1971); sale, Parke-Bernet, New York, October 22, 1980, no. 33; private collection, New York (1980); Sandra Kanning Kasper, Inc., New York (1986); Jacques and Natasha Gelman (1986–98)

EXHIBITIONS
"Four Americans in Paris: The Collections of Gertrude Stein and Her Family," Museum of Modern Art, New York, December 19, 1970–March 1, 1971, Baltimore Museum of Art, April 4–June 13, 1971, San Francisco Museum of Art, September–October 1971, unnumbered cat.; "Gertrude Stein and Picasso and Juan Gris," National Gallery of Canada, Ottawa, June 25–August 15, 1971, no. 8; "Twentieth-Century Modern Masters: The Jacques and Natasha Gelman Collection," Metropolitan Museum of Art, New York, December 12, 1989–April 1, 1990, unnumbered cat.; "De Matisse à Picasso: Collection Jacques et

Natasha Gelman," Fondation Pierre Gianadda, Martigny, June 18–November 1, 1994; "Painters in Paris, 1895–1950," Metropolitan Museum of Art, New York, March 8–December 31, 2000, unnumbered cat.

SELECTED REFERENCES
Christian Zervos, *Pablo Picasso*, 33 vols., Paris and New York, 1932–78, vol. 1, p. 177, ill., and no. 371; Per-Olov Zennström, *Pablo Picasso*, Stockholm, 1948, fig. 13 opp. p. 64; Denys Sutton, *Picasso, Peintures, époques bleue et rose* [1948], 2nd ed. Paris, 1955, unpaginated, no. 52, ill.; Frank Elgar and Robert Maillard, *Picasso*, Paris, 1955, p. 47, ill. (color); Lothar-Günther Buchheim, *Picasso: A Pictorial Biography* [Munich, 1958], trans. Michael Heron, New York, 1959, pp. 43, ill., 135, no. 43; Pierre Daix and Georges Boudaille, *Picasso: The Blue and Rose Periods, A Catalogue Raisonné of the Paintings, 1900–1906* [Neuchatel, 1966], trans. Phoebe Pool, Greenwich, Conn., 1967, p. 327 no. XVI.27, ill.; Hélène Seckel et al., *Les Demoiselles d'Avignon*, 2 vols., exh. cat., Paris, 1988, vol. 2, pp. 496, ill. 8, 497

Camille Pissarro
French, 1830–1903

A Cowherd at Valhermeil, Auvers-sur-Oise
1874
Oil on canvas
21⅝ x 36¼ in. (54.9 x 92.1 cm)
Signed and dated (lower left): C. Pissarro. 1874
Gift of Edna H. Sachs, 1956
56.182
See no. 49

PROVENANCE
Jean-Baptiste Faure, Paris (until d. 1914); his son, Louis Maurice Faure, Paris (from 1914); his wife, Mme Louis Maurice Faure, Paris (until 1919; sold to Petit and Durand-Ruel); [Georges Petit, Paris, and Durand-Ruel, Paris and New York, on February 1, 1919]; [Paul Rosenberg, Paris and New York, in 1925]; half-share bought from Rosenberg by Wildenstein and Co., New York in 1928 (until 1939; sold to Salomon); Mrs. Arthur K. Salomon, New York (in 1939); Mrs. Walter (Edna H.) Sachs, New York (until 1956; life interest, 1956–d. 1975)

EXHIBITIONS
"Les Grandes Influences au XIXe siècle (d'Ingres à Cézanne)," Paul Rosenberg, Paris, January 15–February 7, 1925, no. 12; "Cinquante ans de peinture française, 1875–1925," Musée des Arts Décoratifs, Paris, May 28–July 12, 1925, no. 57; "Great Masters of the French XIXth Century (Ingres to Picasso)," French Gallery, London, February 1926, no. 35 (possibly this work); "Camille Pissarro: His Place in Art," Wildenstein and Co., Inc., New York, October 24–November 24, 1945, no. 12; "Summer Loan Exhibition," Metropolitan Museum of Art, New York, June 22–September 30, 1956, no catalogue; "C. Pissarro," Wildenstein and Co., Inc., New York, March 25–May 1, 1965, no. 27; "Franse meesters uit het Metropolitan Museum of Art: Realisten en Impressionisten," Rijksmuseum Vincent van Gogh, Amsterdam, March 15–May 31, 1987, no. 15; "Camille Pissarro," Art Gallery of New South Wales, Sydney, November 19, 2005–February 19, 2006, National Gallery of Victoria, Melbourne, March 4–May 28, 2006, no. 22

SELECTED REFERENCES
Ludovic Rodo Pissarro and Lionello Venturi, *Camille Pissarro, Son art—son oeuvre*, 2 vols., Paris, 1939 [repr. 1989], vol. 1, pp. 40, 116, no. 260, vol. 2, pl. 52, no. 260; Charles Sterling and Margaretta M. Salinger, *French Paintings: A Catalogue of the Collection of The Metropolitan Museum of Art*, 3 vols., New York, 1955–67, vol. 3, pp. 16–17, ill.; Anthea Callen, *Jean-Baptiste Faure, 1830–1914: A Study of a Patron and Collector of the Impressionists and Their Contemporaries*, master's thesis, University of Leicester, 1971, p. 393, no. 521; Anne Schirrmeister, *Camille Pissarro*, Mount Vernon, 1982, p. 11, colorpl. 3; Charles S. Moffett, *Impressionist*

and Post-Impressionist Paintings in The Metropolitan Museum of Art, New York, 1985, pp. 86–87, color ill.; Joachim Pissarro, Camille Pissarro, New York, 1993, pp. 111–12, fig. 104; Bent Lantow, "Pissarro contre la A104," Vivre en Val d'Oise 50, June–August 1998, pp. 25, 29, color ill.; Joachim Pissarro and Claire Durand-Ruel Snollaert, trans. Mark Hutchinson and Michael Taylor, Pissarro: Catalogue critique des peintures / Critical Catalogue of Paintings, 3 vols., Milan, 2005, vol. 2, p. 271, no. 354, color ill.

Washerwoman, Study
1880
Oil on canvas
28¾ x 23¼ in. (73 x 59.1 cm)
Signed and dated (upper left): C. Pissarro 80
Gift of Mr. and Mrs. Nate B. Spingold, 1956
56.184.1
See no. 50

PROVENANCE
Camille Pissarro, Paris (1880–d. 1903); his wife, Mme Camille Pissarro, née Julie Vellay, Paris (1903–d. 1926), until 1921, by deed of gift to their son, Ludovic Rodo Pissarro, Paris (1921–47; sold to Salz); [Sam Salz, New York, 1947–49; sold to Spingold in February 1949]; Mr. and Mrs. Nate B. Spingold, New York (1949–56; his life interest, 1956–d. 1958; her life interest, 1956–d. 1976)

EXHIBITIONS
"7me exposition des artistes indépendants," Salons du Panorama de Reischoffen, Paris, March 1882, no. 107; "Rétrospective d'oeuvres de Camille Pissarro," Galerie Manzi et Joyant, Paris, January 26–February 14, 1914, no. 40; "Memorial Exhibition of the Works of Camille Pissarro," Leicester Gallery, London, May 1920, no. 67; "Exposition de la collection de Madame Veuve C. Pissarro," Galerie Nunès and Fiquet, Paris, May 20–June 20, 1921, no. 38; "Études et portraits de femmes," Galerie Marcel Bernheim, Paris, May 25–June 12, 1923, no. 43; "Tableaux par Camille Pissarro," Durand-Ruel, Paris, February 27–March 10, 1928, no. 34; "Centenaire de la naissance de Camille Pissarro," Musée de l'Orangerie, Paris, February–March 1930, no. 122; "Pissarro et ses fils," Galerie Marcel Bernheim, Paris, November 30–December 13, 1934, not in catalogue; "Fifty Years of Portraits (1885–1935)," Leicester Gallery, London, May–June 1935, no. 101; "C. Pissarro: Tableaux, pastels, dessins," Galerie de

l'Élysée, Paris, April–May 1936, no. 10; "C. Pissarro: des peintures et des pastels de 1880 à 1900 environ," Galerie de l'Élysée, Paris, April 23–May 5, 1948, no catalogue; "The Nate and Frances Spingold Collection," Metropolitan Museum of Art, New York, March 23–June 19, 1960, unnumbered cat.; "Paintings from the Nate B. and Frances Spingold Collection," Wildenstein and Co., New York, January 23–March 8, 1969, no. 25; "The New Painting: Impressionism 1874–1886," National Gallery of Art, Washington, D.C., January 17–April 6, 1986, M. H. de Young Memorial Museum, San Francisco, April 19–July 6, 1986, no. 126; "Corot to Cézanne: 19th Century French Paintings from The Metropolitan Museum of Art," Museum of Art, Fort Lauderdale, December 22, 1992–April 11, 1993, no catalogue

SELECTED REFERENCES
Arthur Hustin, "L'Exposition des peintres indépendants," L'Estafette, March 3, 1882, p. 3; [Jules Renard] Draner, "Une visite aux impressionnistes," Le charivari, March 9, 1882, ill. p. 3; Arthur Hustin, "L'Exposition des impressionnistes," Le moniteur des arts, March 10, 1882, p. 1; Armand Silvestre, "Le monde des arts: Septième exposition des artists indépendants," La vie moderne, March 11, 1882, p. 151; Maurice Hamel, "Camille Pissarro: Exposition rétrospective de ses oeuvres," Les arts, March 1914, p. 32; Claude Phillips, "Art Exhibitions: Camille Pissarro," Daily Telegraph, London, May 24, 1920, p. 6; A. Tabarant, trans. J. Lewis May, Pissarro, London, 1925 [French ed., 1924], pl. 21; Gustave Kahn, "Les Beaux-Arts: Exposition Camille Pissarro et ses fils," Le Quotidien, December 3, 1934, p. 2; Ludovic Rodo Pissarro and Lionello Venturi, Camille Pissarro, Son art—son œuvre, 2 vols., Paris, 1939 [repr. 1989], vol. 1, pp. 45, 153, no. 513, vol. 2, pl. 105, no. 513; Lionello Venturi, De Manet à Lautrec, Paris, 1953, p. 103, fig. 74; John Rewald, Camille Pissarro (1830–1903), Paris, 1954, colorpl. 25; Meïr Stein, Camille Pissarro (1830–1903), Copenhagen, 1955, colorpl. 25; Charles Sterling and Margaretta M. Salinger, French Paintings: A Catalogue of the Collection of The Metropolitan Museum of Art, 3 vols., New York, 1955–67, vol. 3, pp. 18–19, ill.; James J. Rorimer and Dudley T. Easby Jr., "Review of the Year 1956–1957," Metropolitan Museum of Art Bulletin 16, October 1957, n.s., p. 45, ill.; John Rewald, Pissarro, Paris [1960], fig. 32; John Rewald, Camille Pissarro, New York, 1963, pp. 118–19, colorpl.; John Rewald, Pissarro, Paris, 1970, no. 27, color ill.; John Rewald, C. Pissarro, 1974, no. 27, color ill.; Richard R. Brettell and Christopher Lloyd, A Catalogue of the Drawings by Camille Pissarro in the Ashmolean Museum, Oxford, Oxford, 1980, p. 143; Anne Schirrmeister, Camille Pissarro, New York, 1982, pp. 11–12, colorpl. 7; Charles S. Moffett, Impressionist and Post-Impressionist Paintings in The Metropolitan Museum of Art, New York, 1985, pp. 90–91, color ill.; John Rewald, Camille Pissarro, Paris, 1989, p. 118, no. 27, ill. p. 119; John Rewald, Camille Pissarro, London, 1991, pp. 92, 104, ill. p. 93; Joachim Pissarro, Camille Pissarro, New York, 1993, p. 156; Martin Reid, Pissarro, London, 1993, pp. 124, 144, no. 99, ill. p. 99; Ruth Berson, The New Painting: Impressionism 1874–1886, Documentation, 2 vols., San Francisco, 1996, vol. 1, pp. 377, 394–97, 413, vol. 2, p. 208, ill. p. 226; Joachim Pissarro and Claire Durand-Ruel Snollaert, trans. Mark Hutchinson and Michael Taylor, Pissarro: Catalogue critique des peintures / Critical Catalogue of Paintings, 3 vols., Milan, 2005, vol. 2, pp. 426–27, no. 640, ill. p. 427

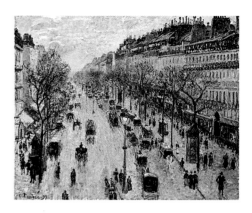

The Boulevard Montmartre on a Winter Morning
1897
Oil on canvas
25½ x 32 in. (64.8 x 81.3 cm)
Signed and dated (lower left): C.Pissarro.97
Gift of Katrin S. Vietor, in loving memory of Ernest G. Vietor, 1960
60.174
See no. 52

PROVENANCE
[Durand-Ruel, Paris, 1897–1944; bought from the artist on May 11 for Fr 2,000, stock no. 4237; consigned to Durand-Ruel, New York, in 1933, consignment no. 8928; sold on April 28, 1944, for $14,000 to Carstairs]; [Carroll Carstairs, New York, from 1944]; Stanley Newbold Barbee, Beverly Hills (until 1951; sold in December to Knoedler); [Knoedler, New York, 1951–52; sold on January 15 for $25,000 to Vietor]; Mr. and Mrs. Ernest G. Vietor, New York and Greenwich, Conn. (1952–his d. 1959); Katrin S. (Mrs. Ernest G.) Vietor, New York and Greenwich, Conn. (1959–60; life interest, 1960–65)

EXHIBITIONS
"Oeuvres récentes de Camille Pissarro," Durand-Ruel, Paris, June 1–18, 1898, no. 14; "Frühjahrs-Ausstellung," Galerie Ernst Arnold, Dresden, March 1899, no. 23; "Pictures by Boudin, Cézanne, Degas, Manet, Monet, Morisot, Pissarro, Renoir, Sisley," Grafton Galleries, London, January–February 1905, no. 174; "Franco-British Exhibition," Art Palace, London, May 14–December 1908, no. 379; "Tableaux, pastels et gouaches par Camille Pissarro," Durand-Ruel, Paris, January 27–February 19, 1921, no. 5; "Cinquante ans de peinture française (1875–1925)," Museé des Arts Décoratifs, Paris, May 28–July 12, 1925, no. 59; "Paintings by Camille Pissarro in Retrospect," Durand-Ruel, New York, January 3–24, 1933, no. 12; "Independent Painters of XIXth Century Paris," Museum of Fine Arts, Boston, March 15–April 28, 1935, no. 34; "C. Pissarro," Baltimore Museum of Art, November 1–30, 1936, no. 13 (possibly this work); "Paintings by French Impressionists and Post-Impressionists," Toledo Museum of Art, November 7–December 12, 1937, no. 22; "Impressionism: Paintings by Monet, Pissarro, Renoir, Seurat, Sisley," San Francisco Museum of Art, summer 1938, no. 22; "The Sources of Modern Painting," Museum of Fine Arts, Boston, March 2–April 9, 1939, no. 69; "Paintings of London and Paris," Durand-Ruel, New York, October 29–November 16, 1940, no. 4; "The Art of Camille Pissarro in Retrospect," Durand-Ruel, New York, March 24–April 15, 1941, no. 23; "Paris," Coordinating Council of French Relief Societies, New York, December 9, 1943–January 9, 1944, unnumbered cat.; "Pissarro in Venezuela," Art Gallery, Center for Inter-American Relations, New York,

February 1–March 6, 1968, not in catalogue; "Franse meesters uit het Metropolitan Museum of Art: Realisten en Impressionisten," Rijksmuseum Vincent van Gogh, Amsterdam, March 15–May 31, 1987, no. 17; "The Impressionist and the City: Pissarro's Series Paintings," Dallas Museum of Art, November 15, 1992–January 31, 1993, Philadelphia Museum of Art, March 7–June 6, 1993, no. 44; "Impressionists in Winter: Effets de neige," Brooklyn Museum, May 27–August 29, 1999, not in catalogue; "Impressionism to the Present: Camille Pissarro and His Descendants," Museum of Art, Fort Lauderdale, January 29–April 30, 2000, no. 64; "Paris and the Countryside: Modern Life in Late-19th-Century France," Portland Museum of Art, June 23–October 15, 2006, unnumbered cat.

SELECTED REFERENCES
Wynford Dewhurst, "Impressionist Painting: Its Genesis and Development," *Studio* 24, July 15, 1903, p. 96, ill.; Ludovic Rodo Pissarro and Lionello Venturi, *Camille Pissarro, Son art—son œuvre*, 2 vols., Paris, 1939 [repr. 1989], vol. 1, p. 217, no. 987, vol. 2, pl. 199, no. 987; Charles Sterling and Margaretta M. Salinger, *French Paintings: A Catalogue of the Collection of The Metropolitan Museum of Art*, 3 vols., New York, 1955–67, vol. 3, pp. 20–21, ill.; Dénes Pataky, *Pissarro*, Budapest, 1972, p. 23, pl. 40; J. Kirk T. Varnedoe et al., *Gustave Caillebotte*, exh. cat., Museum of Fine Arts, Houston, Houston, 1976 [2nd ed. 1987], p. 132, fig. 2; John Rewald, ed., *Camille Pissarro: Letters to His Son Lucien*, London, 1980, pp. 307, 313; Christopher Lloyd, *Camille Pissarro*, New York, 1981, pp. 122–23, 127, 146, ill.; Anne Schirrmeister, *Camille Pissarro*, New York, 1982, p. 17, colorpl. 13; Charles S. Moffett, *Impressionist and Post-Impressionist Paintings in The Metropolitan Museum of Art*, New York, 1985, pp. 98–99, color ill.; Kathleen Adler, Christopher Lloyd, eds., "Camille Pissarro: City and Country in the 1890s," *Studies on Camille Pissarro*, London and New York, 1987, p. 113 n. 1; Joachim Pissarro and Claire Durand-Ruel Snollaert, trans. Mark Hutchinson and Michael Taylor, *Pissarro: Catalogue critique des peintures / Critical Catalogue of Paintings*, 3 vols., Milan, 2005, vol. 3, p. 729, no. 1160, color ill.

Rue de l'Épicerie, Rouen (Effect of Sunlight)
1898
Oil on canvas
32 x 25⅝ in. (81.3 x 65.1 cm)
Signed and dated (lower left): C.Pissarro. / 1898
Purchase, Mr. and Mrs. Richard J. Bernhard Gift, 1960
60.5
See no. 51

PROVENANCE
[Durand-Ruel, Paris, 1898–1900; bought from the artist October 21, 1898, sold on March 21, 1900 to Bernard]; Louis Bernard [Monsieur L. B.], Paris (until 1901; his sale, Hôtel Drouot, Paris, May 11, no. 47, sold for Fr 8000 to Leclanché); Maurice Leclanché, Paris (1901–d. 1923; his estate, 1923–24; his estate sale, Hôtel Drouot, Paris, November 6, 1924, no. 62, sold for Fr 83,000 to Savard); Auguste Savard, Paris (1924–39/40; sold through an intermediary to Varenne); Roger Varenne, Geneva (1939/40–60; sold to the Metropolitan Museum)

EXHIBITIONS
"Tableaux par Camille Pissarro," Durand-Ruel, Paris, February 27–March 10, 1928, no. 69; "Camille Pissarro, 1830–1903," Kunstmuseum Bern, January 19–March 10, 1957, no. 98; "De Gericault à Matisse: Chefs-d'œuvre français des collections suisses," Musée du Petit Palais, Paris, March–May 1959, no. 110; "C. Pissarro," Wildenstein and Co., Inc., New York, March 25–May 1, 1965, no. 68; "Impressionist Treasures," M. Knoedler and Co., New York, January 12–29, 1966, no. 24; "Masterpieces of Painting in The Metropolitan Museum of Art," Museum of Fine Arts, Boston, September 16–November 1, 1970, unnumbered cat.; "Treasured Masterpieces of The Metropolitan Museum of Art," Tokyo National Museum, August 10–October 1, 1972, Kyoto Municipal Museum of Art, October 8–November 26, 1972, no. 101; "Impressionism: A Centenary Exhibition," Metropolitan Museum of Art, New York, December 12, 1974–February 10, 1975, not in catalogue; "100 Paintings from the Metropolitan Museum," State Hermitage Museum, Leningrad [St. Petersburg], May 15–June 20, 1975, Pushkin State Museum of Fine Arts, Moscow, August 28–November 2, 1975, no. 69; "Pissarro," Museum of Fine Arts, Boston, May 19–August 9, 1981, no. 81; "Camille Pissarro," Staatsgalerie Stuttgart, December 11, 1999–May 1, 2000, no. 63; "Camille Pissarro," Art Gallery of New South Wales, Sydney, November 19, 2005–February 19, 2006, National Gallery of Victoria, Melbourne, March 4–May 28, 2006, no. 89

SELECTED REFERENCES
Camille Mauclair, trans. P.G. Konody, *The French Impressionists (1860–1900)*, London, 1903, ill. p. 135; Camille Mauclair, trans. P. G. Konody, *The Great French Painters and the Evolution of French Painting from 1830 to the Present Day*, New York, 1903, ill. p. 27; Curiosa, "Jeudi 6 Novembre," *Le figaro artistique*, no. 49, 1924, p. 93, ill.; Ludovic Rodo Pissarro and Lionello Venturi, *Camille Pissarro, Son art—son œuvre*, 2 vols., Paris, 1939 [repr. 1989], vol. 1, pp. 65, 225, no. 1036, vol. 2, pl. 208, no. 1036; Charles Sterling and Margaretta M. Salinger, *French Paintings: A Catalogue of the Collection of The Metropolitan Museum of Art*, 3 vols., New York, 1955–67, vol. 3, pp. 21–22, ill.; John Rewald, *The History of Impressionism*, New York, 1961, [4th rev. ed., 1973], p. 570, ill.; John Rewald, "The Impressionist Brush," *Metropolitan Museum of Art Bulletin* 32, no. 3, 1973–74, p. 54, no. 28, ill.; Charles Kunstler, *Camille Pissarro*, Milan, 1974, p. 70; John Rewald, *C. Pissarro*, Paris, 1974, ill. under no. 44; John Rewald, ed., *Camille Pissarro: Letters to His Son Lucien*, London, 1980, p. 329; Christopher Lloyd, *Camille Pissarro*, New York, 1981, pp. 128–29, 132, 147, color ill.; Anne Schirrmeister, *Camille Pissarro*, New York, 1982, p. 16, colorpl. 16; Charles S. Moffett, *Impressionist and Post-Impressionist Paintings in the Metropolitan Museum of Art*, New York, 1985, pp. 100, color ill., 101; Christopher Lloyd, ed., "Camille Pissarro and Rouen," in *Studies on Camille Pissarro*, New York,

1986, pp. 86, 88, 93 n. 53, pl. 45; Richard R. Brettell and Joachim Pissarro, *The Impressionist and the City: Pissarro's Series Paintings*, exh. cat., Dallas Museum of Art, New Haven, 1992, fig. 33; Christopher Lloyd, *Pissarro*, London, 1992, 2nd ed. [1st ed., 1979], pp. 21, 29 no. 40, p. 110, ill. p. 111; Joachim Pissarro, *Camille Pissarro*, New York, 1993, p. 260, fig. 302; Martin Reid, *Pissarro*, London, 1993, p. 144 no. 133, ill. p. 133; Joachim Pissarro and Claire Durand-Ruel Snollaert, trans. Mark Hutchinson and Michael Taylor, *Pissarro: Catalogue critique des peintures / Critical Catalogue of Paintings*, 3 vols., Milan, 2005, vol. 3, p. 763, no. 1221, color ill.

The Garden of the Tuileries on a Winter Afternoon
1899
Oil on canvas
28⅞ x 36⅜ in. (73.3 x 92.4 cm)
Signed and dated (lower right): C.Pissarro.99
Gift from the Collection of Marshall Field III, 1979
1979.414
See no. 53

PROVENANCE
[Durand-Ruel, Paris, 1899–1915; bought from the artist on May 18, 1899, for Fr 3,000, stock no. 5249; sold November 11, 1915, for Fr 12,000 to Durand-Ruel, New York]; [Durand-Ruel, New York, 1915–45, stock no. 3901; sold on January 18 for $9,500 to Carstairs]; [Carroll Carstairs, New York, in 1945]; Marshall Field III, New York (until d. 1956); Mrs. Marshall Field III, New York (1956–79)

EXHIBITIONS
"C. Pissarro," Durand-Ruel, Paris, January 14–February 2, 1901, no. 9 (possibly this work); "VIII. internationale Kunstausstellung," Glaspalast, Munich, June 1–end of October, 1901, no. 1350a; "Vª Exposición Internacional de Arte," Palau de Belles Artes, Barcelona, April 27–July 1907, no. 28; "Pissarro," Durand-Ruel, Paris, March 1908, no. 17; "Art moderne," Galerie Manzi et Joyant, Paris, 1912, no. 63; "Exposition centennale de l'art français," Institut Français, St. Petersburg, from January 28, 1912, no. 484; "Paintings by Camille Pissarro," Durand-Ruel, New York, January 27–February 12, 1916, no. 17; unidentified exhibition, Brooks Reed Gallery, Boston, December 1916–January 1917; "Paintings by Pissarro," Durand-Ruel, New York, February 3–17, 1917, no. 7; "Paintings by Camille Pissarro and Alfred Sisley," Durand-Ruel, New York, from February 18, 1925, no. 4; "Sesquicentennial

International Exposition," Philadelphia, June 1–
December 1, 1926, no. 1526; unidentified exhibi-
tion, Lehigh University Art Galleries, Bethlehem, Pa.,
April–May 1928; "Loan Exhibitions—Paintings of
London and Paris for the Benefit of the British War
Relief Society," Durand-Ruel and Knoedler Galleries,
New York, October 29–November 16, 1940, no. 2;
"Six Impressionists," Carroll Carstairs, New York,
April 16–May 5, 1945, no. 1; "Camille Pissarro: His
Place in Art," Wildenstein and Co., Inc., New York,
October 24–November 24, 1945, no. 38; "Modern
French Painting," Wildenstein and Co., Inc., New
York, April 11–25, 1962, Rose Art Museum, Brandeis
University, Waltham, Mass., May 10–June 13, 1962,
no. 50; "C. Pissarro," Wildenstein and Co., Inc., New
York, March 25–May 1, 1965, no. 75; "New York
Collects," Metropolitan Museum of Art, New York,
July 3–September 2, 1968, no. 155; "Pleasures of
Paris: Daumier to Picasso," Museum of Fine Arts,
Boston, June 5–September 1, 1991, IBM Gallery of
Science and Art, New York, October 15–December
28, 1991, no. 44; "The Impressionist and the City:
Pissarro's Series Paintings," Dallas Museum of Art,
November 15, 1992–January 31, 1993, Philadelphia
Museum of Art, March 7–June 6, 1993, no. 76;
"Impressionists in Winter: Effets de neige," Brooklyn
Museum, May 27–August 29, 1999, not in catalogue

SELECTED REFERENCES
Arsène Alexandre, "Exposition d'art moderne à
l'Hôtel de la revue 'Les arts,'" Les arts 128, August
1912, p. 9, ill.; Léo Koenig, Camille Pissarro, Paris,
1927, pl. 1; Ludovic Rodo Pissarro and Lionello
Venturi, Camille Pissarro, Son art—son œuvre, 2
vols., Paris, 1939 [repr. 1989], vol. 1, p. 233,
no. 1097, vol. 2, pl. 219, no. 1097; John Rewald,
C. Pissarro, Paris, 1974, ill. p. 41; Janine Bailly-
Herzberg, ed., Correspondance de Camille Pissarro,
5 vols., Paris/Val d'Oise, 1980–91, vol. 5, p. 26;
C[harles] S. M[offett] and A[nne] W[agner] et al., The
Metropolitan Museum of Art: Notable Acquisitions,
1979–1980, New York, 1980, pp. 45–46, ill.;
Christopher Lloyd and Anne Distel et al., Pissarro,
exh. cat., Hayward Gallery, London, 1980, p. 146;
John Rewald, ed., Camille Pissarro: Letters to His
Son Lucien, London, 1980, pp. 333, 336; Anne
Schirrmeister, Camille Pissarro, New York, 1982,
p. 17, colorpl. 15; Charles S. Moffett, Impressionist
and Post-Impressionist Paintings in the Metropolitan
Museum of Art, New York, 1985, p. 103, ill.
pp. 102–03; Joachim Pissarro and Claire Durand-
Ruel Snollaert, trans. Mark Hutchinson and Michael
Taylor, Pissarro: Catalogue critique des peintures /
Critical Catalogue of Paintings, 3 vols., Milan, 2005,
vol. 3, p. 782, no. 1257, color ill.

Pierre Puvis de Chavannes
French, 1824–1898

Cider
ca. 1865
Oil on paper, laid down on canvas
51 x 99¼ in. (129.5 x 252.1 cm)
Signed (lower right): P.Puvis de Chavannes
Catharine Lorillard Wolfe Collection, Wolfe Fund,
1926
26.46.1
See no. 41

PROVENANCE
[Durand-Ruel, Paris, 1894–at least 1899; bought from
the artist]; prince de Wagram, Paris [Durand-Ruel,
Paris, by 1905–at least 1909]; [Galerie Barbazanges,
Paris, by 1912–13]; John Quinn, New York (1913–d.
1924); Quinn estate (1924–26, sold to the
Metropolitan Museum)

EXHIBITIONS
"Puvis de Chavannes," Durand-Ruel, Paris, 1894,
possibly no. 4 or 5; "Exposition de tableaux, pastels,
dessins par M. Puvis de Chavannes," Durand-Ruel,
Paris, June–July 1899, possibly no. 26 or 27;
"Exposition centennale de l'art français," Institut
Français, St. Petersburg, 1912, no. 503 or 504; "Puvis
de Chavannes: Une voie singulière au siècle de l'im-
pressionnisme," Musée de Picardie, Amiens,
November 5, 2005–March 12, 2006

SELECTED REFERENCES
François Monod, "L'Exposition centennale de l'art
français à Saint-Pétersbourg," Gazette des beaux-arts
7, 1912, pér. 4, p. 323; B[ryson] B[urroughs], "A
Recent Loan of Paintings," Metropolitan Museum of
Art Bulletin 10, April 1915, p. 76; John Quinn, 1870–
1925: Collection of Paintings, Water Colors, Drawings,
and Sculpture, Huntington, N.Y., 1926, p. 13; Charles
Sterling and Margaretta M. Salinger, French Paintings:
A Catalogue of the Collection of The Metropolitan
Museum of Art, 3 vols., New York, 1955–67, vol. 2,
pp. 225–27, ill.; Richard J. Wattenmaker, Puvis de
Chavannes and The Modern Tradition, exh. cat., Art
Gallery of Ontario, Toronto, 1975, pp. xxi, xxiv,
27–29, 58, 65; Louise d'Argencourt et al., Puvis de
Chavannes, 1824–1898, exh. cat., Galeries
Nationales du Grand Palais, Paris, 1976, p. 67;
Aimée Brown Price, Pierre Puvis de Chavannes, exh.
cat., Van Gogh Museum, Amsterdam, 1994, p. 104
n. 2, under no. 38; Judith Zilczer, "The Noble
Buyer": John Quinn, Patron of the Avant-Garde, exh.
cat., Hirshhorn Museum and Sculpture Garden,
Smithsonian Institution, Washington, D.C., 1978,
p. 179

The River
ca. 1865
Oil on paper, laid down on canvas
51 x 99¼ in. (129.5 x 252.1 cm)
Signed (lower right): P.Puvis de Chavannes
Catharine Lorillard Wolfe Collection, Wolfe Fund,
1926
26.46.2
See no. 42

PROVENANCE
[Durand-Ruel, 1894–at least 1899; bought from the
artist]; prince de Wagram, Paris [Durand-Ruel, Paris,
by 1905–at least 1909]; [Galerie Barbazanges, Paris,
by 1912–13]; John Quinn, New York (1913–d. 1924);
Quinn estate (1924–26; sold to the Metropolitan
Museum)

EXHIBITIONS
"Puvis de Chavannes," Durand-Ruel, Paris, 1894,
possibly no. 4 or 5; "Exposition de tableaux, pastels,
dessins par M. Puvis de Chavannes," Durand-Ruel,
Paris, June–July 1899, possibly no. 26 or 27;
"Exposition centennale de l'art français," Institut
Français, St. Petersburg, 1912, no. 503 or 504; "Puvis
de Chavannes: Une voie singulière au siècle de l'im-
pressionnisme," Musée de Picardie, Amiens,
November 5, 2005–March 12, 2006

SELECTED REFERENCES
François Monod, "L'Exposition centennale de l'art
français à Saint-Pétersbourg," Gazette des beaux-arts
7, 1912, pér. 4, p. 323; B[ryson] B[urroughs], "A
Recent Loan of Paintings," Metropolitan Museum of
Art Bulletin 10, April 1915, p. 76; John Quinn, 1870–
1925: Collection of Paintings, Water Colors, Drawings,
and Sculpture, Huntington, N.Y., 1926, p. 13; Charles
Sterling and Margaretta M. Salinger, French Paintings:
A Catalogue of the Collection of The Metropolitan
Museum of Art, 3 vols., New York, 1955–67, vol. 2,
pp. 225–27, ill.; Richard J. Wattenmaker, Puvis de
Chavannes and The Modern Tradition, exh. cat., Art
Gallery of Ontario, Toronto, 1975, pp. xxi, xxiv,
27–29, 58, 65; Louise d'Argencourt et al., Puvis de
Chavannes, 1824–1898, exh. cat., Galeries
Nationales du Grand Palais, Paris, 1976, p. 67;
Aimée Brown Price, Pierre Puvis de Chavannes, exh.
cat., Van Gogh Museum, Amsterdam, 1994, p. 104,
under no. 37; Judith Zilczer, "The Noble Buyer":
John Quinn, Patron of the Avant-Garde, exh. cat.,
Hirshhorn Museum and Sculpture Garden,
Smithsonian Institution, Washington, D.C., 1978,
p. 179

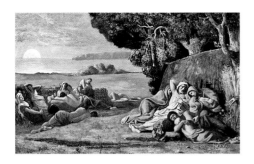

Sleep
ca. 1867–70
Oil on canvas
26⅛ x 41¾ in. (66.4 x 106 cm)
Signed (lower left): P. Puvis de Chavannes.
Theodore M. Davis Collection, Bequest of Theodore
M. Davis, 1915
30.95.253
See no. 43

PROVENANCE
[Durand-Ruel, New York by 1896; sold on April 8,
1896, for $3,000 to Davis]; Theodore M. Davis,
Newport, Rhode Island, and New York (1896–
d. 1915; his estate, on loan to the Metropolitan
Museum, 1915–30)

EXHIBITIONS
"Landscape Paintings," Metropolitan Museum of Art,
New York, May 14–September 30, 1934, no. 47;
"Pierre Puvis de Chavannes," Van Gogh Museum,
Amsterdam, February 25–May 29, 1994, no. 47;
"Night," Haus der Kunst München, Munich,
November 1, 1998– February 14, 1999, not in cata-
logue

SELECTED REFERENCES
Philippe Burty, "L'Exposition de Limoges," *Gazette
des beaux-arts* 4, September 1870, pp. 222–23 (pos-
sibly this painting); Bryson Burroughs, "The Theodore
M. Davis Bequest: The Paintings," *Metropolitan
Museum of Art Bulletin* 26, March 1931, section 2,
pp. 15–16, ill. p. [18]; Charles Sterling and
Margaretta M. Salinger, *French Paintings: A Catalogue
of the Collection of The Metropolitan Museum of Art,*
3 vols., New York, 1955–67, vol. 2, pp. 227–28, ill;
Richard J. Wattenmaker, *Puvis de Chavannes and
The Modern Tradition,* exh. cat., Art Gallery of
Ontario, Toronto, 1975, p. 28; Jacques Foucart et al.,
Puvis de Chavannes, 1824–1898, exh. cat., Galeries
Nationales du Grand Palais, Paris, 1976, p. 88, under
no. 63; William M. Griswold et al., *Masterworks
from the Musée des Beaux-Arts, Lille,* exh. cat.,
Metropolitan Museum of Art, New York, 1992,
p. 277, under no. 85

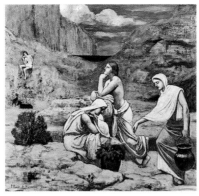

The Shepherd's Song
1891
Oil on canvas
41⅛ x 43¼ in. (104.5 x 109.9 cm)
Signed and dated (lower left): P.Puvis de Chavannes /
1891
Rogers Fund, 1906
06.177
See no. 44

PROVENANCE
[Durand-Ruel, Paris, in 1891]; A. W. Kingman, New
York (by 1894–96; sold on March 5, 1896, to
Durand-Ruel); [Durand-Ruel, Paris and New York,
1896–1906; stock no. 1586; sold on April 3, 1906,
to the Metropolitan Museum].

EXHIBITIONS
"Puvis de Chavannes," Durand-Ruel, Paris, 1894,
no. 15; "First Annual Exhibition," Carnegie Art
Galleries, Pittsburgh, November 5, 1896–January 1,
1897, no. 233; "Temporary Exhibition," Metropolitan
Museum of Art, New York, April 1906, no. 26; "Puvis
de Chavannes et la peinture lyonnaise du XIXe
siècle," Musée de Lyon, 1937, no. 42; "19th-Century
French and American Paintings from the Collection of
The Metropolitan Museum of Art," Newark Museum,
April 9–May 15, 1946, no. 24; "The Classical
Contribution to Western Civilization," Art Gallery of
Toronto, December 15, 1948–January 31, 1949,
Metropolitan Museum of Art, New York, April 1949,
not in catalogue; "Portraits, Figures and Landscapes,"
Society of the Four Arts, Palm Beach, January 12–
February 4, 1951, no. 31; "French Pre-Impressionist
Painters of the Nineteenth Century," Winnipeg Art
Gallery, April 10–May 9, 1954, no. 70; "Aspects of
the Desert: The Dedication of the Phoenix Art
Museum," Phoenix Art Museum, November 14,
1959–January 31, 1960, no. 25; "French Symbolist
Painters: Moreau, Puvis de Chavannes, Redon and
their Followers," Hayward Gallery, London, June 7–
July 23, 1972, Walker Art Gallery, Liverpool, August
9–September 17, 1972, no. 226; "Puvis de
Chavannes and the Modern Tradition," Art Gallery of
Ontario, Toronto, October 24–November 30, 1975,
no. 32; "Puvis de Chavannes, 1824–1898," Grand
Palais, Paris, November 26, 1976–February 14, 1977,
Galerie Nationale du Canada, Ottawa, March 18–
May 1, 1977, no. 195; "Treasures from The
Metropolitan Museum of Art: French Art from the
Middle Ages to the Twentieth Century," Yokohama
Museum of Art, March 25–June 4, 1989, no. 85;
"Symbolism in Danish and European Painting,
1870–1910," Statens Museum for Kunst, Copenhagen,
September 29, 2000–January 14, 2001, no. 4; "From
Puvis de Chavannes to Matisse and Picasso: Toward
Modern Art," Palazzo Grassi, Venice, February 10–
June 16, 2002, no. 21

SELECTED REFERENCES
Charles Sterling and Margaretta M. Salinger, *French
Paintings: A Catalogue of the Collection of The
Metropolitan Museum of Art,* 3 vols., New York,
1955–67, vol. 2, p. 231, ill.; *Collection de Monsieur
X . . . lettres autographes de peintres des XIXe et XXe
siècles . . . ,* sales cat., Hôtel Drouot, Paris, June 25,
1975, under no. 138; Gary Tinterow et al., *The
Metropolitan Museum of Art: Modern Europe,* New
York, 1987, p. 79, color ill.; Pierre Vaisse et al., *Puvis
de Chavannes au Musée des Beaux-Arts de Lyon,*
exh. cat., Musée des Beaux-Arts de Lyon, 1998,
pp. 47, 132, fig. 26 and ill. p. 132; T. J. Clark,
*Farewell to an Idea: Episodes from a History of
Modernism,* New Haven, 1999, p. 90, fig. 47 (color)

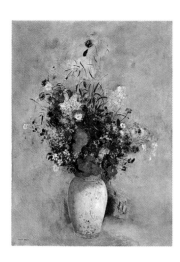

Odilon Redon
French, 1840–1916

Vase of Flowers (Pink Background)
ca. 1906
Oil on canvas
28⅜ x 21¼ in. (72.7 x 54 cm)
Signed (lower left and at base of vase): ODILON REDON
Bequest of Mabel Choate, in memory of her father,
Joseph Hodges Choate, 1958
59.16.3
See no. 94

PROVENANCE
The artist, Paris (about 1906–d. 1916; placed on consignment with Carroll Galleries by 1915); his widow, Camille Redon, Paris (1916–17; remained on consignment with Carroll); [sold through Carroll Galleries, New York, February 1917, for Fr 2,000 to Quinn]; John Quinn, New York (1917–d. 1924); his estate (1924–26); Mrs. Joshua Montgomery Sears (*née* Sarah Carlisle Choate), Boston (by 1926–about 1944); Mabel Choate, Boston (in 1944–d. 1958)

EXHIBITIONS
"Redon," location unknown, New York, 1906, no. 11 (purportedly shown on the basis of an inscription, no longer extant, on a label on reverse); "Second Exhibition of Works by Contemporary French Artists," Carroll Galleries, New York, January 25–February 13, 1915, no. 16; "Paintings by Odilon Redon . . . ," John Herron Art Institute, Indianapolis, April 6–May 2, 1915, no. 8; "Fiftieth Anniversary Exhibition," Metropolitan Museum of Art, New York, May 8–August 1920, unnumbered cat.; "Loan Exhibition of Impressionist and Post-Impressionist Paintings," Metropolitan Museum of Art, New York, May 3–September 15, 1921, no. 94; "Odilon Redon," Museum of French Art, French Institute, New York, April 3–May 1, 1922, no. 4; "Exposition d'œuvres d'Odilon Redon (1840–1916)," Galerie Druet, Paris, June 11–23, 1923, no. 32; "Memorial Exhibition of Representative Works Selected from the John Quinn Collection," Art Center, New York, January 7–30, 1926, no. 31; "Odilon Redon," Acquavella Galleries, Inc., New York, October 22–November 21, 1970, no. 46; "'The Noble Buyer': John Quinn, Patron of the Avant-Garde," Hirshhorn Museum and Sculpture Garden, Washington, D.C., June 15–September 4, 1978, unnumbered cat., pp. 180–81; "From Delacroix to Matisse," State Hermitage Museum, Leningrad [St. Petersburg], March 15–May 10, 1988, Pushkin State Museum of Fine Arts, Moscow, June 10–July 30, 1988, no. 46; "Corot to Cézanne: 19th Century French Paintings from The Metropolitan Museum of Art," Museum of Art, Fort Lauderdale,

December 22, 1992–April 11, 1993, no catalogue; "Odilon Redon: Prince of Dreams, 1840–1916," Art Institute of Chicago, July 2–September 18, 1994, Van Gogh Museum, Amsterdam, October 20, 1994–January 15, 1995, Royal Academy of Arts, London, February 16–May 21, 1995, no. 164

SELECTED REFERENCES
"Crowds Flock to See Museum Show," *American Art News* 19, May 14, 1921, p. 6; *John Quinn, 1870–1925: Collection of Paintings, Water Colors, Drawings, and Sculpture,* Huntington, N.Y., 1926, p. 14; Forbes Watson, "The John Quinn Collection," *The Arts* 9, January 1926, p. 13, ill.; Charles Sterling and Margaretta M. Salinger, *French Paintings: A Catalogue of the Collection of The Metropolitan Museum of Art,* 3 vols., New York, 1955–67, vol. 3, pp. 8–9, ill.; Klaus Berger, trans. Michael Bullock, *Odilon Redon: Fantasy and Colour,* New York, 1965, p. 204, no. 308; B. L. Reid, *The Man from New York: John Quinn and His Friends,* New York, 1968, p. 295; Charles S. Moffett, *Impressionist and Post-Impressionist Paintings in The Metropolitan Museum of Art,* New York, 1985, pp. 240–41, color ill.; Gary Tinterow et al., *The Metropolitan Museum of Art: Modern Europe,* New York, 1987, pp. 86–88, fig. 63; Alec Wildenstein, *Odilon Redon: Catalogue raisonné de l'oeuvre peint et dessiné,* 4 vols., Paris, 1992–98, vol. 3, pp. 110–11, no. 1520, color ill.

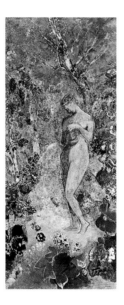

Pandora
ca. 1914
Oil on canvas
56½ x 24½ in. (143.5 x 62.2 cm)
Signed (lower right): ODILON REDON
Bequest of Alexander M. Bing, 1959
60.19.1
See no. 95

PROVENANCE
The artist, Paris (about 1914–d. 1916; placed on consignment with Carroll Galleries by 1915); his widow, Camille Redon, Paris (1916–17; remained on consignment with Carroll); [sold through Carroll Galleries, New York, February 1917, for Fr 4,000 to

Quinn]; John Quinn, New York (1917–d. 1924); his estate (1924–26); Alexander Max Bing, New York (by 1928–d. 1959)

EXHIBITIONS
"Second Exhibition of Works by Contemporary French Artists," Carroll Galleries, New York, January 25–February 13, 1915, no. 23; "Paintings by Odilon Redon . . . ," John Herron Art Institute, Indianapolis, April 6–May 2, 1915, no. 7; "Odilon Redon," Museum of French Art, French Institute, New York, April 3–May 1, 1922, no. 1; "Memorial Exhibition of Representative Works Selected from the John Quinn Collection," Art Center, New York, January 7–30, 1926, no. 28; "Exhibition of Paintings, Pastels, Drawings, Water Colours, Lithographs by Odilon Redon," De Hauke and Co., New York, November 1928, no. 9; "Tenth Loan Exhibition: Lautrec and Redon," Museum of Modern Art, New York, February 1–March 2, 1931, no. 94; "Masterpieces of Art: European and American Paintings, 1500–1900," World's Fair, New York, May–October 1940, no. 350; "Odilon Redon, 1840–1916," Joe and Emily Lowe Art Gallery of the University of Miami, February 24–March 13, 1955, Society of the Four Arts, Palm Beach, March 18–April 3, 1955, no. 3; "An Exhibition of Paintings and Pastels by Odilon Redon, 1840–1916," Paul Rosenberg, New York, February 9–March 7, 1959, no. 18; "Odilon Redon, Gustave Moreau, Rodolphe Bresdin," Museum of Modern Art, New York, December 4, 1961–February 4, 1962, no. 45; "Odilon Redon, Gustave Moreau, Rodolphe Bresdin," Art Institute of Chicago, March 2–April 15, 1962, no. 45; "Rousseau, Redon, and Fantasy," Guggenheim Museum, New York, May 31–September 8, 1968, unnumbered cat.; "Odilon Redon," Acquavella Galleries, Inc., New York, October 22–November 21, 1970, no. 43; "French Symbolist Painters: Moreau, Puvis de Chavannes, Redon, and Their Followers," Hayward Gallery, London, June 7–July 23, 1972, Walker Art Gallery, Liverpool, August 9–September 17, 1972, no. 247; "Nudes in Landscapes: Four Centuries of a Tradition," Metropolitan Museum of Art, New York, May 18–August 5, 1973, no catalogue; "L'Oeuvre de Marcel Duchamp," Musée National d'Art Moderne, Centre Georges Pompidou, Paris, January 31–May 2, 1977, no. 204; "'The Noble Buyer': John Quinn, Patron of the Avant-Garde," Hirshhorn Museum and Sculpture Garden, Washington, D.C., June 15–September 4, 1978, unnumbered cat. p. 180; "Odilon Redon, 1840–1916," Galerie des Beaux-Arts, Bordeaux, May 10–September 1, 1985, no. 241; "From Delacroix to Matisse," State Hermitage Museum, Leningrad [St. Petersburg], March 15–May 10, 1988, Pushkin State Museum of Fine Arts, Moscow, June 10–July 30, 1988, no. 47; "Corot to Cézanne: 19th Century French Paintings from The Metropolitan Museum of Art," Museum of Art, Fort Lauderdale, December 22, 1992–April 11, 1993, no catalogue; "Odilon Redon: Prince of Dreams, 1840–1916," Art Institute of Chicago, July 2–September 18, 1994, Van Gogh Museum, Amsterdam, October 20, 1994–January 15, 1995, Royal Academy of Arts, London, February 16–May 21, 1995, no. 177

SELECTED REFERENCES
"Imaginative Paintings in Current Exhibitions," *New York Times,* January 31, 1915, p. 5, 22; Louise Gebhard Gann, "The Metaphor of Redon," *International Studio* 78, November 1923, p. 103, ill.; Charles Sterling and Margaretta M. Salinger, *French Paintings: A Catalogue of the Collection of The Metropolitan Museum of Art,* 3 vols., New York, 1955–67, vol. 3, pp. 10–11, ill.; Klaus Berger, trans. Michael Bullock, *Odilon Redon: Fantasy and Colour,*

New York, 1965, p. 194, no. 172; Michael Wilson, *Nature and Imagination: The Work of Odilon Redon,* Oxford, 1978, pp. 72, 74, color ill.; Albert Boime, *Thomas Couture and the Eclectic Vision,* New Haven, 1980, p. 493; Gary Tinterow et al., *The Metropolitan Museum of Art: Modern Europe,* New York, 1987, p. 88, colorpl. 64; Alec Wildenstein, *Odilon Redon: Catalogue raisonné de l'œuvre peint et dessiné,* 4 vols., Paris, 1992–98, vol. 1, p. 285, no. 724, ill.

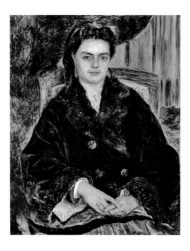

Auguste Renoir
French, 1841–1919

Madame Édouard Bernier (Marie-Octavie-Stéphanie Laurens, 1838–1920)
1871
Oil on canvas
30¾ x 24½ in. (78.1 x 62.2 cm)
Signed and dated (lower right): A. Renoir .71.
Gift of Margaret Seligman Lewisohn, in memory of her husband, Sam A. Lewisohn, and of her sister-in-law, Adele Lewisohn Lehman, 1951
51.200
See no. 98

PROVENANCE
Madame Édouard Bernier, the sitter (from 1871); J. Bernier (until 1919; sold on July 26 for Fr 10,000 to Durand-Ruel); [Durand-Ruel and Bernheim-Jeune, Paris, 1919; sold on July 29 to Bernheim-Jeune]; [Bernheim-Jeune, Paris and Lausanne, 1919–20; sold to Stransky]; Joseph Stransky, New York (1920–25; probably sold to Lewisohn); Adolph Lewisohn, New York (1925–38); his son, Samuel A. Lewisohn, New York (1938–51); his wife, Margaret Seligman Lewisohn, New York (in 1951; life interest to her sister-in-law, Adele Lewisohn Lehman, 1951–d. 1965)

EXHIBITIONS
"Loan Exhibition of Impressionist and Post-Impressionist Paintings," Metropolitan Museum of Art, New York, May 3–September 15, 1921, no. 101; "The Taste of Today in Masterpieces of Painting before 1900," Metropolitan Museum of Art, New York, July 10–October 2, 1932; "Renoir: A Special Exhibition of His Paintings," Metropolitan Museum of Art, New York, May 18–September 12, 1937, no. 1; "Great Portraits from Impressionism to Modernism," Wildenstein and Co., Inc., New York, March 1–29, 1938, no. 36; "The Lewisohn Collection," Metropolitan Museum of Art, New York, November 2–December 2, 1951, no. 67; "Impressionist and Modern Paintings from Private Collections: Summer Loan Exhibition," The Metropolitan Museum of Art, New York, July 11–end of summer 1957, no catalogue; "Renoir: In Commemoration of the Fiftieth Anniversary of Renoir's Death," Wildenstein and Co., New York, March 27–May 3, 1969, no. 6; "Renoir's Portraits: Impressions of an Age," National Gallery of Canada, Ottawa, June 27–September 14, 1997, Art Institute of Chicago, October 17, 1997–January 4, 1998, Kimbell Art Museum, Fort Worth, February 8–April 26, 1998, no. 9

SELECTED REFERENCES
Gustave Geffroy, "Peintre de la femme," *L'Art et les artistes* 1, January 1920, p. 162, ill.; Stephan Bourgeois, *The Adolph Lewisohn Collection of Modern French Paintings and Sculpture,* New York, 1928, pp. 128–29, ill.; Edith von Térey, "Die Sammlung Adolph Lewisohn, New York," *Kunst und Künstler* 27, August 1929, p. 418, ill.; Julius Meier-Graefe, *Renoir,* Leipzig, 1929, pp. 42, 52 no. 1, ill.; Stephan Bourgeois and Waldemar George, "The French Paintings of the XIXth and XXth Centuries in the Adolph and Samuel Lewisohn Collection," *Formes* 28–29, 1932, pp. 301, 305, ill.; R. H. Wilenski, *Modern French Painters,* New York [1940], pp. 61, 339; Charles Terrasse, *Cinquante Portraits de Renoir,* Paris, 1941, unpaginated, pl. 4; Charles Sterling and Margaretta M. Salinger, *French Paintings: A Catalogue of the Collection of The Metropolitan Museum of Art,* 3 vols., New York, 1955–67, vol. 3, pp. 145–46, ill.; Bruno F. Schneider, *Renoir,* Berlin [1957], p. 22; François Fosca, trans. Mary I. Martin, *Renoir: His Life and Work,* Englewood Cliffs, N.J., 1961, pp. 24, 32, ill.; Henri Perruchot, *La vie de Renoir* [Paris], 1964, pp. 78–79; Claus Virch, *The Adele and Arthur Lehman Collection,* New York, 1965, pp. 67–69, ill.; Margaretta M. Salinger, "Windows Open to Nature," *Metropolitan Museum of Art Bulletin* 27, summer 1968, n.s., unpaginated, ill.; François Fosca, trans. Mary I. Martin, *Renoir,* New York [1970?] [French ed., 1923], pp. 31–32, 35; François Daulte, *Auguste Renoir: Catalogue raisonné de l'oeuvre peint,* Lausanne, 1971, vol. 1, unpaginated, no. 69, ill.; Elda Fezzi, *L'Opera completa di Renoir,* Milan, 1972 [repr., 1981], p. 92, no. 64, ill.

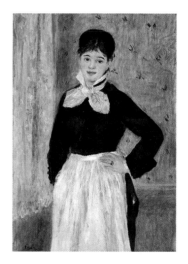

A Waitress at Duval's Restaurant
ca. 1875
Oil on canvas
39½ x 28⅛ in. (100.3 x 71.4 cm)
Signed (lower left): Renoir.
Bequest of Stephen C. Clark, 1960
61.101.14
See no. 97

PROVENANCE
[Durand-Ruel, Paris, by 1885–1906, bought from the artist for Fr 800; sold in February 3, 1906, for Fr 15,000 through Hébrard to Wagram]; Louis-Alexandre Berthier, prince de Wagram, Paris (1906–9; consigned October 6, 1909, to Druet; sold 1910 for Fr 12,000 to Barbazanges); [Barbazanges, Paris, 1910–12; sold to Scherbatow]; S. A. Scherbatow, Moscow (1912–1918/19); Museum of Modern Art, Moscow (1918/19–May 9, 1933; sold

through Knoedler, New York, to Clark); Stephen C. Clark, New York (1933–d. 1960)

EXHIBITIONS
"Works in Oil and Pastel by the Impressionists of Paris," American Art Association, New York, April 10–28, 1886, National Academy of Design, New York, May 25–June 30, 1886, no. 213; "Exposition centennale de l'art français," Institut Français, St. Petersburg, 1912, no. 529; "French Masterpieces of the Nineteenth Century," Century Club, New York, January 11–February 10, 1936, no. 15; "Renoir: A Special Exhibition of His Paintings," Metropolitan Museum of Art, New York, May 18–September 12, 1937, no. 13; "Masterpieces of Art: European and American Paintings, 1500–1900," World's Fair, New York, May–October 1940, no. 336; "Renoir, Centennial Loan Exhibition, 1841–1941," Duveen Galleries, New York, November 8–December 6, 1941, no. 15; "Paintings from the Stephen C. Clark Collection," Century Association, New York, June 6–September 28, 1946, unnumbered checklist; "Collectors' Choice: Masterpieces of French Art from New York Private Collections," Paul Rosenberg and Co., New York, March 17–April 18, 1953, no. 5; "A Collector's Taste: Selections from the Collection of Mr. and Mrs. Stephen C. Clark," M. Knoedler and Co., New York, January 12–30, 1954, no. 14; "Pictures Collected by Yale Alumni," Yale University Art Gallery, New Haven, May 8–June 18, 1956, no. 110; "Renoir," Wildenstein and Co., Inc., New York, April 8–May 10, 1958, no. 11; "Masterpieces of Impressionist and Post-Impressionist Painting," National Gallery of Art, Washington, D.C., April 25–May 24, 1959, unnumbered cat. (p. 41); "Franse meesters uit het Metropolitan Museum of Art: Realisten en Impressionisten," Rijksmuseum Vincent van Gogh, Amsterdam, March 15–May 31, 1987, no. 18; "From Delacroix to Matisse," State Hermitage Museum, Leningrad [St. Petersburg], March 15–May 10, 1988, Pushkin State Museum of Fine Arts, Moscow, June 10–July 30, 1988, no. 19; "Corot to Cézanne: 19th Century French Paintings from The Metropolitan Museum of Art," Museum of Art, Fort Lauderdale, December 22, 1992–April 11, 1993, no catalogue; "The Clark Brothers Collect: Impressionist and Early Modern Paintings," Sterling and Francine Clark Art Institute, Williamstown, Mass., June 4–September 4, 2006, Metropolitan Museum of Art, New York, May 22–August 19, 2007, fig. 127

SELECTED REFERENCES
Louis Hautecoeur, "L'Exposition centennale de peinture française à Saint-Pétersbourg," Les arts 129, September 1912, p. 30, ill.; [Boris Nikolaevich] Ternovietz, "Le Musée d'Art Moderne de Moscou," L'Amour de l'art 6, 1925, pp. 459, 462, ill.; Josephine L. Allen, "Paintings by Renoir," Metropolitan Museum of Art Bulletin 32, May 1937, pp. 109, 112, ill.; James W. Lane, "Thirty-three Masterpieces in a Modern Collection: Mr. Stephen C. Clark's Paintings by American and European Masters," Art News Annual 37, 1939, pp. 132, 138, ill.; Michel Drucker, Renoir, Paris, 1944, pp. 39–41, 193, no. 23, ill.; Denis Rouart, trans. James Emmons, Renoir, Geneva, 1954 [French ed., 1954], p. 32; Charles Sterling and Margaretta M. Salinger, French Paintings: A Catalogue of the Collection of The Metropolitan Museum of Art, 3 vols., New York, 1955–67, vol. 3, pp. 147–48, ill.; François Daulte, Auguste Renoir: Catalogue raisonné de l'oeuvre peint, Lausanne, 1971, vol. 1, unpaginated, no. 101, ill.; Charles S. Moffett, Impressionist and Post-Impressionist Paintings in The Metropolitan Museum of Art, New York, 1985, pp. 90–91, color ill.; Anne Distel et al., Renoir, exh. cat., Hayward Gallery, London, 1985, p. 26 [French ed., 1985, p. 42]

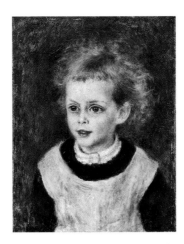

Marguerite-Thérèse (Margot) Berard
(1874–1956)
1879
Oil on canvas
16⅛ x 12¼ in. (41 x 32.4 cm)
Signed and dated (upper left): Renoir 79.
Bequest of Stephen C. Clark, 1960
61.101.15
See no. 99

PROVENANCE
Paul Berard, Paris and Wargemont (from 1879); his daughter, the sitter, Mme Alfred (Marguerite) Berard, Paris (probably sold to Knoedler); [Knoedler, Paris and New York, 1937; sold on January 25 to Clark]; Stephen C. Clark, New York (1937–d. 1960)

EXHIBITIONS
"Exposition des oeuvres de P. A. Renoir," Durand-Ruel, Paris, April 1–25, 1883, no. 19; "Troisième exposition annuelle des XX," Palais des Beaux-Arts, Brussels, February 6–March 7, 1886, no. 4; "Exposition Renoir," Bernheim-Jeune, Paris, March 10–29, 1913, no. 15; "Renoir: A Special Exhibition of His Paintings," Metropolitan Museum of Art, New York, May 18–September 12, 1937, no. 26; "Art in Our Time," Museum of Modern Art, New York, May 10–September 30, 1939, no. 51; "Modern Masters from European and American Collections," Museum of Modern Art, New York, January 26–March 24, 1940, no. 7; "Masterpieces of Art: European and American Paintings, 1500–1900," World's Fair, New York, May–October 1940, no. 333; "Renoir, Centennial Loan Exhibition, 1841–1941," Duveen Galleries, New York, November 8–December 6, 1941, no. 27; "Paintings from the Stephen C. Clark Collection," Century Association, New York, June 6–September 28, 1946, unnumbered checklist; "A Collector's Taste: Selections from the Collection of Mr. and Mrs. Stephen C. Clark," M. Knoedler and Co., New York, January 12–30, 1954, no. 15; "Paintings from Private Collections," Museum of Modern Art, New York, May 31–September 5, 1955, no. 127; "Renoir's Portraits: Impressions of an Age," National Gallery of Canada, Ottawa, June 27–September 14, 1997, Art Institute of Chicago, October 17, 1997–January 4, 1998, Kimbell Art Museum, Fort Worth, February 8–April 26, 1998, no. 34; "Faces of Impressionism: Portraits from American Collections," Baltimore Museum of Art, October 10, 1999–January 30, 2000, no. 57; "Renoir, O pintor da vida," Museu de Arte de São Paulo, April 22–July 28, 2002, unnumbered cat.; "The Clark Brothers Collect: Impressionist and Early Modern Paintings," Sterling and Francine Clark Art Institute, Williamstown, Mass., June 4–September 4, 2006, Metropolitan Museum of Art, New York, May 22–August 19, 2007, fig. 190

SELECTED REFERENCES
Théodore Duret, trans. J. E. Crawford Flitch, Manet and the French Impressionists, London, 1912 [1st ed., 1910], p. 178; Madeleine Octave Maus, Trente années de lutte pour l'art: 1884–1914, Brussels, 1926, p. 43 n. 1; Josephine L. Allen, "Paintings by Renoir," Metropolitan Museum of Art Bulletin 32, May 1937, p. 112; Maurice Berard, Maîtres du XIXe siècle: Renoir à Wargemont, Paris, 1938, unpaginated ill.; Maurice Berard, "Maîtres du XIXe siècle: Renoir à Wargemont et la famille Berard," L'Amour de l'art 19, 1938, ill. p. 319; James W. Lane, "Thirty-three Masterpieces in a Modern Collection: Mr. Stephen C. Clark's Paintings by American and European Masters," Art News Annual 37, 1939, p. 133; Lionello Venturi, Les archives de l'impressionnisme, Paris, 1939, vol. 2, pp. 227–29; Charles Sterling and Margaretta M. Salinger, French Paintings: A Catalogue of the Collection of The Metropolitan Museum of Art, 3 vols., New York, 1955–67, vol. 3, pp. 152–53, ill.; Maurice Berard, "Un diplomate ami de Renoir," Revue d'histoire diplomatique 70, July–September 1956, p. 243; "Ninety-first Annual Report of the Trustees for the Fiscal Year 1960–1961," Metropolitan Museum of Art Bulletin 20, October 1961, ill. p. 43; Margaretta M. Salinger, "Windows Open to Nature," Metropolitan Museum of Art Bulletin 27, summer 1968, n.s., unpaginated, ill.; François Daulte, Auguste Renoir: Catalogue raisonné de l'oeuvre peint, Lausanne, 1971, vol. 1, unpaginated, no. 286, ill.; Barbara Ehrlich White, Renoir: His Life, Art, and Letters, New York, 1984, p. 92

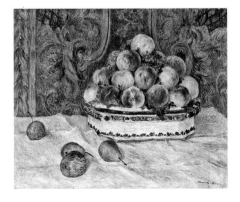

Still Life with Peaches
1881
Oil on canvas
21 x 25½ in. (53.3 x 64.8 cm)
Signed and dated (lower right): Renoir. 81.
Bequest of Stephen C. Clark, 1960
61.101.12
See no. 100

PROVENANCE
[André Schoeller, Paris]; [Raphael Gérard and Jacques Lindon, Paris]; Haviland collection; [Mme Paul Guillaume, Paris, and Jacques Seligmann, New York, 1936; sold by Seligmann on December 30, 1936, to Clark]; Stephen C. Clark, New York (1936–61)

EXHIBITIONS
"7me exposition des artistes indépendants," Salons du Panorama de Reischoffen, Paris, March 1882, no. 159; "Exposition de tableaux de Monet, Pissarro,

Renoir, and Sisley," Durand-Ruel, Paris, April 1899, no. 76; "Renoir: A Special Exhibition of His Paintings," Metropolitan Museum of Art, New York, May 18–September 12, 1937, no. 35; "Renoir, Centennial Loan Exhibition, 1841–1941," Duveen Galleries, New York, November 8–December 6, 1941, no. 37; "Jardin d'été," Coordinating Council of French Relief Societies, New York, May 3–31, 1944, unnumbered checklist; "Paintings from the Stephen C. Clark Collection," Century Association, New York, June 6–September 28, 1946, unnumbered checklist; "Delacroix and Renoir," Paul Rosenberg and Co., New York, February 16–March 13, 1948, no. 17; "A Collector's Taste: Selections from the Collection of Mr. and Mrs. Stephen C. Clark," M. Knoedler and Co., New York, January 12–30, 1954, no. 16; "Pictures Collected by Yale Alumni," Yale University Art Gallery, New Haven, May 8–June 18, 1956, no. 105; "Renoir," Wildenstein and Co., Inc., New York, April 8–May 10, 1958, no. 29; "The Clark Brothers Collect: Impressionist and Early Modern Paintings," Sterling and Francine Clark Art Institute, Williamstown, Mass., June 4–September 4, 2006; Metropolitan Museum of Art, New York, May 22–August 19, 2007, unnumbered cat., fig. 192

SELECTED REFERENCES
Jacques de Biez, "Les petits salons: Les 'Indépendants,'" Paris, March 8, 1882; La Fare, "Exposition des impressionistes," Le gaulois, March 2, 1882, p. 2; Armand Sallanches, "L'Exposition des artistes indépendants," Le journal des arts, March 3, 1882, p. 1; Maurice Berard, Maitres du XIXe siècle: Renoir à Wargemont, Paris, 1938, pp. 12–13; James W. Lane, "Thirty-three Masterpieces in a Modern Collection: Mr. Stephen C. Clark's Paintings by American and European Masters," Art News Annual 37, 1939, pp. 133, 146, ill.; Charles Sterling and Margaretta M. Salinger, French Paintings: A Catalogue of the Collection of The Metropolitan Museum of Art, 3 vols., New York, 1955–67, vol. 3, p. 154, ill.; Margaretta M. Salinger, "Windows Open to Nature," Metropolitan Museum of Art Bulletin 27, summer 1968, n.s., unpaginated ill.; Elda Fezzi, L'Opera completa di Renoir, Milan, 1972, pp. 109–10, no. 473, ill.; Anthea Callen, Renoir, London, 1978, pp. 72–73, no. 54, ill.; Charles S. Moffett, Impressionist and Post-Impressionist Paintings in The Metropolitan Museum of Art, New York, 1985, p. 167, color ill.; Ruth Berson, ed., The New Painting: Impressionism 1874–1886, Documentation, 2 vols., San Francisco, 1996, vol. 1, pp. 377, 380–81, 400, 412, vol. 2, pp. 211–12, 232, no. VII-159, ill.

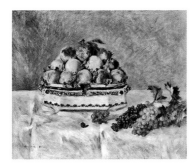

Still Life with Peaches and Grapes
1881
Oil on canvas
21¼ x 25⅝ in. (54 x 65.1 cm)
Signed and dated (lower left): Renoir. 81.
The Mr. and Mrs. Henry Ittleson Jr. Purchase Fund, 1956
56.218
See no. 101

PROVENANCE
[Durand-Ruel, Paris, 1881; bought from the artist on October 10 and sold same day to Berard]; Paul Berard, Paris and Wargemont (1881–1905; his estate sale, Galerie Georges Petit, Paris, March 8–9, 1905, no. 27, for Fr 6,000 to Guérin for Pra); Albert Pra, Paris (1905–38; his estate sale, Galerie Charpentier, Paris, June 17, 1938, no. 51, for Fr 465,000 to Rosenberg); [Paul Rosenberg, Paris, 1938; sold to Bignou]; [Étienne Bignou, Paris, 1939; sold to Cargill]; William A. Cargill, Carruth, Bridge of Weir, Scotland (1939–52; stored by Lefevre with Bignou, New York, during the war and sold in October 1952 to Bignou); [Étienne Bignou, Paris, 1952; sold to Salz]; [Sam Salz, New York, 1952–53; sold to Vogel]; Edwin C. Vogel, New York (1953–56; sold to the Metropolitan Museum)

EXHIBITIONS
"Exposition A. Renoir," Durand-Ruel, Paris, May 1892, no. 60; "Exposition A. Renoir," Bernheim-Jeune, Paris, January 25–February 10, 1900, no. 7; "Exposition Renoir, 1841–1919," Musée de l'Orangerie, Paris, 1933, no. 63; "The Age of Impressionism and Objective Realism," Detroit Institute of Arts, May 3–June 2, 1940, no. 36; "A Selection of 19th Century French Paintings," Bignou Gallery, New York, October 22–November 17, 1945, no. 9; "Renoir," Lefevre Fine Art Ltd., London, 1948, no. 8; "Renoir: In Commemoration of the Fiftieth Anniversary of Renoir's Death," Wildenstein and Co., New York, March 27–May 3, 1969, no. 38; "Capolavori impressionisti dei musei americani," Museo di Capodimonte, Naples, December 3, 1986–February 1, 1987, Pinacoteca di Brera, Milan, March 4–May 3, 1987, no. 42; "Corot to Cézanne: 19th Century French Paintings from The Metropolitan Museum of Art," Museum of Art, Fort Lauderdale, December 22, 1992–April 11, 1993, no catalogue

SELECTED REFERENCES
Maurice Berard, Maitres du XIXe siècle: Renoir à Wargemont, Paris, 1938, pp. 12–13, unpaginated ill.; Charles Sterling, La nature morte de l'antiquité à nos jours, Paris, 1952, p. 90, pl. 89 [2nd French ed., rev. 1981, p. 124, pl. 89]; Charles Sterling and Margaretta M. Salinger, French Paintings: A Catalogue of the Collection of The Metropolitan Museum of Art, 3 vols., New York 1955–67, vol. 3, pp. 153–54, ill.; Elda Fezzi, L'Opera completa di Renoir, Milan, 1972 [repr. 1981], pp. 109–10, ill.; Charles S. Moffett, Impressionist and Post-Impressionist Paintings in The Metropolitan Museum of Art, New York, 1985, p. 166, ill. in color

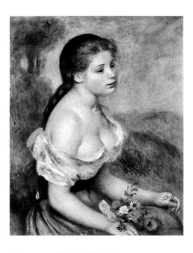

A Young Girl with Daisies
1889
Oil on canvas
25⅝ x 21¼ in. (65.1 x 54 cm)
Signed (lower right): Renoir.
The Mr. and Mrs. Henry Ittleson Jr. Purchase Fund, 1959
59.21
See no. 102

PROVENANCE
[Alexandre Rosenberg, Paris, bought from the artist, about 1890]; Mme Alexandre Rosenberg, Paris (until 1912; sold to Bernheim-Jeune); [Bernheim-Jeune, Paris, from 1912]; Mme Gaston Bernheim de Villers, Monte Carlo (until 1959; sold to the Metropolitan Museum)

EXHIBITIONS
"Exposition Renoir," Bernheim-Jeune, Paris, March 10–29, 1913, no. 35; "Exposition Renoir, 1841–1919," Musée de l'Orangerie, Paris, 1933, no. 88; "French Painting in the XIXth Century," McLellan Galleries, Reid and Lefevre, Ltd., Glasgow, May 1934, no. 38; "Renoir, Cezanne, and Their Contemporaries," Reid and Lefevre, Ltd., London, June 1934, no. 29; "Renoir, Portraitiste," Bernheim-Jeune, Paris, June 10–July 27, 1938, no. 14; "Renoir: In Commemoration of the Fiftieth Anniversary of Renoir's Death," Wildenstein and Co., New York, March 27–May 3, 1969, no. 66; "5,000 Years of Faces," Bellevue Art Museum, Bellevue, Wash., January 28–July 30, 1983, checklist no. 90; "Treasures from The Metropolitan Museum of Art: French Art from the Middle Ages to the Twentieth Century," Yokohama Museum of Art, March 25–June 4, 1989, no. 96

SELECTED REFERENCES
Octave Mirbeau, ed., Renoir, Paris, 1913, p. 60, ill. bet. pp. 34 and 35; L'Art moderne et quelques aspects de l'art d'autrefois: Cent-soixante-treize planches d'après la collection privée de MM. J. and G. Bernheim-Jeune, 2 vols., Paris, 1919, vol. 2, pl. 112; Gustave Coquiot, Renoir, Paris, 1925, p. 228; Julius Meier-Graefe, Renoir, Leipzig, 1929, p. 149, ill.; Léo Larguier, "Entre mille images, Renoir et le médicin," L'Art vivant 60, July 1933, p. 288, ill.; Violette De Mazia and Albert C. Barnes, The Art of Renoir, New York, 1935, pp. 85, 107, 459, no. 179; Ole Vinding, trans. Ingrid Rydbeck-Zuhr, Renoir, Stockholm, 1951, unpaginated, ill.; Charles Sterling and Margaretta M. Salinger, French Paintings: A Catalogue of the Collection of The Metropolitan Museum of Art, 3 vols., New York, 1955–67, vol. 3, p. 157, ill.; François Daulte, Auguste Renoir: Catalogue raisonné de l'oeuvre peint, Lausanne, 1971, vol. 1, unpaginated, no. 565, ill.

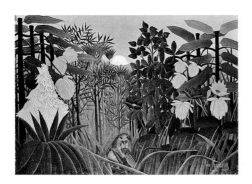

Henri Rousseau (le Douanier)
French, 1844–1910

The Repast of the Lion
ca. 1907
Oil on canvas
44¾ x 63 in. (113.7 x 160 cm)
Signed (lower right): Henri Rousseau
Bequest of Sam A. Lewisohn, 1951
51.112.5
See no. 104

PROVENANCE
Wilhelm Uhde, Paris (1910–at least 1911; purchased from the artist by July 1910 for Fr 200, sold to Keller); Julius Keller, Aachen (in 1914); [Stephan Bourgeois, New York, in 1923]; Adolph Lewisohn, New York (about 1923–d. 1938); his son, Sam A. Lewisohn, New York (1938–d. 1951)

EXHIBITIONS
"Salon d'automne," Grand Palais des Champs-Élysées, Paris, October 1–22, 1907, no. 1493 or 1494 (probably this picture); "Salon des indépendants (27me exposition)," Société des Artistes Indépendants, Quai d'Orsay, Pont de l'Alma, Paris, April 21–June 13, 1911, no. 21; "Exhibition of 'Modern' Pictures Representing Impressionist, Post-Impressionist, Expressionist, and Cubist Painters," Union League Club, New York, April 8–10, 1924, no. 30 (probably this picture); "Modern Works of Art," Museum of Modern Art, New York, November 20, 1934–January 20, 1935, no. 23; "The Lewisohn Collection," Metropolitan Museum of Art, New York, November 2–December 2, 1951, no. 75; "Rousseau, Redon, and Fantasy," Solomon R. Guggenheim Museum, New York, May 31–September 8, 1968; "Treasured Masterpieces of The Metropolitan Museum of Art," Tokyo National Museum, August 10–October 1, 1972, Kyoto Municipal Museum of Art, October 8–November 26, 1872, no. 105; "Die Kunst der Naiven: Themen und Beziehungen," Haus der Kunst München, November 1, 1974–January 12, 1975, no. 69, Kunsthaus Zürich, January 30–March 31, 1975, no. H18; "Le Douanier Rousseau," Galeries Nationales du Grand Palais, Paris, September 14, 1984–January 7, 1985, Museum of Modern Art, New York, February 5–June 4, 1985, no. 49; "Picasso and the School of Paris: Paintings from The Metropolitan Museum of Art," Municipal Museum of Art, Kyoto, September 14–November 24, 2002, Bunkamura Museum of Art, Tokyo, December 7, 2002–March 9, 2003, no. 7; "Le Douanier Rousseau, Jungles à Paris/Jungles in Paris," Tate Modern, London, November 3, 2005–February 5, 2006, Galeries Nationales du Grand Palais, Paris, March 15–June 19, 2006, National Gallery of Art, Washington, D.C., July 16–October 15, 2006, no. 48

SELECTED REFERENCES
Wilhelm Uhde, *Henri Rousseau,* Paris, 1911, unpaginated, fig. 13; Carl Einstein, *Die Kunst des 20 Jahrhunderts,* Berlin, 1926, p. 49, pl. 241; Philippe Soupault, *Henri Rousseau, Le douanier,* Paris, 1927, unpaginated, no. 19, ill.; Stephan Bourgeois, *The Adolph Lewisohn Collection of Modern French Paintings and Sculpture,* New York, 1928, pp. 196–97, ill.; Ambroise Vollard, trans. Violet M. Macdonald, *Recollections of a Picture Dealer,* London, 1936, p. 217; R. H. Wilenski, *Modern French Painters,* New York, 1949, pp. 205–6, 363; "A Selection from the European and Asiatic Collections of The Metropolitan Museum of Art. Presented by the Curatorial Hall," *Art Treasures of the Metropolitan,* New York, 1952, p. 234, no. 153; Charles Sterling and Margaretta M. Salinger, *French Paintings: A Catalogue of the Collection of The Metropolitan Museum of Art,* 3 vols., New York, 1955–67, vol. 3, pp. 166–67, ill.; Dora Vallier, *Henri Rousseau,* Paris, 1961, p. 101, ill.; Jean Bouret, *Henri Rousseau,* Neuchätel, 1961, p. 219, fig. 160; Dora Vallier and Giovanni Artieri, *L'Opera completa di Rousseau il doganiere,* Milano, 1969 [French ed., 1970], p. 105, no. 193, ill. colorpls. XXXIX and XL; Carolyn Keay, *Henri Rousseau, Le douanier,* New York, 1976, pp. 140–41, fig. 41; Dora Vallier, *Henri Rousseau,* New York, 1979, unpaginated, ill.; Yann le Pichon, *Le monde du douanier Rousseau,* Paris, 1981, pp. 154–55, color ill.; Henry Certigny, *Le douanier Rousseau en son temps,* 2 vols., Tokyo, 1984, vol. 2, pp. 664–65, no. 307, ill.; Cornelia Stabenow, *Henri Rousseau: Die Dschungelbilder,* Munich, 1984, unpaginated, no. 4, ill.; Charles S. Moffett, *Impressionist and Post-Impressionist Paintings in The Metropolitan Museum of Art,* New York, 1985, pp. 246–47; Gary Tinterow et al., *The Metropolitan Museum of Art: Modern Europe,* New York, 1987, pp. 96–97; Cornelia Stabenow, *Henri Rousseau, 1844–1910,* Cologne, 1991, pp. 83–85; Werner Schmalenbach, *Henri Rousseau: Dreams of the Jungle,* Munich and New York, 1998, pp. 30–35, 39

Georges Seurat
French, 1859–1891

The Forest at Pontaubert
1881
Oil on canvas
31⅛ x 24⅝ in. (79.1 x 62.5 cm)
Purchase, Gift of Raymonde Paul, in memory of her brother, C. Michael Paul, by exchange, 1985
1985.237
See no. 110

PROVENANCE
The artist's brother, Émile Seurat, Paris (until about 1900); Alexandre Natanson, Paris (about 1900–at least 1909); [Bernheim-Jeune, Paris]; Otto von Waetjen, Paris, Barcelona, and Düsseldorf (by 1914–about 1919); [Galerie Alfred Flechtheim, Berlin and Düsseldorf]; [Julio Kocherthaler, Madrid, in 1935]; Kenneth Clark, Lord Clark of Saltwood, London (by 1937–d. 1983; his estate, 1983–85; sold through E. V. Thaw to the Metropolitan Museum)

EXHIBITIONS
"Georges Seurat (1860 [*sic*]–1891): Oeuvres peintes et dessinées," Revue Blanche, Paris, March 19–April 5, 1900, not in catalogue; "Georges Seurat (1859–1891)," Bernheim-Jeune, Paris, December 14, 1908–January 9, 1909, no. 6; "I. Ausstellung: Expressionisten," Galerie Alfred Flechtheim, Düsseldorf, Easter–mid-May, 1919, unnumbered cat. (ill. p. 15); "Paysages," Alfred Flechtheim, Berlin, 1923; "L'Impressionnisme," Palais des Beaux-Arts, Brussels, June 15–September 29, 1935, no. 79; "Exposition Seurat," Paul Rosenberg, Paris, February 3–29, 1936, no. 3; "Seurat and His Contemporaries," Wildenstein and Co., Inc., London, January 20–February 27, 1937, no. 35; "Nineteenth-Century French Paintings," National Gallery, London, December 11, 1942–January 1943, no. 42; "Landscape in French Art 1550–1900," Royal Academy of Arts, London, December 10, 1949–March 5, 1950, no. 291; "Neo-Impressionism," Solomon R. Guggenheim Museum, New York, February 9–April 7, 1968, no. 64; "Treasures from The Metropolitan Museum of Art: French Art from the Middle Ages to the Twentieth Century," Yokohama Museum of Art, March 25–June 4, 1989, no. 101; "Georges Seurat, 1859–1891," Galeries Nationales du Grand Palais, Paris, April 9–August 12, 1991, no. 78, Metropolitan Museum of Art, New York, September 24, 1991–January 12, 1992, no. 79; "Corot to Cézanne: 19th Century French Paintings from The Metropolitan Museum of Art," Museum of Art, Fort Lauderdale, December 22, 1992–April 11, 1993, no catalogue; "Neo-Impressionism: The Circle

of Paul Signac," Metropolitan Museum of Art, New York, October 1–December 31, 2001, no catalogue

SELECTED REFERENCES
Lucie Cousturier, "Georges Seurat (1859–1891)," *L'Art décoratif* 27, June 1912, ill. p. 362; Walter Cohen, "Rheinisher Kunstbrief," *Kunstchronik und Kunstmarkt* 30, May 1919, p. 683, ill. p. 686; Lucie Cousturier, *Seurat,* Paris [1921], pl. 5; Gustave Coquiot, *Seurat,* Paris, 1924, pp. 198, 245; Lucie Cousturier, *Seurat,* Paris, 1926, fig. 3; Claude Roger-Marx, *Seurat,* Paris, 1931, fig. 2; Douglas Lord [Douglas Cooper], "Shorter Notices: The Impressionists at the Palais des Beaux Arts," *Burlington Magazine* 67, August 1935, p. 87; Benedict Nicolson, "Seurat's 'La Baignade,'" *Burlington Magazine* 79, November 1941, p. 146; John Rewald, *Georges Seurat,* New York, 1943 [2nd, rev. ed., 1946; French ed., 1948], p. 8; John Rewald, *Seurat (1859–1891),* Paris [1948; rev. and enlarged from 1943 ed.], unpaginated, pl. 13; R. H. Wilenski, *Seurat (1859–1891),* exh. cat., Faber Gallery, London, 1949, p. 2; Henri Dorra and John Rewald, *Seurat: L'Oeuvre peint, biographie et catalogue critique,* Paris, 1959, p. 7, no. 8, ill.; William I. Homer, "Henri Dorra and John Rewald, Seurat: L'Oeuvre peint, biographie et catalogue critique," *Art Bulletin* 3, September 1960, p. 230; C. M. de Hauke, *Seurat et son oeuvre,* 2 vols., Paris, 1961, vol. 1, pp. 8–9, 258, 263, no. 14, ill.; William I. Homer, "Seurat's Paintings and Drawings," *Burlington Magazine* 105, June 1963, p. 284; John Russell, *Seurat,* New York, 1965, pp. 105–6, 278, colorpl. 101; Anthony Blunt, ed., *Seurat,* London, 1965, p. 77, colorpl. 3; Pierre Courthion, trans. Norbert Guterman, *Georges Seurat,* New York [1968], pp. 68–69, color ill.; Fiorella Minervino and André Chastel, *L'Opera completa di Seurat,* Milan, 1972, p. 91–92, no. 12, ill.; Angelica Zandov Rudenstine, *The Guggenheim Museum Collection, Paintings 1880–1945,* New York, 1976, vol. 2, p. 639; Norma Broude, ed., *Seurat in Perspective,* Englewood Cliffs, N.J., 1978, n.p., fig. 1, p. 170; Richard Thomson, *Seurat,* Oxford, 1985, p. 41, colorpl. 30; Gary Tinterow et al., "Recent Acquisitions: A Selection, 1985–1986," *Metropolitan Museum of Art Bulletin,* fall 1986, p. 34, ill.; John Rewald, *Seurat: A Biography,* New York, 1990, color ill. p. 19; Alain Madeleine-Perdrillat, trans. Jean-Marie Clarke, *Seurat,* New York, 1990 [French ed., 1990], color ill. p. 43; Catherine Grenier, *Seurat: Catalogo completo dei dipinti,* Florence, 1990, p. 23, colorpl. 12; Luc de Nanteuil, "Seurat: Une certaine révolution," *Connaissance des arts,* no. 470, April 1991, pp. 42–43, fig. 8; Richard Tilston, *Seurat,* London, 1991, pp. 32–33, color ill.; Michael F. Zimmermann, *Seurat and the Art Theory of His Time,* Antwerp, 1991, p. 103, fig. 169; Peter Paquet, *Helldunkel, Raum und Form: Georges Seurat als Zeichner,* Frankfurt am Main, 2000, p. 141; Robert L. Herbert, *Seurat: Drawings and Paintings,* New Haven, 2001, pp. 74–75, colorpl. 53; Christophe Duvivier et al., *Georges Seurat et le néo-impressionnisme, 1885–1905,* exh. cat., Tokyo, 2002, pp. 11, 228, fig. 8

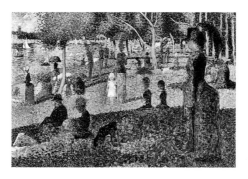

Study for "A Sunday on La Grande Jatte"
1884
Oil on canvas
27¾ x 41 in. (70.5 x 104.1 cm)
Bequest of Sam A. Lewisohn, 1951
51.112.6
See no. 111

PROVENANCE
The artist's brother-in-law, Léon Appert, Paris (in 1892); Félix Fénéon, Paris (by 1904–at least 1909); [Stephan Bourgeois, New York, in 1918]; Adolph Lewisohn, New York (1919–d. 1938); his son, Sam A. Lewisohn, New York (1938–d. 1951)

EXHIBITIONS
"Salon des Indépendants (8e exposition)," Société des Artistes Indépendants, Pavillon de la Ville de Paris, March 19–April 27, 1892, no. 1088; "Georges Seurat (1860 [*sic*]–1891): Oeuvres peintes et dessinées," Revue Blanche, Paris, March 19–April 5, 1900, no. 16; "Entwicklung des Impressionismus in Malerei u. Plastik," Secession, Vienna, January–February 1903, no. 118 (possibly this picture); "Exposition rétrospective Georges Seurat," Cours la Reine, Paris, March 24–April 30, 1905, no. 5; "Französische Künstler," Kunstverein, Munich, September 1906, Kunstverein, Frankfurt, October 1906, Galerie Arnhold, Dresden, November 1906, Kunstverein, Karlsruhe, December 1906, Kunstverein, Stuttgart, January 1907, no. 99; "Georges Seurat (1859–1891)," Bernheim-Jeune, Paris, December 14, 1908–January 9, 1909, no. 45; "La Faune," Bernheim-Jeune, Paris, December 19–30, 1910, no. 96; "French Post Impressionists," Arts Club of Chicago, April 9–23, 1919, no. 19; "Georges Seurat (1859–1891)," Bernheim-Jeune, Paris, January 15–31, 1920, no. 22; "Loan Exhibition of Impressionist and Post-Impressionist Paintings," Metropolitan Museum of Art, New York, May 3–September 15, 1921, no. 113; "Exhibition of 'Modern' Pictures Representing Impressionist, Post-Impressionist, Expressionist, and Cubist Painters," Union League Club, New York, April 8–10, 1924, no. 32; "First Loan Exhibition: Cézanne, Gauguin, Seurat, van Gogh," Museum of Modern Art, New York, November 8–December 7, 1929, no. 56; "Summer Exhibition, Retrospective," Museum of Modern Art, New York, June 15–late September, 1930, no. 96; "The Nineteenth Century: French Art in Retrospect, Eighteen Hundred to Nineteen Hundred," Albright Art Gallery, Buffalo, November 1–30, 1932, no. 56; "Exhibition of French Art: 1200–1900," Royal Academy of Arts, London, January 4–March 12, 1932, no. 523 [commemorative catalogue, no. 503]; "The Taste of Today in Masterpieces of Painting before 1900," Metropolitan Museum of Art, New York, July 10–October 2, 1932, no catalogue; "Modern European Art," Museum of Modern Art, New York, October 4–25, 1933, unnumbered cat.; "Important Paintings by Great French Masters of the Nineteenth-Century," Durand-Ruel, New York, February 12–March 10, 1934, no. 48; "Modern Works of Art,"

Museum of Modern Art, New York, November 20, 1934–January 20, 1935, no. 27; "24 Paintings and Drawings by Georges-Pierre Seurat," Renaissance Society of the University of Chicago, February 5–25, 1935, no. 15; "Views of Paris: Loan Exhibition of Paintings," M. Knoedler and Co., New York, January 9–28, 1939, no. 37; "Art in Our Time," Museum of Modern Art, New York, May 10–September 30, 1939, no. 74; "Masterpieces of Art: European and American Paintings, 1500–1900," World's Fair, New York, May–October 1940, no. 369; "Paintings from New York Private Collections," Museum of Modern Art, New York, summer 1946, unnumbered cat.; "Six Masters of Post-Impressionism," Wildenstein and Co., Inc., New York, April 8–May 8, 1948, no. 50; "Seurat, 1859–1891: Paintings and Drawings," Knoedler Galleries, New York, April 19–May 7, 1949, no. 7; "'What They Said'—Postscript to Art Criticism," Durand-Ruel, New York, November 28–December 17, 1949, no. 7; "The Lewisohn Collection," Metropolitan Museum of Art, New York, November 2–December 2, 1951, no. 79; "Art Treasures of the Metropolitan," Metropolitan Museum of Art, New York, November 7, 1952–September 7, 1953, no. 150; "De David à Toulouse-Lautrec: Chefs-d'œuvre des collections américaines," Musée de l'Orangerie, Paris, spring 1955, no. 51; "Seurat: Paintings and Drawings," Art Institute of Chicago, January 16–March 7, 1958, Museum of Modern Art, New York, March 24–May 11, 1958, no. 100; "Neo-Impressionism," Solomon R. Guggenheim Museum, New York, February 9–April 7, 1968, no. 76; "Masterpieces of Painting in The Metropolitan Museum of Art," Museum of Fine Arts, Boston, September 16–November 1, 1970, unnumbered cat., p. 86; "Impressionism: A Centenary Exhibition," Metropolitan Museum of Art, New York, December 12, 1974– February 10, 1975, not in catalogue; "100 Paintings from the Metropolitan Museum," State Hermitage Museum, Leningrad [St. Petersburg], May 15–June 20, 1975, Pushkin State Museum of Fine Arts, Moscow, August 28–November 2, 1975, no. 75; "Vom Licht zur Farbe: Nachimpressionistische Malerei zwischen 1886 und 1912," Städtische Kunsthalle, Düsseldorf, May 27–July 10, 1977, no. 104; "Seurat: Drawings and Oil Sketches from New York Collections," Metropolitan Museum of Art, New York, September 29–November 27, 1977, no. 49; "Seurat, 1859–1891," Galeries Nationales du Grand Palais, Paris, April 9–August 12, 1991, no. 139, Metropolitan Museum of Art, New York, September 24, 1991–January 12, 1992, no. 141; "Seurat and the Bathers," National Gallery, London, July 2–September 28, 1997, no. 84; "Seurat and the Making of 'La Grande Jatte,'" Art Institute of Chicago, June 16–September 19, 2004, no. 64

SELECTED REFERENCES
Julius Meier-Graefe, *Entwicklungsgeschichte der Modernen Kunst,* 3 vols., Stuttgart, 1904, vol. 3, ill. p. 102; Julius Meier-Graefe, trans. Florence Simmonds and George W. Chrystal, *Modern Art, Being a Contribution to a New System of Aesthetics,* 2 vols., London, 1908, vol. 1, p. 311, ill. opp. p. 310; Ulfred Kirstein, "Ein Sonntag auf der Grande Jatte," *Meister der Farbe* 5, no. 10, 1908, essay no. 343, unpaginated, color ill.; J.-F. Schnerb, "Un Dimanche à la Grande Jatte (Esquisse)," *Les maîtres contemporains,* 1908, unpaginated, no. 55, color ill.; Julius Meier-Graefe, *Entwicklungsgeschichte der Modernen Kunst,* 3 vols., 2nd ed., Munich, 1914–15, vol. 2, pl. 383; Fritz Burger, "Einführung in die Moderne Kunst," *Die Kunst des 19. und 20. Jahrhunderts,* 2 vols., Berlin, 1917–24, vol. 1, pp. 92–93, pl. 106; Hans Hildebrandt, *Die Kunst des 19. und 20. Jahrhunderts,* 2 vols., Wildpark-Potsdam, 1917–24,

255

vol. 2, pl. 374; Walter Pach, *Georges Seurat*, New York, 1923, p. 22; Anton Springer, "Von 1800 bis zur Gegenwart," *Handbuch der Kunstgeschichte* 5, 1925, p. 290, ill.; Forbes Watson, "A Note on the Birch-Bartlett Collection," *The Arts* 9, June 1926, p. 304, ill. p. 309; Stephan Bourgeois, *The Adolph Lewisohn Collection of Modern French Paintings and Sculpture*, New York, 1928, pp. 186–87, ill.; Stephan Bourgeois, "The Passion of Collecting: Notes on the Adolph Lewisohn Collection," *Art News*, April 14, 1928, pp. 60, 65, ill.; Robert Allerton Parker, "The Drawings of Georges Seurat," *International Studio* 91, September 1928, pp. 16, 20, color ill.; R. H. Wile[n]ski, *French Painting*, Boston, 1931, pp. 318, 322; Samuel A. Lewisohn, "Drama in Painting," *Creative Art* 9, September 1931, ill. p. 192; Stephan Bourgeois and Waldemar George, "The French Paintings of the XIXth and XXth Centuries in the Adolph and Samuel Lewisohn Collection," *Formes* nos. 28–29, 1932, pp. 301, 306, ill. between pp. 304 and 305; [René] Édouard-Joseph, *Dictionnaire biographique des artistes contemporains 1910–1930*, 3 vols., 1930–34, Paris, vol. 3, 1934, pp. 293–95, ill. p. 294; Daniel Catton Rich, *Seurat and the Evolution of "La Grande Jatte,"* Chicago, 1935, pp. 17, 24–25, 58, no. 49, pl. XLIV; Meyer Schapiro, "Seurat and 'La Grande Jatte,'" *Columbia Review* 17, November 1935, ill. p. 8; Sam A. Lewisohn, *Painters and Personality: A Collector's View of Modern Art*, [New York] 1937, p. 46, 49, pl. 7 [rev. ed., 1948, p. 46, pl. 7]; Sam A. Lewisohn, "Personalities Past and Present," *Art News* 37, February 25, 1939, section I (The 1939 Annual), pp. 69, 155, ill.; Mary H. Piexotto, "Famous Art Collections: The Lewisohn Collection," *Studio* 117, March 1939, p. 99, ill.; R. H. Wilenski, *Modern French Painters*, New York [1940], p. 349; Alfred M. Frankfurter, "383 Masterpieces of Art," *Art News* 38, May 25, 1940 (The 1940 Annual), p. 66; John Rewald, *Georges Seurat*, New York, 1943 [2nd, rev. ed., 1946, pp. 20–21, fig. 71; French ed., 1948, p. 54, fig. 50]; Lionello Venturi, "The Art of Seurat," *Gazette des beaux-arts* 26, July 1944, sér. 6, pp. 426–27, fig. 5; Hans Huth, "Impressionism Comes to America," *Gazette des beaux-arts* 29, April 1946, sér. 6, p. 239 n. 22; John Rewald, *Seurat (1859–1891)*, Paris [1948], unpaginated, pl. 25; Lionello Venturi, trans. Francis Steegmuller, *Impressionists and Symbolists*, 2 vols., New York, 1947–50, vol. 2, p. 145, fig. 147 [French. ed., *De Manet à Lautrec*, Paris, 1953, p. 193, ill.]; Jacques de Laprade, *Seurat*, Paris, 1951, ill. p. 49; Aline B. Loucheim, "Sam Lewisohn and His Legacy to Art," *New York Times*, March 25, 1951, p. 85; Raymond Cogniat, *Seurat*, Paris [1951], pl. 13; Giulia Veronesi, "Saluto alla Francia," *Emporium* 122, September 1955, pp. 119–21, ill.; Charles Sterling and Margaretta M. Salinger, *French Paintings: A Catalogue of the Collection of The Metropolitan Museum of Art*, 3 vols., New York, 1955–67, vol. 3, pp. 194–97, ill.; Paul Bonnet, "Seurat et le Neo-Impressionnisme," *Le crocodile: Bulletin de l'Association Générale de l'Internat des Hospices Civils de Lyon*, October–December 1957, pp. 11, 14, 22; John O'Connell Kerr, "Seurat, the Silent Post-Impressionist," *The Studio* 155, May 1958, pp. 129–31, ill.; Henri Dorra and John Rewald, *Seurat: L'Oeuvre peint, biographie et catalogue critique*, Paris, 1959, pp. LXXVI n. 59d, LXXXV, 150–51, no. 138, ill.; John Rewald, *The History of Impressionism*, New York, 1961 [4th rev. ed., 1973], ill. p. 513; C. M. de Hauke, *Seurat et son oeuvre*, 2 vols., Paris, 1961, vol. 1, pp. 94–95, 197, 200, 231, 234, 238, 273, 285, no. 142, ill.; William Innes Homer, *Seurat and the Science of Painting*, Cambridge, Mass., 1964, pp. 123,125, fig. 35; John Russell, *Seurat*, New York, 1965, pp. 164–65, colorpl.

151; James Laver, "Fashion, Art, and Beauty," *Metropolitan Museum of Art Bulletin* 26, November 1967, ill. p. 126; Margaretta M. Salinger, "Windows Open to Nature," *Metropolitan Museum of Art Bulletin* 27, summer 1968, n.s., p. 47, ill.; Pierre Courthion, trans. Norbert Guterman, *Georges Seurat*, New York [1968], pp. 106–7, color ill.; Edith A. Standen et al., *Masterpieces of Painting in The Metropolitan Museum of Art*, Museum of Fine Arts, Boston, New York [1970], p. 86, color ill.; Niels Luning Prak, "Seurat's Surface Pattern and Subject Matter," *Art Bulletin* 53, September 1971, p. 367, fig. 2; Louis Hautecoeur, *Georges Seurat*, Milan, 1972, ill. p. 5, fig. 51; Fiorella Minervino and André Chastel, *L'Opera completa di Seurat*, Milan, 1972, pp. 99–101, no. 141, ill. p. 100, colorpl. XIX B; Iku Takenaka et al., *Seurat et le néo-impressionnisme*, [Tokyo] 1972, p. 116, no. 31, ill.; Mitsuhiko Kuroe, *Pissarro/Sisley/Seurat*, Tokyo, 1973, p. 140, no. 58, ill.; Norma Broude, ed., *Seurat in Perspective*, Englewood Cliffs, N.J., 1978, pp. 72, 76, fig. 14; [Sarane] Alexandrian, trans. Alice Sachs, *Seurat*, New York, 1980, p. 34; Erich Franz and Bernd Growe, *Georges Seurat, Zeichnungen*, exh. cat., Kunsthalle Bielefeld, Munich, 1983 [Eng. ed., 1984] p. 83; Sylvie Gache-Patin, *Sisley*, Paris, 1983, p. 71, fig. 94; Charles F. Stuckey, *Seurat*, Mount Vernon, N.Y., 1984, p. 16, colorpl. 4; Charles S. Moffett, *Impressionist and Post-Impressionist Paintings in The Metropolitan Museum of Art*, New York, 1985, pp. 224–25, 254–55, color ill.; Richard Thomson, *Seurat*, Oxford, 1985, pp. 102–3, 106, 109, 124, colorpl. 117; Gary Tinterow et al., *The Metropolitan Museum of Art: Modern Europe*, New York, 1987, pp. 9, 68, colorpl. 46; Richard R. Brettell, *French Impressionists*, Chicago, 1987, p. 89; Herbert Wotte, *Georges Seurat: Wesen, Werk, Wirkung*, Dresden, 1988, p. 216, colorpl. 54; John Rewald with the research assistance of Frances Weitzenhoffer, *Cézanne and America: Dealers, Collectors, Artists, and Critics, 1891–1921*, Princeton, 1989, p. 325; Richard Thomson, "The 'Grande Jatte': Notes on Drawing and Meaning," *Museum Studies* 14, 1989, p. 195, colorpl. 26; Margrit Hahnloser-Ingold and Charles S. Moffet et al., *The Passionate Eye: Impressionist and Other Master Paintings from the Collection of Emil G. Bührle, Zurich*, exh. cat., National Gallery of Art, Washington, D.C., Zurich, 1990, pp. 182, 241 n. 6, under no. 64; John Rewald, *Seurat: A Biography*, New York, 1990, color ill. p. 72; Alain Madeleine-Perdrillat, trans. Jean-Marie Clarke, *Seurat*, New York, 1990, pp. 63, 65, color ill.; Catherine Grenier, *Seurat: Catalogo completo dei dipinti*, Florence, 1990, p. 83, colorpl. 140; Michael F. Zimmermann, *Seurat and the Art Theory of His Time*, Antwerp, 1991, pp. 143, 182, 193–95, colorpl. 350 and ill. p. 134; Richard Tilston, *Seurat*, London, 1991, p. 88–89, color ill.; John Russell, "Paris, Grand Palais: Seurat," *Burlington Magazine* 133, July 1991, p. 478, fig. 59; Floyd Ratliff, *Paul Signac and Color in Neo-Impressionism*, New York, 1992, pp. 164–65, fig. 77; Sarah Carr-Gomm, *Seurat*, London, 1993, p. 22–23, color ill.; Matthias Waschek, Eva Mendgen, eds., "George Seurat: The Frame as Boundary and Extension of the Artwork," *In Perfect Harmony: Picture + Frame, 1850–1920*, Van Gogh Museum, Amsterdam, 1995, pp. 158, 260 n. 31, fig. 134; Paul Smith, *Seurat and the Avant-Garde*, New Haven, 1997, pp. 19, 21, 44, 48, figs. 5 and 26, 27; Nico J. Brederoo, et al., *Pointillismus: Auf den Spuren von Georges Seurat*, exh. cat., Wallraf-Richartz-Museum, Cologne, Munich, 1997, pp. 15–17, color ill.; Richard R. Brettell, "Martha Ward: Pissarro, Neo-Impressionism, and the Spaces of the Avant-Garde," *Art Bulletin* 81, March 1999, p. 171; Peter Paquet, *Helldunkel, Raum und Form: Georges Seurat als*

Zeichner, Frankfurt am Main, 2000, pp. 153–55, 160, 353, 443; Michel Draguet, *Signac, Seurat: Le néo-impressionnisme*, Paris, 2001, color ill. p. 24; Robert L. Herbert, *Seurat: Drawings and Paintings*, New Haven, 2001, pp. 84, 102–4, colorpl. 82; Laura Iamurri, "Gli appunti di viaggio di Lionello Venturi, 1932–1935," *Storia dell'arte* no. 101, 2002, pp. 96–98 n. 17

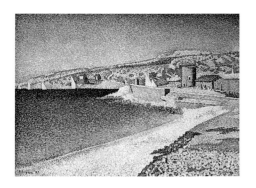

Paul Signac
French, 1863–1935

The Jetty at Cassis
1889
Oil on canvas
18¼ x 25⅝ in. (46.4 x 65.1 cm)
Signed, dated, and inscribed: (lower left) P.Signac 89;
(lower right) Op.198; (on stretcher) La Jetée de Cassis
– PS [monogram]
Bequest of Joan Whitney Payson, 1975
1976.201.19
See no. 113

PROVENANCE
Antoine de La Rochefoucauld (from 1890, bought
from the artist through an intermediary, Vincent
d'Indy); [Galerie de l'Élysée, Paris, until 1950; sold
on November 13 for $4,000 to Lehman]; Robert
Lehman, New York (1950–59); [Lock Galleries, New
York, from 1959]; [Knoedler, New York, until 1960;
sold on April 13 for $42,000 to Payson]; Joan
Whitney Payson, New York and Manhasset (1960–
d. 1975)

EXHIBITIONS
"Salon des indépendants (5e exposition)," Salle
de la Société d'Horticulture, Société des Artistes
Indépendants, Paris, September 3–October 4, 1889,
no. 246; "Les XX (7me exposition)," Ancien Musée
de Peinture, Brussels, January 18–February 23, 1890,
no. 11; "Paul Signac," Fine Arts Associates, New York,
November 5–December 1, 1951, no. 3; "Seurat and
His Friends," Wildenstein and Co., Inc., New York,
November 18–December 26, 1953, no. 40;
"Neo-Impressionism: The Friends and Followers
of Georges Seurat," Robert Lehman Collection,
Metropolitan Museum of Art, New York, September
14, 1991–January 12, 1992, unnumbered checklist;
"Pointillismus: Auf den Spuren von George Seurat,"
Wallraf-Richartz-Museum, Cologne, September 6–
November 30, 1997, Fondation de l'Hermitage,
Lausanne, January 23–June 1, 1998, no. 144;
"Signac, 1863–1935," Galeries Nationales du Grand
Palais, Paris, February 27–May 28, 2001, Van Gogh
Museum, Amsterdam, June 15–September 9, 2001,
Metropolitan Museum of Art, New York, October 9–
December 30, 2001, no. 35; "Neo-Impressionism:
Artists on the Edge," Portland Museum of Art,
June 27–October 20, 2002, unnumbered cat.

SELECTED REFERENCES
Félix Fénéon, "5e Exposition de la Société des
Artistes Indépendants, *La vogue* 3, September 1889,
p. 252; Arsène Alexandre, "Les artistes indépen-
dants," *Paris,* September 3, 1889, p. 2; Alphonse
Germain, "Beaux-Arts: L'Exposition des Indépendants,
Les néo-impressionistes et leur théorie," *Art et cri-
tique,* September 15, 1889, p. 251; J.-J. Court,
"Exposition des artistes indépendants," *Le moniteur
des arts,* September 20, 1889, p. 337; Jules Christophe,

"L'Exposition des artistes indépendants," *Journal des
artistes,* September 29, 1889, pp. 305–6; *La revue
indépendante,* September 1889, p. 492; A. Retté,
"Septième exposition des artistes indépendants,"
L'Ermitage, May 1891, p. 295; John Rewald, "Extraits
du journal inédit de Paul Signac, I, 1894–1895,"
Gazette des beaux-arts 36, July–September 1949,
pp. 106, 168; Jean-François Revel, "Charles Henry
et la science des arts," *L'Oeil,* November 1964,
p. 26; Henri Dorra and Sheila C. Askin, "Seurat's
Japonisme," *Gazette des beaux-arts* 73, February
1969, pp. 89, 94; Joan U. Halperin, ed., *Félix
Fénéon: Oeuvres plus que completes,* Geneva, 1970,
p. 165; Charles S. Moffett et al., *The Metropolitan
Museum of Art: Notable Acquisitions, 1975–1979,*
New York, 1979, p. 55, ill.; Gary Tinterow et al., *The
New Nineteenth-Century European Painting and
Sculpture Galleries,* New York, 1993, p. 73; Françoise
Cachin, *Signac, Catalogue raisonné de l'œuvre peint,*
Paris, 2000, pp. 35, 192, no. 184, ill.

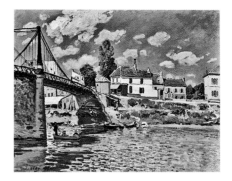

Alfred Sisley
English, 1839–1899

The Bridge at Villeneuve-la-Garenne
1872
Oil on canvas
19½ x 25¾ in. (49.5 x 65.4 cm)
Signed and dated (lower left): Sisley. 1872
Gift of Mr. and Mrs. Henry Ittleson Jr., 1964
64.287
See no. 81

PROVENANCE
[Durand-Ruel, Paris, 1872–73; bought from the artist,
August 24, 1872, stock no. L.1877, for Fr 200; sold
April 15, 1873, for Fr 350 to Fauré]; Jean-Baptiste
Fauré, Paris (from 1873–d. 1915; ca. 1910–14,
deposited with Durand-Ruel, Paris, date book no.
L.11941); Madame Maurice Faure, Paris; (1915–19;
sold to Georges Petit and Durand-Ruel); [Georges
Petit and Durand-Ruel, Paris and New York, from
1919]; Alfred Bergaud, Paris (by 1920; his sale,
Galerie Georges Petit, Paris, March 1–2, 1920,
no. 56, for Fr 37,200 to Gérard Frères); [Gérard
Frères, Paris, from 1920]; Fernand Bouisson, Paris (by
1930); [Sam Salz, New York]; Mr. and Mrs. Henry
Ittleson Jr., New York (by 1957–64)

EXHIBITIONS
"Exposition d'oeuvres de Alfred Sisley," Galerie
Georges Petit, Paris, 1917, no. 54; "Loan Exhibition
of Paintings by Alfred Sisley, 1839–1899," Paul
Rosenberg and Co., New York, October 30–
November 25, 1961, no. 3; "Impressionism: A
Centenary Exhibition," Galeries Nationales du Grand
Palais, Paris, September 21–November 24, 1974,
Metropolitan Museum of Art, New York, December
12, 1974–February 10, 1975, no. 41; "From
Delacroix to Matisse," State Hermitage Museum,
Leningrad [St. Petersburg], March 15–May 10, 1988,
Pushkin State Museum of Fine Arts, Moscow, June
10–July 30, 1988, no. 32; "Alfred Sisley," Royal
Academy of Arts, London, July 3–October 18, 1992,
"Sisley," Musée d'Orsay, Paris, October 28, 1992–
January 31, 1993, "Sisley: Master Impressionist,"
Walters Art Gallery, Baltimore, March 14–June 13,
1993, no. 14; "Impressionists on the Seine: A
Celebration of Renoir's 'Luncheon of the Boating
Party,'" Phillips Collection, Washington, D.C,
September 21, 1996–February 9, 1997, unnumbered
cat.; "Alfred Sisley: Poeta dell'impressionismo,"
Palazzo dei Diamanti, Ferrara, February 17–May 19,
2002, no. 6, Museo Thyssen-Bornemisza, Madrid,
June 8–September 15, 2002, no. 7, Musée des
Beaux-Arts de Lyon, October 9, 2002–January 6,
2003, no. 9

SELECTED REFERENCES
John Rewald, *The History of Impressionism,* New
York, 1946, p. 274, ill.; Charles Sterling and
Margaretta M. Salinger, *French Paintings: A*

Catalogue of the Collection of The Metropolitan Museum of Art, 3 vols., New York, 1955–67, vol. 3, pp. 119–20, ill.; François Daulte, Alfred Sisley: Catalogue raisonné de l'œuvre peint, Lausanne, 1959, p. 24, no. 37, fig. 37; Theodore Rousseau Jr., "Ninety-fifth Annual Report of the Trustees, for the Fiscal Year 1964–1965," Metropolitan Museum of Art Bulletin 24, October 1965, pp. 55–56, ill.; Anthea Callen, Jean-Baptiste Faure, 1830–1914: A Study of a Patron and Collector of the Impressionists and Their Contemporaries, master's thesis, University of Leicester, 1971, p. 416, no. 568; Anthony M. Clark et al., The Metropolitan Museum of Art: Notable Acquisitions, 1965–1975, New York, 1975, p. 81, ill.; Albert Kostenevich, Western European Painting in the Hermitage: 19th–20th Centuries, Leningrad [St. Petersburg], 1987, p. 292, under no. 81, ill.; Robert L. Herbert, Impressionism: Art, Leisure, and Parisian Society, New Haven, 1988, p. xi nn. 227–28, pp. 226–29, ill.; Anne Distel, trans. Barbara Perroud-Benson, Impressionism: The First Collectors, New York, 1990, pp. 87–89; Joel Isaacson, Impressionists in Winter: Effets de neige, exh. cat., Phillips Collection, Washington, D.C., 1998, p. 70, fig. 10

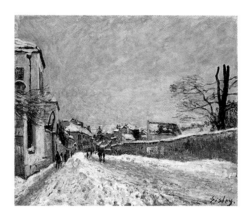

The Road from Versailles to Louveciennes
ca. 1879
Oil on canvas
18 x 22 in. (45.7 x 55.9 cm)
Signed (lower left): Sisley.
Gift of Mr. and Mrs. Richard Rodgers, 1964
64.154.2
See no. 82

PROVENANCE
[Durand-Ruel, New York, after 1879; sold to Davis]; Erwin Davis, New York (until 1899; sold on April 14 to Durand-Ruel); [Durand-Ruel, New York, 1899–at least 1947]; [Sam Salz, New York]; Mr. and Mrs. Richard Rodgers, New York (by 1959–64; his life interest, 1964–d. 1972; her life interest, 1964–d. 1992)

EXHIBITIONS
"Exhibition of Paintings by Alfred Sisley, 1839–1899," Durand-Ruel Galleries, New York, April 19–May 3, 1927, no. 7; "Alfred Sisley: Centennial, 1840–1940," Durand-Ruel Galleries, New York, October 2–21, 1939, no. 16; "Early Impressionism: 1868–1883," M. Knoedler and Co., New York, March 31–April 12, 1941, no. 25; "Exhibition of Modern French Paintings: Drawings, Lithographs, Etchings, Fine Printing, and Bookbinding," Skidmore Art Gallery, Saratoga Springs, February 8–25, 1942, no. 10; "56th Anniversary Exhibition," University of

Nebraska, Lincoln, 1946, no. 199; "Music Makers," Wadsworth Atheneum, Hartford, July 9–August 9, 1959, no. 16; "Loan Exhibition of Paintings by Alfred Sisley, 1839–1899," Paul Rosenberg and Co., New York, October 30–November 25, 1961, no. 12

SELECTED REFERENCES
Durand-Ruel, [A Selection of Paintings from the Durand-Ruel Galleries] 19th and 20th Century French Paintings, 20th Century American Paintings, 4 vols., New York, 1947–48, vol. 1, unpaginated, ill.; Charles Sterling and Margaretta M. Salinger, French Paintings: A Catalogue of the Collection of The Metropolitan Museum of Art, 3 vols., New York, 1955–67, vol. 3, p. 120, ill.; François Daulte, Alfred Sisley: Catalogue raisonné de l'oeuvre peint, Lausanne, 1959, unpaginated, no. 381, ill.

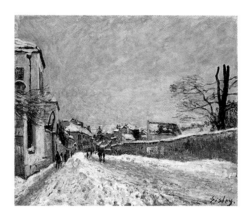

Rue Eugène Moussoir at Moret: Winter
1891
Oil on canvas
18⅜ x 22¼ in. (46.7 x 56.5 cm)
Signed (lower right): Sisley.
Bequest of Ralph Friedman, 1992
1992.366
See no. 83

PROVENANCE
Baron Blanquet de Fulde, Paris (until 1900; his sale, Hôtel Drouot, Paris, March 12, 1900, no. 58, for Fr 6,900 to Foinard); Foinard, Paris (from 1900); Maurice Goldfiel, Paris (until 1963; sale, Sotheby's, London, October 23, 1963, no. 45, for £20,000 to Bernier); M. G. B. Bernier (from 1963); private collection, France (until April 1965; sold to Wildenstein); [Wildenstein, New York, 1965–66; sold to Friedman, January 1966]; Ralph Friedman, New York (1966–d. 1992)

EXHIBITIONS
"Sisley," Wildenstein and Co., Inc., New York, October 27–December 3, 1966, no. 23; "Sisley: Master Impressionist," Walters Art Gallery, Baltimore, March 14–June 13, 1993, not in catalogue; "Impressionists in Winter: Effets de neige," Phillips Collection, Washington, D.C., September 19, 1998–January 3, 1999, Yerba Buena Center for the Arts, San Francisco, January 30–May 2, 1999, Brooklyn Museum, May 27–August 29, 1999, no. 57

SELECTED REFERENCES
François Daulte, Alfred Sisley: Catalogue raisonné de l'oeuvre peint, Lausanne, 1959, unpaginated, no. 780, ill.; Gary Tinterow et al., "Recent Acquisitions, A Selection: 1992–1993," Metropolitan Museum of Art Bulletin 51, fall 1993, p. 54, color ill.

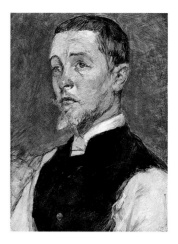

Henri de Toulouse-Lautrec
French, 1864–1901

Albert (René) Grenier (1858–1925)
1887
Oil on wood
13⅜ x 10 in. (34 x 25.4 cm)
Inscribed (verso): Mon portrait par / Toulouse Lautrec / en 1887 / atelier rue Caulaincourt / [Grenier?]
Bequest of Mary Cushing Fosburgh, 1978
1979.135.14
See no. 114

PROVENANCE
Gustave Pellet, Paris; Pierre Decourcelle, Paris (by 1921–26; his sale, Hôtel Drouot, Paris, June 16, 1926, no. 75, for Fr 60,000 to Sanchez-Abreu); Pierre Sanchez-Abreu, Paris (1926–at least 1931); [André Weil, New York, until 1948; sold in November to Wildenstein]; [Wildenstein, New York, 1948–52; sold in December to Astor]; Vincent Astor, New York (1952–53; part of divorce settlement to his second wife, née Mary Cushing, later Mrs. James W. Fosburgh]); Mary Cushing Fosburgh (1953–d. 1978)

EXHIBITIONS
"Exposition rétrospective de l'oeuvre de H. de Toulouse-Lautrec," Galerie Manzi, Joyant, Paris, June 15–July 11, 1914 [handwritten addendum to catalogue, no. 202]; "Exposition H. de Toulouse-Lautrec," Musée des Arts Décoratifs, Paris, April 9–May 17, 1931, no. 48; "Toulouse-Lautrec," Philadelphia Museum of Art, October 29–December 11, 1955, Art Institute of Chicago, January 2–February 15, 1956, no. 10; "Toulouse-Lautrec: Paintings, Drawings, Posters, and Lithographs," Museum of Modern Art, New York, March 20–May 6, 1956, no. 9; "Pictures Collected by Yale Alumni," Yale University Art Gallery, New Haven, May 8–June 18, 1956, no. 95; "Toulouse-Lautrec in The Metropolitan Museum of Art," Metropolitan Museum of Art, New York, July 2–September 29, 1996, unnumbered cat. (fig. 27); "Toulouse-Lautrec from The Metropolitan Museum of Art," Denver Art Museum, July 15–October 15, 1999, no catalogue; "Toulouse-Lautrec: A Look Inside Life," Museo Centrale del Risorgimento, Rome, October 10, 2003–February 8, 2004, no. I.12

SELECTED REFERENCES
Gustave Coquiot, Lautrec, ou Quinze ans de mœurs parisiennes, 1885–1900, Paris, 1921, pp. 61, 121; Achille Astre, H. de Toulouse-Lautrec, Paris, 1925, p. 81; Maurice Joyant, Henri de Toulouse-Lautrec, 1864–1901, 2 vols., Paris, 1926–27, vol. 1, pp. 106, 264, vol. 2, p. 8 n. 1; Gerstle Mack, Toulouse-Lautrec, New York, 1938, p. 268; Achille Astre,

H. de Toulouse-Lautrec, Paris [1938], p. 81; François Gauzi, *Lautrec et son temps*, Paris, 1954, pp. 27, 58 n. 2; Henri Perruchot, trans. Humphrey Hare, *T-Lautrec*, Cleveland, 1960, p. 129 [French ed., 1958, p. 146]; M. G. Dortu, *Toulouse-Lautrec et son oeuvre*, 6 vols., New York, 1971, vol. 1, p. 124, vol. 2, pp. 138–39, no. P.304, ill.; G. M. Sugana, *The Complete Paintings of Toulouse-Lautrec*, London, 1973 [Italian ed., 1969; French ed., 1977], p. 100, no. 204; Mary Sprinson de Jesús et al., *The Metropolitan Museum of Art: Notable Acquisitions, 1979–1980*, New York, 1980, pp. 44–45, ill.; Charles S. Moffett, *Impressionist and Post-Impressionist Paintings in The Metropolitan Museum of Art*, New York, 1985, pp. 11, 232–33, color ill.

SELECTED REFERENCES
Gustave Coquiot, *H. de Toulouse-Lautrec*, Paris, 1913, p. 76 (possibly this painting); Maurice Joyant, *Henri de Toulouse-Lautrec, 1864–1901*, 2 vols., Paris, 1926–27, vol. 1, p. 268, ill. p. 111; Paul de Lapparent, *Toulouse-Lautrec*, 1927, p. 21, pl. 5; Jean Adhémar et al., *T-Lautrec*, 1952, p. 117, no. 19, fig. 19; M. G. Dortu, *Toulouse-Lautrec et son oeuvre*, 6 vols., New York, 1971, vol. 2, pp. 172–73, no. P.344, ill.; G. M. Sugana, *The Complete Paintings of Toulouse-Lautrec*, 1973, p. 102, no. 237, ill.; Charles S. Moffett et al., *The Metropolitan Museum of Art: Notable Acquisitions, 1975–1979*, New York, 1979, p. 54, ill.; Charles S. Moffett, *Impressionist and Post-Impressionist Paintings in The Metropolitan Museum of Art*, 1985, pp. 11, 234, ill. p. 235 (color); Richard Thomson, *Theo van Gogh: Marchand de tableux, collectionneur, frère de Vincent*, Paris, 1999, p. 139, fig. 139 (color)

"Masterpieces of Painting in The Metropolitan Museum of Art," Museum of Fine Arts, Boston, September 16–November 1, 1970, unnumbered cat. (p. 87); "100 Paintings from the Metropolitan Museum," State Hermitage Museum, Leningrad [St. Petersburg], May 15–June 20, 1975, Pushkin State Museum of Fine Arts, Moscow, August 28–November 2, 1975, no. 74; "Toulouse-Lautrec," Hayward Gallery, London, October 10, 1991–January 19, 1992, Galeries Nationales du Grand Palais, Paris, February 18–June 1, 1992, no. 139; "Toulouse-Lautrec in The Metropolitan Museum of Art," Metropolitan Museum of Art, New York, July 2–September 29, 1996, unnumbered cat. (fig. 58); "Toulouse-Lautrec from The Metropolitan Museum of Art," Denver Art Museum, July 15–October 15, 1999, no catalogue

SELECTED REFERENCES
Romain Coolus, "Souvenirs sur Toulouse-Lautrec," *L'Amour de l'art* 12, April 1931, fig. 8; M.-G. Dortu, Madeleine Grillaert, and Jean Adhémar, *Toulouse-Lautrec en Belgique*, Paris, 1955, p. 35, pl. 32; Charles Sterling and Margaretta M. Salinger, *French Paintings: A Catalogue of the Collection of The Metropolitan Museum of Art*, 3 vols., New York, 1955–67, vol. 3, pp. 204–5, ill.; Maurice Rheims, "La cote des Lautrec," *Toulouse-Lautrec*, Paris, 1962, p. 224; M. G. Dortu, *Toulouse-Lautrec et son oeuvre*, 6 vols., New York, 1971, vol. 1, ill. pp. 60, 61, vol. 3, pp. 370–71, no. P.601, ill.; G. M. Sugana, *The Complete Paintings of Toulouse-Lautrec*, London, 1973 [Italian ed., 1969; French ed., 1977], p. 110, no. 368, ill.; Charles F. Stuckey, ed., *Toulouse-Lautrec: Paintings*, exh. cat., Chicago [1979], p. 252, fig. 4; Charles S. Moffett, *Impressionist and Post-Impressionist Paintings in The Metropolitan Museum of Art*, New York, 1985, pp. 11, 238, ill. pp. 238–39 (color; detail and overall); Gary Tinterow et al., *The Metropolitan Museum of Art: Modern Europe*, New York, 1987, p. 73, fig. 52 (color); Margrit Hahnloser-Ingold and Charles S. Moffet et al., *The Passionate Eye: Impressionist and Other Master Paintings from the Collection of Emil G. Bührle, Zurich*, exh. cat., National Gallery of Art, Washington, D.C., Zurich, 1990, pp. 188, 242 n. 4 under no. 67

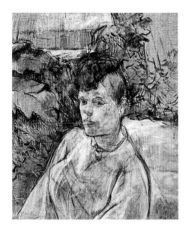

Woman in the Garden of Monsieur Forest
1889–91
Oil on canvas
21⅞ x 18¼ in. (55.6 x 46.4 cm)
Signed (lower left): HTLautrec [HTL in monogram]
Bequest of Joan Whitney Payson, 1975
1976.201.15
See no. 115

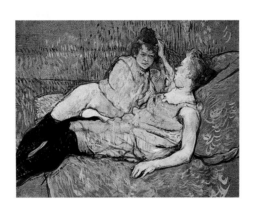

The Sofa
ca. 1894–96
Oil on cardboard
24¾ x 31⅞ in. (62.9 x 81 cm)
Stamped (lower left): HTL [monogram]
Rogers Fund, 1951
51.33.2
See no. 116

PROVENANCE
Eugène-Guillaume Boch (bought from the artist; until d. 1941); his widow, Mme Eugène-Guillaume Boch (from 1941–her d.; sold by her estate to a private collector); private collection (sold to Brame); [Hector Brame, Paris, until 1951; sold May 2, 1951, for $42,000 to Payson]; Joan Whitney Payson, New York and Manhasset (1951–d. 1975)

EXHIBITIONS
"Toulouse-Lautrec," Musée de l'Orangerie, Paris, May ?–August 8, 1951, no. 22; "Toulouse-Lautrec," Philadelphia Museum of Art, October 29–December 11, 1955, Art Institute of Chicago, January 2–February 15, 1956, no. 18; "Toulouse-Lautrec: Paintings, Drawings, Posters, and Lithographs," Museum of Modern Art, New York, March 20–May 6, 1956, no. 11; "Henri de Toulouse-Lautrec: A Loan Exhibition," Municipal Art Gallery, Los Angeles, May 27–June 28, 1959; "Toulouse-Lautrec: Paintings," Art Institute of Chicago, October 4–December 2, 1979, no. 40; "Toulouse-Lautrec in The Metropolitan Museum of Art," Metropolitan Museum of Art, New York, July 2–September 29, 1996, unnumbered cat.; "Toulouse-Lautrec: Uno sguardo dentro la vita," Museo Centrale del Risorgimento, Rome, October 10, 2003–February 8, 2004, no. I.13

PROVENANCE
Robert Duplan; Dr. Jacques Soubies, Paris (until 1928; his sale, Hôtel Drouot, Paris, June 14, 1928, no. 90, for Fr 141,000 to Druet); P. Druet, Paris (1928); Albert S. Henraux, Paris (1928–at least 1938); Chabert, Switzerland; [Wildenstein, New York, until 1951; sold to the Metropolitan Museum]

EXHIBITIONS
"Exposition H. de Toulouse-Lautrec," Musée des Arts Décoratifs, Paris, April 9–May 17, 1931, no. 114; "L'Impressionnisme," Palais des Beaux-Arts, Brussels, June 15–September 29, 1935, no. 92; "Toulouse-Lautrec: Paintings and Drawings," M. Knoedler and Co., London, January 19–February 2, 1938, no. 18; "Toulouse-Lautrec, 1864–1901," Knoedler, Paris, March 1938, no. 23; "Toulouse-Lautrec," Philadelphia Museum of Art, October 29–December 11, 1955, Art Institute of Chicago, January 2–February 15, 1956, no. 49; "Toulouse-Lautrec: Paintings, Drawings, Posters, and Lithographs," Museum of Modern Art, New York, March 20–May 6, 1956, no. 28; "Toulouse-Lautrec," Wildenstein, New York, February 7–March 14, 1964, no. 37; "Centenaire de Toulouse-Lautrec," Palais de la Berbie, Albi, June–September 1964, Musée du Petit Palais, October–December 1964, no. 56;

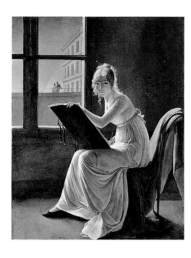

Marie-Denise Villers
French, 1774–1821

Young Woman Drawing
1801
Oil on canvas
63½ x 50⅝ in. (161.3 x 128.6 cm)
Mr. and Mrs. Isaac D. Fletcher Collection, Bequest of
Isaac D. Fletcher, 1917
17.120.204
See no. 1

PROVENANCE
Val d'Ognes family; Commandant Hardouin de
Grosville (by 1897–1912; sold to Wildenstein);
[Wildenstein, Paris, 1912; sold to Rothschild]; baron
Maurice de Rothschild, Paris (1912–15; sold to
Wildenstein); [Wildenstein, Paris and New York,
1915–16; sold to Fletcher]; Mr. and Mrs. Isaac D.
Fletcher, New York (1916–his d. 1917)

EXHIBITIONS
Salon, Paris, 1801, no. 338 (among the paintings
included under this number); "Portraits de femmes
et d'enfants," École des Beaux-Arts, Paris, April 30,
1897–?, no. 44; "Diamond Jubilee Exhibition:
Masterpieces of Painting," Philadelphia Museum of
Art, November 4, 1950–February 11, 1951, no. 49;
"Art Treasures of the Metropolitan," Metropolitan
Museum of Art, New York, November 7, 1952–
September 7, 1953, no. 138; "The Painter's Light,"
Metropolitan Museum of Art, New York, October 5–
November 10, 1971, no. 11; "100 Paintings from the
Metropolitan Museum," State Hermitage Museum,
Leningrad [St. Petersburg], May 15–June 20, 1975,
Pushkin State Museum of Fine Arts, Moscow, August
28–November 2, 1975, no. 54; "In Quest of
Excellence: Civic Pride, Patronage, Connoisseurship,"
Center for the Fine Arts, Miami, January 14–April 22,
1984, no. 92

SELECTED REFERENCES
Maurice Tourneux, "L'Exposition des portraits de
femmes et d'enfants," *Gazette des beaux-arts* 17,
June 1897, 3e pér., pp. 457–58; Charles Saunier,
Louis David, Paris, 1904, p. 55, ill. p. 97; "The Mr.
and Mrs. Isaac D. Fletcher Collection," *Metropolitan
Museum of Art Bulletin* 13, March 1918, pp. 59–60,
ill. on cover; W. R. Valentiner, *Jacques Louis David
and the French Revolution*, New York, 1929, frontis.;
Richard Cantinelli, *Jacques-Louis David, 1748–1825*,
Paris, 1930, p. 117, no. 183; G. L. McCann, "A
Portrait by David," *Bulletin of the Cincinnati Art
Museum* 4, April 1933, p. 60; Gaston Brière, "Sur
David portraitiste," *Bulletin de la Société de l'Histoire
de l'Art Français*, année 1945–46, 1948, p. 174;

Henry S. Francis, "A Portrait by Jacques Louis David,"
Bulletin of the Cleveland Museum of Art 32, June
1945, p. 84; Douglas Cooper, "Jacques-Louis David:
A Bi-Centenary Exhibition," *Burlington Magazine* 90,
October 1948, p. 277; André Maurois, *J.-L. David*,
Paris, 1948, unpaginated; Charles Sterling, "Sur un
prétendu chef-d'oeuvre de David," *Bulletin de la
Société de l'Histoire de l'Art Français*, 1951, pp.
118–30, ill.; Charles Sterling, "A Fine 'David'
Reattributed," *Bulletin of the Metropolitan Museum
of Art* 9, January 1951, pp. 121, 123–32, ill. (whole
and detail); James Thrall Soby, "A 'David'
Reattributed," *Saturday Review*, March 3, 1951,
pp. 42–43; Theodore Rousseau Jr., "A Guide to the
Picture Galleries," *Metropolitan Museum of Art
Bulletin* 12, January 1954, n.s., part 2, pp. 6, 42, ill.;
Charles Sterling, *The Metropolitan Museum of Art:
A Catalogue of French Paintings*, 3 vols., New York,
1955–67, vol. 1, pp. 196–200, ill.; René Verbraeken,
*Jacques-Louis David jugé par ses contemporains et
par la postérité*, Paris, 1973, pp. 15, 19–20 n. 54;
Ann Sutherland Harris et al., *Women Artists: 1550–
1950*, exh. cat., Los Angeles County Museum of Art,
New York, 1976, p. 207; Germaine Greer, *The
Obstacle Race: The Fortunes of Women Painters and
Their Work*, New York, 1979, pp. 142–43, 215,
colorpl. 16; Rozsika Parker and Griselda Pollock, *Old
Mistresses: Women, Art and Ideology*, New York,
1981, p. 106, fig. 60; Georges Bernier, *Consulat–
Empire–Restauration: Art in Early XIX Century France*,
exh. cat., Wildenstein, New York, 1982, p. 90; Amy
M. Fine, "Césarine Davin-Mirvault: 'Portrait of Bruni'
and Other Works by a Student of David," *Woman's
Art Journal* 4, spring/summer 1983, p. 16; Whitney
Chadwick, *Women, Art, and Society*, London, 1990,
pp. 22–24, fig. 7; Margaret A. Oppenheimer, "Nisa
Villers, née Lemoine (1774–1821)," *Gazette des
beaux-arts* 127, April 1996, pp. 166, 170–72, 176,
fig. 2; Margaret A. Oppenheimer, *Women Artists in
Paris, 1791–1814*, unpublished Ph.D. dissertation,
Institute of Fine Arts, New York University, 1996,
pp. 281, 309, fig. 259; Frances Borzello, *Seeing
Ourselves: Women's Self-Portraits*, New York, 1998,
pp. 86–87, ill.; Liana De Girolami Cheney, Alicia
Craig Faxon, and Kathleen Lucey Russo, *Self-Portraits
by Women Painters*, Aldershot, England, 2000,
pp. 128–30, fig. 23 (color); Astrid Reuter, *Marie-
Guilhelmine Benoist: Gestaltungsräume einer
Künstlerin um 1800*, Berlin, 2002, pp. 229,
231–32, ill.

Édouard Vuillard
French, 1868–1940

Self-Portrait with a Friend
1889
Oil on canvas
36½ x 28½ in. (92.7 x 72.4 cm.)
Signed (lower left): E. Vuillard
Gift of Alex M. Lewyt, 1955
55.173
See no. 117

PROVENANCE
Ker Xavier Roussel, the artist's brother-in-law, Paris
(possibly upon Vuillard's death in 1940–d. 1944); his
son, Jacques Roussel, Paris (by 1944–likely 1949; to
Salz); [Sam Salz, New York, 1948/49–February 3,
1953; sold to Lewyt]; Alex M. Lewyt, New York
(1953–55)

EXHIBITIONS
"Vuillard," Galerie Charpentier, Paris, 1948, no. 4;
"Édouard Vuillard," Kunsthalle, Basel, March 26–
May 1, 1949, no. 35; "Great Portraits by Famous
Painters," Minneapolis Institute of Arts, November 13–
December 21, 1952, no. 46; "Édouard Vuillard,"
Cleveland Museum of Art, January 26–March 14,
1954, Museum of Modern Art, New York, April 6–
June 6, 1954, unnumbered cat.; "Treasures from The
Metropolitan Museum of Art: French Art from the
Middle Ages to the Twentieth Century," Yokohama
Museum of Art, March 25–June 4, 1989, pl. 153;
"The Intimate Interiors of Édouard Vuillard,"
Museum of Fine Arts, Houston, November 18, 1989–
January 29, 1990, Phillips Collection, Washington,
D.C., February 17–April 29, 1990, Brooklyn Museum,
May 18–July 30, 1990, colorpl. 1; "Édouard Vuillard,"
National Gallery of Art, Washington, D.C., January
19–April 20, 2003, Museum of Fine Arts, Montreal,
May 15–August 24, 2003, Galeries Nationales du
Grand Palais, Paris, September 23, 2003–January 4,
2004, Royal Academy of Arts, London, January 31–
April 18, 2004, no. 1

SELECTED REFERENCES
Claude Roger-Marx, *Vuillard et son temps*, Paris,
1946, p. 26 (ill.); Claude Roger-Marx, *Vuillard: His
Life and Work*, New York, 1946, pp. 26 (ill.), 83;
Charles Sterling and Margaretta M. Salinger, *French
Paintings: A Catalogue of the Collection of The
Metropolitan Museum of Art*, 3 vols., New York,
1955–67, vol. 3, pp. 212–13, ill.; Theodore Rousseau
Jr., "New Accessions of Paintings," *Metropolitan
Museum of Art Bulletin* 14, no. 8, April 1956,
pp. 198–99, ill.; Stuart Preston, *Édouard Vuillard*,
New York, 1971, fig. 2; John Russell, "The Vocation

of Édouard Vuillard," in *Édouard Vuillard, 1868–1940*, London, 1971, p. 16; Lucy Oakley, *Édouard Vuillard*, New York, 1981, pp. 5, 17, colorpl. 1; Patricia Ciaffa, *The Portraits of Édouard Vuillard*, Ph.D. dissertation, Columbia University, New York, Ann Arbor, 1985, pp. 91–100, fig. 8; Belinda Thomson, *Vuillard*, Oxford, 1988, p. 16, colorpl. 6; Michel Makarius, *Vuillard*, Paris, 1989, p. 82, ill.; Nancy Ellen Forgione, *Édouard Vuillard in the 1890s: Intimism, Theater, and Decoration*, Ph.D. dissertation, Johns Hopkins University, Baltimore, Ann Arbor, 1992, pp. 96, 114–16, fig. 50; Gloria [Lynn] Groom, *Édouard Vuillard Painter-Decorator, Patrons and Projects, 1892–1912*, New Haven and London, 1993, pp. 6–7, colorpl. 6; Antoine Salomon and Guy Cogeval, with the collaboration of Mathias Chivot, *Vuillard, The Inexhaustible Glance: Critical Catalogue of Paintings and Pastels*, 3 vols., Milan and Paris, 2003, vol. 1, pp. 61–62, no. I-97, color ill.

At Table
1893
Oil on cardboard
11½ x 10 in. (29.2 x 25.4 cm)
Initialled and dated (lower left): ev 93
Bequest of Scofield Thayer, 1982
1984.433.25
See no. 118

PROVENANCE
Roger Marx, Paris (acquired from the artist; his sale, Galerie Manzi, Joyant & Cie, May 11–12, 1914, no. 89, for Fr 2,900); Alphonse Kann, Paris; [Galerie Druet, Paris, until ca. 1920, possibly stock no. 10193]; Scofield Thayer, New York (ca. 1920–d. 1982; on view at the Worcester Art Museum as part of the Dial Collection, 1931–82)

EXHIBITIONS
"Original Paintings, Drawings, and Engravings being Exhibited with the Dial Folio, 'Living Art'," Montross Gallery, New York, January 26–February 14, 1924, no. 42; "Exhibition of the Dial Collection of Paintings, Engravings, and Drawings by Contemporary Artists," Worcester Art Museum, Mass., March 5–March 30, 1924, no. 36; ["The Dial Collection"], Hillyer Art Gallery, Smith College, Northampton, Mass., spring 1924, no catalogue; "Loan Exhibition of Paintings and Prints by Pierre Bonnard and Édouard Vuillard," Art Institute of Chicago, December 15, 1938–January 15, 1939, no. 29; "Paintings by Édouard Vuillard," Phillips Memorial Gallery, Washington, D.C., January 22–

February 22, 1939, no. 10; "'La Vie Française,' An Exhibition of Paintings Chiefly by Pierre Bonnard and Édouard Vuillard, for the Benefit of American Relief for France," Institute of Modern Art, Boston, October 6–November 11, 1944, no. 22; "Modern French Masters," Columbus [Ohio] Gallery of Fine Arts, November 20–December 31, 1952; Akron [Ohio] Art Institute, January 13–February 16, 1953, Worcester Art Museum, Mass., March 5–April 12, 1953, no. 36; "The Dial and The Dial Collection," Worcester Art Museum, Mass., April 30–September 8, 1959, no. 84; "Selections from The Dial Collection," Worcester Art Museum, Mass., November 13–30, 1965, no catalogue; "The Dial Revisited," Worcester Art Museum, Mass., June 29–August 22, 1971, no catalogue; "The Dial: Arts and Letters in the 1920s," Worcester Art Museum, Mass., March 7–May 10, 1981, no. 146

SELECTED REFERENCES
The Dial 79, no. 3, September 1925, colorpl. 31 opp. p. 179; Nicholas Joost, *Scofield Thayer and The Dial, An Illustrated History*, Carbondale and Edwardsville, Ill., 1964, plate section, n.p., ill.; Patricia Ciaffa, *The Portraits of Édouard Vuillard*, Ph.D. dissertation, Columbia University, New York, Ann Arbor, 1985, pp. 135–36, fig. 44; Antoine Salomon and Guy Cogeval, with the collaboration of Mathias Chivot, *Vuillard, The Inexhaustible Glance: Critical Catalogue of Paintings and Pastels*, 3 vols., Milan and Paris, 2003, vol. 1, p. 275 no. IV-87, color ill.

Luncheon
1901
Oil on cardboard
8¾ x 17 in. (22.2 x 43.2 cm)
Signed (upper right): E.Vuillard
Bequest of Mary Cushing Fosburgh, 1978
1979.135.28
See no. 119

PROVENANCE
[Bernheim-Jeune, Paris, purchased from the artist on October 17, 1903, for Fr 200, stock no. 13378; sold same day for Fr 200 to Bernheim]; Alexandre Bernheim, Paris (from October 17, 1903); Émile Laffargue, Paris; Mr. and Mrs. Paul Rosenberg, New York (by 1943); Mrs. Vincent (Mary Cushing) Astor, later Mrs. James W. Fosburg, New York (1943–d. 1978)

EXHIBITIONS
"Oeuvres de Bonnard et Vuillard provenant de collections particulières," Paul Rosenberg, Paris, December 2–31, 1936, no. 28; "Édouard Vuillard," Cleveland Museum of Art, January 26–March 14, 1954, Museum of Modern Art, New York, April 7–June 6, 1954, unnumbered cat.; "Paintings,

Drawings, and Sculpture Collected by Yale Alumni," Yale University Art Gallery, New Haven, May 19–June 26, 1960, no. 67

SELECTED REFERENCES
Antoine Salomon and Guy Cogeval, with the collaboration of Mathias Chivot, *Vuillard, The Inexhaustible Glance: Critical Catalogue of Paintings and Pastels*, 3 vols., Milan and Paris, 2003, vol. 2, p. 622, no. VII-155, color ill.

261